DIARY OF THE CAVALIERE BERNINI'S VISIT TO FRANCE

PAUL FRÉART DE CHANTELOU

❦ *Diary of the* ❦
Cavaliere Bernini's Visit to France

EDITED AND WITH AN INTRODUCTION BY ANTHONY BLUNT
ANNOTATED BY GEORGE C. BAUER
TRANSLATED BY MARGERY CORBETT

PRINCETON UNIVERSITY PRESS

Publication of this book has been aided by a grant from
the Ira O. Wade Fund of Princeton University Press

This book has been composed in Linotron Bembo

Clothbound editions of Princeton University Press books
are printed on acid-free paper, and binding materials
are chosen for strength and durability. Paperbacks,
although satisfactory for personal collections,
are not usually suitable for library rebinding

Printed in the United States of America
by Princeton University Press
Princeton, New Jersey

352835

❧ *Contents* ❧

❧ *List of Illustrations* ❧

FOLLOWING PAGE 338

FIGURE 1
Gian Lorenzo Bernini, *Self Portrait*, drawing.
Royal Library, Windsor Castle
(Copyright reserved. Reproduced by gracious permission
of Her Majesty Queen Elizabeth II)

FIGURE 2
Robert Nanteuil, *Portrait of Jean-Baptiste Colbert*, engraving.
New York, The Metropolitan Museum of Art, Gift of Carl J.
Weinhardt, Jr., 1958 (58.558.1)

FIGURE 3
Robert Nanteuil, *Portrait of Louis XIV*, engraving.
New York, The Metropolitan Museum of Art,
Rogers Fund, 1920 (20.13.1)

FIGURE 4
Gian Lorenzo Bernini, *Louis XIV*, marble bust.
Versailles (Alinari, Florence)

FIGURE 5
Gian Lorenzo Bernini, First Project for the Louvre,
Plans of the Ground and First Floors, drawing.
Paris, Musée du Louvre, Cabinet des Dessins

FIGURE 6
Gian Lorenzo Bernini, First Project for the Louvre,
Design for the East Façade, drawing.
Paris, Musée du Louvre, Cabinet des Dessins

FIGURE 7
Gian Lorenzo Bernini, Second Project for the Louvre,
Design for the East Façade, drawing.
Stockholm, Nationalmuseum (Museum photo)

FIGURE 8
Gian Lorenzo Bernini, Third Project for the Louvre,
Plan of the Ground Floor, engraving by Jean Marot.
New York, The Metropolitan Museum of Art (Museum photo)

[*vii*]

LIST OF ILLUSTRATIONS

FIGURE 9

Gian Lorenzo Bernini, Third Project for the Louvre,
Design for the East Façade, engraving by Jean Marot.
New York, The Metropolitan Museum of Art (Museum photo)

FIGURE 10

Gian Lorenzo Bernini, Third Project for the Louvre,
Design for the West Façade, engraving by Jean Marot.
New York, The Metropolitan Museum of Art (Museum photo)

FIGURE 11

Gian Lorenzo Bernini, Third Project for the Louvre,
Design for the Courtyard Façade, engraving by Jean Marot.
New York, The Metropolitan Museum of Art (Museum photo)

FIGURE 12

Gian Lorenzo Bernini, Third Project for the Louvre,
Design for the South Façade, engraving by Jean Marot.
New York, The Metropolitan Museum of Art (Museum photo)

FIGURE 13

Gian Lorenzo Bernini, Third Project for the Louvre, Design for the
Junction of the South Façade with the Existing Building, drawing.
Paris, Musée du Louvre, Cabinet des Dessins

FIGURE 14

Gian Lorenzo Bernini, Fourth Project for the Louvre,
Plan of the First Floor, drawing.
Paris, Musée du Louvre, Cabinet des Dessins

FIGURE 15

Gian Lorenzo Bernini, Fourth Project for the Louvre, Design for
the East Façade, drawing after Mattia de' Rossi's large model.
Stockholm, Nationalmuseum (Museum photo)

FIGURE 16

Louis Le Vau, South Façade of the Louvre,
engraving by Jean Marot.
New York, The Metropolitan Museum of Art (Museum photo)

FIGURE 17

Plan of the Abbey Church of Saint-Denis,
engraving from Michel Felebien, *Histoire de l'abbaye royale
de Saint-Denys en France*, Paris, 1706

[*viii*]

FIGURE 18
Gian Lorenzo Bernini, Two Projects for the
Bourbon Chapel at Saint-Denis, drawing.
Stockholm, Nationalmuseum (Museum photo)

FIGURE 19
Paolo Bernini, *The Christ Child Playing with a Nail for the Cross*,
marble sculpture.
Paris, Musée du Louvre

FIGURE 20
Gian Lorenzo Bernini, *The Penitent St. Jerome*, drawing.
Paris, Musée du Louvre, Cabinet des Dessins

✿ *Foreword* ✿

✿ This translation of Chantelou's *Journal du voyage du Cavalier Bernin en France* is based on the text published by Ludovic Lalanne in a series of articles in the *Gazette des Beaux-Arts* from 1877 to 1884, which were republished in a single volume, now very rare, in 1885. Lalanne's edition was based on a manuscript that he discovered in the library of the Institut de France, which is a copy, made at the order of Chantelou for his brother, Jean, of his own original version of the diary, which has disappeared. A new edition of the Institut manuscript with full critical apparatus is in preparation, but it was thought worthwhile to produce an English translation of the text, since it is of importance not only for specialists in the history of 17th-century art but for those interested in the social history of France in the same period. Though Chantelou is mainly concerned with Bernini's activities as an artist, he also records, with great vividness, many details about life at the court—and in Paris—at a period about which we are otherwise not well informed (the memoirs of Saint-Simon, Dangeau, and others do not begin till later).

The translation was originally planned by the late Rudolf Witt-kower in the years before and during the Second World War with the assistance of Margery Martin, now Margery Corbett. Wittkower was, however, later distracted from it by other occupations and it was not till recently that Mrs. Corbett took up the project again and completed the translation. Her text, edited by Professor Anthony Blunt, is the basis of the present volume.

The translation has been kept as literal as is consistent with modern usage. Certain simplifications have been introduced. For instance, all measurements, which in the text are given in *toises* or *pieds*, are given in feet, irrespective of the fact that the French *pied* in the 17th century was slightly bigger than the English foot. No attempt has been made to convert currency into modern terms because, given the present fluctuation of monetary values, any such conversion would be out of date before this book was published. The relative values of the sou, livre, crown, and pistole, the principal units of currency in France in the 17th century, are as follows:

$$\text{I LIVRE} = \text{20 SOUS}$$
$$\text{I CROWN (ÉCU)} = \text{3 LIVRES}$$
$$\text{I PISTOLE} = \text{10 LIVRES}$$
$$\text{I LOUIS D'OR} = \text{11 LIVRES}$$

Problems arise, however, over the manner in which members of the nobility were referred to in France in the 17th century. As far as possible these have been translated in forms which, it is hoped, will make them intelligible; for instance, when Chantelou simply refers to a group of courtiers as "MM. de . . . ," in the translation they have been given their precise titles of duc, marquis, bishop, etc., thus in many cases avoiding the need for the reader to refer to the explanatory footnote. A particular problem arises, however, over the way in which members of the royal family are referred to. The King's only brother, Philippe, duc d'Orléans, was known as "Monsieur," and had the appellation of His Royal Highness (abbreviated by Chantelou to "S.A.R.," "son altesse royale"; his cousin, the prince de Condé, who was first prince of the blood, was known as "Monsieur le Prince," and had the appellation of "His Highness" (abbreviated to "S.A.," "son altesse"); his son, the duc d'Enghien, was known as "Monsieur le Duc" and was also "His Highness." At the risk of losing some of the flavor of the original, these members of the Royal Family are referred to here on their first mention on any occasion by what seemed their most intelligible titles: the duc d'Orléans, the prince de Condé, and the duc d'Enghien. In the same way "Madame," wife of "Monsieur," is referred to as the duchesse d'Orléans.

In some passages Chantelou's text is not easy to follow. There is one sentence in which the word *il* occurs six times, apparently referring to four different persons or things, and in these cases the translators have produced what they believe is the most convincing version. In a few cases the text is manifestly corrupt, either because Lalanne misread it or because Chantelou's scribe miscopied it; in most of these cases it is possible to reconstruct what was probably the original text, but wherever this has been done the fact is recorded in a footnote. Where there are dots in the text here printed it means that there are gaps in the manuscript.

As it is hoped that this book will be read by people of varied interests, the notes are based on the assumption that different readers may need explanations of different kinds. So for instance, the art historian should not feel insulted if he is told who Annibale Carracci is, and the historian of France should not object to being reminded that the Queen Mother was Anne of Austria! Individual works of art mentioned by Chantelou are listed in the index under the names of the artists concerned.

The annotations, the index, and Appendixes B and C have been provided by George C. Bauer of the University of California, Irvine,

and incorporate the notes of Lalanne and the suggestions of Margery Corbett, which included some notes left by Rudolf Wittkower. Anthony Blunt is responsible for the Postscript and Appendix A, as well as a few of the notes.

A. B.

✿ *Introduction* ✿

✿ On 2 June 1665, Paul Fréart de Chantelou, one of the *maîtres-d'hôtel* (or stewards) at the court of the young King Louis XIV, drove out of Paris in a coach-and-six put at his disposal by the King's first minister, Jean-Baptiste Colbert, to greet the Cavaliere Gian Lorenzo Bernini, who had been invited to France to work for the King. Chantelou met Bernini at Juvisy, some dozen miles south of the city, conveyed the King's greetings, and drove him to the house near the Louvre that had been allotted to him as lodgings. For the next five months, till Bernini's departure from Paris on 20 October, Chantelou was the artist's constant companion and guide and he wrote a day-by-day diary of everything that took place.

The choice of Chantelou, whether it was made by the King or by Colbert, was a wise one. He came from a family of minor nobility from the province of the Maine and had made a career in the civil service as secretary to his cousin, François Sublet de Noyers, who had been Secretary of State for War and surintendant des bâtiments (Minister of Works) under Richelieu in the last years of Louis XIII's reign. One of his missions had been to Rome where he was sent in 1640 to bring back to France Nicolas Poussin, whom Louis XIII had invited to work for him. He became a close friend of the artist whose letters to him remain the most important source about Poussin's later career.

The death of Richelieu at the end of 1642, followed a few months later by that of the King, led to drastic changes in the administration. De Noyers was dismissed and Chantelou went into retirement, in which, however, he continued to develop his interest in the arts and to enlarge his collection, which soon included the most important group of paintings by Poussin, which Bernini saw and greatly admired on his visit to Paris. Chantelou's younger brother, Roland Fréart de Chambray, was also deeply concerned with the arts and wrote two books, one called *La Perfection de la Peinture* (1662), largely in praise of Poussin, and the other *Parallèle de l'architecture antique avec la moderne* (1650) in which he laid down strict, almost pedantic, rules for the use of the classical orders in architecture. In addition he published translations of the four books on architecture of Palladio and Leonardo da Vinci's treatise on painting (1651).

In 1645, just before the death of de Noyers, Chantelou became secretary to the duc d'Enghien, better known by his later title of prince de Condé, then at the height of his fame as a military commander. Two years later, in 1647, he became maître-d'hôtel du roi, that is to

say one of the 170 members of the royal household whose business it was, under the direction of the Grand Maître or Master of the Household, to act as stewards at the royal table. He was also made comptroller of the household of the duc d'Anjou, later duc d'Orléans, the King's younger brother. These posts gave him a good position at court and brought him into regular contact with the young King, and this connection made him a candidate for the job of bear-leading Bernini, but it was primarily his knowledge of the arts that led the King in 1665 to choose him for this important and, as it turned out, difficult duty.

The primary purpose of Bernini's visit was to complete the building of the Louvre (see Appendix A). The mediaeval royal castle on the site had been pulled down in the last years of Francis I (d. 1549) who began the construction of what is now the Square Court to the designs of Pierre Lescot. His successors continued the work, though slowly, and by the time Louis XIV took over personal power on the death of Mazarin in 1661 three sides of the court were more or less finished. It remained to close the court with a wing on the east side, the outer façade of which, facing the parish church of Saint-Germain-l'Auxerrois, would form the principal approach to the palace.

The obvious choice for the completion of the work was Louis Le Vau, the official First Architect to the King, who had been engaged on the construction of the north wing since the death of Jacques Lemercier in 1654. In the early 1660s he prepared designs for the east wing but was prevented from carrying them out by the fact that in January 1664 Colbert was appointed Minister of Works and he, for reasons which are not known to us, was violently opposed to Le Vau as architect. Instead, Colbert applied to François Mansart who produced a series of highly original designs but lost the job because he refused to tie himself absolutely to any one of them. Colbert then submitted Le Vau's plans to other French architects, asking for their criticisms. Still not satisfied, he sent the plans to Rome where they were submitted to several of the leading architects including Bernini, Pietro da Cortona, and Carlo Rainaldi, who were first asked for their comments and then invited to produce alternative designs of their own. The three architects just mentioned all produced projects, to which was added one by an otherwise unknown architect called Candiani, but it soon became evident that Bernini was going to be the winner of the competition, and in due course he was officially invited to undertake the job. The Pope, Alexander VII, gave his approval, though reluctantly, because Bernini had in hand several projects to which he attached great importance, notably the *Cathedra Petri*, the

great structure put up in the apse of St. Peter's to enshrine the supposed throne of St. Peter, and the colonnade round the piazza in front of the church; but he could not afford to offend the French King who had already shown himself a powerful and dangerous opponent. He therefore gave Bernini leave of absence for three months, and the artist in fact left Rome for Paris towards the end of April. He travelled via Siena, Florence, Bologna, Milan, Turin, and over the Mont-Cenis to Chambéry. At the French border town of Pont-de-Beauvoisin he was officially received by the local authorities and from there onwards was given a splendid reception wherever he stopped. At Lyons, where he spent the night of 22 May, the city fathers gave him honors usually reserved for princes of the blood or foreign ambassadors. As we have seen, Bernini reached Paris on 2 June, after being greeted at Juvisy by Chantelou on behalf of the King.

The omens for the visit seemed good. At 67, Bernini was still at the height of his powers and of his fame. He was without question the most famous sculptor in Europe and the personal favorite of the reigning Pope. His achievement in the field of architecture was considerable. For Urban VIII he had built the façade of the little church of S. Bibiana, invented the *baldacchino* for St. Peter's, remodelled the piers of the crossing and designed various monuments in the church, including the Pope's tomb. During the pontificate of Urban's successor, Innocent X, Bernini was for a time out of favor, but he recovered his position and captured the commission for the Fountain of the Four Rivers in the piazza Navona from his rival Borromini. With the election of Alexander VII in 1655 he enjoyed even greater favor than under Urban. He embarked on the two colossal projects for St. Peter's mentioned above and added the *Scala Regia* as the grand entrance to the Vatican. For the same patron he remodelled the church of S. Maria del Popolo and built two churches outside Rome at Castel Gandolfo and Ariccia, and, for Prince Camillo Pamphili, nephew of Innocent X, he created what is perhaps his masterpiece in architecture, the church of S. Andrea al Quirinale, built for the Novitiate of the Jesuits, an Order with which he had close associations. He also had experience in the building of palaces for the great Roman families, notably the Palazzo Chigi in Piazza SS. Apostoli and the Palazzo Ludovisi (later Montecitorio) in both of which he made revolutionary innovations, which he was to incorporate into his final designs for the Louvre.

The King was young and energetic and ambitious to prove that he was the greatest monarch in Europe. True, he had no great knowledge of the arts, but he was well aware of their importance as a means

of imposing his image on the world; and in his chief minister, Colbert, he found a man capable of creating a coherent and efficient administrative system for the kingdom, and of finding the funds necessary for his ambitious building projects.

But even before Bernini reached Paris there were signs of trouble ahead. His first design had been sent from Rome in 1664, and though it had greatly impressed the King, Colbert had pointed out that from the point of view of practical convenience it had many disadvantages. This difference of attitude between the artist and the minister was to be at the bottom of all their later disagreements. Bernini—supported by the King—wanted to create a magnificent and impressive exterior; Colbert wanted the King to be given comfortable and convenient accommodation. The first plan contains another feature that was to cause trouble: we can see from the plan that Bernini intended to add a loggia running all round the courtyard and this would have largely—perhaps even completely—hidden the earlier façades of which the French were not unnaturally proud. This matter was later to be frequently mentioned in discussions between the King and the architect, and though in the end the former gave in, it was clear that he did so reluctantly.

Bernini was furious at Colbert's criticisms, but sent a second modified design of which unfortunately no plan is known. Colbert sent further criticisms. It is not known whether these reached Rome before Bernini left, but if they did not, they would certainly have been conveyed to him by Colbert after he had reached Paris. As a result Bernini produced a third design quite different from the first two, which was to be the basis of all the discussions among the King, the architect, and the minister while Bernini was actually in Paris, though further small modifications were introduced.

Externally, the last design is entirely different from the first two, in which the east façade was based on curves—convex and concave in the first, concave in the second. This third design is a massive, almost cubical, block with surfaces in a single plane broken only slightly by projections and by half-columns and pilasters. Although it was never actually built, this design was to have a wide influence through the engravings after it that were prepared by Jean Marot at Bernini's request just before he left Paris. It became a model of what a royal palace should be and was to affect the design of such buildings, from Hampton Court—built by Louis's greatest enemy, William III of England—to the royal palace at Stockholm, built in the mid-18th century, and it is perhaps not fanciful to see traces of its influence in the façade added to Buckingham Palace by Aston Webb in 1909.

In addition to temperamental incompatibility with Colbert, Bernini had to contend with the jealousy of Parisian architects. François Mansart seems to have kept to himself; indeed, although he does not seem to have met Bernini, he is recorded by Chantelou as approving of his designs for the Louvre and for the *baldacchino* for the Val-de-Grâce, both projects over which the Frenchman might reasonably have felt a certain jealousy. Naturally, however, Louis Le Vau and the other architects who had offered designs for the Louvre had their noses put out of joint. Their opposition was stimulated and up to a point orchestrated by Charles Perrault, Colbert's chief assistant in connection with the royal buildings, and his brother Claude, a doctor of medicine, who already had ambitions as an architect and was later to play a crucial part in designing the Colonnade, that is to say, the east façade of the Louvre actually built after Bernini's design had been abandoned.

The last ingredient in the cauldron that the witches were brewing was the character of Bernini himself. He was acknowledged as the artistic dictator in Rome; even his rivals, such as Borromini or Pietro da Cortona, could not deny his supremacy in public opinion, however much they might disagree with his ideas and sometimes with his methods of achieving success. He was cultivated—he wrote verse and produced plays—charming, and a good talker, and above all he had immense self-confidence. Add to this that, like all Italians of the period, he despised French art, and particularly French architecture; in painting he made an exception for Poussin, whose works in Chantelou's house he greatly admired, leading the King to say when he heard about it: "At least he's praised something in France!" He made no attempt to conceal his opinions, and even over matters of construction connected with the foundations of the Louvre he constantly compared French methods unfavorably with those to which he was accustomed in Rome, and insisted on having workmen sent from Italy, saying that they were the only people he could trust.

Gradually the opposition built up. In Chantelou's account we can follow the increasing anxiety that Bernini felt about the Louvre project. Rumors reached him that his enemies were whispering criticisms of his plans to the King; worse, that the King was listening to them. The tension was increased by constant disagreements with Colbert, who wanted him to consider practical points such as the placing of kitchens or accommodation for the offices of the court or security from possible assassination, all things which Bernini felt were beneath his dignity as an artist—and said so in terms that gave great offence.

In spite of all these difficulties, however, the King continued to give Bernini his support, believing that, whatever disadvantages his

plans might have, the palace that he proposed would be the finest visible expression of his greatness as a monarch. In spite of this and in spite of the ceremonial laying of the foundation stone on 17 October, it must have been obvious by this time to everyone—except Bernini and possibly the King—that his project would never be carried out. At the end, the situation became so tense that at one point Bernini threatened to leave for Rome without having a final audience with the King. He was eventually convinced—though with great difficulty—that this would only be playing into the hands of his enemies.

But the Louvre was not the only project on which Bernini was engaged while in Paris. At a fairly early stage in the visit it was suggested that he should make a marble bust of the King, and he took up the idea with enthusiasm, the more so as the working out of the plans for the Louvre could in great part be left to his assistants. The bust, now at Versailles, is the one tangible result of Bernini's visit to Paris, and the account given by Chantelou of its inception and execution is one of the most fascinating parts of the diary. Not only does it throw much light on Bernini's methods in conceiving and executing a piece of sculpture, but it also gives a vivid picture of the surprisingly intimate relationship built up between the King and the sculptor, and of the character and behavior of Louis's courtiers. The King gave the sculptor every opportunity of studying him as he wanted. Bernini was able to watch him walking about and talking to his courtiers; he saw him playing tennis; he was allowed to attend meetings of the royal council and to be present when the King was receiving ambassadors; it was even suggested at one point that he might observe him while at Mass. When it came to the stage of actual sittings, the King was again amenable. The courtiers were shocked when the artist sat on the floor in order to see the royal face from below, but the King only smiled, and Chantelou notes in his diary that Bernini's action was logical because the bust would be seen from below when it was given its final position.

Chantelou's account of these sittings, when the King always arrived—to the exasperation of the artist—accompanied by a group of attendants, sometimes large enough to make it necessary to open more windows, and of the visits paid by members of the court, who clearly felt that they could invade the artist's studio at will, provide interesting sidelights on the life of the court at that time. The dominant theme is the stupidity of the comments made by the visitors about the bust. Most simply expressed astonishment at the likeness—one even said he would have recognized the King from a back view; others, slightly more highbrow, praised the artist for the way in which he had put

into the bust the nobility of the subject and the idea of kingship. Yet others, showing erudition, employed a more subtle kind of flattery, saying that the bust reminded them of ancient representations of Alexander, a hero with whom Louis was known to like comparison. One even went so far as to compare it with the head of Jupiter. Others ventured to criticize details: the nose was too broad at the bottom, the cheeks were not exactly symmetrical. Bernini—presumably—listened and Chantelou certainly recorded these comments, but there is no reason to think that they exercised any influence on the execution of the bust.

The only other major project on which Bernini was consulted by the King was a mausoleum for the Bourbon dynasty to be added to the royal abbey of Saint-Denis, where it was to outshine the Valois chapel where the members of the previous dynasty were buried but which had never been completed and was in danger of collapsing. Bernini produced a plan for a new chapel and also an alternative scheme for putting the tombs of the Bourbon kings round the choir of the mediaeval church, but nothing was done about either scheme.

Others, however, wanted his advice on all sorts of projects. The Queen Mother, Anne of Austria, widow of Louis XIII, asked his help over the *baldacchino* for the church of the Val-de-Grâce, a convent to which she had a particular attachment. "Monsieur," the King's brother, wanted a design for a cascade in the gardens of his château of Saint-Cloud; the commandeur de Souvré hoped he would be able to tidy up the mediaeval buildings of the Temple, which was his official residence; the duchesse d'Aumont was having difficulties over the staircase in her Paris house; and monsieur de Lionne—and more particularly his rather pushy wife—hoped to get advice about the house which Louis Le Vau had designed for them and which was still in building.

In almost every case the result was frustration. Bernini's comments on the designs proposed by local architects were outspoken and were no doubt immediately relayed to those concerned. On the other hand he complained that, after he had taken a good deal of trouble to give advice or produce alternative designs, both his advice and his designs were ignored.

Bernini was also asked by the King and Colbert to visit certain institutions not directly connected with architecture. He paid two visits to the Gobelins where he admired the tapestries and praised the designs of Le Brun, partly, no doubt, because he knew that whatever comments he made would be passed on to the artist and to the King; but on a later occasion he said to Chantelou that one of Poussin's *Sacra-*

ments, which he had seen in his house, was worth more than all the big pictures that he had been shown at the Gobelins. He also paid a long visit to the academy of painting and sculpture where he enunciated to the members and the students a series of propositions that were little more than the commonplaces of current art criticism, and made one or two practical suggestions, such as that it was unwise to work in summer by the light of a lantern because it merely increased the heat of the studio. The King also asked Bernini's advice about the academy that he proposed to found in Rome for the training of young artists and asked him whether he would agree to give guidance to any sculptors who came there. Bernini promised to do so, but when the academy was actually set up in 1667 he rarely put in an appearance, no doubt partly because his relations with the French were by that time embittered owing to the failure of the Louvre project.

During his stay, Bernini was taken by Chantelou to see a number of the most important buildings recently erected there. In the 16th-century buildings he found little to praise. When shown the château de Madrid he only remarked it was a pity that so much money had been spent on building in France. The Tuileries Palace he described as "una grande picciola cosa," "a big little thing." At the Val-de-Grâce he criticized the relation of the dome to the body of the church; he particularly disliked the design of the *baldacchino* which Le Duc had produced, but he avoided criticizing it because he noticed that the architect was touchy. The one feature of which he really approved was Mignard's painting of the dome. Can he have been partly encouraged to this view by the fact that the artist was the declared enemy of Le Brun, Colbert's favorite? At Versailles—still the little château built by Louis XIII with only small additions by his son—he was more cautious, partly no doubt for fear of offending the King, but partly, perhaps, because he was shown round by Le Nôtre, a well-known charmer, whose gardens he admired.

His recorded comments on contemporary architects are few. He seriously criticized Le Vau's hôtel de Lionne, but he was enthusiastic about the two wings that he had added to the château of Vincennes, saying that the King was better lodged there than at the Louvre—a slightly two-edged compliment. He greatly admired Antoine Lepautre's hôtel de Beauvais, particularly for the disposition and decoration of the main rooms. He admired François Mansart's hôtel de La Vrillière, but unfortunately his comments on the château of Maisons are not recorded. However, he spoke well of the architect in general, and, what is perhaps more surprising, Mansart was reported to have spoken well of him.

But it was not a matter of chance that the buildings he most admired in Paris were the most Italianate. He praised the Novitiate of the Jesuits, partly no doubt out of tact, because he knew that Chantelou and his master, Sublet de Noyers, had been largely responsible for its erection, but also because the French architect, Etienne Martellange, had taken as his model S. Maria dei Monti, one of the purest of late 16th-century Roman churches. When he and Chantelou passed in front of the Luxembourg Palace he insisted on getting out to look at it and told his son and Mattia de'Rossi that it was the most beautiful building that he had seen in France. The rustication that Salomon de Brosse had introduced at the instruction of Marie de Médicis evidently evoked in him, as it did in the Queen, memories of the Palazzo Pitti.

He was able to inspect one work in Paris by an Italian architect, the Theatine church of Sainte-Anne-la-Royale, which was being built out of funds bequeathed by Mazarin to the designs of Guarino Guarini. He was cautious in his comments, saying: "I think it will turn out well." But then Guarini was an admirer and a follower of his great personal enemy, Borromini. On his very last day in Paris he delivered his judgment on his rival: "A painter or a sculptor when they deal with architecture take as their rule for proportions those of the body of a man, whereas Borromini must have based his proportions on those of chimaeras." He was scarcely less harsh on his other rival, Pietro da Cortona, saying: "What is wrong with the designs of Cortona—who is by the way a very able man—is that when he says they may cost 500 or 600 crowns, once you were embarked on the project it would mount up to 2,000 or 3,000." As an instance of this he quoted the expense in which Cardinal Francesco Barberini had been involved by Cortona over the church and altar of S. Martina in Rome—a particularly unfair example because Cortona had himself paid for the whole of the very elaborate and expensive altar in the lower church of SS. Luca e Martina and had contributed large sums out of his own pocket to keep going the construction of the upper church during the years when the Cardinal was in exile in France and unable to make any serious contribution.

Chantelou also took Bernini to see the most important collections of paintings in Paris, and his accounts of these visits not only provide facts useful to art historians tracing the histories of individual paintings, but give a vivid impression of how the pictures were hung and how visitors actually looked at them. When they visited the duc de Richelieu's house in the place Royale, for instance, the duke was absent—mercifully, because it made it possible for the visitors to ex-

press their feelings freely. Bernini admired the collection very much, but pointed out that the sky in one painting by Titian had darkened and therefore came forward instead of receding, and complained that Poussin's *Plague at Ashdod* was hung so high that it was impossible to see it properly. At Cerisier's the pictures were brought out one by one and Bernini, who was fascinated by Poussin's self-portrait, had twice to ask for it to be left longer so that he could examine it really carefully. But the most vivid account of all is of the Cavaliere's visit to Chantelou's own house, where the deepest impression was made on him by Poussin's second series of *Sacraments*. These were normally kept covered by curtains, and when the party came into the room where they hung only one was visible. Bernini looked at them long and intently. Chantelou had some of them taken down off the wall and put near the window. Bernini knelt down to examine them, from time to time changing his spectacles to get a better focus. One has the impression that for most of the visit Bernini was silent, simply looking at the paintings, but when he did speak it was with unmeasured enthusiasm. Finally he said: "You have done me a great disservice today by showing me the genius (*virtù*) of a man who makes me realize that I know nothing."

It may seem surprising at first sight that Bernini, the great protagonist of the Baroque, should have manifested such enthusiasm for the leader of the "classical" school, but in fact this clear-cut opposition between "Baroque" and "classicism" is a modern over-simplification. Bernini and Borromini admired the works of classical antiquity as deeply as Poussin and believed themselves to be working in the tradition that the ancients had founded. The particular models which they chose among the vast range of ancient works of art may have been different, and they may have put different interpretations on them, but both parties appealed with equal confidence to antiquity for justification of their styles, and it is no surprise that Bernini in his remarks to the academy in Paris or to those, like Colbert, who were anxious to set up proper training for artists should have continually— almost monotonously—emphasized the importance of studying and copying the antique as a means of correcting the "irregularities" of nature.

From Bernini's comments on the works of art that he saw in Paris we can form a fairly clear picture of his taste. In the highest place, indeed in a category by themselves, came the ancients, though Bernini was not overly enthusiastic about the actual works of antiquity he saw in Paris. Next, almost but not quite on the same level, came Raphael who possessed "purity of drawing, skill in composition, de-

corum, grace, elegance in his draperies, correctness and discretion in placing his figures in space." Raphael was followed, in order of merit, by Annibale Carracci, who if he had lived at the same time as Raphael might have seemed a dangerous competitor. Other painters were allowed their merits, but they all had defects. The Venetians—and Veronese is the one most often mentioned—were masters of the brush but could not draw, and they had no notion of decorum, that is to say, giving a suitably noble tone to their paintings of religious or historical subjects (the Bassano family were the greatest sinners in this respect). Barocci appealed instantly to the eye, but his paintings grew steadily less satisfying as one studied them more carefully, whereas the works of Michelangelo might seem austere, almost repellant at first sight, but grew in stature as one came to know them better. No paintings had more grace than those of Guido Reni, but his drawing was sometimes faulty and his St. Sebastian did not look like a saint. Caravaggio had "neither spirit nor invention."

Poussin would have proposed almost exactly the same order of merit and would have endorsed most of the comments on individual artists. Bellori, the mouthpiece of the "classical" party in Rome, would have done the same, and this scheme lay at the basis of the doctrine of the French Academy of Painting as it was being formulated at this very time by Charles Alphonse Du Fresnoy, Fréart de Chambray, Le Brun, and André Félibien.

The *Journal* also tells us a good deal about Bernini as a man. We have already seen his arrogance in relation to the artists and works of art he encountered in France and his touchiness over any criticism of his designs, and other foibles appear. He was vain about his own inventions and praised them with almost childlike openness, adding in justification that he could do so without shame because the real inventor was not himself but God or an angel who had inspired him. He occasionally used the opposite technique of affecting modesty. Speaking on one occasion of fine works of art, he quickly added that he, of course, was incapable of producing such things, and he described the bust of Louis XIV as "his least bad portrait." He enjoyed telling stories showing the favors showered on him by the great, particularly popes Urban VIII and Alexander VII, and he loved recounting episodes from his comedies, of which he was very proud, and describing the ingenious scenic effects that he had introduced into them.

On the other hand Chantelou's account also reveals his absolute devotion to his work. Unless he was actually ill he worked on the plans for the Louvre or on the bust from the early morning until he was interrupted by business visits from Colbert or some other official,

or by casual callers who dropped in to look at the bust and might be important members of the court who could not be turned away, although they wasted much of his time. He even obtained permission from the priest of the parish in which he lived to work on Sundays or feast days, saying that when he was in Rome he had a general permission from the Pope to do so. Towards the end of his stay, when the bust was finished, he devoted some of his evenings to making drawings, which he presented to Colbert, Chantelou, and others.

These drawings were always of religious subjects, and many of them presented the great penitents—St. Jerome, St. Mary Magdalen, and St. Mary of Egypt—and these themes are rendered with the feeling of profound devotion which is characteristic of all Bernini's late religious works, such as the statue of the Blessed Ludovica Albertoni in S. Francesco a Ripa, Rome, or the *Blood of the Redeemer* known from an engraving. Bernini's piety is strongly brought out in the *Journal*. He heard Mass every day and usually visited a church in the evenings to pray, and he communicated regularly. When Chantelou took him to Saint-Germain to present him to the King, he immediately went to the chapel and prayed for a long time. Chantelou frequently accompanied him on his visits to churches, but seems generally to have sat at the back, waiting for the Cavaliere to finish his devotions, rather than sharing in them, and he was slightly shocked to notice that Bernini sometimes bent down and kissed the ground.

We know from Bernini's early biographers that he was widely read in religious literature, and while in Paris he pressed Chantelou to read Thomas à Kempis' *Imitation of Christ* and Saint François de Sales' *Introduction to Holy Life*, two of the most popular guides to a good life, and to the marquis de Ménars, Colbert's brother-in-law, he recommended the sermons of his friend, Father Oliva, General of the Jesuits. It is worth noticing that the churches that Bernini visited most frequently were those of the Feuillants, an austere body of reformed Cistercians, and the Oratoire, founded by Cardinal de Bérulle on the lines of St. Philip Neri's Oratory in Rome, rather than the more popular churches of the Jesuits, with whom, surprisingly enough, he seems to have been on bad terms while in Paris, saying on his last visit to their church of Saint-Louis, that he would complain to their general that theirs was the only Order that had not sent representatives to wait on him when he arrived in Paris.

The *Journal* is a unique document. From the literary point of view it is not a masterpiece. Chantelou was evidently intent on writing while events were still fresh in his memory and he did not waste time on turning an elegant phrase; indeed it is not always easy to follow

his exact meaning, but the entries have the immediacy that would have vanished if he had labored at the text. The result is an almost photographic—one might say cinematographic—record of the daily life and conversation of one of the greatest artists of the 17th century, a man of fascinating, if not always attractive, personality, who captivated popes and completely charmed the King of France.

The visit to Paris was not the happiest episode in his life; indeed, apart from the disastrous story of the towers of St. Peter's, it was probably the saddest, but the story, as told by Chantelou, shows a man, however tactless he may have been and however often he fell into the traps laid for him by his enemies, came to Paris with a noble mission to build a great palace. He was frustrated by circumstances from fulfilling it, but he left behind what is perhaps the finest of all Baroque busts and a series of designs for the palace which, through the engravings that he caused to be made of them, exercised a profound influence on European architecture for more than a century.

A.B. November 1982

DIARY OF THE CAVALIERE BERNINI'S VISIT TO FRANCE

To my dear brother,[1]
Knowing how much you wish to learn everything about the Cavaliere Bernini,[2] who was summoned by the King to France from Rome to design the new palace of the Louvre, I have tried to remember what happened during the first days of his visit, before I thought of noting down the events of his daily life. On your advice I have arranged it as a sort of journal, which I am sending with this letter.[3]

George Bauer gratefully acknowledges and thanks the University of California, Irvine, for its support of his work on the annotations and especially appreciates the generous help given to him by the staff of the Inter-library Loan Department. Hellmut Hager, Tod Marder, Catherine Puglisi, Richard Spear, David Thomson, and M. Pierre Verlet all gave timely assistance in different ways, and Linda Freeman Bauer's help and constant vigilance have left their mark on every line of the notes. Special thanks are due to the late Anthony Blunt for his many suggestions and to Professor Irving Lavin, who by example and precept has encouraged, chastened, and inspired the annotator.

[1] Jean Fréart de Chantelou (1604–74), older brother of the author, who was a Counsellor of the King and who had been Provincial Commissioner of Champagne, Alsace, Lorraine, and Germany, where his duties seem to have concerned the building of fortifications in these areas on the frontiers between France and the Empire or the Spanish Netherlands.

[2] Bernini received a gold chain and was made a knight of the Papal Order of Christ in 1621 as a reward for having portrayed the reigning Pope, Gregory XV (Fraschetti, p. 32, and D'Onofrio, *Roma vista da Roma*, p. 283). The practice of recognizing artistic service with a knighthood goes back to the 15th century—Crivelli, Mantegna, and Gentile Bellini all having been honored in this way. By the end of the 16th century, and in the 17th century, the distinction, if still coveted, had become fairly common among artists.

[3] Although this statement suggests that the *Journal* in its present form dates to the years following Bernini's visit, such a conclusion seems untenable. Chantelou himself tells us he had decided to keep a record of Bernini's sojourn in Paris on 6 June, only four days after meeting the artist, and that he did so with the concurrence of his brother and for their mutual enjoyment. Thus the advice given by his brother with regard to the form of the *mémoire* would logically date to this time, and only the first few pages would have been written after the fact, as Chantelou admits and as may be seen from the occasional lapses of memory noted below. For Lalanne's dating of the *Journal*, see below, 4 June, n. 20.

At the end of May 1665, while the King was at Saint-Germain-en-Laye,[1] the news arrived at the court that the Cavaliere Bernini had entered France. It was said that His Majesty had made arrangements for him to be given 3,000 pistoles[2] before he left Rome, and that he had despatched servants to attend him from Marseilles, with orders that he should be shown hospitality wherever he stopped.[3]

One day, finding myself beside the Archbishop of Lyons[4] at the King's Mass, I took the opportunity of asking him whether he had heard if the Cavaliere had reached Lyons. He said no, but he had already passed on the royal command that on his arrival in the city he should be given an official reception and the aldermen were to give him lodging; this last was a quite extraordinary honor, usually accorded by the city of Lyons only to the princes of the blood.[5]

[1] A town some 21 km. west of Paris which until the enlargement of Versailles by Louis XIV from the late 1660s onwards was the country residence to which the kings of France most frequently retired from Paris. It contained a mediaeval château remodelled for Francis I and the Château Neuf, begun under Henry II and completed under Henry IV, which was where the King and Queen and their immediate entourage lived when at Saint-Germain. The officers of the court had their lodgings in the old château.

[2] That is to say, 30,000 livres.

[3] The gift to Bernini is confirmed by a document (Guiffrey, *Comptes*, col. 61), but the artist evidently refused the King's proposal that he avail himself of the "favorable opportunity offered by the return of my cousin, the duc de Créqui, Ambassador Extraordinary" to sail to Marseilles (Clément, p. 271). In the event, Bernini seems to have left Rome on 25 Apr. 1665 (Gould, p. 1) accompanied by Paolo Valentino, his son; Mattia de' Rossi, an architect who was to be his chief assistant and draftsman in Paris; Giulio Cartari, a young sculptor; Cosimo Scarlatti, his majordomo; and three servants (Dom. Bernini, p. 124). The party was led by M. Mancini, a royal courier, who along with a quartermaster, had been detailed by the King. They travelled overland by way of Siena, Florence, and Bologna; avoiding Modena because Bernini feared he would be too long delayed there (Fraschetti, p. 340, n. 2), they passed through Milan and into Savoy before entering France at Pont-de-Beauvoisin (Mirot, pp. 189–200).

[4] Camille de Neufville de Villeroi (1606–93), Lieutenant General of the Lyonnais, and from 1653, Archbishop of Lyons.

[5] In a letter to the Cardinal Nephew, Flavio Chigi, urging his support of Bernini's trip to France, the King had assured him that the artist would know in what consideration his merit was held by the treatment he received (Fraschetti, p. 339, n. 2). In fact, Colbert and the King had decided that Bernini should be given unprecedented honors; and although everywhere well received on his progress through Italy, it was in France that his journey acquired that aura he later mocked with the words "then the elephant travelled," for the sight of which everyone comes running when it passes (Dom. Bernini, p. 125). Jacques Esbaupin, a maître d'hôtel to the King, who was sent to meet Bernini at Verpellière, later reported to Colbert that from Lyons to Paris the artist had been received with extraordinary honors: "The Cavaliere having been visited by all the officials of the cities through which he passed with those courtesies that are usually given to great princes and ambassadors." Everything possible was done to ensure the artist's comfort—apartments furnished, a boat equipped, carriages provided. Ice was even sent as far as Roanne to make sure that his drinks should always be cool and fresh (Mirot, pp. 200–203). Although undoubtedly flattered, Bernini was too per-

Several days later, while at the King's Mass, I happened to be near M. Colbert, who told me that the Cavaliere would be in Paris within two days.

ceptive and intelligent to be altogether easy at the unheard-of liberality with which the King had kept his word. "So many are the honors," he wrote from Lyons, "that are given me in this kingdom that they make me doubt my ability to live up to the magnitude of that idea which I know the King holds of me" (Dom. Bernini, pp. 126–27).

❧ *June* ❧

❧ During the evening one of the minister's servants was sent to look for me. I went over to him, and he told me that the King had chosen me to welcome the Cavaliere Bernini, not in my capacity as maître d'hôtel[6] but as a special emissary to entertain and accompany him while he was in this country. I said this was a great honor but that it gave me cause for some anxiety; the Ambassador Extraordinary of the Knights of Malta[7] was arriving at court the next day, the King was going to entertain him, and I was solely responsible for the arrangements as I was the only maître d'hôtel at Saint-Germain, both for ordinary and special duties.[8] M. Colbert replied that I must send a note that evening to the other maîtres d'hôtel in waiting to come at once to relieve me, and that I should without further delay, leave very early the next morning.

I then went to see the grand maître,[9] to inform him of this decision, and to take my leave of His Highness. As he was not at home I went to the King's apartments to look for him. There I found the marquis de Bellefonds,[10] the chief maître d'hôtel, and I told him my difficulties. He begged me not to worry, saying that he and

[6] That is, one of the royal stewards responsible for serving the King's table.

[7] Lomellini, Bailey of the Order of St. John of Jerusalem and Grand Prior of England, who entered Paris on 2 June and took leave of the King on 27 July.

[8] Although the multiplication of offices during the minority of Louis XIV had greatly increased the number of stewards in the King's Household—there were 318 in 1660—only twelve were normally in service during the year, three for each quarter.

[9] Henri-Jules de Bourbon (1643–1709), duc d'Enghien, son of the Grand Condé, whom he succeeded as prince de Condé at the latter's death in 1686. From 1660, he was grand maître of France and, as head of the King's Household, was therefore Chantelou's superior.

[10] Bernardin Gigault (1630–94), marquis de Bellefonds and Marshal of France (1668). As premier maître d'hôtel du roi (from 1663), he ranked immediately below the grand maître.

M. Sanguin[11] would take over my duties. He added that, while they were having refreshments in the park, the King had asked him whether in his opinion he had not made a very good choice in appointing me, and that he had replied as befitted a good friend.

I had decided to remain so that I could attend the King at dinner, but M. Colbert sent for me again and told me that I must depart for Paris in the morning; I must leave again at midday and travel towards Essonne until I met the Cavaliere who was to dine there. He asked me if I had a coach-and-six; I told him no, whereupon he said, "You must take my brother's;[12] I will let him know." He then told me that I should be present at the King's evening toilet, when His Majesty would give me his direct command. I said it was not necessary, that I would write to the maîtres d'hôtel who were in waiting, and would start next day early, which I did.

<div align="center">2 JUNE</div>

🐝 I took the carriáge belonging to M. Colbert and started on the road for Essonne. On leaving Juvisy[13] I met the Cavaliere's party. I signalled to his *litter* to stop and got down from my carriage. He had also alighted and I went to greet him addressing him in French. I realized at once that he did not understand a word and I said in Italian that I would not risk making compliments in his tongue, but begged him to get into the carriage that I had brought. His son[14] and Signor Mattia[15] also got out and came up to greet me. Having exchanged civilities, the Cavaliere and I, as well as my nephew, your son,[16] whom I had taken with me, got into M. Colbert's carriage. Once installed

[11] Jacques Sanguin (d. 1680), seigneur de Livry and, like Chantelou, a maître d'hôtel to the King. In 1676 Sanguin purchased from the marquis de Bellefonds the office of premier maître.

[12] Charles-François Colbert (1629–96), later marquis de Croissy, Secretary of State for Foreign Affairs, and Minister of State, who appears in person later in the diary. Having a carriage drawn by six horses placed at his disposal was a mark of the honor being accorded Bernini, and Chantelou rarely forgets to give the number of horses whenever the coach is mentioned.

[13] A village about 15 km. south of Paris on the road to Fontainebleau.

[14] Paolo Valentino Bernini (1648–1728), trained as a sculptor by his father. Although he became a member of the Accademia di San Luca in 1672, he never seems to have been more than a mediocre artist, who is chiefly documented as an assistant to his father.

[15] Mattia de' Rossi (1637–95), an architect and Bernini's longtime assistant to whom Leone Pascoli (*Vite de' pittori, scultori, ed architetti moderni*, Rome, 1730–31, I, pp. 322–30) dedicated a biography. In 1661 *misuratore* of the Papal Camera, he succeeded Bernini as architect of St. Peter's (1680). In 1672 he became a member of the Accademia di San Luca, which he served as Principe in 1681 and from 1690 to 1693.

[16] Roland, son of Jean Fréart de Chantelou, who later became a maître d'hôtel du roi (1675).

I repeated my speech to him in as good Italian as I could muster. I explained to him the King's orders and with what pleasure I had received them, on account of the very great admiration I had always felt for him and for his talent. I reminded him that he had once done me the honor of giving me some of his figure studies which I treasured dearly.[17] I then recalled to him several maxims on the subject of portraiture in marble, which I had heard him express and had carefully remembered because I had always greatly esteemed his opinions; he could judge for himself, therefore, of my eagerness to obey His Majesty's command to meet him and remain with him during his stay in France. He thanked me most courteously, and said that it was a great honor to be asked to serve a king of France; moreover the Pope, his master, had commanded him.[18] Had it not been for these considerations he would still be in Rome. He had heard on all sides that the King was a great prince with a great heart and a great intelligence, as well as the greatest gentleman in his kingdom. It was this that had chiefly induced him to set out, for he was curious to make his acquaintance and eager to serve him; he only regretted that his gifts were not sufficient to justify the honor done him, nor the high opinion in which he was held. He then turned to the business that had brought him. Beauty in architecture, he declared, as in all else, lay in proportion, the origin of which it might be said was divine; for did it not derive from the body of Adam which not only was shaped by divine hands but was made in the likeness and image of God? The difference between the male and female forms and proportions was the source of the various orders in architecture, and he added many other observations on the same subject, with which we are familiar.[19] Later, when talking about the ambassadors, he said that first Cardinal

[17] Chantelou, then secretary to Sublet de Noyers, had been sent to Rome in 1640, in part to bring Poussin back to France. In 1642–43 he was again in Rome, this time to get the Pope's blessing for the gifts being offered by the King and Queen to the Madonna di Loreto in gratitude for the unexpected birth of Louis XIV.

[18] For the troubled political relations between Pope Alexander VII Chigi (1655–67) and France, which made necessary the embassy mentioned below of Cardinal Chigi in 1664 and played their role in bringing Bernini to France, see Schiavo, pp. 81–89, and Pastor, XXXI, pp. 91ff.

[19] In fact, these first comments by Bernini on beauty and proportion repeat traditional Renaissance beliefs that had been formulated from both ancient and mediaeval ideas. See the now classic statements of E. Panofsky, "The History of the Theory of Human Proportions as a Reflection of the History of Styles," in *Meaning in the Visual Arts*, Garden City, N.Y., 1955, pp. 55–107, and R. Wittkower, *Architectural Principles in the Age of Humanism*, 2d ed., London, 1952. However, as will appear below, Bernini developed a typically Baroque interpretation of proportions on the basis of this inherited foundation.

d'Estrées[20] and then the Cardinal Legate[21] had spoken so highly of
M. Colbert, under whose personal direction he would be working, that
he had finally made up his mind to come; further, Father Oliva,[22]
General of the Jesuit Order and his intimate friend, whose opinion he
had sought at the time, had told him that he should not hesitate; if
an angel appeared from heaven telling him that he would die during
his journey, he would still advise him to go. I replied that we in France
had reason to be very grateful to Father Oliva and I was sure that the
King would thank him. While we talked, we reached Paris and drove
to the hôtel de Frontenac which M. Colbert had had got ready for
the Cavaliere and his suite.[23] On alighting, we found M. Du Metz,[24]

[20] César d'Estrées (1628–1714), Cardinal (*in petto* 1671, published 1672), Bishop of
Laon (1653–81), member of the French Academy (1658), and abbé de Saint-Germain-
des-Prés (1703). Because d'Estrées became cardinal only in 1671, Lalanne and such later
writers as Gould (pp. 141–42) suppose that the *Journal* was written in the form we
know after that date. This is, however, an unreasonable conclusion and entirely at
variance with the nature of the *Journal*, which after 6 June must have been written
almost day by day. Moreover, when d'Estrées later visits the Cavaliere (below, 22
Aug.), he is called M. de Laon after the bishopric he held from 1653. Chantelou (or
his copyist) may of course have made later revisions and small corrections such as this.

[21] Cardinal Flavio Chigi (1631–93), nephew of Alexander VII, created cardinal in
1657. As Papal Legate to France in 1664, he too was served by Chantelou, who however
acted in his official capacity as maître d'hôtel du roi. See below, 3 Sept., for Chantelou's
report on the legation.

[22] Giovanni Paolo Oliva (1660–81) became General of the Society of Jesus in 1661.
The role assigned to Oliva here and below (23 July) in persuading Bernini to go to
Paris in spite of the dangers occasioned by his advanced age is also reported by Bal-
dinucci, *Vita*, pp. 49–50, and Domenico Bernini, p. 122.

[23] A lapse of memory evidently led Chantelou to abbreviate his account of Bernini's
reception at Paris, for they were no more than half way to the city when they en-
countered a group led by the Papal Nuncio, whom we shall meet often below. Both
parties having descended from their vehicles and exchanged greetings, Bernini, his son,
and Chantelou joined the Nuncio in his carriage for the entry into Paris (Mirot, p. 205,
n. 3). The hôtel de Frontenac in which Bernini was lodged no longer survives. It took
its name from Antoine de Buade, seigneur de Frontenac, baron de Palluau, premier
maître d'hôtel du roi, chevalier de ses ordres, conseiller d'état, capitaine et gouverneur
du château de Saint-Germain-en-Laye et de La Muette, but its identification remains
problematic. David Thomson, who very kindly supplied information on de Buade and
his holdings in Paris, suggests that of the properties he is known to have owned in
1656, the only reasonable candidate for the hôtel de Frontenac would be a part or most
of the hôtel Combault at the south end of the rue de Poulies on the east side of the
street, facing across the river to the place Dauphine and the hôtel de Nevers/Guénégaud.
However, if it stood in the rue de Poulies, the hôtel would have been outside the
courtyard of the Louvre, which is where it is placed by Mattia de' Rossi (Mirot, p.
207, n. 1). Although the house must have been acquired with the view of expanding
the palace, since the Nuncio reports it was one of the buildings to be destroyed (Schiavo,
p. 32), it was in the meantime used by the court when the King was in Paris (see below,
6 Aug.).

[24] Gédéon Barbier (1626–1709), sieur Du Metz, from 1663 Intendant of the Furniture
of the Crown and an honorary member of the Royal Academy of Painting and Sculpture.
He later became Controller-General of the Furniture of France and an honorary President
of the chambre des comptes.

Keeper of the Royal Furniture and clerk to M. Colbert, who welcomed him with a speech and showed him the apartment that had been prepared. It was very well furnished and fitted up. He then showed him a gallery and smaller rooms in which there was everything necessary for his comfort; apartments for his son Paolo and Signor Mattia de' Rossi, his architectural assistant, and rooms for his other attendants. Then, as the Cavaliere was tired I took my leave and left him to rest.

3 JUNE

In the morning I went to see him to ask whether there was anything he required. He asked me for drawing boards and drawing materials, which M. Du Metz, who happened to be there, ordered at once. After dinner M. Colbert arrived.[25] The Cavaliere was lying down after the meal according to the Italian custom and wanted to get up at once, but M. Colbert would not allow it. Addressing him as he lay in bed, the minister first conveyed to him his great pleasure at his safe arrival and good health. The Cavaliere thanked him profusely, saying that he desired with all his heart to serve the King and His Excellency and prayed that he might be capable and fortunate enough to do so. He repeated more or less the reasons he had given the day before for his having determined at his age to embark on such a long and difficult journey. M. Colbert then said that he considered the Cavaliere under his special care, which I have previously noted, and after this exchange of compliments, left him, saying he would call for him the next day to take him to Saint-Germain, where he would be presented to the King.

4 JUNE

Corpus Christi. In the morning M. Colbert came to fetch the Cavaliere as he had promised. Signor Paolo and Signor Mattia, the abbé

[25] According to Baldinucci (*Vita*, p. 52) and Domenico Bernini (p. 127), Colbert had already visited the Cavaliere the night before; and a letter of Mattia de' Rossi (Mirot, p. 205, n. 3) indicates that Chantelou, who had not yet begun to keep his journal, simply transposed his memory of the event to the following day. In his report to Rome, the Papal Nuncio wrote: "The Cavaliere Bernini arrived here Tuesday evening in the best of health. . . . He was visited the same evening by my Lord Colbert, and on Wednesday morning the same Colbert showed him the Palace and all of the streets opening on the Louvre. After dinner, he saw all the Louvre . . . and from what he said to me, he thinks that what has been built can be of little use" (Schiavo, p. 32). In an age when elaborate displays of courtesy were the counterpart of jealously guarded claims to precedence, Colbert's refusal to allow Bernini to leave his bed was a pretty piece of deference.

Buti,[26] and myself all got into his carriage. There was another carriage from the King's stables for the Cavaliere's attendants. We arrived at Saint-Germain at nine o'clock in the morning. M. Colbert got down at the old palace, where he has his apartments, and remained there for some time with the Cavaliere. Then he took him across to the new palace where the King and the Queen and the Queen Mother have their suites. In the antechamber we were told that the King was not yet dressed. M. Colbert went in, and on coming out, made us go round, and took the Cavaliere into the King's study, where there were the maréchal de Gramont,[27] the maréchal Du Plessis,[28] and others of high rank, with whom he talked. When the King was dressed, M. Colbert took him into the bedchamber and presented him to His Majesty, who was standing at the window with the First Gentleman of the Bedchamber and the Master of the Wardrobe. The maréchal de Gramont had also entered. The Cavaliere made his speech with perfect assurance and told the King, as he had told M. Colbert, the reasons which had persuaded him to come to France. Turning to the question of the designs for the Louvre, he said to His Majesty; "Sir, I have seen the palaces of emperors and popes and those of sovereign princes which lie on the road from Rome to Paris, but a palace for a king of France, a modern king, must outdo them all in magnificence." Then addressing the circle around the King, he added, "To my mind there must be nothing trivial in connection with this building."[29] The

[26] Francesco Buti (1604–82), secular abbot of a monastery in the diocese of Toulouse, man of affairs, and librettist, who introduced the Italian opera into France. A protégé of the Barberini, he accompanied them in their exile in France, where he became a naturalized citizen in 1654. In 1673, on promising to remain in France, he received permission to dispose of his goods, although he died in Rome. He wrote, among others, the libretti for Luigi Rossi's *Orfeo* (1647), for Caproli's *Le Nozze di Teti e Peleo* (1654), and for the *Ercole Amante* (1662) with music by Francesco Cavalli and Jean-Baptiste Lully, which inaugurated the Salle des Machines in the Tuileries (below, 26 July). His relations with Colbert were not always amicable (Rouchès, p. 11, n. 3), and after Mazarin's death in 1661, his fortunes seem to have declined. In 1664 he was reported to be great friends with M. de Lionne, Secretary of State for Foreign Affairs (Schiavo, p. 4).

[27] Antoine de Gramont (1604–78), Marshal of France (1641), created peer and duc de Gramont in 1663.

[28] César de Choiseul (1598–1675), comte Du Plessis-Praslin, Marshal of France (1645), created peer and duc de Choiseul in 1665. Governor of Monsieur, the King's brother, in 1648, he then became Superintendent of Monsieur's Household and First Gentleman of his Bedchamber.

[29] This proud statement recalls the confident assertion made in not dissimilar circumstances by Bernini's great contemporary, Peter Paul Rubens: "I confess that I am, by natural instinct, better fitted to execute very large works than small curiosities. Everyone according to his own gifts; my talent is such that no undertaking, however vast in size or diversified in subject, has ever surpassed my courage" (*The Letters of Peter Paul Rubens*, trans. R. S. Magurn, Cambridge, Mass., 1955, p. 77). Bernini's previous

King replied saying that he had some desire to preserve the work of his predecessors, but, if later it were found necessary to pull it down, he would surrender it to the Cavaliere, and further, no expense should be spared. His Majesty ended by giving him the most cordial welcome and then M. Colbert took him back to the old palace. The royal tapestries, among them the *Acts of the Apostles*, the *Triumph of Scipio* and the others from the cartoons of Giulio Romano,[30] were hung up in the courtyards for the procession of the host, as it was the feast of *Corpus Christi*. The Cavaliere looked at them and greatly admired them. He then asked me to conduct him to the chapel, where he remained a long time in prayer. After this ceremony he dined at the chamberlain's table with M. Colbert and the rest of us.[31] When we rose from table, he went to rest in the apartment of M. de Bellefonds. In the evening M. Colbert took him back to Paris.[32]

5 JUNE

❧ M. Colbert came for him in the morning to show him over the Louvre. They began inside the courtyard, and then went to the Tui-

comments, however, show that here he is not referring to the exigencies of his own genius, but to those of a great king.

[30] The tapestries with scenes from the *Acts of the Apostles* based on Raphael's cartoons (J. Shearman, *Raphael's Cartoons in the Collection of Her Majesty the Queen and the Tapestries for the Sistine Chapel*, London, 1972) were made for Francis I and burned for their gold in 1797 (E. Müntz, *Les tapisseries de Raphael au Vatican*, Paris, 1897, p. 24), as were the Scipio tapestries designed by Giulio Romano (*Jules Romain, L'Histoire de Scipion*, exh. cat., Paris, Grand Palais, 1978). Other tapestries woven from the designs of Giulio Romano are described in Félibien, *Entretiens sur les vies et sur les ouvrages des plus excellents peintres*, 2d ed., Paris, 1686, I, pp. 436–37.

[31] Because one's place at table was also a measure of respect in the 17th century, it was duly recorded by both Baldinucci (*Vita*, p. 53) and Domenico Bernini (p. 128) that Bernini and his son were placed "at the table of the princes and chief ministers of the realm."

[32] A letter of 5 June 1665 sent to Rome by Mattia de' Rossi (Mirot, p. 205, n. 3) gives a more circumstantial account of Bernini's first day at the French court. After the King expressed his pleasure at Bernini's arrival in good health, the artist "gave a most beautiful discourse on the Louvre, which greatly pleased the King, who was delighted with the Cavaliere's ideas. It is true that all of the Cavaliere's speeches are very beautiful and well founded, but that morning one saw he was aided greatly by God. Not a word left his mouth that the King did not admire and turning to the court, he said, 'Now indeed do I know that this is the man whom I imagined.' So well considered was the Cavaliere's address that all the court was astonished and satisfied, taking him for an oracle." Before the day was finished, he had seen the Queen Mother, the Queen, the Dauphin, and "the Prince, brother of His Majesty, who along with Madame, his wife, gave the Cavaliere the same reception he had received from the Queen. And they asked the Cavaliere if, had he the time, he would be willing to make a portrait of the King. To these words, he replied that he was fighting against time, but that were it to be done . . . he would be able to do it." But cf. the King's comment reported by Vigarani in a letter to Modena of 19 June 1665 in Rouchès, no. 217, and Fraschetti, p. 343, n. 1.

leries, and from there back along the quay and the Long Gallery. After this tour they got into the carriage, and M. Colbert drove him around the Ile du Palais,[33] and showed him the Sainte-Chapelle and the interior of the palais, and the area behind Notre Dame, and then on to the Ile Saint-Louis.[34] At the tip of the island they visited the house of M. de Bretonvilliers[35] to see the beautiful view from it. He looked at the gallery painted by Bourdon which he liked and then returned to the hôtel de Frontenac.[36]

6 JUNE

While the tables and other things necessary for drawing were being installed, we passed the time in conversation, and as the Cavaliere is a man with a great reputation whose name is very famous, I considered as you did, my dear brother, that it would not be entirely fruitless to keep a record of what he said for our common study and even for our amusement. As you have never seen him, perhaps it would help you if I made a little sketch, or *schizzo* as the Italian painters say, of him and his character. Let me tell you then that the Cavaliere Bernini is a man of medium height but well proportioned and rather thin. His temperament is all fire. His face resembles an eagle's, particularly the eyes. He has thick eyebrows and a lofty forehead, slightly sunk in the middle and raised over the eyes. He is rather bald but what hair he has is white and frizzy.[37] He himself says he is sixty-five.[38] He is very vigorous for his age and walks as firmly as if he were only thirty or forty. I consider his character to be one of the finest formed by nature,

[33] Now the Ile de la Cité. It owed its original name to the fact that it contained the mediaeval palace of the French kings—now the Palais de Justice—which was turned over to the Paris Parlement (the law courts) when the kings removed their principal residence to the Louvre. It included the Gothic Sainte-Chapelle built by Louis IX and also the Great Hall which was much admired by the Cavaliere (cf. Brice, II, p. 463).

[34] The "île," then known as the Ile Notre-Dame and now as the Ile Saint-Louis, was developed in the early 17th century.

[35] The hôtel de Bretonvilliers was built, mostly by Louis Le Vau, for Claude le Ragois de Bretonvilliers (1582–1645) and was pulled down about 1840. Its gallery, which is admired by Bernini below, was decorated in 1663 by Sébastien Bourdon (1616–71) for Claude's son, Bénigne (1624–1700), who was a considerable collector (cf. J. Wilhelm, "La Galerie de l'hôtel de Bretonvilliers," BSHAF, 1956, pp. 137ff.).

[36] According to a later statement by Bernini (below, 7 Sept.), the purpose of this tour was to consider other sites on which an entirely new palace might be built.

[37] Bernini's features are well known from a fairly large number of portraits by himself and others. Among those by his own hand may be mentioned the youthful self-portrait in the Galleria Borghese, Rome, and the imposing drawing at Windsor Castle (fig. 1), which is probably contemporary with his trip to France (Brauer and Wittkower, p. 17). A handy list of the works in which Bernini is portrayed appears in M. and M. Fagiolo dell'Arco, Bernini, Rome, 1967, schedario, no. 260.

[38] Since Bernini was born on 7 Dec. 1598, he was in his 67th year at the time he went to Paris.

for without having studied he has nearly all the advantages with which learning can endow a man. Further, he has a good memory, a quick and lively imagination, and his judgment seems perspicacious and sound.[39] He is an excellent talker with a quite individual talent for expressing things with word, look, and gesture, so as to make them as pleasing as the brushes of the greatest painters can do.[40] This is no doubt the reason why his comedies have been so successful. I believe they were generally acclaimed and made a great sensation in Rome, on account of the décor and the surprising incidents which he introduced and which deceived even those who had been told about them beforehand.[41] He is always eager to quote Pope Urban VIII,[42] who loved him and valued his qualities from his earliest years. One of the first things I remember his telling me was how one day this pope, then still Cardinal Barberini, came to see his father, who was also a sculptor.[43] He looked at something the Cavaliere, then only eight years old, had just finished, and, turning to the father, said with a smile,

[39] All of the contemporary descriptions of Bernini are remarkably alike and reveal a curious combination of the old psychology of the four humors with the new 17th-century interest in "character": physique, complexion, natural disposition, and habits, uniting, as Domenico Bernini writes (p. 177), to form a man of great ideas and great deeds.

[40] Bernini's gifts as an entertaining and witty, if occasionally waspish, conversationalist and raconteur echo only faintly from the pages of Chantelou's diary, but they were widely recognized at the time. Charles Perrault, who appears below, betrays the classicizing taste with which the artist had to contend in France by describing Bernini's speech as "full of apothegms, parables, little stories, and bon mots, which he employs in all his answers, disdaining to reply simply to what he is asked" (*Mémoires*, p. 62), but Cardinal Decio Azzolino said of Bernini that "not just his work, but his every word was worthy of being recorded in the memory of posterity" (Dom. Bernini, p. 99).

[41] In his eulogy of the artist, the abbé de La Chambre (below, 18 Oct.) wrote that to all he said, Bernini added "certain extremely expressive gestures, which are natural to Neapolitans" (*Préface pour servir à l'histoire de la vie et des ouvrages du Cavalier Bernin*, Paris, 1681, p. 25), and Chantelou's suggestion that his theatrical productions were a deeply rooted expression of his personality has been developed by Cesare D'Onofrio (*Fontana di Trevi*, pp. 21–24). Again and again, throughout his stay in Paris, Bernini spoke of the comedies he had given during Carnival beginning in the early 1630s (see Appendix B, A Note on Bernini and the Theatre). Consequently, the *Journal* is one of the most important sources for our knowledge of his theatrical activity.

[42] Maffeo Barberini (1568–1644), created cardinal in 1606 and elevated to the papacy in 1623, and according to both Baldinucci and Domenico Bernini, the artist's patron and protector from his earliest childhood, and indeed one of the great patrons of the arts in the 17th century.

[43] Pietro Bernini (1562–1629), a sculptor active in Rome, Florence, and Naples, where he married Bernini's mother, Angelica Galante. In 1605–1606, he moved his family permanently to Rome, where he worked first for the Borghese at S. Maria Maggiore, and then for Cardinal Maffeo Barberini at S. Andrea della Valle. In 1623 he was made Architetto dell'Acqua, but after 1624 he seems to have been active mainly on projects directed by his son. See V. Martinelli, "Contributi alla scultura del Seicento: IV, Pietro Bernini e figli," *Commentari*, IV, 1953, pp. 133–54.

"Take care, Signor Bernini, this child will surpass you and will certainly be greater than his master." He says that his father replied sharply, "That doesn't worry me. Your Eminence knows that in this game the one who loses wins."[44]

Speaking of sculpture and the difficulty of making a success of it, and particularly of getting a likeness in marble, he told me a remarkable thing, which he has since repeated on many occasions—that if a man bleached his hair, his beard, his eyebrows, and, if it were possible, the pupils of his eyes and his lips, and showed himself in this state to those who were accustomed to see him every day, they would have difficulty in recognizing him. To prove it he added that the pallor which fainting brings makes a man almost unrecognizable, so that people exclaim, "He no longer seems to be the same man."[45] For this reason it is extremely hard to get a likeness in marble that is all of one color. He told me something even more extraordinary, that to imitate nature in marble it may be necessary to put in that which is not there. He said something even more paradoxical, that sometimes in a marble portrait, in order to represent the dark which some people have around their eyes, one must hollow out the marble, in this way obtaining the effect of color and supplementing, so to speak, the art of sculpture, which cannot give color to things. So naturalism is not the same as imitation. Later he made an observation on the subject of sculpture, which did not convince me so entirely. "A sculptor," he said, "makes a figure with one hand raised, the other placed on the breast. Practice makes one realize that the hand in the air must be

[44] This quote is in Italian in the manuscript. Along with the story of his childhood encounter with Paul V Borghese (below, 5 Aug. and 6 Oct.), this anecdote argues Bernini's precocious development as an artist. Modern scholars have tended to discount this claim because of errors in sequence and chronology reported by the sources. D'Onofrio (*Rome vista da Roma*, pp. 89–105), basing his argument in part on this and other passages in Chantelou's diary, has even suggested that the origin of this belief was a kind of autopropaganda on the part of the aging artist; but the traditional view has been sustained by Irving Lavin, "Five New Youthful Sculptures by Gianlorenzo Bernini and a Revised Chronology of His Early Works," *AB*, L, 1968, pp. 223–48; and Bernini himself, when he sensibly recommended that the student alternate days of drawing with actual work in stone or paint, traced this practice to his earliest years (below, 6 Oct.). Moreover, at a time when apprenticeships began early, Bernini's precocity may not have seemed so unusual as it would today. Thus it is reported of Le Brun, who appears often below, that before he was nine he had already carved a Bacchus in wood and modelled masks, eagles, and griffons; at eleven or twelve, he made illustrations from the Apocalypse for the prayer book of Chancellor Séguier (*Charles Le Brun*, p. xxxx); and Bernini on his visit to the Academy admired the drawings from life of a boy said to be ten or twelve years old (below, 5 Sept.).

[45] The quote is in Italian in the manuscript. This was evidently one of the artist's favorite examples, since it is also cited by Baldinucci (*Vita*, p. 79) and Domenico Bernini (p. 30).

made larger and broader than the other because the air surrounding the first changes and consumes something of its form or rather of its quantity."[46] As for me, I believe that in nature itself the object undergoes a certain diminution, so that it is not necessary to put into the imitation what is not in nature. I said nothing at the time, but since then I have remembered that the ancients were careful to make the columns at the angles of their temples larger by a sixteenth than the others, for, as Vitruvius says, they are surrounded by a greater quantity of air that consumes something of their size and without it would appear slenderer than those next to them, which in fact they are not.[47]

He next compared painting with sculpture, both of which have had their supporters, who during the course of the last two or three hundred years, just as in the time of ancient Greece have argued endlessly about which of them should be regarded as superior and more noble;[48] but he endeavored to show with many excellent reasons

[46] Bernini's comments depend on the notion, already stated by Lomazzo, that "similitude proper is not found in quantity, but only in quality, which is the color used by the painter" (*Trattato*, p. 25). But unlike the overly rigorous Lomazzo, who therefore denied similitude to sculpture, Bernini clearly recognized that the likeness created by the artist was an illusion and that this illusion was always and necessarily limited by the materials and means available to sustain it. Thus he remarks below (17 Aug.) that Raphael himself could not make a painted sky convincing if the real sky were visible; and later (24 Aug.) he says that in any competition with its natural object, art must be the loser. Artistic excellence therefore lay not in the identity of the natural object and its imitation, but in the artist's ability to create an illusion of reality (cf. Dom. Bernini, p. 30). But without color to aid his illusion, the sculptor's task was a more difficult one than the painter's, since he had to supply from his own invention what was lacking in his art in order to simulate a nature that normally appears composed of variegated hues. Nor could he rely on the fact that, as a three-dimensional body in space, his work reproduced the size and shape of its object, as was sometimes argued. Instead, just because his work was a real object, the visual impression created by its various parts was subtly altered by their relationship to what surrounded them. Bernini called this effect the *contrapposti*, assimilating it to those mutual adjustments imposed on an organic system by each of its members (see below, 23 Aug.), and argued that the sculptor had to compensate for such apparent distortions so that the appearance of reality would be preserved. This alteration of what is objectively correct (nature) in favor of what will appear correct (the imitation) is the leading principle of his art, indeed of the 17th century as a whole; and it represents a thoroughgoing revision of the traditional Renaissance faith in the validity of absolute, mathematically determined proportions.

[47] The fact that Chantelou first demurs, then recalls the authority of Vitruvius (*De architectura*, III, 11) shows quite clearly why the subjective notion of optically conditioned proportions came to be accepted by classicizing critics. It is ironic that the first critic to deny outright the need for optical "corrections" was Claude Perrault (1613–88), brother of Charles, translator of Vitruvius (1673), and eventual designer, or at least collaborator on the design (the point is disputed), of the east façade of the Louvre (see W. Herrmann, *The Theory of Claude Perrault*, London, 1973, pp. 70–94). Yet when his design for a triumphal arch at the porte Saint-Antoine was tried out in a full-scale model, it was rejected by the members of the Academy of Painting and Sculpture just because he had failed to make the necessary optical adjustments (ibid., pp. 93–94).

[48] Literature disputing the respective merits of two interested parties—summer and

that painting is by far the easier art, and that it requires much more ability to obtain perfection in sculpture. To prove his claim, he gave me an example, "Let us suppose," he said, "that the King wants a beautiful piece of sculpture. He discusses the matter with a sculptor and allows him to choose his subject and take one, two, or three years or as long as he likes to complete it. He makes the same proposal to a painter, asking for a product of his art and laying down the same conditions as regards time and subject. If at the end of the given time, he asks the painter whether he has put all his skill into the work, the painter can assent without hesitation, for not only has he been able to imbue it with all the knowledge with which he began, but has been able to add what he has learned during the six or twelve months or longer during which he has been engaged on it. How different is the sculptor's case! If when his work is finished he is asked whether that is the best he can do, he is obliged to reply in the negative and with good reason, for he can add nothing to the knowledge that he possessed in the beginning; the pose must remain that which he first selected, nor can he modify it as he acquires more skill in the practice of his art."[49]

Then, passing from his room in which we were into the gallery, he told me he had one very similar in his house in Rome; it was there that he designed most of his compositions, walking up and down the while; using charcoal, he drew his ideas on the wall as they came into his head; it is usual for fertile and lively minds such as his to pile up

winter, violet and rose, body and soul—is very old and widespread. During the Renaissance, and especially in the 16th century, writing dedicated to a comparison or rivalry (*paragone* in Italian) among the arts became a popular branch of the genre. These works sought, on one hand, to elevate the status of painting and sculpture by enrolling them in the ranks of the liberal arts and, on the other, to establish the superiority of painting over sculpture or vice versa. Although often tedious and academic, as Chantelou's comment suggests, the *paragone* literature nevertheless contributed to the rising prestige of the visual arts and to the professional definition of their respective aims and techniques.

[49] Bernini's argument is that of a marble carver and derives from the ways of working identified during the Renaissance with different kinds of sculpture. Sculpture in stone it was said was an art of taking away, whereas painting was, like modelling in clay or wax, an art of adding on (cf. Michelangelo's letter to Varchi in *The Letters of Michelangelo*, trans. by E. H. Ramsden, Stanford, 1963, II, p. 75). Thus the sculptor, because he can neither add to nor change his work once it is begun, faces a more difficult task than the painter, who is entirely free to alter his picture as he works and therefore to include all he learns along the way (cf. Dom. Bernini, p. 30). This argument is not new. It was already stated in precisely the same terms by Baldassare Castiglione in 1528 (*Opere di Baldassare Castiglione, Giovanni della Casa, Benvenuto Cellini*, ed. C. Cordié, Milan and Naples, 1960, p. 83). But if therefore commonplace, it nevertheless sustained Bernini's practice, as will be seen below from his painstaking preparations for the bust of the King and from his firm conviction that the general effect must take precedence over the individual detail (below, 19 Aug.). See too below, 6 Oct.

idea after idea on the same subject; when one occurs to them they jot it down; then a second, they jot that down, too; a third and a fourth, without altering or improving any of them; he always preferred the last on account of its novelty. In order to remedy this inclination he found it desirable to leave these different ideas for a month or two without looking at them, until his mind was ready to judge which was the best. But if it so happened that there was need for haste or his patron was unable to give sufficient time for this process, then he resorted to colored spectacles or to a magnifying glass, or one that made objects smaller, or to looking at the sketches upside down; in fact by changing the color, the size, and the position, he tried to correct the illusion which love of novelty engenders, and which nearly always prevents one from choosing the best idea.[50]

7 JUNE

He began to work on his design for the Louvre and was busy with it all day long. In the evening he took a drive in the coach that the King had put at his disposal. Of the high roofs of the palais des Tuileries he remarked that their faulty proportion probably came about little by little. As an illustration he told the story of the man who liked to drink his wine cooled and ordered his valet to attend to the matter so the valet served it very cold to please his master. Seeing that he had given satisfaction, the next time he served it colder, then

[50] Bernini's account of designing on the gallery wall of his house (today 11 Via della Mercede) documents the survival into the 17th century of drawing on surfaces other than paper. It adds another category to the list of those artistic "ephemera" that have all but disappeared. Although the mediaeval practice of making drawings in full size on the surface to be worked had gradually given way during the Renaissance to the practice of preparing works of art in small scale on paper, artists continued to draw on walls and floors (see Paolo Dal Poggetto, *I disegni murali di Michelangiolo e della sua scuola nella Sagrestia Nuova di San Lorenzo*, Florence, 1978, and below, 15 July). Sometimes these drawings simply continued the tradition of the mediaeval tracing house and served as full-scale templates (T. Thieme, "Disegni di cantiere per i campanili del Pantheon graffiti sui marmi della copertura," *Palladio*, n.s. 20, 1970, pp. 73–88). Bernini, however, has transferred to the more ample surface of the wall the quick idea sketch with its connotations of invention and inspiration. His description of piling sketch on sketch obviously depends on the notion of Platonic frenzy, which in turn accounts for his constant assertions that his "ideas" came from God. But if copiousness of invention was regarded as a desirable attribute (Serlio, IV, 130r and 135r), succumbing to the *furor divinus* was not considered to be without its dangers (Lomazzo, II, p. 99), as Bernini too recognizes. He therefore invokes the concept of judgment. Following the ecstasy of inspired creation, the artist reasserts his own judgment in choosing the best of his designs (cf. Dolce, p. 70). According to a widely canvassed allegory, to which Bernini himself dedicated a work (see below, 23 Aug.), Time was the surest means to Truth. Lacking the time to arrive at right judgment, however, the artist could resort to those mechanical aids recommended from the time of Alberti and Leonardo that allowed the artist to see his design with other eyes (cf. below, 14 Aug.).

colder still, and so on colder and colder, until his master was practically drinking ice, which in fact endangered his health without his noticing it. Similarly the roofs, which were low at one time, were raised a little and then a little more and finally so much that they had become as high as the whole of the rest of the building, although it did not strike the eye that the structure was thus horribly disfigured. I said laughing that roofs had been built high in imitation of hats; should it become fashionable to wear them low, roofs would also be made low.[51]

Referring to the fact that the King had summoned an architect from Italy to work for him, he said this was not at all derogatory to the honor of France, for on questions of military art it was France that was supreme, and everyone resorted to her for soldiers expert in the use of battalions, the formation of squadrons and the command of troops.[52] During all our conversations he continually quoted Urban VIII on every kind of subject, either to recall some trait of his character that was, he said, the most sensitive and responsive he had ever known, or to show on what intimate terms he had been with him. I remember he told me how one day he was pleading with him for a dowry for a young orphan girl. He had said, "Holy Father, she is very beautiful," to which the Pope replied at once, "If she is beautiful, she has her dowry."[53]

He told me that when Urban VIII ordered the fortification of Rome at the time of the war with the Duke of Parma,[54] he wanted the Cavaliere to undertake the construction of the defense works, but he had told His Holiness that it would first be necessary for him to have permission to go for three or four years to Flanders to acquire

[51] Whether the roofs of the Louvre should be flat or pitched to better withstand the rigors of the Parisian climate had been a bone of contention between Bernini and Colbert from the very beginning (Clément, p. 246). Although not all Frenchmen agreed with the Minister (Hautecoeur, II, p. 283), it is nevertheless revealing that in explaining the high, steep roofs of French architecture the artist ignores this practical question and offers an explanation in accord with the psychological interpretation of perception that runs throughout his work and thought.

[52] Although hopelessly wide of the mark psychologically, Bernini's view was probably a fairly accurate assessment of contemporary opinion. Thus in the preface to his translation of Vitruvius (Paris, 1673) Claude Perrault compares the progress of arms and arts in France to their progress in ancient Rome, laments the fact that French architects have little recognition and few opportunities, and believes that "there is reason to hope that those of our nation who devote themselves to architecture, moved by the care taken by the King to make the arts flourish, will not fail to show that in this they yield to no other peoples."

[53] The exchange is in Italian in the manuscript.

[54] The War of Castro (1641–44) prosecuted by Urban VIII against Odoardo Farnese (1612–46), Duke of Parma and of Castro, a small duchy near Viterbo lying within the Papal States. Costly in both money and prestige, if not in lives, it proved to be an unfortunate adventure for the papacy.

a knowledge of the art. This reminiscence gave rise to the reflection that very often when a prince finds a servant whom he likes and who has his confidence, he entrusts him with every kind of responsibility and thinks nothing properly done unless he does it. In this he makes a mistake; he would be better served and his projects better executed if he were to use those whose talents and experience best fitted them for the work. He then went on to tell me of a little lesson given to the king of Spain, Philip IV, which concerned the Count of Olivares.[55] A preacher was praising the qualities of St. John the Evangelist. When he came to the end of his sermon he suddenly recalled what he pretended to have forgotten—the most important fact about St. John—his special privilege of laying his head on the bosom of Our Lord, "a lesson to kings," he said, "to allow their ministers to rely on them, but never themselves to rely on their ministers." I then related how Philip III, father of Philip IV, had been addressed from the pulpit in a similar manner. It was about the Duke of Lerma,[56] the King's favorite, who was so powerful that he disposed of the whole of Spain as if he had been the king himself, with his own favorites whom he even made grandees. The preacher's text was the temptation of Our Lord in the desert, when the devil took him to the topmost pinnacle of the temple and offered Him the kingdoms he could see before him if he would worship him. He turned to the King and said, "Your Majesty should know that to give everything to one person is the work of the devil."[57]

8 JUNE

❧ The Nuncio[58] came to see the Cavaliere and found him pencil in hand. For sometime they talked about the Louvre and discussed the grandeur of the buildings. The Nuncio then asked the Cavaliere why it was that certain works of art gave great pleasure at first, but after long contemplation or being seen several times, they satisfied very much less or not at all, while on the other hand there were paintings that did not strike the spectator instantaneously, but from one day to

[55] Gaspar de Guzmán (1587–1645), Count of Olivares and Duke of Sanlúcar de Barrameda (1635), favorite of Philip IV, and Minister of State from 1621 until he was disgraced in 1643.

[56] Francisco de Sandoval y Rojas (1552–1625), Marqués de Denia and first Duke of Lerma (1600), favorite of Philip III, and Minister of State (1598), whose policies proved disastrous. Created cardinal in 1618 by Paul V, in the same year he fell from favor.

[57] The quote is in Spanish in the manuscript.

[58] Carlo Roberti de Vittorij (1610–73), titular Archbishop of Tarsus and Papal Nuncio to France from 1664. Created cardinal in 1666, he was subsequently Papal Legate to the Romagna and Archbishop of Faenza.

another pleased him more and more, until he might be overcome by their beauty. He replied that this difference proceeds from the knowledge or lack of it in the artist; those pictures which are not constructed on correct principles nor based on a groundwork of drawing, which are distinguished only by lovely coloring or an unskilled charm, please only the eye and not the mind, which searching for satisfaction recoils with disgust from works not designed strictly according to good rules and imbued with intelligence and knowledge. Take for example a picture by Barocci, with its beautiful coloring[59] and graceful figures, which may please even the learned at first sight more than a work by Michelangelo. His work may seem rough and disagreeable, so much that one averts the eyes, yet even in the act of turning away and leaving it, one feels that it draws and retains the gaze and after examining it for a little while one is forced to exclaim, "Ah! This really is beautiful"; indeed it fascinates imperceptibly, making it hard to move away and every time it seems more and more lovely. Is not the opposite the case, where the picture is by Barocci or some other painter whose only talent lies in his coloring and his charm of manner, for then the beauty of the painting grows less and less each time one sees it.[60]

[59] Chantelou describes the color of Federico Barocci (1535–1612) as *vague*, no doubt because Bernini had said *vago*, beautiful.

[60] The prejudice against the seductive sensuality of color and its identification with shallow pleasures is already present in Vitruvius (VII, v, 7–8), but that Bernini, who founded his practice on the optical precepts of *colore* and brilliantly exploited the profound emotional potential of light and color, here seems to be denying his own artistic nature is at first sight surprising. It has even been suggested, on the authority of this and other passages in the diary, that while in Paris the artist deliberately adapted his views to the classicizing ones of his hosts; or alternatively, that such passages owe more to Chantelou than to Bernini. Either conclusion would be overhasty. Here, as elsewhere, the artist is the victim of the still primitive theoretical and critical approaches of his time. A practicing artist, little given to systematic thinking, Bernini necessarily expressed himself obliquely, making use of such ideas as were available. In this passage he is not concerned with arguing the superiority of design (*disegno*) over color (*colore*), though his argument nominally takes that form, but rather with vindicating the autonomous intellectual content of art. True art does not aim at the immediate pleasure of superficial effects, but is informed by knowledge and intelligence, by theory and principle; it is meat for the mind as well as the eye, and so attracts even as it repels (cf. Dolce, p. 149). Thus in this argument Michelangelo and Barocci, *disegno* and *colore*, are only the lay figures with which Bernini composes his thoughts. Surface appeal, represented by color, satisfies only those who are content with "trifles and ornaments," like the Neapolitan artist below who failed to appreciate the art and grandeur of the Colosseum in its ruinous state; or those naive Spaniards, "without taste or knowledge of art," who confuse art with life or hold so stubbornly to some misconstrued "rule" that they destroy it. Real art survives even mutilation and it is no accident that when the talk turns to antiquity, Bernini chooses as his favorite statue the ruinous *Pasquino* and numbers second the fragmentary *Torso Belvedere*. The irony is that in the 18th and 19th centuries Bernini came to play the role of Barocci in the same argument.

The conversation turned to another subject, and the Nuncio said he was of the opinion that the popes, who at present daily order the construction of fresh works of art to beautify the city, might instead undertake the restoration of some of the monuments of antiquity, such as the triumphal arches which lie ruined and half-buried, and also the Colosseum which is such a fine building; to this end the funds might be diverted that are now used with such an appearance of vanity and unnecessary pomp in the canonization of saints. I replied that this might be ill-interpreted; few people were sensitive to the beauties of classical works, and the rest might disapprove of his admiration for them. The Cavaliere intervened with an anecdote about a Neapolitan painter. In Naples, he said, only trifles and gilding are appreciated. A certain painter however, having heard of the beauty and magnificence of the Colosseum, decided to make the journey to Rome on purpose to see it; he drew near to the city and his route lay past San Gregorio;[61] he saw around him the massive ruins. He asked what they were and, on hearing that it was the Colosseum, stopped immediately and began to look at them. He saw it, of course, just as it was, all broken down, and it struck him as hideous. "What," he exclaimed, "is this the Colosseum which is supposed to be one of the marvels of antiquity, the grandest work surviving from that time!" And he turned back to Naples there and then, without even having entered Rome.

The Cavaliere added that Spaniards have no taste or knowledge of the arts; when he was working on the *Rape of Proserpine*,[62] the Spanish ambassador came to see the group with some of the cardinals and, having looked at it for a considerable time and handled the Proserpine, remarked, "She is very pretty, very pretty indeed, but she would be much improved if she had those black eyes that the nuns give to the little black dogs that they embroider."[63] At this he had the greatest difficulty in not laughing outright.

He then told a story about a Spanish nobleman who on his way to Naples fell off his mule in the neighborhood of Macerata; and rolled with the animal down a hillside. He called on the Virgin for protection and thought he saw a light which blinded him; eventually he found himself safe and sound at the bottom of a ravine. He climbed out and at last reached Naples. To commemorate this miracle he decided to

[61] A church, built on the site of the house that St. Gregory had turned into a monastery (575), not far distant from the Colosseum.

[62] One of Bernini's early works made for Cardinal Scipione Borghese. See Wittkower, *Bernini*, cat. no. 10.

[63] The ambassador's comment is in Spanish in the manuscript.

order a votive picture. He related his adventure to Filippo Angeli,[64] describing to him the mountain and how his fall had happened. Filippo made a painting in which he represented to the best of his ability the place where the accident had occurred. The Spaniard liked it very much but complained that the mishap should have been represented on the other side of the mountain. The artist pointed out that it would then be out of sight, but his patron reiterated that this was falsifying history, that he must insist on the incident being painted on the other side of the mountain, so that finally Filippo, who was well aware of his stupidity, promised to change it and, having effaced the figure, brought back the picture, saying he had placed him on the other side. The Spaniard declared that he was well satisfied and paid the artist a good price. I said with a smile that formerly the French would have been delighted to see the Spaniards as laughingstocks, but now peace reigned between the two countries and this was no longer so.[65] "That may be," he said, "but I must tell you just one more story about a Spaniard and the votive picture he wished to order to commemorate an adventure which he had in a wood, where he was set upon, half an hour after sunset, by six highwaymen. Luckily he had escaped being killed. The artist in representing the incident illuminated it only by a dim light. The Spaniard was not satisfied with it, however, because it had been darker in the wood, and he asked the painter to alter it. On seeing it a second time he still found it too light. The artist then lost all patience and exclaimed that if it were made any darker, nothing would be visible, 'Of course nothing was visible when those rascals attacked me,' answered the Spaniard, 'if I had known there were only six, I would have soon disposed of them. You must make it completely black.' " Whereupon the painter asked for his fee and then so smeared over the picture that nothing was left of it at all.

The Nuncio changed the subject and asked the Cavaliere which was his favorite ancient statue. He replied that it was the *Pasquino*,[66] and said that he had once expressed his opinion to a cardinal who had asked him the same thing; he had thought that he was laughing at

[64] Probably, as Lalanne suggested, to be identified with Filippo d'Angeli to whom Baglione (p. 335) devoted a biography. According to Mancini (I, p. 255), he was especially esteemed for his small paintings of fires, ships, animals, and skeletons of animals, as well as for battles, martyrdoms, and the like.

[65] The Peace of the Pyrenees between France and Spain had been sealed with the marriage in 1660 of Louis XIV to Marie-Thérèse of Austria (1638–83).

[66] The name, of uncertain origin, given during the Renaissance to a much damaged group located at a corner of the Palazzo Braschi in Rome. The voice of both popular and learned unrest, numerous anonymous satires of governments and people have been written in the name of Pasquino and posted on the statue—hence our word *pasquinade*. A typical 17th-century example appears below, 28 Aug. In Domenico Bernini's account (pp. 13–14) the part of the Cardinal is taken by a noble foreigner from the North.

him and had been quite offended. "But," said the Cavaliere, "he cannot have read what has been written about this work, that it is by Phidias or Praxiteles and portrays the figure of Alexander's servant supporting him, after he had received an arrow wound at the siege of Tyre.[67] However the figure is so mutilated and ruined that the beauty which remains is recognized only by real connoisseurs." The Cavaliere put second the *Belvedere Torso*,[68] saying that it is known to be a figure of the resting Hercules, although it has neither head, legs, nor arms. It is believed that this statue was never completed, which is obvious. He added that one day Michelangelo was studying it and knelt down to see it better. Cardinal Salviati[69] happened to come in and, finding him in this position, spoke to him with some surprise. There was a pause, and then the artist, coming to himself and noticing the Cardinal, replied, "This is the work of a man whose mind went beyond nature; it is the greatest pity that it should be so mutilated."[70]

I mentioned the *Laocoön*,[71] a masterpiece of Greek art. He agreed that it was a wonderful work but said that the *Torso* was altogether grander. I asked him his opinion of the *Gladiator*[72] and *Cleopatra*,[73] both of which he put among the finest pieces of sculpture in existence. He praised the *Farnese Hercules*,[74] observing it was by an excellent Greek artist but that it had been made to be seen at a certain distance,

[67] Lalanne pointed out that Alexander was not wounded at Tyre, but at a battle for a town in India. The work is now thought to represent Menelaus with the body of Patroclus and has been attributed to Antigonus of Carystus (fl. 240 B.C.).

[68] A fragmentary figure of unknown provenance in the Vatican Museum. It is signed by Apollonius, son of Nestor, of Athens. The figure has been variously interpreted, but was frequently identified as Hercules because it sits on a feline skin.

[69] Because the "same Cardinal Salviati" is mentioned below in connection with the Porta Pia (begun 1561), Bernini is presumably referring to Bernardo Salviati (1492–1568), who was created cardinal by Pius IV in 1561, rather than his brother, Cardinal Giovanni Salviati, who died in 1553, although this may be putting too fine a point on clearly anecdotal material.

[70] Michelangelo's reply is in Italian in the manuscript.

[71] Then, as now, one of the most famous of ancient sculptures. It was carved by Agesander, Polydorus, and Athenodorus, three Rhodian sculptors, in the second half of the first century A.D. In Roman times it stood in the palace of the Emperor Titus. Rediscovered in 1506, it is now in the Vatican.

[72] The *Borghese Warrior* found near Anzio during the reign of Paul V (1605–21). Formerly in the Villa Borghese, it is now in the Louvre. The statue is signed by Agasias, son of Dositheus, of Ephesus and is dated to the late 2d or early first century B.C.

[73] The *Sleeping Ariadne* now in the Vatican Museum, a late Hadrianic or early Antonine copy of a Hellenistic work of the later Pergamon school. In 1512, shortly after its discovery, it was installed as part of a fountain in the Belvedere Court of the Vatican. The figure was traditionally thought to be a Cleopatra because of the double-wound, snake bracelet on its upper left arm.

[74] A huge figure over three meters high (which explains Bernini's comment), it was found in the Baths of Caracalla in 1506. In 1787 it went to Naples and is now in the National Museum there. It is signed by Glycon of Athens and is believed to be an enlarged copy of a work by Lysippus.

and in its present position the further one moves back from it the more it improves. The Nuncio mentioned the *Farnese Bull*,[75] which is remarkable only for its size and the number of figures carved from one stone. The *Medici Venus*[76] was also mentioned.

Then the Cavaliere told us another anecdote about Michelangelo. It appears that when the Porta Pia was erected, this being one of the gateways of Rome designed by Michelangelo, he himself wished to do the mask that decorates it. The same Cardinal Salviati, who was a particular friend of his, had a vineyard near the gate and begged him to go there as often as he wished and gave orders to his servant to look after him and make him welcome in the house and the garden. The Cardinal visited the vineyard sometime later and asked the servant for news of Michelangelo. To the astonishment of the Cardinal, he said that unhappily the artist had gone out of his mind; he had realized he was mad when he found him taking his valet aside and forcing him to open his mouth as wide as possible, while he shouted at him, "More, more,"[77] taking pleasure in nothing more than the grimaces of this valet.

9 JUNE

� The Nuncio and the Venetian ambassador[78] came to see the Cavaliere. In my presence, he read them the following notes which he had made on the subject of the Louvre.

Reflections on the Subject of the Building that the King wishes to erect

The present King of France is a very great king; his intelligence and his character are great and so is his power. He has time to do great things, because he is young and, at the moment, his country is at peace. He desires to make this palace worthy of such a prince. It would be a huge fault not to construct a building of majesty and grandeur. In order to put this idea into execution, an architect has been sent for from Italy for the purpose.

Bearing this in mind a grand and majestic building

[75] Found in Rome in the Baths of Caracalla in 1545, it remained in the Palazzo Farnese until 1788 when it was sent to Naples where it is today (National Museum). Formerly considered the work described by Pliny (*Nat. Hist.*, xxxvi, 34) as cut from a single block, it is now thought to be a copy with variations.

[76] The famous statue now in the Galleria degli Uffizi, which was then in the Villa Medici in Rome. It is based on a prototype from the school of Praxiteles of the late 4th or early 3d century B.C. and is signed by Cleomenes, son of Apollodoros, of Athens, although the signature is controversial. It was removed to Florence ca. 1677.

[77] The exclamation is in Italian in the manuscript.

[78] Alvise Sagredo, who entered Paris on 11 Mar. 1663.

should be erected. On the other hand it must be remembered that life is short. The prince, who is determined to build something beautiful, wishes to see and enjoy it as soon as possible, particularly if it is to his own taste. The Frenchman is by nature not phlegmatic, and the calm of peace in France usually does not endure for long. There is no space for a large building, unless a good part of Paris is to be pulled down, which would cost millions and take years to do—and anyway a major part of the Louvre is completed. Having regard to these facts too vast a project should perhaps not be undertaken.

These considerations must be weighed one against the other and the best course in the circumstances adopted.[79]

He then added that he would build two sets of royal apartments, with everything that he thought conducive to comfort and magnificence in the front wing of the Louvre; that as the ground floor of the existing structure has not sufficient height, he would use it in the façade as the base for the Corinthian order he intended to erect, and that he would join the two royal apartments to the old building that would remain.[80]

The two visitors discussed these notes at length, together highly approved of them and praised the sound reasoning of the Cavaliere. Then they left.

I0 JUNE

He worked hard at his drawings. One of his attendants brought him some modelling clay, and he asked me if it would not be possible to obtain a cartload so as to keep his people occupied, as they had nothing to do at present. I gave the order immediately. About six in the evening I had the coach brought around which the King had put at his disposal. It was one of the suite of royal coaches and had six horses. We drove as far as the Cours-la-Reine[81] without his saying a

[79] Bernini's program is in Italian in the manuscript.

[80] A *mémoire* on Bernini's second plan, sent to the artist in Rome, says that "at present there are two and one-half sides of the Square Court of the Louvre entirely built, one half of the face on the front elevated to the first story, and the foundations of all the rest entirely made" (Clément, p. 259). As his "program" indicates, Bernini has given up his alarming plan of building an altogether new palace and bowed to the King's desire to preserve the work of his ancestors (cf. the letter of 19 June written by Vigarani in Rouchès, no. 217, and Fraschetti, p. 343, n. 1). Two issues however are still unresolved: the location of the royal apartments (see below, 19 June) and the height of the palace (cf. the letter of 19 June by Alberto Caprara in Fraschetti, p. 342, n. 1).

[81] A promenade laid out during the regency of Marie de Médicis between the present Champs Elysées and the Seine. It was divided into three alleys by trees and entered through a monumental gate that stood at the side of what is today the place de la Concorde.

word. Seeing that he was not his usual self, I asked him if he were not well. He said no, but that he was exhausted from the work of the afternoon. He did not wish to enter the Cours but having driven along the river, he began to converse as agreeably as usual.

I I JUNE

🐿 When I went to see the Cavaliere during the morning, I found him drawing heads on paper. I just glanced at them in passing and went over to see Signor Mattia, who was drawing the elevation of the Louvre façade. Having watched him a little at work, I returned to the Cavaliere who stopped what he was doing and, drawing me aside, told me in confidence he was very annoyed; he had heard from various different sources that the King wanted him to do his portrait, and that of the Queen, but that M. Colbert had said nothing about it; the duc de Créqui[82] had been the first to mention it, then M. de Lionne[83] and Cardinal Antonio Barberini;[84] he had no greater desire than to please and serve His Majesty in every way, so that if it were true that he really wanted the portraits he would like to start as soon as possible; he had planned to leave at the end of August, but for such an under-taking he would willingly stay until the end of October, two months longer than he had intended, but he could not spend the winter here because of the cold, nor set out on his journey later than November on account of his age.[85] I replied that M. Colbert had meant to make

[82] Charles III de Créqui (ca. 1623–87), Lieutenant-General (1651), Duke and Peer of France (1653). In 1662, as the first French ambassador to Rome in nine years, he precipitated a crisis over an incident involving the Pope's Corsican soldiers that ended in the Pope's humiliation, sent Cardinal Chigi as Legate to France (1664), and played a part in bringing Bernini to Paris (see Pastor, XXXI, pp. 91ff., and Schiavo, pp. 23–31).

[83] Hugues de Lionne (1611–71), marquis de Berny, a celebrated statesman. From 1663, Secretary of State for Foreign Affairs, a position he held until his death.

[84] Antonio Barberini (1607–71), nephew of Urban VIII, Cardinal (1627), Grand Al-moner of France (1653), and Archbishop of Rheims (1667). As a member of the family who were the patrons and protectors of the artist before they fled to France following the death of Urban VIII (1644), Cardinal Barberini was a useful intermediary between Bernini and the French court, as he proved in 1641–42 (Fraschetti, p. 112) and again in 1662 (Mirot, pp. 168–69).

[85] Bernini's wishes alone did not set the term of his stay in Paris. The Pope had reluctantly conceded to Louis XIV the artist's services for only three months (Fraschetti, p. 340, n. 3), and he must have followed anxiously the efforts described below to attach Bernini permanently to the French court. Already on 7 July the Nuncio reported to Rome that he did not think the Cavaliere could return before the end of September, adding, "I have not failed to remind him of the need Your Holiness has for him in Rome and of the time he has been granted, so that he can well consider his plans" (Schiavo, p. 33). And in his response to a letter from the artist (below, 23 July), Cardinal Chigi none too subtly rehearsed all that called the Cavaliere back to Rome—the time conceded by the Pope, the projects under way, the benefits received and to be expected,

the same proposition, that he had spoken to me about it, but as he had not authorized me to talk about it, I had remained silent. I added that the minister had probably waited before making this suggestion until he was less busy with the designs at present in hand. The Cavaliere replied that did not matter, as he could be preparing for the work on the bust while Mattia was finishing the designs; that was why he had asked for clay so that he could try out a pose while waiting to start work on the likeness. He repeated he would gladly stay two more months than he had planned; further, if it needed ten years (had he so long to live) he would give them, even if it meant that he had to die here; that he was so grateful for the honorable way in which he had been received, he felt he ought to devote the rest of his life to the King's service. I offered to write to M. Colbert, but he said it was not necessary; he would think about it between now and Wednesday when M. Colbert was coming again, and then he would speak to him himself; he thought that by Thursday the drawings would be finished and ready to be taken to the King; he would soon know what decisions had been reached.

We then went to see the procession of the Octave of the Blessed Sacrament. While waiting for it to pass, in the parish of Saint-Sulpice, the Cavaliere went into the Luxembourg.[86] He looked at it very carefully, and declared it was the most beautiful building that he had yet seen in France.

12 JUNE

✿ I went to see him and he told me he was troubled with colic, which he had had once before. I accompanied him to the Oratoire[87] where he attended Mass. On our return I saw that he was ill and advised him to go to bed and take nothing solid. I asked him if he would like

his friends, his family, and even beautiful Italy herself (Baldinucci, *Vita*, p. 58 and Dom. Bernini, pp. 139–40).

[86] The palace built by Marie de Médicis in emulation of the Pitti Palace in Florence, although this cannot entirely account for Bernini's approbation since its design is largely French. It was begun in 1615 on the designs of Salomon de Brosse. By 1625 the palace was not yet habitable and when it passed in 1646 to Gaston d'Orléans, the interior was still not finished. For de Brosse and his work, see Rosalys Coope, *Salomon de Brosse*, London, 1972.

[87] A congregation of regular clerics founded in 1611 on the model of the Oratory of St. Philip Neri at Rome. They were established near the Louvre on the site of the hôtel du Bouchage in 1616. The church was begun in 1621, probably on plans furnished by Jacques Le Mercier, who, however, was shortly thereafter replaced by Clément Métezeau. It was officially declared the chapel of the Louvre in 1627 and completed in 1630. The principal façade on the rue Saint-Honoré, however, was built by Pierre Caqué (1745–50). It is now a Protestant church.

me to send for the First Physician to the King,[88] who had been charged with the care of his health. He refused and went to bed. When I went back about five or six o'clock, he said he felt a little better but would not go out. He got up and I was with him at least two hours, strolling up and down his room discussing painting.

I remember, among other things, he told me that when Michelangelo was shown a work by a good painter, he used to say, "This is by a rogue, a real wretch," but about those of the mediocre, "This is by a good fellow, who will give no one any trouble."[89]

The Cavaliere also talked about the many differences in taste and that there was nothing that pleased everyone, and this sprang from the fact that no two minds were alike; only if one mind were common to all would everything please everybody. When he was working on the *Daphne*,[90] Pope Urban VIII (then still a cardinal), came in to see it with Cardinal de Sourdis[91] and Cardinal Borghese[92] who had commissioned it. Cardinal de Sourdis remarked to the latter that he would have some scruples about having it in his house; the figure of a lovely naked girl might disturb those who saw it. His Holiness answered that he would attempt a cure with a couple of verses. Whereupon, he made an epigram from the fable of Apollo and Daphne; the story is that Apollo chased Daphne for hours; he was on the point of catching her when she was changed into a laurel bush, the leaves of which he grasped, and in the madness of love put to his lips. The bitterness of their flavor made him exclaim that Daphne was no kinder to him after her transformation than before. This was the substance of the epigram:

[88] Antoine Vallot (1594–1671) who became the Royal Physician in 1652 and was Director of the Royal Garden of Medicinal Herbs.

[89] Michelangelo's comments are in Italian in the manuscript.

[90] Another of the early works Bernini made for Cardinal Borghese. See Wittkower, *Bernini*, cat. no. 18.

[91] François d'Escoubleau (1575–1628), created cardinal in 1598 and from the following year Archbishop of Bordeaux. His patronage of the Bernini is documented by the sculptures still at Bordeaux, one of which—his portrait bust (Wittkower, *Bernini*, cat. no. 14)—is by the Cavaliere. However, he is not named in either Baldinucci's (p. 14) or Domenico Bernini's (pp. 19–20) account of the following event, and a payment for the marble in Aug. 1622 (Wittkower, *Bernini*, cat. no. 18) suggests that Bernini can have done no more than begin to carve the *Apollo and Daphne* before the Cardinal, who was back in Bordeaux by 17 July 1622 (I. Lavin, "Five New Youthful Sculptures by Gianlorenzo Bernini and a Revised Chronology of His Early Works," *AB*, L, 1968, p. 238, n. 102), had returned to France.

[92] Scipione Caffarelli (1579–1633), son of Paul V's sister, who assumed the Borghese name and arms when he was made cardinal in 1606. Enriched by his uncle, he lived the life of a great noble and grand patron. He early recognized the genius of the youthful Bernini and commissioned from him the outstanding series of works still in the Villa Borghese at Rome.

The joy which we pursue will never be caught or, when caught, will prove bitter to the taste."[93] In Latin,

> Quisquis amans sequitur fugitivae gaudia formae,
> Fronde manus implet, baccas seu carpit amaras.[94]

Whoever, when in love, pursues the delights of a fleeting form, fills his hand with leaves or plucks bitter berries.

13 JUNE

✍ At five in the morning the Cavaliere sent word that he would like to see the establishments of the Jesuits. I ordered the royal coach and drove to the Oratoire where we heard Mass, then to the church of the Jesuit Novitiate,[95] where we again heard Mass, after which he looked at the picture over the High Altar and remarked that it must be by Poussin.[96] He thought it very beautiful and the church also. I said that it had been built by M. de Noyers, and that my brothers and I had had not a little to do with it. He studied it then rather more carefully and said that the decorations were well carried out. Afterwards he visited the house and gardens. On our way to the Collège de Clermont[97] he wished to get out at the Luxembourg so that he could show it to his son and Signor Mattia. He repeated what he had said the day before, that it was the finest thing he had yet seen in France. When he was in the courtyard he had the arcade measured and then passed into the gardens, where he studied the other façade and drew the attention of his son and his assistant to it.

We then went to the Collège de Clermont where after praying in the church he returned almost immediately to the hôtel de Frontenac.

Towards four o'clock the Nuncio and the abbé Buti came to see

[93] Quoted in Italian in the manuscript.

[94] The Latin distich quoted here was never added to the space left for it in the manuscript (Lalanne), but it is reported by Baldinucci and Domenico Bernini in their accounts of the event, and it appears in an elaborate cartouche on the pedestal of the statue.

[95] Formerly in the rue Pot-de-Fer, the church was designed and built (1630–42) by the Jesuit architect Etienne Martellange under the patronage of François Sublet de Noyers (1589–1645), baron de Dangu, Intendant of Finances, Secretary of State for War, and from 1638, Superintendent of the King's Works, who wished to be buried there. Both Chantelou and his brother, M. de Chambray, were active in the affairs of the King's Works under Sublet de Noyers, to whom they were related, before he was forced to retire from court following the death of Richelieu.

[96] Bernini's attribution was correct. The painting, *A Miracle of St. Francis Xavier*, was commissioned in 1641 by Sublet de Noyers. It is now in the Louvre. See Blunt, *Poussin Cat.*, no. 101.

[97] The Jesuit college established by Guillaume Duprat, Bishop of Clermont, in the rue de la Harpe after authorization had been given by Henry II in 1551. In 1682 it became a royal foundation and was subsequently known as the Collège Louis-le-Grand.

him. We went to the Val-de-Grâce.[98] He studied the church very carefully, and went up into the cupola to get a view of Mignard's decorations.[99] Thence to the convent, where M. Tubeuf[100] showed him round. Le Duc,[101] the architect, and many other people were there. Next he went to look at the model for the altar.[102] He gazed at it for a long time and, when M. Tubeuf asked him what he thought about it, he only replied that Michelangelo used to say that money spent on drawings brought a hundredfold profit.[103] Back in his apartment once more, I asked him why he had said nothing about the model. He answered that the young man (he was speaking of Le Duc)

[98] The church, in the rue Saint-Jacques, was built to commemorate the birth of Louis XIV by the Queen Mother, Anne of Austria, at the convent she founded in 1621 of Benedictine nuns from the Abbaye du Val-de-Grâce de Notre-Dame de la Crèche. Childless since her marriage to Louis XIII in 1615, she had vowed to erect a magnificent temple in this new Val-de-Grâce, should she conceive. Several years after the unexpected birth of Louis XIV in 1638, the commission for the church was given to François Mansart. In 1645, the young King laid the foundation stone, setting precedents that are recalled below (17 Oct.). Mansart was dismissed in the following year for reasons still not clear, and the building was entrusted to Jacques Le Mercier. After the latter's death in 1654, direction of the work passed to Pierre Le Muet, who was assisted by Gabriel Le Duc, the young architect Bernini meets below. The sculptural decoration of the interior, still in progress at the time of the Cavaliere's visit, was directed by Michel Anguier, and only in 1710, five years before the King's death, was the church consecrated.

[99] Pierre Mignard (1610–95), was the great rival of Le Brun, who on the latter's death in 1690 became First Painter to the King and only then a member of the Royal Academy of Painting and Sculpture, when he was made Associate, Member, Rector, Director and Chancellor, all on the same day. He had been in Rome from 1636 to 1657 (when he was recalled to France by the King) with only a short trip to Venice and North Italy in 1654–55. He had received the commission to decorate the dome of the Val-de-Grâce, apparently along with Charles-Alphonse Dufresnoy (1611–65), in 1663.

[100] Jacques Tubeuf (1607–70), Superintendent of the Finances of the Queen Mother and président à la chambre des comptes. From 1645 he had been in charge of the work at the Val-de-Grâce.

[101] Gabriel Le Duc (d. 1704), Architect in the King's Works from 1664. Few of the works known to have been designed by Le Duc survive, and he is remembered today mainly as the successor of other more famous architects, brought in to complete their work. This was the case at the Val-de-Grâce, where he succeeded Le Muet after having served as his assistant. See Hautecoeur, II, pp. 174–76.

[102] The artist responsible for the design of the high altar at the Val-de-Grâce, certainly built in conformity with this model (P. Chaleix, "A propos du baldaquin de l'église du Val-de-Grâce," BSHAF, 1960, pp. 211–14), has been much disputed. P. Lemoine ("Le maître-autel de l'église du Val-de-Grâce," BSHAF, 1960, pp. 103–7), adopting the suggestion of Pierre Du Colombier and Louis Hautecoeur, has argued that François Mansart was the designer. It is more likely, as the diary itself suggests, that M. Beaulieu is correct in attributing the design to Le Duc ("Gabriel Le Duc, Michel Anguier et le Maître-autel du Val-de-Grâce," BSHAF, 1945–46, pp. 150–61) though the contracts let for its construction ascribe the model to both Le Muet and Le Duc (C. Mignot, "L'Eglise du Val-de-Grâce au faubourg Saint-Jacques de Paris: architecture et décor [nouveaux documents 1645–1667], BSHAF, 1975, pp. 101–36).

[103] Cf. the statement attributed to Michelangelo by Vasari "that the most blessed money spent by a builder is that for models" (K. Frey, Il carteggio di Giorgio Vasari, Munich, 1923, no. CCCLXVII).

did not take criticism well; this had become apparent while they were discussing the dome of the Val-de-Grâce. Le Duc had maintained that the proportions were those of St. Peter's; when he had said they were not, the young architect had replied, that "everyone has his own taste." So as not to give offence, he had refrained from commenting on the decorations with which the interior had been ruined nor had he referred to the other defects.[104] Talking about the dome of the church on another occasion, he said that a little cap had been placed on a very large head, which is true enough.

14 JUNE

He went to see the church of the Theatines.[105] The Fathers asked him what he thought of it, to which he only replied, "I think it will come out well."[106] In the course of conversation one of them mentioned the Gesù in Rome, saying that its vault was too low, but that the vault of S. Andrea della Valle, which had been constructed on the same model, was higher. The Cavaliere said that both churches had the proportions that suited them. He pointed out that it was a mistake to attempt to give a building a height out of proportion to its width because such an arrangement forced one to raise one's head uncomfortably high. An architect, who wanted to make fun of the extravagant height of a certain church, spread his cloak and lay down on his back to show there was no other convenient way of looking at it. The Cavaliere told the Fathers that he believed that when the vault of the church was finished it would appear bigger, and to illustrate his meaning he told them a story about a church at Castel Gandolfo,

[104] Domenico Bernini (p. 31) wrote that when the Cavaliere could not praise a work "he kept quiet rather than criticize it and, if forced to say something, found ways to speak of it without committing himself." As is the case here, however, his ambiguity often concealed a sting. The example given by Domenico is his father's comment to an admiring cardinal on his protégé's cupola decoration that "the work speaks for itself," energetically repeated three times. Similarly in Baldinucci, *Vita*, p. 75.

[105] The Theatines were introduced into France in 1644 by Cardinal Mazarin, who later left them 300,000 livres to build their church. In 1648, they were installed in a house on the quai Malaquais (today 23 quai Voltaire), where their provisionary chapel was known as Sainte-Anne-la-Royale. Their church of the same name, begun in 1662, was designed by Padre Guarino Guarini, the great architect of the Order, whose plans are known from his posthumously published *Architettura Civile*. Work on the church was stopped before 1669 and not resumed until 1714. Consecrated in 1720, it was destroyed in 1823. Chantelou does not record a meeting between Bernini and Guarini, perhaps because Guarini had already left Paris or, as in the case of another famous architect, Sir Christopher Wren, who met Bernini and saw the plans for the Louvre, simply because he was not present when the meeting took place. See D. R. Coffin, "Padre Guarino Guarini in Paris," *Journal of the Society of Architectural Historians*, XV, 1956, pp. 3–11, and A. Boase, "Sant' Anna Reale," *Guarino Guarini e l'internazionalità del Barocco*, Turin, 1970, I, pp. 345–54.

[106] Bernini's laconic comment is in Italian in the manuscript.

which had been built by the present Pope. The Pope took a cardinal to see it and he thought it was too small. The Pope, who understands the art of building very well, ostensibly approved of this opinion and said he would have it put right. He had the vault constructed which did not then exist. A couple of years later His Holiness returned with the same cardinal, who this time admired the church very much believing that it had been pulled down and rebuilt; he said that it seemed to him bigger by a third. But in fact the only difference was that it had been roofed.[107]

He told them that it would be a good thing to create a small space projecting from a completely round church, for on entering one usually takes six or seven steps and so is prevented from appreciating the circular form. Speaking of the circle he said that according to the story Archimedes, having burned and destroyed by his inventions all the enemy vessels, was offered by the king a huge reward in gold, which he refused, saying that he would have to give it all to the gods who had discovered the circle and the compass with which the circle is made.[108]

[107] Bernini's defense of the Jesuit church of the Gesù—actually much less than twice its width in height, whereas the Theatine church in Rome, S. Andrea della Valle, is rather more than twice its width—derives from his belief in the organic integrity of the work of art. He was convinced, and repeatedly argued, that each individual work necessarily obeys its own law, which orders and regulates its parts. For this reason he rejected the popular "selection" theory of art, according to which the artist simply combines the best motifs from a variety of sources, and dismissed as a "fable" the endlessly and approvingly repeated story of Zeuxis and the Crotonian maidens. Zeuxis, it was said, had assembled the most beautiful of Crotonian maidens and chosen from among them their most perfect parts in order to create his Venus. This procedure could only fail, Bernini thought, because it ignores what the beauty of every single part owes to all of the others: the charming eyes of one face may not appear so when combined with the nose of a second face and the mouth of a third (cf. Lavin, *Bernini and the Unity of the Visual Arts*, p. 11). The source of this "fitness" among the parts lies in the eye of the beholder, which does not see isolated perfections but their effect on one another in the particular context of the whole. No height can be judged without its width, as he said in another place (Brauer and Wittkower, p. 170, n. 1) and reaffirms here. Thus he tells the Fathers that the vault of their church will seem much higher when it is finished than it does now, and cites as an example the church of S. Tommaso di Villanova at Castel Gandolfo (begun 1658), which he had designed for Pope Alexander VII Chigi. This anecdote, which can be compared to one involving Michelangelo told by Vasari (Vasari-Milanesi, VIII, pp. 155–56), also illustrates the necessity of that right judgment which separates the true artist and those who understand art from those who do not. Both the unsuspecting cardinal at Castel Gandolfo and the architect of the Val-de-Grâce betray their ignorance of art—the first because his lack of knowledge duped him into believing that the dome of San Tommaso had been rebuilt, the second because he had willfully placed an incongruous little cap on a very large head. By exercising judgment based on knowledge the good artist will anticipate such subjective effects and design accordingly.

[108] Popular history, from which Bernini's anecdote derives, placed Archimedes, the author of various mathematical works on the circle, cylinder, sphere, and spiral, at the

15 JUNE

✿ He worked extremely hard at the drawings. In the evening he went to see the house of M. Le Coigneux in the faubourg Saint-Germain.[109] The abbé Buti had told me that he thought its position worthy of the Cavaliere's attention. He did not like it however.

16 JUNE

✿ The Royal Academy of Painters and Sculptors came in a body to pay him their respects.[110] He received them very graciously and entertained them most cordially with stories relating to their profession. He told them, among other things, that one day, when he was very young, on his way to the Academy he met Annibale Carracci who accompanied him thither.[111] The Academy, seeing the great painter, asked him to accept the honor of posing the model, which he did without going near him, only ordering the model thus: "Put yourself in such a way, lean your weight on such a leg, lift one arm, lower the other, bend your head so," and once the model was posed, Annibale began drawing like the others. The Cavaliere said how rare it was to find a beautiful model. One day he noticed that a porter who had brought him something, had a fine torso, so he drew him unawares lest he should object. In order to gain more time and to make him stay, he gave him wine and paid him double. Another time he made him bare his arms, which he considered marvelously beautiful and one day when he had a nude model, he asked him to come so as to accustom him to the idea of working in this way. The model informed the man that he himself earned fifteen crowns a month, and that he could easily earn as much. He finally brought himself to do it and the

siege of Syracuse (213–11 B.C.), where his marvelously effective war machines forced Marcellus to take the city by stealth (Plutarch, *Marcellus*, 14–19). For Bernini and the circle, see below, 19 Sept.

[109] The house (now destroyed) had been built for Jacques Le Coigneux (1589–1651), marquis de Bélâbre (1650) and président à mortier of the Parlement of Paris (1630). It stood in the rue de Grenelle in the faubourg Saint-Germain, which was then not much built up. The architect is not known, but the appearance of the house is recorded in an engraving by Israël Silvestre. On his father's death, the house passed to Jacques II (d. 1686), who also succeeded to his father's office in the Parlement of Paris.

[110] The Academy was officially founded in 1648, but there is some evidence to suggest that plans for such an institution were already laid under Richelieu, when Sublet de Noyers was Superintendent of the King's Works, and that Chantelou and his brother, M. de Chambray, were also involved. See Thuillier, pp. 183–84.

[111] Annibale Carracci, who often figures in Bernini's stories, died on 16 July 1609, when Bernini was not yet eleven years old. The academy Bernini describes was probably not the official Accademia di San Luca, although it seems to have had provisions for drawing from life as early as 1596, but a private "accademia del nudo," of which many are known. See N. Pevsner, pp. 60–62, 71–75, and cf. below, 13 Sept. and 11 Oct.

Cavaliere in order not to scare him off put him into a fairly easy position, with his right leg crossed over the left and his chin on his right hand and his elbow on his knee. After a little while, in order not to put him off, he allowed him to rest. When after a short time he told him to take up his position again he put his left leg over his right and his left elbow on his knee, which was the opposite of his original pose. When he was told that this was not how he had been seated before, he insisted that it was, and when he was told that it was not he got up in a temper, picked up his clothes and left, declaring they were making fun of him and swearing never to return.

He told them some other similar stories and then the academicians took their leave. The Cavaliere accompanied them as far as the spot where he had met them, which was at the further end of his studio where they had entered. Some people have since reported that the members were offended that he had not seen them out, but he had treated them as he treats the greatest, even M. Colbert himself.[112]

17 AND 18 JUNE

�ख The Cavaliere worked very hard at the drawings so that they would be ready to show to M. Colbert who was expected in Paris. In the evening the Nuncio took him out for a drive. As I left he repeated what he had said before, that he was growing used to French wine but that he lived too well in Paris.

19 JUNE

✒ M. Colbert called on the Cavaliere before I got there. Signor Paolo told me when I arrived that the Cavaliere had shown him the plan of the Louvre and that he had not liked it because he had placed the block containing the King's suite in the pavilion near Saint-Germain-l'Auxerrois so that the King would be exposed to all the noise that occurred at the Port de l'Ecole.[113] Moreover, the arcade which he had designed so that the King could get in and out of his carriage under cover would serve as a hiding place for anyone intending assassination, and so

[112] Etiquette was extremely precise about how far one accompanied a guest when he was leaving: if relatively unimportant, to the door of the room; if slightly more important, to the stairs; and if very important, to his coach.

[113] That is, Bernini placed the King's apartment opposite the mediaeval church of Saint-Germain-l'Auxerrois and closest to the docks on the bank of the Seine. From the time of his first design, Bernini "was convinced that because the most noble part of the palace was the principal façade, it was here that the King must have his apartment" (Mirot, p. 178, n. 1). As we have seen (above, 9 June), no criticism of this location as being noisy and unhealthy (Clément, pp. 247–48) could shake this conviction, and the placement of the royal apartments remained a problem (below, 7 Oct. and p. 334).

would the columns carrying the vestibule.[114] The Cavaliere said nothing to me about all this but appeared depressed.

20 JUNE

❧ We went to Saint-Germain-en-Laye with M. Colbert. The Cavaliere presented his plan for the Louvre and the design for the elevation of the façade. The whole pleased His Majesty so much that he told the Cavaliere how very glad he was that he had begged the Pope to allow him to come. The King noticed among other features the rock-like base on which the Louvre was to rest; this was covered by a sheet of paper with a drawing showing this story rusticated, as an alternative because the rock would be difficult to execute. The King considered both carefully and said that he liked the rocky effect very much and asked for it to be carried out. The Cavaliere explained that he had drawn the alternative because he was afraid that the entirely novel idea of the rock might not please, but also because if it was to be carried out in accordance with his intention he himself would have to do it. The King repeated that he was extremely impressed by the rock design.[115] To this the Cavaliere answered that it was a great pleasure to

[114] The plan of Bernini's third project (fig. 8), engraved by Jean Marot (below, 20 and 21 Sept.), shows a hypostyle atrium parallel to the façade on the ground floor. It is joined to the main courtyard of the palace by a colonnade with three courses, which divides a subsidiary courtyard into two equal parts. Colbert's aversion to the plan arises from the fact that both Henry III, in 1589, and Henry IV, in 1610, had been assassinated. Cf. below, 15 Oct., where the minister, haunted by the unsuccessful regicide of James I in the Gunpowder Plot of 1605, objects to having cisterns in the palace.

[115] Bernini was led to a rough-hewn, rocklike basement because he had decided to use the existing ground floor as the base for a colossal order (above, 9 June). But if this base was rusticated, the basement in the moat below would then have had to appear even more crude in keeping with the traditional progression from the simple and rough to the rich and refined in the several stories of the Renaissance façade (cf. Tessin, p. 159). The effect sought by Bernini in this rocky foundation was evidently the combination of awe, wonder, and formidable beauty that Vasari recognized in Michele Sanmicheli's fort of S. Andrea al Lido in Venice, which appeared to be cut from living rock (Vasari-Milanesi, VI, p. 348). Such ideas had been popularized by Vitruvius' account of the architect Denocrates, who wished to carve Mt. Athos into an image of Alexander the Great holding a city in his hand (*De arch.*, II, preface) and had already entered into Bernini's design of the Four Rivers Fountain (Wittkower, *Bernini*, cat. no. 50), where he reputedly also insisted on carving the rocky mass supporting the obelisk (Baldinucci, *Vita*, p. 38, and Dom. Bernini, p. 89). Typically, however, Bernini informed his design with a conceit that metaphorically particularized it in relation to the King. "Above the great mass of rock," Mattia de' Rossi wrote in his description of the elevation (fig. 9), "instead of ornamenting the principal portal with two columns, he has placed there two Herculean figures, which seem to guard the palace and to which the Cavaliere has given a meaning; he says that Hercules, in his fortitude and labor, is the image of Virtue that resides on the mountain of effort, which is the mass of rock described above; and he says that whoever wishes to reside in this realm must attain it by virtue and labor" (Mirot, p. 217, n. 1, which also contains an account of Bernini's presentation of his

see what a delicate and discriminating taste the King had, there being few, even among the profession, who would have decided so judiciously. The King asked him also to make a design for the façade facing the service courtyard, to which he agreed and then withdrew.

On leaving we went into the chapel where the Cavaliere remained a long time in prayer, from time to time kissing the floor.

I learnt that after the Cavaliere had left, the King had gone to show the designs which he had kept to the Queen Mother and had told her how delighted he was with them; for two or three years he had had it in mind to have a palace built that would be worthy of the kings of France and himself, but that all the designs he had seen so far had left him dissatisfied; that was why he had been forced to summon the Cavaliere Bernini from Italy; that now his mind was at rest, having entrusted this task to the ablest man in Europe; henceforth he would have nothing to regret on that account.

I forgot to mention that the King had asked him to undertake his portrait. The Cavaliere had replied that it was a most difficult thing to do and would cause the King a certain amount of inconvenience, as he would need twenty sittings, each of two hours.[116] I also learnt that the same evening before supper the King had taken the designs to the Queen and had said again how extremely pleased he was with them, but that he had not explained them to her because he had discussed them so much that his jaws ached.

designs to the King). It is this same conceit that was later used by Bernini for his equestrian portrait of Louis XIV (cf. below, 13 Aug., and R. Wittkower, "The Vicissitudes of a Dynastic Monument. Bernini's Equestrian Statue of Louis XIV," *De Artibus Opuscula XL: Essays in Honor of Erwin Panofsky*, ed. Millard Meiss, New York, 1961, pp. 497–531). See, too, the verses written in praise of Bernini's work by the abbé Buti (below, 20 Aug.), which are published in Schiavo, p. 41. Bernini had used similar figures flanking a portal in his earlier design for the Ludovisi palace at Montecitorio.

[116] Bernini's unusual and demanding procedure for making the King's bust (fig. 4)—from selecting the marble block to finishing the final details from life—is minutely documented in the pages that follow and has been carefully analyzed by Rudolf Wittkower, *Bernini's Bust of Louis XIV*, London, 1951. However, the special nature of the commission in Bernini's mind appears in his agitated conversation with Chantelou of several days earlier (11 June) when he himself brought up the question of the bust. On other occasions, when properly persuaded, he was willing to work from painted portraits provided by the sitter (Wittkower, *Bernini*, cat. nos. 39, 42, 54), and although the lifelike results were considered all the more amazing for having been done in this way (cf. Bauer, p. 44), the artist himself found such work extremely difficult ("The Notebook and Account Book of Nicolas Stone," ed. W. L. Spiers, Walpole Society, VII, 1918-19, pp. 170–71). Altogether, the bust required seventeen sittings: five during which Bernini drew the King and twelve during which he worked on the marble. By way of comparison, the diary of Alexander VII records only four sittings for a bust of the Pope, although there may have been others and Bernini, of course, knew his features well (Krautheimer and Jones, pp. 199–225).

21 JUNE

🐝 The day was spent looking for suitable marble.[117] We went to the gardens of the Tuileries, along the waterside and to various other places, and in the evening to the Val-de-Grâce where among several blocks the Cavaliere only found two that were possible, neither however being exactly what he required. Orders were given to bring a piece from the Tuileries and one of those at the Val-de-Grâce.

22 JUNE

🐝 Signor Mattia took the necessary measurements for making the designs for the front facing the service courtyard. The Cavaliere was there himself, and when he learnt that the piece of marble ordered had not yet arrived, he grew very vexed. The delay was caused, according to M. Perrault,[118] because certain people wished to suggest to the Cavaliere that he should make a statue rather than a bust; and that M. Colbert had written to the abbé Buti about it. The Cavaliere insisted that for several reasons it should be a bust; one should begin with it any way; first it was possible in a bust to study the delicate molding of the face and peculiarities of feature which could not be done in a statue; the bust was more suitable for a room, the statue for a gallery, as the one was to be seen close up, the other from a distance, and for this very reason it would have to be seven or eight feet high and they had in fact hardly enough marble for a bust, let alone a statue.[119] All this was communicated to M. Colbert, who was also asked to arrange an hour's sitting for the next morning if His Majesty was agreeable.

[117] Bernini's not entirely successful search for a marble of statuary quality (see below, 4 Aug.) is also described in a letter written by Chantelou of 21 June to Colbert (Clément, p. 507, where it is incorrectly dated 14 June) and in a similar letter by Charles Perrault of 22 June (ibid., p. 508).

[118] Charles Perrault (1628–1703), brother of Claude, member of the French Academy (1671), Counsellor of the King, and Controller of the King's Works. His poem, *Le Siècle de Louis XIV* (1687), and later his *Parallèle des anciens et des modernes* (1688) argued the superiority of the present over the past in the ongoing quarrel of the ancients and the moderns. At this time first *commis* in the King's Works, his not always disinterested nor accurate *Mémoires* (1672) present a frequently unflattering picture of Bernini.

[119] Bernini's arguments in favor of a bust are interesting as a stylistic interpretation of decorum. They are rooted in the artist's optical approach to art and depend on the notion that size and scale must be increased with the distance from which the work is to be seen (cf. Bernini's comment on the Farnese Hercules above, 8 June). So firmly fixed had this conviction become that a supposed increase in the height of the spiral pictorial fields on the columns of Trajan and Marcus Aurelius in Rome was stated as fact long after it had been disproved (below, 19 Oct.). Although the artist won his point, the idea of a full statue was not forgotten, and an equestrian portrait of the King proposed by Bernini (below, 13 Aug.) was eventually executed (Wittkower, *Bernini*, cat. no. 74).

23 JUNE

❧ M. Perrault came to find me about four o'clock in the morning to say that the Cavaliere could go to Saint-Germain. I sent for the coach and we set off. We found His Majesty playing tennis and during the game the Cavaliere had time to watch him. He dined with M. de Lionne and when he had eaten and slept, M. Colbert sent me to conduct him to the King who admitted him a quarter of an hour later. He was then getting ready to receive the English ambassador and the Danish minister.[120] The Cavaliere made two drawings of his head from the life, one full face and one in profile, and then we returned to Paris.[121]

24 JUNE

❧ He worked at the model of the bust until seven o'clock when he went to the church of Saint-Jean,[122] it being the Saint's Day, and then strolled along the river.

25 JUNE

❧ M. Colbert returned the drawings for the Louvre to him. The Nuncio saw them and congratulated him on gaining the royal approval. The Cavaliere replied that God was the author of his success; before he had begun work he had entrusted himself to Him and every day since had prayed that grace might be vouchsafed him to succeed; what he had done he could truly say had been inspired by God, for he could not have created anything more magnificent even had he not been forced to submit to the conditions which the existing buildings imposed. When finished it would be the grandest and noblest palace in Europe; France was famous formerly only for her armies but in future travellers would come to see the glories of her architecture.

[120] Denzil Holles, ambassador in Paris 1663–66.

[121] A much fuller account of Bernini's first session with the King is given by Mattia de' Rossi, who accompanied the Cavaliere to Saint-Germain. Bernini posed the King against a small table for support, rearranged his hair to suit himself, and completed the two drawings in an hour and a half (Mirot, p. 217, n. 1). As appears directly below, these two studies guided the artist's initial work on a clay model for the bust. Unfortunately, the only drawing by the artist that can be securely identified with the preparation of a portrait is the black chalk drawing of Cardinal Scipione Borghese in the Pierpont Morgan Library, New York (see Brauer and Wittkower, pp. 29–30 and pl. 11). Like one of the two here, it is a profile view taken from life, although the casual sense of immediacy it conveys also relates it to the later drawings of the King engaged in his normal activities.

[122] Of the various churches in Paris dedicated to St. John, the most likely is Saint-Jean-en-Grève, which stood next to the Hôtel-de-Ville and near the river.

M. Tubeuf and M. de Bartillat[123] came the same day to ask him on behalf of the Queen Mother to make a design for the altar of the Val-de-Grâce. He intimated that he feared this request might only be at the instigation of the spiritual director of the nuns, who had already spoken to him about it, and for this reason he would have preferred an order in writing. I replied that one of his visitors was the Superintendent and the other the Treasurer of the Queen Mother's Household, and that they assured him that it was the wish of the Queen. He answered that in that case he would consider it.

He worked the whole day at the model of the bust. In the evening we went for a drive with the Nuncio and the abbé Buti. Referring to his great devotion to his work, the Nuncio asked him whether he had in fact completed a hundred figures in marble during his life. He replied that Michelangelo, who lived to be ninety-two,[124] had done only nine or ten, of which some were unfinished. He said that Michelangelo was great as a painter and sculptor but divine as an architect, for architecture consists entirely in drawing; in sculpture and painting he had not the gift of making creatures of flesh and blood, and they were beautiful and remarkable only for their anatomy. I said that he made muscles appear even in women.[125] This is visible in his figure of *Night* in Florence, which has been so much praised. This remark prompted

[123] Etienne de Jehannot de Bartillat (1610–1701), conseiller d'état (1647), trésorier général of the Queen Mother, and from 1662, garde du trésor royal.

[124] Michelangelo died in 1564 at 89 years of age.

[125] These comments on Michelangelo refine Bernini's use of *disegno* and *colore* as critical categories. Above, 8 June, he had contrasted the lasting intellectual pleasures of *disegno* (Michelangelo) with the passing intellectual pleasures of *colore* (Barocci). Here he extends their content to embrace imitation. *Disegno* is theoretical and abstract; it represents nature understood in principle. *Colore* is practical and concrete; it represents nature perceived by the senses. These too are conventional ideas. Passeri, for example, wrote: "The most essential prerogative of a good painter is design (*disegno*) because it is his principal foundation; this is followed by coloring (*colorito*) with which he expresses all that appertains to the imitation of nature" (Passeri-Hess, p. 274). Thus Michelangelo, as the very incarnation of *disegno*, is "divine" as an architect, because architecture is a nonrepresentational art that consists entirely in design. As painter or sculptor, however, he falls short because he had not that sympathy for *colore*—for the sensible imitation of nature—required of the representational arts. Anatomy is a "science" and is too far removed from concrete reality to supply this deficiency. It contributes to beauty apprehended intellectually, but cannot yield that corporeal beauty which is the object of our senses (cf. Tessin, p. 159). *Colore* in this sense was the particular virtue of painting (below, 9 Aug.) and consequently it posed the central problem of Bernini's professional life, which appears over and over in the diary: how to create in stone true imitations of reality—figures of flesh and blood—without recourse to color or to the other sources of illusion available to the painter (cf. above, 6 June). As the lock of hair he added to the bust of the King reveals, it was a challenge he rarely refused (below, 22 and 29 July).

him to repeat some verses in celebration of this figure, written during the lifetime of Michelangelo, to which the artist replied in the name of *Night*.

> La Notte che tu vedi in sì dolci atti
> Dormir, fu da un Angelo scolpita
> In questo sasso: e, perché dorme, ha vita.
> Destala, se no'l credi, e parlerati.

RISPOSTA DI MICHELANGELO IN PERSONA DELLA NOTTE

> Grato m'è il sonno, e più d'esser di sasso,
> Mentre ch'il danno e la vergogna dura.
> Non veder, non sentir, m'è gran ventura;
> Però non mi destar; deh! parla basso.

> The Night that thou seest, so sweetly sleeping
> Was by an angel carved in the rude stone,
> Sleeping, she lives, if thou believst it not,
> Wake her, and she will surely answer thee.

(Michelangelo makes the figure of Night reply:)

> Dear is my sleep, more dear to be but stone;
> Whilst deep despair and dark dishonor reign
> Not to hear, not to feel is greatest gain:
> Then wake me not; speak in an undertone.

These verses were written while the Republic of Florence was still under a tyranny and before the Grand Dukes had made themselves masters of the city.[126]

He recalled another story about Michelangelo and his work. One day Annibale Carracci went to S. Maria sopra Minerva with some pupils from his school. One of them was a Florentine and always singing the praises of his compatriots. He said to him, "Well, Signor Annibale, what do you say to this statue of Christ?" "Caspitra,"

[126] The quatrain on Michelangelo's statue of *Night* on the tomb of Giuliano de' Medici, Duke of Nemours, in the New Sacristy of San Lorenzo in Florence was written by Giovanni Battista Strozzi (1517–70). Strozzi, who was consul of the Academy of the Umidi, belonged to an anti-Medicean family that had sheltered the artist during an illness in Rome. Traditionally, Michelangelo's rejoinder has been read as a republican response to the Medici restoration of 1530, when Duke Alessandro took over Florence. However, the poem probably dates to the mid-1540s when the artist's relations with the Florentine exiles were close. Widely known from its publication in Vasari's *Lives*, it was the first of Michelangelo's poems to appear in English. See R. S. Clements, *The Poetry of Michelangelo*, New York, 1965, pp. 98–100.

exclaimed Annibale and, turning to the assembled company, said, "It is by Michelangelo; look well at its beauty, but to understand it thoroughly you must realize how bodies were constructed at that time," in this way making fun of Michelangelo, whose style did not imitate nature.[127]

He then spoke of the project which he had put to the Pope, of moving the Column of Trajan to the square where that of Marcus Aurelius stands and making two fountains there to cool the whole piazza, which would then have been the most beautiful in Rome.[128] The Nuncio asked whether the Column of Trajan was a fine work, to which the Cavaliere replied that it was made by some of the greatest men who had ever lived. The Nuncio wanted to know whether it was called *Trajan* after the Trojan city, which made everybody laugh.

Referring to the way to measure water, he said that a waterclock should be used.

26 JUNE

🦋 I wrote M. Colbert at the request of the Cavaliere to say that it would be necessary for him to go to Saint-Germain on Sunday the twenty-eighth, so as to see the King. His visit should not inconvenience His Majesty as it would be enough for him to see the King at Mass or elsewhere.[129]

27 JUNE

🦋 He continued to work at the model.

28 JUNE

🦋 We went to Saint-Germain. There he drew the King from the life during the meeting of the council, without His Majesty being forced to remain still. The Cavaliere used his time to best advantage. Now and then when the King was looking at him, he said, "I am taking something from you." Once the King rejoined in Italian, "Yes, but

[127] The mild Italian expletive expresses impatience. The statue by Michelangelo that Annibale criticizes is the *Resurrected Christ* (1519–21), which is still in the Roman church of S. Maria sopra Minerva.

[128] Bernini's plan for moving the Column of Trajan to Montecitorio and creating a vast piazza between it and the Column of Marcus Aurelius is also described below (19 Oct.) and is discussed by Richard Krautheimer in the *Römisches Jahrbuch für Kunstgeschichte*, 20, 1983, pp. 193–208.

[129] Chantelou's letter is in Jal, p. 358, col. 2.

it is only to give it back," to which he replied, "I give back less than I take."[130]

29 JUNE

❧ Feast of St. Peter. After prayer we drove to Auteuil where we met M. Du Metz and many others who tried him considerably by their conversation. He said to me, "I have one great enemy in Paris, but a great one"; he repeated, "the idea they have of me."[131]

30 JUNE

❧ Two pieces of marble were brought and put in the Council Room of the Louvre, which had been allotted to him for his work on the bust. One was sent by Bistel, the other by Guérin, and both were quite good.[132] He worked the whole day at the model. About six o'clock the marquis de Sourdis[133] came to see him and told him that the Queen Mother had spoken to him about his design but had been unable to explain it to him. He asked me to tell the Cavaliere that he would very much like to see the design.

On our drive we talked of Naples, his birthplace. He described to me a mountain in the neighborhood which had been tunnelled and a road made a mile long right through it.[134] The work had been done by Spaniards under the orders of the French, when the latter were rulers in Naples. One day a Frenchman, so as to recall the slavery of the Spaniards, remarked that it had been their undertaking. The Span-

[130] The exchange is in Italian in the manuscript. As well as being a good example of courtly bandinage—quick, clever, and flattering—this account reveals Bernini's novel approach to portraiture. According to Domenico Bernini (pp. 133–34), "In portraying others either in marble or on paper, the custom of the Cavaliere was very different from the usual one. He did not wish the sitter to be still, but to move and speak naturally. In this way, he said, he saw all of his beauty and portrayed him as he was, asserting that when one remains still, one is never so like oneself as when moving, which reveals all those individual qualities that belong to no other and that give likeness to a portrait. Nevertheless, many times he wanted the sitter to remain immobile in order to portray most diligently those parts that demanded a steady and attentive visual examination." For the purpose of these drawings from life, see below, 29–30 July.

[131] Bernini's comment is in Italian in the manuscript.

[132] Guiffrey (*Comptes*, col. 98) records a payment of 784 livres "for a block of white marble that he has furnished to make the bust of the King" to the sculptor Philippe de Buyster (1595–1688), and another of 819 livres to the sculptor Gilles Guérin (1606–78) for a similar block.

[133] Charles d'Escoubleau (1588–1666), marquis de Sourdis, chevalier des ordres du roi, and Governor of Beauce, Orléanais, etc.

[134] Bernini's anecdote evidently refers to the Grotta Vecchia, or Romana di Posillipo, near the so-called *Tomb of Virgil* in Naples, which had passed from the French Angevin dynasty to the Aragonese in 1442 and from 1503 was actually ruled from Madrid. Close to 700 m. long, the tunnel was excavated in the first century B.C. and was many times enlarged and restored. It is now closed.

iard, with native quickness, replied, "It is an amazing thing for the slaves to become the masters."[135]

We spoke of where poetry had its birthplace. He said he had heard it maintained that it was in Spain, because the word *le donne*, that is to say, "the Muses," must have come from that country as the title Don Juan, Don Gaspar, Don Rodriguez is in use nowhere else.[136]

[135] The quote is in Italian in the manuscript.

[136] This playful etymology presumably seeks to link the Muses, *le donne*, with the Spanish origin of the honorific titles *Don* and *Doña*, but this seems slightly silly, and Chantelou may not have understood Bernini.

❧ *July* ❧

❧ I went to see the Cavaliere in the morning and found him shading the drawing for the façade on the service courtyard.[1] He was rusticating the base of the façade round the door and putting a window over it. He asked me my opinion. I said that it was a novel idea, which had not occurred to ancient architects and that among the moderns only Giulio Romano and Ammannati had used rustication really well.[2] I told him that I liked it better than the Corinthian order, which he had placed above, which was decorative but not so original; the rusticated order placed where it was greatly enhanced the other. I added that this façade seemed to me nobler than the one he had designed for the front of the Louvre, and remarked in jest that it could be said that he had made the back more elaborate than the front. He replied that he had intended this façade to be richer in decoration as it was inside the Louvre and looked toward the gardens; he would make the design for the interior of the courtyard more elaborate than for the exterior on either side, for that was how it should be.[3]

[1] That is, the west façade. The following passage is obscure, and the text may be corrupt. In the final design (fig. 10) the base was still rusticated and had the Corinthian order referred to by Chantelou, but over it there was an open loggia without windows. The fact that Bernini must have changed the design for this front is also indicated by Colbert's comment that it was the same as his design for the east front. Bernini pointed out that this was not the case, but if it had already included the double loggia of eleven bays Colbert could hardly have made this mistake.

[2] Chantelou is probably thinking of such works as Ammannati's remodelling of the Palazzo Pitti in Florence or Giulio Romano's Palazzo del Tè in Mantua.

[3] The idea of a formal progression from front to back and outside to inside advocated by Bernini was an old one in Italy. The series of binary oppositions—active versus contemplative, public versus private, city versus country—with which the Renaissance attempted to order its ethical norms described not only duties, responsibilities, and behavior, but what at that time was virtually the same thing, their forms, and this naturally included architecture. Thus Alberti (*De re aedificatoria*, cited in the Leoni ed. of 1755, ed. J. Rykwert, London, 1955, p. 188) wrote that between houses in the city

My brother[4] and I went to the Tuileries to await M. Colbert who was expected there. When he arrived we accompanied him over the whole building. While in the gallery that leads off the end of the Long Gallery, he asked me what the Cavaliere had been doing. I said that he had been working at the rear façade of the Louvre. He asked me whether he had made it as high as the one for the front. "Yes," I said. "It won't be successful then," he replied.[5] He enquired whether the Cavaliere had seen anything by Mansart.[6] I said no; it had been proposed to arrange discussions between them in Paris, but in fact they had not met: he had seen nothing in Paris except the Luxembourg, the Val-de-Grâce and the establishments of the Jesuits; he had thought the Church of the Novitiate extremely beautiful; I had also previously shown him the Fontaine des Innocents,[7] which he had studied at length and found very fine. M. Colbert remarked that it was but a trifle. I answered that it might be little, but within its limits it was a great work of art and the most notable in Paris.

From the Tuileries he went to visit the Cavaliere, who showed him the design for the façade on the service court. On first seeing it

and those in the country there was this difference: "that the Ornaments for that in Town ought to be much more grave than those for a House in the Country, where all the gayest and most licentious Embellishments are allowable." This difference was to be observed also within the urban palace, where those parts which are more public "may be allowed somewhat more of the Splendor of the publick Structure," whereas in the private areas "we may allow ourselves more Liberty in departing out of the common Road, and contriving something new." This conception of architectural decorum remained unbroken in theory, if not always in practice. Thus when asked to comment on the plans for the Palazzo Ducale in Modena, Bernini wrote: "As regards the windows, those which look toward the garden are most beautiful as designed, there being charm and caprice; but those which face the piazza and the city do not appear to have all of that decorum and magnificence which is proper" (Fraschetti, p. 227, n. 1).

[4] Roland Fréart de Chambray (1606–76), author and critic, who was active with Chantelou in the King's Works under Sublet de Noyers. His works included translations of Palladio (1650), Euclid (1662), and Leonardo's *Trattato della pittura* (1651), as well as the *Parallèle de l'architecture antique avec la moderne* (1650) and the *Idée de la perfection de la peinture* (1662).

[5] As appears immediately below, because it would then be higher than the adjoining galleries connecting the Louvre with the Tuileries (cf. fig. 13).

[6] François Mansart (1598–1666), the celebrated architect whose works are usually seen as the purest manifestation in architecture of 17th-century French classicism. His difficult temperament and a restless creativity not unlike that described by Bernini above (6 June) seem to have deprived him of commissions in later life without affecting the esteem in which his works were held. Thus the plans he made at the request of Colbert for both the Louvre and the Bourbon chapel at Saint-Denis remained on paper. For a full account of Mansart and his work, see P. Smith and A. Braham, *François Mansart*, London, 1972.

[7] The Fontaine des Innocents was built between 1547 and 1549. It originally stood at the intersection of two streets with façades of one and two bays respectively. Its sculptured ornaments, most of which are now in the Louvre, were by Jean Goujon. See Blunt, *Art and Architecture*, pp. 125–26.

M. Colbert said it was the same as for the front. The architect answered that there was a considerable difference and to demonstrate it he had the other design brought in. Then M. Colbert acknowledged the difference and remarked on the height and told the Cavaliere that the façade should have been adapted so as to fit in with the Long Gallery and the other buildings adjoining, which would appear smaller in comparison with the height of the new façade; on the main front there were not these difficulties. The Cavaliere replied that they existed no more at the back than at the front; the galleries were like the arms in relation to the head, and should not therefore be so high; in any case the roofs of these buildings would be level with the façades. He took a pencil to show what he meant. He said that only once had he had to face this problem, at St. Peter's in Rome, because there the façade seemed to everyone to be too low. To remedy this fault he had advised the Pope to build two colonnades, one on either side of the façade to make it appear higher than it was. He showed what he meant with a pencil and compared the effect to that of the arms to the head, saying it would be the same with these two galleries and the façade;[8] architecture consisted in proportions drawn from the human body, and the reason why painters and sculptors succeeded better than others in that art was their constant study of the human form.[9]

M. Colbert then saw the model for the royal bust, and said that

[8] The reference to two galleries presumably implies that Bernini was already contemplating a second gallery to the north linking the Louvre to the Tuileries, as shown in one of Marot's engravings (fig. 8).

[9] As Chantelou remarks above (2 June), the anthropomorphic basis of architectural proportions was a theoretical commonplace, but the conclusions to be drawn from it were not always the same. Michelangelo, for example, had deduced from the relationship of architecture and the human body the lesson of organic unity. He replaced the traditional notion of fixed relationships derived from the geometry of a static, symmetrical figure with dynamic ones based on the figure in action (cf. Condivi, *Vita di Michelagnolo Buonarroti*, ed. by E.S. Barelli, Milan, 1964, pp. 76–77). From this conception of the architectural work as an organism composed of mutually interdependent parts, he naturally deduced that painters and sculptors, who were most familiar with the human body, would make the best architects (Ackerman, pp. xxxiv, 1–10). That Bernini understood the analogy in the same way appears not only from what has been said above (notes to 14 June), but from his example of the colonnades at St. Peter's. He had already compared the colonnades to the arms of the Church in a memorandum on his design for the piazza (Brauer and Wittkower, p. 70, n. 1), and his comments here and later (below, 15 July) show he intended it to be taken as a meaningful conceit that would illuminate his architectural aims and ideas, rather than as a literal, descriptive metaphor. By contrast, a naive interpretation of the comparison appears in a 'counter proposal" for the piazza, which criticizes Bernini's plan and argues for a circular one (R. Wittkower, "A Counter-project to Bernini's 'Piazza di San Pietro'," *Journal of the Warburg Institute*, III, 1939, pp. 88–106). On the other hand, Borromini's application of the same metaphor to the very different façade of the Oratory of St. Philip Neri in Rome can only be understood in the same sense intended by Michelangelo and Bernini (*Opus architectonicum equitis Francesci Boromini*, Rome, 1725, p. 11).

His Majesty had given him the duc de Mazarin's apartment to work in at Saint-Germain. The Cavaliere thanked him and spoke a great deal about the portrait, saying among other things, that he would not trouble to attempt any other work once it was completed. When M. Colbert left he accompanied him as far as the end of the room, and his son and Mattia conducted him to his carriage. After dinner the Cavaliere worked at the memorandum which M. Colbert had given him on the laying out of the first or main floor of the Louvre, so as to fit in a large chapel or church which would serve as the parish church for the Louvre, where episcopal and parochial functions could be performed, as had always been the custom in the old royal palace, to which the Sainte-Chapelle had been attached, and also inclusion of ballrooms and banqueting halls and other rooms for pictures and statues.[10] The abbé Buti explained the memorandum to him and helped him with it.

The Nuncio came later and we went for a drive. The Cavaliere was in a good humor and recounted various passages from his comedies, among others, one concerning two valets who, dismissed by their masters, determined to adopt a calling that was both noble and useful; though they gave it much thought they found none that corresponded to what they were looking for. At last the one who had made the suggestion declared they must choose the profession of locksmith, and to show that it was a useful calling he gave a hundred reasons, but on the question of nobility he did not know what to say until he struck on the idea that nobility came from coats-of-arms; France had the lily, and England the rose, the Empire the eagle, and so on. They would take the keys which were the noblest coat-of-arms in the world.[11]

2 JULY

🎔 I called on M. Colbert at about six in the morning. Finding me in his room he asked me what I wanted. I said I had come to enquire whether he had any command for me in connection with the Cavaliere.

[10] A memorandum on the palace published by Clément (pp. 251–58, incorrectly dated 1664) conforms with the layout described here, but as Wittkower first noted (Brauer and Wittkower, p. 130, n. 7), it seems to be run together with material from a later memorandum (below, 19 Aug.).

[11] The point of this banal story of two simple-minded fellows who take the sign for the substance appears when it is read in the opposite sense. Thus instead of conferring nobility, the keys of St. Peter in the papal coat-of-arms become the skeleton keys of the locksmith, possession of which opened the locks on untold riches; and it is not difficult to imagine how Bernini could have turned this ambiguity to satirical account (see Appendix B, A Note on Bernini and the Theatre) by particularizing the mien, gesture, or voice of some member of the court who with an eye to his purse dreamed wistfully of the papal crown.

He replied no. From there I went to the architect's apartments and found him finishing his drawing. He asked me, as I looked at it, how it struck me. I told him that I thought it noble and magnificent. We studied it for a long time together with that for the main façade.

3–4 JULY

✿ He worked at and finished the design for the altar of the Val-de-Grâce commissioned by the Queen Mother.[12] He had worked very hard at it and it was a beautiful and grand design. On the 4th, my brother, while walking round the buildings of the Tuileries, met M. Warin,[13] who remarked that what they were doing there was very bad;[14] M. Madiot[15] said the same thing.

M. Perrault came in the evening to tell my brother about certain alterations contemplated in the Tuileries. We told him our opinion; that the urns placed on the entablature were neither beautiful nor suitable; it would be better to continue the cornice of the Corinthian order right along the terrace rather than adding the cornice of another order, which would have no bearing or relationship to it; it would be more correct instead of the consoles to have the same Corinthian order between the windows, so that each window should be separated by two pilasters; there were in the whole construction many things that could be set right, others that were bad and very badly executed; it might be a good thing to try to economize but often the result was a poor piece of work. This was particularly to be avoided in building where the faults are exposed to every eye and last for posterity. More-

[12] Bernini's design for the altar is known from a description written by Mattia de' Rossi (Mirot, p. 226, n. 2), who says it was oval in form with eight Corinthian columns, an entablature composed of architrave, frieze, and cornice, and a frontispiece with God the Father and a glory of angels. In keeping with the dedication of the altar to the Nativity, Bernini planned a sculptural group consisting of Joseph, Mary, and the Child. The composition for this group is probably preserved in a drawing by Bernini now in Berlin (Harris, *Selected Drawings*, pl. 86), which can be compared in several respects to the *Nativity* (now in Saint-Roch) actually carved for the altar by Michel Anguier. Since Bernini presumably would have known Anguier's sculpture only from the model for the altar (above, 13 June), it seems reasonable to recognize in the Berlin *Nativity* a composition that originated in Paris.

[13] Jean Warin, or Varin (1604–72), sculptor and medalist, head of the French Mint (1646), and a member of the Academy of Painting and Sculpture (1665). Warin designed the foundation medal for the Louvre (below, 16 Sept.), for which, see *La Médaille au temps de Louis XIV*, exh. cat., Paris, Hôtel de la Monnaie, 1970, nos. 116 (gold) and 451 (silver).

[14] The palace was at this time being enlarged and redecorated according to the designs of Louis Le Vau.

[15] M. Madiot, seigneur Du Val, was an intendant in the King's Works. He is described by Chantelou below, 30 Aug.

over, it was somewhat humiliating to keep on making alterations; the Italian proverb, "Who spends more spends less," was only too true.

5 JULY

We went to Saint-Germain, the Cavaliere taking the designs for the rear façade of the Louvre and for the altar of the Val-de-Grâce. As we left he said there was something he wished to say to me when we got there. On our arrival he told me he would be very glad if I would talk about the design for the altar and say what I knew about it; as I was one of those who realized that fine works of art—though of course he was not capable of making them—did sometimes need help. He had said to me before that this design would show that a man was painter, sculptor, and architect as well.[16]

At Saint-Germain we called on M. Colbert. We went into his office and he looked at the designs, particularly the one for the Val-de-Grâce. Having studied them carefully he said, "I could wish that it would cost the King 200,000 crowns and that there was in France one man capable of creating such designs," which seemed to mean that he would give 200,000 crowns to keep the Cavaliere in France. But he explained himself further, saying that if there were but one man in France who could do comparable things there would be others who would be nearly as competent. He then added that His Majesty would spare nothing to make the arts flourish in France, and for this purpose he wished to give material support to young artists so that they might study sculpture and painting in Rome; he was sending an artist called Errard to act as their guide; he would take a house for them, where they could live at the expense of the King.[17] The Cavaliere replied that was all to the good, but it was necessary to adopt methods of training different from those of the past; it was customary to go to Rome at fifteen and to devote the next nine or ten years only to drawing; this meant that artists only began to work at the age of twenty-five; this arrangement should be altered so that they should draw one day and work the next either at sculpture or at painting; by

[16] For Bernini's integration of the arts (Baldinucci, *Vita*, p. 74 and Dom. Bernini, pp. 32–33), see now I. Lavin, *Bernini and the Unity of the Visual Arts.*

[17] Colbert's plans for establishing a French Academy at Rome where young artists would "form their taste and manner on the originals and the models of the greatest masters of antiquity and the last centuries" are announced in a letter to Poussin, whom he proposes as director (Perrault, *Mémoires*, pp. 54–57). This letter, which must date to early 1664, was never sent, and Colbert's intention was not realized until 1666, when Charles Errard (1606–89), a painter and architect, who was a foundation member of the Royal Academy (1648), was appointed the first director, a position he held until 1672 and again from 1675 to 1683.

this method they would become much more proficient.[18] M. Colbert fully agreed and asked him whether he would be willing for young sculptors whom the King supported to come to him for instruction. He said that he would, and that they must work at the statues for the Louvre, for which he would make the models and would supervise the execution.[19] He told us that in Rome there were two or three very competent French sculptors; M. Colbert asked him their names but he could not remember them. During this conversation he showed him openly that the King hoped he would remain in France to carry out all his work, to which he replied nothing.[20]

While we were on our way home from Saint-Germain we discussed painting and he gave the highest praise to Annibale Carracci, saying that he hád combined the grace and draftsmanship of Raphael, the knowledge and anatomical science of Michelangelo, the nobility of Correggio and this master's manner of painting, the coloring of Titian, the fertile imagination of Giulio Romano and Andrea Mantegna. His manner was formed from the ten or twelve greatest painters as if by walking through a kitchen with a spoon he had dipped into each pot, adding from each a little to his own mixture.[21] I did not

[18] As both the consequence and the guardians of the Renaissance conception of art, the academies naturally desired new methods of training artists that would do justice to painting and sculpture as liberal arts and therefore supersede, or at least supplement, the traditional instruction offered by the guilds. Inevitably, there was a widespread tendency, already apparent in the programs of instruction, drawn up, but never put into effect, by the first academies of art (Pevsner, pp. 41–53, 60–63), to favor theory over practice. Bernini, of course, gave ground to no one in his defense of the artist's intellectual status, but he was a shrewd observer with close to sixty years' experience behind him; and by recommending here and to the Academy itself (below, 5 Sept.) that students alternate days of drawing with days of painting or carving, he repudiated a potential breach between theory and practice that he recognized as pernicious. Only when theoretical knowledge and manual skill were developed *pari passu* would they spur one another on and the student make remarkable progress.

[19] Bernini's proposal was evidently considered seriously, for Chantelou, reporting to Colbert on the artist's visit to Saint-Germain of 19 July, says that the King mentioned it to him (Jal, p. 358, col. 2, no. 3); and it was apparently the procedure later adopted for Bernini's equestrian portrait of the King (Mirot, p. 280, n. 1).

[20] This visit to Saint-Germain, including the conversation with Colbert, is also described by Mattia de' Rossi, who reports the success that attended Bernini's presentation of his designs. In addition, "the Cavaliere drew various parts of the portrait of His Majesty in order to incorporate them in the model at Paris" (Mirot, p. 226, n. 2). Similarly, the Nuncio wrote to Rome that the design for the rear façade (fig. 10) of the Louvre "was received with the greatest applause, as was also the new design for the high altar of the Val-de-Grâce" (Schiavo, p. 33).

[21] For the history of this type of eulogy based on the excellences associated with the styles of earlier artists, see Mahon, pp. 204–29, and idem, "Eclecticism and the Carracci: Further Reflections on the Validity of a Label," *JWCI*, xvi, 1953, pp. 303–41. It was a way of speaking, not acting, and Bernini, who otherwise rejected the selection theory of art (Baldinucci, *Vita*, p. 77), certainly would not have wished his cookery metaphor to be taken literally.

agree that he had nobility and natural grace, maintaining that his capacity was of the kind acquired by study and learning.

He returned to the subject of the design for the altar of the Val-de-Grâce, and told us that he had apologized to the architect for being forced to set his hand to his work but that he, Bernini, could not do otherwise as the Queen Mother had commanded him. The architect replied that there was one thing he could do; say that he found the model of his altar very fine; to which Bernini had answered that if it was very fine his would by comparison make it appear even more so.

6 JULY

❧ He began to block out the marble.[22] In the evening the Nuncio and the abbé Buti came. We went to the site of the Collège des Quatre-Nations[23] to get a view of the river façade of the Louvre, as the Cavaliere had orders to adapt it so that it would conform to the façade for the front.[24] From there we went for a drive and he recalled a passage from one of his comedies, in which he had introduced a young nobleman who was very talented in drawing.[25] This young man had fallen in love with the beautiful daughter of Gratiano; he discussed with his valet the means of gratifying his desire to see her without arousing the suspicions of her father and decided that he must try to enter the house as an art student. For this he would have to talk to Zani, Gratiano's valet, and if necessary win him over with bribes. This advice did not please the lover who said that Zani was a rascal and a good-for-nothing in whom no confidence could be placed. He had heard it from everyone; the walls and pavements shouted it aloud. The valet replied that this might all be untrue, one proof that his wickedness was not much to be feared being that everyone knew about it; he heavily stressed this consideration as being important.

[22] Bernini tried out all three of the blocks he had selected (above, 21 June), but as he had feared, none turned out to be of truly portrait quality (Mirot, p. 226, n. 2). He therefore chose the two best pieces (Schiavo, p. 33) and began to rough-out both with the aid of his young assistant, Giulio Cartari (Dom. Bernini, pp. 135–36). One of these blocks contained a hidden vein that surfaced in the eye of the portrait, and the other required cautious handling because it was tender and friable (Fraschetti, p. 345, n. 1 and below, 4 Aug.).

[23] Across the river, before the Collège des Quatre-Nations (today the Institut de France), which was designed by Le Vau and built with a legacy from Cardinal Mazarin. Begun in 1662 and conceived in relation to the Louvre, Le Vau's building is on axis with the Square Court, but the bridge intended to connect the two was only built in a much reduced version in the 19th century. See Blunt, *Art and Architecture*, p. 336.

[24] The existing front by Le Vau is shown in fig. 16.

[25] This long narrative again suggests that Bernini plotted his comedies, interweaving traditional themes of love, jealousy, seduction, and intrigue; for the timeless point of his story—the predicament of the voluntary mute—must have been only one incident in a larger plot. See Appendix B, A Note on Bernini and the Theatre.

The nobleman therefore spoke to Zani, who first of all raised a number of difficulties based on Gratiano's jealousy, but finally his help was secured by bribes and he said that he had found a means of effecting his introduction: this was for him to simulate a deaf mute, neither mouth nor ears being needed in painting; it could be explained to Gratiano that his parents, who were of good family, wished him to undertake these studies. Gratiano was approached and the fact that the young man had these defects removed his suspicions. The young man came into the house and worked with the daughters. One day Gratiano having gone out at the usual time, Zani was giving the young gentleman a lesson and, accompanying his remarks with many gestures, told him that if ever he should reveal that he could talk and hear, they would all be shown the door. During this conversation Gratiano who had only pretended to leave, watched the scene from the end of the gallery and, noticing Zani's gestures, wanted to know what they meant. Zani replied that he had been throwing insults at the nobleman to see whether he was indeed deaf and dumb, taunting him with his birth and telling him that he had a coarse and rustic mind, all of which had had no effect. This was proof that he really could not hear. Gratiano disagreed and himself came forward to flatter and praise him, saying it was praise that moved and roused people more than abuse; the lover however kept his mouth shut.

Later he talked about some drawings that Mignard had shown him at his studio, saying that he derived the utmost enjoyment from seeing the first productions from the minds of great men; in them one saw the splendor of a pure, clear, and noble idea; Raphael had so fine a mind that his first conceptions were as complete and as beautiful as any works in the world; the drawings of a great master were to a certain extent more satisfying than the works that he executed from them after great study and care.[26] We told him that if he so desired we could arrange for him to see a large number of good drawings by

[26] Bernini's comments may be explained both by the Neoplatonic doctrine that the idea is corrupted by translation into matter and by the ever growing appreciation for the aesthetic virtues of bold, restless, inchoate forms that began in the 16th century (Vasari-Milanesi, II, pp. 170–171). From such ideas, it was a short step to the conviction that "works of art are not only paintings, but also the drawings made by painters, down to their first ideas and sketches" (Baldinucci, *Notizie*, VI, pp. 469–70) and to the formation of the great Seicento collections of drawings, such as those of Evrard Jabach or Cardinal Leopoldo de' Medici. See J. Held, "The Early Appreciation of Drawings," *Studies in Western Art* (Acts of the Twentieth International Congress of the History of Art), Princeton, 1963, II, pp. 72–95. For Bernini, however, who experienced the bliss of unmediated creation (above, 6 June) and the despair of final execution, these ideas were the matrix and the consequence of his life as an artist.

the hands of great masters, which Jabach[27] had collected from many sources. I added that there were in Paris a great quantity of fine pictures, bought during the last twenty years for their weight in gold; among other masters, there were many of Annibale Carracci's. He told us that there was a little *Nativity* by Carracci,[28] which had been presented during the papacy of Innocent X to Cardinal Pamphili;[29] it was so exceptionally beautiful that its possessor should rather sacrifice his life than part with it, that is to say, should not part with it for anything in the world.

8 JULY

✿ M. Colbert came to Paris. My brother and I went to meet him at the building of the Tuileries. When we were upstairs, he asked whether the Cavaliere had not been very annoyed at the way the Queen Mother had received the design for the altar of the Val-de-Grâce. I told him that he had not let it appear as far as I had heard; he had made the design without knowing that they were going to put a grille on the left side of the church similar to the one on the right; that he had placed the altar so as to cover the lack of symmetry caused by having one big arm and one little one[30] and to enable the Queen to see it from her oratory, which she could not do if it were in any other position. M. Colbert commented on the fact that the Cavaliere never bothered to make enquiries; to which I replied that the truth was that he had gone alone to study the site of the altar; M. Tubeuf had asked me to inform him when he was coming but this I had been unable to do as he had gone two days earlier than he had originally intended, visiting it at the same time as he had gone to see his block of marble.[31]

[27] Evrard Jabach (d. 1695), the banker and famous collector from Cologne, who had moved to Paris, where he became Mazarin's man of affairs and Director of the East Indies Company. In 1671, 101 paintings and 5,542 drawings from his collection were acquired by the King for 220,000 livres. For Jabach and his collection, see R. Bacou, "Préface," *Collections de Louis XIV, dessins, albums, manuscrits,* exh. cat., Paris, Orangerie des Tuileries, 1978, pp. 9–18.

[28] The original is not now traceable, but the composition may be preserved in a copy by Domenichino in the National Gallery of Scotland. Cf. Posner, cat. no. 108, and Spear, cat. no. 30.

[29] Camillo Pamphili (1622–66), nephew of Innocent X, who made him cardinal in 1644. In 1647, however, he renounced his position in the church in order to marry Olimpia Aldobrandini (d. 1681), Princess of Rossano.

[30] As planned by François Mansart, the church of the Val-de-Grâce was to be symmetrical, but as actually built, it has a large rectangular nuns' choir leading off to the right of the crossing which is only balanced on the left by a small semicircular apse.

[31] The sudden withdrawal of favor after Bernini's design had been received with enthusiasm initially is probably to be explained by its location. Typically, Bernini had planned the altar relative to its site and sought to "correct" an imbalance in what he mistakenly thought to be the final formal conditions of the church. Chantelou's reference

He then requested me to go and see whether the Cavaliere was resting, in which case he would return in the evening. I found he was finishing his dinner. MM. Paolo and Mattia went to meet M. Colbert when he entered with the abbé Buti, and took him into the gallery where he passed the time looking at the model of the King's bust. Soon afterward the Cavaliere came in and showed him the elevation of half of the court façade of the Louvre, which the minister greatly praised. The Cavaliere told him that he himself was very satisfied with the work; he hoped its execution would be a great success, and that there would be nothing like it in all Europe. M. Colbert replied that he was impatient to see the foundations laid. The architect informed him that the design would be finished by Sunday together with the one for the riverside façade, for which the King had already asked twice; he intended to take everything to His Majesty on Sunday. He wished to take certain measurements before beginning to work on the foundations as there was nothing easier than to make mistakes. He was happy to be able to say that so far in his career there may have been mistakes due to lack of knowledge but not to his having been at fault in the measurements. Usually he made Mattia take them, then his brother,[32] and then, even when these two agreed, he took them himself again.[33] He dwelt again on his good fortune in having hit upon a successful design, and one that could be carried out while the King remained in the Louvre. M. Colbert said that as long as they were not obliged to buy many houses, work could be begun on all parts

to these—the nuns' choir or Chapel of St. Louis on the right transept with its grille and the Chapel of St. Anne on the left without—suggests that Bernini intended to place the altar well in advance of the eccentric position it now occupies. In fact, the location of the altar seems to have been fixed by a Sacrament chapel behind the apse, which was reserved for the nuns, since in its present position the altar allows them to communicate and worship the Host without entering the church (see Lemoine, "Le maître-autel de l'église du Val-de-Grâce," *BSHAF*, 1960, pp. 95–96). As appears below, the unfortunate history of his design for the altar, which mirrors in small that for the Louvre, made a deep impression on Bernini.

[32] Luigi Bernini (1612–81), the Cavaliere's younger brother, "a good sculptor, a better architect, and an excellent mathematician" (Baldinucci, *Vita*, p. 86), active chiefly as an assistant to his brother. In 1634 he became Soprastante della Fabbrica di San Pietro, and under Alexander VII, Custodian of the Vatican Palace and Architetto dell'Acqua. In 1672 an unsavory adventure led to his exile, which was not lifted until four years later (see V. Martinelli, "Novità berniniane, no. 3: Le sculture per gli Altieri," *Commentari*, x, 1959, pp. 204–216). During Bernini's absence in Paris, Luigi assumed direction of the works in progress at St. Peter's and of the Palazzo Chigi.

[33] The effort Bernini expended on ensuring correct measurements was motivated by the problems eventually created when there were errors in the original layout of a building. He encounters such problems below when his survey of the site reveals that the alignment of the existing buildings is not true (see below, 27, 29–30 July, and cf. 3–4 Aug.).

of the site at once. The Cavaliere answered that works executed in this way were always the most successful, and everyone agreed with this opinion. M. Colbert added that the King had the palace of the Tuileries at his disposal, where he would be able to live for seven or eight years if necessary. He then left and the Cavaliere conducted him as usual as far as the end of the salle.

On our evening drive he told me that he thought the reason why he had caught cold was that he had been working in the room where the marbles were kept in which all the windows were broken. I said that I would give orders for them to be mended. He asked me to return the arms that I had first brought him—they were those from a design by Giulio Romano—which I did.[34]

9 JULY

✿ Calling at M. Colbert's in the morning, I learnt that he had gone to the Gobelins[35] where I followed him. We saw all the work going on there. He then returned to the Louvre and went up to the King's apartment,[36] telling those who accompanied him to remain in the large antechamber. He remained there for about an hour; when he came out he got into his coach-and-six and went to Saint-Germain. After dinner I had the arms designed by Giulio Romano brought back to the Cavaliere. In the evening he asked for the coach to be there at six in the morning for Signor Mattia, who wished to go out to draw the façade along the river.

10 JULY

✿ I found the Cavaliere shading the drawing for the courtyard façade of the Louvre and watched him working at it for an hour. He told me several times that it was necessary to be very sparing in this work in the use of light and shade, and that he hoped that the King would

[34] This suit of armor (*armes* or elsewhere *paire d'armes*) with battles and ornaments designed by Giulio Romano is listed in the inventory of the King's collection (Guiffrey, *Mobilier*, II, p. 82, no. 323). It had been given to Francis I by the Duke of Mantua and was used by Bernini as a model for the bust of the King (cf. below, 10 Sept.). Little is now known about Giulio Romano as a designer of arms and armor, although designs for maces or sword hilts are attributed to him (F. Hartt, *Giulio Romano*, New Haven, 1958, pp. 293–94, nos. 117–19, and P. Pouncey and J. A. Gere, *Italian Drawings . . . in the British Museum: Raphael and his Circle*, London, 1962, nos. 107, 116).

[35] The manufactory famous for its tapestries, which took its name from a family of dyers who had established themselves on the site in the 15th century. Reorganized by Colbert and placed under the direction of Le Brun, who provided designs for a small host of artists and craftsmen, it was intended to be a school for training apprentices as well as a general factory to produce all that was necessary for furnishing the royal palace.

[36] Specifically, to the council chamber, where Bernini worked on the bust.

find it to his taste. "Of course he will," I told him, "for His Majesty is a better judge of these things than one would have thought possible. Did he not show it when you presented your first design?" The architect said that, indeed, His Majesty after prolonged study had pronounced it very beautiful and had said that all the others had only served by comparison to show up the grandeur and beauty of his; the King had declared that he was very pleased with himself for having begged the Pope to allow him to come.[37]

11 JULY

🕭 I wrote to M. Colbert to tell him that the Cavaliere had finished the design for the court façade of the Louvre and that he intended to take it to the King the next day at Versailles[38] or Saint-Germain, and I asked him to inform me where the King would be. I said that I would like to tell him in advance that the design was simple with no other ornament than that of the order, but that it was as rich, magnificent, and stately as anything yet beheld; in my opinion, no words could express its glories. He told the messenger I had sent, that I should take the Cavaliere to Saint-Germain the next day.

12 JULY

🕭 On our way there, while discussing architecture with me and the abbé Buti, he told us that he had seen among Villamena's[39] papers, a letter from Michelangelo to Lorenzo de' Medici in reply to one of his, in which the latter had asked for advice on which of two artists he should employ for the library he wished to erect in Florence, Vasari the painter or Ammannati the sculptor. He had replied in this letter that both were his friends but that, other things being equal, in matters of architecture the sculptor was to be preferred to the painter, for architecture was in relief so that it came within the normal scope of a sculptor's work, whereas the painter only sought to give the appearance of relief. He had therefore advised him to employ Ammannati.[40]

[37] Cf. the account of this exchange given by Mattia de' Rossi in Mirot, p. 217, n. 1.

[38] The royal palace begun as a hunting lodge about 1624 by Louis XIII, which under Louis XIV came to rival and then surpass the Louvre. Successively enlarged and transformed by Le Vau, Le Nôtre, Le Brun, and Jules Hardouin-Mansart in campaigns of 1661, 1669, 1678, and later, it became the King's permanent residence and represents, better than any other monument, the spirit of the French monarchy. See Blunt, *Art and Architecture*, pp. 332–42.

[39] Francesco Villamena (1566–1624), a painter and engraver, in Rome from 1604, who did works from his own designs, as well as reproductive engravings after Raphael, Veronese, Barocci, Muziano, and Guido Reni.

[40] No such letter is now known, and Bernini's account is somewhat confused, since Michelangelo himself received the commission to design the Laurentian Library from

When we got to Saint-Germain, we found M. Colbert closeted with the maréchal de Villeroi.[41] After him the maréchal de Schulemberg[42] was given an audience, and several others. He then asked us to enter. He studied the drawing closely and praised it very highly. The Cavaliere said that he was not the author but that God had inspired him with the idea.

M. Colbert told me to conduct him to the King as he had to finish something urgent; today there were to be two councils, but he would come as soon as possible; in fact immediately afterwards he appeared and himself conducted the Cavaliere to His Majesty. The drawing was laid before the King, who was even more pleased with it than he had been with the others. The Cavaliere told the King that the Vatican surpassed the Louvre in beauty, but that when this design was carried out the Louvre would be by far the more glorious building;[43] he was so well satisfied that if God granted him sufficient time he would return in order to see it finished.

He made more drawings of the King while the council was in session, and afterwards went into the chapel to render thanks to God as he had done on former occasions. Then I took him to M. de Bellefonds, who showed the drawings to all who were collected there to dine at the chamberlain's table. He told the Cavaliere that the King had ordered him to show them to the Queen while he was resting, and after dinner he came for them and showed them to Mlle. de La Vallière.[44] On his return he told the Cavaliere that she had thought them very beautiful. He remarked that in order to judge such things it was necessary to understand them. M. de Bellefonds replied that

Pope Clement VII de' Medici in 1523, long after Lorenzo was dead. Later, however, Vasari and Ammannati were commissioned by Cosimo I de' Medici to complete the vestibule stairway, for which Michelangelo provided a design. This project was never built, and the stairway, based on a new design by Michelangelo, was finally completed by Ammannati in 1559–60. See Ackerman, pp. 33–44, and cat. vol., pp. 33–36. Bernini repeats the same anecdote below, 22 July. Its point is a refinement, based on the standard definitions of painting and sculpture established by the *paragone* literature, of the notion that painters and sculptors make the best architects because they study the human body (above, 1 July).

[41] Nicolas de Neufville (1598–1685), marquis, then duc de Villeroi (1663). Marshal of France and Governor of Louis XIV in 1646, he became a Minister of State and head of the Royal Council of Finances in 1661.

[42] Jean de Schulemberg (1598–1671), comte de Montdejeu, Marshal of France (1658), and Governor of Artois (1661) and Berry (1665).

[43] The ambition of the French to emulate and surpass Rome in the magnificence and grandeur of the Louvre was already reported by the Papal Nuncio in March of 1665 before Bernini's departure for Paris (Schiavo, pp. 29–30).

[44] Françoise-Louise de La Baume-Le Blanc (1644–1710), duchesse de La Vallière (1667) and from 1661, mistress of Louis XIV, by whom she had several children. In 1674 she became a Carmelite nun and took for her name Louise de la Miséricorde.

she was very clever, the fact that she had reached her present position was evidence of it—"And kept it for four years," I added. M. de Bellefonds also showed the drawings to the commandeur de Jars[45] and to several others while the Cavaliere was resting and praying in the chapel. We later went to see M. Colbert, but were informed that he had gone to the council meeting. He wanted to see M. de Lionne, but at midday he was lying down and when we called after dinner he was at the council meeting. At about five o'clock we left to go back to Paris[46] and on our arrival found the Nuncio waiting, with whom the Cavaliere then had a talk.

13 JULY

�轮 In the morning I found the Cavaliere working at the model. After dinner M. Colbert's footman brought a note, saying that he thought the Cavaliere might like to see the review of the troops of the King's Household whom His Majesty was to place in battle array on the plaine Colombes.[47] He was sending the message at top speed so that I could put the project to him, for if he wished to go we would have to have the coach at once. We did go, and watched the troops and the review. On our return, near Chaillot[48] we met the Nuncio, who asked the Cavaliere what were his impressions. He replied that he had never seen anything like it. Asked how many men he thought there were, he said about eight thousand.

14 JULY

✲ The Cavaliere worked at the bust. The abbé Buti was with him for a part of the day. We discussed various things connected with the subject of expression, the soul of painting. The Cavaliere said he had discovered a method that had helped him; this was to put himself in the attitude that he intended to give to the figure he was representing, and then to have himself drawn by a capable artist.[49]

[45] François de Rochechouart (1595–1670), chevalier de Jars, Commander of the Order of Malta, and abbé de Saint-Satur, for whom François Mansart built the hôtel de Jars (1648–50, destroyed 1792). See Braham and Smith, pp. 76–78.

[46] This visit to Saint-Germain is also described by Mattia de' Rossi in one of his letters to Rome (Mirot, p. 229, n. 1).

[47] A village 8 km. northwest of Paris.

[48] A village at the end of the Cours-la-Reine, then outside the gates of Paris to the west, which contained the Savonnerie carpet factory.

[49] Cf. below, 9 Aug., where Bernini attempts to assume the pose of a figure by Veronese in order to demonstrate its lack of naturalism. The use of physical imitation to prove and master the natural and expressive qualities of his figures—already practiced in the Carracci circle (Spear, p. 37)—reflects the demand of Horace and other ancient writers that the artist himself feel the emotion he seeks to convey (see Lee, pp. 23–26).

15 JULY

❧ In the morning I found M. Colbert with the Cavaliere in the room where he worked at the bust. He was looking at the drawing for the river façade brought in by Signor Mattia who was working on it. He asked the Cavaliere to plan a capacious storeroom and requested him to consider in good time where it should be placed. The Cavaliere replied that it would go over the entrance door.

Then M. Colbert asked whether he could find a means of providing a courtyard where horse tournaments could be held and devise some way of getting stage properties in. He replied that it was impossible to make entrances sufficiently large for the latter, but that on the occasions when these pieces were used it was customary to construct them in different bits which could be easily assembled, and space should be provided for making and keeping them. M. Colbert then began to discuss with him the square in front of the Louvre, whereupon the Cavaliere took a stick of charcoal and sketched it on the floor, using a compass to mark a distance one and a half times the height of the façade, and said that this would be sufficient to get a perfect view of the façade with yards to spare[50] and that further, as the church of Saint-Germain[51] was only on the one side, it would leave space for a large approach sixty or seventy feet across, leading up to the principal entrance, along which the façade would be visible from any point one chose. Then for the two sides of the square he marked two arcs of circles. M. Colbert said that the guardroom and other apartments, which must be near the Louvre, could be placed there. The Cavaliere remarked that it might turn out to be like the Piazza of St. Peter's, the façade of which he sketched, adding that when it had been executed during the pontificate of Paul V, Michel-

It recalls as well those stories told by Bernini's biographers to guarantee the veracity of his imitations and the efficacy of their expression. In one, he grimaces into a mirror held by Cardinal Barberini to represent the face of his *David* (Dom. Bernini, p. 19); in another, for his statue of *St. Lawrence*, he lays his thigh against a burning brazier in order to "experience in himself the martyrdom of that Saint. He then portrayed in pencil from the image in a mirror the painful movements of his face and observed the varied effects made in his own flesh by the heat of the flame" (ibid., p. 15).

[50] Attempts to fix the minimum distance from which a work of art will not appear distorted by the effects of foreshortening go back to Piero della Francesca. The distance of one and one-half times the height of the façade proposed by Bernini is rather less than that usually recommended. See E. Panofsky, *La prospettiva come forma simbolica*, Milan, 1966, pp. 110–11, n. 69.

[51] The mediaeval church of Saint-Germain-l'Auxerrois, which was the parish church of the Louvre, stood to the east of the Square Court of the Louvre. It was necessary to incorporate it into any scheme for the square in front of the east façade, and this problem presented difficulties because the axis of the church was not at right angles to the line of the façade.

angelo's design had not been followed and the façade had always been found too low in relation to its width. This was the reason why suggestions had often been made to pull it down, both Urban VIII and Innocent X after him having had this in mind, but as popes only assumed office late in life, they did not care to undertake this great work which would have had to begin with extensive demolition. The present Pope having consulted him, he studied the problem and found that by adding a low colonnade on either side the façade could be made to appear higher by contrast and the fault was thus corrected.[52] He drew out what had been done with a piece of charcoal.

M. Colbert then turned his attention to the bust, and admired the way it had already acquired likeness and majesty. I told him that he had only worked at it for one day, but that he worked almost too hard at it. On Tuesday evening he was so tired that I feared he would be ill.[53] M. Colbert begged him to take care of himself, to which he reiterated that making the effort to govern one's own nature was the most difficult thing in the world. He added as a joke that I was always goading him to work harder, at which M. Colbert laughed. He then took his leave and went over to the Tuileries, passing through Le Brun's gallery [54] on his way. As he had done on a former occasion, he uncovered a figure for me to see. It was *Sleep scattering Poppies*, the only finished thing there. He asked me what I thought of it and I said that I considered it very beautiful. As we walked along, he remarked that he had to admit the Cavaliere was a very able man. I replied that apart from his work, his conversation was full of noteworthy things and that he never talked rubbish. He answered, "that is so, but I wish he would spare others a little." I said that I never heard him speak of people. He asked whether he had seen this gallery. I pointed out that he had been there with him, M. Colbert. Someone had said that he had been there alone once with a servant.

[52] See above, 1 July, where Bernini also attributes this visual effect to the colonnades and cf. his statement below, 28 July, that the lack of alignment in the doors of the palace might be corrected by means of "perspective," a procedure that recalls the Scala Regia (E. Panofsky, "Die Scala Regia im Vatikan und die Kunstanschauungen Berninis," *Jahrbuch der preuszischen Kunstsammlungen*, XL, 1919, pp. 241–78). Urban VIII had been dissatisfied with Maderno's façade of St. Peter's when still a cardinal, and there are projects by Bernini of 1645 (under Innocent X) and 1659 (under Alexander VII), which, if built, would have radically altered the façade in the direction of Michelangelo's design. See Brauer and Wittkower, pp. 39–43, 83–84.

[53] Mattia de' Rossi (Mirot, p. 229, n. 1) also remarks on the ill effect overworking was having on Bernini's health at this time.

[54] The Galerie d'Apollon, which had been rebuilt by Le Vau after a fire of 1661. Le Brun was commissioned to decorate the gallery in 1663, but work was halted when Louis XIV abandoned the Louvre, and the decorations were completed only in the 19th century when Delacroix added the *Apollo killing Python*.

M. Colbert then entered the Long Gallery, where he saw some youths drawing from M. Poussin's paintings.[55] He looked at their work and asked me whether I knew that he intended to found an academy in Rome. I said that he had already told me that he was going to send M. Errard there to act as counsellor to the young painters. He added that the Cavaliere had said he would welcome in his studio those who were going to study sculpture.[56]

When M. Colbert arrived in the new building, he was shown two models for the decoration of the pediments of the Long Gallery. I came up and looked at them carefully for a while and then told him that this piece of sculpture was designed only for the middle of the tympanum between the two projecting areas in the corners, whereas it should be made to fill the whole, or at least there should be ribbons or oak or laurel leaves to fill the space. One of the Gaspart brothers,[57] who had done the design and was carrying it out, said this was impossible; I answered that if it were done otherwise the effect would suffer. When we were below we talked about it again and I repeated my advice. The mason said that it was to be like a sort of bas-relief and he had done it as M. Le Vau[58] had wanted it. I answered that either the tympanum must be quite plain (in antiquity it was rarely decorated) or the space must be entirely filled. Besides it would not be very great an honor for the King to have his royal emblem there and so have the building attributed to his reign. M. Le Vau who was there, said that a pediment must be fully decorated. He then showed M. Colbert a design for the dome of this façade, at which I did not bother to look. On their return I was told that the front facing the terrace was going to be altered by adding the cornice of the Corinthian order, which adjoins it. I asked them to explain and they said the

[55] After a campaign of almost two years, in which Chantelou too had been involved, Poussin was persuaded to return to France in 1640. One of the tasks with which he was charged was planning the decorations for the Long Gallery of the Louvre. An uncongenial labor, it remained incomplete when the artist left for Rome in 1642. See Blunt, *Poussin*, pp. 157–59.

[56] Cf. above, 5 July.

[57] Either Gaspard (1624–80) or his brother, Balthazar (1628–78), sons of the sculptor Gaspard de Marsy, who worked together at the Louvre, the Tuileries, and Versailles. From June of 1665, they had been working on the pediments for the exterior faces of the Long Gallery (L. Hautecoeur, *Le Louvre et les Tuileries de Louis XIV*, Paris, 1927, pp. 119–20). Below, 29 July, Le Brun also criticizes one of their designs, and Chantelou continues his criticism in a later letter to Colbert (Depping, pp. 556–57).

[58] Louis Le Vau (1612–70), First Architect to the King (1654), whose plans for completing the Louvre had been set aside by Colbert when he became Superintendent of the King's Works in 1664. Le Vau continued his other projects, however, and in 1667 was part of the commission (along with Le Brun and Claude Perrault) established by Colbert to finish the palace after Bernini's designs had been rejected.

cornice would only be between the windows, which seemed a great mistake to me.

16 JULY

🐝 I wrote to M. Colbert about the architrave which it was proposed to break, and told him that it would be better to leave it as it was than to alter it badly, that my brother thought as I did and had said that the architrave was so important that it should not be broken for any reason whatsoever, and all else should be subjected to this over-riding consideration.

I then went to see the Cavaliere and found him working at the bust. At midday he sent a delicious present of melons and apricots to Mme. de Chantelou.[59] In the evening he went to the convent of the Carmelites[60] where the Blessed Sacrament was being exposed. We found it locked up and the tabernacle covered over. This tabernacle is silver and cost a great deal. There are two cherubs hiding two-thirds of the picture, which is by Guido Reni. When the Cavaliere saw this, he remarked that these ladies had made a great mistake; they had hidden an object as beautiful as you could see anywhere, which alone was worth half Paris, by something very ugly and in so doing they had given the impression that the French were a very ignorant people; that either the picture should be removed or the tabernacle, which was dwarfed where it was; if it remained it should be raised as high as the cornice round the pedestals, to give it dignity and fill the space, and the picture should be taken away and treasured like a jewel by the nuns in their convent.[61] I told their chaplain that it would be better to put it to the left of the altar, opposite the grille, where it would be seen by the nuns and the public—it was not an object to be hidden in a corner to which no one came, or put where it would only be seen by those who valued neither its beauty nor its worth. The

[59] Françoise Mariette (1610–90), first married to René Le Roy, then to Jacques-Nicolas Chevalier, sieur de Montmort, and in 1656 to Chantelou.

[60] The convent of the Discalced Carmelites in the faubourg Saint-Jacques was founded by Mme. Acarie and Cardinal de Bérulle, who installed six nuns from Spain in the Benedictine priory of Notre-Dame-des-Champs. The convent, based on plans sent from Spain, was built by the architect Biard. The high altar in the mediaeval church, with its *Annunciation* by Guido Reni (Gnudi and Cavalli, no. 69), was commissioned by Marie de Médicis.

[61] Some years later, Bernini was to face a situation precisely analogous to that described here when he was commissioned to design the altar of the Holy Sacrament in St. Peter's (Wittkower, *Bernini*, cat. no. 78). In the event, the Cavaliere proved less generous to Pietro da Cortona, whose painting of the *Trinity* stood over the altar, than he would have the nuns be to Guido Reni. See K. Noehles, "Zu Cortonas Dreifaltigkeit-gemälde und Berninis Ziborium in der Sakramentskapelle von St. Peter," *Römisches Jahrbuch für Kunstgeschichte*, 15, 1975, pp. 169–82.

Cavaliere repeated that this picture was worth more than Paris, it was a work worthy of Guido and from his best period; he did not mention the other pictures by Le Brun and Stella, only asking by whom was the *Apparition of Christ to the three Marys*. I told him it was by La Hyre.[62]

17 JULY

🕮 He worked at the bust.

18 JULY

🕮 He worked at it again. In the evening he went to see the maréchale d'Aumont,[63] who had come to see him the day before and had begged him to give her his advice on a staircase she wished to have built. She had asked me to let her know when he would come, which I had done during the morning. The maréchal, who had arrived from Saint-Germain, was also there. They came to receive the Cavaliere at the foot of the stairs and led him into the garden, which is very pretty. He admired the beauty of the flowers, particularly the carnations, of which they have the choicest examples. The maréchal said that it was his wife who wanted the decorations; for himself, he was not accustomed to such refinements. The Cavaliere remarked that while campaigning one was satisfied with a tent, but that Caesar, Pompey, and Lucullus, and the other great captains took a delight in beautifying their houses and gardens when they returned home. Afterwards they took him round the rooms. There is one room where there are stuccoes and a ceiling showing the *Deification of Aeneas*, said to be by Le Brun.[64] He looked at the ceiling and said "The whole thing is beautiful. These

[62] The paintings referred to by Chantelou were beneath the windows on the right wall of the nave and, along with an earlier series of pictures by Philippe de Champaigne opposite, formed a New Testament cycle (Brice, II, p. 157). Le Brun was represented by a *Feast in the House of Simon* (Venice, Accademia) and a *Christ in the Desert* (Paris, Louvre); Jacques Stella by a *Miracle of the Loaves* (untraceable) and a *Christ and the Samaritan Woman* (Paris, Notre-Dame de Bercy); and Laurent de La Hyre by an *Entry into Jerusalem* (untraceable) and the *Christ Appearing to the Three Marys* (now in the Louvre), which caught Bernini's eye. For Le Brun's other paintings here, see *Charles Le Brun*, pp. 43–47, 67.

[63] Catherine Scaron de Vaures (d. 1691), wife of Antoine de Rochebaron (1601–69), duc d'Aumont, Marshal of France (1651), Governor of Paris (1662), created Duke and Peer in 1665. The hôtel d'Aumont in the rue de Jouy had been built for Michel-Ange Scaron, probably by Le Vau. On Scaron's death in 1655, it was purchased from the other heirs by his son-in-law, Antoine de Rochebaron, who had it enlarged. The staircase for which Bernini's advice is being sought was eventually built on the designs of François Mansart (Blunt, *Art and Architecture*, pp. 220–21).

[64] An early version of this subject by Le Brun is now in the Museum of Fine Arts, Montreal; but elsewhere the painting in the hôtel d'Aumont is described as an *Apotheosis of Romulus*.

ornaments are beautiful and the room is well proportioned."[65] They then went to see the place where they wanted to have the staircase and showed him the designs. Having seen the position, he said he would think about it at home, and do it as he would like it for himself. Refreshments had been prepared but he refused to take anything.

19 JULY

The Cavaliere went to Saint-Germain.[66] On the way he told the abbé Buti and me how worried he was about the materials for the building of the Louvre; he had heard various conflicting views, that it was a question he could not begin to discuss; both in Rome and in Paris he had talked with stucco workers, who had said that they could make the ceilings and decorations with mortar as they did in Rome and not of plaster, but that no one here would consider it, for fear of making fresh experiments or of breaking away from the usual practice and custom. He said that some to whom he had spoken had considered it would cost too much, and when he had explained that it was a case of expense being no object, they had answered that it would take too long and, when he had said that there was no need for haste, had replied simply that they could not do it. For this reason he hoped very much that the men for whom he had sent from Rome[67] would soon arrive, as there were certain experiments he could not undertake himself; they were matters quite beneath his profession; if he were to do them himself, it would be as if the King were to give audience to a poor widow over some trifling affair, and in so doing waste the time he should have been giving to the business of the Council of State and other things.

When we arrived he repeated the gist of his remarks to M. Colbert and later showed him the design for the riverside façade. About the workmen from Rome, the minister said they were to be employed whatever it cost. The Cavaliere repeated that he needed them for the experiments of which he had spoken. He added that, if there were a clay suitable for a lighter brick, it could be used for making the vaults of the second story economically and with greater effect. Pozzolana was mentioned and someone asked whether it was the same as Dutch clay. I said that I had heard that Dutch merchants trading in the Levant

[65] Bernini's comment is in Italian in the manuscript.

[66] This visit to Saint-Germain is also described by Chantelou in a letter to Colbert (Jal, p. 358, col. 2, no. 3) and by Mattia de' Rossi (Mirot, p. 233, n. 1).

[67] The decision to send to Rome for three master builders recommended by Bernini had been made by 26 June. See the report of the Papal Nuncio in Schiavo, p. 33. The three masters—Pietro Sassi, Giacomo Patriarco, and Bernardino or Bellardino Rossi— arrived in September. Cf. below, 3 and 28 Sept.

put their ships on their return journey in ballast with this clay and sold it afterwards as Dutch clay. It was further debated whether the ceilings might not be made with brick, or mill stone, which is porous— and whether our lime is good enough. Someone suggested that pot clay might be used for the bricks, as it is very light; the different kinds of clay would have to be examined and there must be intelligent people to conduct these experiments. The Cavaliere said that he could only have confidence in those whom he had already sent for. Pinewood would be necessary for the reception rooms. I said that pine grew in the Auvergne. M. Colbert replied that there was little there, and the Cavaliere mentioned Tuscany where it grew plentifully; as regards the length of the beams, they could well be made in three pieces, and would in fact be stronger so. Everyone agreed that pine was better than oak, which crushes the walls with its weight.

This discussion ended, M. Colbert told me to take the Cavaliere to the King and said that he himself was coming at once; in fact he arrived immediately afterwards. As he was entering the King's study the Cavaliere said that he would like half an hour of the King's time in which to make some drawings different from those he had done previously, but that His Majesty could move about and talk without constraint. M. Colbert came out to say that the King could not grant him the time at present, as he was holding two Councils of State that morning, but that after dinner he could allow him a whole hour. He then told me to take the Cavaliere to eat straightaway so that he would be ready to work when the King rose from table.

When His Majesty had finished dining I presented myself and he asked me whether the Cavaliere was awake. I said he was in the antechamber, and when the King went into his room he was summoned. As soon as the Cavaliere came in, he showed His Majesty his design for the riverside façade. The King studied it and had it explained to him and then showed it to the duc de Saint-Aignan,[68] who was present, and to others. The King then wanted to see it beside the façade for the front of the Louvre, and asked me to hold them together, so that he could see the effect of the angle made by the two new façades.[69] He looked at them hard and then placed himself in the position in which he thought the Cavaliere would want to draw him. The Cavaliere first studied him attentively standing and then asked

[68] François de Beauvillier (1610–79), first duc de Saint-Aignan (1663), First Gentleman of the Bedchamber (1649), Governor of Touraine (1661), and a member of the French Academy (1663).

[69] For Bernini's opinion on this view of the palace from the Pont-Neuf, see below, 20 July.

him to sit down. As he began to draw, Angeli[70] came in and told the King something in a low voice, and went out. Then the Queen entered and remained sitting there all the time, while Bernini, on his knees on the floor, drew the King. The duc de Noailles[71] and M. de Beringhen[72] came in and the duchesse de Montausier,[73] and the King asked me to show them the drawings.

20 JULY

❧ The Cavaliere worked at the bust and at seven in the evening the duc d'Aumont came to see him and the Cavaliere told him he had made a drawing for the staircase which he said he would have liked in his own home; the plan shown him had faults in his opinion; he had no wish to put his hand to the work of another but the maréchale had asked him and he had not dared to refuse; a model would have to be made to see the effect of the design; the stairs would be wider than in the first design, where there was no proportion of breadth to height, neither in the whole nor between the lower and the upper flights; further, the staircase had not finished in the center of the landing, which was a grave error. He then showed the Marshal his drawings for the Louvre, and told him that the arcades round the courtyard would be about thirty feet across, and that three coaches would be able to pass together. Discussing what the effect of the finished façade would be, he said that its grandeur would dwarf Paris, particularly from the Pont-Neuf side, where it would be seen from an angle, the most favorable view for it. When the Marshal had left, he went to the church of Saint-Marguerite,[74] outside the porte Saint-Antoine. As we went through the gateway I drew his attention to the two bastions which protect it. He found them very beautiful, but

[70] A court jester of the prince de Condé, who then passed into the service of Louis XIV.

[71] Anne (1615–78), comte d'Ayen, then first duc de Noailles (1663), Lieutenant-General (1650), Governor of Rousillon (1660), and Captain of the First Company of the King's Bodyguard.

[72] Henri de Beringhen (1603–92), First Equerry of the Small Stables of the King (1645), called Monsieur le Premier, and Chevalier of the Orders of the King (1661). A favorite of Louis XIII, he had been disgraced by Richelieu and later attached himself to Mazarin.

[73] Julie Lucinie d'Angennes (1607–71), daughter of the celebrated marquise de Rambouillet and recipient of the *Guirlande de Julie*, a collection of verses written by the literati of the hôtel de Rambouillet. Governess of the Children of France (1661) and dame d'honneur of the Queen (1664), in 1645 she had married Charles de Sainte-Maure (1610–90), first marquis then duc de Montausier (1664).

[74] A chapel of this name had been established in the faubourg Saint-Antoine from 1625 by Antoine Fayet, curé of Saint-Paul. Enlarged between 1669 and 1678, it was completely reconstructed in the early 18th century.

after looking at the gate itself, remarked, "It looks like the door of a cupboard."[75]

🎨 He worked at the King's bust the whole day.

🎨 The marquis de Bellefonds sent in the morning to know whether I was there and to say that he was coming. He entered the room where the bust was, and after looking at it said he wished the Cavaliere had put hair over the forehead. I said the forehead was one of the principal parts of the head and from the point of view of physiognomy the most important, that it therefore should be visible; moreover, the King had a forehead of great beauty and it should not be covered up; besides he might not always wear his hair as he did at present. He replied that should the King at some future time not have as much hair as now, he would wear a wig. The Cavaliere said that the sculptor was not so fortunate as the painter who, by means of different colors, could make on object appear through another so that the forehead could be seen even when depicted with the hair falling over it; the sculptor could not do this; each art had its own limitations.[76] When the Nuncio and the abbé Buti came in, I went to see M. Colbert, who I knew had arrived from Saint-Germain. I waited an hour with various other people, among them MM. Le Brun and Le Vau. M. Colbert came down from the library and walked over to ask whether I had anything to say to him. I said no; he told me he was going to see the Cavaliere immediately. I then returned and found him at dinner. I told him what I had just heard. He waited for M. Colbert and did not go to rest as usual, but the minister did not come.

At four o'clock we went to see M. Mignard, who showed the Cavaliere various works of his, among other things a drawing in which he had painted the design that he had made for the altar at the Val-de-Grâce.[77] He looked at it for a long time without uttering a word,

[75] Bernini's remark is in Italian in the manuscript, and this judgment on the porte Saint-Antoine—a 16th-century city gate with sculpture by Germain Pilon, later modified by Clément Métezeau and, under Louis XIV, by François Blondel—neatly inverts Chantelou's defense of the Fontaine des Innocents (above, 1 July). The fountain, though small, was a great work of art; the gate, though large, was a trifle. Cf. below, 23 July, the artist's opinion of the Tuileries.

[76] Cf. above, 6 June, on the difficulty of creating a likeness in sculpture.

[77] In the several studies touching on the design of the altar for the Val-de-Grâce, it has sometimes been assumed that this project, put into colors by Mignard, was Bernini's. From what follows, however, this seems unlikely, since there would have been no need then for the Cavaliere to study it so intently or to give Mignard a lecture on

then he said that the difference between this design and the one which was being carried out there now was like that between a torch and the sun; one would not be surprised to see a torch worth four shillings preferred to one worth five, but to prefer it to the sun itself was more than blind, it was incomprehensible. While he was on this subject he told us how when he was quite young, the comte de Béthune had tried hard to persuade him to come to France and offered him as inducement a great salary and rewards from the King; he had weighed the advantages and resolved on coming, but Urban VIII, then only Cardinal Barberini, had made him change his mind, saying that he knew the French court well; the enthusiasm with which an enterprise was started very soon petered out; after being fussed over and thought much of for a year or two, one was dropped completely; besides in leaving Rome he would be leaving his school, going where he knew no one and no one knew his work; the cleverest man in Paris was the best schemer and intriguer even if devoid of talent and skill; now he saw proof of what the Pope had said.[78] To this I answered that things had changed since then; the King, who was in all things firm and constant, imparted this quality to the government and his subjects and anyway, injustice and ignorance often prevailed in Rome as elsewhere, witness the treatment given to Annibale Carracci as reward for his work in the gallery of the Farnese Palace, which is without doubt the most beautiful thing in Rome, the paintings of Raphael excepted; at the time this must have been worth at least 20,000 crowns, for which he received notwithstanding only five hundred gold crowns,[79] not to

what one must consider in designing architecture. Nor is it in character for Bernini to extoll so extravagantly his own work without a disclaimer that his ideas came from God. (Chantelou inverted the comparison, but Bernini's meaning is clear.) Thus it would seem that this design was by Mignard and had been done sometime around 1663, when the Queen Mother inspected the models for the altar and the decorations in the dome (Hautecoeur, II, p. 52). See too below, 7 Sept.

[78] Philippe de Béthune (1561–1649), comte de Selles et de Charost, was ambassador to Rome in 1601 and 1624. Since Cardinal Maffeo Barberini was elected pope on 6 Aug. 1623, the Cavaliere's account cannot be entirely correct. Yet here and elsewhere when he recalls the events of long ago, the substance of what he says is probably true. Thus it was Cardinal Barberini who on the death of Gregory XV reassured the young Gian Lorenzo that "whoever becomes pope will find he must necessarily love you if he does not want to do an injustice to you, to himself, and to whoever professes love of the arts" (Dom. Bernini, pp. 23–24). And shortly before his own death in 1644, when Mazarin was urging the artist to come to France (for which, see Laurain-Portemer, "Mazarin et le Bernin," pp. 185–86), the same Maffeo Barberini, now pope, dissuaded Bernini from going with the assurance that "he was born for Rome and Rome made for him" (Dom. Bernini, pp. 69–70).

[79] The story of Annibale's poor treatment at the hands of Cardinal Odoardo Farnese and its deleterious effect on his health and work was a notorious one in the 17th century. It is already hinted at by Mancini (II, p. 21) and then told by Baglione (p. 106).

speak of the immeasurable injury that he suffered by the choice of mere daubers in place of him for the painting of the room to which Clement VIII had given his name.[80] The abbé Buti said he thought at the time that the treatment he had received in connection with the gallery might drive him out of his mind; once Cardinal Farnese sent word that he was coming to him and Carracci replied to the message that he could come when he felt like it; the front door would be open but he himself would be out at the back door the moment he saw him arrive.[81] The Cavaliere replied that at this period there was one man in Rome (whom he did not name) to whose knowledge the public always gave its due whatever might be said or done against him, which goes to show that in Rome even if an individual might be unfair, the public was not.[82]

Referring to the architectural considerations in connection with the altar, the Cavaliere said they must bear in mind the place for which a work was destined; the members of a cornice appeared smaller in the light of out-of-doors, than when lit by special means; moreover great attention must be paid to what are termed the *contrapposti*.[83] He repeated to M. Mignard, Michelangelo's reply to Lorenzo de' Medici, on the subject of the library in Florence, "Vasari and Ammannati are both men of ability and both are my friends, but, given equal talent, for architecture one should always choose the sculptor."[84] He said that the Legate, when describing all that he had seen in France, praised the tapestries, the richness of the decorations, the wonderful troops, but not the architecture.

23 JULY

🦋 The Cavaliere worked at the bust all day. At half past five someone came to say that M. Colbert's brother was at the hôtel de Frontenac and wished to see him. He was still working at the bust and was extremely displeased. He said that they were to excuse him on the grounds that he was not dressed; but that if the visitor cared to wait

[80] The Sala Clementina in the Vatican was decorated by Giovanni and Cherubino Alberti and others for Clement VIII from 1596 onwards.

[81] Bellori (p. 83) tells a similar anecdote about Annibale, but with Cardinal Scipione Borghese as the artist's antagonist.

[82] The person Bernini does not name is probably himself. During his brief fall from favor after the death of Urban VIII in 1644, he said that "Rome sometimes sees poorly, but never goes blind, in order to infer that it is a city in which virtue is sometimes opposed by envy, but is never oppressed" (Dom. Bernini, p. 80).

[83] For Bernini's conception of the *contrapposti*, see above, 6 June, and below, 23 Aug.

[84] Michelangelo's statement is quoted in Italian in the text. The same line is cited above, 12 July, on the authority of a letter by Michelangelo that Bernini claims he had seen.

he would come soon. I went back and there was M. de Ménars,[85] brother-in-law of M. Colbert, and as I was aware that he knew the Cavaliere very well since the time when he was in Rome, I sent word to say that he was not to put himself to any inconvenience, that I would talk to M. de Ménars meanwhile and persuade him to return. A little later the Cavaliere sent a message to say that I was to take M. de Ménars into the gallery and show him the drawings. While we were there he arrived and gave him the warmest welcome and they talked about Rome and how M. de Ménars had wished at the time to see him in France.[86]

We went to the Quinze Vingts[87] in the coach belonging to M. de Ménars, thus leaving the King's carriage for Signor Paolo and Signor Mattia. From there we went to the Feuillants,[88] thence along the river. The Cavaliere told us how the King had received his first design, how satisfied he had been with the others too, and what he had said to him. I also related what I had heard elsewhere. The Cavaliere said he had an even better proof that all his work had greatly pleased His Majesty, and M. de Ménars asked immediately what it was. I knew that he was going to say that the King had wished to show them to Mlle. de La Vallière and to prevent his naming her, I said that he had exhibited them with every show of delight, to the Queen Mother, the Queen, to the prince de Condé and indeed to everyone of note.[89]

He continued saying that the King had asked him what he thought of the palace of the Tuileries, and how he had replied that it seemed to him a colossal trifle,[90] and it was like an enormous troop of tiny children.[91] Turning then to M. de Ménars, he addressed a little ex-

[85] Jean-Jacques Charron (1643–1718), sieur de Ménars, the brother of Marie Charron, whom Colbert married in 1648.

[86] Sojourning in Rome on his return from Naples, M. de Ménars had been one of the people enlisted by Colbert to persuade Bernini to come to France. See the letter of 19 Aug. 1664 from Ménars to Colbert in Depping, pp. 545–46.

[87] A hospital founded by St. Louis about 1254 for three hundred (15 x 20, or quinze-vingts) of the blind. Originally in the rue Saint-Honoré, it was transferred in 1779 to rue de Charenton.

[88] The Feuillants were a congregation of reformed Cistercians who took their name from the Abbey of Feuillants near Toulouse. They were established in Paris in the rue Saint-Honoré in 1587. In 1601 Henry IV laid the cornerstone for their church, the façade of which was designed by François Mansart in 1623. Now destroyed, it is Mansart's first recorded commission. See Braham and Smith, pp. 15–16.

[89] Mlle. de La Vallière, it will be recalled, was the King's mistress, about whom there had been some indelicate banter (above, 12 July), and Chantelou hastens to forestall the artist from bringing up her name.

[90] Bernini's reply is in Italian in the manuscript.

[91] It is interesting to compare this with La Fontaine's description of the château of Blois: "The part built by François I, seen from the outside, pleased me more than

hortation to him, saying he was young and handsome and at that age one must take good care not to abandon oneself to pleasure; in his own case God had put out his hand to save him, for, although he had a fiery temperament and a great inclination to pleasure in his youth, he had not allowed himself to be carried away; like a man in midstream held up by gourds; he might sink sometimes to the bottom but would rise to the top again immediately.[92] He advised him to read the sermons of Father Oliva in which he would find many excellent things which would help him along the path of virtue and would instruct him in the Italian tongue.[93] Then he repeated what Father Oliva had said about his journey: "If an angel came and told me that you would die on this journey I should still say: 'Go',"[94] and said that he had told

anything else. There are many little galleries, little windows, little balconies, little ornaments without regularity or order; these make up a whole which is big and rather pleasing."

[92] The youthful errancies to which Bernini alludes are confirmed by a remarkable *supplica* published by P. Pecchiai in *Strenna dei Romanisti*, x, 1949, pp. 181–86. Undated, this petition is addressed to Cardinal Francesco Barberini by Angelica Galante, the artist's mother. It reports that Gian Lorenzo, accompanied by his henchmen, had broken into his mother's house, sword in hand, in search of his brother, Luigi, whom he wished to kill. Finding Luigi in the street leading to S. Bibiana, he chased him to S. Maria Maggiore, where his brother took sanctuary: "nor were there lacking many priests who, seeing him kick disdainfully at the door, wanted to defend the holy right of the church; but for fear of his great power, which today seems to have reached the point of no longer fearing justice, they had little enthusiasm for the task, and even less because, to her extreme regret and the astonishment of all Rome, he is never punished for anything. Therefore, she petitions you anew . . . that you use the authority given you by God . . . and restrain the impetuosity of her son, who today indubitably stops at nothing, almost as if for him there were neither great lords nor justice." It has reasonably been suggested that Bernini's blind rage had been provoked by rivalry over a woman, and his fiery ardor of those years has been preserved in one superb work of art. It is the bust portrait of Costanza Buonarelli, wife of Mattia Buonarelli, one of Bernini's studio hands (Wittkower, *Bernini*, cat. no. 35). According to a contemporary report the bust was carved while Bernini "was passionately in love with her" (Fraschetti, p. 49, n. 1); and Domenico Bernini (p. 27) candidly reports that his father "either jealous of her or, because love is blind, for some other reason carried away," had gravely and publicly insulted Mattia in some way. In 1639, however, he married Caterina Tezio and from then on lived the exemplary life of a respectable and devout *paterfamilias*, presiding over the fortunes of his growing household. His quick temper and irascibility he retained, as appears frequently below, but his illicit passion he now expiated in devotion to God, attending Mass daily and reading devotional literature (below, 23 Aug.). During his life, he prepared for death by studying the Art of Dying (see I. Lavin, "Bernini's Death," *AB*, LIV, 1972, pp. 158–86), and the composition of the Blood of Christ (ibid., and Brauer and Wittkower, pp. 166–68) is a curiously appropriate pendant to the portrait of Costanza.

[93] The sermons Bernini recommends are Father Oliva's *Prediche dette nel Palazzo Vaticano*, Rome, 1659–77, for the second volume (1664) of which Bernini had designed a frontispiece. Later for the five volumes of Father Oliva's *In selecta Scripturae loca Ethicae Commentationes*, Lyons, 1677, Bernini provided the design for another frontispiece. See Brauer and Wittkower, pp. 141–43, 175–78, and *Bernini in Vaticano*, cat. nos. 71, 75.

[94] Quoted in Italian in the manuscript.

the King of this, who had commanded M. de Lionne to write to Father Oliva on his behalf to thank him; that he expected the reply on the following Sunday.[95] He said that in the last few days he had written to Cardinal Chigi,[96] Cardinal d'Este[97] and to one other for the first time since he had come to France, and also to Father Oliva.[98] To him he had begun by saying that he had great difficulty in finding words with which to write to him of all people. M. de Ménars begged him to visit Ménars on his return journey, which would hardly be out of his way, saying that he had brought back from Italy a picture by Albani which I found[99] extremely beautiful. The Cavaliere replied that in this case it must be so, and went on to say that he wondered whether there was anyone in France with as good an understanding in matters of painting and architecture or such taste as myself; he had realized how excellent my judgment was in everything I said as I watched him work. M. de Ménars replied that the King was well aware of this and for that reason he had appointed me as his companion. He then asked the Cavaliere whether he had seen my pictures. He was so surprised to hear that he had not that he could hardly believe it. He praised *The Seven Sacraments* very highly. I said that I had a picture by Raphael and several copies after him.[100] The Cavaliere said there were many pictures that were passed off as by Raphael that were not; that he died young and worked almost always in fresco. I did not insist, on the contrary. Our conversation then turned to his own works—the *David*,[101] the *Proserpine*, the *Daphne*—M. de Ménars repeated the epigram of Urban VIII[102] and praised the works of

[95] Bernini had reported Father Oliva's advice when he first arrived (above, 2 June). Two letters written by Oliva to M. de Lionne in response to the latter's letter are in Baldinucci, *Vita*, pp. 54–56, the first of which, with minor variations and slightly abbreviated, is also in Domenico Bernini, pp. 141–42.

[96] Bernini's letter to Cardinal Chigi is in Gould, pp. 71–72, the latter's reply in Baldinucci, *Vita*, p. 58, and Domenico Bernini, pp. 139–40.

[97] Bernini's letter of 22 July to Cardinal d'Este (not the Duke of Modena, Francesco II, who was only five years old) in Fraschetti, p. 353, n. 1. Rinaldo d'Este (1616–72), protector of French interests in Rome, was created cardinal in 1641. During the reign of Alfonso IV (1658–62) and during the minority of Francesco II, he acted as Minister of Foreign Affairs for the duchy.

[98] Oliva's reply to Bernini's letter is in Baldinucci, *Vita*, pp. 56–57, and with minor variations and slightly abbreviated in Domenico Bernini, pp. 142–43.

[99] The text reads *lequel se trouvait*, which makes nonsense in the context. It must originally have read *lequel je trouvais*.

[100] Chantelou's collection is described below, 25 July, on the occasion of Bernini's visit.

[101] Like the others mentioned here, one of the statues executed for Cardinal Scipione Borghese and still in his villa (now the Galleria Borghese, Rome). See Wittkower, *Bernini*, cat. no. 17.

[102] See above, 12 June.

the Cavaliere above those of antiquity. He replied with great modesty that he owed all his reputation to his star which caused him to be famous in his lifetime, that when he died its ascendancy would no longer be active and his reputation would decline or fail very suddenly.[103]

He said his evenings here were melancholy; in Rome, when he had worked all day, his wife and children entertained him in the evening. I said he should have them brought to France. That was not possible, he told me; he would have to return—he had leave only for six months; some of his children could not travel; there was the chair of St. Peter awaiting him and the work on the Piazza, no one dared to write to him about it and thinking of it brought tears to his eyes; he had great feeling for his work, but it never entirely satisfied him as he could never be content with his productions. I replied that, as the idea comes from heaven, on entering matter it must be affected by corporeal imperfection, so that it disgusts even its creator who had cherished it as divine.

I said that he had seen none of the great houses in France; he answered he had come to France to work and not to sightsee; he had heard that there had been great expenditure of money, but it was not that which made a beautiful house but this, tapping his forehead.

24 JULY

He worked at the bust. After dinner he told me he had asked M. Perrault to say to M. Colbert that he should not complain[104] that when he (Colbert) had come to Paris he (the Cavaliere) had not waited on him, but that he would not have waited on the King. He did not go out at all as he had six letters to write. Cardinal Antonio[105] came to see him and he showed him his drawings.

25 JULY

I gave orders that the coach should be there at eight o'clock for us to go to Jabach's to see his drawings, M. Mignard having volunteered to tell him we were coming. But at a quarter past eight he sent a note to say that Jabach had gone to the country. The Cavaliere was somewhat surprised. I told him that Mignard had been very wrong to leave it so late before letting us know. He replied "It's not his fault, it's a

[103] For the course of Bernini's posthumous reputation, which he presciently intuits here, see L. Welcker, "Die Beurteilung Berninis in Deutschland im Wandel der Zeiten," diss., Cologne, 1957, and Bauer.

[104] For *dire* in Lalanne's text one should probably read *redire*, but this passage is obscure and the text may be corrupt.

[105] That is, Cardinal Antonio Barberini.

national failing; they don't know what punctuality is."[106] I said that not everyone here was the same. Just before the note came we had been discussing drawings. I said that they were valuable things but, much as I appreciated them, I had never embarked on forming a collection because it was so easy to be taken in. He replied that it was the same in painting. I agreed that was so, but to a lesser extent.[107] To bear out what he had said he told us about a picture supposedly by Raphael which had been in a convent at Urbino. The nuns had several times been asked to sell but they had never wished to. Finally however they were prevailed upon to part with it. The picture was taken to Rome, and it was found to be less than mediocre, by whomever it was, a good lesson to pay attention to the picture and not to the name. I told him that a Frenchman, Laurier, a pupil of Guido Reni, had advised me about my picture[108] and it was he who had informed me that it was a favorable time to buy, as Cardinal Antonio was at Bologna commanding the papal army against the Duke of Parma and other allied princes, and it was feared that he might insist on having the picture very cheap; it was a well-known picture, and Guido never looked at it but on his knees. The Cavaliere said that fact more than anything else assured him of its worth, and as he had put aside this morning for looking at Jabach's drawings and the arrangements had gone wrong, he expressed a desire to visit me;[109] it was half past eight. His son and Mattia accompanied him.

On coming into the anteroom he first looked at a bust of myself done in Rome. He threw a glance at a copy after Domenichino, the canvas of which had been knocked and unfortunately was torn just across the head of one of the girls. He noticed it and said with a laugh,

[106] Bernini's reply is in Italian in the manuscript.

[107] The problem of distinguishing between original and copy in the 17th century was conceived in analogy to the spontaneity of handwriting (Mancini, I, p. 134). For this reason, Baldinucci disagreed with Chantelou. He believed that "if one speaks of drawings, and particularly of the first ideas and sketches in which the painter follows his fancy . . . it is most difficult for whomever to imitate with boldness and freedom those quick and subtle strokes so that they appear original, with nothing lacking in those things characteristic of a good drawing" (*Notizie*, VI, p. 470). And Bernini was of the same opinion (below, 11 Oct.).

[108] The painting Chantelou believed to be an original is now recognized as an old and good copy of Raphael's *Vision of Ezekiel* (Palazzo Pitti, Florence). It was formerly in the Ashburnham Collection and was sold at Sotheby's (London, 24 June 1953). As a pendant to this picture Chantelou commissioned from Poussin the *Ecstasy of St. Paul* (Ringling Museum, Sarasota, Fla.). See Blunt, *Poussin Cat.*, no. 88. The artist who advised Chantelou on his purchase was Pierre Laurier, known in Italy as Monsù Piero di Guido.

[109] Chantelou lived nearby in rue Saint-Thomas-du-Louvre.

"This was touched with too much vigor."[110] He looked for a minute at the pictures by Lemaire, saying the architecture was very good.[111] Passing into the small room where the copies of Raphael were, he examined them all thoroughly.[112] I drew his attention to the copy by Mignard[113] and then to the *Virgin with a Cat*, copied by Ciccio of Naples.[114] He remarked that those were the sort of copies that he valued. He looked at the *Madonna della Misericordia* by Annibale Carracci, and asked me who had made the copy. I replied that it was a painter by the name of Lemaire.[115] He looked for a very long time at the portrait of Leo X,[116] saying that Raphael had painted it in the manner of Titian. He admired its truth, its air of grandeur, its beauty and the painting of the velvet and the damask and said, "It is in his latest and grandest manner, grander even than that of the *Virgin*," pointing to the copy of Mignard. He studied Poussin's *Virgin*[117] for a long while, without asking whose it was, and everyone admired its beauty and its grandeur. From there, we went into the study; before entering he gazed at length at the portrait of M. Poussin,[118] and then enquired whose it was; I asked him if he did not recognize the features,

[110] Bernini's remark is in Italian in the manuscript.

[111] Since Bernini specifically mentions the architecture in these paintings, they are probably by Jean Lemaire (1597–1659), called le gros Lemaire, who was a specialist in this field, rather than his brother Pierre (ca. 1612–88), le petit Lemaire. See A. Blunt, "Jean Lemaire: Painter of Architectural Fantasies," *BM*, LXXXIII, 1943, pp. 241ff., and idem., "Additions to the work of Jean Lemaire," *BM*, CI, 1959, pp. 440ff.

[112] All of the copies mentioned below were ordered by Chantelou on his second trip to Rome in 1642–43 and were made from paintings then in the Farnese Palace. After Chantelou returned to France, Poussin, with no little trouble to himself, acted as agent and saw to their execution. See Poussin, *Correspondance*, pp. 198ff.

[113] Pierre Mignard's copy of a *Virgin with the Child in her lap* was described by Poussin as being as different in coloring from the original as day is from night (*Correspondance*, p. 204).

[114] This copy by Francesco, or Ciccio, Graziani, a Neapolitan painter, of a painting now attributed to Giulio Romano (Naples, Galleria Nazionale di Capodimonte) was said by Poussin to be the best of all the imitations (*Correspondance*, p. 205).

[115] The copyist of Annibale Carracci's *Pietà* (Naples, Galleria Nazionale di Capodimonte) was Pierre Lemaire, since he is specifically referred to by Poussin in a letter of 11 Sept. 1644 (*Correspondance*, p. 284) as "le petit Lemaire."

[116] Charles Errard was the artist responsible for this copy of a copy (cf. below, 6 Oct.) of Raphael's famous *Leo X with his Nephews* (Florence, Uffizi).

[117] Chantelou's text is a little ambiguous, and grammatically he might be referring either to a copy by or after Poussin or a painting of the Virgin, but it must be to the latter given the high praise bestowed on it. The painting in question is probably the *Holy Family* in the Hermitage (Blunt, *Poussin Cat.*, no. 56) painted for Chantelou in 1655, since no painting of the Virgin alone or with the Child is recorded in Chantelou's collection, and the word *vierge* is often used in the 17th century for *Holy Family*.

[118] Made for Chantelou in 1649–50, this self-portrait is today in the Louvre. See Blunt, *Poussin Cat.*, no. 2. Poussin himself in a letter of Mar. 1650 told Chantelou that he took no pleasure in painting portraits and had not made one for 28 years (*Correspondance*, p. 412).

he said it must be Nicolas Poussin. I then told him it was his self-portrait, and that he was not accustomed to portraiture. He said he thought this one was unique. Everyone admired it and then passed into the study. I told him that there were several copies there, the originals of which were in the château de Richelieu. He looked at the first—the Bacchanal,[119] where the masks are thrown on the ground—for a good quarter of an hour at least. He thought the composition admirable. Then he said, "Truly this man was a great painter of history and fable."[120] He then studied Hercules carrying off Dejanira[121] and said, "This is beautiful." Then after considering it again, added, "He has made the Hercules very elegant and also the little children carrying the club and the skin." Of the Triumph of Bacchus, he said he would not have taken it to be by Poussin. He examined the third thoroughly and praised the foreground and the trees and the whole composition, repeating once again "Oh! What a great painter of fables."[122] He then passed into the room where the Seven Sacraments[123] were; only the Confirmation was uncovered. He looked at it with real interest, remarking, "In this picture he has imitated the coloring of Raphael; he is a great painter of history: What piety! What silence! How beautiful is that little girl."[124] His son and Mattia admired the young Levite, then the woman clad in yellow, then each figure, one after another. I had uncovered the Marriage,[125] which he examined as he had done the first, in silence, drawing aside the curtain which hid part of a figure that is behind a column, and finally said, "It is St. Joseph and the Virgin," and added that the priest was not dressed as a priest. I replied that it was before the establishment of our religion. He answered that there had still been High Priests in Judaism. They admired its qualities

[119] After Poussin's Triumph of Pan, which was formerly in the Morrison Collection and is now in the National Gallery, London. See Blunt, Poussin Cat., no. 136.

[120] Bernini's comment is in Italian in the manuscript.

[121] The original by Poussin is now lost. See Blunt, Poussin Cat., L63. Bernini's comments on the picture were again recorded by Chantelou in Italian.

[122] Poussin's Triumph of Bacchus is now in the William Rockhill Nelson Gallery of Art, Kansas City. The original of the third Bacchanal made for the château de Richelieu, The Triumph of Silenus, is lost, but it is recorded in a copy in the National Gallery, London. See Blunt, Poussin Cat., nos. 137–38 and the catalogue of the exhibition, Poussin: Sacraments and Bacchanals, Edinburgh, 1981, nos. 18, 24, 26. The comment is in Italian in the manuscript.

[123] The second series of the Seven Sacraments, today on loan to the National Gallery, Scotland, from the Duke of Sutherland. They were painted by Poussin for Chantelou between 1644 and 1648, after Chantelou's attempt to obtain copies of the first set belonging to Cassiano dal Pozzo had failed. For the Confirmation, see Blunt, Poussin Cat., no. 113.

[124] Bernini's remark is in Italian in the manuscript.

[125] Blunt, Poussin Cat., no. 118.

of grandeur and majesty and studied the whole with the greatest attention. Coming to details, they admired the nobility and the intentness of the girls and women whom he has introduced into the ceremony, and among others, the one who is half behind[126] a column. They then saw the *Penitence*,[127] which they also looked at for a long time and greatly admired. I had the *Extreme Unction*[128] got down and placed it near the window so that the Cavaliere could see it better. He looked at it standing for a while, and then got onto his knees to see it better, changing his glasses from time to time and showing his amazement without saying anything. At last he got up and said that its effect on him was like that of a great sermon, to which one listens with the deepest attention and goes away in silence while enjoying the inner experience.

Next I had the *Baptism*[129] brought in and placed near the window, saying to the Cavaliere that it showed the sunrise. He looked at it for a long while sitting, and then again got on his knees, changing his position from time to time in order to see it better, looking at it sometimes from one end, sometimes from the other, and said, "This one pleases me no less than the others." He asked me if I had the seven, and I replied that I had. He did not tire of studying them for a whole hour. On getting up he declared; "Today you have caused me great distress by showing me the talent of a man who makes me realize that I know nothing."[130] I replied that he should be satisfied to have reached absolute perfection in his own art, and that his works were equal to any of those of antiquity. I then brought him the little picture by Raphael,[131] which he looked at for a long while, turning from time to time to the *Extreme Unction*. At last he said, "In my opinion these pictures are equal to those of any painter in the world."[132] He wanted to know on what the picture by Raphael was painted, so I took it from its box to show him that it was on a wooden panel strengthened with cross pieces. I pointed out to him with what force it was painted. He said that was the more extraordinary as the picture was highly finished. He then saw the two other *Sacraments*, and studied them with the same attention. In the *Ordination*[133] there is a sort of

[126] After *à moitié* in Lalanne's text one must suppose *couverte*.
[127] Blunt, *Poussin Cat.*, no. 115.
[128] Ibid., no. 116.
[129] Ibid., no. 112.
[130] Bernini's comment is in Italian in the manuscript.
[131] This is the painting that Chantelou said above he had purchased in Bologna during the War of Castro.
[132] This comment is in Italian in the manuscript.
[133] Blunt, *Poussin Cat.*, no. 117.

tower. He pointed it out to me with a smile, saying that it should please me as it so resembled a French roof. The *Last Supper*[134] greatly delighted him and he drew the attention of MM. Paolo and Mattia to the beauty of the heads, one after the other, and the harmony of the light. He turned from one to the other and then he said, "If I had to choose one of these pictures, I should be much embarrassed," and, putting Raphael's with the others, he said he would not know which to take. "I have always esteemed M. Poussin very highly, and I remember how annoyed Guido (Reni) was with me because of the way in which I spoke of his Martyrdom of S. Erasmus, which is in St. Peter's,[135] as in his opinion I had exaggerated its beauty to Urban VIII, to which I had replied; 'If I was a painter I should be mortified by that picture.' "[136] He has great genius, and further, he has made antiquity his chief study. Turning afterward to me, he said, "You must realize that in these pictures you possess a jewel that you must never part with."[137]

After dinner he went with M. Mattia to the Tuileries to see the width of certain rooms, and the beams that are used there for the joists. He told me on his return that he had seen some made of pinewood. I said that the late M. de Noyers had had it brought from the Auvergne. "It does grow in France, then," he replied. At home he found M. de Rive, M. de Lionne's uncle, and various others, brought by the abbé Buti, who showed them the designs for the Louvre. In the evening we took a drive. Talking of different things, among them the roofs he had just seen, he said they contained whole forests of wood; they were very unsuitable, but cost nonetheless an enormous sum; then suddenly changing the subject: "I can't stop thinking about your pictures,"[138] he said.

Returning to the subject of costs, Vigarani[139] said that in the

[134] Ibid., no. 11, representing the *Eucharist*.

[135] Today in the Pinacoteca del Vaticano, Rome. The commission was first given to Pietro da Cortona; but when negotiations with Guido Reni for the altarpiece of the Cappella del SS. Sacramento broke down, Cortona received that commission and Poussin his original one. See Blunt, *Poussin Cat.*, no. 97. Bernini later claims to have secured this commission for Poussin (below, 8 Sept.).

[136] Bernini's comment is in Italian in the manuscript.

[137] Chantelou reports Bernini's last comment in Italian.

[138] This comment is in Italian in the manuscript.

[139] Carlo Vigarani (1622 or 1623 to ca. 1713), theatre architect, scenographer, and son of Gaspare, designer of the Salle des Machines (1659–62), with whom he had first come to Paris. After his father's death, he returned to France where he worked on the famous *Fêtes des Plaisirs de l'Ile Enchantée* (1664) organized at Versailles by the duc de Saint-Aignan. Intendant des machines et menus plaisirs du roi, in 1673 he became a naturalized citizen and received an exclusive patent as inventeur des machines des théâtres, ballets, et fêtes royales, although his fortunes declined after 1680. His extensive and valuable correspondence with Modena has been published by Rouchès.

theatre of the palais Cardinal,[140] there were two oak beams that were perished and broken, and he knew they had been ruined by the holes in the middle into which water drips. The Cavaliere said he was astonished that in France the chief apartments were not made in the upper stories, where there was less damp and more sunshine in the winter, which was very long, and that more general use was not made of double apartments; "They warned me when I was still in Italy that one should pay attention to the climate and that in spite of the cold they leave the rooms bare here. One should never say 'One can't do more,' or blame the work of other people."[141] On our way back we stopped at the house of Mme. de Bourlamachi, as the abbé Buti had told the Cavaliere that this lady wished so much to see him. When we reached his apartments he told me that if it was fine on the morrow we could go to Saint-Cloud.[142] I informed M. de Boisfranc[143] of this, as he had requested.

26 JULY

🐝 I learned that the Cavaliere was in the cloister of Saint-Germain l'Auxerrois studying the surroundings of the Louvre façade, the ground floor, and the gradients. I went over and found him near the façade which Le Vau had begun, from where he went into the court-yard of the Louvre to examine the ground floor and the plan of the first floor. Vigarani, who happened to be there, led him and MM. Paolo and Mattia and me over to the playhouse.[144] He studied its

[140] The palace built for Cardinal Richelieu by Jacques Lemercier. He bequeathed it to the King and it was later known as the Palais Royal.

[141] The quote attributed to Bernini is in Italian in the text.

[142] The château of Philippe d'Orléans, brother of the King, who had purchased it from the German banker, Hervart, in 1659. Already famous for its waterworks, it was rebuilt by the architect Antoine Le Pautre. See Berger, pp. 65ff.

[143] Joachim de Seglière de Boisfranc, who went from lackey to Intendant of Monsieur's Household (1673), enriching himself in the process, was at this time in charge of the work at Saint-Cloud.

[144] The Salle des Machines in the Tuileries, which had been designed and built by Gaspare Vigarani (1586 or 1588 to 1663 or 1664), father of Carlo. A theatre architect, engineer, and scenographer, Gaspare had been invited to France by Mazarin to build an appropriate theatre to celebrate the marriage of Louis XIV and Marie-Thérèse. He arrived in Paris in 1659 with his two sons and, like Bernini a few years later, suffered from the hostility of the French artists and difficulties with the local workmen. After surmounting endless problems and agonizing delays, the theatre was finally opened in 1662 with the *Ercole Amante*, for which the abbé Buti provided the libretto, Cavalli the music, and Lully the *entr'actes*. See Rouchès, Introduction; W. Savini Nicci, *Enciclopedia dello Spettacolo*, IX, cols. 1680–83. Bernini had already seen the auditorium of the theatre, which he found "very beautiful" (Fraschetti, p. 352, n. 4), but had not yet had time to see the stage and its machines. The comments by Bernini that follow fall into two groups separated by the anecdote about Michelangelo. There are, first, those directed at the plan of the theatre, and second, those directed at the scenographic practice responsible for the plan. The Salle des Machines was laid out in a long, narrow rectangle

layout, and then sitting down in front of the place where the queens are seated, he discussed the structure of the hall, the difficulty of hearing either spoken verse or the performance of music in so large a space built in such a way. He then told us about various places where he had put on plays, among them one where he had represented an auditorium on the further side of the stage, just as if there were two performances being held at the same time; he told us of the dispute that he and his brother pretended to have as to whether there were two theatres or one, and the retort from his brother that if there were not, everybody would not be able to see or hear the play; how they compromised by agreeing that each should give his performance separately; that one was a sham; while he was giving his play faint bursts of laughter could be heard from the other side, as if they were hearing and seeing something extremely entertaining. It was so arranged and the means so skillfully hidden that it seemed real; at last his brother came on to his stage, apparently very hot and pretending to wipe the sweat from his face; he, the Cavaliere, asked him if he had finished and when he replied that he had, thought for a moment and then requested that they should be allowed to see anyway a part of that honorable company who laughed so loudly and who had been so well entertained; that his brother, agreeing, said that they had only to open a window to which he pointed; through this appeared a representation

with a stage 46 m. deep to accommodate the machinery necessary for numerous scene changes (see Rouchès, pp. xiv–xx). In addition to making it extremely difficult to hear either words or music, the great depth of the stage encouraged scenes with long perspectives that favored a single point of view. (Cf. below, 7 Oct., when Bernini says the auditorium and the stage don't go together and that the theatre is "two or three times as long as it should be and half as wide.") This situation was to be avoided, as Annibale Carracci points out to his brother Agostino, and fortunately could be, as Bernini's perspective scene for the *Two Theatres* demonstrates. The reason appears below: the secret, he says, is to put on a spectacle that creates an illusion. For those who do not occupy the privileged position from which a perspective effect is calculated, the intended illusion can never be compelling. (Cf. below, 7 Oct., where the artist criticizes as a "great mistake" the raised seats from which the stage machinery can be seen.) Similarly, spectacles conceived so grandly that they require large and cumbersome stage machinery too often end up slow and dreary, the very opposite of the quick and lively effect needed to produce a true illusion of reality. Better to do something more modest that will work perfectly, he argues; and Dottore Graziano, Bernini's character in the comedy published by D'Onofrio, commenting on the failure of a scenic device says: "Machines aren't made to be laughed at, but to cause astonishment" (*Fontana di Trevi*, p. 74). Although Bernini's criticism of the Vigarani theatre seems tactless, Carlo was evidently not offended, perhaps because its faults could be explained by the restrictions of the site and the conditions under which Gaspare had worked. In early October, however, when Bernini himself proposed to design a new theatre (below, 7–8 Oct.), the criticism seems to have taken a more personal turn, and Vigarani, rightly angry (Fraschetti, p. 226, n. 2), sought a personal explanation from the artist (Rouchès, pp. 112–13).

of the Piazza of St. Peter's in strong moonlight; on the Piazza were a great number of gentlemen all going to and fro, some on foot, some on horseback, and some in coaches; there were hundreds of torches, some big, some medium, some small, and some no greater than a pin's head, so arranged to give the illusion of perspective, their light diminishing toward the rear; this representation deceived everyone.[145] He explained that for perspectives created by the light of candles it was not necessary for the stage to be more than twenty-four feet in depth; this space was sufficient to give the illusion of infinite distance provided the lights were skillfully arranged; it was desirable to avoid representations which could only be looked at from one point. As a noteworthy example he quoted the case of Annibale Carracci and his brother Agostino, who had together undertaken to paint the gallery of the Farnese Palace. Annibale got working on the historical compositions and left to his brother the care of the partitions and decorations of the ceiling. Agostino made a design of great beauty and grandeur in which all was based on a single viewpoint, and everything was already traced onto the place for which it was intended. He then summoned Annibale to see his work. Annibale, as he told us, had a great brain,[146] and going over to the place indicated by his brother, he knew at once that it was only to be viewed from that one spot. He looked at it and said that he thought it very beautiful, but if people were really to enjoy it, a corridor should be constructed to lead to that one place where there should be a comfortable chair from which the excellent layout might be appreciated, as from every other point it could please neither the eye nor the mind and only leave a bad impression. Agostino listened to his brother and seeing that he was making fun of him grew vexed and told him he could do the job according to his own ideas, which Annibale did, as we can see, dividing the ceiling into panels and decorating it with herms and other ornaments which can be looked at from any angle; thereupon he began to praise the great genius of Annibale and the beauty of the Farnese gallery.

Then he told us how Daniele da Volterra had one day shown a design to Michelangelo to get his advice on a certain difficulty with which he was faced. Michelangelo asked him what he thought he should do to get round this difficulty, and Daniele answered that he

[145] Bernini's production of the *Two Theatres*, as it is conventionally called (the original titles of the comedies, if such existed, are unknown), is also described by Domenico Bernini (p. 56), Baldinucci (*Vita*, p. 84), and Massimiliano Montecuculi, the Modenese correspondent in Rome, whose letter of 1637 fixes its date (in Fraschetti, pp. 262–63).

[146] The phrase is in Italian in the manuscript.

would lower the wall a little in this place, heighten it a bit in another, make a window, the light from which should be partly obscured; to all of which Michelangelo replied, "To remedy these little things something big must be done and one must do like a man who is forced to cross a ditch wider than he expected—go back some way to get a better jump." The Cavaliere added, "To do this you have to have a basis of knowledge; it can't be done by someone with gout in his legs."[147]

As we were coming back, he said that it was better to stage a spectacle of a size that would ensure it the swift and lively effect necessary for its success, than to make it so big that the result was slow and dreary. M. Mattia said that this slowness proceeded not from the size of the machines, but from lack of knowledge; if the machines were given more power, the large ones would be as successful as the smaller. The Cavaliere repeated that in his opinion the secret was only to put on spectacles that could create an illusion; when a suggestion was put forward by the prince it was the business of the engineer to choose what would best succeed; in that lay true excellence, but the Lombards never attained it; at Modena, they constructed machines that needed fifteen or twenty horses to draw them, and they explained that one could not do it better. He went on to say that it was best to avoid putting on anything which lacks perfection, and added that the machines in his plays hardly cost him a penny, and had always succeeded well, which had not always been the case with those which had cost enormous sums.

After dinner he went to Saint-Cloud. He thought it most beautifully situated among its fountains, and the view lovely. He suggested that a rustic waterfall might be made in the square space where the big fountain is, for in those surroundings it would look extremely beautiful.

27 JULY

❦ He worked all the morning at the bust and asked me for a bit of armozeen for the draperies. I sent for a table runner, which he found

[147] Both Michelangelo's reply and Bernini's addition are in Italian in the manuscript. The import of this anecdote is explained later in the diary (below, 13 Sept.) when Bernini states as one of his maxims that it is better to abandon altogether an imperfect idea than to attempt to improve it. Thus Chantelou reported in a letter to Colbert (Depping, pp. 552–53, incorrectly dated) that the 67-year-old artist had used the same analogy of the running start—without reference to Michelangelo apparently, but with an actual demonstration in which he leaped across an imaginary ditch—to criticize the King's desire to preserve what had already been built at Versailles and by inference at the Louvre.

very suitable. In the evening the Nuncio came and the abbé Bentivoglio[148] and the abbé Buti. The Nuncio read a letter from Cardinal Pallavicini[149] in which he said how overjoyed he was to learn from Monsignor Bernini,[150] how well the Cavaliere had been received in France. They talked about the fact that the wings of the Louvre were not built at right angles and that the doors were not exactly opposite each other.[151] As the conversation did not come to an end, the Cavaliere gave me a sign that the Nuncio was wearying him by taking up the time allotted for his drive and saying his prayers.

28 JULY

�} In the morning I found the Cavaliere working at the bas-relief of the *Christ Child*.[152] At the same time the marquis de Bellefonds arrived; he studied the bust and found it very well advanced. The Cavaliere begged him to inform the King that in a week's time he would be coming to Saint-Germain. M. de Bellefonds asked him if he had plotted the site of the Louvre, to which he replied that he had begun and had found that the existing buildings were not on the square. I rejoined that the King was well aware of this. He and M. de La Garde[153] who was with him then studied the bust together, M. de La Garde finding it a very good likeness. I remarked that the important thing was that it should resemble the model in nobility and grandeur.[154]

[148] Giovanni Bentivoglio (d. 1694), Secular Abbot of Saint-Valery-sur-Somme.

[149] Sforza Pallavicini (1607–67), a Jesuit (1637) and professor of Philosophy and Theology at the Collegio Romano, who was created cardinal *in pectore* in 1657 (published 1659). The best known of his numerous works is the *History of the Council of Trent* (1656), intended to refute the earlier history (1619) of Paolo Sarpi. Of Bernini, Cardinal Pallavicini said that he "was not only the most excellent practitioner of his profession, but simply put, a great man" (Dom. Bernini, p. 97; also in Baldinucci, *Vita*, p. 85). Cf. below, 20 Oct.

[150] Pietro Filippo Bernini (1640–99), the Cavaliere's oldest son, who had entered the Church. At this time a Refendario della Segnatura, who examined requests addressed to Rome, his career advanced from pope to pope as a consequence of his father's work. Alexander VII made him a Canon of Santa Maria Maggiore; Clement IX placed him in the Congregazione della Sacra Consulta; and Clement X appointed him Secretary of the Congregazione dell'Acqua. Later, under Alexander VIII, he became an Assessor in the Holy Office.

[151] As appears below, this discovery resulted from the survey of the palace discussed above, 8 July.

[152] This work (fig. 19), today in the Louvre, representing the Christ Child contemplating a nail found among Joseph's tools, had been undertaken by the artist's son, Paolo, but evidently on Bernini's design (below, 1 Aug.) and, as here, with his constant intervention.

[153] Lalanne noted that in the *État de la France* of 1661 there is a baron de La Garde listed as a Lieutenant of the Bodyguard of the Queen Mother. Below, Chantelou describes him as the standard-bearer of the Bodyguard.

[154] Portraiture had become a theoretical problem from the moment when the Ren-

They then left, the Cavaliere repeating to M. de Bellefonds that he would come as soon as he could. After they had gone he asked me who this nobleman was (I replied that he was the ensign of the Queen Mother's bodyguard) and what he had thought of the bust. I told him they had found it very like, and repeated to him what I had said about its nobility and grandeur because we had Warin in Paris who could get the likeness quite well—the important thing was to permeate it with nobility and grandeur. "That's it," he said to me, "it is only you who notice these things and who can point them out."

I told him that the Queen Mother was ill with a prolonged fever; the commandeur de Souvré[155] had told me about it; it was he who wished to entertain him to dinner, in order to ask his advice on what he wished to have done in the Temple.[156] He answered that he wanted to go nowhere; people asked his advice only to annoy him by not following it, as in the case of the altar of the Val-de-Grâce and the staircase of the hôtel d'Aumont; he was sure that it would never be carried out. I said it would not be the same with the commandeur; he retorted that of course he did not know for sure whether the

aissance definition of art as a simple imitation of nature came to be questioned during the 16th century. Once art had ceased to be considered nature's mirror, there arose the paradoxical notion of a portrait perfect with regard to art, but without likeness, and its opposite, perfect likeness without art (Vasari-Milanesi, IV, pp. 462–63; Mancini, I, pp. 135–36), as well as the theory of an ideal portrait, in which beauty could be added without diminishing the likeness (Agucchi, in Mahon, p. 243). Bernini's conception of portraiture was close to what Mancini (I, pp. 115–16) called the "portrait of action," in which the likeness of the "simple portrait" is enhanced by affect and expression, pose and movement. Thus in his bust of Louis XIV, Bernini sought to weight each detail exactingly rendered from life with the amplitude of gesture and fullness of form that he envisioned in the dignity and grandeur of a great king. It was this desire to achieve an active balance between the general and the particular that accounts for his unusual working procedure, and it was the effort required to reconcile, without compromising, the one with the other that made portraiture such a difficult task for him. The underlying tension that resulted is readily recognized in the French reactions to Bernini's bust. Those who saw what he hoped they would see recognized reminiscences of antiquity or imagined the King at the head of his troops, but others, including the King, found the bust too insistently realistic, while still others thought it a poor likeness. See below, 29–30 July, where Bernini develops his conception of portraiture more fully.

[155] Jacques de Souvré (1600–1670), a Commander of the Order of Malta and from 1648 their ambassador in France. In 1667 he became Grand Prior of France.

[156] The establishment, including house and grounds, possessed at Paris from 1211 by the Order of the Temple, from which it took its name. When the Templars were disbanded in 1312, the Temple passed, along with its rights of legal jurisdiction and sanctuary, to the Knights of Malta, who made it the residence of the Grand Prior of France. The commandeur de Souvré wanted to build a house at the Temple and later asked Bernini to make a design. As in the case of the Louvre, however, the Cavaliere's project proved far more grand and costly than was desired (below, 2 Oct.), and the hôtel was later built on the designs of Pierre de Lisle-Mansart, who was given the commission in 1667.

staircase would be built or not, but he suspected that the cabal of architects would prevent it.[157] I pointed out that it was the Queen's health that was holding up the project for the Val-de-Grâce, and the fear that she might not live to see such an extensive work completed. I then returned home with him. I told him that my brother, M. de Chambray, would come after dinner to pay his respects; he would have come earlier but for his respect and his self-restraint, which I had encouraged. That evening my brother came for the first time. The Cavaliere gave him a warm welcome, saying with a laugh that he would like to buy his books as cheaply as Signor Mattia and his son had done; that is, they had received them as a present a few days before when they had been at my house.[158] He asked my brother to look at his designs, saying that as he had even greater understanding of art than I, he would like to have his opinion of them and begged him to excuse his lack of talent. He requested me to show them to him and explain them and left us. Afterwards, while we were waiting for our coach to take us out, he told me what difficulties he was having in putting right the entrance to the Louvre so that the faulty alignment should not show. He said there were many ways of rectifying it, for instance by means of perspective, but as workmen were very often lacking in intelligence, it was best to give them only straight lines to carry out; it was imperative to discover and put right errors; though it was only about eighteen inches out of the true, it was extremely difficult to hide; the greater the distance the more noticeable the fault; I could see the trouble that this was causing him and how much he had had to scribble in the course of finding a solution, but no one else realized it.

We then got into the coach and went to the church of the Theatines where plenary indulgences were being granted, and then to the Barefooted Carmelites where there is a statue in marble executed after his design.[159] He told the Fathers that in France people cared little for

[157] Vigarani had written to Modena before Bernini's arrival (Rouchès, no. 215; Fraschetti, p. 340, n. 2) that the Cavaliere had been promised that all of the French architects would be ordered to say not a single word contrary to his ideas and that the Louvre would be built as if it were his own building. Such edicts, however, are rarely effective, and in Bernini's mind, as well as in that of Vigarani (Rouchès, no. 224; Fraschetti, p. 354, n. 1), criticism of his plans assumed the malevolent dimensions of an organized conspiracy.

[158] See above, 1 July, n. 4, for the books published by M. de Chambray.

[159] The monastery of the Discalced Carmelites (now the Institut catholique) was established by two monks from Genoa sent to Henry IV by Pope Paul V. They arrived in 1610 and in the following year were installed in the rue de Vaugirard, where Marie de Médicis laid the cornerstone for their church (1613). The church, dedicated to St. Joseph, was finished in 1628–29. The statue of the Virgin, designed by Bernini and

beautiful things; that when they had a fine picture it was hidden away, as in the Carmelites; the view of this figure was spoilt by the walls of the chapel, and by the pall that hangs in front; these palls should be draped borderwise in several tiers, but no one had sufficient intelligence to do this. He said the windows in the cupola[160] had been placed too high and were too small. On our way back he told me that he was having the surroundings of the Louvre on the side of Saint-Germain levelled, so that he could take his measurements and his level for the square in advance. I replied that the level of the Louvre seemed higher on all sides than the surrounding land. He agreed and as the ground floor is low, he could lower the courtyard by a little over a foot in order to give it some height.

29 JULY

❦ I found him working at the bust and saw that he had added a lock of hair where formerly the forehead had shown. I commented on this new feature, and said that it was no doubt in deference to the views of M. de Bellefonds who had pointed out that the King never wore his forehead uncovered.[161] I added that I had liked it that way as it showed the slight hollow in the middle of the forehead. He agreed with me. I brought him my bust of Ptolemy, or Hephaistion, as some think it is. He looked at it closely, admiring the beauty of this Greek work. He pointed out to me how similar was the forehead to that of the King, and said they were both beautiful in shape; he looked at it from every side and made his son observe it too. I then went with my brother to meet M. Colbert who had arrived at the Tuileries. Having looked at what was being done, he turned towards the Long Gallery. As we went along he was shown the decorations for the pediments, one of which has the royal emblem.[162] M. Le Brun who was present thought the sun was too big and shaped like a ciborium rather than an Apollo's head with the hair surrounded by rays. M. Colbert asked me if the Cavaliere had seen my pictures and what he had said about them. I told him he had, and that he had praised them to the skies considering them as good as the works of any painter whatsoever. He replied that he was glad; at any rate he had praised

carved by Antonio Raggi, who was allowed considerable freedom, was commissioned by Cardinal Antonio Barberini, reportedly for 10,000 livres. The statue arrived at Paris in Aug. 1663 and was dedicated by the Cardinal on 8 Sept. See Wittkower, *Bernini*, cat. no. 53.

[160] Chantelou wrote *coupe*, which would mean a section of the church, but it makes better sense to suppose that he meant *coupole*, dome.

[161] Above, 22 July.

[162] For these pediments on the exterior of the Long Gallery, see above, 15 July.

something in France. He added that he had heard it said that he did not admire the works of M. Poussin, nor M. Poussin his. I gave him an account of the discussion we had had about the *St. Erasmus* in St. Peter's.[163]

M. Colbert then went to the apartments of the Cavaliere. It was rather earlier than usual, and learning that he was still at table (the duc de Créqui and M. de Lionne having kept him for some time one after the other) he went on to the room where the bust was and looked at it with great attention, also at the work of Signor Paolo. The abbé Buti accompanied him and Signor Paolo came in immediately afterwards. After studying it for a long time he went out, meeting the Cavaliere in the vestibule. They went back together into the room. M. Colbert said he was astonished to find the work so advanced, in fact in his opinion it did not seem necessary to work at Saint-Germain. The Cavaliere replied that there was always something to do if it was to be done well; until now he had worked entirely from his imagination, looking only rarely at his drawings; he had searched chiefly within, he said, tapping his forehead, where there existed the idea of His Majesty; had he done otherwise his work would have been a copy instead of an original. This method of his was extremely difficult, and the King, in ordering a portrait, could not have asked anything harder; he was striving to make it less bad than the others that he had done; in this kind of head one must bring out the qualities of a hero as well as make a good likeness. On top of all this he was trying to take the measurements of the Louvre, where there were some faulty angles and this would have to be put right; it was a difficult matter but not so hard as it was at first thought, though a small fault at one end became a large one at the other if nothing were done to remedy it. He told him, as he had told me, that he had had the ground around Saint-Germain levelled.

30 JULY

🎄 I went to M. Colbert's at six o'clock in the morning and remained there until nine. While waiting for him to come down, I talked with M. Dubois and M. Olivier, the gentleman usher.[164] The latter told us that he had learnt from M. Coiffier[165] the day before, that no one wished to have the Louvre brought so near the church of Saint-Ger-

[163] Above, 25 July.

[164] Lalanne identified two members of the court named Dubois, one was a valet de chambre, the other, like M. Olivier, an usher.

[165] Charles Coiffier, baron de Dorvilliers and later Secretary of State.

main;[166] it would therefore be left where it was and a new building constructed on a different site. To that I said nothing, but when he added that the Cavaliere had made the plans I intervened and said that this was simply a tale of which he had heard nothing. A little while later M. de La Motte, Surveyor of Buildings, who was also there, drew me apart and told me that Le Vau had made a new design in which the Louvre was to be built in the place of the service courtyard, that there were to be three gardens, and the present Louvre would be used only as a stable yard and to house members of the nobility.[167] During this conversation M. Colbert came down and got into his coach and asked me to drive with him; he asked Le Vau, who was near, to get in also and MM. Desmarets[168] and Perrault as well. On the way he remained uncovered. He did not speak and his face was gloomy; then he said to me, "I do not know whether the Cavaliere has taken the right measurements for the square in front of the Louvre. It should be big enough for drill to be held there." I did not reply. A little later he added, "There will be difficulties about the houses to be demolished where the foundations are to be built; we can only get possession after the necessary formalities." By then we had arrived at the hôtel de Frontenac where we were informed that the Cavaliere was in the big room. M. Colbert went in and greeted him most cordially. He looked at length at the bust. The Cavaliere, who was working at the hair, remarked that the artists of antiquity managed to give the impression of lightness to the hair, which he strove to imitate but without success. Then M. Colbert told me to inform him that he was worried about two things; one, the square in front of the Louvre which ought to be big enough to hold the regiment of guards, the light and heavy cavalry, and be used sometimes to conduct exercises with the troops arranged in battle formation; secondly, to see the lines of the foundations, in order to know exactly which houses

[166] According to Marot's engraving of Bernini's plan (fig. 8), the east wing of the palace was to be separated from the Square Court by two subsidiary courtyards. Therefore it would have been situated well forward of the present façade and closer to the mediaeval church of Saint-Germain. See, too, the report on the excavations carried out in the early 1960s, which exposed the foundations laid by Le Vau and Bernini, in A. Erlande Brandenburg, "L'identification des fondations du Bernin au Louvre," *Bulletin de la société nationale des antiquaires de France*, 1965, pp. 135-39. However, pushing the east wing forward in this way caused concern because it diminished the space available for actual use (cf. below) and decreased the maximum distance from which the façade could be seen (cf. Perrault's criticism of the façade, below, 19 Sept.).

[167] For Le Vau's new project, see M. Whiteley and A. Braham, "Louis Le Vau's Projects for the Louvre and the Colonnade," II, *GdBA*, LXIV, 1964, pp. 349-52.

[168] Jean Desmarets, or Desmaretz (1608–82), trésorier de France (1634), maître d'hôtel to the King (1650), and conseiller d'état (1652), who had married Marie Colbert (1626–1703), sister of the Minister, in 1646.

would have to be pulled down. He knew it would not be possible to keep the Cavaliere longer than October and that much time would be needed to get out the people who were occupying them; they could not be put on the street in one day; he had no idea what was done in Rome, but that was not the custom in France; besides, if the rest of the Petit-Bourbon[169] was to be demolished as well, it would be very awkward, as furniture of the King's was kept there, and there was nowhere else to put it; of course he knew that it was his business and he should have thought of it, but from one day to another he had waited for the stakes to be driven in. I repeated some of this to the Cavaliere, and the rest he understood for himself; on the subject of the foundations he said he had not been able to finish them earlier; Signor Mattia had worked without stopping; when he had plotted the lines of the Louvre he had found that some were out of the true, and he had had to work hard to put this right, for although it was only about fifteen inches it made a noticeable difference to the line of the doors; the one already in existence was on the straight, but, as the line of the river façade made an obtuse angle instead of a right angle, the new doorway, the foundations of which were laid in the center of the front façade, would not have its center exactly opposite the other entrance; he illustrated this with a piece of charcoal on the floor; would it not be a great pity to have it thus in a palace on which so much money had been lavished? He had to work at this so that it should not be obvious everywhere, affecting even the plan for the staircases he wished to put in the corners of the courtyard; it had been a great weight on his mind, he had sweated blood in trying to remove it, but God had come to his deliverance; everything was now adjusted and nothing would hold him up henceforth. He did not refer to the houses it would be necessary to purchase, but demonstrated to us where the entrance would be and said that it was possible to establish with certainty the layout of the "royal lines"; he did not explain what he meant but these are doubtless lines at right angles.[170] M. Colbert said that he was impatient because it was now the best season for laying the foundations, on account of the low water; if it was allowed to pass, it would not be possible to do anything until June of next

[169] Properly the petit hôtel de Bourbon, a house to the east of the Louvre, near the river, which had belonged to the constable de Bourbon and was confiscated by the Crown when he defected to Charles V. In 1614 and 1615 the assembly of the States-General took place there, and later it was used for the Garde-Meuble, where the royal furniture, tapestries, and carpets were stored.

[170] "Royal" lines were the major center lines that determined the alignment of all the other lines in the layout of a building. Cf. Carlo Fontana, *Il tempio Vaticano e sua origine*, Rome, 1694, pp. 383–85.

year owing to the nearness of the river, and this was very worrying. Then M. Colbert repeated quite sincerely that he should have thought about the pulling down of the houses, but it had not occurred to him to do so. The Cavaliere again addressed him saying that this unforeseen piece of work had prevented him from going to Saint-Germain as early as he had wished; he must see the King to study the details of his face; until now he had worked only at the general impression; during this period he had hardly looked at his drawings; in fact he had made them only to imprint the image of the King on his mind as forcibly as possible, so that it should be soaked and impregnated with it, to use his own words; had he used the drawings very closely, he would have made a copy instead of an original; indeed, were he forced to make a copy of the bust after it was finished, he would not be able to make it exactly the same; the nobility of the idea is suppressed by the slavery of imitation;[171] thoughts that he once told Father Oliva, who had made a note of them and used them in his sermons, so he had told him afterwards.

He told us that M. and Mme. de Lionne[172] had been to see him; Mme. de Lionne was a woman with an exceptionally lively mind, in Italy it would be impossible to meet a woman of such intelligence; while looking at the bust of the King she had said to him more than once, "Leave it alone now; it is so good that I am afraid you will spoil it." He had shown her the drawings for the Louvre, which she looked at with considerable understanding, searching in the plan for enlightenment where she had not understood the façade. He then spoke of the great knowledge that the King possessed. He said his mind was what one called of sound metal.[173] Explaining the metaphor, he added that he had never heard him say anything on any subject that was not absolutely to the point; he had exquisite taste in everything. This he had realized when he had shown him the first design for the façade and His Majesty had chosen the more beautiful of the two designs for

171 Cf. Domenico Bernini, p. 134. Bernini's assertion on having to make a copy of the bust may be judged by the two busts of Scipione Borghese still in the Villa Borghese, Rome (Wittkower, *Bernini*, cat. no. 31). Baldinucci (*Vita*, pp. 11–12) and Domenico Bernini (pp. 10–11) each tell how in finishing the nearly completed bust of the Cardinal a flaw appeared in the forehead. Undaunted, the artist turned to a new marble and in three nights (15 days according to Baldinucci) carved a second bust.

172 Paule Payen (1629–1704), who had married Hugues de Lionne, the Secretary of State, in 1645. She was exiled in 1671 for her "scandalous infamy" (Mme. de Sévigné), which had also involved their daughter, the marquise de Coeuvres, and which embittered the last years of Lionne, who was said to have been responsible for her exile. Below, 13 Aug., Bernini again praises her knowledge of art.

173 The metaphor, "of good metal," is explained below, 28 Sept., when Bernini uses it again.

the rocky structure that he had prepared for the foundations of the Louvre, just as someone highly experienced in design might have done; this power of discrimination was evidence of an intelligence beyond the endowment of nature, which might manifest itself in other spheres as well as in the affairs of state.[174]

M. Colbert said that every day the members of the Council and he himself were astonished at what he said. When the conversation ended he went out and got into his carriage. During the evening on our drive I told the Cavaliere that from what I had seen and from what M. Colbert had said he was impatient for the work to be begun on the foundations and therefore the lines should be marked out, so that it could be seen which houses would have to be purchased, for which of course the formalities would have to be observed. He replied that I knew very well that no time had been lost; in three days it would be two months since he had arrived in Paris; first of all he had had to set out his plan, he had then made four different elevations, he had then worked on the interiors in order to complete the preparations, which was in itself a six months' task; afterwards, to avoid any mistakes, he had taken the alignments of the existing buildings and had found the angle out of the true; he had striven to put it right and fortunately had succeeded; besides that he had worked at the portrait of the King, which was very trying for him, as it required a state of intense exertion; as regards the houses that would have to be demolished, he said that it was none of his business and he would never have spoken about it; it was quite sufficient that he should apply himself only to that part which concerned the design. These other matters were not in his sphere, and it would be to the detriment of the more important part if he were to give them his attention; in Rome there was a prelate in charge of buildings with the power necessary to carry out their execution; he could not and ought not to take on such duties; that since his designs were finished it should have been possible to do what was necessary in connection with the houses; it had not seemed proper to him even to speak about it; it should have

[174] This, as well as Bernini's later eulogies of the King's taste and intellect were more than the ingratiating flattery of the practiced courtier. Uneasy over his position in a strange land, increasingly frustrated, and growing steadily more impatient with the meticulous Colbert's attention to detail—what Bernini later describes as "privies and drains" (18 Oct.)—the artist, abetted by Chantelou, seized hopefully on the idea of a king with perfect taste and a natural knowledge of beauty. Such a king unerringly chose the best design (above, 20 June) and would undoubtedly be the sympathetic patron of that image of grandeur and magnificence that the artist had conceived in his mind. Unhappily for Bernini, Louis XIV, at least for him, was not that king, and gradually disabused of his hopes, the artist had sadly to admit that the King's taste was undeveloped, since he had seen no truly great works of architecture (below, 8 Oct.).

been possible to demolish what had been begun on the first façade, which would have cleared the space, and the stones that were there might have been used again, but he had not liked to say anything. I replied that, if he realized the responsibilities that the King put on M. Colbert and how overburdened he was, he would be surprised at the way he managed to give so much attention to these matters with all the appearance of having time to spare. He said he quite well understood that there were things of greater importance and he sympathized with him in his heavy tasks but no one ought to blame him for what was not his fault. He went on to say that they ought to have talked to Signor Mattia who was to be in charge of the execution of his designs and who at the moment said he did not wish to stay in France; they ought to have realized, as he did, that it was one of the first things that had to be settled. I said certainly Signor Mattia must remain; it was in his, the Cavaliere's, interest that he should, for otherwise the designs would not be carried out to his satisfaction. We would make terms that would be attractive to him.

3 1 JULY

🐾 I wrote to M. Colbert about what the Cavaliere had said the night before.[175] I found him in the morning working at his bust while Signor Mattia worked at the alignments. Our evening drive was rather short; he wanted to go on the Pont-Rouge[176] and stopped the coach on it for a good quarter of an hour looking first from one side of the bridge and then the other. After a while he turned to me and said, "It is a beautiful view; I am a great lover of water, it calms my spirits."[177] Then we returned home.

[175] Chantelou's letter is in Depping, pp. 554–55.

[176] The wooden bridge built in 1632 that crossed the Seine at the Tuileries. Damaged by fire in 1656, Lorenzo Tonti, the Italian banker, had proposed a lottery to finance its reconstruction in stone, but nothing was done, and Colbert and Bernini discuss a project for the bridge below, 7 Oct. In 1684 it was carried away by ice and then replaced by the stone-built Pont-Royal.

[177] Cf. the artist's intentions with regard to the slightly later remaking of the Ponte Sant'Angelo (Wittkower, *Bernini*, cat. no. 72), as reported by Domenico Bernini (pp. 158–59), who says that his father opened up the railings of the bridge with iron grilles, so that the water could be seen and enjoyed.

❧ *August* ❧

I AUGUST

❧ I went to the Cavaliere and asked him when the commandeur de Souvré was coming to fetch him, for he had promised to visit a site in the Temple with him where he intended to build. He said nine o'clock. At five o'clock I returned and found M. Perrault there. The Cavaliere had given him a note for M. Colbert, informing him that they had finished plotting the site and could now show any person named by him the houses to be demolished to make way for the foundations. On M. Perrault saying that it would be enough if he saw them, the Cavaliere begged me to find M. Mattia to go over the site with him. We walked round together and noted that M. de Buisson's first house was among those to be pulled down, the remaining part of the hôtel de Bourbon, where the King's furniture is stored, the part of the hôtel de Longueville where Le Vau lives, part of the hôtel de Provence and the hôtel d'Aumont.[1] Then I went back to the studio where I found the Cavaliere working at the hair on the portrait. He said it was difficult work. I remarked that anyone else might find it so, but that lightness of hand which he had said belonged only to classical sculptors was beginning to make itself evident. He then went over to give a touch or two to M. Paolo's bas-relief, and when I joined him, he said he was trying to show that the cloth which the Christ Child holds in front of him was the Virgin's. He asked me what

[1] A more precise description of what had to be destroyed is contained in a letter of 1 Aug. written by M. de La Motte to the Superintendent of Finances (Depping, p. 554, n. 1): a wing of the hôtel de La Force next to the Louvre, the stables of the hôtel d'Aumont, a *corps-de-logis* on the rear of the hôtel de Provence, a part of the remaining stables of the hôtel de Longueville, the rest of the petit hôtel de Bourbon, and a *corps-de-logis* (one of two) in the form of a pavilion belonging to M. Du Buisson, who is probably to be identified with Nicolas Heudebert Du Buisson (d. 1715), Secretary to the King (1655–75), maître des comptes (1664–75), maître des requêtes (1679), and Intendant of Finances (1690).

I thought of his idea of portraying Our Lord in meditation over a nail found among St. Joseph's tools. I replied that I considered it a lofty and pious conception. In the evening we went to the Feuillants and then for a drive. After we had gone towards the Cours-la-Reine he asked to go to the Pont-Rouge where we had been the night before; he remained there a good quarter of an hour; we came back by the Pont-Neuf and through the streets. He asked me who the commandeur de Souvré was. I replied that he was one of the chief figures at the court; he had free access to the royal presence and a large following because of his great hospitality. The King had entrusted him with the entertainment of the Papal Legate when he was at Versailles. I had been well pleased when he had accepted an invitation to dine with him; it was as well to be on good terms with those round the King, apart from the fact that the commandeur de Souvré had many friendly ties with the ministers. He said that he disliked eating anywhere but at home, in case he ate too much and felt ill and also because of the waste of time involved in sitting down to an elaborate meal.[2]

2 AUGUST

I did not find the Cavaliere at home. I met the abbé Buti, with whom I attended Mass at the Oratoire. When we came out I sent someone to find my brother, who had also been invited by the commandeur de Souvré to dine and come to the Temple. We also found the Cavaliere and were just beginning to talk when the commandeur arrived; but as he had not heard Mass he left us again. On his return we looked at the drawings for the Louvre and then went to the Temple. The commandeur asked the Cavaliere, the abbé Buti, and myself to get into his coach. On our way he talked about various things but particularly of the drawings. The Cavaliere praised the quality of the King's mind, saying that its peculiar power enabled him to recognize beauty instinctively; this he had perceived at the time when he showed him his first design; no one had a better understanding of beauty. The commandeur added that it was a miracle considering how the King had been educated, that Cardinal Mazarin had kept him down and had given him no opportunities for learning. The abbé Buti said that it would have made a very great difference to him and to his people had he studied; many things are being done that would not have been done, because the King would have realized how important they were

[2] Bernini's normally abstemious eating habits—other than the craving for large quantities of fruit, which he said was the original sin of those born in Naples—as well as his impatience over the time lost at meals are also mentioned by Baldinucci (*Vita*, p. 72) and Domenico Bernini (p. 177).

for good administration.³ The Cavaliere repeated what he had said many times before, that it was the King's reputation that had determined him to come, more than the Pope's command or the honor of being sent for by a king of France; that he had found the King even greater than his reputation. The commandeur returned to the subject of the Louvre, and the Cavaliere said that it would be the grandest building in the world because of its size and the cost. He could not of course speak of the nobility of the design. I myself asserted that the design he had found for the Louvre could not have been more felicitous nor better conceived, but only the good fortune of his continued presence in France would complete its success. He said it was quite impossible, but had there been a question of his remaining, he would have requested His Majesty to be allowed to deal only with him. At this the abbé Buti, next to whom I was sitting, nudged me several times. The Cavaliere went on to say that there was no one who understood these matters as well as the King.

When we reached the Temple, we went into the garden, which is the place where the commandeur wants to build, and someone was told to fetch the plan. The Cavaliere, afraid that the ideas of others would stop the flow of his own, said he did not want to see it as he was on the site itself. Nevertheless they brought it. He saw at once that it neglected the fact that the angle was out of the true on the side of the road, and he asked the commandeur to have another plan made for him of the whole site and nothing else. We went into the church and into several private houses and then got back into the carriage. On our return journey the commandeur asked me if the Cavaliere had seen Maisons;⁴ I said he would go and see it while he was at Saint-Germain. He offered to give him dinner that day and accompany us. We went to M. Renard's⁵ from the Temple. The Cavaliere thought the terrace very beautiful; he said it had the loveliest situation in Paris. He then looked at the house and found the decorations very elegant. He liked the *Icarus* of Giulio Romano,⁶ but said that it would be seen

³ The scant attention paid by Mazarin to the King's education was notorious, and the Cardinal has often been blamed for it.

⁴ The château of Maisons, built by François Mansart for René de Longueil (d. 1677), marquis de Maisons. Begun in 1642, work continued even after Mansart's death, but the main structure was probably finished by 1646 and most of the decoration by 1651. See Braham and Smith, pp. 48–55, 219–23, who describe it as "probably the most perfect building erected in France" (p. 48).

⁵ The house of Louis Renard, sieur de Saint-Malo, which had been built by his father, Pierre, to whom in 1630 Louis XIII had conceded a large plot at the end of the Tuileries garden, near the porte de la Conférence. It was destroyed by Le Nôtre when he remade the gardens for Colbert in 1668.

⁶ Perhaps, like the copies by Nicolas Chapron after Raphael's frescoes in the Vatican

to better advantage if it were placed at the top of the staircase, where it would be further from the spectator. He looked closely at the copies of Raphael's decorations for the Loggie. During dinner an epigram occurred to him on the subject of the Louvre. He asked the commandeur to tell the King that "As much as he had wished to preserve the Louvre, he had in fact destroyed it." No one replied and he asked me if I understood what he meant. I said I did, that he had clothed it in new raiments so that its ancient form was no longer visible. The commandeur assured him that he would tell the King that very evening. After dinner the Cavaliere visited Meudon,[7] where we met the Nuncio. He remarked that, looking down from the height where they were, Paris seemed nothing but a mass of chimneys, standing up like the teeth of a carding comb. He added that Rome was a very different sight; St. Peter's in one part, the Capitol in another, the Palazzo Farnese, Montecavallo,[8] the Palazzo di San Marco,[9] the Colosseum, the Cancelleria, the Palazzo Colonna, and many more scattered here and there, gave a superb impression of grandeur. I answered that these palaces were big because there was plenty of space available, whereas in Paris, however beautiful the houses might be, they were so jammed together that it was impossible to see one apart from the others; land was expensive and sites small so that everywhere buildings were obscured by others and from a distance could not be distinguished. Seeing the staircase of the château he said that in Italy no owner of an inn would want to have one like it and then, smiling, said he supposed that I liked the roof of the dome very much. On our way back, he requested the carriage to stop in front of the terrace of the monastery of the Capuchins of Meudon,[10] where he had caught sight of Cardinal Antonio. His Eminence said he knew he had been to Saint-Cloud. He replied that the position, the gardens and the fountains were very beautiful. His Eminence asked him what he thought of the waterfall,[11]

mentioned below (see Bonnaffé, pp. 266–67), this picture was a copy after Giulio's now destroyed *Fall of Icarus* in the Palazzo del Tè. A large drawing of this painting, which once belonged to Vasari, was purchased by Louis XIV from Jabach and is now in the Louvre.

[7] The château (demolished in 1804) formerly belonging to Charles de Guise (1525–74), Cardinal de Lorraine, who had acquired it from Antoine Séguier in 1552. In 1654 it was purchased from the Guise by Abel Servien (d. 1659), marquis de Sablé, Superintendent of Finances, for whom it was remade by Le Vau. The central pavilion, with the stairway and high, steep roof criticized by Bernini below, were part of the remodelling.

[8] That is, the papal palace on the Quirinal Hill.

[9] That is, the Palazzo Venezia.

[10] The first house of Franciscan Capuchins in France, which was established in 1574. According to Brice (I, p. 172), the monastery was founded by the Cardinal de Lorraine.

[11] The Grande Cascade (?1664–65) designed by Antoine Le Pautre. See Berger, pp. 57ff., and below.

was it not too elaborate? The Cavaliere said that was its fault; art should be disguised with an appearance of naturalness; in France, just the opposite generally happened. When we got back to the hôtel de Frontenac he asked my brother and me to find someone who knew enough about spectacles to be able to tell when the lenses were evenly cut. He told us that in Rome a certain Signor Stefano chose for him from a number of pairs suitable to his age those that were well cut, and through which objects appeared without falsification; this was not necessary for people who required glasses only for reading.

3 AUGUST

❧ I found him working at the portrait while M. Mattia had gone to plot the lines of the chief entrance to the Louvre. He told me he had taken a great deal of trouble with this and had discovered that the lines plotted at the newly begun façade, did not square, which made him fear that he had himself made a mistake: he wished that I could have been with him, but he had gone very early because it was so crowded later in the day. He had taken one reading which seemed right but he was not going to rely on that but would make another attempt later. In the evening he asked me whether the day's work at the bust had made a difference. I said it had. He showed me the drapery he was adding to the portrait which he wanted to look as light as possible. The Nuncio arrived bringing us bad news, which turned out to be false, that the Queen Mother had died at eleven that morning. The abbé Buti who came at the same time, said he thought mourning would be worn. When the Nuncio had left, we went to the Feuillants and thence to the hôtel de Frontenac.

4 AUGUST

❧ I found the Cavaliere working at the bust, but depressed by the false rumor of the Queen's death. He asked me what I thought of the drapery. I told him I thought it was looking very nice. He told me that he was very worried by the marble, which he called *marmo cotto*, which was so friable that he was forced to work with a trepan lest it broke under the chisel. I then went to see if M. Mattia was working at the lines of the foundations. I found him drawing in the gallery. He said he had finished all the work to do with bringing the doors into line—he would not have to go back to it; he had taken every care and tested it many times and found nothing wrong; he had been much bothered by the houses and the tennis court, which prevented him from getting a clear view, as well as the other obstacles in the space where the lines were being plotted; he had not only laid the rules opposite each other, which might have left some fault undiscovered,

but he had also laid one rule alongside the other leaving a tiny space between them, which he said was the most infallible method of all; in measuring the considerable distance across the square where the gateway was to be, he had found a deviation of just over a foot. He showed me that the foundations of the façade would occupy the sites of one of the houses belonging to M. de Buisson, part of what remains of the hôtel de Longueville, part of the hôtel d'Aumont and of the hôtel de Provence; that the square in front of the Louvre would be just over 200 feet deep and 520 feet wide giving an area of about 104,000 square feet. While we were in conversation, M. Perrault came over to tell me that some marble had arrived from Genoa and asked me to inform the Cavaliere, which I did.

The same day M. Le Nôtre[12] came to see me and told me that Le Vau had taken a design to the King which was the one we had been discussing.[13] In this the present Louvre is left as a forecourt and the main building is erected at right angles to the rue Saint-Thomas du Louvre. He said he personally had liked it very much.

In the evening M. de Ménars and the abbé Buti came. The abbé told me on good authority that it was Le Brun who had prevented Jabach from showing his drawings to the Cavaliere,[14] lest he should notice all the ideas he had borrowed from them for his pictures. For the same reason he did not want the Cavaliere to go to the Gobelins; Italian artists had told him that all his best work had been taken from Jabach's drawings, so that a visit to Jabach would have to be arranged without his knowing. M. de Ménars said he would arrange for the Cavaliere's visit for next Sunday. The Nuncio came and I told him that happily his sad news had proved false. He said he had heard it from the Venetian ambassador who had sent a special page to inform him. He left and the Cavaliere went with him to his house where he met M. Le Nôtre who was waiting for him. He greeted him and asked to be forgiven if he did not entertain him, for he felt extremely tired. He said the same to M. Blondeau, too, who had brought his spectacles. We then went in M. de Ménars' coach, to the Grands Jacobins[15] and

[12] André Le Nôtre (1613–1700), the great landscape architect of 17th-century France, who was responsible for the gardens at Vaux-le-Vicomte and Versailles. He succeeded his father as Gardener of the Tuileries (1637), became Designer of the Plantations and Gardens of the King (1645), and was made Controller-General of the King's Works (1657). A great favorite of the King, he was ennobled in 1675.

[13] Above, 30 July.

[14] See above, 25 July, for Bernini's unsuccessful attempt to see Jabach's collection.

[15] The monastery of the Dominicans (called Jacobins) in the rue Saint-Honoré. After they were reformed in 1611, Marie de Médicis authorized construction of their house, to which the Bishop of Paris contributed 50,000 livres.

later to see the marbles which had just arrived. He tested them and found two blocks that were suitable for sculpture.

5 AUGUST

🐦 In the morning I went to see the Cavaliere and found him working; from there I went on to the Tuileries to meet M. Colbert at 11:30. He went down to the riverside. He asked me first what the Cavaliere was doing. I said he was working at the bust. He went round all the buildings and came back by way of the Long Gallery and that of Le Brun, who was there. I asked him when his picture would be finished[16] and he replied that he did not know. I told him the Cavaliere would have visited the Gobelins if this picture had been finished, but M. Du Metz had told me that we should wait to take him there until it was. We were in the apartments of the Queen Mother, which were decorated by Romanelli,[17] and M. Colbert asked me whether the Cavaliere had seen them, and what he thought of them. I replied that he had said nothing in particular, as he made very little comment on what he saw. "That is very discreet of him," remarked M. Colbert, "nevertheless he does give his opinion sometimes, even about M. Poussin's paintings." I retorted that of course he had spoken of them when he saw them, but always with the greatest admiration. He added that it was said that he had hardly glanced at the picture in the Novitiate. I told him that he had, and that, as regards the one at Saint-Germain,[18] he had told me that it was not one of the best works of Signor Poussin. M. Le Brun himself had told me that M. Colbert asked him what he thought of the work and he had praised it very highly, as indeed the picture deserves. He asked me to let him know when the Cavaliere was going to the Gobelins. M. Colbert then went to his apartments, but before he left he met the abbé Buti, who told him the Cavaliere was asleep. However he entered at once. As they looked at the bust the Cavaliere said he intended to make the drapery like heavy taffeta,

[16] The picture referred to here was presumably either the *Triumph of Alexander* or the *Battle of the Granicus*, both of which Bernini saw when he visited the Gobelins on 10 Oct.

[17] On his second trip to France of 1655–57, Giovanni Francesco Romanelli (ca. 1610–62), one of the best followers of Pietro da Corona, frescoed the ceilings of four rooms for the apartment of Anne of Austria, the Queen Mother, under the Petite Galerie of the Louvre. The stucco work was done by Michel Anguier, Pietro Sassi, one of the Italian masters for whom Bernini sent, and probably François Girardon. Although the apartment still exists, it has been much altered. See D. Bodart, "Une description de 1657 des fresques de Giovanni Francesco Romanelli au Louvre," *BSHAF*, 1974, pp. 43–50.

[18] The *Institution of the Eucharist*, now in the Louvre, commissioned by Louis XIII in late 1640 for the chapel at Saint-Germain. See Blunt, *Poussin Cat.*, no. 78.

but did not know whether it would succeed. In any case diligence will make up for the lack of intelligence.[19] He told him that he had had the lines plotted, and he thought it had been done in such a way as to remedy the discrepancy between the doors; perhaps he had erred; he would have wished that his measurements would tally with those which had been taken before, in that case his mind would have been more at ease. To be as certain as possible he had verified the measurements more than once. M. Colbert then looked at Signor Paolo's work and said he thought it very beautiful. The Cavaliere said it was the idea behind it that was important. M. Colbert asked how old his son was. He told him eighteen, then the minister went on to ask him if he was not afraid lest he would prove to be even more talented than his father. I interrupted to repeat the story that the Cavaliere had told me when he first arrived in France about Cardinal Barberini (later Urban VIII) and his father,[20] how the Cardinal had asked him a similar question and he had replied, "Your Excellency must realize that in this game whoever loses wins."[21] Then the Cavaliere told him that he had done the *Daphne* at eighteen,[22] and at the age of eight had done a *Head of St. John* which was presented to Paul V by his chamberlain. His Holiness could not believe that he had done it and asked if he would draw a head in his presence. He agreed and pen and paper were sent for. When he was ready to begin he asked His Holiness what head he wished him to draw. At that the Pope realized that it was really the boy who had done the *St. John*, for he had believed that he would draw some conventional head. He asked him to draw a head of St. Paul, which he did there and then.[23]

Later I told M. Colbert that the Cavaliere had looked at the marbles that had arrived and that he had found one or two blocks that were quite suitable. He replied that those were the first that had come as a result of his orders. Then we went to see the lines of the foundations, and the Cavaliere pointed out where the trench would come to. M. Colbert continually expressed his fear that there would be too little room for the square in front of the Louvre, although M. Mattia had said that there would be between eighteen and twenty-

[19] The comment is in Italian in the manuscript.

[20] Bernini had told this story on 6 June.

[21] Pietro Bernini's reply is in Italian in the manuscript.

[22] In fact, Bernini was in his twenty-third year when he began the *Apollo and Daphne*. See Wittkower, *Bernini*, cat. no. 18.

[23] The child-artist's encounter with Paul V Borghese (1605–21) is also described by Baldinucci (*Vita*, p. 9) and by Domenico Bernini (pp. 8–9), who says that twelve gold medals—all that his little hands could hold—were given to Gian Lorenzo as a reward and that they were still in the house of his sons.

four feet more than what was shown on the plan that had been sent to Rome.[24] A prolonged discussion was held, and at last the minister said that the King wished to see the matter for himself and would come to Paris for the purpose. While we were talking, a messenger brought a letter from the King which was, as far as I could judge, written by the royal hand. When he had read it he told the messenger there was no reply, and that he would carry out the King's orders. Then he said the court was returning very soon and he asked the Cavaliere to prepare a plan of the square in front of the Louvre, so that it could be seen whether there would be enough room for the usual number of coaches, as this was worrying him. Then he left.

The Cavaliere worked until seven o'clock. When he returned to his apartments he was so tired that he did not want to go out in the coach and went instead to benediction at the Oratoire. On returning he found M. de Bellefonds who told him he would not have to have the bust taken to Saint-Germain and that the court would be here in a week. He asked him if he needed anything and then left. M. de Bartillat was there too and began telling him some details concerning the Queen's courage when the abbé Montaigu[25] had told her on the third that she must prepare herself for death. He told me afterwards that M. Le Vau had shown him his latest design and was most enthusiastic about it himself, declaring it to be the finest in the world; he said M. Colbert had remarked to him, M. de Bartillat, that the Cavaliere, who was the foremost man of his time, spoke of his own superb work only with the greatest modesty, while M. Le Vau praised himself outrageously, which showed their comparative worth.

6 AUGUST

🐝 In the morning I visited M. Colbert who was going to Vincennes[26] to prepare for the arrival of the court. Then I went to see the Cavaliere, whom I found working.

Next I went to the abbé Bruneau's[27] as I knew M. Colbert was

[24] That is, the original project by Le Vau, which Colbert had first subjected to the criticism of the French architects and then sent to Rome for comments by the Italians, with the additional request that they submit designs of their own. See Mirot, pp. 171–72.

[25] Walter Montaigu (d. 1677), abbé de Nanteuil et de Saint-Martin-de-Pontoise, Grand Almoner of the Queen Mother, and then of the duchesse d'Orléans, who had been an agent of Buckingham before converting to Catholicism (1635) and settling in France (1641).

[26] The royal château of Vincennes, which had been rebuilt by Le Vau (1653) on the order of Cardinal Mazarin. See below, 16 Aug.

[27] Gaston Bruneau (d. 1666), the librarian of the duc d'Orléans, who was named Intendant of the Cabinet of Medals and Antiques of the King in 1664.

going to the Louvre, and I found he had arrived, bringing Le Vau with him. He had been looking at the Queen Mother's new apartments. He said the Cavaliere would have to be moved but that he could be accommodated in the palais Mazarin.[28] He then went to see the Cavaliere and, on entering the room, assumed a frank and smiling expression. He first told him that it was difficult to refrain from visiting him and the King at the same time. He then asked him if he had worked at the square. He replied that M. Mattia was working on it and he considered that it had been completely measured. He went to look at M. Paolo's work and then took his leave, calling both M. Paolo and M. Mattia by their names. I went with him and he said he had forgotten to mention to the Cavaliere that he would have to move, and went back to tell him.

The difficulty was the bust, to know whether or not it should be taken to the palais Mazarin: if it stayed at the Louvre it would be further to come to work, but it would be more convenient for the King. The Cavaliere said he would be glad not to have to change the light. M. Colbert replied that he would find out the wishes of the King and bade him adieu.

At about two o'clock M. Boutard[29] came to see me and said that he knew on good authority that there was a certain cooling off with regard to the Cavaliere's designs: the way things were going, the Louvre would be finished as it had been begun; the disposition of the King was one in which a melancholy humor predominated. He was always drawn to what was new; then to distract him something else was brought along, and he would become interested in it, and whatever decision he may have come to before was imperceptibly altered. I replied that I found the King's disposition quite the opposite and I could not believe that they could wish to go on making mistakes and refuse to profit by the work, experience, and genius of the Cavaliere, particularly after all the expense, which still continued; M. Colbert was too clever for that. We then went to the Cavaliere's, who said

[28] That is, in order to make room for the court. The palais Mazarin was in rue Neuve-des-Petits-Champs. The original hôtel was built in 1635 by Jean Thiriot for Duret de Chevry. It was acquired in 1641 by Jacques Tubeuf, who built three further small houses on the site to the designs of Pierre Le Muet. All of these houses were then leased to Mazarin. François Mansart was commissioned to make alterations for the Cardinal, who wished to house his vast collections of books and art there. After Mazarin's death in 1661, the property was divided, the old hôtel Tubeuf with its alterations going to the duc de La Meilleraye and the remainder to Philippe Mancini, duc de Nevers. For the complicated history of the palace, see Braham and Smith, pp. 70–74, 223–26.
[29] Lalanne noted that a Boutard, who must be the same as the Boutart who appears below, is listed as auditeur des comptes in the État de France of 1665.

that Beaupin[30] had told him that he would bring M. Mazarin's steward so that they could go together to see the apartments allotted to him.

The abbé Buti came at the same time with M. de Bellinzani,[31] then two Italian plasterers arrived to see the Cavaliere; they said they had come from Vienne.[32] Later we went to the palais Mazarin to see his new lodgings, which are those that the duc de Mazarin[33] uses himself when he is here. He then went to try to find a suitable place for the bust and said he had been thinking that if it stayed in the Louvre he would have the greatest difficulty in preventing people from coming into the room where he worked, which would very much disturb him.[34] He then went to see the apartments above and looked at the pictures, stopping to study a Paolo Veronese. He said Cardinal ———— had the original and this was only a copy.[35] Veronese's pictures were admired for their coloring, but there was neither taste, *costume*,[36] nor decorum in the works of painters outside Rome; it was obvious from this picture, for instance, a *Nativity* in which the Virgin lacked nobility and the shepherds were devoid of dignity. He only stopped in front of a few of the antique statues. Among them is the *Poppaea* which it is rumored the King will take. M. de Bellinzani said that he would write to M. Colbert about having the bust moved to the palais Mazarin.

[30] Jacques Esbaupin, the maître d'hôtel who had been sent to Verpellière to receive Bernini when he entered France.

[31] Lalanne noted that Bellinzani was employed by Colbert in commercial affairs. In 1670 he was Inspector General of Manufactures and in 1671, directeur de la chambre des assurances in Paris.

[32] Presumably Vienne on the Rhône, not Vienna.

[33] Armand-Charles de La Porte (1632–1713), marquis et duc de La Meilleraye, Grand Master of Artillery (1648–1669), Lieutenant–General (1654), and Governor of Alsace, of La Fère, and of the château de Vincennes. Through his marriage (1661) to Hortense Mancini (1646–99), niece of Cardinal Mazarin, he became duc de Mazarin.

[34] A few years later, Carlo Cartari, librarian of Cardinal Altieri, recorded in his diary (M. Weil, *The History and Decoration of the Ponte S. Angelo*, University Park and London, 1974, p. 133) that the Cavaliere did not object to being watched as he worked, so long as he was advised of one's entry beforehand. Cf. below, 21 Aug.

[35] Chantelou did not record the name of the cardinal who Bernini said owned the original of this painting, an *Adoration of the Shepherds*, which is today in a private collection in London, and no other version is now known. See Pignatti, cat. no. 157.

[36] As critical categories, *costume* and decorum—the latter corresponding to the French *bienséance* and *convenance* (Italian, *convenienza*)—tended to blur together, since both referred to a certain fitness, aesthetic or moral, pertaining among the elements of a picture. *Costume*, however, seems to have been more especially associated with those expressive qualities through which the figures were said to disclose the state of their souls or reveal their characters and ages. Thus the painting by Veronese seen here is judged lacking in *costume* because the Virgin fails to display that nobility of soul which is proper to her, but it is indecorous because the shepherds are represented without regard for what is decent or dignified. Cf. too Bernini's comments below (11 Oct.) on the Magi in Poussin's *Adoration*.

7 AUGUST

✿ The Cavaliere had an inflamed tongue, which he said was caused by his having broken a tooth yesterday and losing one of the pieces. But he did not stop working at the portrait. He asked me what the place was called to which the soldiers withdrew. I said the guardroom. M. Mattia was working at the design for the square in front of the Louvre. He showed me that it stretches 300 *palmi* (198 feet) in front of the Louvre, and that a broad road could be made opposite the entrance to the Louvre which would be 100 *palmi* across, that is, more than sixty-six feet. In the evening the Cavaliere went only to the Oratoire and then returned to write his letters for Rome.

8 AUGUST

✿ I found the Cavaliere working at the portrait and M. Mattia busy with the square in front of the Louvre, which he has designed in the shape of an oblong, making a straight road along the side of the church of Saint-Germain, which, where it opens out on to the Louvre, will be about sixty-nine feet across. On my return I met M. de Bartillat, who told me that M. Colbert had allowed M. Du Buisson until October to move, although he had received an order to be out in three days, and instructions had been given for the demolition of the tennis court of the Louvre: he had seen the designs prepared by Le Vau;[37] the Louvre is left as a forecourt, then there is another building in the shape of a section of a circle; access for coaches to the King's quarters is along the slopes; on either side of the royal quarters there are to be two gardens and one opposite, all of which are also to serve the Tuileries Palace. The same day, I received from the commandeur de Souvré the plan of the site on the Temple where he wants to build. I handed it on to the Cavaliere that evening.

9 AUGUST

✿ Sunday: I went to the palais Mazarin where the Cavaliere slept. He had not yet got up because of his inflammation. Lefebvre de Venise[38]

[37] That is, Le Vau's new design, of which no record is now known. Cf. above, 30 July.

[38] Roland Lefebvre (1608–75 or 1677), called de Venise because of his long sojourn in Venice. The criticism of Le Brun and the Academy that follows may be explained by his personal experience. In 1662 he had been recommended by Le Brun to do a portrait of Colbert, and in January of 1663 he was received into the Royal Academy of Painting and Sculpture. In March of 1665, however, after his painting of *Truth revealing herself to the Academy* failed to win him acceptance as a history painter, Lefebvre resigned from the Academy and in the following May joined its weaker rival, the Académie de Saint-Luc. He died in England.

came, and told me about Le Brun and the tricks he employed to take credit to himself for the work of others, and of the kind of tyranny he is setting up in art through the confidence which M. Colbert has in him. Moreover the setting up of the Academy had failed to produce a flow of clever artists; instead there was nothing but incompetence owing to the lack of another academy to provide competition. He told me that the Cavaliere had promised to come and see his pictures; and when he got up, we set off and made our way to a house near the Jesuits' establishment in the rue Saint-Antoine where we saw a big picture by Veronese of *The Children of Zebedee presented to Our Lord by their Mother.*[39] The Cavaliere looked carefully at this picture from close up and then from a distance; he finally declared that it was a beautiful picture but could not have taken more than eight days at the outside to complete. He looked at the other picture, also by Veronese, in which is depicted *Adonis detained by Venus.*[40] He studied it for a long while and in answer to Lefebvre, who asked him what he thought of it, replied that the Lombards were great painters, but poor draftsmen. "Look," he said "at that woman," pointing to the mother of two apostles "the upper part of her torso is turned one way, and the lower part the other, an impossibly unnatural contortion." On saying this he tried to assume the posture but was unable to maintain it; he then showed how badly the arms and hands were drawn. "It isn't that there are no pictures by Veronese which are well drawn and well painted; but there are very few. The Queen of Sweden has some of them. She admires this style very much and she might buy these." Looking again at the large picture, I said to the Cavaliere that the Christ looked as if he were about to fall. With a laugh he replied, "There is an apostle who is supporting him." That is in fact how it looked. Returning to the other picture he pointed to the arm of the Adonis, and said to Lefebvre, "You are a painter; do you see the head is bigger than the arm?" He agreed. He thought that the Cupid holding the dog was exquisitely painted and the back of the Venus also.[41] He

[39] Probably the painting today in Grenoble, Musée des Beaux-Arts. See Pignatti, cat. no. A119.

[40] Probably the painting today in Augsburg, Städtische Kunstsammlungen. See Pignatti, cat. no. 116.

[41] Bernini's judgment on Veronese's paintings follows the *disegno-colore* formula: good painter, bad draftsman. However, here too the connotations of his usage are more complex than the formula suggests, since his admiration and respect for the illusionistic potential of *colore* counteracts its traditional association with superficiality and vulgar appeal (above, 8 June). It was this specifically realistic content attaching to the sensuous values of color (above, 25 June) that probably led Bernini and others of the 17th century to associate *colore* with Lombardy, rather than Venice. At the time, our concept of such "schools" was still forming, and because the artists who were identified with the revival

later asked Lefebvre what was the value of these pictures. He put the big one at 500 pistoles and the smaller at 300. The Cavaliere replied, "I do not want to undervalue the pictures, but if I can get you 1000 crowns for the larger, and 150 pistoles for the other from the Queen of Sweden, I think you will have obtained a good price." However, what he would do when he came to describe them was not to speak of their beauty but only say they were originals by Veronese.

Later when we were discussing the Lombard painters, he told us how Paul III at the time when he was building the Farnese Palace, had taken Michelangelo to look at a *Venus* painted by Titian, who was then in Rome. When he had had a good look, the Pope asked him what he thought of it; he answered, "The Lord knows well what he does, for if those painters (speaking of Titian) knew how to draw, they would not be men, but angels."[42] From there Lefebvre took us to the house where he works and showed the Cavaliere a half-length of the *Magdalen* by Guido.[43] He looked at it for a long while and said, "This picture is not beautiful" and then added, "it is superb; I wish I had not seen it. These paintings are from paradise."[44]

From there we went to the Oratoire. At about four I went to see him and learned that the Nuncio had called for him and taken him to see Berny.[45] I returned at eight o'clock to find that he was very un-comfortable on account of the inflammation.[46] I asked him if I should

of naturalism in the 17th century were either from Lombardy (Caravaggio) or had been attracted by a wide variety of North Italian artists (the Carracci), the Venetians seem to have been subsumed in a wider concept of Lombard color, which included such artists as Correggio (whose *colore* was already praised by Vasari) and Barocci, as well as Titian and Veronese. Thus if Bernini thought that the "Lombard" painters tended to the grandiose and weighty (below, 6 and 9 Sept.) and not excepting Correggio could have benefitted from studying the style of Raphael (below, 13 Sept.), their paintings might still be beautiful and, as here, display exquisite effects. Moreover, Raphael himself could be faulted for never having studied *colore* like the Lombards (below, 10 Oct.), since only late in his life had he begun to paint in the manner of Titian (below, 6 Oct.).

[42] This anecdote must be based on Vasari's account of his visit to the Belvedere with Michelangelo, where Titian was working on his *Danaë* (Vasari-Milanesi, VII, p. 447), since when Bernini again tells the story (below, 19 Oct.), the painting he cites is a *Danaë*, not a *Venus*.

[43] Only a few paintings with half-length Magdalens can now be associated with Guido Reni, and none is by his hand (Garboli and Baccheschi, cat. no. 116). However, the painting now in the National Gallery, London, was formerly in the collection of Colbert's son, Jean-Baptiste (1651–90), marquis de Seignelay, and it seems to have enjoyed a certain repute, since a copy on copper (Versailles, Musée National) was once owned by the King.

[44] Bernini's comment is in Italian in the manuscript.

[45] An estate south of Paris purchased by Hugues de Lionne in 1653. The château of Berny had been remodelled (1623–24) by François Mansart for Pierre Brûlart (1583–1640), son of Chancellor Nicolas Brûlart de Sillery (d. 1624). See Braham and Smith, pp. 16–19, 192–94.

[46] From a broken tooth, see above, 7 Aug.

call a doctor, and he said that could be done tomorrow if he was not better.

I saw M. Boutart, who told me that the marquis de Liancourt[47] had heard from Father Bourzé[48] and de Carcavi[49] that the King had rather gone off the Cavaliere's designs; Mansart admired them, and, as regards the Val-de-Grâce, he appreciated the Cavaliere's idea of putting the altar in front of the grille and relegating the smaller one to the back; he repeated that the Cavaliere and Mansart could have worked together at the Louvre, the Cavaliere being responsible for the larger conception and idea and M. Mansart for the internal arrangements.[50]

10 AUGUST

✣ St. Lawrence. The Cavaliere said it was his name day as he was baptized Gian Lorenzo; his father had six daughters so that when he was born he wished his son to have both his father's and his grandfather's names. I said as a joke that he had been celebrating his name day for several days as he had had to invoke his patron saint for his toothache. While we were talking, M. Perrault sent to say that the King agreed that he should work at the palais Mazarin, and he would have the bust transported thither, which could be done when he liked, now or during the evening. The Cavaliere replied that it was his name day, and had he asked permission to work, it could have been taken over, but he did not wish to commit a trespass, lest permission might have been withheld. The comte de Ménars sent word, at the same time, to ask if the Cavaliere wished to see Jabach's drawings. I said he had to put it off for another time on account of his toothache. The Cavaliere asked who had made this arrangement. I replied that it was the abbé Buti, who had told me that Jabach had refused the first time to show him the drawings, at the request of Le Brun, who feared that they would notice the composition and figures that he borrowed from

[47] Probably Roger Du Plessis de Liancourt (1599–1674), duc de La Roche–Guyon (1643), Chevalier of the Orders of the King, and First Gentleman of the King's Bedchamber (1624).

[48] Amable de Bourzeïs (1606–72), an author and theologian, abbé de Saint-Martin de Cores, and one of the first members of the French Academy and the Academy of Inscriptions.

[49] Pierre de Carcavi (d. 1684), geometer and foundation member of the Academy of Science (1666), librarian of Colbert, and then Keeper of the King's Library (1663).

[50] That a "good mix" based on the Italian sense of form and the French understanding of function offered the optimal solution had already been suggested to Colbert by the abbé Elpidio Benedetti, his agent in Rome, when he forwarded Bernini's first design for the palace (Mirot, p. 178, n. 2). For Mansart's Louvre designs, see Braham and Smith, pp. 121–49.

them for his own pictures.[51] The Cavaliere replied that he had never harbored such a suspicion. "Nor have I," I said. We then went to the Oratoire where he took Communion. On coming out of the church he asked if we could return by the market to see the fruit; he had been told that no garden was more beautiful. I said the best time to see it was early in the morning. We went by it on our way to Saint-Laurent.[52] On our return journey (when we were opposite Saint-Merry)[53] I suggested to the Cavaliere that we should have a look at some pictures belonging to a merchant; I did not mention who they were by; we went into M. Cérisier's[54] and I asked him to show me the picture of *Queen Esther*.[55] M. Paolo lifted the curtain which covered it, and said first, "It is by Poussin." His father studied it most attentively, and then remarked, "This is an extremely beautiful picture, painted in Raphael's style." He showed him the *Virgin*,[56] a half-length, which he also looked at closely, saying however that this one should not be seen after the other. He then saw Poussin's self-portrait.[57] He immediately said that it was not so good a likeness as the one I had. Then I asked for another picture, for they were shown to us one after another. He motioned to them to leave the portrait there and studied it with great concentration; a little later, when they tried a second time to take it away, he asked for it to be left there a little longer. Then M. Cérisier showed him three little landscapes, also by Poussin.[58] He liked them. When the picture of the *Madonna with ten figures*[59] was

[51] Above, 4 Aug.

[52] A church of this name outside the porte Saint-Martin was already mentioned in Merovingian times by Gregory of Tours. It was entirely rebuilt in the early 15th century, and a classicizing façade was added in 1621.

[53] In the rue Saint-Martin. The church of St. Merry was a mediaeval foundation dedicated to an abbot of Saint-Martin in Autun, who died ca. 700. It was entirely rebuilt in the 16th century.

[54] Jacques Cérisier, or Serisier, a silk merchant from Lyons established at Paris. He was a friend and patron of Poussin, who calls him his "bon ami" (*Correspondance*, p. 258). He was later (1675) involved in the *querelle des Poussinistes et Rubénistes* and is linked to Chantelou, who "loved, admired, and revered only the works of Poussin," in the verses of the *Banquet des Curieux* (J. Thuillier, "Doctrines et querelles artistiques en France au début du XVII^e siècle: quelques textes oubliés ou inédits," *Archives de l'art français*, XXIII, 1968, p. 165).

[55] The *Esther before Ahasuerus* today in the Hermitage. See Blunt, *Poussin Cat.*, no. 36.

[56] Now lost, but evidently the painting engraved by Jean Pesne. See Blunt, *Poussin Cat.*, no. 45.

[57] Presumably the *Self-Portrait* painted for Pointel and finished in June of 1649. It is today in the Staatliche Museen, Gemäldegalerie, East Berlin. See Blunt, *Poussin Cat.*, no. 1.

[58] Now lost, see Blunt, *Poussin Cat.*, no. L 102.

[59] The *Holy Family with Ten Figures* painted for Pointel in 1649. It is now in the National Gallery of Ireland, Dublin. See Blunt, *Poussin, Cat.*, no. 59.

shown us, I said that I liked everything in this picture except the head of the Virgin. He asked me whom it was by, which surprised me. "Poussin," I replied. He said he would never have believed it, that another hand no doubt had painted the children. Then he saw the big landscape with *The Death of Phocion*[60] and liked it. Of the other, *The Gathering of Phocion's Ashes*, he remarked after a long look, "Signor Poussin is a painter who works from here,"[61] pointing to his forehead. I said his pictures had always been the product of his mind, as his hands were clumsy. He then saw the *Virgin in Egypt*,[62] which I told him was one of his latest works. He gazed at it attentively then remarked. "There comes a time when one should cease work; for there is a falling off in everyone in old age." I replied that those who were accustomed to work found it hard to do nothing, and worked perhaps only to keep themselves amused. He agreed but said their later works often did harm to their reputations.[63]

After he had returned to his apartments, the maréchal de Gramont came to see him. He told me this when I went to see him in the evening accompanied by my brother, who presented him with a copy of his *Parallèle de l'architecture*. He refused to accept it, saying that it was enough if there was a copy in his studio, that he had already given his book to MM. Mattia and Paolo.[64] But when he was told that my brother had hoped to be allowed to do him this honor, he accepted it and said he was greatly obliged to us.

We then went to the Barefooted Carmelites and thence to see the abbé Buti, who we heard was ill. We saw his pictures among which are two drawings of the Cavaliere's, with beautiful frames, one of a *Head*, done in pen and ink, the other of a *Monk in Prayer*. On my return home I learned from Mme. de Chantelou, who had come from M. Renard's, that he had told her that there was a cabal of architects

[60] These two landscapes by Poussin were painted in 1648 for Cérisier. The *Landscape with the Body of Phocion carried out of Athens* now belongs to the Earl of Plymouth, Oakly Park, Shropshire, the *Ashes of Phocion collected by his Widow* to the Earl of Derby, Knowsley, Lancashire. See Blunt, *Poussin Cat.*, nos. 173–74.

[61] Bernini's comment is in Italian in the manuscript. Cf. above, 26 July, where he attributes to Annibale Carracci *un cervellone grande*, "a great big brain.".

[62] This *Flight into Egypt* was painted for Cérisier in 1658. See A. Blunt, "A newly discovered late work by Nicolas Poussin: The Flight into Egypt," *BM*, cxxiv, 1982, pp. 208ff.

[63] Bernini himself worked until the very end of his days, and he may perhaps be pardoned the inconsistency for then saying that "an artist excellent in design need fear no want of vivacity or tenderness on reaching the age of decrepitude, because the practice of design alone is so efficacious that by itself it can supply what is lacking in the spirits, which languish in old age" (Dom. Bernini, p. 167, and similarly in Baldinucci, *Vita*, pp. 66–67).

[64] Above, 28 July.

intriguing against the Cavaliere and among a large gathering of the profession, only the younger Anguier had taken his part.[65]

11 AUGUST

The Cavaliere worked at the portrait all the morning, M. Paolo at the *Christ Child*, and M. Mattia at a small-scale drawing of the plan of the Louvre. This was for the Cardinal Legate who, he told me, had asked the Cavaliere for it in a letter written in his own hand. On my return after dinner I found that the King was there and the Cavaliere was drawing him from life with intense concentration. The prince de Condé[66] was present, also the duc de Gesvres,[67] the duc de Noailles, the duc de Charost,[68] M. Colbert, and M. de Bellefonds. The maréchal de Gramont came later. The King said he had been on the point of coming with the duc d'Orléans to dine with him, as the Queen had dined already. The maréchal replied that the King would not have eaten especially well, but he would have been most welcome to what there was. When I first came in the King was leaning against the back of an armchair. After remaining some time in this pose the Cavaliere took the armchair and placed it on the other side of the portrait to enable him, as he told the King, to see the other side of the face. The King placed himself as the Cavaliere wanted and stayed there for a little while longer and then said that he had to leave but would come back whenever he was asked. The Cavaliere replied that he was always there and that, whenever His Majesty had time, he could come for a sitting. As the King was leaving, he begged him to come and see the plan and the square in front of the Louvre. He explained to His Majesty its length and width, and that of the road,

[65] Three members of the Anguier family were active as artists at this time. François (1604–69) and Michel (1612 or 1614 to 1686) were sculptors; Guillaume (1628–1708) was a painter of architectural views and ornaments. It is uncertain whether Chantelou is here referring to Guillaume, actually the youngest, or to Michel, the younger sculptor and most gifted of the three. From 1663 Michel had been working on the sculptural decoration of the Val-de-Grâce, and he later carved the *Nativity* for its high altar (today in Saint-Roch), so he would presumably have seen himself as Bernini's rival. On the other hand, he had spent ten years in Italy, and Bernini's project for the altar had already been rejected.

[66] Louis II de Bourbon (1621–86), duc d'Enghien, then prince de Condé (1646), called le Grand Condé, one of the great soldiers of France.

[67] René Potier (d. 1670 a nonagenarian), duc de Tresmes et de Gesvres (1648), Captain of the King's Bodyguard, Lieutenant-General of Champagne, Governor of Châlons, and Counsellor of State.

[68] Louis de Béthune (1605–81), comte, then duc de Charost (1672). He was variously Master of the Camp of the Regiment of Picardy, Captain of the King's Bodyguard, Governor of Calais, and Master of the Camp.

which at its beginning, in the square, would be about sixty-six feet wide and forty-eight feet at its other end.

M. Colbert stayed a little while after the King had gone and then left. The Cavaliere told me that he had come a little time before the King and he had explained to him the plan of the square. He worked at the portrait a little while longer while the King's face was fresh in his memory. Then when the King's coach arrived we went together to the Barefooted Carmelites. After he had prayed, several of the worthy Fathers came up to us and told me that many people thought the Infant Jesus in the *Madonna and Child* at which I was gazing was blind as there was no color in His eyes. I said there was none in the hair nor in the eyes of the Virgin nor red in their lips. They wanted me to ask the Cavaliere whether he would spare a moment one day to turn the Virgin to the position in which he had said she should be. When I spoke to him he said that he would give them a sketch at the first opportunity, and the Virgin could then be moved without his being there.[69] We went on to the abbé Buti's, who knew already that the King had been to see the Cavaliere and congratulated him on the satisfaction that the King had expressed at his work. The Cavaliere said that when the prince de Condé saw the bust, he had exclaimed, "What Majesty!" His Highness had said many things, on this and on former occasions, which showed that he had an altogether exceptional mind. He talked a little about the plan of the square which the King had seen. The abbé Buti asked how wide it was. I said more than two hundred and ten feet one way and more than four hundred and eighty feet the other. The Cavaliere intervened to say that it was thirty or thirty-five feet wider than was necessary for the façade to be seen in all its beauty; there were five courts which would take any number of coaches. I said that this privilege was limited to a certain number of people; the rest were not permitted to enter the court.[70] He replied that the number might be increased but I told him it did not happen like that. Finally he said it could hold nearly all the coaches in Paris; as for the rest, when he first began to work on the designs for the Louvre, M. Colbert had told him that the King would sacrifice every-

[69] On his first visit to the church (above, 28 July), the artist had criticized the placement and setting of the statue, which was of marble and so "without color." Although the "many people" who thought the Christ Child blind can be compared to the naïve Spaniards in Bernini's anecdotes (above, 8 June), the sculptural treatment of the eyeball was nevertheless a challenge to which he usually responded (below, 12 Aug.). During his long career, he tried in various ways to duplicate the sparkle and focus of the human eye. See Wittkower, *Bernini's Bust*, pp. 9–12.

[70] Only those of a certain rank were entitled to enter a château or residence of the king in their carriages.

thing, even the church of Saint-Germain, if necessary; however, were it possible to save it the King would be very glad; he had therefore made a plan that luckily had pleased the King. It was by God's help that he had achieved his success, and he did not consider it the fruit of his genius nor his experience but the work of God, who had wished to use for His purpose such a worthless individual as himself. The abbé Buti replied with a smile that it seemed as if the Cavaliere would like to make one believe that God gave people spectacles to deceive them and make His works appear other than they are. I said that a sure sign of the beauty of his designs was that Mansart himself was reported to have said[71] that the Cavaliere's conception could not be bettered, and that he had been extremely pleased with the idea of the two small courtyards on either side of the vestibule; they would be very useful indeed in the Louvre because it would mean that the royal kitchen and the butteries would not be in the principal courtyard. The abbé Buti said that the Cavaliere Rainaldi had sent another new plan. I retorted that, if it was not more successful than the first, it could not be much; I had examined the other, in which he finished off the chief façade of the Louvre with an erection seventy or ninety feet in diameter.[72] The Cavaliere said nothing and soon afterwards returned to the hôtel Mazarin. I forgot to note that after dinner, I went to M. de Langlée's,[73] where his wife told me, among other things, that the Cavaliere's designs were now meeting with a somewhat chilly reception.

12 AUGUST

✵ I found the Cavaliere working at the portrait. The Nuncio came to see him and stayed half an hour. M. Mattia was working at the plan for a theatre, to be situated in the space that will be left between the Tuileries and the façade of the service courtyard. It would face both ways, towards the Louvre and towards the Tuileries. The design consisted of two concave areas of circles with a central section composed of a convex semicircle. There were flights of steps on either

[71] Above, 9 Aug.

[72] Carlo Rainaldi (1611–91) was one of the Italian architects who, along with Bernini, had been asked to submit designs for the Louvre. His plan was completed by 15 July 1664, when Benedetti forwarded it to Paris (Mirot, p. 174, n. 3). For this and his second plan, see K. Noehles, "Die Louvre-Projekte von Pietro da Cortona und Carlo Rainaldi," *Zeitschrift für Kunstgeschichte*, XXIV, 1961, pp. 40ff., and P. Portoghesi, "Gli architetti italiani per il Louvre," *Quaderni dell'Istituto di Storia dell'architettura*, nos. 31–48, 1961, pp. 243–68.

[73] Claude de Langlée (1604–67), Counsellor of the King, Commissioner of War under Louis XIII, and Marshal-General of the Encampment and Lodging of the Armies. His wife was Catherine-Rose de Cartabalan, femme de chambre to the Queen Mother.

side and where they finished, a colossal order of columns. M. Mattia said it would be for spectacles of various kinds, tournaments, races and musical rides which could be held on the side facing the Tuileries or the other one facing the Louvre.[74] At five o'clock in the afternoon M. Le Tellier[75] and M. de Lionne came to see the Cavaliere. They began by praising the beauty of his work. The Cavaliere said the King had come to see it on his arrival from Saint-Germain and declared his satisfaction. M. de Lionne asked what were the black marks in the eyes. The Cavaliere told him that when the work was finished he would make a tap or two where the black was and the shadow of the cavity would represent the pupil of the eye. The two ministers told him that M. Colbert had assured the King, in front of them, that he was always at work whenever the King would like to visit him. He told them that His Majesty had had the goodness to say, as he went out, that he would come back whenever the Cavaliere needed him and that he had replied that he never moved from his work and would be delighted to see His Majesty at any time; that the King and he would have to finish the face together. He had got it to that state in which they saw it from memory, from the image he had formed of it and imprinted on his imagination while drawing at the council room, as they had seen him, with the King walking around and talking as usual without being tied down in any way; had he been constrained to stay in one position, he would not have been able to make the portrait so lively, he had not even used his own drawings, lest he should make a copy of his own work instead of an original: he had made these many studies only "to soak and impregnate his mind with the image of the King";[76] those were his own words. He spoke again of the difficulties of doing a portrait in marble, which I have put down at length in one or two places in this journal and will not repeat here.[77] He said Michelangelo was always reluctant to do one.

M. de Lionne mentioned portraits in bronze. The Cavaliere said it was an even less suitable material than marble because it darkened. If it were covered in gilt, the luster made reflections which prevented one from observing the delicacy and beauty of the portrait; on the

[74] Colbert had first raised the possibility of including a theatre for spectacles of this kind on 18 July (above). Its unusual design is also described in a letter to Rome by Mattia de' Rossi (Mirot, p. 250, n. 2), which included a plan (*Rome a Paris*, exh. cat., Paris, 1968, no. 500). Cf. below, 13 Aug.

[75] Michel Le Tellier (1603–85), who became Minister of State after Mazarin's death (1661) and Chancellor of France in 1677. He was one of the chief proponents of the revocation of the Edict of Nantes (1685).

[76] The phrase is in Italian in the manuscript. Cf. above, 30 July.

[77] See above, 6 June.

other hand, nine or ten years after marble had been worked, it acquired an indescribable softness of tone and in the end became the color of flesh. He told these gentlemen how great was his anxiety every time he was forced to undertake a portrait; that he had already made up his mind many times never to do one again, but as the King had done him the honor to ask him for his, he could not refuse so great a prince for whose person he cherished so great a love and admiration. Moreover, his feelings towards him were heightened by the fact that, as far as those sciences that he professed were concerned, he was the most learned man in the country; His Majesty had noticed things in his drawings which those with great knowledge of art might not have recognized. In Rome there were a good two hundred people who were concerned with architecture; he would boldly assert that in this great number there would be few who would have recognized, in the way the King did, what was admirable in his designs (supposing there was that which was admirable): he had never heard him say anything not perfectly correct and suited to the subject under discussion. His hearers assured him that the King was equally versed on every subject and that they were amazed at his insight on all matters, M. Le Tellier and M. de Lionne outdoing each other in praise of the King.

Later the Cavaliere said that the prince de Condé too had, as far as he could judge, a mind of extraordinary power and great vitality; he would not mention his courage and vast experience in war, but only say he had the readiest understanding imaginable—in his own words, the clearest and most lucid—that one could find. He finished by repeating, "The King and I must finish it" (pointing to the portait). "If the wish could complete it, it would already be finished and I dare to say it would be perfect." Then they left and he did not accompany them out.

In the evening we went to the Feuillants. As my brother met us he accompanied us also. The Cavaliere said with a smile that he was never to be seen and asked jokingly why he was forever running round paying his court here and there and everywhere. We then went along the waterside and later returned to his apartments. As he took leave of us he said he ought to visit the Academy from time to time; then he apologized for not having entertained us, saying that his work had exhausted him.

13 AUGUST

My brother and I went to visit the Cavaliere. As soon as he saw us, he said to my brother that it must be difficult for him to defend himself against the falsehoods that I broadcast about him at all times

and that it was to him he would have to come for news of the King and the court. Then we looked at the portrait and saw that the drapery was well advanced. We saw M. Paolo's work also and found M. Mattia working at the amphitheatre. The abbé Buti arrived at the same time, and as soon as the Cavaliere saw him he withdrew without saying good day or greeting him; then, as if he were afraid of the sight of him, he began to tell us a bit from one of his comedies. Coviello, he said, was the valet of Cintio, who one day accompanied his master on a visit to a young woman with whom he was desperately in love. He found her in a very peculiar frame of mind; she refused absolutely to let Cintio come near her and poured on him so much scorn and disgust that he fell down in a faint. Coviello, seeing him in this condition, went to help him, but finding him without pulse or movement, he thought he was dead, and fearing that he would get into trouble when the authorities arrived, he made up his mind to leave him. A little later he saw Cintio somewhere and began to study him from afar so as to make out whether he was real or a ghost; he did not dare to come any nearer although Cintio called him several times. He continued in this way, saying that he knew he was dead and he did not want anything to do with spirits. He said that that was how he felt about the abbé Buti whom only yesterday he had seen sick in bed. He told him that M. Colbert had asked him to think of something to fill the large space that there would be between the two palaces of the Louvre and the Tuileries, which would serve for festivals and tournaments, and he had considered the matter and believed that a sort of amphitheatre might do, in imitation of the Colosseum and the Theatre of Marcellus, which having two fronts would look toward both the Louvre and the Tuileries; in each part there would be room for ten thousand members of the nobility. Further, there would be, in the center, an apartment that might accommodate some great foreign prince on a visit to France, who would be splendidly housed in its nine or ten rooms. This amphitheatre would be magnificent in appearance; the columns would be a hundred *palmi* high, which is about 66 feet, and the façade 420 feet across, while the Louvre is only 408 feet. Before that he had the idea of putting up two columns in the space, like those of Trajan and Marcus Aurelius with between them a pedestal on which should have been an equestrian statue of the King inscribed *non plus ultra*, in allusion to the motto of Hercules.[78]

[78] This project, which recalls his unexecuted plans for moving the Column of Trajan to Montecitorio (above, 25 June), was the starting point for Bernini's portrait of Louis XIV on horseback (Wittkower, *Bernini*, cat. no. 74). The decision to commission such a statue must have been made by 12 October, when it is mentioned by the abbé Buti

Referring again to the subject of the Tuileries, my brother pointed out that the construction of the amphitheatre would spoil it altogether, making it appear even lower than it is. "But it would be in harmony with the Louvre," replied the Cavaliere. The abbé Buti added that the palais des Tuileries, being so low, would be the garden palace. The Nuncio then arrived, and the conversation was interrupted. As he came in, he exclaimed, "You are a great knave," and added, turning to us, with a smile, "You are up to nothing but knaveries."[79] The Cavaliere repeated to the Nuncio some of our conversation, then he left and we did too.

After dinner I returned and learned from the Cavaliere that the King had come at midday just as he was going to lie down; he had worked from the life for about three quarters of an hour; M. Colbert had accompanied him and thirty or forty other people. The abbé Buti, who had dined with him, was there also. M. de Lessin[80] had brought the envoy of the Margraf of Brandenburg[81] to see the portrait, accompanied by the comte de Marsan,[82] M. Colbert's brother, and M. de Vergne,[83] all of whom also saw the drawings. The Cavaliere, knowing who they were, greeted them with much ceremony. The comte d'Armagnac[84] and the chevalier de Lorraine[85] arrived later. The Cavaliere asked me who it was that had come with the envoy, and when I told him that he was a relation of M. de Lionne, he asked him to convey his compliments to Mme. de Lionne and told him he knew two women who had great knowledge of the arts—the Queen of Sweden and Mme. de Lionne. Pointing to the portrait, he added that the Queen of Sweden knew as much about the mysteries of art as

as one of the things that the Cavaliere had to do (below). For a political interpretation of Bernini's project, see K. O. Johnson, "Il n'y a plus de Pyrénées: The iconography of the first Versailles of Louis XIV," *GdBA*, xcvii, 1981, pp. 29–40.

[79] The Nuncio's remarks are in Italian in the manuscript.

[80] Charles de Lionne de Lesseins (d. 1701), abbé de Saint-Calais.

[81] Christoph Gaspar von Blumenthal (d. 1689), a Knight of Malta (1652) and diplomat in the service of Friedrich Wilhelm, Elector of Brandenburg. From 1661 he was frequently at the French court.

[82] Charles de Lorraine (1648–1708), comte de Marsan, fifth son of Henri de Lorraine, comte d'Harcourt.

[83] Perhaps Louis de La Vergne de Tressan (1638–1712), Almoner of Monsieur, Bishop of Vabres (1669) and of Le Mans (1671), Prior of Cassan (1673), and Almoner of the duc d'Orléans (1706).

[84] Louis de Lorraine (1641–1718), comte d'Armagnac, who succeeded his father, Henri de Lorraine, comte d'Harcourt, as Grand Equerry of France (1658). He was also High Seneschal of Burgundy and Governor of Anjou, etc.

[85] Philippe de Lorraine (1643–1702), known as the chevalier de Lorraine. The younger brother of Louis, comte d'Armagnac, a Knight of Malta, and Marshal of the Camp (1668), he was for several years the favorite of Philippe d'Orléans, brother of the King, Louis XIV.

those whose profession it was.[86] They also looked at the work of Signor Paolo and then left.

In the evening we accompanied the abbé Buti home and from there went to the Carmelites. The Cavaliere, who had not rested after dinner, was more exhausted than usual and retired rather early to his apartment. I told him on leaving that I would ask M. Colbert to beg the King to choose henceforth a less inconvenient hour. The Cavaliere said the abbé Buti had himself asked the King.

14 AUGUST

I went in the morning to see the Cavaliere and Signor Paolo told me that the King would be coming at half past twelve, which made it necessary for me to stay there for dinner. The Cavaliere asked me for the glasses that Blondeau had promised him. He was sent for and brought them. He decided to put off dining until after the King's visit; he only took a little soup and then went to rest. While he was lying down, Mme. de La Baume[87] arrived and told us she had some business with the King and would take this occasion of approaching him. She stayed in the room and conversed with Signor Paolo and Signor Giulio,[88] both of whom promised to do her portrait. The Cavaliere then got up and, finding her there, paid her many compliments. She told me she had an excellent way of making herself see the likeness of the bust to the King; she shut her eyes for some time and then opened them; she found that as she opened them the portrait resembled the King greatly. The Cavaliere agreed it was a good way; there were two methods that enabled an artist to judge his own work, the one to stay away for some time and so not to see it at all, the other, if there were not time enough for this method, was to wear glasses that change the color of the work or make it bigger or smaller, and so disguise it in some manner and make it appear the work of another,

[86] The mutual respect and affection that Bernini and the Queen of Sweden shared is described by both Domenico Bernini (pp. 103–104, 167, 174–78) and Baldinucci (*Vita*, pp. 44–45, 66, 69–71, 76), who wrote his biography of the artist at her request.

[87] Catherine de Bonne d'Auriac (d. 1692), comtesse de Tallart and marquise de La Baume, wife of Roger d'Hostum (d. 1692), marquis de La Baume, Seneschal of Lyons (1641) and Marshal of the Camp.

[88] Little is known about the life and work of Giulio Cartari. According to Domenico Bernini (p. 114), he entered Bernini's studio before he was eighteen years old and was the only one among his pupils that the Cavaliere allowed to work on those marbles he carved himself. He is known to have worked on the copy of the *Angel with the Title of the Cross* for the Ponte Sant' Angelo and on the Tomb of Alexander VII, and he seems to have worked for Queen Christina between 1667 and 1678. See the article by F. Negri Arnoldi in *Dizionario biografico degli Italiani*, XX, pp. 791-92.

thus removing the illusion born of vanity.[89] During this conversation Marshal Turenne[90] arrived and immediately afterwards the King, although it was only noon. As soon as His Majesty entered, Mme. de La Baume presented herself in the antechamber and spoke to him at great length while the King listened most attentively, smiling now and again. The Cavaliere, seeing that the time allotted to the sitting was going, appeared once or twice before His Majesty, showing visibly that he wished this audience could be shorter, but it had no effect, and Mme. de La Baume was with him nearly half an hour, which made everyone think that the matter could not be disagreeable to the King. Then he came into the room, and the Cavaliere began to work, looking at the King from many different angles, from below, from the side, from near, and from far; for this reason many of the young people, present there for the first time, seeing the Cavaliere look at the King in so many ways and with so great a show of energy, wanted to giggle; the King had difficulty in preventing himself from laughing, but he restrained himself and so did the others, so that the Cavaliere noticed nothing. He worked at the right cheek, the mouth, the right eye, and the chin. Before the King left he had a look at the drawing for the amphitheatre which Signor Mattia was doing, and then he said that as the next day was a holiday he would not come; then there was Sunday; nor would he come on the Monday as he was going to take a cure, but after that he could come regularly every day. During this conversation the duc de Noailles, next to whom I was standing, asked me if the Cavaliere had seen Versailles. I said he had not and that I had not dared to suggest taking him as I did not know whether the King would like it.[91] He said His Majesty would be very glad, but the invitation should not come from him. I said that I would make the suggestion and in fact as soon as the King had gone I went to see the commandeur de Souvré and told him about it because it was he

[89] The same two methods by which an artist may judge his own works are described above, 6 June.

[90] Henri de La Tour d'Auvergne (1611–75), the famous soldier who became a Marshal of France in 1643.

[91] Versailles at this time was still by way of being the King's private retreat, and Chantelou's reluctance to suggest a visit may be explained by the fact that Louis had already denied Bernini an invitation to the *fête* at which Molière improvised a prologue for Mlle. Desjardins's *La Coquette ou Le Favory* (13 June). Vigarani writing to Modena on 19 June reported that the Cavaliere could have used some good counsel on his arrival, which he hadn't had: "I speak with certainty because I know what was said by His Majesty at Versailles in the presence of fifty great lords after he had asked me whether I had seen him. The discussion ended by his saying to me that he did not wish that Bernini see the *fête* at Versailles because after only half an hour of conversation, he had known him for a man predisposed to find nothing in France well done" (Rouchès, no. 217; Fraschetti, p. 343, n. 1).

who had offered to give us dinner whenever I wanted to go to Maisons, and both places might be seen on the same day. The commandeur replied that he had given us this invitation when the court was at Saint-Germain but now that all the members of his household were here it would be very inconvenient to send them back. He said he would talk it over with M. de Longueil[92] or M. de Maisons and let me know their reply. That evening the Cavaliere did not go out but wrote his letters for Rome.

15 AUGUST

✖ The Cavaliere went to pray in the Oratoire and from there to Notre Dame. Afterwards we visited the Nuncio, and took him to the Carmelite church in the rue Chapon[93] where he said Mass. Then he brought the Nuncio back to the palais Mazarin. He came in to see the portrait and found great changes. The Cavaliere said that in the last two days he had studied the King's face intensively and had found that one side of his mouth differed from the other, and this was also true of the eyes and even of the cheeks; these details would help him to get a resemblance; the beauty of the King's head derived from various elements and did not consist only in a delicacy of coloring as in many people; His Majesty had something of Alexander about him, particularly in the forehead and the look in his face. Then he said that the marble was turning out more satisfactory than he had hoped; he took the greatest care in working it and, for that, needed more time. When I left he asked me to order the coach-and-six for four o'clock, when we went with the Nuncio to the Bons-Hommes.[94] We prayed and then strolled along the upper walks of the garden. From there we went to the château de Madrid.[95] As soon as he saw its flat roofs he told M. Mattia to go up and study them; he himself ascended to the first floor, where he pointed out that the rain coming in had ruined

[92] Jean de Longueil (ca. 1625–1705), Chancellor of Anne of Austria, président à mortier in the Parlement of Paris, and later marquis de Maisons et Poissy. He was the brother of René (d. 1677), marquis de Maisons.

[93] In 1619, after the convent of the Discalced Carmelites in the rue Saint-Jacques had become too small, some of the nuns moved to an hôtel in rue Chapon (rue Transnonain) belonging to the Chapter of Châlons. The church they built, with an altar by Simon Vouet, was consecrated in 1625.

[94] The monastery of the Minims or Bons-Hommes stood in the village of Chaillot beyond the Cours-la-Reine. It was founded in the last years of the 15th century on land given by Anne of Brittany, queen of Louis XII. She laid the foundation stone, but the church was not consecrated until 1578.

[95] Near the Bois de Boulogne. According to tradition, built by Francis I in 1529 on the model of the building where he had been held captive in Spain. It was ordered demolished by an edict of 1788.

them, the state of the floors was evidence. Having looked around, he remarked that in France a lot of money was thrown away in building. I said that the château de Madrid was built at the very beginning of the revival in architecture and, further, was only a copy of a palace in Spain, where there is greater liking for what is sweet and agreeable to the eye than for splendor and majesty. I suggested that something really beautiful could have been built on the site, to which they could have conducted the water from Saint-Cloud. But he did not agree, saying it lay too low, and added that so far he had seen nothing that pleased him so well as Saint-Cloud.

On our way back in the coach several anecdotes were told—one about Paul III[96] who had given a refusal to several cardinals on the granting of a pardon to a man convicted of a serious crime. This man had two very pretty sisters, and these same cardinals advised them to walk in the Farnese gardens, when they knew the Pope would be coming there. They followed this advice and threw themselves at the feet of His Holiness; when he had seen them and heard their story, he granted them the pardon they begged for, although he had withheld it from various important personages. When someone asked him why, he replied, "When I refused, my judgment was here," pointing to his forehead, "later it fell lower."[97]

The abbé Ciri[98] told us how one day Clement VIII[99] was informed of the misdemeanor of a monk, who had made a nun pregnant. The man who reported the fact gave many reasons to show the enormity of the sin, which he said was not only astonishing, but stupendous. The Pope, tired of such exaggeration, said it would have been even more marvelous if the nun had made the monk pregnant.

I learnt on my return, that the commandeur de Souvré had been to see me, and immediately afterward M. Mattia brought me a note, which he had sent to the Cavaliere's, thinking I was there still, in which he had let me know that the président de Maisons expected the Cavaliere and company to dinner the next day. I went back immediately to inform the Cavaliere, but he told me that M. Colbert had just left and had asked to see the drawings, and tomorrow he was going to work with him. So I was forced to ask the commandeur to postpone the arrangement to another day.

[96] Alessandro Farnese, pope from 1534 to 1549.
[97] The Pope's reply is in Italian in the manuscript.
[98] The historian, Vittorio Siri (1608–85), who became a Benedictine in 1625, then a secular priest and professor at Venice. When his sympathy for the French aroused the suspicions of the Venetian Republic, he retired first to Modena and then to France.
[99] Ippolito Aldobrandini, pope from 1592 to 1605.

16 AUGUST

✿ In the morning I found the Cavaliere modelling some clay. He told me he had a strong desire to work at his portrait and asked me from whom he should request permission.[100] I said, from the parish priest; if he wished I would go and ask him, so I went to the rector of Saint-Germain, who granted it, saying it would give no cause for scandal as it was for the King. I returned to tell him and so he was able to work; while we were talking he said he thought my brother so good and saintlike in character that should he die in France, he would beg him to be present at his death.

Before he went to dine he received his letters from Rome. After he had read them he told me that his friend[101] who was very witty, had given the following verses to his son the prelate:

Si consiglia il signor cavaliere Bernini a non far il ritratto del gran Luigi decimo quarto

A più d'un regio heroe
La tua virtù infinita
E ver ch'ha dato in marmi doppia vita;
Non tentar ciò in Parigi
Ch'il ciel ha dato al mondo un sol' Luigi.

(Advice to the Cavaliere Bernini not to do the portrait of the great Louis XIV.

To more than one regal hero your unbounded genius has truly given a second life in marble. Do not attempt this in Paris, for heaven has given to the world only one Louis.)

He said he would be very happy if I would take a copy of the verses and have them shown to the King, either through M. Colbert or M. de Bellefonds or another. I promised to see to it. In the evening about six o'clock we went to Vincennes. While waiting for the custodian to be found, he went into the chapel, and after some time passed in prayer he began looking at the courtyard and the buildings. I told him that it was Cardinal Mazarin who had had it built, while he was Governor of the château. Inside, when he saw how low the staircase was, he threw up his hands in astonishment, but said

[100] The 16th of August is the feast day of St. Roch, and the artist therefore needs a special dispensation in order to do any work. Cf. below, 24 Aug.

[101] Bernini's friend, and author of the following verses, was Father Filippi. See below, 22 Aug. and the letter of Mattia de' Rossi in Mirot, p. 250, n. 2.

nothing.[102] He went up into the King's apartments and after looking
at them passed into the Queen's, remarking that it was a beautiful
suite and the King was better accommodated there than in the Louvre.
He asked me whom the paintings were by. I told him that the first
were by an artist called Sève,[103] the others by Bourson,[104] and those
in the apartment of the Dauphin by the late Dorigny.[105] He looked at
them and said they were all good; those in the small room were also
good; apparently the painter had tried to imitate Poussin. He then
went into the apartments of the Queen Mother; he thought the wood-
work and the gilding very beautiful; he said it looked like gilt bronze
and even touched it wondering whether it was. As it was growing
dark, he did not look at the pictures here nor in Monsieur's rooms.
We got back into the coach, and on our return he said he would be
very glad to go back a second time and have a look at the woods
as well.

 I forgot to say that before leaving, Benserade[106] brought Mme.
de La Baume to see him. As he was looking at the portrait I remarked
that here was a subject on which to exercise his talents. I said that
there was a time when the *Dido* by a sculptor named Cochet[107] had
inspired all the wits of the day who had vied with each other in praising
it, and although it was a work which was less than mediocre, an entire
volume of charming things had been said about it.[108] He did not speak
to the Cavaliere as he does not know any Italian.

[102] The southern half of the mediaeval château had been rebuilt by Le Vau. It was
burnt in the Second World War, but the structure has been well restored. The chapel
was mainly built in the late 14th century, but was finished by Philibert de l'Orme
in 1548.
[103] Gilbert de Sève (1615 or 1618–98), a painter and foundation member of the Acad-
emy of Painting and Sculpture (1648), who was later elected Professor (1655) and Rector
(1689). Little remains of the work he did at Versailles in the apartment of the Queen
(1671–80) and at Trianon-sous-Bois, or at Vincennes, where he painted the life of
St. Theresa.
[104] Francesco Maria Borzoni (1625–79), called Bourson, a native of Genoa, who
became a naturalized citizen of France in 1659 and a member of the Academy of Painting
and Sculpture in 1663. In addition to his work at Vincennes (1656), he painted land-
and marinescapes for the apartment of the Queen Mother under the Petite-Galerie of
the Louvre (1664).
[105] Michel Dorigny (1617–65), the student, son-in-law, and engraver of Vouet. A
member of the Academy of Painting and Sculpture from 1663, he had died at the end
of the previous February. Some fragments from his ceilings for the apartment of Anne
of Austria at Vincennes are now in the Louvre.
[106] Isaac de Benserade (1613–91), a poet and member of the French Academy (1674).
He composed topical verses for the *ballets de la cour*, as well as theatrical pieces.
[107] Christophe Cochet, a student of Biart, who was in Rome in 1618 and who may
or may not be the same as the Claude Cochet who worked in the Luxembourg Palace
from 1630.
[108] Ekphrastic verse, which celebrates works of art and their authors, was common

17 AUGUST

🐝 He worked at the portrait. Cardinal Antonio and the Nuncio came to see him. The King should have come also but at twelve-thirty he sent word that he would not be able to do so. There were lengthy conversations between the Cardinal, the Nuncio and the abbé Buti. One of them said that Haliot,[109] a doctor from Bar, had begun to treat the Queen for cancer and that he had asked for an order in writing to authorize him to do so. The bishop of Coutances,[110] the comte de Gramont,[111] the chevalier de Nogent,[112] and M. Sanguin arrived.

Returning after dinner I found the Venetian ambassador and the Nuncio there. The ambassador praised the portrait and said the King looked as if he were giving a military command to the prince de Condé, or the comte d'Harcourt[113] or Marshal Turenne; although it had no limbs it had a great feeling of movement. The Cavaliere told us that one of the first portraits he did was of a Spanish prelate called Montoya.[114] Urban VIII, then still a cardinal, came to see it, accompanied by various prelates who all thought it was a marvelous likeness, each outdoing the other in praising it and saying something different about it; one remarked, "It seems to me Monsignor Montoya turned to stone," while he remembered another said with great gallantry, "It seems to me that Monsignor Montoya resembles his portrait."[115] This Spaniard paid him extremely well, but left his portrait in his studio for a long time without sending for it. He was rather surprised and spoke to several people about it, who explained to him that, as many cardinals and prelates saw the portrait in the studio, this did honor to Monsignor Montoya, for these same cardinals, ambassadors, and prel-

during antiquity and the Middle Ages. It remained popular during the 16th and 17th centuries when close analogies were drawn between the means and aims of poetry and painting. As appears below in the case of the portrait of Louis XIV, Bernini and his works were frequently the subject of these poetic accolades.

[109] Pierre Aliot or Alliot, a doctor from Bar-le-Duc, who had been called to Paris to attend the Queen Mother.

[110] Eustache II Leclerc de Lesseville (d. 1665), from 1658 the Bishop of Coutances.

[111] Philibert (1621–1707), chevalier then comte de Gramont, younger half-brother of Antoine, duc de Gramont.

[112] Louis Bautru (d. 1708), chevalier, and afterwards, marquis de Nogent.

[113] Henri de Lorraine (1601–66), comte d'Harcourt, called the cadet la Perle from the pearl earring he wore as a young man, a celebrated soldier active chiefly before Louis XIV's majority.

[114] For the tomb monument and portrait of Monsignor Pedro de Foix Montoya, see Wittkower, *Bernini*, cat. no. 13. According to the accounts of this incident in Baldinucci (*Vita*, p. 11) and in Domenico Bernini (p. 16), Montoya appeared just as one of the prelates said of the portrait, "This is Montoya turned to stone." Cardinal Barberini, turning to Montoya, said, "This is the portrait of Monsignor Montoya," and then, turning to the statue, said, "and this is Monsignor Montoya."

[115] These remarks are in Italian in the manuscript.

ates stopped their carriages when they saw him in the street to talk
to him about it, which pleased and flattered him, as before he had
been remarkable in nothing. He recalled how Michelangelo had often
said that a statue was so great an ornament that, if one room were
hung with velvet hangings and embroidered with gold and in another
there was nothing but a beautiful statue, the latter would appear royally
decorated while the other would seem "like a nun's cell."[116] The
ambassador urged him to return by way of Venice, saying that he
would be very happy for the city of Venice to be honored in this way.

In the evening about six he went to M. de Lionne's house[117] to
try to put right many faults in its architecture, one being the door at
the entrance, which is much too small. He was of the opinion that
the Doric order of the door should be continued beyond the windows;
the door should be built to the same height as the windows and
enlarged on both sides by the whole width of its architrave. He did
a drawing of it which he made on a table brought out to him and put
in the middle of the courtyard. There are also two lion-masks on the
inside of the chief entrance, which he thought were very poor. He
made a little drawing to show how they could be improved. He also
made a sketch to show how the balustrade, which it was proposed to
put above the entablature, should be placed at the same height as the
dormer windows, adding that it could be omitted on the side facing
the garden. As regards the floors of the *salle* and the bedroom, of
which they did not dare[118] to fill the interstices between the beams
for fear of overloading the ceiling of the room below, the Cavaliere
said that they should cut the beams at an angle on both sides so that,
if the gaps were then filled with plaster, they would be wider at the
top than the bottom, like the stones cut to make a vault, so that its
weight would fall on the two sides of the beams and would not
therefore press on the ceiling; they could further add cross-beams
which would bind them together. He did not like the idea of putting
columns of black marble in the vestibule; they should be of colored
marble or[119] of a hard stone and should be fluted. The ceiling of this
vestibule is low and he said a balustrade should be painted round it
to give it height. Someone asked him if a sky should be painted on a
ceiling above it, to which he replied that a sky should never be imitated

[116] This phrase is in Italian in the manuscript.
[117] The hôtel de Lionne (now destroyed) was built by Louis Le Vau for Hugues de
Lionne, Secretary of State for Foreign Affairs. It had been begun in 1662 and was
habitable by 1664 but as appears below, it was still not wholly finished. For its unusual
vestibule and staircase, see Blunt, *Art and Architecture*, p. 228.
[118] For *ose* the text should read *n'ose*.
[119] For *et* in Lalanne's text read *ou*.

in a place where the real thing is visible, that Raphael himself could not make it look convincing. Instead of a sky the space should be decorated with coffering filled with rosettes painted in black and white. He had the width of the principal bedroom measured. It is a very high room and he pointed out that it should only be as high as it was broad; the height was found to be about three feet greater than the width, but he assured them that a painter could easily remedy this fault by making the figures a little larger than he would have done, had the room been in proportion.[120]

18 AUGUST

As I arrived in his rooms, M. Du Metz entered and gave him one letter from Rome and Signor Mattia another. The latter read his aloud, saying it was from Pietro Sassi, the plasterer.[121] He wrote that he was starting the following week and would have left before but was detained by some business. The Cavaliere did not read his but merely asked by what way it had come. M. Du Metz replied, by the ordinary courier on Saturday; that their letters had come in his own bag, and his own in M. Colbert's bag. The Cavaliere only said, "I must use that way to have news quickly." M. Du Metz replied that he had come at once to deliver them but the Cavaliere had not been in. I then left him working at the portrait and went to attend the levee of the duc d'Orléans.[122] His Royal Highness called me and whispered to me, "Is it true that the Cavaliere thought the cascades at Saint-Cloud too elaborate?" I replied that that was so. Monsieur then went on to say, "Boisfranc told me that the Cavaliere had thought that something beautiful could be made from my bubbling pond. I should be very glad if you would ask him for a design, as it were of your own accord."[123] I assured him that I would do so, that I had in fact already asked the Cavaliere to work at it. A little while later, he recalled me and asked me if it might not be necessary for the Cavaliere to visit Saint-Cloud again. I said if that were so I would take him there especially for the purpose.

[120] Bernini evidently assumes that the ceiling is to be decorated with painted figures, which if increased in size slightly beyond that normally expected, would appear to be closer than usual to the viewer and therefore make the ceiling with which they were identified seem lower.

[121] That is, one of the Italian masters for whom Bernini had sent. Cf. above, 19 July.

[122] In addition to his other offices, Chantelou was intendant des maisons, domaines, et finances of the King's brother.

[123] Bernini had suggested that a rustic cascade might be built at Saint-Cloud on the occasion of his visit (above, 26 July). Later, when asked his opinion by the Nuncio, he had agreed that Le Pautre's cascade was too elaborate (above, 2 Aug.).

After dinner, I went back to the Cavaliere's with my brother. When he saw my brother he said in his ironical way that it was from him that he was expecting to hear news of the court, then he went on working. I asked M. Mattia if he would kindly put a letter I had written to M. Poussin in the Cavaliere's post-bag, which he did. The abbé Buti was there, busy telling Bernini various anecdotes, among them one about a certain Jesuit who was well known for his ready wit. One day when he was crossing Genoa in a litter he was brought to a standstill in the chief square by a body of noblemen who, to amuse themselves, told him that St. Ignatius had not travelled in a litter. To which the good Father had replied sharply, "But at that time there were not so many beasts about as there are now,"[124] and then proceeded on his way.

The Nuncio had arrived, but he stayed only a moment, taking abbé Buti away with him. In the evening we went to the Feuillants. On our way he repeated some reflections which he said often occurred to him in the palais Mazarin—how little it profits a man to have built great palaces, possessed vast wealth and high favors; it might have been better for the Cardinal had he thought about having good quarters where he now is. Father ———, a Dominican and a papal preacher, often said that men of no faith should be sent to the Inquisition, but those who were Christians and refused to give up their sinful ways should be put in the madhouse. Leaving the Feuillants we went along the waterfront and then returned to the palais Mazarin. As we took our leave he advised my brother to leave off gambling when he had lost 2,000 ducats.

19 AUGUST

On going to the Cavaliere's, I learnt that M. Colbert had just left, having brought back the drawings for the Louvre and with them a memorandum[125] giving a full description of everything necessary for the comfortable accommodation of His Majesty, the two Queens, the Dauphin, and the members of their households; for the chief officials of the kitchens, the table, the buttery, and the five catering departments; offices and rooms for the tables of the master of the household, the chamberlain, the maîtres d'hôtel, and others; for a storage tank of water from which water could be pumped off in the event of fire and a room to put other necessary apparatus for such contingencies; for

[124] The priest's retort is in Italian in the manuscript.

[125] This memorandum (incorrectly dated 1664) is in Clément, pp. 251–58, where, however, it seems to be run together with a memorandum given to the artist on an earlier date (above, 1 July).

ballrooms and banqueting halls and for the alteration of the playhouse; for a large armory inside the Louvre; inside or outside, to find a place for the construction of a large and magnificent library, for which the Cavaliere was asked to make designs for the woodwork; a theatre for public displays, musical rides, tournaments, and other festivities, which should hold a large gathering of the people.

In the memorandum it was pointed out that in the French climate there were only four or five months of summer, which the King spent in the country, so that he was only in Paris in the winter; the apartments in the front of the Louvre were not suitable for the King because of the noise of the square and because it faced east and north, while those at the back faced north and west; the expense was all unnecessary as only the apartment facing south should be used, which had nevertheless been left as it was; some kind of window should be found for the larger and smaller rooms which could be easily closed and opened, otherwise it would be impossible to use them in winter, apart from the fact that the rain and snow would ruin the ceilings; it would be advisable to decide early where the pipes carrying water to the Louvre were to run and where they could be discharged, so that the foundations should not be harmed by installing them later; the arrangement of cisterns suggested by Bernini was good and a site for them should be found; the King wished the four Secretaries-of-State to have apartments in the Louvre, also the three financial offices, the council, the high Steward of France, the colonel of the regiment of guards, and many others.

At midday the maréchal de Villeroi came to see the portrait and announced the arrival of the King, who came in immediately afterwards with crowds of people. The Cavaliere began by giving sharper form to the nose, which was only roughly shaped out; M. de Créqui came up to whisper something to the King, and the Cavaliere said with a smile, "These gentlemen have the King to themselves all day long and they won't leave him to me even half an hour. I have a good mind to make a caricature of one of them." No one understood him. I explained to the King that a caricature was a portrait bringing out the ugly and the ridiculous. The abbé Buti added that the Cavaliere excelled in this sort of portrait and that an example should be shown to His Majesty. Someone suggested one of a lady, but the Cavaliere answered, "There was no need to burden the ladies save at night."[126]

[126] Bernini's reply is in Italian in the manuscript. The interest of this passage for the history of caricature was pointed out by Brauer and Wittkower (pp. 182f.). It shows that at the time of Bernini's visit to Paris caricature in the modern sense as the representation of a specific and recognizable individual was as yet unknown in France. Thus,

The prince de Condé, who was there, declared from time to time that he could see the likeness to the King appearing from the Cavaliere's chisel, and the maréchal de Villeroi agreed with him. After three quarters of an hour His Majesty left, saying he would not return the next day but on the following Thursday would give him two or three hours. On his going out of the room Mme. de La Baume came up to the King who took her to the window and gave her an audience of a good quarter of an hour. Then M. Colbert gave her a long audience. When it was ended, he came to see the portrait and stayed in the room for some time. I took the opportunity of telling him that I had taken the Cavaliere to Vincennes, and he had liked it very much and had said that the King was not so well housed anywhere else, and

caricature, as something distinct from the earlier traditions of physiognomic studies and genre types, seems to have been a 17th-century invention. Several Seicento writers beginning with Mancini (1620) place its origins in the Carracci circle in Bologna, where it was probably made one with the "divinarelli pittorici," or pictorial guessing games that were popular in their workshop (Posner, pp. 65–70). The 17th-century notion of caricature (Mahon, *Studies*, p. 61, n. 45) was that of a portrait in which natural defects of figure or feature were given more weight (*carico*) or emphasis and thus exaggerated for comic effect. (The French use a term exactly equivalent to caricature, namely *portrait chargé*.) Although Bernini may have inherited the Carracci legacy directly, his own contribution was decisive (Irving Lavin, "Duquesnoy's 'Nano di Créqui' and Two Busts by Francesco Mochi," *AB*, LII, 1970, p. 144, n 75). In his hands, caricature became completely autonomous in conception and execution. He drew single figures and even busts in an intentionally simplified and primitive style (cf. his comments below on the individuality of a man's shadow), and these drawings done with a few strokes of the pen (below, 10 Sept.) were then given away or kept as independent works of art. However, caricatures in other media cannot be excluded. In an early description (1648) of Bernini caricaturing by Paolo Giordano II Orsini, the Duke of Bracciano, portraits on paper, in wax, and even in marble are described as the bases for caricatures (in A. Muñoz, *Roma Barocca*, Rome, 1919, pp. 368–70). For Bernini, who was likely to have kept his hands busy modelling when they were not otherwise engaged (cf. above, 16 Aug.), a caricature sketched in wax or clay seems entirely plausible, and Irving Lavin has pointed out that the "franchezza di tocco" to which Baldinucci (*Vita*, p. 140) relates his drawn caricatures as easily describes his *bozzetti*. Moreover, a caricature of the Marchese Biscia appeared on the curtain in one of Bernini's plays (Wilhelm Boeck, *Inkunabeln der Bildniskarikatur*, Stuttgart, 1968, p. xii); and in an artist's quarrel of 1635 between G. B. Greppi and Tommaso Luini, which ended in violence, various painted portraits had added fuel to the fire. In a comedy recited by G. B. Greppi, "certain portraits were carried out, perhaps satirizing someone," Francesco di Grassi later testified, "but I don't know to whom they were intended to allude, because I am a sculptor and they are painters, and I don't work with them" (A. Bertolotti, *Artisti subalpini in Roma*, Mantua, 1884, pp. 178–84). These two examples also reveal the natural relationship between Bernini's caricatures and the *ad hominem* arguments of his comedies. His earliest datable caricatures, like his comedies, were done in the early 1630s when, as even his mother complained (above, 23 July, n. 92), he could do no wrong in the eyes of the ruling Barberini. He was thus able to sharpen the sting of these derisive portraits, not only by making absolutely convincing, and therefore inescapable, likenesses, but as he threatens here, by caricaturing "princes and great lords" (Dom. Bernini, p. 28). See now I. Lavin, "Bernini and the Art of Social Satire," in *Drawings by Gianlorenzo Bernini*, pp. 27–54.

thought the woodwork and the gilding extremely beautiful, and the paintings, too.

After he had left, the Cavaliere said that another two sittings would suffice; however, if the King wished to come more often, the portrait would not only resemble him, it would speak. I forgot to mention that Warin was there all the time that the Cavaliere was working from the life and everyone asked him about the bust. He told me that he thought the Cavaliere had taken too much off the forehead, and the marble could not be put back. I assured him that this was not so, that he had intended to give deep modelling to that part of the forehead above the eyes, which would not only be true to life, but would follow the style of all the beautiful heads of antiquity; the Cavaliere and I had discussed the matter from the beginning.[127]

After dinner the Nuncio came and with him Lefebvre, the painter. They admired the close resemblance of the portrait; Lefebvre looked at it from every side and exclaimed that it even looked like the King from behind. The Cavaliere, hearing this remark, said something that should be noted: if a candle is placed behind someone when it is dark so that the shadow falls on a wall, it is possible to recognize that person from his shadow, for no two people have their heads placed on their shoulders in the same way, and so with other parts of their bodies; the first thing in getting a likeness is to study the general appearance, before turning to details.

The Cavaliere had told me in the morning while he was working at the King's nose that it has a very individual trait, for the lower part which adjoins the cheek is narrower than the bridge; this is a detail which could help him towards a likeness. In the evening we went to the Feuillants. After he had prayed, the Fathers showed him some silver figures on the altar from Sarrazin's designs.[128] They told him how much their façade was admired. He looked at it and told me as we left that the last bit above the pediment was superfluous; if there had been only figures and a cross it would have been better; the second order was also a little too high; I replied that in my opinion this was caused by the height of the pedestal of the second order which was too great.[129]

The commandeur de Souvré, who had come in a little before the King in the morning, said we must renew the arrangement for our

[127] Cf. above, 29 July.

[128] Jacques Sarazin, or Sarrazin (1590–1660), a sculptor and one of the foundation members of the Royal Academy (1648).

[129] The façade of the Feuillants (1623), now destroyed, is the earliest recorded commission of François Mansart. See Braham and Smith, pp. 15–16.

visit to Maisons; that when I had fixed it with the Cavaliere, I was
to let him know; at the same time a visit should be made to Versailles,
about which he had already spoken to the King.

20 AUGUST

❧ I found the Cavaliere working at the portrait. The abbé Buti arrived
bringing Mattia who presented to the Cavaliere a sonnet in Italian in
praise of him and the portrait, which I think should be inserted here:

Per la Statua dell'augustissimo Monarca Luigi XIV
Al signor cavaliere Bernino, da lui egregiamente scolpita

Stupor del Tibro, e della Senna eletto
Per alzar meraviglie in sù le sponde,
Bernin famoso, il cui scolpir perfetto
Lo spirito vital nei marmi infonde.
Prova è dell'arte tua l'eccelso oggetto
In cui natura i pregi suoi infonde,
E con sorte parzial del regio aspetto
Ai lineamenti il tuo saper risponde.
Vivo è del gran Luigi il genio espresso
In quel sasso felice, il suo sembiante
Il decoro che serba ivi a concesso.
Fidia si omai ceda, che se tonante
Scolpi il suo Giove, in questo marmo stesso
La clemenza del nostro appar constante.

For the statue of the most august monarch, Louis XIV!
To the Cavaliere Bernini, who carved it so admirably!

Wonder of the Tiber, you who have been chosen to raise
marvels on the banks of the Seine, illustrious Bernini, whose
chisel puts the breath of life into marble! The proof of your
art is the sublime object on which nature has lavished all her
gifts, and thanks to favorable chance, your knowledge is
worthy of the features of royal majesty. The genius of great
Louis has become alive in this blessed stone; his image has
here imparted to the marble the honor which belongs to him.
Phidias must now give way; he may have carved his Jove
thundering, in this marble there shines forth the clemency
which is in ours.

Then the abbé read another poem which we guessed at once was
his. He did not want to give himself away but finally confessed.[130]

[130] These verses by the abbé Buti have been published by Schiavo, p. 41.

M. Mattia worked at a design for reducing the height of the main floor in the façade for the front of the Louvre, following the wishes of M. Colbert, who wanted to make the rooms more comfortable, their excessive height being unusual in France. I told M. Mattia that it was not for me to speak of such matters in front of the very masters of the profession, but had I dared, I should have said at the time he was working at his first façade that I had liked it extremely, except in that one respect; it seemed to me there was too great a space between the second and third floors which is a result of the height given to the main floor, and it seems too empty. He replied that the Cavaliere had been obliged to give it this height so as to obtain the right proportion for the spaces between the columns which should be at least twice as high as they are broad. For the same reason he was adding bands in the design on which he was now working in order to arrive at the correct proportions. This is the problem that arises if one uses an order running through all floors. While on this topic he said it was Michelangelo who was the first to use it this way, there being no example of it in classical buildings. In every one of these, different orders are used, one above another.[131] I replied that Michelangelo had done great things, but it was he who had introduced license into architecture because of his ambition to be original and not to imitate any of his predecessors; it was he who was the inventor of cartouches, of masks, of broken cornices, which he had used to advantage for he had a profound sense of design. Those who had wanted to imitate him had not had the same success for they lacked his basic knowledge.[132] As regards the broken cornices, he said Michelangelo had only made use of them in places where the blocks were too long and would otherwise have resembled a fortification. When we had finished talking we worked together at the execution of M. Colbert's memorandum and found places for the King's and the Queen's kitchens and butteries.

In the evening, the Cavaliere went with M. de Lionne to his house and tried to put right some of its faults.[133] He thought that on the staircase the architrave, the frieze, and the cornice, which are placed between the two columns, should be removed because they take away much of the light from the vestibule; he had told Mme. de Lionne,

[131] De' Rossi presumably did not know the Temple of Jupiter at Baalbeck where a giant order occurs, although drawings of it existed at this time in France and were engraved in the *Grand Marot*.
[132] This view of Michelangelo as an innovator in architecture goes back to Vasari (Vasari-Milanesi, I, pp. 135–36; VII, pp. 193–94); but Chantelou's negative attitude to originality and his interpretation of the effects of such "license" as pernicious are typical of the classicizing critique that was later to be used against Bernini. See Bauer, pp. 9–15.
[133] Cf. above, 17 Aug.

who was eager to have columns of black marble, and niches also decorated with it, that black was the one color that was not suitable; any other marble, white, red, or mottled, would do very well. Further, he was astonished that the custom had not been introduced in France of getting in and out of coaches under cover and that the houses, at least the larger ones, had not this arrangement. In Rome even working men had it; if three arcades had been built in place of the vestibule, this would have been possible and with it a view would have been obtained of the whole garden, and the house would have been much gayer in appearance. The Cavaliere condemned the windows opposite the flights of stairs because their centers did not correspond with the center of the aforementioned flights. He said it would have been better to make the aperture of a single window opposite the central flight. The levels of the floors were not the same because it had been found necessary to raise the level of one or two rooms to that of the reception room; he said the levels of the others should be raised little by little beginning at each door where several inches could be added so that the level of the reception room could be reached without the process being noticed. This house had been very badly built, for it not only lacked stability, but the floors were constructed of such an enormous quantity of wood that they crushed the walls, and both space and height had been lost, and the cost had been appalling. The Cavaliere always refrained from giving his real opinion, only letting it be known by such phrases, as, "If it were mine, I should do so and so." Mme. de Lionne finally asked the Cavaliere if he would be so good as to make a drawing for her, so that his advice could be carried out. He promised to do this and said that when a holiday came round he would send M. Mattia to take the measurements.

21 AUGUST

In the morning, I continued to work with Signor Mattia at the execution of the memorandum and while we were thus occupied, the abbé Le Tellier[134] and the abbé de Saint Pouange[135] came into the studio without saying anything. As soon as I noticed them I told the Cavaliere who they were. The Cavaliere greeted them, saying that he had a high opinion of M. Le Tellier, not so much for his position as minister, but because his face showed that he was a great thinker. After working a little while in front of them he went to scold the man in charge of

[134] Charles-Maurice Le Tellier (1642–1710), Chapel Master of the King (1668), Archbishop of Rheims (1671), and conseiller d'état (1679).
[135] Michel Colbert de Saint-Pouange (d. 1676), Almoner of the King, and from 1666, Bishop of Mâcon.

the door for letting anyone come in without announcing them be-
forehand. When they had gone, Signor Mattia told the Cavaliere that
he had settled the placing of some of the apartments according to the
instructions given in M. Colbert's memorandum. He replied that this
work was quite useless and that the distribution lay with the maréchal
des logis,[136] who would not bother with any of their plans. Then he
went to dine and I accompanied him. The abbé Buti followed us and
handed me ten or twelve printed copies of his sonnet, asking me to
be so kind as to present one to the King.

After dinner, the duc de Créqui came and with him the maréchal
de La Ferté[137] who told the Cavaliere that they were neighbors and
that he must come to dine with him and see his house. At this very
moment the King arrived, accompanied by thirty or forty people.
Immediately, the King remarked that it was too warm and the win-
dows should be opened. The Cavaliere once more repeated what he
had said before,[138] that these gentlemen had the King the whole time,
yet would not leave him for one half-hour to the sculptor. This time
he worked at the eyes. Earlier that morning he had said that this was
his intention and there was one thing that would cause him great
difficulty—the length of the King's eyelashes, which could not be
represented in marble. He said the setting of the eyes was very deep,
though the eyes themselves were not large; great attention must be
given to that kind of thing. Sometimes, while he was working, he
came up to the King and looked at him from the front and from one
side and the other, from head to foot every way possible, and then
returned to the marble. The maréchal de Gramont was present with
his eyeglass, watching very closely. M. Colbert stayed for a while
and then withdrew. His Majesty talked a great deal with the maréchal
de La Ferté. The Cavaliere never stopped working all this time, some-
times at one eye and sometimes at the other, and a little bit at the
cheeks. Then Mattia read the sonnet that he had written on the subject
of the bust, which I mentioned above,[139] and afterwards he presented
it to His Majesty.

A little while later, I presented the abbé Buti's verses to His

[136] That is, a member of the chamberlain's department responsible for the distribution
of accommodation.

[137] Henri II de Saint-Nectaire, or Senneterre (1599–1681), duc de La Ferté (1651),
Governor of Lorraine, and Marshal of France (1651). The hôtel de La Ferté-Senneterre,
with decorations by Charles Errard and Nicolas Loir, was later demolished by Jules
Hardouin-Mansart to make way for the place des Victoires (see Hautecoeur, II,
pp. 603–7).

[138] Above, 19 Aug.

[139] Above, 20 Aug.

Majesty. The duc de Montausier,[140] who was there, asked me if they were mine whereupon I pointed out the abbé Buti to the King as their real author. His Majesty said he should read them himself. I joined my voice to the King's to try to get him to do this, but he excused himself, saying he would need his spectacles. Whereupon the King ordered me to read them, which I did and distributed the other copies to whoever wanted one. As everyone thought the sonnet very good and praised it highly, the Cavaliere mentioned that I had other verses on the subject of the bust which had been sent from Rome. They were sent for and given to the Cavaliere who himself read them to His Majesty. They were the ones mentioned above.[141] Everyone liked them very much, and the marquis de La Vallière[142] and the comte de Magalotti[143] both took copies.

While the Cavaliere was still working, Mignard d'Avignon[144] came in and told His Majesty that M. Colbert had sent him to take his measurement for a full-length portrait which was to be sent abroad. He measured him with a blue ribbon, M. Biscarat[145] holding one end and he the other. Immediately afterward the King left, saying he would not be able to come on the following day, but if he could, he would send word. Before the King left the Cavaliere showed him the finished drawing for the amphitheatre, saying that besides the magnificent apartments it would provide, it would hold ten thousand spectators on either side.[146]

When the King had gone, the Cavaliere threw himself on a chair saying as usual that he was absolutely exhausted and his mind and energy were used up. At this moment M. de La Vrillière[147] arrived.

[140] Charles de Sainte-Maure (1610–90), marquis then duc de Montausier (1664). Maréchal de camp, chevalier des ordres du roi, and Governor of the Provinces of Angoumois, Saintonge, Normandie, etc., in 1668 he was appointed Governor of the Dauphin. According to tradition, he was the model for Molière's *Misanthrope*.

[141] Above, 16 Aug.

[142] Jean-François de La Baume-Le Blanc (1641–76), marquis de La Vallière, brother of Mlle. de La Vallière, and in 1670, Governor of the Bourbonnais.

[143] Bardo di Bardi (1630–1705), comte de Magalotti. Of Florentine origin, he became Captain (1654) then Colonel (1675) of the Guards, Commander of the Royal-Italian Regiment (1671), Lieutenant-General (1676), and Governor of Valenciennes (1677) where he died.

[144] Nicolas Mignard d'Avignon (1606–68), a painter and brother of Pierre, whose long residence in Avignon, where he married, earned him his appellation. In 1663 he became a member of the Royal Academy. See now, *Mignard D'Avignon (1606–1668)*, exh. cat., Palais des Papes, Avignon, 1979.

[145] Perhaps Jean-Armand de Rotondis de Biscarras (d. 1702), Bishop of Digne (1668), Lodève (1669), and Béziers (1671), but it may rather be the Biscarat who had been an officer in Mazarin's guard.

[146] The amphitheatre is described above, 12–13 Aug.

[147] Louis I Phélypeaux (1598–1681), seigneur de La Vrillière et de Châteauneuf-sur-

I told the Cavaliere he was a Secretary-of-State but he did not come forward to receive him, so he spent a little time looking at the portrait and at the work of Signor Paolo. Later the Cavaliere begged to be forgiven. They talked about sculpture; on the subject of the bust the Cavaliere repeated what he had said many times, that Michelangelo never wanted to undertake a portrait; he was a great man, a great sculptor, and architect; nevertheless, he had more art than grace, and for that reason had not equalled the artists of antiquity: he had concerned himself chiefly with anatomy, like a surgeon;. it was this that had caused Annibale Carracci who had, he said, "a great intelligence"[148] to jest about his *Christ* in the Sopra Minerva, and then he repeated various remarks that have already been recorded elsewhere in this journal.[149] He added also, that one day Michelangelo was with Cardinal Salviati and His Eminence said he would like to show him some models by N—— and had them brought in. Michelangelo said he liked them and began to study them more carefully while the Cardinal went to speak to some people; on his return he said to Michelangelo, "Don't you think these are the work of a man of great talent?" Michelangelo asked him after the Florentine fashion, "Did he carry them out?" The Cardinal replied that he had not. Then Michelangelo said with great indignation, "Well, then don't tell me he's a very talented man."[150] A propos, M. de La Vrillière said that in Rome, when some painter or sculptor was mentioned, it was customary to ask "Where are his works?"[151] After this conversation he looked at the drawings for the Louvre, and meanwhile the comte d'Armagnac arrived with Benserade, who looked at them too. M. d'Armagnac told the Cavaliere that he was one of the wittiest people in France. He greeted him cordially and then asked M. d'Armagnac where his brother, the comte d'Harcourt,[152] was and remarked that he was one of the most notable men in society. When these gentlemen had left, I asked the Cavaliere if we should go to Maisons. He answered that while the abbé Buti was there, he would rather not decide until the morrow.

Loire, who succeeded his father, Raimond (d. 1629), as Secretary of State. A great lover of art (Sauval), he assembled an outstanding collection of paintings which Bernini was to see (below, 11 Oct.).

[148] The phrase is in Italian in the manuscript.

[149] Above, 25 June.

[150] The exchange is in Italian in the manuscript.

[151] The question is in Italian in the manuscript.

[152] Louis, comte d'Armagnac, Charles, comte de Marsan, and Philippe, chevalier de Lorraine—the sons of Henri de Lorraine, comte d'Harcourt—had visited the Cavaliere on 13 August.

22 AUGUST

✖ The bishop of Laon[153] and the marquis de Coeuvres,[154] his brother, came to see the Cavaliere. They recalled the time when they were in Rome with the maréchal d'Estrées,[155] their father. He showed them the abbé Filippi's epigram, that is, the one sent from Rome about the bust, which he had shown to the King the day before.[156] M. Bellinzani brought M. Boucherat[157] and several others to look at the portrait and then at the drawings for the Louvre. When they had gone M. de Turenne came in but he did not stop. I spoke again to the Cavaliere about our excursion to Maisons and how we should decide on a day for it. He replied that we could go on Monday, but he did not wish to dine there. In the evening I told the abbé Buti about the objections that the Cavaliere was making about dining at Maisons; that it would be difficult to see the house and grounds if we only left Paris after dinner. So the abbé kept on talking to the Cavaliere about it, saying that it would be most awkward as we had already refused to go once on a false pretext and in the end he agreed to our plans.[158] I at once wrote to the commandeur de Souvré and went to try to see him later but did not meet him.

In the evening the Cavaliere went to the Feuillants. After he had prayed, the monks showed him their sacristy which is very beautiful and contains much silver. They told him their church was built by Marie de Médicis, but Henry IV had often said, "It may be my wife who builds the church of the Feuillants, but she builds it with my money."

23 AUGUST

✖ I went to the Cavaliere's who had not yet finished dressing. While he was doing so he advised me to read *Of the Imitation of Christ* by

[153] César d'Estrées (1628–1714), who became cardinal only in 1671, is here given the title of the bishopric that he held from 1655 to 1681.

[154] François-Annibal II d'Estrées (1623–87), marquis de Coeuvres, then duc d'Estrées (1670), Lieutenant-General (1667), governor of the Île-de-France (1671), and ambassador to Rome from 1672 until his death.

[155] François-Annibal I d'Estrées (1573–1670), marquis de Coeuvres, created peer and duc d'Estrées in 1648. A Marshal of France from 1626, he was the French ambassador to Rome in 1621 and again from 1636 to 1642.

[156] The epigram above, 16 Aug.

[157] Louis Boucherat (1616–99), who after having been conseiller au Parlement (1641), maître des requêtes (1643), intendant de Guyenne, de Languedoc, de Picardie et de Champagne, conseiller d'état (1662), and a member of the Royal Council (1681) became Chancellor of France in 1685.

[158] Bernini had refused to go to Maisons on 16 August, excusing himself by saying he had to work with Colbert on the plans for the Louvre (above, 15 Aug.), but this was evidently not true.

Thomas à Kempis, an excellent work, he said, and the favorite book of St. Ignatius; he read a chapter every evening with his son and family; everyone found in it what he needed. The *Philotée*[159] was also excellent; it was the book that the Pope preferred to all others. I replied that he must think highly of the author, as he had canonized him. He agreed and added that Saint François de Sales had left his shirt and his cup to His Holiness in his will; since then the Pope had always drunk from this cup and had never taken off the shirt. When the Cavaliere was dressed we went to the Oratoire alone, as MM. Paolo and Mattia were not yet dressed. The Cavaliere took Communion. When we were leaving the church, Signor Mattia, who had arrived with his son, came up and whispered something to him. He then asked me if we could go to the Louvre, so we set off. He first went into the chapel but only stayed a little while. He told me as we left that he did not like it at all. I said it was only a temporary chapel.

We then went to the King's apartment where I was informed that the King had gone to have his foot bled in the new apartments of the Queen Mother; we therefore went downstairs where we found the maréchal de Bellefonds who told us that when the King was finished, he would announce that the Cavaliere was there. We remained in the antechamber and Vigarani entered and came up to the Cavaliere. While waiting, they started to converse on various topics, among them, architecture; what a difficult art it was and how, in order to be successful, practice and theory must be joined together.[160] Vigarani said it was essential for an architect to have a sound knowledge of geometry and perspective. The Cavaliere added that one of the most important things was to have a good eye in assessing the *contrapposti*, so that

[159] The *Introduction to the Devout Life* (1609), a celebrated treatise written by Saint François de Sales and addressed to Philotée, or Philothea, a name chosen by the author because it "signifies a soul loving, or in love with God." Saint François, who died in 1622, was canonized by Alexander VII on 19 April 1665, a few days before Bernini left for Paris.

[160] The following discussion is Bernini's clearest statement on the relative, optical approach to artistic form that has been noted several times above (14 June, 22 July, 17 Aug.). Here he defines the *contrapposti* as those apparent changes that occur when an object is seen within the context of what surrounds it. As examples of this effect, he cites his own work, including again the colonnades of St. Peter's (above, 1 and 15 July), and two instances of optical illusions that recall Leonardo and Lomazzo. Because these perceptual deformations are contingent on the conditions under which an object is seen, neither mathematical knowledge nor application—geometry or perspective—can ensure that a work of art will be pleasing to the eye when it is finally finished and in place. Therefore, to be successful, an artist must have a "good eye," that is, judgment, for anticipating and accommodating such effects. Turning then to the subject of machines, he again points out to Vigarani (cf. above, 26 July) that the same disparity between theory and reality is liable to occur in the case of mechanical inventions.

things should not only appear simply to be what they were, but should be drawn in relation to objects in their vicinity that change their appearance. He gave an example of this: He had once made a statue the head of which when completed seemed too small, although it was the right size, one-ninth of the whole, which was customary in a Christ (though in a Bacchus or Mercury different proportions were used). It looked too small not only to him but to one of his friends, and he was forced to remeasure it several times and also measured the *Antinous*[161] and the *Apollo*[162] and found there was no difference. Finally, however, by dint of examining it and thinking about it he discovered that the effect was caused by a piece of drapery on the shoulder; he had made it very much smaller, and the appearance of the head was quite changed. When his friend returned and saw the figure with the head apparently in its true proportion, he was astonished and could not understand how he had corrected it.

As another example of what he meant, he mentioned the façade of St. Peter's and the much lower colonnades he had placed on either side of it in order that the façade should look taller in contrast. This design had succeeded just as he had imagined. Continuing our discussion on the appearance of objects, he said a man clothed all in one color looked taller than a man at the same height whose doublet was one color, hose another and stockings yet another. I said I could well believe him and thought that was the reason why a palace decorated only with one order that ran from bottom to top looked much taller than another in which several different orders were used one above another. He agreed and added that a mile of sea water looks so much longer than a mile on land where the landscape was broken up by different colors. Turning to the subject of machines he said to Vigarani that when they[163] were considering the means of erecting the obelisk in front of St. Peter's (the contract having been concluded in a council) a model had been shown demonstrating how the job could be done at a third less than the estimated cost. One cardinal, however, was of the opinion that they should wait eight days while a test was carried out, for the model was in miniature. When it was examined it was found that the machine would need a screw a mile long with giants

[161] Presumably the *Hermes* now in the Vatican Museum, which was formerly thought to represent Hadrian's favorite, Antinous. A Hadrianic copy of a bronze original perhaps executed by a follower of Praxiteles, it was discovered in 1543 and installed in the Belvedere garden by Paul III.

[162] The famous *Apollo Belvedere* in the Vatican Museum, thought to be a Hadrianic copy of a bronze by Leochares. It was found at the end of the 15th century and entered the papal collections when Julius II became pope in 1503.

[163] The text should read *on* instead of *il*.

to turn it. "And so it is with most mechanical inventions," he said. He added that under the pontificate of Paul V a Frenchman was invited to Rome who at that time was famous for his knowledge of water-works. The Pope wanted him to bring water to the *vigna* in the Borghese Gardens.[164] He declared quite frankly that he could construct a machine that would carry up a certain quantity, but that it would only last twelve or fifteen years. And in fact it did not last that much time and could not be mended afterwards.

So an hour of waiting was passed in discussion of this and other subjects, after which the Cavaliere asked if we might leave. I said I must let M. de Bellefonds know so that he should not tell the King that the Cavaliere was there after he had gone. But as soon as I entered the apartment, I learnt that the King had asked for the Cavaliere so I went to fetch him. The maréchal de Gramont came forward and pointed out the *Diana of Ephesus* from among the many statues and busts that are in these first rooms; he praised it highly, saying it had a great reputation. The Cavaliere looked at it closely and admired it. He saw the *Bacchus*, which he thought very beautiful, and the *Poppaea*, which he liked except for its head. When he saw the *Dancing Faun* he exclaimed that he looked at it against his will, for it made him realize that he knew nothing. Going on, he entered the King's bedchamber; the King was in bed having just had his foot bled. The bed was covered in amaranth-colored velvet with heavy gold embroidery, like the wall covering of the room and the anterooms, which the Cavaliere had looked at, as well as the fine cabinets in the rooms. There was no rail round the King's bed but on the dais there were many silver vases filled with tuberoses. He gazed around for some time and then re-marked that the decorations of this and the adjoining rooms were designed to the taste of the ladies but the first rooms through which he had passed, with their statues and busts, were more masculine in character.[165] He placed himself at the foot of the bed, the curtains of

[164] The Villa Borghese on the Pincio in Rome was described by John Evelyn in 1644 as "a real Elysium of delights, a Paradise." It was created for Cardinal Scipione Borghese, nephew of Paul V, at the beginning of the 17th century. Later transformed and enlarged, in 1902 it was acquired by the King of Italy, who then gave it to the city of Rome.

[165] The "feminine" taste exhibited by Louis's bedchamber and remarked by the artist (cf. below, 6 Sept.) is the first hairline crack in that otherwise flawless ideal of the King on which the artist had been building his hopes. Bernini's reaction may be compared to that of Sir Christopher Wren, who was in Paris at the same time and who wrote to a now unknown friend: "The Palace, or if you please, the Cabinet of Versailles call'd me twice to view it; the Mixtures of Brick, stone, blue Tile and Gold make it look like a rich Livery: Not an Inch within but is crouded with little Curiosities of Ornaments; the Women, as they make here the Language and Fashions, and meddle with Politicks

which were drawn back, with the leading people at the court grouped around it. His Majesty told him he would not be able to see him for three days but that during his absence he could work at the hair. He replied that he would do that; he dared to tell His Majesty that it was no easy thing to attain that lightness in the hair to which he aspired, for he had to struggle against the contrary nature of the material. Had His Majesty seen his *Daphne* he would realize that his efforts in that way had not been unsuccessful. M. de Créqui mentioned the statue of *Truth*[166] which is in the Cavaliere's house in Rome: it was the perfection of beauty. The Cavaliere said he had done this statue for his house, but that the figure of Time, which supports the figure of Truth and points to its meaning, was not yet finished: his idea is to represent Time bearing Truth aloft, and to show by the same means the effects of time which in the end ruins or consumes everything; for in the model he had made columns, obelisks, and tombs which appear to be overturned and destroyed by Time, though they were nevertheless the things that support him in the air; without them he could not remain there, "although he has wings," he added with a smile. He said it was a saying current in Rome that Truth was only to be found in Bernini's house.[167] Thereupon he began to describe to the King a piece from one of his plays where a character is reciting the tale of his misfortunes and speaks of the unjust persecution of which he is the victim. In order to console him, one of his friends begs him to take courage, saying that the reign of calumny will not endure forever, and that Time will at last reveal the Truth: to which the unhappy creature replied, "It is true that Time reveals Truth but he often doesn't reveal it in time."[168] The King let it be seen that the

and Philosophy, so they sway also in Architecture; Works of Filgrand, and little Knacks are in great Vogue; but Building certainly ought to have the Attribute of eternal, and therefore the only Thing uncapable of new Fashions. The masculine Furniture of Palais Mazarine pleas'd me much better, where there is a great and noble collection of Antique statues and Bustos (many of Porphyry), good Basso-relievos; excellent Pictures of the Great Masters, fine Arras, true Mosaicks, besides Pierres de Rapport in Compartiments and Pavements; Vases on Porcelain painted by Raphael, and infinite other Rarities" (quoted from the *Parentalia* by M. S. Briggs, *Wren the Incomparable*, London, 1953, pp. 40–41).

[166] For Bernini's statue of *Truth Unveiled by Time*, see Wittkower, *Bernini*, cat. no. 49 and Lavin, *Bernini and the Unity of the Visual Arts*, pp. 70–74.

[167] *Truth* was to remain in the house of Bernini until 1924. It had been left to his descendants as an unalienable possession, which would remind them, as he said in his will, that truth is the greatest virtue on earth.

[168] The reply is in Italian in the text. As earlier (above, 22 July), Bernini is naturally reticent about the one great setback in an otherwise extraordinarily successful career. This occurred after the death of Urban VIII, when Innocent X ordered his almost completed tower on the façade of St. Peter's demolished (Brauer and Wittkower, pp. 37ff.). From Domenico Bernini's account of the event (pp. 76ff.), it appears that the *Truth Unveiled* had been begun as Bernini's answer to what he considered mistaken and

epigram amused him very much. Someone—I think it was the commandeur de Jars—mentioned another play the Cavaliere had staged in which he made it appear that the theatre was on fire and the Tiber in flood,[169] and to amuse His Majesty he described how he had done it and also how he had represented the sunrise, which pleased everyone.[170] What gave him pleasure was that, as he had all these things fixed up at home and at his own expense, they cost so very little.

The Cavaliere told us how a prelate who had heard that he was to be represented in one of his plays came to ask him to be so kind as not to put it on; he would have liked to comply with his wishes, but as the Pope and other eminent people at court were especially interested in it, he had to go ahead. However after the first five or six words the thread of the play was interrupted by the fall of a wall which of course was pre-arranged, and the thing was then abandoned.[171] The King showed that he was amused and entertained by these tales. Then M. de Créqui mentioned a statue in a private house near the Farnese Palace which is for sale, which the King said he would like to buy. The Cavaliere informed him that it was the *Meleager*,[172] a famous Greek work; he added that, when he returned to Rome, he

overhasty attacks on this work. But in similar circumstances a few years earlier, he had fought his critics with a less conventional weapon than allegory: "The Cavaliere Bernini, who had actually thought to give up doing comedies has prepared a beauty, the subject of which will be the crack that one sees in the cupola of St. Peter's and the calumnies directed against him, namely, that it is all his fault" (*avviso* of 24 Jan. 1637, in Bibl. Vat., ms. Ottob. lat. 3340, c. 34, kindly given to me by Margaret Murata). The exchange from the comedy cited here suggests that at this time too he took his case directly to the public.

[169] The apparent fire that Bernini created on the stage during one of his plays is described below, 5 Oct. For the related effect from the *Inundation of the Tiber*, in which a great quantity of water suddenly burst its barriers and threatened to engulf the audience, see Baldinucci, *Vita*, p. 83; Domenico Bernini, p. 55; and the *avviso* of 1638 in Fraschetti, p. 261.

[170] According to both Baldinucci (*Vita*, p. 84) and Domenico Bernini (pp. 56–57), the artist's stage machine for representing the rising sun came to the attention of Louis XIII, who requested a model of it. The Cavaliere complied, but the instructions he sent for its operation concluded with the line: "It will work when I send you my head and hands." This anecdote must refer to 1640, when Mazarin sought Bernini's counsel on theatres and stage effects, including "the way in which one illuminates and in which one makes the sun and the night." See M. Laurain-Portemer, "Mazarin militant de l'art baroque au temps de Richelieu (1634–1642)," *BSHAF*, 1975, pp. 73–74. The drawing of the sun rising over the sea (Domenico Bernini says the effect was used in a comedy called *La marina*) formerly attributed to Bernini (Brauer and Wittkower, pp. 33–34) is now generally given to Filippo Juvarra.

[171] Cf. the collapsing house in Bernini's *Inundation of the Tiber* of 1638 (Fraschetti, pp. 264–65).

[172] The statue, after Skopas, now in the Vatican Museum. In the middle of the 16th century, it had belonged to Francesco Fusconi, physician to Paul III, and apparently the statue had remained in his house, which lay between the Palazzo Farnese and the Campo dei Fiori. It was acquired for the papal collections during the reign of Clement XIV (1769–74).

would try to find one or two good pieces to decorate some of the King's rooms. Then he withdrew, accompanied by Mattia and his son. As he went out he met the Queen, who was on her way to see the King. She greeted him most cordially. He stopped to look at the busts and statues and remained so long that he was still there when the Queen came out again. She told him, as she went by, that she would come on Wednesday to see the bust. I forgot to mention that the Dauphin[173] also came to see the King, attended by Mme. Arsan.[174] The Cavaliere seeing what a large and powerful woman she was whispered to me, "There's no danger that the Dauphin (dolphin) will overturn the vessel that he is accompanying."[175]

I took the Cavaliere back to the hôtel Mazarin and then went home, where I learnt from my brother that during the morning M. Colbert had sent to enquire whether his health and inclination would permit him to work at the Louvre, where he would have the task of supervising the execution of the Cavaliere's designs. If he were willing he would suggest it to the King, who would doubtless agree. My brother had replied that he would consider it a great honor.

After dinner we went together to the hôtel Mazarin where we were told that the Cavaliere had gone with M. Mattia to M. de Lionne's. We followed him. He was examining the various architectural errors and trying to put them right. Vigarani, who was there, told us that the large pavilion that is being erected near the big stables would fall to pieces before it was finished. We then went to the Barefooted Carmelites and took the abbé Buti home. Then, as we were taking the Cavaliere back, he saw a lot of people outside M. Colbert's door and got out and went in and was immediately taken into his office. First he told him that this morning he had had the honor to see the King and had talked to him about many things; he had realized that, among all those there, no one had so well understood him as His Majesty, and he continued to praise the intelligence of the King. M. Colbert went even further, saying he had never known anyone with more common sense or a better grasp of what was right

[173] The title given the heir to the crown of France, in this case, Louis (1661–1711), first born of Louis XIV and his queen, Marie-Thérèse. In early 1662 Cardinal Antonio Barberini had commemorated the birth of the Dauphin with a series of celebrations held in Rome. The festivities culminated in a spectacular display of fireworks designed by Bernini for the slope of the Pincio connecting the Piazza di Spagna with the church of SS. Trinità dei Monti. See P. Gordon's discussion in *Drawings by Gianlorenzo Bernini*, pp. 219–25.

[174] Marguerite Baron, called Arsan, one of the women attendants who watched over the Dauphin.

[175] Bernini's comment is in Italian in the manuscript.

than the King; he had noticed it not only in those matters that appertained to the functions of a King, but in everything else; when there arises at the council some business on which there were nine or ten different opinions, he never fails to choose the right one; even on such a subject as finance, of which he could have learnt little, he was astonished at his admirable insight; two or three years ago, financial matters had not been easy, but even then he had always taken the right course; further, he possessed unparalleled firmness which was never allowed to falter. If he made a plan he followed it up step by step turning neither to the right nor to the left, pursuing it over ten years perhaps; that even now His Majesty was working on things of which he would never see the conclusion; the advantages they would bring might appear only fifty years after his death; for instance, the replanting of the forests. At present, France had to get the wood for shipbuilding from abroad. The King hoped to bring the forests to such a state that in the future we should not be reduced to this necessity. Moreover, the King had a most singular trait in that he caused no anxiety in the minds of those who served him well; that he, M. Colbert, in serving the King well, was as sure of his mind as of his own; if he was away from the King for a fortnight he had no less peace of mind than when he saw him twice a day.[176] The Cavaliere said that was the reward promised by those who exhorted us to serve God, telling us that He saw all our deeds which, if they were good, brought us a tranquillity that one never, or rarely, has in the service of men.

Then M. Colbert said that M. Mattia must peg-cut the lines for the foundations of the Louvre because the King was going to see them on Wednesday. Then he mentioned that the King had noticed on the last occasion how tired he was. He agreed it was true, work from the life exhausted him so that he felt as if he had been flogged. Further, there had been such a crowd of people there; he was quite used to working in public, but they made it even hotter than it was already.

24 AUGUST

St. Bartholomew's Day. I found the Cavaliere at Mass at the Petits-Cordeliers Irlandais.[177] When he came out he said the weather was very bad and he was afraid that as he had a cold, going out would

[176] Bernini believed the French to be fickle (above, 22 July, and below, 2 Sept.) and Colbert's asseverations on the constancy and steadfast purpose of the King are the opening maneuvers in an intensified campaign to keep Bernini in France.

[177] As appears below, their monastery was near the hôtel Mazarin, but it is otherwise unidentified.

harm him; for this reason he could not go to Maisons. I replied that there was no need to go if he did not want to. The abbé Buti arrived and begged him to go and his son too, but it was useless and he persisted in staying in Paris. Thereupon I wrote a note so that M. Colbert should be informed that the Cavaliere would be able to hold the proposed meeting with him, which had been postponed because of the visit to Maisons. Between four and five o'clock M. Colbert arrived and found him working. The Cavaliere explained that he had permission from the priest, which I had obtained for him,[178] but anyway he had permission from the Pope to work two or three hours on Sundays and on holy days, provided he did not overdo it.

The abbé d'Effiat[179] had arrived a few minutes before; he admired the fine bearing of the King. The Cavaliere said posing was so natural to him that every time he came he took up his place in the same attitude. M. Colbert commented on the extraordinary likeness, saying that even when the King was there one could not imagine a closer resemblance. The Cavaliere answered that it was always unfair to compare a piece of sculpture or even a painting, which has the advantage of natural coloring, with the living thing. To give an illustration he told us of the difficulties that Daniele da Volterra had encountered when he was working at a *Pallas*; he had wished to depict a shield on the arm, which he was copying from a steel model, and Michelangelo came in to find him disgusted and ashamed that he was unable to give to his shield the splendid gleam of the one he was copying. He begged Michelangelo to give a touch or two to this part of the picture. Michelangelo, who thought there was as great a likeness as possible between the painting and the object, agreed to do this on the condition that he should leave the studio for he did not wish to paint in front of him. Daniele went outside; Michelangelo did nothing more than remove the shield from its place. He then recalled the painter, who thought his work looked quite different since he no longer saw it alongside the original. Astonished, he asked Michelangelo how he had done it and what colors he had used. He would not tell him for a little while, then he confessed he had not touched the painting and had only turned the shield round.[180]

[178] Above, 16 Aug.

[179] Jean Coiffier de Ruzé d'Effiat (1622–98), brother of Cinq-Mars, the favorite of Louis XIII, and abbé of Saint-Sernin in Toulouse and of Trois-Fontaines in Champagne. Involved in numerous intrigues, he was exiled in 1677.

[180] Bernini's conviction that imitation in art is an illusion and therefore a perceptual problem has arisen before. Elsewhere, a "trick" of the kind perpetrated here by Michelangelo demonstrates someone's ignorance of art (above, 14 June); in this instance, however, it illustrates the inevitable gap that separates nature and the illusion of reality

M. Colbert asked him if he would like to see some tapestries that were hanging in an apartment upstairs. He agreed and we went up passing through the lower gallery, where we did not stop as there is no bust or statue of value. The Cavaliere only remarked that a light from above was needed to see statues well, and that this gallery was suitable only for busts; in the Pantheon, which was built to house statues of all the gods, there was only one light, from the top of the vaulted roof; for this reason, everything in this temple, whether a statue or a man or woman, appears more beautiful than it would elsewhere.[181] M. Colbert remarked that it was quite the opposite in France; ladies dread nothing like a falling light, which they think gives them hollows round the eyes; they never return to a place where the light gives this effect. The Cavaliere replied that light from above must be correct, for if (in a darkened room) a candle is placed on the floor, the light is so strange that it is almost impossible to recognize other people, or even oneself. In the upper gallery and the rooms adjoining he found only three or four busts and a small number of pictures that were worth anything. He only stopped to look at one by M. Poussin, with full-length figures, of which he remarked, "This is a beautiful picture."[182] I said it must be more than forty years since it was painted. "That doesn't matter, it is painted and colored in the manner of Titian."[183] He then looked at various tapestries, among which were *The Acts of the Apostles* reduced to a quarter or less than a quarter of the size of those belonging to the King.[184] He said, "They are always beautiful, although the execution is somewhat mediocre." There were other tapestries which I said I thought were designed by Holbein; he added, "They show Flemish influence."[185] When we went downstairs, M. Colbert took aside the Cavaliere and his son and walked up and down the lower gallery with them for a good three-quarters of an hour. He then left and the Cavaliere talked with abbé Buti, while waiting for the royal coach, which I had sent for to fetch

created by the artist (above, 6 June). Cf. the similar anecdote in Vasari-Milanesi, VII, p. 657.

[181] Tod Marder has pointed out that Bernini's remarks repeat almost exactly those of Sebastiano Serlio on the light of the Pantheon in the third book of his *Architettura*, fol. 50r.

[182] Bernini's comment is in Italian in the manuscript. The painting to which he is referring has been identified by Blunt (*Poussin Cat.*, no. 124) as the *Inspiration of the Epic Poet*, today in the Louvre, because none of the other paintings by Poussin in Mazarin's collection had large figures.

[183] This remark is in Italian in the manuscript.

[184] Cf. above, 4 June.

[185] The comment is in Italian in the manuscript.

him. Then we went to the church of Saint-Barthélemy.[186] On our way we came upon such a big crowd in front of the house of the Public Prosecutor that we could hardly get past. That morning he and his wife had been assassinated by a couple of thieves to whom they had refused to give the twenty pistoles they demanded.[187]

When we came out of Saint-Barthélemy we took abbé Buti home. On our way back, I said to the Cavaliere that I thought M. Colbert would very much like to keep M. Paolo in France. "Yes," he said, "he talked to me about it and about various other matters on which he was most pressing." With regard to his son, he said that to leave him behind would be to lose him; his education was not finished, he showed great promise but would not succeed if he were away from him. I answered that he must remain himself; the Louvre was his child, which he should cherish like his others; nothing would augment his reputation nor render it more lasting than this great undertaking. He told me that when he left Rome he had explained to His Holiness that the works at St. Peter's would not need him to be present during August; but if he stayed longer they would suffer. Anyway, his presence was not required while they were working at the foundations, though he could be useful when they began to build. I said it was always a good thing for him to be there even if it was not strictly necessary. There had never been a greater opportunity and it was a happy day for both the King and the Cavaliere when they were brought together, for they seemed made for one another. He demurred, saying that he was nothing but that he would always try to do more than he had undertaken; that was his way; he had asked for twenty sittings from the King of two hours each; His Majesty had so far only been four times, yet in a little while the face would be finished; so one could see that he had done more than he had promised. He had such a tremendous admiration for the King that, had he been on the throne thirty years ago, he would have entered his service. If I had seen him working at that time I would have been astonished at the confidence with which he handled marble; now he hesitated at every stroke, for only since then had he learnt that he knew less than nothing, a truth of which he was not aware at that time.[188] I answered

[186] The church of Saint-Barthélemy, on the Ile de la Cité, was originally a Benedictine priory, but later became the parish church of Parlement. Described by Brice (II, p. 459) as "dark and very badly built," it was demolished in 1791. Gabriel Le Duc, Bernini's rival at the Val-de-Grâce, designed a high altar for the church in 1675, but the wooden model built to his design was never executed in stone.

[187] Tardieu, the Public Prosecutor, was married to Marie Ferrier, who had inherited a valuable collection of medals. See below, 26 Sept.

[188] Cf. Domenico Bernini's report (p. 18) that in his very old age the artist said that

that the more man advances by experience the better he realizes that art is more perfect than the artist; that he can never put into matter the excellence of his idea, which is of divine inspiration. But he owed gratitude to God for making him the first man of the century in his art. Those who came after him would have no such splendid opportunity compared with what had been offered him; it was up to his reputation to use it. He said that Father Oliva had employed this argument in persuading him to come; he said he had told him that, just as a great prince had to search for men of talent, so these must always look for the golden opportunity and grasp it when it came along. I said it was our good fortune that he had come to France, for we might have spent millions and the result would only have served to shame us. He said we would have continued with the old design. I answered that even if we had followed it, the same criticism could have been made, and he could see from the things that had been done elsewhere how money had been wasted; this reflection should make him feel that he ought to stay. He explained to me that he had work in Rome for a year; he would have nothing to do here while the foundations were being laid; he might well return. He knew himself and his own constitution; God might allow him another ten years of life; if he returned to France it would be for good and he would bring his wife and children. He could do many things in ten years. I told him that the King was the first representative of the monarchy to love the arts. He asserted that a king might have no feeling for the art or science in which a man excels, nevertheless that he should all the same try to make him enter his service, for his reputation would be greatly enhanced. François I, I told him, had summoned Leonardo to his court and had grown so to love him that he had died in the arms of this great prince.[189] François I thought the world of him although he was a man who had done little and had abandoned himself to thought and speculation. "Further," he said, "he would grow old over one work."

"in his youth he never struck a false blow." Both his biographers also tell an anecdote recalling one told of Michelangelo (Vasari-Milanesi, VII, p. 140) in which the aged Bernini, seeing again after many years his early statues in the Villa Borghese, laments the fact that his art had profited so little by his long life (Baldinucci, *Vita*, p. 12; Dom. Bernini, p. 19).

[189] The story that Leonardo died in the arms of Francis I (Vasari-Milanesi, IV, p. 49), which became a popular subject for paintings in the 19th century, is now considered false, since on 2 May 1519 when the artist died at the château de Cloux (today Clos-Lucé) near Amboise, the King was with the court at Saint-Germain-en-Laye. However, as earnest for the status of the arts and royal solicitude for their prosperity, the tale already appears in the petition for the creation of the Royal Academy of Painting and Sculpture presented to the King by Martin de Charmois on 20 Jan. 1648. See Thuillier, pp. 190–91.

I agreed; proof of it is that there was nothing remaining by him here save a few unfinished pictures.[190] The Cavaliere told me how he would take six years over a head of hair. I added, "And Correggio in less than an hour and with four strokes of the brush would create the same effect, given that both works were studied at the distance required to see them properly."

25 AUGUST

✥ St. Louis. In the morning I found the Cavaliere working at the portrait. "In virtue of the permission granted me by the priest of Saint-Germain," he said. I asked him when he wanted the coach. He replied it would do at twenty-two o'clock.[191] I returned after dinner with Mme. de Chantelou, whom he greeted with his usual good humor, and told me that the comte d'Harcourt[192] had only just left and he had been delighted to receive a man of such high reputation. Mme. de Chantelou began to talk to him but he understood nothing she said nor she, him. So the conversation did not last and she went away. In the evening we went to the Jesuits' church in rue Saint-Antoine.[193] On our way back he asked me how M. d'Harcourt was addressed. I said he was called *His Highness*. "Heavens, I did not know that," he exclaimed. "I only called him *Excellency*," whereupon he begged me to convey to him his apologies, or at least to have them conveyed through his secretary. "I shall call upon him and address him as *Highness*," he added. He said he would like to see the portraits in wax that the Legate had described to him. I said they were done by a man named Benoît,[194] and he lived in the same neighborhood as the abbé Buti. "I should imagine," he said, "that these are for feminine taste[195] but still I should like to see them before Friday."

[190] With the exception of architecture, little is certainly known about Leonardo's activity in France. Several months before his death, he showed Cardinal Louis of Aragon three paintings, two of which can be identified as the *St. John the Baptist* and the *Virgin and Child with St. Anne* in the Louvre. The third picture, a portrait of a Florentine lady, is now lost and no record of it survives.

[191] In Italy the 24 hours of the day were counted from sundown to sundown.

[192] That is, Henri de Lorraine, comte d'Harcourt.

[193] The church of Saint-Louis, designed and built by the Jesuit architects, Etienne Martellange and François Derand (after 1629). Louis XIII, assisted by the Archbishop of Paris, laid the cornerstone in 1627 and was present in 1641 when Cardinal Richelieu said Mass in the choir of the church. In 1802 when the neighboring church of Saint-Paul was pulled down, the parish was transferred to Saint-Louis, which took on its present name Saint-Paul-Saint-Louis.

[194] Antoine Benoît, or sometimes Benoist (1638–1717), a painter and sculptor of portraits in colored wax, valet de chambre of the King, and a member of the Royal Academy (1681).

[195] The phrase is in Italian in the manuscript. Bernini probably doesn't mean that

26 AUGUST

❧ On my arrival at the Cavaliere's, I learnt that the King had appointed M. Colbert Treasurer of the Order of the Saint-Esprit, which office M. de Nouveau had held;[196] and that the Duke of Mantua[197] was dead. The Cavaliere worked the whole morning at the bust without anyone coming. After dinner the Nuncio and the Venetian ambassador came to see him. The Queen, in spite of her promise, did not come. In the evening we went to the Feuillants. The Cavaliere, after he had been sometime on his knees, was overcome by faintness and was forced to go and sit on the steps near the altar rail. When he got back he was unable to walk and we carried him to his bed. But he said it was nothing; and so I left him.

27 AUGUST

❧ He worked during the morning and the evening at the bust, and M. Mattia worked at the design for M. de Lionne's house. The Nuncio came and was followed by M. d'Albon,[198] the comte de Gramont, and Mme. de La Baume. The Nuncio thought she was the princesse de Monaco[199] and paid her many compliments, which ceased when he realized who she was. In the evening we went to Benoît's house to see the portraits in wax, but found no one at home. I had asked the Cavaliere in the morning if I should let him know, so that he would be there, but he had said it was not necessary.

28 AUGUST

❧ During the morning he worked as usual. At two o'clock M. Colbert came while the Cavaliere was still asleep. He was wearing the blue

such portraits are women's work, like the Venetian lace he used as a model for the collar in the bust of the King (below, 21 and 22 Sept.), but that they would appeal to the same feminine taste as the King's bedroom (above, 23 Aug.), since when he actually sees Benoît's portraits he remarks that they would give pleasure in the family circle (below, 14 Oct.).

[196] The chivalric Order of the Saint-Esprit was founded in 1578 by Henry III, who named it in memory of Pentecost, 1574, the day on which he had succeeded his brother, Charles IX, as king of France. In its final state the Order was limited to one hundred members, who had various emoluments and privileges. Colbert assumed the position vacated by the death two days earlier on 24 August of Hiérôme de Nouveau, surintendant des postes et relais de France.

[197] Carlo III Gonzaga (1629–65), who had become Duke of Mantua on the death of his grandfather, Carlo I, in 1637.

[198] Gilbert-Antoine d'Albon (d. 1680), comte de Chazeul and chevalier d'honneur of Madame.

[199] Catherine-Charlotte de Gramont (1639–78), Superintendent of the Household of Madame (1673) and wife of Louis Grimaldi (1642–1701), prince de Monaco, who became a peer and duc de Valentinois in 1668 and was the French ambassador in Rome from 1698 until his death.

riband and told M. Mattia that he had done no work yet because he
had so much to do with this business, and he pointed to the Cross of
the Saint-Esprit. He greeted Signor Paolo, who asked him if he should
awaken his father. M. Colbert told him not to. Meanwhile I spoke
to him about some private affairs; he asked me to send him a note of
them and then left.

In the evening M. de Ménars came; he brought a little picture of
the *Annunciation* to show it to the Cavaliere who said it was by Albani.
He asked for a word in writing from him, which he gave, saying,
"This pleases me very much."[200] M. de Ménars said to me in private
that various other designs had been made for the Louvre, and he did
not know whether the Cavaliere's would be carried out, as differences
had arisen between the French and papal courts and it was feared that
the Italians might abandon the work after they had started. M. Du
Metz and he looked at the plan of the Louvre, M. Du Metz maintaining
that the square in the front of it would be too small. When they left,
the Cavaliere mentioned that it was the day for despatching the mail.
I took the abbé Buti home and on our way asked him about these
misunderstandings with Rome. He said we in France did not know
how to deal with the Pope; he should be treated like a child and
beguiled with an apple or a sugarplum: in this way one could get
anything one wanted from him, big things in exchange for little ones;
his temperament was such that he grew angry over trifles and would
charge in if he saw fists being raised; indeed, one had good cause to
say, "Maximus in minimis, minimus in maximis,"[201] and he repeated
to me the lampoon that at the beginning of his pontificate had been
stuck on the *Pasquino*. Inspired by the mountains in his coat-of-arms,
it ran: *parturient* and then the parody of the famous line, *parturient
mures: nascitur terribilis mons . . .*[202]

29 AUGUST

✹ I was unwell.

[200] This comment is in Italian in the manuscript.

[201] That is, "Greatest in the least things, least in the greatest."

[202] The famous line being parodied is from Horace's advice to a young poet not to
begin too grandly, for what can possibly live up to such promises: "Parturient montes,
nascetur ridiculus mus" (*Ars poetica*, 139), which might be read, the mountains will go
into labor and bear what?—a ridiculous little mouse. In this pasquinade on Alexander
VII Chigi, who is identified with the mountains in his coat-of-arms, the mice bear the
mountain—an equally absurd affair. The line from Horace was also used in an anon-
ymous diatribe (Bauer, p. 46) against Bernini's statue of the Emperor Constantine at
the foot of the Scala Regia, which was completed for Alexander VII. There is no need,
says the author, for the mountains to be parturient, since from those of the Chigi has
come a topic (*topos*, playing on *topo*, the Italian word for mouse) for all the satires.

30 AUGUST

🖎 The Cavaliere sent me a message to ask me to order the royal coach for seven o'clock because he wanted to congratulate M. Colbert on his new appointment. M. Colbert received the Cavaliere with smiles and in reply to his compliments said that he hoped he would be tempted to stay in France when he saw how the King repaid those who served him; he could say quite truthfully that he had not expected this honor, nor asked nor hoped for it. The Cavaliere replied that he had great influence with the King.[203] And repeating the remark, said that it was his merit that had earned it. M. Colbert replied that he (the Cavaliere) had even greater merit. He (Colbert) served His Majesty in a post where he had had trouble to start with because his predecessors had made a point of creating confusion, but it was really so easy that he was annoyed if it took up more than one day in the week; there were a number of people in France who could do his job just as well as he did, but only the Cavaliere was capable of interpreting the grand ideas that the King had in his mind. It seemed as if they were made for one another, and this fact and his own interest should determine him to stay here to see his plans carried out. The Cavaliere answered that if it had been possible he would have done it out of love for the King, for his feelings were so strong that although he could not remain more than half an hour in the morning in prayer without some support, he could stand for five whole hours applied to his work without feeling exhausted, using his arms and his whole body in handling chisel and hammer, strengthened by his devotion to His Majesty.[204] However, the works he had begun in Rome made it impossible for him to remain here; he repeated what he had said on all other occasions, that he had assured the Pope that his presence was not necessary during August as his brother could supervise his work for him; when His Majesty had asked him to do his portrait, he had considered it improper to refuse and had thought that he could finish it in two extra months. He had asked the King for twenty sittings, each of one or two hours; his character was such that he always liked to do more than he promised; of this they would surely see the proof; when he had been back to Rome to finish his work there, he might well return. Then M. Colbert said that it was time to give orders for the building of the Louvre; he would come to see him in the palais

[203] Bernini's reply is in Italian in the manuscript.

[204] Baldinucci (*Vita*, p. 72) said of the Cavaliere: "When not distracted by architectural projects, Bernini spent up to seven straight hours without resting when working in marble: a sustained effort that his young assistants could not emulate." Cf. too, Dom. Bernini, p. 179.

Mazarin to arrange what had to be done. The Cavaliere took his leave, and M. Colbert left him at the door of his office, saying he did not stand on ceremony with him.

The Cavaliere went back to the palais Mazarin and M. Colbert arrived soon after and expressed his astonishment at the progress he had made with the portrait. He said the King had not come during the past week because he had taken medicine, but he was coming tomorrow. Some time passed in ordinary conversation. Then M. Colbert told me he had sent for my brother and M. Madiot and asked me to see whether they had arrived. I went into the antechamber, and while waiting for them, talked to M. de La Motte and MM. Perrault, Mazières, and Bergeron.[205] One of the Cavaliere's young attendants, who had remained in the room with him and M. Colbert, was sent away leaving them and M. Paolo alone for half an hour.[206] When they came out and M. Colbert saw my brother and Madiot, he suggested we should all assemble in a room where there was a table. I told him there was one in the room he had just left, so we went back and he called me and the other gentlemen in. We drew up our chairs; he sat at the end of the table with the Cavaliere on his right, myself next to him, MM. Paolo and Mattia opposite, my brother and M. Madiot, one on each side. M. Perrault whispered to M. Colbert that M. de La Motte was in the other room. He made a face and shook his head, showing that he did not wish him to come in.

Then M. Perrault sat down at the other end of the table with pen, paper, and ink; a moment later the abbé Buti arrived and sat down beside M. Paolo. Then M. Colbert spoke, saying we must consider all the possibilities and examine the best means of succeeding in an undertaking of such importance as the Louvre: as the Cavaliere himself could not remain in France to supervise its construction, he had chosen my brother to take his place; he would go down to the site from time to time to relieve M. Mattia, and he himself would too, most gladly, if he had the time. M. Madiot would attend regularly to see that all the materials were of the quality they should be. Now was the time to consider in which way the work should be organized.

The Cavaliere said that work by the day was best; his interest

[205] André Mazières and Antoine Bergeron, both masons, were the entrepreneurs or contractors for the Louvre. They also worked together on the Apartment of the Queen Mother under the Petite Galerie of the Louvre (1661) and on the royal châteaux at Versailles and Fontainebleau.

[206] According to Paolo's report (below, 7 Sept.), Colbert was again urging them to remain in France.

was to see that the Louvre was properly built, otherwise his design would not succeed. M. Colbert agreed but said there was one great disadvantage; there could be a great deal of swindling as no one felt any loyalty under those conditions, also there could be no planning, as there was in the case of contracts being given for piece-work. For some time everyone argued; the Cavaliere said there was the same difficulty in Rome, where some made contracts but supplied all the lime. M. Colbert replied that there could be swindling even then; for instance, in the artillery a lieutenant had been made responsible for despatching 400 hundredweight of powder and had only sent half that quantity; if it had been brought in one lot, at least it would have been distributed, but, as he said, half had been held back, and the same thing might happen with the lime, and therefore in his opinion we should adhere to the method of making contracts; however, if the Cavaliere wished it to be arranged otherwise, the King would no doubt consent.[207] The Cavaliere said he only wished to see the work well carried out; that was why, not trusting the workmen here, he had sent for some from Italy. Then we discussed mixtures of lime and sand, whether the proportion should be a half or a third, the quality of these materials, and how the French stuff compared with the Italian. M. Colbert asserted that so great was his desire for the Louvre to be as perfect as possible, that should the Cavaliere say that it could not be built without pozzolana, he would make it his business to summon and send forth all the King's ships to collect it from Italy or even from Egypt and wait six years before beginning the Louvre, for the King wished to spare neither time nor money. Finally they decided to put up two walls as a test, one built according to French methods, the other according to Roman, then a choice could be

[207] Then, as now, getting something built well at a fair price within a reasonable amount of time was not always easy. Charges of corruption and profiteering were frequent, delays constant, and shoddy workmanship was all too common. In the *Journal* alone, Sublet de Noyers is suspected of lining his own pockets (below, 6 Sept.); the men excavating the foundations of the Louvre turn over no more dirt than hens scratching (below, 2 Sept.); and a building by Le Vau is said to be falling down before it is finished (above, 23 Aug.). As described here and below (6 and 7 Sept.), there were basically three ways of organizing and paying for large building projects: by contract, by piece-work, and by the day. When the work was paid day by day, the architect assumed responsibility for the construction, whereas work contracted for at an agreed price placed this responsibility on an independent contractor. Work paid for by the piece represented a compromise between the other two. Each had advantages but each was also susceptible to abuse. As an architect, Bernini naturally preferred work paid day by day because it ensured him maximum control over the execution of his design and his opposition to the contract system was well known in Rome (*Bernini in Vaticano*, p. 318, col. 1). Colbert, who had to provide and disburse the money, favored the contract system because it fixed both costs and accountability.

made.[208] It was decided to make a cut into some old and some modern pieces of masonry to see the strength and quality of the lime. M. Colbert then had MM. Mazières and Bergeron summoned and ordered them to have materials brought the next day to the back courtyard of the hôtel Mazarin and to have thirty or forty workmen at the Louvre to prepare the foundations. He commanded M. Perrault to notify M. Du Buisson to bring his title deeds but said that demolition of the Petit-Bourbon would have to wait as the King's furniture was there. Then we rose as it was nearly one o'clock.

After dinner the Cavaliere said he would like to go to the Gobelins but I told him that as it was Sunday we should see nothing. He said he might see M. Le Brun and asked me to find out if he was there, which I did, without any success, so the Cavaliere worked with M. Mattia and later we went to the Feuillants.

On our return he asked me who were all these *sovrastanti*.[209] I replied that one was my brother who had not sought this work; his temperament would certainly not incline him to solicit any favor, for he asked nothing more than peace and the distraction he found in his library; his constitution was delicate and further undermined by study, application to the science of mathematics, and a sedentary life. As for M. Madiot, he was not experienced like my brother in theory, but he knew much more about the practice of building, having a thorough knowledge of materials. He was very trustworthy and when M. de Noyers had been Superintendent of Building he had great confidence in him; further, he was an engineer and had experience of fortifications. He asked me to send for him, which I did, and he came together with my brother. The Cavaliere had a long discussion with them on the quality of different stones, lime, sand, on vaults and the quality of the masonry. He asked whether vaulted ceilings were built on the second floor in this country. M. Madiot said no. The Cavaliere replied that doubtless that was because insufficient height was given to the buildings; if they were made higher, vaulted ceilings could be made on the second floor as on the first, for the walls, with their strength increased by the additional height, would be able to resist the thrust of the vault.

31 AUGUST

🎔 My brother and I went to see the Cavaliere. He told my brother that Signor Mattia had gone to the Louvre some time ago to begin the

[208] This trial of the French and Italian methods of construction is described by Perrault, *Mémoires*, pp. 64–65.

[209] That is, "superintendents."

setting out of the foundations, so he left immediately to go there. A little later Vigarani came. The Cavaliere, seeing him with me, came up without looking in his direction and told me what I should say to him when I saw him—he was young; he must work hard and prepare everything for when the opportunity presented itself, so that later he should not be overcome by work—all the time not looking at him; then suddenly he turned his head and, pretending to be surprised, said good day to him. Vigarani said he had come to ask him if he would be so kind as to give his opinion on a picture which M. Nocret[210] was bringing, which Le Brun said was by Michelangelo and Errard said was by Raphael. The Cavaliere said he would look at it with pleasure; provided it was by the one or the other or by any of the seven or eight great masters, he hoped to be able to attribute it correctly. There were a number of little-known Lombards with whose manner he might not be acquainted. This reminded him of a bit from one of his plays: a girl disguised herself as a boy and meeting someone she knew was afraid of being recognized. Someone asked her, "Do you know yourself?" and the girl without wavering replied, "If knowing oneself is the most difficult thing, I do not know myself."[211]

After dinner he worked at the portrait while waiting for the King. But he did not come. Nocret brought the picture, which he said he had got in Portugal, when he was there with M. de Cominges.[212] It was a *St. John in the Wilderness*. We put it in the other room in the best light available. Before the Cavaliere saw it, I wanted to give my opinion. I examined it and saw that it had neither the drawing nor the painting of Raphael; on the contrary, it leaned more to Michelangelo's style; it was rather well painted and might therefore be by Sebastiano del Piombo. Then I called the Cavaliere and told him what I thought; he agreed with me. But he whispered to me that Michelangelo would never have drawn a foreshortened thigh like the one there. He praised the rest of the picture and was most cordial to Nocret.

In the evening he did not wish to go out and asked me to go to the Louvre to see what had been done. I went over with my brother and found M. Mattia there, who pointed out to us that the layout made by Le Vau was faulty in two different places on the main façade.

[210] Jean Nocret (1612–72), a painter, was a valet de chambre of the King (1649) and a member of the Royal Academy of Painting and Sculpture (1663). In 1642–43, he had copied Parmigianino's *Virgin with the Sleeping Infant and St. Joseph* (Naples, Gallerie Nazionali di Capodimonte) for Chantelou (Poussin, *Correspondance*, p. 205).

[211] The exchange is in Italian in the manuscript.

[212] Gaston-Jean-Baptiste de Cominges, or Comminges (1613–70), Captain of the Queen Mother's Bodyguard (1663), who had been Ambassador Extraordinary to Portugal in 1657.

The corner angle of return on the side towards the Oratoire is not equal to, nor does it correspond with, the other two, that is to say, the one on the river side and the one near the lodgings of the maréchal de Gramont; secondly, the chief entrance of the Louvre, besides not being exactly opposite the other one already built, has four columns, while the other only has two. We also noticed other faults in the new wing near the Bourbon where there are parts that do not correspond.

❦ *September* ❦

1 SEPTEMBER

❦ M. Mattia marked out the corners of the façade. M. Perrault and his brother came to see the portrait and told my brother, who was there, that cartloads of ashlar and roughstone had been brought into the courtyard at the back of the hôtel Mazarin with various kinds of sand and lime, so that the proposed tests could be carried out. I told the Cavaliere who said to me, "This is a miracle," because he believed we could not be punctual in France. M. Perrault asked why he said that. My brother intervened, saying he had said, "This is no miracle," lest he should be forced to enlighten him.[1] Then all of us, except the Cavaliere, went into the courtyard where we found that in one part they were preparing trenches where the lime was to be slaked according to French methods, and in another, according to Roman methods. M. Mattia thought it was of excellent quality and the ashlar also, but he said the roughstone was too damp and earthy, which might prevent it from taking well with the lime. Sites were chosen where the walls were to be erected. They then left and I stayed to dinner with the Cavaliere.

Nocret's picture was mentioned, and he said to the abbé Buti, who was also dining with him, that he had met no one with a better knowledge of pictures than M. de Chantelou; it was I who had said who the picture was by; I had been more discerning in this matter than all the painters and sculptors. He told us he had dreamt the Pope was dead.

After dinner, the abbé Buti and I discussed the numerous opinions that had been given about the designs for the Louvre, and the rumor going around that they were not going to be carried out. He told me

[1] Bernini had said in Italian, "è meraviglia." Chantelou's brother changed it into the negative, "non è meraviglia."

that the Nuncio had been the day before to tell the Cavaliere this; he had been told that Le Vau, Le Brun, and Mansart had got together to make another design. I pointed out that these three were not even friends. Whereupon he quoted: *Et facti sunt amici in illo die, Herodes et Pilatus*,[2] but he added that the Cavaliere's design was of such beauty that he had only to take the device of Tassoni, a pen and inkstand, with the word *fate*.[3] Then turning to another subject he expatiated on the success of M. Colbert. It was marvelous, really, considering what Vittorio Siri had told him, who had himself read the letter in which M. Colbert had resigned from Cardinal Mazarin's service; another man had held the position when times had been bad and the Cardinal subject to persecution, but he had died, which was fortunate for M. Colbert; again it was a piece of luck for him to have my brother to help with the building of the Louvre; as he had written about architecture and was known to be a clever man, he should be protected from blame concerning anything to do with the execution of such a vast work. He added a number of other things about the death of Cardinal Mazarin and the reason for M. Colbert's success, saying he was cleverer than the other two; His Eminence had put a memoir into Colbert's hands and told him only to give it to the King a month after his death; this showed that the Cardinal had more confidence in him than in M. Le Tellier or M. de Lionne.

At about four o'clock we heard by a special messenger that the Pope was near death. M. d'Albon, Mme. de La Baume, and M. de Jussac[4] came to see the portrait. The Nuncio also arrived. They discussed the news about the Pope and then they all left to take a drive. I said to the Cavaliere that if the Pope was dead, he must remain with us. He replied with feeling that it could not be, unless the King put him in prison; the work on the Cathedra Petri necessitated his return, more even than his wife and children; it was absolutely impossible for him not to go back, but, as he had told me many times, he might return to France a year later. He was greatly attached to the King and his work here. He said the architects ought not to bear him any ill will; had the Pope wanted a building in the French style and sent for a French architect he would not have said anything; the King had

<hr>

[2] That is, "And on that day Herod and Pilate became friends," from Luke 23:12.

[3] That is, the imperative of *fare*, "to make, do." Alessandro Tassoni (1565-1635) a poet and critic whose *Considerations on Petrarch* (1609) adopted a harsh attitude toward the earlier poet. His chief poem was the mock-heroic *Secchia rapita*, or *Rape of the Bucket* (1622), which took to task the debilitating civil wars fought between neighboring Italian cities.

[4] Claude de Jussac (d. 1690), Equerry-in-Ordinary of the duchesse d'Orléans, capitaine des archers de la porte de Monsieur, Governor, and then First Gentleman of the Bedchamber to the duc Du Maine, son of Louis XIV and Mme. de Montespan.

wanted a palace in the Roman style and in his opinion they ought not to complain.

2 SEPTEMBER

❧ M. Mattia brought in a piece of mortar from the demolished Provost's Tower, which he considered was of excellent quality; they remarked that it was made from river sand. Then he told him that the men working on the foundations did nothing, they turned over no more earth than hens scratching about. The Cavaliere asked me to tell M. Colbert, which I did immediately, just catching him before he left for Versailles. He said my brother should look over this matter. I pointed out that he was not yet known and had no authority, so then he suggested M. Madiot. I also told him that they had not brought enough material into the base-court of the palais Mazarin.

After dinner some mortar from the new buildings of the Louvre was brought in, taken from two or three different parts of the river front; it was found to be no good. M. de La Vrillière came again to see the bust and had a man named Patel with him. He also asked to see the Louvre designs which I showed them when the Cavaliere had given his permission. As Patel talked about them very pertinently, I asked M. de La Vrillière who he was. He said he was just a man he knew, nothing more. When they had gone someone who knew him said it was Patel, one of the contractors for the Louvre.

In the evening the design for M. de Lionne's staircase was brought back to M. Mattia, as they wanted some more enlightenment on it. When the Cavaliere saw this he left his work and, snatching a pen, wrote across the bottom of the plan that it would be better to carry out the first one. The abbé Buti thought he was angry, but the Cavaliere said he was not, that there was little difference between them and it would save a great deal of demolition. He insisted on it for some time, saying that what he had done was only to show M. de Lionne that he did not wish to spare himself trouble in his service; he could not consider him the equal of the King, but after His Majesty, he was the person he would have most liked to serve. The drawing was left with M. Mattia and then we took the abbé Buti back. When we were in the coach he said he realized more and more that the nation was fickle; he noticed that even the King's enthusiasm for his portrait seemed to have grown less, and instead of the King being eager to see it finished, it was only he, Bernini, who still had some interest left, and many other things besides. As regards the Louvre, everything should have been prepared a month ago, and the buildings that were not to remain should have been demolished; but he would never mention it again even if he stayed here all his life, for it did not befit

him. I excused the King, saying he had not been able to come on account of the waters he had had to take, and as for the Louvre, I said M. Colbert was overburdened with business.

3 SEPTEMBER

❧ M. Mattia went up to the towers of Notre-Dame and brought down a piece of the mortar of which they are built, which was found to be made from river sand. He told the Cavaliere that he had talked to Mazières about it, and they had both agreed that it was the best material but would cost too much to provide. Then, obeying the Cavaliere's orders, he worked at making several changes in the plan of the façade of the Louvre so that there should be a hall for statuary and rooms for pictures.

The same morning M. Rosteau brought M. Villedo[5] to meet the Cavaliere. He looked at the drawings for the Louvre and mentioned the custom which they had in Rome of washing down their masonry; he said he did not disapprove of it; on the contrary when it rained on the walls under construction here, he was always very glad because it bound the materials together and made the texture harder. Dinner time arrived and I stayed to eat with the Cavaliere. Then, while he was resting, I went downstairs and found that M. de Princé[6] had arrived with three or four guards, who had taken possession of the doors. He told me the King was coming and he had orders to let no one come in except the duc de Créqui, that I was to awaken the Cavaliere, which I did not do; and in fact the King did not come for an hour and a half. We talked together and he told me that the Cavaliere, while pointing to the bust, had said to someone, "This is beautiful; in the original it is actually ugly."[7] I insisted that this was an invention; the Cavaliere considered the King's face as the most comely and noble he had ever set eyes on. At this moment the Cavaliere came down and intimated that he would be happy if, when the King arrived, I would point out how some locks of hair in the portrait showed through others; it was a most difficult effect to achieve in marble. His Majesty arrived at two o'clock and was accompanied only by the duc d'Orléans, the duc de Gesvres, and the comte de Bellingham.[8] A little later M. de Bellefonds, the duc de Noailles, and

[5] Michel Villedo, a master mason (1654), and later Master of Masonry in the King's Works, who was Le Vau's usual contractor.

[6] At this time an officer in the King's guards, M. de Princé (d. 1708) later became lieutenant-colonel du régiment Dauphin, brigadier d'infanterie (1695), and maréchal de camp (1704).

[7] Quoted in Italian in the manuscript.

[8] Henri de Beringhen, comte de Bellingham, First Equerry of the Small Stables of the King.

M. de Lionne arrived, one after the other. The duc d'Orléans asked me to convey to the Cavaliere that he had not been to see the portrait until now because he had had to undergo some treatment. This I did. He commented on one or two details in the likeness and the King asked me to tell the Cavaliere what he had said. His Royal Highness intervened, saying to the King, "Sir, you could tell him, yourself, what I said." "Yes," replied the King, "but I don't want to put it badly." The duc d'Orléans then whispered an enquiry as to whether I had spoken to the Cavaliere about the design for Saint-Cloud. I replied that I had, and he had promised to do one and we were going to make a special excursion for the purpose. The Cavaliere continued to work at the mouth. Then his Royal Highness left and meanwhile I took the opportunity of pointing out to the King what the Cavaliere had asked me to show him. Then I presented to His Majesty an account of the services rendered by the officers of his Household under my direction to the Cardinal Legate, giving him all the details of his stay in France, at least all those that had been brought to my knowledge. His Majesty told M. de Bellefonds that it should be inscribed in the office journal, and told me to bring it to his bedchamber that evening. Just as His Majesty was going out, the Cavaliere showed him a bit of mortar from the Provost's Tower of the Hôtel de Ville which, he said, was of excellent quality and made with river sand. Then I told the King about the two walls that were being erected at the palais Mazarin as a test of the comparative strength of the French and Roman methods.

His Majesty stopped for a moment to watch M. Mattia and asked me what he was working at. I replied that he was trying to lower the height of the main floor in the elevation of the façade of the Louvre in pursuance of M. Colbert's instructions, so that it should be more suitable to the French climate. Then the Cavaliere presented to him two Italians, whom he had sent for from Rome: one was a stone cutter, the other a master mason.[9] His Majesty asked what they would do at the Louvre. I said, "Follow their profession, and further, see that the work was carried out according to the wishes of the Cavaliere." Then the King left, saying, "Tomorrow, at the same time."

M. de Saint-Laurent[10] came with Mlle. de La Varenne,[11] M. Sain-

[9] The stone cutter was Bernardino or Bellardino Rossi, the master mason, Giacomo Patriarco. See Guiffrey, *Comptes*, cols. 105–6, 224.

[10] Nicolas-François Parisot (d. 1687), sieur de Saint-Laurent, introducteur des ambassadeurs in the Household of Monsieur and tutor of the duc de Chartres, later duc d'Orléans and regent of France.

[11] Lalanne suggested that Mlle. de La Varenne might have been the daughter of the Varenne-Andrieu, who was a femme de chambre of the Queen Mother.

tot,[12] and his brother, the abbé.[13] The Nuncio had arrived earlier. Mlle. de La Varenne was asked to sing, which she did with her usual skill, and the Nuncio and the Cavaliere were much moved. When they had all gone, we went to the Feuillants and then drove along the riverside. The Cavaliere said it was the fifth time the King had been, and he need only come as many times again. In the evening, I was at the King's supper and His Majesty, referring to a one-eyed fellow, said in Italian, "E cieco d'un occhio." The duc d'Orléans asked me if there were no other word. I said *guercio* was the right expression. His Majesty remarked in a bantering tone, "Chantelou is acquainted with all the subtleties of the language; this afternoon he aspired to some wonderful phrases." I answered that I only tried to make myself understood by the Cavaliere. Then the King said of Bernini, "He praises very little here," and I rejoined, "He also finds little fault; he has seen nothing yet worthy of praise because he has been hard at work since he arrived in France." His Majesty asked me what he thought of Vincennes. I said he had admired it very much and as it had grown late before we had finished looking at it, he had asked to go back another time. I then asked the King to whom I should give the account for the Legate's visit. He told me to take it to M. de Niert.[14] When I gave it to him, he asked me if it were true that on the day when the Cavaliere had visited the King in bed he had remarked, of the royal apartments, "There are no rooms here to masculine taste."[15] I retorted that what he had said had not been heard correctly, or had been distorted by someone who wished to do him harm.

4 SEPTEMBER

The abbé Buti came to the Hôtel Mazarin and I told him what the King had said about the Cavaliere in the hope that he would pass it on, and the Cavaliere, when he heard, might be readier to look at

[12] Nicolas II de Saintot (1632–1713), who succeeded his father as Master of Cere-monies (1655) and in 1691 purchased the office of introducteur des ambassadeurs.

[13] Etienne de Saintot (d. 1709), conseiller au Parlement de Paris, abbé de Ferrières (1669), and Prior of Saint André de Vienne.

[14] François-Louis de Niert (1647–1719), son of Pierre (1597–1681), the well-known singer and musician. At five years of age he received the reversion of his father's office as premier valet de la garde-robe and later succeeded him as premier valet de chambre.

[15] The statement attributed to Bernini is in Italian in the manuscript. Cf. Vigarani's report to Modena: "I know that the other day he entered the new apartment where His Majesty, having had his foot bled, was in bed that morning. His Majesty has had the apartment filled with a great quantity of furniture, *lasinetti* (?), filigrane, and other furnishings, and Bernini was somewhat disdainful of all that richness as not being suitable to the grandeur of the King. But instead of being taken in good part, it has been taken so badly that this too has done him great damage" (Rouchès, no. 224; Fraschetti, p. 354, n. 1). For Chantelou's account of the event, see above, 23 Aug.

things and admire them. The abbé told me that it was Le Brun who spread these rumors because the Cavaliere did not praise his pictures; he added that, in fact, they were worthless and did not deserve it; he painted like a Fleming. I said at least it must be admitted that he had originality. "This originality is only taken from Jabach's drawings," the abbé Buti replied. "In Rome there is an artist by the name of Carluccio,[16] who is a great deal more remarkable." While we were engaged in conversation, the King arrived, having with him only the comte d'Armagnac and the duc de Gesvres; the comte de Bellingham arrived a little later, and the abbé Montaigu. The Cavaliere worked at the mouth. To be successful in a portrait, he said, a movement must be chosen and then carried through; the best moment for the mouth, is just before or just after speaking, and he was trying to catch it. He also worked at the cheeks. During the sitting the King got up from time to time to see how he was getting on, and then returned to his place.

The abbé Buti told the King that the Cavaliere had been given a delightful treat: Mlle. de La Varenne had sung for him, which had moved him greatly. "There are many others who sing better than she does," replied His Majesty. The abbé Buti asserted that the late Luigi[17] always said that he had never heard anyone sing as well as she did. The Cavaliere also worked at the eyebrows and the forehead and remarked that His Majesty was wearing his hair in the same style as the first time he had drawn him. The abbé Montaigu thought that the lock of hair in the middle of the forehead was not right; he had put it there when M. de Bellefonds had criticized the uncovered forehead;[18] in his opinion the King would never have it arranged like that, for should he one day have less hair, he would wear a wig.

5 SEPTEMBER

❧ The Cavaliere worked as usual and in the evening went to the Academy.[19] MM. Du Metz, Nocret, and de Sève[20] came to meet him at the entrance, as representatives of the Academy. The Cavaliere first

[16] That is, Carlo Maratta (1625–1713), "who because of his tender years was called Carluccio d'Andrea Sacchi [his master], instead of Carlo" (Bellori, p. 75).

[17] Almost certainly Luigi Rossi (1598–1653), the Italian composer with whom Buti had collaborated as librettist for the *Orfeo* of 1647.

[18] Above, 22 July.

[19] Since 1661, when its rooms in the Louvre were given to the Royal Printing Press, the Academy of Painting and Sculpture had been installed in the palais Brion, which was part of the Palais Royal. It remained there for thirty-one years, before returning to the Louvre in 1692.

[20] Either Gilbert de Sève, a foundation member of the Academy, whose paintings at Vincennes Bernini had admired (above, 16 Aug.), or his brother, Pierre (1623–95), a member of the Academy since 1663 and in 1665 an associate professor.

saw the studio reserved for drawing from the model; the models, when they saw him, immediately assumed poses that had been chosen for them. He stayed a little while and then passed into the hall where lectures are given. They offered him the place of honor, but he did not want to sit down. There were a great number of people; M. Héliot,[21] conseiller de la cour des aides, was there. The Cavaliere glanced at the pictures round the room: they are not by the most talented members. He also looked at a few bas-reliefs by various sculptors of the Academy. Then, as he was standing in the middle of the hall surrounded by members, he gave it as his opinion that the Academy ought to possess casts of all the notable statues, bas-reliefs, and busts of antiquity. These would serve to educate young students; they should be taught to draw after these classical models and in that way form a conception of the beautiful that would serve them all their lives.[22] It was fatal to put them to draw from nature at the beginning of their training, since nature is nearly always feeble and niggardly, for if their imagination has nothing but nature to feed on, they will be unable to put forth anything of strength or beauty; for nature itself is devoid of both strength and beauty, and artists who study it should first be skilled in recognizing its faults and correcting them; something that students who lack grounding cannot do. To prove his point, he said that there were things in nature that appeared to stand out and yet ought not to, and vice versa. A student with a developed sense of design omits what should not be there and puts in what should be there but is missing. He repeated that a youth is incapable of doing

[21] Héliot, a counsellor in the third chamber of the cour des aides, the court concerned with royal levies, was said to be a collector of contemporary paintings.

[22] Drawing after sculpture had already been recommended by Alberti (De pictura, p. 100) in the 15th century, but he seems to have thought of it simply as a means of approaching changeable nature in a stable and therefore more accessible state. In the 16th century, when the strict imitation of nature no longer seemed a worthy goal— either because resistant matter must inevitably be imperfectly formed, or because with age nature herself had become enfeebled, or because, as Bernini suggests here and elsewhere, the natural model does not necessarily correspond to our perception of it— drawing after statuary assumed a new importance. Sculpture from the golden age of antiquity was now seen as an image of nature as she ought to be and as the repository of that perfection for which the artist must constantly strive. Studied and imitated, this ideal version of nature, it was believed, would inculcate the knowledge of beauty necessary to overcome the defects in ordinary natural models (Vasari-Milanesi, VII, pp. 447–48; Dolce, p. 138). Such an attitude easily led to the "academic" error of making existing works of art the end of art; but Bernini, as were others of his time, was well aware of this danger, and so insisted that drawing after the antique always be accompanied by actual work in paint or stone. Nor, as one would expect of a sculptor so sensitive to materials and surface, did Bernini believe that casts were anything more than a necessary expedient, which could never replace the experience of the originals.

this, as he does not possess a knowledge of the beautiful. He said that when he was very young he used to draw from the antique a great deal,²³ and, in the first figure he undertook, resorted continually to the *Antinous* as his oracle. Every day he noticed some further excellence in this statue; certainly he would never have had that experience had he not himself taken up a chisel and started to work. For this reason he always advised all his pupils, and others, never to draw and model without at the same time working either at a piece of sculpture or a picture, combining creation with imitation and thought with action, so to speak, and remarkable progress should result.²⁴ For support of his contention that original work was absolutely essential I cited the case of the late Antoine Carlier,²⁵ an artist known to most of the members of the Academy. He spent the greater part of his life in Rome modelling after the statues of antiquity, and his copies are incomparable: and they had to agree that, because he had begun to do original work too late, his imagination had dried up, and the slavery of copying had in the end made it impossible for him to produce anything of his own. The Cavaliere added that in addition to drawing from bas-reliefs and antique statues, painters should also have access to copies of pictures by artists who painted in the grand manner, which would be of help to them; he was referring to Giorgione, Pordenone, Titian, and Paolo Veronese rather than to Raphael, although his knowledge of good proportion was better than any of them; it had been said that no one could touch this artist as regards composition because he had Cardinal Bembo and Baldassare Castiglione as his friends and was always able to draw on their knowledge and intellect.²⁶ He said it was an academic question whether an artist should show his picture to the public as soon as it was finished or should leave it for a while, then

²³ According to Baldinucci (*Vita*, p. 9) and Domenico Bernini (pp. 12–13), the young Gian Lorenzo went almost every morning for three full years to the Vatican Palace, where he passed the day until sundown, drawing from ancient sculpture.

²⁴ Bernini had already recommended this practice to Colbert (above, 5 July).

²⁵ Little more is now known about the sculptor Antoine Carlier than what Chantelou says below. His presence in Rome can be traced from 1636 to 1643, and he is later recorded at Laon, where in 1655 he made his will.

²⁶ Chantelou means that Cardinal Pietro Bembo (1470–1547), the celebrated stylist, and Baldassare Castiglione (1478–1529), author of the famous *Courtier* (1528), had helped Raphael with the *istoria*, or what might be loosely described as the subject or theme of a picture but comprehending as well the moral bearing and import of the action and therefore of its form. It was with this end in view that Alberti had advised painters to cultivate the friendship of poets (*De pictura*, p. 94); but in the period following the Council of Trent the historical accuracy of what was represented became an increasingly important criterion of criticism, as may be seen from Bernini's comments on Sarrazin's *Crucifix*, below, or the exchange on Poussin's *Adoration of the Magi* (11 Oct.). See Lee, *Ut pictura poesis*, pp. 41–48.

look at it again before exposing it to view; in Annibale Carracci's opinion it should be shown as soon as possible so that its faults could be learnt, whether it was too dry or too hard, or had other errors that might then be put right. He added that it was a good thing to make awards to encourage the spirit of competition in the Academy. In his Academy in Rome prizes were given by Cardinal Francesco Barberini.[27] Here the prize for the artist who submits the best drawing should be a commission for a picture from it, to be purchased at a liberal sum; likewise, the sculptor who submits the best model should be rewarded by a commission for a statue for the Louvre and likewise be well paid for it. He finished by saying that, as an artist who had been practicing for nearly sixty years, he ought to be able to give good advice. I replied that a man of his calibre and experience who spoke sincerely could make one hour of instruction more profitable than whole years of research and study. While he was talking, M. Le Brun arrived; the Cavaliere greeted him courteously and then continued. He asserted that the three things necessary for success in sculpture and in painting were, first, at an early stage to see what was beautiful and to grow accustomed to it; second, to work a great deal on one's own; third, to have good advice, for an experienced artist can, with a few words, save a great deal of trouble in putting things right and suggesting shortcuts. He repeated that Annibale Carracci was of the opinion that pictures should be exposed to public view as soon as they were finished; for the public makes no mistakes, nor does it indulge in flattery; it would never fail to remark, "It is dry, it is hard," and so on, if that were the case. Further, he said, each artist must seek to correct his own faults by cultivation of the opposite qualities; a tendency to draw dumpy figures must be corrected by drawing tall ones; on the other hand, an admiration for the too elongated must be modified by a determined selection of short models; or, if he were inclined to prefer the weak and feeble, he must force himself to study the coarse and fat. He was shown a *Crucifixion* by Sarrazin which he looked at and said he liked but remarked that the body had been drawn as one might imagine it yielding to such agony, whereas, according to the Scriptures, the body of Our Lord had been stretched with ropes, so that it was incorrect for the artist to portray it in this way.

[27] Bernini's comment is confirmed by Malvasia (1, p. 229), and Passeri (Passeri-Hess, pp. 81–82) who traces the practice of giving prizes back to the Carracci Academy in Bologna: Cardinal Francesco Barberini "wished that this good practice should continue, and he himself used to participate in the selection of the winner; and he wished that the best down to fourth place be recognized with a prize of money which he himself provided; and from the winner of the first prize, he ordered a painting of the same subject as the drawing, and this lasted many years." See Pevsner, p. 77.

Then he returned to the studio and looked at the drawings from life of one or two academicians, and also those of a boy of ten or twelve, whom he thought very advanced. In an aside to me he suggested that in summer they should study by daylight and not with lamps on account of the heat. Then he took his leave of all the members, who conducted him as far as the entrance, MM. Du Metz and Perrault, who had arrived later, coming too.

6 SEPTEMBER

🐝 I went very early to the Cavaliere's, but he had already been to Mass. He first remarked to me that it was the day on which the council met, but so far he had not heard whether M. Colbert was coming in the morning or the afternoon; he could not make any plans and was waiting about with nothing to do. Then he called his valet to bring his working jacket and began to give a touch or two to the drapery of Signor Paolo's figure of the *Christ Child*. Then Mme. de La Baume arrived, accompanied by M. d'Albon, which annoyed the Cavaliere very much, but he went on working. They looked at the portrait and the *Christ* and complimented the Cavaliere and then left. The Cavaliere gave a further couple of strokes with the chisel and then stopped working and began to walk up and down. He opened the conversation by telling me that things were not being done as promptly or as correctly as they should be; he repeated that the houses should have been demolished to facilitate the work on the foundations. The impatience that M. Colbert had shown on the ———[28] as if he were accusing him of being behind-hand, although he had done all that was humanly possible, had very much annoyed him, for the simple reason that the pulling down of the houses and what Le Vau had built should have been done before the pegging-out of the ground plan if they really intended to carry out his design; nevertheless, in spite of the difficulties he had plotted the lines two days later; he had written a note to M. Colbert on the . . .[29], and since then, almost a month ago, no progress had been made; however long it stayed like that he would never refer to it, for he did not consider it befitted him. I pointed out to him once again that M. Colbert was overburdened with a mass of important business, that anyone in his position who was responsible for so much could only advance his project slowly as he liked to direct everything himself. M. Colbert had learnt this method of conducting business in the school of Cardinal Mazarin.

[28] The date is missing in the manuscript, but Bernini must be referring to the discussion of 30 July.
[29] Again the date is missing in the manuscript.

The Cavaliere then went into detail on the subject of the materials for the Louvre. He said that the masons had themselves praised the wall built by the Italians; one would see by comparing it with the other that the work of the Roman masons was stronger in many ways;[30] for one thing they had the example of classical architects who used either very small stones or very large ones in their constructions. There were two factors that made the building inferior here: the method of slaking the lime was not so good, so the best of the lime was lost in the ground; nor was the stone wetted as it was placed in the wall, so its dryness drew forth the goodness from the mortar which having lost its humidity was then inclined to turn to dust. He asserted that river sand, mixed if necessary with ordinary sand, would make an excellent mortar if the lime were well slaked; in fact, it might equal that made with pozzolana. We discussed various methods of organizing the work on the Louvre; whether men should be paid by the day, or by piece-work, or the whole thing done by contract;[31] by the day was the best, piece-work less good, and contracting useless. In Rome only work done by the day was any good at all. He told me the history of the building of St. Peter's, which had been constructed by a number of architects, Bramante, Sangallo, Baldassare Peruzzi, Raphael, and Michelangelo. One of the conditions that he made with the Pope for the conduct of such a vast undertaking was that all the work should be by the day, otherwise he would have nothing to do with it. His Holiness agreed, with the result that the only masonry that was any good was that done under his direction.[32] To suggest that the wall built by the Italians would take too long to dry was a poor argument, for by the time *gli conci*—the moldings—were carved, it would have had more than enough time to dry out; the moldings would take two years and they would have to be finished before the work could go forward. To change the subject, I told him what I had heard two nights before at the King's supper and what young M. de Niert and de Princé, the cavalry officer, had said to me.[33] His reaction was the same as mine had been; he had never opened his mouth about the bust and he would not have dreamed of saying such a thing: the forehead, nose, and mouth of the King were well proportioned in relation to each other, his eyes were a bit lifeless, but that did not matter in sculpture; he did not open his eyes wide at all. His mouth

[30] But cf. Perrault, *Mémoires*, p. 64–65.

[31] Chantelou uses the Italian names for these different ways of paying for the work.

[32] For Michelangelo's relations with the Fabbrica of St. Peter's, see now, R. De Maio, *Michelangelo e la Controriforma*, Bari, 1978, pp. 309–25.

[33] Cf. above, 3 Sept.

changed often, so that he sometimes had to spend a long time watching the King before choosing the expression that was most becoming. As for M. de Niert, the King himself had heard his remark; it was quite true that he could not bring himself to praise all those silver vases and crystal chandeliers; he could have told the King that Roman ladies would have been horrified at the sight, but that would have been worse than what he had said, "when people came in,"[34] etc. He could have wished that the King, instead of being surrounded by so many young people, could sometimes have had the company of men learned in the sciences, whose knowledge and experience would have come to him in the course of conversation without any trouble on his part. It was the custom for the Pope to surround himself with talent from which he reaped very great profit. As for the other matter, instead of so many cabinets, vases, cut-glass, etc., he would have wished the King to have examples of some Greek statuary in one or two rooms and pictures by first-class masters in others. I told him that all the cabinets and cut-glass had been put there at the time of the Regency, which was a government feminine in character, and Cardinal Mazarin had encouraged it because he thought it amused and distracted the King. While we talked M. Colbert arrived. He seemed quite amiable, but not so much as on former occasions. He looked at the portrait and the abbé Buti showed him what had been freshly done; at that the Cavaliere said to the abbé that his words were to little purpose, if the work did not speak for itself. The abbé apologized, saying it was only his French impulsiveness. When M. Madiot and my brother arrived, M. Colbert sat down, and the others took the same places as before. The Cavaliere began by saying that he had been to the Academy and had taken the liberty of giving his opinion on the training of the students. M. Colbert said he knew, and thanked him and said he would be grateful if he would have his address put in writing. He promised to do so and repeated that nothing was more harmful to students than to make them begin by drawing from nature and that they must have casts of classical busts and statues to study. I intervened to say that we possessed the cast of the Farnese *Hercules*; it was even more beautiful than the one in Rome because the legs were original, whereas those in the Farnese statue were restored. M. Colbert said he had given orders for the Academy to have it. The Cavaliere went on to say that the French school must have different precepts from the Lombard school; the French had vitality but their style was poor and

[34] A proverbial expression meaning that when things are reported or talked about they are distorted and exaggerated.

cramped; on the other hand, the Lombards leaned towards the coarse and heavy, but possessed a sense of grandeur. The Lombards must be livened up; the French must acquire grandeur. He then turned to the subject of the building of the Louvre and repeated much of what he had said to me before M. Colbert had arrived, only he put it very well. He showed them the mortar from the towers of the Louvre and Notre Dame, which he said was excellent; with such material one could do anything one wished, that is, make the walls of less thickness and let in more light. Next he discussed the three methods of organizing labor and stressed the fact that he considered an arrangement by the day was the only one possible. He emphasized that this was the only way to succeed, and that his sense of obligation to the King and his own honor forced him to say it; further, he was in love with this work. M. Colbert frowned when he heard all this and retorted that there were great disadvantages attached to this method of working; M. de Noyers, who was a man *omni exceptione major*,[35] had not been exempt from suspicion, for there had been contractors who had offered to do the job by piece-work for a lower sum than that charged to the King, under the arrangement that he, M. de Noyers, had made of working by the day. At this everyone protested—even the abbé Buti— and began praising the honesty and efficiency of this minister. M. Colbert continued by saying they would get people whom they would be able to watch so closely that it would be impossible for them to swindle. The Cavaliere replied that even a loaded musket pointed at them would not prevent them from carrying on as usual. M. Colbert told him that there were some builders who had been debarred forever from working on the royal buildings; this acted as a deterrent to others. He added that he would give the Cavaliere all the *sovrastanti* that he required. Then he made a decision to have the estimates, which they call *capitoli*, drawn up, so that orders could be given for wood, stone, and all the other things, and so brought the meeting to an end.

My brother was instructed to work at them with M. Mattia and M. Madiot. Then M. Colbert went to see the walls in the courtyard and, at the same time, looked at the Roman method of slaking lime.

On the same day my brother and I, together with M. Mattia, began to work at the Cavaliere's on the estimates for the building of the Louvre; meanwhile Cardinal Antonio came but did not stay. He returned shortly afterwards with the Nuncio and discussed the illness

[35] That is, "superior to every objection."

of the Pope at great length,[36] and then went away. When M. Madiot came, the Cavaliere questioned him closely about different materials and about the sort of stone most suitable for the foundations. After much discussion they decided on large pieces of roughstone, three or four feet long at least, the spaces between to be filled with small stones; the partition walls should be of free-stone from Saint-Leu[37] dressed on two faces. M. Perrault also came in and I showed him the grotto-stone or mill stone, which is considered excellent for the construction of vaults because of its light and porous nature, which enables it to bind very easily with mortar. He said straightaway that it would be difficult to find a sufficient quantity because this sort of stone in the quarry at ————[38] is not of the same quality as the sample; it only acquires this lightness after a great length of time and as the result of exposure to air and rain. With regard to vaults, my brother demonstrated a method of building by which their thrust would be much reduced; if it were followed, the walls could be made much less thick.

I forgot to mention that early that morning I had sent a note to M. Bontemps,[39] Captain of the château of Versailles, to say that on the Day of Our Lady I was to have taken the Cavaliere there but that he had asked me to alter the arrangement because it was a Saint's Day, and also he had been upset by our excursion to Maisons. I therefore let M. Bontemps know that the arrangement had to be altered.

At about four o'clock the Cavaliere went to the Gobelins, where he looked at all its products. He thought the tapestries very well carried out and particularly those in high warp. He gave high praise to M. Le Brun's designs and pictures and admired the fertility of his imagination. Seeing a plaster cast of the *Belvedere Torso*, he repeated the anecdote that I have recorded elsewhere[40] about Cardinal Salviati and Michelangelo and added another about the death of Michelangelo. Cardinal Salviati was present at the artist's deathbed; as he lay dying this famous man had told him that he had only two things to regret: he had not done all he should for his salvation, and he must depart when he was only beginning to master his profession.

[36] Cf. above, 1 Sept.

[37] That is, a stone known as vergelé from the quarries at Saint-Leu-d'Essérent, which was used for quays and other constructions exposed to the wet.

[38] The name of the quarry is blank in the manuscript, but see below, 25 Sept., for places near Paris where mill stone was quarried.

[39] Alexandre Bontemps (1626–1701), chief of the four premiers valets de chambre du roi, who served by quarters and slept at the foot of the King's bed. At this time capitaine or gouverneur du château et parc de Versailles, he later became intendant des châteaux, parcs, domaines, et dépendances de Versailles.

[40] Above, 8 June.

Then the Cavaliere asked whether the Cardinal Legate had visited the Gobelins. He was told that he had not. M. Colbert remarked that a great prince should support the establishment of factories such as the Gobelins for the renown that they bring him, even if he did not admire their products. M. Du Metz, who was there, came back with us. I told him on our way that he had better find out about the bas-reliefs and statues that I had had copied in Rome and brought back to France; among other things there were sixty or eighty pieces of Trajan's Column, bas-reliefs from the roundels on the Arch of Constantine and a number of other casts taken from the Medici and Borghese collections, which would be useful, the Cavaliere said, for the Academy.[41]

7 SEPTEMBER

☙ In the morning I had the King's coach brought round at the hour the Cavaliere had requested. When I arrived I found that he had attended Mass. M. Paolo and I went to Mass too, and when we got back the Cavaliere told me that Cardinal Antonio Barberini had asked him to dine, and asked me if we might fetch the abbé Buti, so that he could go with us. On our way he told me that he had been thinking before he got up that there was no one who knew better than I the trouble that he took, who was better acquainted with his work or knew with what love he worked at everything; that I had access to the King at mealtimes[42] when he was not busy, and without pushing

[41] The casts commissioned by Chantelou on his two trips to Italy are described by Roland Fréart in his eulogy of Sublet de Noyers (*Parallèle de l'architecture antique avec la moderne*, Paris, 1650) and by Bellori (pp. 443–44) in his life of Poussin. On the first trip (1640), Chantelou had molds made, among others, of two capitals from the Pantheon, two medallions from the Arch of Constantine, and seventy reliefs from the Column of Trajan. Two years later, on his second trip (1642–43), he had molds taken from the *Flora*, the *Farnese Hercules*, two more medallions of the Arch of Constantine, and the *Horse Tamers* on the Quirinal, which Sublet de Noyers intended to have reproduced in bronze for the principal entrance of the Louvre, an idea revived by Le Brun after Bernini's designs for the palace had been rejected. Only the first group of molds reached France. There, casts in bronze were taken of the Nike relief from the Villa Medici and of two reliefs from the Villa Borghese (the *Dancers* and the *Maidens Adorning a Candelabrum*), while others were cast in plaster to be used by Poussin in his decorations for the Long Gallery. The molds Chantelou had made on his second trip remained in Rome, abandoned in the courtyard of Cardinal Mazarin's palace (below, 4 Oct., and Poussin, *Correspondance*), presumably because of Sublet de Noyers' fall from power. The mold of the *Farnese Hercules* was later rescued by Poussin, who had it moved to his house (ibid., p. 357); but by the time of Bernini's trip to Paris, all of the molds must have disappeared or been destroyed, since shortly thereafter, Errard, as director of the French Academy, undertook to have molds taken of many of the same works (A. de Montaiglon, *Correspondance des directeurs de l'Académie de France a Rome*, I, Paris, 1887, p. 17).

[42] In performance of his duties as a maître d'hôtel du roi.

myself, I could, when the King asked me news of how things were going, tell His Majesty what I saw and knew. I told him that I would have done so willingly but there were certain reasons that prevented me from attending; I would inform His Majesty some other time; I certainly did not lack a desire to speak in his favor—if only in the cause of truth and justice—but I refrained for certain reasons, as I had told him. He replied that the King must want sometimes to ask how things were getting on and where he had been and his opinion on what he saw. I agreed.

Meanwhile we had arrived at the abbé Buti's. Learning that he was at Mass the Cavaliere and I strolled in the garden, and when M. Paolo left us, he returned to the topic we had been discussing in the coach. I reminded him that from the start I had not even wanted my brother to come to see him, nor to look at the designs for the Louvre; the reason why I took all these precautions was that the late M. de Noyers, to whom I was related, had been superintendent of buildings and I had been employed under him; I wanted to remove any suspicion that M. Colbert might harbor that I desired advancement for myself; he could rely on me to help him with what he could not do himself in the matter of building, and he could see I knew something about it. But I held a post that gave me access from time to time to the King; and a maxim of ministers—though it might not be his—was never to make use of anyone who was not entirely dependent on them but could rely on some other support. I did not wish, by attending the royal table and thus giving the King occasion to speak to me, to give any kind of offense, for my only ambition was to work quietly. At the right time and place I should do and say for him what I believed to be fair. He repeated that there was no one else who knew better what he was doing or was so capable of understanding it. He then added that the last time the King had posed for him His Majesty had remarked that I knew a great deal about these matters, and he had replied that no one other than an artist could equal me; perhaps it was a gift of nature or the fruit of my journeys in Italy and elsewhere. He asked me if I had heard what he said to the King. I said I had not. He said he had simply wanted to put the truth on record, for of course I had not asked him to say anything about me. Then he said that it really mattered to him that the King should know how things were, for it could so easily be concealed from him or wrongly construed; for instance, yesterday at the Gobelins, he had freely admired what he had seen, although there were many worthless things displayed. I replied that perhaps he had adopted this attitude as a result of the talk we had had a couple of days ago. He agreed that in a way this was

true, but that it could be interpreted differently; perhaps there might be some other way of informing His Majesty of the facts; might I, who had access to the King at dinner and supper, not be able to do something about it? I answered that I lost no opportunity to be of service to him when I was on duty in the King's Household, but besides that, I was attached to the Household of His Royal Highness,[43] and if I should seem to be too often near the King while I was in attendance on him, it might be thought that I was trying to meddle in what was not my affair. He pointed out that I had been with the King three days ago; I replied that I had been summoned to give His Majesty a certain memorandum for which he had been asking. "Yet," he repeated once again, "what you say carries much weight, for it was the King who appointed you to be my companion. You see with what constancy and devotion I work, better than any one. The abbé Buti is Italian and would therefore not be listened to in the same way." I agreed, adding that I did what I could on every possible occasion and would continue to do so.

I went on to say that the King had need of a man such as he, and his genius on the other hand must benefit from the influence of such a great prince; for this reason, he should consider in earnest settling at the French court; if he were some kind of philosopher, without ties, he could despise the great opportunity that was being offered him, but he had a number of children and he must think of providing them with as bright a future as possible; moreover, the son in the priesthood[44] might go far with the protection of France. He praised his ability and his character, declaring he was fit to aspire to the papal chair. I said with a smile that one had to be cardinal first. He agreed and making a joke of it, added that to become cardinal with the help of France would spoil any chance one had of becoming pope; but of course there were means of avoiding this; becoming a cardinal was a matter of money; one took on certain offices, through which one became a member of the college of cardinals. He said to me, this time

[43] That is, to the Household of Monsieur, the King's brother.
[44] That is, Pietro Filippo Bernini. This was an argument calculated to appeal to the Cavaliere, who worked hard to advance his family. From the popes for whom he worked, he obtained canonries, benefices, and offices for his father, brothers, and children. And if the artist's son, Paolo Valentino, was derided for wishing to marry above his station (Fraschetti, p. 105, n. 3) the legacy of Bernini's efforts was enjoyed by the following generation. Nicola Pio, writing in the early 18th century, reports that Bernini's "descendents were related by marriage to ladies and prelates, and live with great decorum like true cavalieri on a par with any other noble of Rome" (*Le vite di pittori, scultori, et architetti*, ed. by C. and R. Enggass, Vatican City, 1977, p. 66), and the family was included in the list of Roman nobility compiled for Benedict XIV (Fraschetti, p. 106).

seriously, that he could not say more than he had already said and repeated that he always did more than he promised. He told me he had given M. Colbert to understand that one of the things that had put him off remaining in France was the little appreciation that had been shown for the beautiful design that Mignard had made for the altar of the Val-de-Grâce; the one which was now being carried out had been preferred to it.[45] This had made him hesitate and decide against remaining. I explained to him that the choice had lain to a certain extent with the nuns, who understood nothing about it and left themselves in the hands of their architect, who had used all the means at his disposal to persuade them to accept his own design; it was quite different as far as the King's affairs were concerned because he himself had great understanding and was guided by his own good taste to choose what was correct and beautiful.

I repeated to him once again that there should be nothing he could desire more than to remain in France and that in times of peace, like the present, he was the right man for the King. He told me that he did intend to return, but did not wish to promise anything; the King would be less obliged to him if he came back without having given his word to do so. I answered that devotion to his work, if not to the person of His Majesty, should make him feel bound to stay, for it was the grandest, the most notable, building in the whole world. I then dwelt on the beauty of the design, which I considered the more admirable because he had managed to adapt it to the old building, and I told him that on every occasion that the subject was under discussion, I pointed out the paradox of having changed nothing in the Louvre and yet changed it completely. He repeated what he had once said to the commandeur de Souvré, that in trying to preserve the Louvre he had in fact destroyed it.[46] He said that the Cardinal Legate had told him on his return from France that the King wanted him to make a plan without being hampered in any way, a point that his ministers had not conveyed to him. I answered that I had not been near enough to the King the first time the subject had been broached to hear what he had said, but there had been a rumor that he, the Cavaliere, had asked for everything to be pulled down and the King had replied that he wished to preserve the work of his predecessors. He gave me an account of what had happened, how he had told the King that he had seen the palaces of emperors, popes, and kings and, on his journeys,

[45] The Cavaliere had seen Mignard's design on 22 July (above). After his own project had been rejected, work was resumed on that already begun, which must have been designed by Le Duc.

[46] Above, 2 Aug.

those of lords and nobles, but the palace for the reigning king of France should outdo them all in splendor and magnificence. Then he had turned to the circle round the King and had declared that he would not listen to a suggestion of anything trivial; the King had then told him that he had a certain feeling for preserving the work of his ancestors, but if a splendid building could only be erected if everything was pulled down, he would abandon the whole thing to him, even the choice of another site altogether, and he would spare no expense. He had replied to His Majesty that proportion was the most beautiful thing in the world; palaces did not gain in splendor by the amount of money spent on them, but by the grandeur of the style and the nobility of the idea, which sprang from the architect's conception.[47] Following this conversation M. Colbert had taken him round all the best sites in Paris to have his opinion on them and let him see that the King had really given him a free hand,[48] but he had adjusted his ideas to what was reasonable, had dropped all the vast plans that would have involved a chimerical expense; one of these was to build on the Ile du Palais, where, before laying the foundations, it would have been necessary to demolish fifteen or twenty million [sic] houses; he had therefore adapted his designs to the site of the old Louvre and was convinced that if they were well carried out it would be the most beautiful palace in the world. At that time, M. Colbert had let him know through the abbé Buti that he would be glad if he would put the ideas they had discussed in writing, which he had done;[49] his devotion to his work made him want to come back; he thought he could arrange it easily, and two hundred pistoles would enable him to travel in comfort; further, if he brought his family with him, he would have some company on the way; the air here was good for him and he felt he had more vigor and appetite than in Rome. He repeated that he felt an extraordinary devotion to the King; without it he would not have been able at his age to work five hours at a time as he did.[50] He added that he dared to say that his work, which was nearly completed, had brought him a very great reputation in Rome; he had always thought of coming to France and had wondered why this had never been arranged, for Cardinal Mazarin had liked him very much and had told him so whenever they had met, and at that time in Rome he had suffered something like persecution.[51]

[47] Above, 4 June.
[48] Above, 5 June.
[49] Above, 9 June.
[50] The same remark above, 30 Aug.
[51] Bernini, of course, had never gone to France because he did not wish to. Mazarin

Then the abbé Buti arrived and we went to dine with Cardinal Antonio Barberini. He wished to talk to the Cavaliere in private and asked him to go up with him into his room, while Signor Paolo and I remained below. Signor Paolo asked me if he was right in assuming that the conversation which I and the Cavaliere had just had was about his affairs. I did not want him to have too much to guess about and told him merely that I had pressed his father to stay in France and told him the reasons that ought to persuade him to do so, but I realized that the work on the throne of St. Peter was an obstacle that could not be overcome, and I took this opportunity of asking him for a description of it. He told me that it was a chair carried by four Doctors of the Church, two Latin and two Greek; the figures stood thirty-six feet high and were of gilt bronze; they were placed on alabaster pedestals; it was crowned with a glory in which there were innumerable angels; altogether it stood at least 120 feet high and reached the cornice of St. Peter's; it was destined for the end of the church behind the altar. He went on to say that the other day, when M. Colbert had walked up and down with him and his father, as I had seen, in the gallery of the palais Mazarin, he had urged them to remain here.[52] When his father had complimented M. Colbert on his qualities as a minister, saying how well he deserved the rewards that he received from the King, he had replied that the King would never think more highly of him as a minister than if he were able to bring the news that he had succeeded in persuading the Cavaliere to remain in France. He said that his father intended to return to this country after making the trip to Rome; there was only one thing that worried him, that one of his daughters, whom he loved dearly, was a nun in a convent where, however, no vows were taken; he did not wish to leave her behind but perhaps the Pope would not permit him to bring her with him.[53]

While we were talking, the Cavaliere and the abbé Buti came downstairs. Before we sat down to table, His Eminence showed the Cavaliere a clock for use at night, which had a dial illuminated by a lamp, so that one could tell the time at any hour. In the clock there

especially had tried in every way to persuade him (Laurain-Portemer, "Mazarin et le Bernin," pp. 185–86), but even when his close association with the Barberini had brought him into disfavor following the death of Urban VIII, he preferred to remain in Rome rather than accept the generous offers urged on him to enter the service of the French king (cf. Dom. Bernini, p. 80).

[52] Above, 30 Aug.

[53] Two of Bernini's daughters, Agnese Celeste (b. 1647) and Angela Cecilia (b. 1649), became nuns at the Ursuline convent attached to SS. Rufina e Seconda in Rome. See Domenico Bernini, p. 53, and Fraschetti, p. 105.

was a picture by Carlo Maratta composed of little figures a foot high, which the Cavaliere admired very much.

I forget to note that he had asked me to speak well of his work, and when I told him it spoke for itself, he answered that the princes had so much in their heads one had to call their attention to things and remind them of them; to bear this out he told me how in the time of Urban VIII, a canonry of St. Peter's had fallen vacant; he had not wished to ask it of His Holiness as he thought he would give it to him because he had a son who was in a position to hold it.[54] However, the Pope did nothing. He showed that he was offended about the matter, but His Holiness had pointed out to him that those who were burdened with innumerable matters of great importance cannot be expected to remember things as other people do and must therefore be reminded. He also talked to me about the marble for the bust, which he had feared at first might have been faulty but which he had found to be *cotto*;[55] he had been astonished how well he had succeeded. I replied that it was the great care that he took with his work. He said that was true, but there must be something else as well, meaning the grace of God, to which he ascribes everything.

In the afternoon Father Otoman came to see the Cardinal. After talking to him for a while we tried to find the abbé Bentivoglio, who was not in, so we followed him to Signora Anna Bergeroti, where there were a number of Italians. They were singing part songs. The Cavaliere recited some passages from his plays with as much charm as usual. On leaving he complained to Bentivoglio not because he had not visited him, but because he had not come to see His Majesty. We took the abbé Buti back and then tried in vain to look at one or two churches, which were locked.

8 SEPTEMBER

When I went to the Cavaliere's in the morning, M. Perrault was there, but he was on the point of going. He asked me in the frankest way whether the Cavaliere had not been delighted with what he had seen at the Gobelins. I said that he was, and particularly with the way in which the tapestries were executed. He asked me my opinion of the *Four Elements*;[56] I replied that I thought them very beautiful. I left him and went to work with M. Mattia on the specifications for the Louvre building. We were trying to see in what respects we could

[54] At the time of Urban's death in 1644, Pietro Filippo, the artist's eldest son, was four years old.
[55] That is, friable.
[56] Designed by Le Brun. See Jouin, pp. 544–45.

make them clearer. I added a note to the effect that the stones should be laid as close together as possible, as in ancient buildings, and even closer if it could be managed.

Meanwhile the Nuncio had arrived, and a little later my brother came in. Then Cardinal Antonio's night clock with the picture by Maratta was brought in, as it was to be presented to the King when he came for a sitting. The Nuncio only stayed a minute, and when he left we began our dinner. While we were at table the Cavaliere told me he found more to satisfy him in one of my pictures of the *Seven Sacraments* than in all the vast canvases he had seen at the Gobelins. "For," he said, "in the works of Signor Poussin, there is profundity, and much of antiquity, and of Raphael, of everything indeed that one could desire in painting; those are the things that satisfy the real connoisseur." I replied that it was a great pity that M. Poussin had had no opportunity for large-scale commissions and he told me it was he who had obtained for him the commission to do the picture in St. Peter's[57] and that various well-known painters had borne him a grudge on that account. I said that in my opinion this picture was not one of his best, but he replied that it was very beautiful, "There is in it a basic and solid learning."[58] I added that I thought his inclination to paint small figures was due to the fact that in spite of his great richness of imagination and fertility of mind, he had never yet had the opportunity to treat a big subject in a big way, in a gallery, ceiling, or church picture, and had been forced to work on cabinet pictures in which the figures were less than life-size.[59]

In the afternoon M. Le Brun came to see the Cavaliere, who greeted him most cordially and asked him to give him his opinion on the portrait, saying that he could still profit from his advice. At the same time Cardinal Antonio arrived and the Nuncio and M. de Benserade, who brought with him Mme. de Villars.[60]

9 SEPTEMBER

�膠 I found the Cavaliere working at the portrait. He told me that the evening before he had worked by the light of torches at the lock of

[57] That is, the *Martyrdom of St. Erasmus* (Blunt, *Poussin Cat.*, no. 97).

[58] Bernini's reply is in Italian in the manuscript.

[59] Poussin, of course, had had the opportunity to do such work as Chantelou suggests in the Long Gallery of the Louvre, but by all accounts he had found the task uncongenial and returned to Rome and his cabinet pictures as quickly as he could. See Blunt, *Poussin*, pp. 157–58.

[60] Probably Marie Gigault de Bellefonds (d. 1706), who in 1651 had married Pierre (1623–98), marquis de Villars, Lieutenant-General (1657), Ambassador Extraordinary (1672–79), and conseiller d'état (1683).

hair that is pierced through on the forehead. Immediately afterwards the Nuncio arrived, then Mlle. de Saint-Christophe, who sang some French and Italian songs. She looked at the portrait and remarked that, though it had neither arms nor legs, it seemed to move and walk. Lefebvre had said on a former occasion that it resembled His Majesty even from behind.[61]

The King arrived at three o'clock in the afternoon. The marquis de Villeroi[62] had come a little beforehand and then the duc de Saint-Aignan and Magallotti, who was there on behalf of Cardinal Antonio, to present the clock to His Majesty. The King looked at it and the Cavaliere told him that the picture that he saw there was by one of the best painters in Rome. His Majesty considered it for some time, then he said that if he had studied pictures from an early age he would have learnt something about painting, but it was only three or four years ago that he had begun to look at them. To the Cavaliere he remarked that he had heard that he had visited the Academy.[63] He replied to His Majesty that he had expressed his opinion on the right way of teaching students; they should not be set to draw from life until they had studied antiquity from the beautiful Greek heads of Apollo and Jupiter and others, of which casts exist, and also from statues and bas-reliefs; nature was everywhere, yet artists developed more fully in Rome than in France or Spain for the reason that both painters and sculptors were marvelously helped in their professions by the great number of Greek statues and fine portrait busts from classical times that are to be found in Rome and nowhere else; those who were used to copying these masterpieces could, when they came to nature, correct it where it was at fault. Thereupon I informed the King that with the education of French artists in mind and also the decoration of the Louvre, I had some twenty years ago had casts made of a number of bas-reliefs and some statues and had had them brought to France;[64] some of these might be used for the Academy. His Majesty requested me to speak to M. Colbert about it. The Cavaliere added that the French, whose style was cramped and feeble, should be made

[61] Above, 19 Aug.

[62] François de Neufville (1644–1730), marquis and then duc de Villeroi (1685), Lieutenant-General (1677), Marshal of France (1693), and Governor of King Louis XV from 1717 to 1722.

[63] Above, 5 Sept.

[64] If Chantelou is not being swayed by the current demand for casts after the antique, his statement would provide additional evidence that plans for establishing an academy of art had been laid under Sublet de Noyers (cf. above, 16 June, n. 110). That some of the casts were intended to be used in the decoration of the Louvre is confirmed by Roland Fréart (above, 6 Sept., n. 41).

to study the works of the Lombard school, while the Lombards, who tend to the grandiose and heavy, should learn from the nobility, grace, and refinement of Raphael.

The abbé Buti remarked that Le Brun had been the day before to see the portrait, whereupon the Cavaliere took the occasion to praise what he had seen at the Gobelins, particularly the tapestries; the King should feel well satisfied with the way this establishment carried out its tasks. The King asked me if he had seen the tapestries of the *Elements*. I said that he had. He then mentioned the tapestries of his houses,[65] but I told His Majesty that the Cavaliere had so far only seen the pictures that M. Le Brun had had executed by various painters as he could not possibly do everything with his own hands. I added that the tapestries made at the Gobelins are a great deal better carried out than those copied from the cartoons of Raphael. The King said that Le Brun sometimes had changed whole arms and legs. After this conversation, the Cavaliere set to work and the abbé Buti recited a madrigal in Italian, which runs;

Al signor Cavaliere Bernino per il ritratto de Luigi XIV fatto da lui in marmo

Pende in dubii litigii
Qual sia più favorevole destino,
Che trovat' il Bernino habbia un Luigi,
O Luigi un Bernino.

Senza si gran scultor foran sicuri
Non poter adorar il ver sembiante
D'un Rè si grande i secoli futuri;
E senza un Rè si grande e trionfante,

Non havria ne men quello
Nel mondo un degno oggetto al suo scarpello.
Ma, in mutuo pro del gemino valore,
Far il ciel non potea coppia magiore.

To the Cavaliere Bernini for his marble portrait of Louis XIV

The question hangs in doubt whether it was a more fortunate destiny for Bernini to find Louis or Louis, Bernini. Without so great a sculptor it is certain that future centuries would not be able to adore the true likeness of so great a king, and no less true that there could not be in the world a subject

[65] Like the tapestries of the *Elements*, the series representing the Months of the Year or the Royal Houses and Châteaux were designed by Le Brun. See Jouin, pp. 546–48.

better meriting his chisel. But heaven could not make a greater couple in exchange for their twin worth.

The King thought it very fine, and asked M. Dangeau[66] to put it into French there and then. When His Majesty saw it he asked him to write the French and the Italian version on the same sheet of paper, which he put in his pocket.

At first no one entered except the duc de Navailles[67] and the marquis de Pradel,[68] whom the King had asked to come in; all the others remained at the door of the antechamber, then the maréchal Du Plessis, the maréchal de Villeroi, and the comte d'Armagnac arrived and they came in. The abbé Le Tellier stayed at the door, but the King made him come forward and in the end all the others did the same. I wanted to show the King the abbé Tallemant's[69] sonnet, but he said that he had seen it that morning.

Sonnet

Il le faut avouer, ta Rome est admirable
La sculpture surtout y triomphe en tous lieux;
Bernin, on ne voit rien aujourd'hui sous les cieux
Qui remplisse l'esprit d'une grandeur semblable.

Je trouve comme toi l'*Hercule* incomparable;
L'*Apollon* est l'amour de tous les curieux;
Tes ouvrages encor sont le charme des yeux,
Et l'on ne conçoit rien qui leur soit comparable.

A la Seine pourtant le Tibre doit céder;
Elle t'offre un objet tel qu'on peut demander:
Magnanime, charmant, où toute grâce abonde.

[66] Philippe de Courcillon (1638–1720), marquis de Dangeau, Colonel of Infantry (1665), member of the French Academy (1668), page to the Dauphin (1680), and chevalier d'honneur to the first wife of the Dauphin (1685) and to the duchesse de Bourgogne (1696). Madame de Sévigné wrote in a letter of 1 Dec. 1664 that the King had lately begun to write verse under the tutelage of Dangeau and the duc de Saint-Aignan.

[67] Philippe II de Montault de Bénac (1619–84), duc de Navailles, Lieutenant-General (1650) and Ambassador Extraordinary in Italy (1658–59). Disgraced, along with his wife, Suzanne de Baudéan (1609–84), and stripped of his charges in the wake of an intrigue, he nevertheless went on to be Governor of La Rochelle and of Aunis (1665) and became a Marshal of France (1674).

[68] François (d. 1690), marquis de Pradel, Lieutenant-Colonel of the Guards, Lieutenant-General of the Armies (1657), and Governor of Saint-Quentin.

[69] Probably François Tallemant (1620–93), brother of Gédéon Tallemant, the author of the *Historiettes*, Almoner of the King and member of the French Academy (1651); but possibly their relative, the abbé Paul Tallement (1642–1712), member of the French Academy (1666) and of the Academy of Inscriptions (1672).

Tes yeux de son éclat peuvent être éblouis,
Si tu n'as pour ton art rien d'égal dans le monde,
Ton art n'a rien trouvé d'égal au grand Louis.

It must be acknowledged that thy Rome is wonderful. Sculpture above all triumphs everywhere. Bernini, one sees nothing today beneath the skies which fills the spirit with a similar grandeur. Like thee, I find the *Hercules* incomparable; the *Apollo* is beloved by all amateurs of art; thy works ever charm the eyes and one could conceive of nothing to which they could be compared. But the Tiber must give way to the Seine; it offers thee such a subject as one might demand; magnanimous, charming, where every grace abounds, thine eyes may be dazzled by his brilliance. If there is nothing in the world to equal thine art, thine art has found nothing to equal great Louis.

Everyone studied the extreme delicacy of the portrait, and someone remarked that it would be most difficult to prevent people from touching it, which was the way the French began looking at sculpture. The King thereupon repeated what Cardinal Mazarin had said to M. de Gramont when the latter had been inspecting from close up one of the classical pieces in his gallery, "Monsieur, I must point out that these pieces break when they fall"; he did not say, "Don't touch." Then the conversation turned to the silverwork which was being manufactured at the Gobelins, where they are making very beautiful ewers and basins. His Majesty said that so far they had made only . . . ewers and basins, but in ten years' time there would be enough to make up a fair-sized service, which would fill a cupboard reaching from floor to ceiling in one of his rooms. The Cavaliere told His Majesty that he had made a good beginning, and everything he saw confirmed what he had heard in Rome before he set out, "that the King had a great mind."[70]

In the meantime Perdigeon had arrived. The King had sent for him to see what decoration could be added to the clock presented by Cardinal Antonio which, apart from the picture, was just plain ebony. The King looked to see what time it was, and then looked at M. de Villeroi and said he must go as he had two matters to deal with in his council. He told the Cavaliere he would come the same time the next day. After His Majesty had left he worked a little while longer from memory and then we went to the Feuillants where the Sacrament

[70] Bernini's comment is in Italian in the manuscript.

was being exposed and they were holding a long service with the elevation of the Host and prayers for the Queen Mother. His Royal Highness was present.

<center>10 SEPTEMBER</center>

🎔 I found the Cavaliere working at the portrait. Signor Mattia was drawing a section of the façade of the Louvre on a large scale, and Signor Paolo was working at his bas-relief[71] of the *Christ Child*. At ten o'clock M. Boutart arrived and with him M. de Grinville,[72] who knew the Cavaliere in Rome when the marquis de Fontenay-Mareuil[73] was ambassador. When he had seen the Cavaliere and looked at the bust, he was shown the designs for the Louvre. The abbé Buti recited his madrigal to M. Boutart, who thought it very good. Meanwhile my brother and nephew had arrived and M. Boutart, in one of those fits of enthusiasm to which he is given sometimes, began praising our family, saying wonderful things about us and stressing particularly our honesty and good faith.

After they had left, the Cavaliere took me aside and showed me a design he had made for the pedestal of the bust. It was in the form of a terrestrial globe, with an inscription reading *Picciola basa*.[74] He asked me what I thought of his idea. I said it was a fine and lofty conception; it signified great things from the King in the future. He pointed out that apart from its innate grandeur it had another advantage, which was that the spherical shape of the globe would prevent people from touching the bust, which is what happens in France whenever there is anything new to be seen. I remarked that his idea recalled very happily the King's *Nec pluribus impar*.[75] The pedestal could not be more imposing; the Cavaliere must put his name to it to show that it was he who had thought of the idea and carried it out, lest it might be thought that it was the King declaring thus that the world was too small a sphere for him. He added that the effect would be

[71] The text should read *en bas-relief* not *un bas-relief*.

[72] Grinville, or Grainville, was a seigneurie in Normandy held by an equerry of Fontenay-Mareuil (see the following note).

[73] François Du Val (1595–1665), marquis de Fontenay-Mareuil, Governor of Champagne, Lorraine, and Alsace, ambassador to England (1629) and, in 1641 and 1647, to Rome.

[74] That is, "small base." For the pedestal and its motto, which are discussed further below, 13 Sept., see I. Lavin, "Bernini's Death," *AB*, LIV, 1972, pp. 177–81; idem, "Afterthoughts on 'Bernini's Death'," *AB*, LV, 1973, pp. 334–46; and D. Rosenthal, "A source of Bernini's Louis XIV Monument," *GdBA*, LXXXVIII, 1976, pp. 231–34.

[75] That is, "But not unequal to many." Cf. the medal struck in 1664 cited by Irving Lavin in *AB*, LIV, 1972, p. 180, n. 69, in which the motto is combined with a radiant sun rising over the terrestrial globe.

splendid, the blue of the sea contrasting with the rest of the globe, which would be of gilt bronze.

After dinner, between two and three, His Majesty arrived, accompanied by the duc d'Orléans. At first no one came in except the duc de Gesvres, then the duc de Noailles, and then a little while afterwards, the comte de Séry.[76] All the others remained at the door, not daring to come any further. The Cavaliere worked at the nose and, for a time, at the small mark that the King has on his nose near the eye. His Royal Highness requested me to tell the Cavaliere that he found the likeness much greater than when he had come before, and then to ask him whether, when he was doing the Pope's portrait, His Holiness came to his house. Little Giulio, who was standing quite near His Royal Highness, said that he did and that His Holiness had come ten times.[77] His Majesty left his place once to see the Cavaliere's work. He had a good look at it and then whispered to the duc d'Orléans (whom I had the honor to be very close to), "Is my nose really a little crooked?" The Cavaliere did not hear, but the abbé Buti did and hastened to assure His Majesty that it would not stay like that, although from one side and near to, his nose was a little bit bigger than on the other. He asked me to show him the armor of which I had spoken with so much admiration the day before, and which had been taken from the royal armory to serve as models for the Cavaliere. They are those that were presented to François I by a Duke of Mantua; they are beautifully made in every way and are decorated with low reliefs from a design by Giulio Romano. The King and Monsieur looked at them very carefully. Meanwhile the abbé Le Tellier had arrived and entered, His Majesty having indicated that he permitted him to do so. Before regaining his seat, the King went to look at Signor Paolo's work. Then, someone having mentioned a caricature, the Cavaliere said he had made one of the abbé Buti, and he had a look for it so as to show it to His Majesty, but as he did not find it, he asked for a pencil and paper and drew another with a couple of strokes in front of the King, who studied it with much amusement and then passed it to Monsieur and the others who had come into the room and to

[76] François de Beauvillier (1637–66), comte de Séry, oldest son of the duc de Saint-Aignan, and First Gentleman of the King's Bedchamber (1657).

[77] Although the diary kept by Alexander VII reveals that he saw Bernini almost daily, the Pope's visits to the artist's studio were naturally less frequent. Domenico Bernini reports two, the dates of which are supplied by Alexander's diary: the first in full state and "not less respectful than rare" on 19 June 1662, which had been prompted by Queen Christina's visit two months earlier; the second on 5 June 1663, when the Pope inspected the statues he had ordered for the Cathedral of Siena and again the *Constantine* (Dom. Bernini, pp. 104–7; Krautheimer and Jones, nos. 570, 691).

those who stood by the doorway.[78] Then Rocheplatte, His Royal Highness' Lieutenant of the Guard, came and whispered to him, whereupon he said something in a low voice to His Majesty, who shook his head. I am sure it was that the duchesse d'Orléans[79] had asked to be allowed to come if the King were going to remain there any longer, but a minute later he got up to leave, telling the Cavaliere that he would come at the same time the next day. When His Majesty had gone, the duchesse d'Elbeuf[80] and her stepdaughter and the marquise de Monglas[81] came to see the portrait. They spent a quarter of an hour looking at it from every side and admiring the likeness.

I forgot to mention that Nanteuil[82] had been in the morning and had tirelessly studied the portrait from every angle. Everyone told the Cavaliere that he must leave a portrait of himself here and that no one could do it better than Nanteuil. M. Paolo joined in, saying that Lefebvre had been the first to beg his father to let Nanteuil undertake it. The Cavaliere replied that Nanteuil would certainly be the best, and of all the portraits of the King none were so good as the last one that he had done.

I I SEPTEMBER

🌿 I took M. de Bartillat and . . . to see the Cavaliere. There we found the Marchese Raggi, a Genoese, and the abbé de Lessein. A little later M. de Boisfranc arrived and he made Lepautre[83] come in. They saw the portrait and then I showed them the designs for the Louvre. After they had all gone, the Cavaliere told the abbé Buti and me that this marchese Raggi who had arrived before us had said to him, after having studied the portrait, that for a sketch it was really quite good;

[78] For Bernini's caricatures, see above, 19 Aug. n. 126.

[79] The appellation given to the wife of Monsieur, the King's brother, in this case, Henrietta Anne (1644–70), daughter of Charles I of England and Henriette-Marie (daughter of Henry IV of France), who had married Philippe, duc d'Orléans, in 1661.

[80] Elisabeth de La Tour d'Auvergne (1635–80), second wife of Charles III de Lorraine (1620–92), duc d'Elbeuf.

[81] Cécile-Elisabeth Hurault de Cheverny (d. 1695), wife of François de Paule de Clermont (1620–75), marquis de Monglas or Montglas, maître de la garde-robe (1643). She is known for her affair with Roger de Rabutin (1618–93), comte de Bussy, who at this time was in the Bastille as a result of the publicity given his *Histoire amoureuse des Gaules*.

[82] Robert Nanteuil (1630–78), a celebrated engraver known especially for his portraits, among which are eleven engravings in different sizes of Louis XIV, at least six *ad vivum*.

[83] Antoine Le Pautre (1621–91), architect to the King (1648) and a member of the Academy of Architecture (1671), who remodelled the château of Saint-Cloud for Monsieur and built that of Saint-Ouen for Boisfranc. His design for the cascade at Saint-Cloud is criticized by Bernini above (2 Aug.). For Antoine Le Pautre and his work, see Berger.

then he added, "The Genoese are of all the people of Italy those who have the least sensibility, which is due to the fact that they all engage in commerce, which lowers their standard of judgment and deprives them of any knowledge of other things."[84] To illustrate this, he told us a story about a Genoese, who one day came to see Guido Reni and found him working at a large picture. As he had heard that he was extremely intelligent, Guido asked him to give him his opinion of the picture. This gentleman then began to look at the picture as if he knew a great deal about it. He gave all the appearance of one who looks first at the general effect and then at the details, so that Guido felt obliged, as he had as yet made no complimentary gesture, to say that the work was not finished and he could therefore still profit from any suggestions his visitor would be good enough to make. Then the Genoese began looking at his companion, whereupon Guido asked him once again to speak out, saying that he would be very glad to hear what he had to say. So at last, he said to Guido, "Since you have given me permission, I must tell you that I think the canvas is a little broader at the top than at the bottom." When Guido heard this wonderful criticism he burst out laughing and thanked him, saying that it was probably true and he had suspected as much, making fun of him.

The King came at three o'clock. On his arrival the abbé Buti said that many people had exercised their poetic genius on the portrait and pointed with a smile to M. Etienne, one of the Cavaliere's workmen, who sharpens his tools. He read some of his rubbish, which the King listened to patiently. The Cavaliere set to work, and the King, noticing that he had changed a mark that he has near his mouth, asked him why. He replied that he wanted to do it better. Then he put in a few hairs just below the mouth, but the King pointed out they were not there the last time, that he would have himself shaved before he came for his next sitting and then they would not show. I intervened to say that when one has a portrait done one must make no pretenses, for art will not stoop to imitate art, and delights only to represent nature. The Cavaliere added that a freshly shaven appearance lasts only two

[84] During the 16th and 17th centuries, the man of business frequently became the butt of artists's anecdotes as a consequence of their struggle to detach the value accorded works of art from the ordinary commercial considerations of time, labor, or materials. The notion that the merest sketch by a great artist should be worth more than the great labor of a mediocre one now seems self-evident; but during the Renaissance the intrinsic value of art had still to be vindicated; and a number of stories, like the one told here, might be cited that sought to show that hard-headed calculations of the commercial kind were beside the point when it came to art.

or three hours, so that for the greater part of the time there is hair on the face; one must endeavor to represent people as they are generally.

At first no one came in except the duc de Noailles and the comte de Bellingham; all the others remained at the door. The marquis de Villarceau[85] and M. de Biscarat, who had come a little before the King, withdrew when His Majesty arrived, but towards the end everyone entered. The King spoke at length, in a low voice to the abbé Buti about a friar who was there, who belongs to the Nuncio's household. Towards the end the duc de Créqui arrived and said he thought the Cavaliere had made a great deal of progress. The King asked how many more days he would need to finish. I replied that another five or six days would suffice. The King later asked if care were taken to lock the door when the Cavaliere went out. I said that we closed not only the door but the windows also. The abbé Buti added that someone slept in the room. The King then mentioned that there had been some talk in Rome about the work on the chair of St. Peter. The abbé Buti replied that the Cavaliere knew nothing about it and that it would be best to say nothing and I added that it was the work he had nearest his heart and he would feel obliged to arrange to return to Rome.

Meanwhile the King was glancing at his timepiece and I, thinking he was about to go, approached him and said, "Sire, if Your Majesty has not already disposed of the Treasury of the Gué-de-Mauny of Le Mans, which is vacant, I wish to request it of you." He replied, "The man is not dead, and sixteen people have already asked me for it." Then he asked me for whom I wanted it. I said, for one of my brothers whom M. Colbert employed in the management of the Louvre. "Is he in orders?" asked the King. I said he was. The King then left, saying that he could not come again for some time.

As soon as the King had gone, the Cavaliere threw himself in a chair and put his head between his hands and remained bowed for a considerable time before beginning work again. Then Mme. de La Baume arrived with d'Albon and M. de La Mothe-Fénelon.[86] They looked at the bust and the drawings and then left.

At six o'clock the Cavaliere went to the Feuillants for his usual devotions. The Host was displayed, amidst many ornaments, with a big illumination of the altar. As we were going out, he remarked to me that the ornaments had reminded him how poor and feeble the French style was. In Rome they decorated their churches in a more magnificent fashion; they used large candelabra, silver chef-reliquaries

[85] Louis de Mornay (1619–91), marquis de Villarceau, capitaine-lieutenant des chevau-légers of Gaston, duc d'Orléans (1651), and later of the Dauphin (1674–77).
[86] Probably Antoine de Salignac (1611–83), marquis de La Mothe-Fénelon.

in which relics were encased, and big splendidly shaped vases holding bunches of flowers, which produced quite a different effect from the mass of little objects standing on this altar. My brother said that no one would dare to express such an opinion as it would not be well received; only cultured people had enough humility to listen in good part to what one said to them. The Cavaliere replied that ignorance is always marked by pride and presumption; a learned man constantly realizes how little he knows, which gives him humility.

12 SEPTEMBER

MM. Du Metz and Le Brun came to see the Cavaliere; after having looked at the bust Le Brun was shown the drawings for the Louvre, which he had not seen before. A little later M. Colbert arrived full of amiability, which he usually is when he comes to see the Cavaliere. But, when he heard that the Cavaliere's wife was ill, his face immediately assumed another expression. MM. Du Metz and Le Brun having withdrawn, M. Colbert took his seat and a meeting was held, as on the preceding Sunday. The Cavaliere began by repeating to M. Colbert roughly what he had said to the King about the Gobelins. He praised the establishment highly and the man in charge of it. He added that he had told the King that even a prince who did not delight in beautiful things should show that he appreciated them by encouraging their manufacture. In the course of time one would see great progress being made in this establishment as in others of the kind; it would be a good thing if there were as high a standard in Rome as here. M. Colbert said that it was he who had revived the manufacture of high-warp tapestry, for which only two workmen remained in Paris. It was much better than the other methods, although all the most beautiful tapestries, such as the *Acts of the Apostles*,[87] were in low warp. Then the specifications for the Louvre were discussed. M. Perrault had begun to translate them into French. He read several sections, which were discussed. M. Colbert asked my brother to finish the translation that week with M. Perrault, so that arrangements could be made with the contractors according to the various elevations. I said that the decorations for the capitals and the entablatures, when they came to them, would be one of the chief things; on them would depend the reputation of the whole building. M. Colbert disagreed and argued that if the work was conceived in a grand manner, that in itself would make its reputation. The Cavaliere interjected that there were two things to consider in an undertaking, the general effect and

[87] Designed by Raphael. See above, 4 June, n. 30.

the details, and the latter were certainly of great importance in giving significance to the whole. M. Colbert persisted in his own opinion. Finally it was decided that the specifications should be translated and reduced to the number of chapters absolutely necessary; and the page should be divided, with French on one side and Italian on the other. Regarding the buildings that would have to be pulled down, M. Colbert asked M. Perrault to inform M. Du Buisson about it.

I forgot to note that, when the Cavaliere had talked about the Gobelins, M. Colbert had declared that his coming to France and his hoped-for return would rather diminish the future glory of this establishment, but he would gladly make the sacrifice if he could be assured that he would come back. I mentioned to M. Colbert that I had persuaded the Cavaliere to go to Versailles when the King was there unless there was some objection. He said it would be all right.

The Cavaliere received his letters from Rome. He learnt from them that his wife had been very ill and was not well yet, which caused him much anxiety. The abbé Buti, who had attended the council, dined in town. After dinner I left, and came back at four. Mme. de La Baume, Mme. d'Albon[88] and her daughter came to see the bust. Mignard also came. We found marks on the bust and on M. Paolo's *Christ Child* which pumice stone would not remove. We thought it must be mouse droppings. In the evening we went to the Feuillants and afterwards drove along the river.

13 SEPTEMBER

We went to Versailles. On the way we talked about statues, painting, and sculpture. I told the Cavaliere that we had one figure in France of great beauty, a *Venus*, which was at Richelieu. Only the torso is antique. He told me at once that he had seen it when it had been discovered at Pozzuoli. Then it was sent to France. It was much more beautiful than the *Medici Venus*. Such great works of art should remain in Rome, and permission to remove them should be refused because, as he had explained to the King and M. Colbert, it was this prerogative of possessing what still remains of the beauty of antiquity that enables Rome to produce great sculptors and painters. Nature is everywhere, but one does not become more accomplished by dint of studying and copying it; in order to excel one must see and study the works of antiquity. He repeated what he considered to be the fault of French painters,[89] which was their petty, miserable, niggly style; to

[88] Claude Bouthillier de Rancé, wife of Antoine, comte d'Albon.
[89] Cf. above, 9 Sept.

correct it they must study first the works of antiquity, then those of the Lombard school—among the former, principally the *Belvedere Torso*. The Lombards, on the other hand, tend towards the coarse and heavy, and to correct this fault should study the distinguished and elegant style of Raphael, for there never had been a Lombard, not excepting even Correggio, who had not lacked a sense of proportion and order; for this very reason they should study Raphael who was the most regular in his proportions. He repeated that in the Academy the students should study the antique and draw on a large scale to give them the grand manner which can include more detail than a petty and niggardly style. For this the paper must be placed not on the knees but between the feet as far away as possible, and the artist should draw with a long pencil holder a good distance from his eye. This broadens the style.[90] Drawing should always be very accurate and well finished, so that the habit and facility of really completing a work were acquired, without later having to take extra pain and trouble. He told us that, if he had a pupil who showed exceptional talent and genius, the only teaching he gave him was to make him work near him so that the student could watch how he worked; of course, without such natural talent that would be useless; he who has a little vessel must go to a tiny fountain to fill it and not to the Trevi Fountain which pours forth a hundred gallons a minute.

He stopped and I said that a young man was lucky if he found someone to put him on the right path, without having to look for it himself; often he loses his way and so spends part of his life uselessly; if great men wished to, they could greatly help those who were just beginning their careers; much was said about the laws of art but little or nothing about the rules that guided the artist; I meant the individual experience that every artist acquires in the course of his work. He agreed with me and said that he could compress in a few words, perhaps not more than twenty or thirty, the experience he had gained in forty years of close and continuous work. He then told us that Annibale Carracci, who often worked in Paolo Giordano's Academy,[91] used to say that the torso should be in the same proportion to the arms as the trunk of a tree to the branches; that one day a student

[90] Cf. Bernini's method for composing large pictures described below, 10 Oct.

[91] Evidently a private academy for drawing from the nude, although the identity of its sponsor is uncertain. Paolo Giordano II Orsini, Duke of Bracciano, who was said to be a rare draftsman, distinguished painter, and exquisite worker in relief (Baglione, p. 367), was only eighteen years old at the time of Annibale's death in 1609; and a second likely candidate, the Paolo Giordano (d. 1659) who was a canon of S. Maria in Via Lata (1627) and the friend and heir of the artist Gaspare Celio, probably wasn't much older.

who was drawing a torso made it too narrow by the thickness of a finger on each side, and when Carracci told him to make it bigger, he did so only by a hair's breadth and then showed it to Annibale; he laughed at it and said in his teasing Bolognese way that he had better sharpen his pencil again and draw a form in between the two contours he had made.[92] He added that it was one of his own maxims, if an idea did not work out well, to abandon it altogether and try to find another, rather than attempt to alter it.[93] He said that in the Academy they should draw by daylight in summer and by lamplight in winter; if he had time he would work there; whoever was in charge must correct the studies of the young students; they should draw the draperies of antique bas-reliefs as well as nude figures. Lastly he suggested that to give the Academy a dignified status, it should be established in the new Louvre,[94] and there should be a place for the works of the prize-winning pupils, and the best sculptors should be asked to make statues for the Louvre.

When we had finished our conversation, I asked him if we should go back by way of His Royal Highness' house at Saint-Cloud so that he could have another look at the spot where he had thought of putting a natural waterfall and make a sketch of it. He replied that we had not time, as we would have to stay there for at least an hour or two. Then we talked about the pedestal for the bust. He told the abbé Buti that the device *picciola basa* seemed to him to fit better than *sed parva*, which he, the abbé Buti, had suggested, because he felt that the word *basa* explained too much and that a device should leave something to the imagination. The Cavaliere replied that the word *basa* for a globe did give food for thought.[95] He added that under the bust there would

[92] Annibale's jocular comment depends on a famous story of artistic virtuosity told by Pliny (*Nat. Hist.* XXXV, chap. 10), in which Apelles bests his rival when he succeeds in superimposing a still finer line on the fine line Protogenes had drawn over one of his.

[93] Cf. Bernini's anecdote about Michelangelo, above, 26 July.

[94] The Academy had been forced to move from the Louvre in 1661 when its quarters were given to the Royal Printing Press. It returned there only in 1692.

[95] The energy devoted to the invention and criticism of emblems and devices during the 16th and 17th centuries was enormous, and elaborate rules were prescribed for their design. The device consisted of a picture and a motto, which taken together typically expressed a wish, a purpose, or a desire. Its fascination lay in the new and striking insight that seemed to result when language and image were fused into an apparently transparent means of expression that was superior to each of its parts. Thus, picture and motto had to be mutually interdependent, rather than simply explain one another. The abbé Buti criticizes Bernini's motto, "small base," because it too literally describes the use of the globe as a pedestal or base for the bust and suggests instead "but small," relying on the viewer to associate its sense with the world. Bernini counters that the world globe as a base is sufficiently out of the ordinary as to generate the desired insight into the King's glory.

have to be a kind of mat of the same material as the globe; it would have to be enamelled and decorated with trophies symbolizing war and the virtues. It should be an inch or two thick and wider than the globe so as to provide a further obstacle to people wanting to touch the bust;[96] the whole thing should be covered with a little silk cloth and dusted with a pair of bellows.

On our arrival at Versailles we were met by M. Le Nôtre who took us first of all into the garden, from where the Cavaliere could study the palace in his own time. I noticed that as he sought to praise it, he chose his words most carefully, saying something like this: "This is fine; everything that has proportion is beautiful; this palace is well proportioned"; then he added later, "In these palaces solidity has not been attempted and for that reason a beautiful effect has been achieved; everything done here is very elegant".[97] We went down towards the terraces that Le Nôtre has under construction, and he showed us the design, with its slopes and inclines, its paths and carriage drives, all of which he explained at length. Then we went into the flower garden, which is surrounded with little terraces about two feet high decorated with an evergreen hedge cut in the shape of knobs and balls. The Cavaliere said he liked everything very much, including the slope that leads to the Orangery.[98] We went in and measured its width. He was informed that the ceiling under the terrace was covered with a cement applied to a canvas which had been saturated with it, and that this was a secret process provided by M. Francini.[99] This vault had already withstood two winters. The Cavaliere admired it very much and suggested that it should be decorated and so be made into a very pleasant spot for summer days; it should be painted in chiaroscuro. We objected that the oil would ruin the orange trees and the stucco would not last. He replied that it could be painted in fresco without glue of any kind.

Then we went back and on entering the courtyard he met the King, who was coming out of it. He told the King that everything he had seen was most beautiful and elegant; he was astonished that the King should visit it no more than once a week, it deserved to be visited at least twice. His Majesty intimated that he was glad that he liked the palace and passed on.

[96] Cf. above, 9 and 10 Sept.

[97] Chantelou quotes Bernini in Italian in the manuscript.

[98] Built by Le Vau in 1663 and later replaced by Jules-Hardouin Mansart. See Hautecoeur, II, pp. 267–68, 554–58.

[99] François Francini (d. 1688), a member of an Italian family of hydraulic engineers, who was a maître d'hôtel du roi and ingénieur et indendant général des fontaines, grottes, acqueducs, etc., des maisons royales.

Then the Cavaliere went to visit the Queen; the duc d'Orléans and all the ladies were there. Meanwhile, I went in search of M. de Bellefonds, the first maître d'hôtel, to ask him where the Cavaliere was to dine. He told me that he had arranged for several dishes to be prepared for him in the apartments of the First Groom of the Little Stable,[100] and he himself would serve him, as there were too many people at the chamberlain's table. He asked me to conduct the Cavaliere to the lodge of M. Bontemps. I went to find the Cavaliere in the apartments of the Queen who was about to hold a drawing room that included the duchesse d'Orléans, Mademoiselle d'Orléans,[101] Mlle. d'Alençon,[102] the duchesse d'Elbeuf, the princesse de Monaco, the comtesse d'Armagnac,[103] the duchesse de Bouillon,[104] Mlle. d'Elbeuf,[105] the duchesse de Montausier, the vicomtesse de Tavannes,[106] and others. When he had been as long as he could wish in this very pleasant company, I took him to dine in the lodge and told him that it would be a good thing if afterwards we should see the ceremony of the King at table with all the royal ladies, which we did.

While the King was dining, the Cavaliere and the First Doctor engaged in conversation. The Cavaliere remarked how much the King diluted his wine, and the doctor told him that he had not allowed him to take any wine until he was eighteen years old because the liver in young people is tender, and drinking wine too early dries it up. The Cavaliere replied that his efforts were all in vain, that his King (meaning the bust) would last longer than the doctor's.

When dinner was finished, the Cavaliere went to have his daily rest in the lodge, and when he rose it was time for the hunt, and he went into the park to see the Queen and the ladies on horseback. The King, who was present, asked me to show the Cavaliere the

[100] That is, Henri de Beringhen.

[101] Anne-Marie-Louise d'Orléans (1627–93), duchesse de Montpensier, called la Grande Mademoiselle, daughter of Gaston d'Orléans, brother of Louis XIII, and Marie de Bourbon, heiress of the Montpensier family.

[102] Elisabeth d'Orléans (1646–96), called Mademoiselle d'Alençon from the duchy she inherited from her father, Gaston d'Orléans. In 1667, she married Louis-Joseph de Lorraine (1650–71), sixth duc de Guise.

[103] Catherine de Neufville de Villeroi (1639–1707), wife of Louis de Lorraine, comte d'Armagnac, whom she married in 1660.

[104] Marie-Anne Mancini (1650–1714), niece of Cardinal Mazarin and wife of Godefroy-Maurice de La Tour d'Auvergne (1639–1721), duc de Bouillon and Grand Chamberlain.

[105] Marie-Marguerite-Ignace de Lorraine (1629–79), called Mlle. d'Elbeuf. Daughter of Charles II, duc de Lorraine, and Catherine-Henriette of France, she was dame du palais of the Queen.

[106] Presumably Louise-Henriette de Potier, wife of Jacques Saulx, comte de Tavannes.

Ménagerie[107] and the court used for the game of *Ramasse*[108] and then bring him back to see the hunt later, which I did. It was then late and we returned to Paris.

14 SEPTEMBER

🐝 In the morning Cardinal Antonio Barberini came to see the Cavaliere. With him was a gentleman from Genoa who had much to say about the coming papal elections and declared that Cardinal Corrado of Ferrara[109] would play a considerable part and that he would have the votes of the three Genoese cardinals, *a spada tirata*.[110] He is designated in the prophecies of Joachim by the *sidus olorum*,[111] for he has stars in his coat-of-arms and is a native of Ferrara, which is the birthplace of all the famous poets in Italy. The abbé Tallemant[112] also came in and then the Nuncio. He told us that the Pope was shaved, and had been out on the very day that people were saying that he was mortally ill.

In the afternoon the marquis de Sourdis came to see the Cavaliere. I showed him the design for the Louvre. In the evening a woman brought him a letter which on opening he found to be from Father Zucchi,[113] preacher to the Pope and a particular friend of the Cavaliere. It distressed him terribly, for he inferred from the way in which it was written that either his wife was dead or her life despaired of, although the letter was dated the eighteenth and he had had one written on the twenty-fifth. He was so affected by it that he wept copiously. I did what I could to lessen his fears, but it was useless, and he would not go out as usual. He retired to his bedroom, and as I was leaving M. Mattia said that he would be very glad to meet the architect who

[107] The Ménagerie for the King's collection of rare and exotic animals was built in 1663–64, almost certainly by Le Vau.

[108] *Ramasse* was one of the innumerable pastimes of Rabelais's Gargantua (chap. 22) and consisted of tobogganing or being pulled on a sledge, originally made of branches but later refined. Versailles evidently boasted a place especially adapted for the sport.

[109] Jacopo Corrado (1602-66), a cardinal (1652) born in Ferrara, who had been a Judge or Auditor of the Rota, of which he published a collection of decisions.

[110] That is, "without reserve."

[111] That is, by the "swans's star," *swans* being a metaphor for *poets* in the book of prophecies on the popes erroneously attributed to Joachim, Abbot of Fiore (ca. 1132–1202), an Italian mystic whose influential writings inspired many imitations such as this.

[112] Cf. above, 9 Sept., n. 69.

[113] Niccolò Zucchi (1586–1670), a Jesuit known for the holiness of his life and for his outspoken frankness as a preacher (Pastor, XXXI, p. 125). Bernini had provided the design for an illustration in Zucchi's *Optica philosophia experimentis et ratione a fundamentis constituta* (1652). See Brauer and Wittkower, p. 151, n. 3.

had drawn the plan of the Temple[114] because of various difficulties he had come across. I wrote a note to the commandeur de Souvré and also went to tell M. Renard. He informed me that he had seen M. ———— in the morning, who had spoken very unkindly of the Cavaliere and his son; perhaps it had been inspired by ————, the architect of ————; it was one of M.————'s greatest pleasures to insult a person openly and say something that would cause pain.

15 SEPTEMBER

✿ M. Colbert sent a servant to me very early in the morning to let me know that I was to take the Cavaliere to Saint-Denis.[115] I ordered the royal coach-and-six to be at the palais Mazarin and went there myself at once. I found the Cavaliere in a melancholy humor as a result of Father Zucchi's letter. In this state of depression he told me that M. Madiot was neither so trustworthy nor so able as I had said he was, for he had maintained that the mortar used in the newly begun foundations was of good quality, although it had no lime in it or so little as to be negligible. As I was trying to make excuses for him, M. Colbert arrived with his coach-and-six. The minister said good day and paid his compliments, and then asked him to get in. He demurred and then insisted that M. Colbert should get in first; he refused to sit on his right hand. MM. Paolo and Mattia and I also got in.

On our way I suggested to M. Colbert an idea that I had had for some time, which was to have a set of tapestries made of the story

[114] That is, the architect who had drawn the site plan requested by Bernini (above, 2 Aug.).

[115] A Benedictine abbey where the kings and princes of the French royal family were normally sepulchered. It was magnificently endowed by Dagobert I (d. 638), king of the Franks, who died and was buried there. Subsequently it was enlarged, rebuilt, and restored by the Abbot Suger and Louis IX. It was made a cathedral in 1966. As appears below, Colbert had asked Bernini to design a funerary chapel at Saint-Denis for the Bourbon kings. The idea of having Bernini do such a design goes back to Mazarin, who wrote to his agent in Rome (17 July 1660) that, having resolved to make "a royal and sumptuous tomb for the glorious ashes of Louis XIII, His Majesty would wish to be served by the Signor Cavaliere Bernini; but it is not certain that he will be asked, although the invitation would be in the most honorable form that he could desire, even to sending a special messenger" (M. Laurain-Portemer, "Mazarin et le Bernin," p. 196, n. 12). When Benedetti, Mazarin's agent, reported that Bernini was not interested and suggested instead Carlo Rainaldi, the Cardinal's reply reveals exactly why Bernini was so attractive: "It is necessary for me to make clear that the architect desired here must also be a good sculptor. Our century, which is so short on such men, will not permit that the King be served by anyone but the Signor Cavaliere Bernini. . . . The others, lacking this second quality, are not appropriate, and those who are mere sculptors have not the first" (M. Laurain-Portemer, "Mazarin, Benedetti et l'escalier de la Trinité des Monts," *GdBA*, LXXII 1967, p. 292, n. 69).

of Moses taken from the various pictures by M. Poussin that are in Paris; it could be called the *Old Testament Tapestry*. It would be composed of *The Exposition of Moses*,[116] which is at Stella's, *The Finding of Moses*,[117] which the duc de Richelieu has, *The Manna*,[118] which belonged to M. Fouquet, *The Striking of the Rock*,[119] which is also at Stella's, *Moses Trampling on the Crown of Pharaoh*,[120] which belongs to Cotteblanche, the *Rebecca*,[121] which M. de Richelieu has, Cérisier's *Queen Esther*,[122] and Rambouillet's *Judgment of Solomon*.[123] He said he did not care for the suggestion because of the difficulty of enlarging the small figures of the pictures to a proper scale. The Cavaliere said that the borders of tapestries should never be of flowers or other bright objects; Raphael paid great attention to this rule in the tapestries that he designed for the Pope; he made the borders of marbling and gold so that their brightness and variety should not detract from the brilliance of the main subject. The border was only to complete the tapestry, like the frame of a picture; in every work of art all should be as clear and unconfused as possible; this was also true in worldly affairs. I said it was no doubt for the same reason that Poussin would never have any but the plainest frames, without burnished gold, for his pictures, and also why Michelangelo insisted that the niches should not be decorated as the statues were sufficient ornament.[124] Mattia added that in St. Peter's there was not one decorated niche. The

[116] Painted for Jacques Stella in 1654 and today in the Ashmolean Museum, Oxford. See Blunt, *Poussin Cat.*, no. 11. According to Bellori (p. 443), a set of tapestries with Old Testament subjects by Poussin, which was to accompany the New Testament tapestries designed by Raphael, had been proposed in the early 1640s. At that time the cartoons were to be made by Poussin himself after pictures he had already painted.

[117] Probably the painting made for Pointel in 1647 and today in the Louvre. See Blunt, *Poussin Cat.*, no. 13. It was acquired by the duc de Richelieu, but went to Louis XIV in 1665.

[118] The *Israelites Gathering Manna* (Paris, Louvre) painted for Chantelou ca. 1637–39 and sold to Nicolas Fouquet (Bonnaffé, p. 114). Sometime after the fall of Fouquet in 1661, it passed into the collection of the King. See Blunt, *Poussin Cat.*, no. 21.

[119] The *Moses Striking the Rock* (Leningrad, Hermitage), painted for Jacques Stella in 1649. See Blunt, *Poussin Cat.*, no. 23.

[120] Then in the collection of the financier, Cotteblanche, who lived in the rue des Filles-Saint-Thomas, and now in the collection of the Duke of Bedford, Woburn Abbey, this painting was probably made for Pointel between 1642 and 1647. See Blunt, *Poussin Cat.*, no. 16.

[121] The *Eliezer and Rebecca* (Paris, Louvre), painted for Pointel and acquired by the King from the duc de Richelieu in 1665. See Blunt, *Poussin Cat.*, no. 8.

[122] The *Esther and Ahasuerus* Bernini had seen at Cérisier's on 10 Aug. (above).

[123] Today in the Louvre. It was painted for Pointel in 1649 and bought after his death by Nicolas Du Plessis-Rambouillet, a financier and Secretary to the King. See Blunt, *Poussin Cat.*, no. 35.

[124] For the statement attributed to Michelangelo, cf. Vasari-Milanesi, VI, p. 308; VII, p. 226. A similar conversation on the borders of tapestries appears below, 10 Oct.

Cavaliere said those who design tapestries should be very careful as regards half-tones; where there might be six tones in a picture, in a tapestry or mosaic there should not be more than four so as to make the craftsman's task easier. This was the method used by Lanfranco[125] and he had excelled in the art of designing for mosaics.

I said that the work at the Gobelins was of a very high standard, particularly whatever Jausse did.[126] M. Colbert told us that at first he had been a mediocre craftsman; he copied tapestries but extremely badly, and he had wanted to dismiss him from the Gobelins, but he had begged to be allowed to remain a little longer so that he might show what he knew; he had really grown slack in a period when people knew nothing about beautiful things and paid as much for bad workmanship as for good. He and his son became first-rate workers, and the King had made the latter a grant of two thousand crowns on his marriage. M. Colbert said he hoped the Cavaliere would see the strides made at the Gobelins in four or five years; the King would live another fifty years, and there would be great progress in everything. The question of tapestries had occupied him ever since he became Superintendent of Buildings.

M. Colbert then took out a plan of the church of Saint-Denis, but on looking at it, he found that it was only of the choir without the nave. He asked the Cavaliere whether there were as many abbeys and convents in Italy as in France; in this country they were worth more than a hundred million livres a year; the abbey of Saint-Denis was worth 50,000 crowns to the abbot and 100,000 livres to the monks, it being the most important abbey in France. He added that there were so many livings, places, and favors to be disposed of in France that on an average the King had the gift of twenty thousand livres of income each day. The Cavaliere answered that there were so many convents in Rome that they were nearly as numerous as other houses, but the livings were not so valuable. I remarked to M. Colbert that the ecclesiastics, particularly the monks, were so rich and acquired so much wealth with every week that passed that it would be a good thing to introduce some sort of order in their affairs; in Le Mans nearly all the property in the district belonged to the church; the reforms had made very little difference, for the reformed orders continued to acquire

[125] Then, as now, Giovanni Lanfranco was best known as a painter in oils and fresco (Passeri-Hess, p. 163), although he did do the cartoons for SS. Bonaventura (1629–30) and Cirillo (1632) in the pendentives of the Cappella della Madonna (della colonna di S. Leone) in St. Peter's, which were executed by the mosaicist Giovanni Battista Calandra.

[126] Evidently Jean Jans, who along with his son was employed at the Gobelins.

wealth at a great rate. He replied that the chancellor had been requested not to ratify any more amortizations; they had made a start there and would continue step by step. We got out of the carriage and went into the church, which someone said had been built or founded by Dagobert. Among other tombs that of François I and his wife and children[127] was pointed out to the Cavaliere. Having looked at it for a bit he remarked, "They are very badly housed here."[128] At this M. Colbert's face clouded over and taking me on one side he said, "What does he mean by that?" I replied that he thought the tomb lacked originality and broadness of style and he did not care for it. He next saw the tomb of Louis XII,[129] which is one of the most magnificent of the royal sepulchers. He went inside and looked at it for a long time. He noticed the deathlike grimace on the faces of the recumbent figures and remarked that it was an unpleasant sight, adding, "Thus ends human vanity."[130]

Then he went into the Valois chapel,[131] which is not yet finished; M. Colbert said he would have some work done to it in the coming year, that the design was quite good, but the capitals and the bases of the columns were very badly executed. The Cavaliere did not refer to the bronze figures that adorn the tomb of Henry II,[132] but noticed

[127] Designed by Philibert de l'Orme for Henry II and begun in 1547. The carved ornaments and sculpture were executed by Pierre Bontemps and Germain Pilon, although the eight statues for which the latter received payment have since disappeared. See Blunt, *Art and Architecture*, pp. 91–93, 129, 146.

[128] Bernini's remark is in Italian in the manuscript.

[129] Built for Francis I between 1515 and 1537 by the Italian sculptors Antonio and Giovanni Giusti, who changed their name to Juste after settling in Tours where they founded a dynasty of sculptors. The *gisants*, or reclining effigies of the deceased, with their gaping mouths, sunken cheeks, and reproductions of embalming stitches and incisions, however, are probably by a French artist. They are placed beneath the kneeling figures of the King and Queen in an arcaded enclosure that almost forms a small chapel. See Blunt, *Art and Architecture*, pp. 37–40.

[130] Bernini's comment is in Italian in the manuscript.

[131] The Valois chapel (fig. 17), attached to the north transept of Saint-Denis, was a circular building designed by Primaticcio for Catherine de Médicis as a mausoleum for her husband, Henry II, herself, and her children. However, little seems to have been built before Primaticcio's death in 1570, and by 1585 his successors, Jean Bullant and Baptiste Du Cerceau, had erected the building only to the top of the second order. The work was abandoned, and after falling into disrepair, it was demolished in the early 18th century. See Blunt, *Art and Architecture*, pp. 95–98.

[132] The sculpture on the tomb of Henry II and Catherine de Médicis, which was intended to stand at the center of the Valois chapel but is now in the church, was executed by Germain Pilon under the direction of Primaticcio between 1563 and 1570. It consisted of four bronze Virtues standing at the corners of the architecture enclosing marble *gisants* of the royal couple, who reappear as bronze figures above. The *gisant* admired by Bernini here and below (29 Sept.) must be the later figure of the King in his coronation robes carved by Pilon in 1583. See Blunt, *Art and Architecture*, pp. 147–49.

that of Henry II himself in a royal cloak, which is among the recumbent figures in a space nearby. He said the figure was of great beauty and the marble of which it is made was really suitable for statuary; the King had a face of great distinction. He asked me to enquire of the monks whether they had a plan of the whole abbey and said he wished to see the shape of the exterior of the church.

We went through several rooms and saw the craftsmen working on the embroideries that the Cardinal de Retz[133] had commissioned. Then we walked round various gardens while he looked for a site that could be used for enlarging the church. He said the new building would have to dominate the whole. This alarmed M. Colbert, who said to me in an aside that he feared it was going to be too big an enterprise. I said his idea was no doubt to build on the same level as the back of choir, which is higher and therefore dominates the rest; further, it would provide plenty of room for the bodies of the kings. Then he asked the Cavaliere, who gave him the same explanation. He had pointed out before that the entrance to the proposed building could be made at the back of the church through the two small wings, and that there would be another entrance from outside.[134] Then he went to see the treasury. First we looked at the reliquary which holds some drops of the Blood of Our Lord. The Cavaliere was shown the other relics, but he said that the Blood was the relic of relics. He was then shown an agate cup, cut in low relief, which I had already mentioned to M. Colbert as a very rare piece. As a matter of fact the Cavaliere dal Pozzo[135] had shown me a drawing he had had made of

[133] Jean-François-Paul de Gondi (1613–79), Cardinal de Retz, whose *Mémoires* (1717) are one of the classics of French letters. He was a Canon of Notre-Dame (1627) and the Coadjutor (1643) of his uncle, the Archbishop of Paris, whom he succeeded in 1654. Named cardinal in 1651, he played an important role in the troubles of the Fronde. Arrested and imprisoned first at Vincennes and then at Nantes, he escaped to Spain and returned to France only after having resigned the Archbishopric of Paris (1662). In exchange, he received along with other benefices the Abbey of Saint-Denis.

[134] The location of the church behind the choir of the church had already been recommended to Bernini in the *Memorandum* (Clément, p. 258) on laying out the Louvre given to him on 19 August (above). Like the artist's other Parisian designs, never executed, his ideas are known from two drawings (fig. 18) today in the Nationalmuseum, Stockholm. For these drawings, as well as Mansart's projects for the chapel, see A. J. Braham, "Bernini's design for the Bourbon Chapel," *BM*, CII, 1960, pp. 443–47, and Braham and Smith, pp. 253–54.

[135] For the treasury of Saint-Denis in the 17th century, see now Blaise de Montesquiou-Fezensac, *Le trésor de Saint-Denis*, Paris, 1973–77. Cassiano dal Pozzo (1588–1657), the learned friend of Poussin, was secretary to Cardinal Francesco Barberini, whom he had accompanied on his legations to France and Spain in 1625 and 1626. The drawing he had shown Chantelou was evidently one of two representing the beautiful sardonyx cup from Saint-Denis known as the "Coupe des Ptolémées" (Paris, Bibliothèque Nationale, Cabinet des Médailles). The two drawings were numbered 4 and 5

it when he was in France with Cardinal Francesco Barberini when he was Legate.

The Cavaliere said this cup was worked in the same style as the chair of St. Peter,[136] which proves its great antiquity. I forgot to mention that before we went to see the treasury, we looked at the refectory,[137] the vault of which is carried by Gothic columns down the center. They seemed to us very weak for such a burden. Everyone was admiring it when we noticed that it was composed of two vaults, one supporting the other.

When we got back in the coach to return to Paris, I again spoke to M. Colbert about the tapestries, which I had suggested should be made from M. Poussin's pictures, but I found him convinced that they would not succeed. He reminded me that he had seen the tapestry that I had had made from one of the *Seven Sacraments* and it had been a failure. I replied that this was due to the poor workmen employed by one Soucani, a partner of Comans, with whom I had made a contract for the undertaking. I explained to him my belief that it was impossible for this set of tapestries, if it were well carried out, to be anything less than the most beautiful in France, only excepting the series of the *Acts of the Apostles*, for it would contain landscape, figures, and architecture. He replied that architecture did not look well in tapestry. "That is true," I answered, "if there is nothing but architecture, but if it is mixed with figures and landscape, as in these pictures, it will succeed admirably, that is, if the drawings are carried out by five or six of the best painters such as Bourdon, etc." He said nothing further and went off to sleep. When we got to Paris it was dinner time and he put the Cavaliere down at the palais Mazarin. In the evening the Cavaliere went to the Feuillants.

I forgot to note that he told us that when Annibale Carracci saw something in a tight style, he would say in Bolognese, "Beautiful! It may well be the work of Pietro Perugino." And when he saw something else in a broad manner but lacking proportion, "They seem to be by Giorgione."[138]

in his *Museum Chartaceum*, a vast collection of drawings after ancient works of art, and are now at Windsor Castle (C. C. Vermeule, "The Dal Pozzo-Albani Drawings of Classical Antiquities in the Royal Library at Windsor Castle," *Transactions of the American Philosophical Society*, n.s. 56, 2, 1966, p. 25, nos. 8384–85).

[136] That is, in the same style as the 9th-century ivories ornamenting the relic of Peter's chair, for which the Cavaliere had designed the *Cathedra Petri* as a huge reliquary.

[137] The refectory was a 13th-century building with two vaulted aisles each 36 feet high separated by 6 columns, of which the shafts were 13 feet high and 6 inches thick. Cf. Formigé, *L'Abbaye Royale de Saint-Denis*, Paris, 1960, p. 26.

[138] Annibale's comment is quoted in Italian in the manuscript.

16 SEPTEMBER

🎗 In the morning Warin came to ask to see the design for the façade so that he could put it on the reverse of the medals that he was to make to commemorate the laying of the foundations. The Cavaliere showed it to him and told him how it should be done. He chose only a part of the façade, thinking that it could not be reproduced in its entirety in so small a space as the reverse of a medal. But after dinner M. Mattia showed me a design in which the whole façade is shown in the same space, which gives a much better effect.[139]

The Cavaliere asked me to accompany MM. Mattia and Madiot to view the foundations of the façade begun by Le Vau, which I did. They were no good. This is partly due to the poor quality of the mortar, there being apparently no lime mixed with it, partly to the nesting of rats in between the stones. We also saw that the new work was making no progress because the workmen had not sufficient space in which to move, and there were houses standing where they should have started digging. I went in to M. Du Buisson's, whose house stands on the site of the new foundations, to find out whether it was true that M. Colbert had given him until October in which to move, and learnt from his wife that this was not so. I saw that they could leave the rooms where she was living for a little while, until she had found somewhere else, and pull down the rest. Then I returned to the Cavaliere's, where I dined.

In the evening Cardinal Antonio Barberini came and then the Nuncio. I left him to talk to the Cardinal while I went with M. Mattia and my brother to the Louvre, as M. Perrault had come to tell us that M. Colbert had gone to see the foundations. When he saw how little progress had been made he severely scolded Mazières, telling him that he would send him away from the Louvre and never let him return. Nobody mentioned the bad mortar, and he only wanted to know from my brother why the foundations had to be so deep. He replied that in Italy it was a maxim that the foundations had to be a sixth of the height of the building. All the time that M. Colbert was there he treated my brother with the greatest courtesy. I forgot to say that I had spoken to M. Mattia in the morning about my having a copy of the drawing for the medal to send to my other brother[140] who also likes and understands architecture, but he had replied that it was too small; he would make a bigger one and put in all its façades.

[139] Cf. below, 8 Oct.
[140] That is, Jean Fréart, for whom Chantelou wrote the *Journal*. Cf. above, the introductory letter.

17 SEPTEMBER

In the morning the Cavaliere asked me to tell the King, or have him informed, that the next time he came it would be a good thing if he wore a collar, instead of the cravat that he had worn on other occasions, and he said he would be glad if he could see two or three of the King's collars so as to choose one that would be suitable to portray in marble. At the King's levee I spoke to M. Moreau,[141] the first Valet of the Wardrobe, about the collars and to M. Daniel about the cravat. Then I returned to the Cavaliere whom I found in conversation with Pietro Sassi, the plasterer, who had been sent for from Rome by the Cavaliere and had arrived the night before. We questioned him about our lime. He already knew its qualities as he had worked before in France, and he said it was excellent mixed with sand from the river and elsewhere, but that it must be slaked in the Roman way because if it were done according to the French method, the pebbles that remain in the bottom of the pit where it was slaked ruin the plaster used for coating or rough casting a wall. He had found that the wetter one made and kept the stone, the better it bound. He added that he was in France when they had made a window in the Queen Mother's new apartments facing the river. When the wall, which was of soft stone, was opened, it cut quite easily on the surface, but in the middle, where the dampness had remained, the stone was hard as marble, although the material was exactly the same as the exterior. He said that none of the work he had done in France, at the palais Mazarin, at Saint-Mandé,[142] or elsewhere, had been a failure, and he had used mortar, slaked in the Italian way, with river sand and whatever else was available on the site. He made the first structure in plaster and finished it with mortar. Mattia and he and I went to look at the ceilings in the palais Mazarin and saw that they showed no cracks or splits, although they were made on wood. The Cavaliere had some mill stone brought in, which Sassi said was excellent for ceilings; in Rome they were made with stone from Civitavecchia, which was not half so good.

I stayed to dine with the Cavaliere. While we were at table Mattia said he wanted to go back to Rome. I said with a smile that he must remain at least until the Cavaliere returned, to which the latter gallantly replied that there was no need of a hostage to force him to come back to such a King as ours. Referring to his return, he said Cardinal

[141] Denis Moreau (d. 1707), premier valet de la garde-robe du roi, who became premier valet de chambre of the Dauphine in 1683 and in 1689 of the duc de Bourgogne.

[142] The château de Saint-Mandé, near the château de Vincennes, acquired in 1654 and remodelled by Nicolas Fouquet before he began to build Vaux-le-Vicomte.

Antonio Barberini had given him many remedies against the cold. I said that wadding was the best, for cotton wool was both warm and light at the same time; that bearskin was particularly good for giving a great heat. The Cavaliere went to rest and Mattia and I went downstairs. I asked him while we were alone why he wanted to return to Rome. He said there were various reasons; first, he did not want to leave the Cavaliere as he had no one else to help him if he needed anything; the closest ties bound him to the Cavaliere, and he would not feel happy if he did not go with him; then there were his personal affairs in Rome; if he were to return to this country he would want to bring his wife back with him; she was young and he would entrust her with nobody; he wished to bring her himself. I said she could travel with Signora Caterina.[143] He said he was doubtful whether she would come to France. Anyway, no one had mentioned it yet, but if they did, he would say he wanted to accompany the Cavaliere; he would have nothing to do here this winter; things were not making much progress and it was obvious that they were not putting much enthusiasm into the work. I replied that the contractors were trying to demonstrate by their slowness and the cost that it was not desirable to work by the day; he must have noticed how M. Colbert had spoken to them the day before. While I was talking, the Cavaliere came in and our conversation stopped. In the evening Mme. de Lionne came and the président de Maisons, also M. de Longueil and M. de La Haye senior.[144] I showed them the drawings. Later Mme. de La Baume, who was going down to Touraine, came to say goodbye to the Cavaliere. I forgot to mention that M. Desfontaines, who had come with Mme. de Lionne, said to me, "I fear that these Italians will be put off by the slowness of the work."

19 SEPTEMBER

�急 I happened to meet M. Passart[145] and took him to see the Cavaliere. He thought the portrait was a striking likeness but that the jaw was rather prominent. Gamart[146] also came and he thought that the nose was somewhat larger on one side than the other, and narrower at the

[143] Bernini's wife, Caterina Tezio (1617–73), daughter of Eugenia Valeri and Paolo Tezio (d. 1651), whom the Cavaliere had married on 12 May 1639.

[144] Identified by Lalanne as La Haye de Vauderet, maître d'hôtel of the Queen.

[145] M. Passart, or Passard, was a maître des comptes and a collector of pictures, including works by Poussin and Claude, who appears in the *Banquet des Curieux*. See Bonnaffé, p. 242.

[146] Hubert Gamart, or Gamarre, sieur de Crezé, Lieutenant of the Hunt, and collector of paintings. He appears in the *Banquet des Curieux* among the Poussinistes. See Bonnaffé, pp. 121–22 and below, 3 Oct.

back than at the front; the drapery was, he said, in the Cavaliere's usual style. He added that sculpture demands the greatest patience which is most exhausting to a lively nature. During our conversation the Cavaliere was standing over the mason, who was working at the foot of the bust. He asked him what the marble was like and he told him it was *cotto* (friable). "The same then, as what I used for the bust," he said, and added that he was still astonished at how he had managed to do what he had done, "This was supernatural,"[147] for the marble might have been in Paris for more than fifty years. I noticed that the place for the foot of the bust was square and asked him how the globe was going to fit into it. He said that the space would be hollowed out until it was the same size as the globe. He had succeeded in removing the tie of marble which supported the drapery and asked me how it looked now it was free. I said I admired it very much indeed. He told me he had tried to make it "so that it should not appear that these fluttering draperies were held in place by a nail, nor were as dry as crusts."[148]

The Nuncio came while we were talking, and with him the abbé Buti. The Cavaliere said to them, "When I leave this country I shall want to shout out loud and write on every door" (I am copying his manner of speaking) "there is no one in the whole of Paris who has such good taste as M. de Chantelou or who knows as much as he does; the King would be fortunate to have at least six like him; he had told the King so but did not know if he had properly understood."[149]

Just then two collars belonging to the King were brought in. The Cavaliere compared them with the one he had already, and finding that was the most suitable he gave back the other two. The Nuncio said to me that when the portrait was finished, he ought to undertake others in Paris. I agreed, saying that although we had Warin who made a good likeness, he was unable to impart those qualities of nobility and grandeur with which the Cavaliere had endowed this bust. He added that when the Louvre was finished, other buildings would be erected in the same style. I answered that I could easily believe it would become the fashion; all that we needed in France was a good model. In Rome it was the remains of ancient art that served sculptors and architects as a guide from one age to another, and that were always there to help them to maintain their excellence. He did not agree with me and asserted that there was nothing to rival St.

[147] The phrase is in Italian in the manuscript.
[148] The quote is in Italian in the manuscript.
[149] Bernini's opinion of Chantelou is in Italian in the manuscript.

Peter's in antiquity. "If you mean in the extent of its site and the amount of masonry, I will not argue with you, but in grandeur of style, St. Peter's is smaller than the Pantheon,[150] and the work is less fine, less exact, less careful; and do you not think, Monsieur," I asked, "that there were ancient temples in Greece and Italy that would have equalled St. Peter's in size and grandeur." He stuck to his own opinion and appealed to the Cavaliere, asking him whether it was not true that St. Peter's far excelled the Pantheon in nobility of style. He replied frankly, no, that the most perfect forms were rounds, squares, hexagons, octagons, etc.;[151] the cupola of St. Peter's was beautiful, it was true, and there was nothing like it in antiquity, but there were a hundred errors in St. Peter's and none in the Pantheon; Michelangelo had not wanted there to be a nave at all; Baldassare Peruzzi had made a design for St. Peter's, included in Serlio's book,[152] which is much more beautiful than the one that was carried out. The Nuncio said his favorite building of all that have lasted from antiquity was the Colosseum. He had declared on some other occasion that he would have restored it, if he had been pope.[153] He repeated there was nothing to compare with it in modern times. I did not agree, saying it was mostly remarkable for its size, but it was by no means the most beautiful remaining thing. He asked the Cavaliere whether he knew the name of the architect who had designed it. He replied that he did not.

After our conversation the Cavaliere went to dine. The King's guards arrived at one o'clock; a little later a young girl came in, who was in the service of Mlle. de La Vallière. The abbé Buti said that she had been employed by Mme. de Bellizani, but the King had asked M. Colbert to find someone for Mlle. de La Vallière, and he had sent her this young lady. At two o'clock the King arrived, wearing the kind of collar that the Cavaliere had wanted. The abbé Buti and I pointed out to him how the drapery of the bust had been severed from the little tie which the Cavaliere had left to support it and to prevent the marble from breaking as a result of the hollowing process. Half an hour later the Queen arrived and remarked at once how like the portrait was. The Cavaliere first bowed very low to her, and then said that Her Majesty had the image of the King so imprinted in her

[150] The Pantheon in Rome. Originally built by Agrippa in 27 B.C., it owes its present form to the Emperor Hadrian. In 609, with the permission of the Emperor Phocas, it was consecrated as a church under the title of S. Maria ad Martyres, but was popularly known as S. Maria Rotonda.

[151] An old idea, still common in the Renaissance. See Wittkower, *Architectural Principles in the Age of Humanism*, pp. 27–30.

[152] That is, in Sebastiano Serlio's *Architettura*, bk. III, fol. 65v.

[153] Above, 8 June.

heart and mind that she saw it everywhere, or so it seemed to her.[154] The Queen was seated in an armchair and stayed there to watch the Cavaliere working. The abbé Buti read a quatrain on the subject of the projected stand for the bust, which is, as I have said earlier, a globe with the device *picciola base* on it. It went:

> Entrò il Bernino in un pensier profondo
> Per far al regal busto un bel sostegno,
> E disse (non trovandone alcun degno):
> Picciola base a tal Monarca è il mondo.[155]

> Bernini gave profound thought to making a beautiful support for the royal bust, and finding none worthy, said, the world is but a small base for such a monarch.

The King listened attentively and said that he liked it very much. He took it and gave it to M. Dangeau to put into French. At first he demurred, then he produced a verse on the spot. The abbé Tallemant also read a madrigal on the subject of the bust:

> Louis jusques ici n'avait rien de semblable,
> Et malgré le ciseau, le pinceau, le burin,
> Etait à lui seul comparable.
> On en voit deux, grâce au Bernin,
> Dont l'un est invincible et l'autre inimitable.

> Until now there existed nothing resembling Louis. In spite of chisel, brush, or burin, he was only comparable to himself. Thanks to Bernini, there are two of him, the one invincible, the other inimitable.

The abbé Buti improvising, turned it in this way,

> Fin' hora in van s'affaticò il pennello
> Per far più d'un Luigi a noi visibile;
> Hor' mercé del Bernino, appar gemello:
> Inimitabil l'un, l'altro invincibile.

While the Cavaliere was working, the duc de Montausier remarked to me that he had heard that my brother and I were responsible for the Louvre. I answered that my brother was to be at the Louvre,

[154] Domenico Bernini (p. 136) wrote that after the Queen had praised the portrait, his father replied: "Your Majesty praises the copy so much because you are enamored with the original."

[155] The abbé's quatrain is also in Baldinucci (*Vita*, p. 53) and in Domenico Bernini (p. 137). See below, 26 Sept., for the reply written in the name of Bernini by the abbé Amable de Bourzeïs.

but I had no other appointment than the one I held with the Cavaliere. He said that he was making the King's eyes too wide open. I replied it might be better if they were less open in a living creature, but it was just that which made a dead thing come to life. M. de Thou[156] was also there, and he asked me in a low voice whether they had really decided on the design for the Louvre. I said that I thought they must have done so because they had already started on the foundations, and Warin had even begun making a medal, the reverse side of which would show the façade of the Louvre from a drawing by the Cavaliere; it was to be laid under the foundation stone; I said I knew nothing further about the matter. He then asked me if they were working by the day. I replied they were doing so at present but that specifications were being drawn up for contractors. He asserted that nothing of any value would be done. I told him M. Colbert's reasons. He answered that he might as well undeceive himself; when he, M. de Thou, had asked M. Colbert when he was going to move into his new house, where he had planned to raise the height of the two wings which were too low, he had replied, "Not for some time," because it had been found that the foundations were very poor, and it would be necessary to re-lay them. It was Le Vau who had built this house for M. Bautru;[157] M. Colbert was having much difficulty in extricating himself from this mess for fear of letting it be known that he had made a mistake in his choice, but he would get over it; if he did it suddenly, one thing would lead to another, and people would begin to criticize the Collège des Quatre-Nations, which is very badly planned and situated (on account of the alteration in the river bed) and shamefully executed. He would certainly make them pay heavily because he well knew that the whole thing had been done to enhance the value of the sites that Le Vau and his friends owned in that neighborhood. I told him about the rottenness of Le Vau's foundations, which the Cavaliere discovered when the digging for his façade was begun.[158] Then he turned to look at the bust, using a little eyeglass because he is very short-sighted; he remarked that it was akin to the

[156] Jacques-Auguste II de Thou (1609–77), président aux enquêtes and ambassador to Holland in 1657. He inherited from his father, Jacques-Auguste I (1553–1617), a large collection of books, portraits, and medals to which he continued to add until at his death it contained about 300,000 volumes and 130 portraits. The collection was sold by his son in 1679. See Bonnaffé, pp. 304–5.

[157] The hôtel de Bautru-Colbert in rue Vivienne was one of Le Vau's first works. It was built between 1634 and 1637 for Guillaume Bautru (1588–1665), comte de Serrant, introducteur des ambassadeurs, then himself an ambassador, and a member of the French Academy. After it was purchased by Colbert in 1665, two new pavilions were added to the existing ones flanking the main block. It was destroyed in the 19th century.

[158] Above, 16 Sept.

beautiful classical heads of Jupiter. During our conversation the Queen rose and went to look at the work of M. Paolo. I followed her and told her it was intended for her, at which she was delighted. A little before he left, the King asked the Cavaliere whether he worked on Saints' Days. Without waiting for him to reply, I told the King that he did, that he had the permission of the Pope, and was also allowed to work for three hours on Sundays.

After the King had gone, the minister's oldest son[159] and his brother, the abbé,[160] came with their tutor to see the bust, and afterwards the Cavaliere went with my brother and myself to the Feuillants. On our way, he told me that he had been thinking about what he had to do at Saint-Denis, and asked me if the portraits of the early kings of France still existed. I said that they did but no one knew whether they were done from imagination or from life. He told me that in the place that could be made for the tombs of the Bourbons one could put those of ten or twelve of the royal predecessors of His Majesty and begin with that of St. Louis, if there were that many since him; then make that of the present King, and leave room for another score; afterwards make a large burial place for the kings and carry the whole thing through with the greatest magnificence.

On our return journey we discussed devotional matters, and he told us the significance of two different sermons he had heard, the first about the pilgrims to Emmaus encountered by Our Lord. His every action was meant to serve as an example for our instruction, and therefore He walked between the pilgrims to teach us that extremes must be avoided in all things and that virtue lies in a middle course. The other sermon had been given by a cardinal in one of the services of Holy Week, which Urban VIII had praised very highly. The cardinal began by saying that he had been commanded to address His Holiness and those gathered there on the subject of the agony and sufferings of Our Lord during the Passion. Although it was a subject more suited to meditation than to discussion, nevertheless he had given it much thought himself and wanted to tell them the ideas that had come to him. He was sure, he said, that it was sin that put Our Lord into pain and agony; that the nature of sin was to attempt the destruction of God, if it could; for this reason God, who had the power,

[159] Jean-Baptiste Colbert (1651–90), marquis de Seignelay, who succeeded his father as Secretary of State for Marine Commerce and the Household of the King and in 1689 became Minister of State.

[160] Jacques-Nicolas Colbert (1654–1707), second son of Colbert, who became abbé de Bec-Hellouin in 1665, a member of the French Academy in 1678, titular Archbishop of Carthage in 1680, and Archbishop of Rouen in 1691.

should have destroyed sin and would have done so no doubt if he had been able to, without at the same time destroying the sinner, whom he wishes to save. It is for this reason only that he spares sin and allows its reign, so to speak—just so that he may save the sinner. Once and once only, there had been sin without a sinner, and that was when for our salvation Jesus Christ burdened Himself with all the sins of the world; then the justice of God the Father had put on Him so much sorrow and pain and suffering, without considering that it was His beloved Son, that it could be satisfied only by the cruelest and most ignominious death imaginable, and for the reason that on this occasion the sin existed without the sinner. I said this was a very lofty and pious conception.

As I was leaving I spoke to the Cavaliere about our excursion to Saint-Cloud. He said if it was fine it could be tomorrow, and if not, the day after. As my brother and I were returning, he told me that he had been to see M. Perrault that morning. He had sneered at the Cavaliere's design and had tried hard to push him to say that he did not admire it either; among other things he had found fault with the projecting base of the façade which carries the columns, and also with the cornice of the entablature which juts out so much that the balustrade would not be seen. "What is the good of making a balustrade," he said, "if it is to be invisible."[161] He had criticized many other things and had said that M. Colbert had asked him whether my brother had examined the designs at all. To which my brother had replied that he had only seen them when they had been shown to others, and they were of such extraordinary beauty that all that was required was to show one's admiration; all this had taken place in front of M. Madiot.

20 SEPTEMBER

🦋 In the morning I went to see the Cavaliere and found him working at M. Paolo's *Christ Child*. He said he was giving it one or two loving touches because it was destined for the Queen. I told him she had shown she was very much pleased when I had told her yesterday that it was for her. I then showed him the bearskins that had been sent at

[161] This problem, which arose because the church of Saint-Germain limited the space available for viewing the façade, had already been noticed by Colbert in a query to the artist of 10 August (Clément, p. 265). Bernini, however, argued that, because the church stood opposite only one part of the palace, a wide avenue passing to the right (north) of the church and leading to the entrance would offer views of the façade from whatever distance one wished (above, 15 July). But he also believed that the principal view of the palace would be the oblique one from the Pont-Neuf (above, 20 July).

my request. M. Morain[162] came later and I showed him the bust. Between ten and eleven o'clock M. Colbert came. He began studying the bust as he usually does. The abbé Buti and I pointed out to him the place where the Cavaliere had been working, and we were praising it when the Cavaliere intervened, saying, "The work should speak for itself without your help."[163] He then took M. Colbert aside and started talking to him privately. When I observed this I withdrew, but then I heard that M. Colbert was speaking French, and I came up to them so that I could serve as interpreter. They were talking about the work to be done at Saint-Denis, and the Cavaliere was repeating what he had said to me the evening before. M. Colbert showed that he did not care for the idea of making a place big enough for a dozen or fifteen royal tombs, for if this edifice were erected, the church of Saint-Denis, where all the services were held, would be no more than an adjunct to it, and he considered that its importance should in no way be lessened. It was held that the best place for interment was near the altar and that was where the earliest tombs were. If our kings were buried in another building, the prayers that were offered in the church would not be for them; for this reason the Valois chapel had been placed on the left-hand side of the altar; it should be possible to make a chapel for the Bourbon branch too, which would hold fifteen or twenty sepulchers; the bodies of Henry IV, Louis XIII, and the present King should be the first to be interred there. The tomb of the King, as the founder of the chapel, should be the most magnificent. The Cavaliere agreed, and told us that in St. Peter's, where Paul III, Urban VIII, and Innocent X were buried and where their successors also wanted to lie, there was room for only another five or six tombs, and he had thought a place should have been built for the burial of the popes, like the one he had described for the French kings. He added that in a not particularly large space it was possible with ingenuity to find room for a great number of tombs; his intention had not been to make a different and separate part of the church, but simply to enlarge the older one; it would be possible to pass to the new building through the wings, as well as from outside.

When we had finished with this subject, M. Colbert came up to the table and sat down, so as to hold a meeting. When the Cavaliere had taken his place and the others also, he had two stones brought in, one of them roughstone, the other miller's stone. He said he had had them weighed and the roughstone had weighed nearly a third

[162] Lalanne suggested that M. Morain might be Louis Morin, or Morain (1636–1715), a physician and botanist, who became a member of the Academy of Science in 1699.

[163] Bernini's comment is quoted in Italian in the manuscript.

more; with the lighter material it would be possible to construct vaulted ceilings as they did in Italy, for they had proved that lime mixed with river sand and ordinary sand made an excellent mortar. M. Colbert said he would like to see the experiments, as it was something new and important. The Cavaliere repeated that he was sure that it would succeed here as it had done in Rome, provided he made the walls thicker by a quarter, four parts here to three in Rome. He demonstrated what he meant on paper so that it should be better understood. M. Perrault said that he had had a vault constructed from this material some time ago and it had lasted well. Pietro Sassi, who was present and who knows a great deal about French materials, said he could confirm their good quality, and added that our lime mixed with river sand and even with other sand made an excellent mortar; that for vaults, the soft French ashlar was not good; even when it was rubbed, a kind of dust came off which prevented it from binding with the mortar when it was used in building.

The Cavaliere then spoke, saying that poor masonry in Rome was caused only by not putting water on the work while building was in process; there were workmen so accustomed to do bad work that, even when water was provided for them, they did not bother to use it. M. Colbert suggested that a large vault should be built in the palace of the Tuileries from mill stone; but the Cavaliere said he would first of all have to see the walls, in case they were not strong enough to carry it. Pietro Sassi recalled that in Rome they filled the backs and sides of the vault with old plaster pieces, which are very light and therefore constitute no sort of burden; with regard to the proposed vault, several people pointed out that there was plenty of time to make other experiments on a bigger scale than those in the courtyard of the palais Mazarin.

The Cavaliere then went on to talk about the mortar of Le Vau's foundations, of which he had had a sample brought and which was found to contain little or no lime. He added that the masonry was very poor, and it was much to be hoped that there would be two or three Italian masons here to show what good masonry was. M. Colbert retorted that there were very good French masons from the Limousin, without looking further. The Cavaliere replied that he had sent to ask M. Madiot to look at the foundations and he had agreed with him that they were very poor. M. Madiot had to confess that the mortar was no good at all. The Cavaliere added that the stonework was no good either, and turned to M. Madiot who, he said, must make identical reports to him and to M. Colbert, and he also said that I had seen it. I asserted that I had noticed in one place, where they had cut

open the foundation, that there were holes in the masonry as big as one's fist.[164] Whereupon M. Colbert declared that if this were true, the contractors would not be allowed anywhere near the Louvre, and he would go to see for himself if things were as they said.

Then I read out a list drawn up by M. Perrault of difficulties arising out of M. Mattia's specifications. These were found to be of small importance and M. Colbert said we need not stop over them. Afterwards he asked my brother if there were a great number of people working at the foundations. He told him that there were more than on the previous days. He gave him a memorandum on the capacity of the moat round the Louvre, also other places nearer, to which earth could be carried. He had learnt that this computation had been made so that the small space round the foundations could be cleared.

I forgot to note that while on the subject of masonry the Cavaliere described the foundations of M. de Lionne's house, in which there is no lime at all in the mortar, and also told us about an old architect called the Cavaliere Fontana,[165] who had at an earlier date built the façade of St. Peter's. He had always said that before he undertook any architecture he had been an experienced *capomuratore*,[166] and he, the Cavaliere, who was then very young, watched him at work. This good fellow entirely lacked originality, but he had a great knowledge of masonry and used to go among his workmen, telling them all the time, "Work in loose mortar, my boys."[167] He was surprised at this as he thought it should be the other way round, and he asked him why he said it. He had explained that a great deal of mortar should be used, that the stone should be well beaten up and stirred in so that it should be surrounded by mortar and little of it be left underneath. He had always remembered this.

Before they rose from the meeting the Cavaliere received his letters from Rome. He had been worried at their being late as he thought that it might be a bad augury for his wife's health, although the abbé Buti, who had received his, had shown him that there was no mention of any such thing in them and assured him that, if there

[164] Chantelou and Madiot had inspected Le Vau's foundations on 16 Sept. (above).

[165] Giovanni Fontana (1540–1614), architect of St. Peter's under Clement VIII and Paul V, who is known more as an engineer, and especially as a hydraulics engineer, than as an architect. It does not appear that he was ever knighted, and Bernini is either being generous or confusing him with his brother, the Cavaliere Domenico Fontana, with whom he had a relationship not unlike that of Luigi Bernini to his brother. The façade of St. Peter's was of course designed by Carlo Maderno, who from 1607, when his project was accepted, supervised its construction.

[166] That is, a master mason.

[167] Fontana's admonition is in Italian in the manuscript.

were any bad news for him, he would certainly have been informed. M. Colbert told him to open his letters to as to rid his mind of doubt. He found that his wife had been at death's door in an illness which had lasted for forty-four days, but that she had been without fever for ten days or more now, having made a miraculous recovery. He was overjoyed and said that he was quite sure his pulse must be beating very fast. Then M. Colbert got up and the meeting was brought to an end.

After dinner the Cavaliere went to the Oratoire to give thanks for the recovery of his wife, and then to see Cardinal Antonio Barberini whose doctor[168] he asked to accompany him to the palais Mazarin to see Signor Mattia who was ill. I forgot to mention that the abbé Testu,[169] Monsieur's almoner, sent me a sonnet in praise of the Cavaliere which I explained to him and which I will here transcribe.

For the Cavaliere Bernini, sculptor of the King's portrait

In searching out a mighty monarch's face
From the hard thickness of a marble stone
Thy chisel can forbid the looker-on
'Twixt art and nature severance to trace.
Bernini, bless thy destiny, whose grace
Bids thee acquire such glorious renown.
Louis, our gift from God, through thee alone
Bequeaths his features to the coming race.
Wouldst thou to later nations, newer men,
His nobly regal countenance reveal
Just as it seems to us, a living thing?
Thy art can work the miracle, and then
One look from him will cause a king to feel
What other men must feel before a king.[170]

When we got back to the hôtel Mazarin we found Marigny,[171] who had come to see the bust. He paid the Cavaliere a great many compliments and praised the ease with which he worked. He replied by quoting what Michelangelo had said one day to Ammannati, "I shit blood while I work."[172] When Marigny had gone we took Signor

[168] As appears immediately below, an Italian named Turci.

[169] Jacques Testu (1626–1706), Preacher-in-Ordinary of the King, Prior of Saint-Denis-de-la-Chartre in Paris, and a member of the French Academy (1665).

[170] Translated by the late Rupert Gleadowe, Chelsea, London, especially for this edition.

[171] Presumably the abbé Jacques Carpentier de Marigny (d. 1670), a writer attached to the Cardinal de Retz, who placed his pen in the service of the Fronde.

[172] Michelangelo's statement is in Italian in the manuscript.

Turci back to Cardinal Antonio's. Then we went to the Nuncio's, where I left the Cavaliere. He asked me to send him a trained gilder next day and someone who could copy the designs for the Louvre. I wrote that very night to Marot.[173]

🏵 I took Marot to the Cavaliere's. He gave him the drawing for the main front of the Louvre so that he could copy it. I found Signor Pietro Sassi there working at a translation of a memorandum brought by M. Perrault. This dealt with the quantity and size of the stones that could be provided by the quarries round about Paris, with the names of those to whom they belonged and the quality of the stone in each place; to this memorandum M. Colbert had added notes in various places. I helped him with the translation. Meanwhile the Cavaliere was working at the collar. I noticed that, although he looked occasionally at a collar in Venetian lace which had been left with him, he did not copy it, and when I remarked on this, he said it lacked design. I replied that the lace was the work of Venetian nuns, who had no understanding of what was beautiful.

At midday a gilder named Daret, to whom I had sent word, arrived, and I gave him a note authorizing him to fetch the frame for the *Christ Child* from the carpenter. I asked the Cavaliere if he wanted to go to Saint-Cloud. He replied that the weather was not very suitable, but that he would go, although it was a working day, just to please me and cause me no worry. At dinner he told me that he had dreamt that his wife was better. I said he should rejoice, for it was obvious that many people possessed a faculty of dreaming what was true; I myself did; I had often noticed it. When we rose from table I began to talk to M. Mattia about the design for the Louvre in the presence of Pietro Sassi, and he told me that in the plan which had been sent to Rome, the measurement of the courtyard was short by about six feet.

Sassi said that since his arrival, he had seen the courtyard cleared, and the order with which it is articulated no longer pleased him as it had before. I replied, as I always do and as is the truth, that the courtyard was originally to be no more than a quarter of its present size and that, as it was now, the orders which Pierre Lescot[174] had

[173] Jean Marot (ca. 1619–79), a practicing architect, who however is remembered today chiefly as the prolific, if not always accurate, author of two collections of engravings of architectural subjects, differing in format and known respectively as the *Petit Marot* and the *Grand Marot*. See A. Mauban, *Jean Marot*, Paris, 1944.

[174] The architect, Pierre Lescot (ca. 1510–78), who in 1546 began the southwest wing

designed for it were dwarfed by the distance; in such circumstances, there should be one order only. Mattia said that one order should never run through three stories; that if one only were desired, the ground floor should serve as a base, and the order only run through two stories.[175]

In the evening the Cavaliere and my brother and I went to the Jesuit church of Saint-Louis. He saw the bronze figures that are in front of the altar in the left transept and pointed out that they should not be where they were. He did not comment on the rest.

When we got back to the hôtel Mazarin we found M. Perrault, who had come about the memorandum on the materials. We arranged that on the morrow we should go and see the samples of all the different kinds of stone to be used at the Louvre. He talked to my brother and me about the bust which M. Warin had done and praised it to excess. We all looked at the Cavaliere's bust with the aid of a candle, as by the time we arrived it was already dark. It looked wonderful in this light.

22 SEPTEMBER

🐝 The Cavaliere worked at the King's collar. After dinner my brother and I went to fetch M. Perrault and then we took him to the palais Mazarin to get M. Mattia. The Cavaliere asked us to look at the vault which is being erected over the two walls that had been set up in the courtyard. We went down and observed that it was built of mill stone without any dressed stone, that it was a foot thick at the sides, diminishing to eight inches in the center. Then we went to the Louvre, where we saw all the different kinds of stone from different places around Paris, both from buildings and stonemasons' yards. It was decided that the stone from Arcueil was the most suitable for the rocklike rustication and the base, that it would be even better than that from Saint-Cloud as it was as hard and more porous and could be obtained in greater quantities. Samples were taken of all the different kinds of stone from Saint-Cloud, Saint-Leu, Bicêtre, and other quarries, which had been sent to the palais Mazarin. M. Mattia said they should begin to dress the sides and bottoms of the stones for the rocky base so that they would be ready for use and no delay would be caused

of the Square Court of the Louvre for François I. Although the original plan seems to have been to build a court with four sides of this size, as Chantelou suggests, the idea of increasing the size of the court by doubling the wing, which was carried out under Louis XIII and Louis XIV, almost certainly goes back to Lescot. See Blunt, *Art and Architecture*, p. 79.

[175] As Bernini himself had done in the Palazzo Chigi (Odescalchi) and the Palazzo Montecitorio, Rome.

on account of materials. He thought all the different kinds of stone first-rate and gave orders that the foundations of the vestibule should be at the same level as the rest. Then he told me of the Cavaliere's idea of lowering the level of the courtyard of the Louvre by two feet, and he wanted to show me how easy it would be, as the outer fronts of the Louvre were even lower; he said that it would be necessary to lower the cloister of Saint-Germain,[176] and if this were done, one would not have to step down into the church at the one end. This arrangement was very bad, especially as one had to go up four or five steps on the south side; he added that they would have to lower the level of the square in front of the Louvre in the middle, either by making a dip like the bed of a stream or by making it gently slope down towards the river. We went into Saint-Germain. I pointed out to him the copy of the *Last Supper* by Leonardo,[177] which is near the door on the south side. He thought it was in a very poor light. I also showed him the rood-screen[178] and pointed out its good proportions. He considered it quite pleasing. Then we went back, and as we were passing M. de La Vrillière's door,[179] we went in. As we entered the courtyard, M. Mattia said that he thought it must have been carried out from a design of Mansart. He said he had heard that Mansart had never been in Rome; if he had, he might have become a great man.

We then went back to the palais Mazarin, and the Cavaliere said, smiling, that with this Venetian lace he was working at something of very little taste which really he would never have thought he could do. The Princess of Rossano[180] had begged him for a drawing of such stuff, and others too, but he had always refused,[181] and now he was

[176] The cloister of Saint-Germain-l'Auxerrois lay to the southwest of the church and formed one entrance to it.

[177] Now in the sacristy.

[178] Built in the mid-16th century by Pierre Lescot and Jean Goujon. It was destroyed in 1754 and the five surviving panels by Goujon—a *Pietà* and four *Evangelists*—are now in the Louvre. See Blunt, *Art and Architecture*, pp. 124–25.

[179] The hôtel, near rue des Petits-Champs, designed by François Mansart for Louis I Phélypeaux de La Vrillière in 1635. Since 1811, the hôtel of the Banque de France, and only fragments of the original building remain. See Braham and Smith, pp. 35–38, 209–14. Chantelou later returns to the hôtel de La Vrillière with Bernini (below, 11 Oct.).

[180] Olimpia Aldobrandini (d. 1681), Princess of Rossano, great-grandniece of Clement VIII and Aldobrandini heiress, married in 1638 to Paolo Borghese (1624–46), grand-nephew of Paul V, and then in 1647 to Camillo Pamphili (1622–66), nephew of Innocent X. According to Baldinucci (p. 114), she owned a now lost marble by Bernini of St. Sebastian.

[181] For what little is now known about Bernini as a designer of fancy stuffs, see the introductory remarks and entries by M. Worsdale in *Bernini in Vaticano*, pp. 231–50.

doing more, he was chiselling it from marble. I asked him if I should send for the royal coach, but he said that he did not wish to go out as it was already too late.

23 SEPTEMBER

I went to see the Cavaliere and he told me that he liked the gilding on the frame of the *Christ Child* very much indeed and asked me to tell the gilder, which I did. That day he continued to work at the collar of the bust. M. Mattia and Pietro Sassi went to the Louvre to look at the vaults and decided to construct one according to Roman methods, on the second floor in the pavilion facing the rue de Beauvais. By this means they would be able to test the strength of the walls and the effect of the vaulting. My brother went with them.

In the afternoon I took the abbé d'Argenson[182] to see the Cavaliere. He greeted him, and asked me to show him the drawings for the Louvre. He looked at them carefully and said he was very glad that the large roofs and high chimneys, which had been fashionable, were no longer to be introduced. In the evening the marquise de Raray[183] came with her daughter. They were struck with the great resemblance between the bust and the King. They asked the Cavaliere if he had come to France by way of Florence. He said he had and then they wanted to know if he had seen the Princess of Tuscany.[184] He said no, but that he had seen the Prince, who is a most handsome man. They talked about the Princess' dislike of her husband. He said that, if one were to investigate, one would probably find that it was all about nothing; knowing the seat of the trouble, one would be able to remove it as easily as brushing off a fly; in the end a woman's pride lies in her ability to suffer with forbearance the imperfections of her husband, however great they may be and whatever they are. I replied that a princess like her, brought up in the French court, which is a woman's paradise, had cause to be surprised at the life they lead in Florence. The marquise added that at her age it was unlikely that she would possess those extraordinary qualities which enable a person to see the highest well-being in the performance of duty; she was only

[182] Louis de Voyer de Paulmy d'Argenson (d. 1694), commendatory abbot of the abbaye de la Trinité in Beaulieu.

[183] Catherine d'Angennes de La Loupe (1607-80), marquise de Raré, or Raray, governess of the children of Gaston, duc d'Orléans by his second wife, and the wife of Henri de Lancy, baron and then, in 1654, marquis de Raré. She had two daughters.

[184] Marguerite-Louise d'Orléans (1645-1712), daughter of Gaston, duc d'Orléans and his second wife, Marguerite de Lorraine, and the wife of Cosimo III de' Medici (1642-1723), who became Grand-Duke of Tuscany in 1670, whom she left, with great scandal, to return to France in 1675.

fourteen or fifteen[185] when she left France, and, belonging as she did to a great house, she had hoped that they would show some deference to her in Italy. He answered that the better one's birth, the more capable one was of the higher virtues, which are rarely to be found among the common people; but in reality help must be sought from God to put right this misunderstanding, for He alone could reunite their wills; men had not the power, it must come from above. He repeated to Mme. de Raray that French women had much more intelligence than Roman women; in Rome he had known the greatest and they did not bear comparison. When the two ladies had left, I asked him if he wished to go out. He said he did not.

24 SEPTEMBER

🐾 The Cavaliere worked again at the collar. He chiselled it out and disengaged it from the hair. He told me that Nanteuil had just left with two people who had seemed to him extremely intelligent. Young M. Roland[186] came in, bringing with him some Latin verses, which the abbé Buti read. I busied myself reading the translation of the memorandum on the stone from the quarries around Paris and the faults and merits of each one. My brother then arrived. He had been at the Louvre, where he had found none of the contractors. Later the abbé Tallemant and the abbé de Matignon[187] came to see the portrait, and after lunch the Nuncio came.

I forgot to mention that Marot had finished his drawing of the design for the front of the Louvre. He showed it to the Cavaliere who was vexed that he had drawn in the two Hercules as he wished to do them himself.[188] He asked M. Mattia to rub them out and then gave Marot the plan of the Louvre, on which he began work. I went over the translation of the specifications for the Louvre, which had been put into Italian. I gave M. Mattia the measurements for the staircase

[185] She had been married in 1661, when she was 16 years old.

[186] Chantelou's nephew, Roland Fréart.

[187] Léonor II de Goyon de Matignon (1637–1714), abbé de Lessai et Thorigny, Almoner of the King (1669), and Bishop of Lisieux (1674).

[188] For other instances in which Bernini added the sculpture to carefully finished architectural drawings, see H. Thelen, *Francesco Borromini: Die Handzeichnungen*, Graz, 1967, no. 67 (garden façade of the Barberini Palace), and Brauer and Wittkower, pl. 72 (niche and statue of Constantine). Maquettes for these figures of *Hercules*, which differ from Bernini's first ideas as they appear in Marot's engraving (fig. 9), were later made by the sculptor Etienne Le Hongre (1628–90); their design is preserved in a drawing (fig. 15) after the small model of the Louvre made by Mattia de' Rossi on his return to Paris in 1666. See F. Souchal, *French Sculpture of the 17th and 18th centuries: The reign of Louis XIV*, Oxford, 1977–, II, pp. 303–4.

of the palais de Tucé for Mme. de Lavardin.[189] In the evening the Cavaliere went to the Feuillants; finding the church locked, we entered by way of the convent; after vespers we returned.

25 SEPTEMBER

In the morning I sent a note to M. Perrault asking for the plan of the abbey of Saint-Denis, which the Cavaliere needed. I then went to see the Cavaliere, who told me that a bishop had just left who had said that the bust bore a resemblance to medals of Alexander and that the likeness would be even more striking with the pedestal in the form of a globe. MM. Du Metz and Perrault called to ask the Cavaliere if he would fix how much money should be given to the Italians whom he had sent for, because it might so happen that they did not like their lodgings, and if they were given so much a month, as the Cavaliere had suggested, they might find their own lodgings and make their own arrangements. The Cavaliere replied that their presence was absolutely necessary to him as he could not have complete confidence in the workmen here; besides, the Louvre was to be constructed according to Italian methods, which only they were acquainted with; they might be given an allowance of so much a month, or, if a contract were made, M. Colbert could let them have some interest in it, or if they asked for an advance instead of that, they would take less; besides the assurances he had had of their trustworthiness, there were a great number of things unspecified in a building that were decided on the advice of the architect and for this reason they would have need of him, and this would act as a guarantee of their honesty. The gentlemen thought this was a good idea, but as it would be some time before the contracts could be made out, in the meantime the Cavaliere should fix the allowance.[190] He said he would, that even if they had a share in the undertaking, he would want them to work on the site themselves and in this way supervise the building. He asked them why the casts of the *Daphne* and the *David*, which the abbé Elpidio had sent off, had not arrived.[191] They told him that it was due to there being plague in Provence.

[189] Mme. de Lavardin was Marguerite-Renée de Rostaing (d. 1694), friend of Mme. de Sévigné and widow of Henri II de Beaumanoir (d. 1644), marquis de Lavardin, whom she had married in 1642; but the "palais de Tucé" remains a mystery. There is a village called Tiercé in the Maine-et-Loire not far from Lavardin, and it is possible that *Tucé* is a misreading of this name, but even so there does not appear to be any record of a château there, let alone a palace.

[190] The allowance recommended by Bernini is described below, 28 Sept., while the payments and gifts given to Sassi, Rossi, and Patriarco are in Guiffrey, *Comptes*, cols. 106, 158, 224–25.

[191] Colbert had instructed the abbé Elpidio Benedetti, his agent in Rome, to have

The duc de Mortemart[192] and the président Tambonneau[193] came; they studied the portrait closely, and then I showed them the drawings for the Louvre. M. Tambonneau criticized everything but particularly the ground plan, as he thought the King's bedroom was not large enough; he condemned the passage that leads to it, the lighting arrangements on the back staircases, the smallness of the courtyards, and the curtailment of the principal courtyard. He said he was sure that the different façades were of great beauty and he looked at them for a long time.

After dinner I brought over the plaster cast of the *Venus* that is at Richelieu, which I had had transported from Rome. When I showed it to the Cavaliere he said he had seen the original several times. I then went out to make various calls and learnt on my return that M. Colbert had gone to the Louvre with the Cavaliere. I followed them and found them still there. They were considering the quality of the sand in the foundations, which the Cavaliere said was good when mixed with river sand. Then they looked at the stone from Arcueil, which was being cut for the rocky base of the Louvre. We discussed the suitability of mill stone for vaults and where it would be possible to find sufficient quantities of it; Meaux was suggested, and somewhere near Versailles, and Meudon. I pointed out that we had found, when the Cavaliere had been there, that stone from the two latter places was heavier. M. Colbert said it would be a great advantage if it were suitable for

reductions in silver made after several works by Bernini. In the spring of 1664, four statues after the *River Gods* on the Fountain of the Four Rivers were sent to Paris in the baggage of Cardinal Chigi, the Papal Legate, and Benedetti reported that work had begun on "four larger statues modelled after the most beautiful that exist in this city" (Depping, p. 537). By 21 Oct. 1664, a model after the *Apollo and Daphne* was ready to be cast (Mirot, p. 183, n. 3), but then the work seems to have slowed, probably for lack of money, since the statue, as indicated here, had not yet arrived in Paris almost one year later; and the reduction of the *David*, although finished, was still in Rome when Bernini returned there in December 1665, at which time work was progressing on statues of the *Rape of Proserpina* and the *Neptune* (Depping, p. 540). All eight of these reductions in silver with their weights and measures, as well as a ninth copied after the *Moro* designed by Bernini for the fountain of the same name in the Piazza Navona, are listed in the inventory of Louis XIV's collection finished in 1673 (Guiffrey, *Inventaire général*, I, p. 52, nos. 298–301; pp. 68–69, nos. 539, 543, 546–48). The *Apollo and Daphne* was later melted down for its metal, and the others probably suffered the same fate.

[192] Gabriel de Rochechouart (1600–75), marquis, then first duc de Mortemart (1650), favorite and First Gentleman of the Bedchamber of Louis XIII (1630), Governor of Paris and the Ile-de-France. He was the father of Mme. de Montespan.

[193] Jean Tambonneau (d. 1683), conseiller au Parlement (1629) and président de la chambre des comptes (1634). At his hôtel in rue de l'Université (rue du Pré-aux-Clercs), built by Le Vau and demolished in 1845, Tambonneau assembled a notable collection of botanical specimens, which were cared for by Jean de La Quintinie (1626–88), the celebrated horticulturist. See Hautecoeur, II, p. 97, and Bonnaffé, p. 300.

the construction of vaults on the second floor; he said he would send officers of the police to each of these quarries, to prevent the stone from being removed except for the King's use. My brother said that they had chosen a place in the wing opposite the rue de Beauvais, which he showed us in the plan, to experiment with this kind of vault; he added that it would be carried through the whole width of the building. Then M. Colbert asked me to conduct the Cavaliere back to the palais Mazarin in his coach, while he remained at the Louvre. We went, but I thought it possible that M. Colbert would have asked to be shown the faulty foundations, of which we had been talking at the last meeting, before I had arrived. I asked the Cavaliere and he said no. Before getting into the carriage, he looked at a large round piece of masonry that is in the foundations of the main gateway and is crossed by another piece five or six feet wide. He wanted to know what it was for. I replied that I did not know, unless perhaps it was an aqueduct. When we reached the palais Mazarin, we found the abbé de Saint-Pouange[194] with two or three young counsellors, and Nanteuil. They were all looking at the bust. When the Cavaliere was told that they were there, he welcomed them cordially. Nanteuil drew me apart and as a kind of preliminary, emphasized his friendly feelings and esteem for the Cavaliere and continued saying that both he and the others had noticed that the pupils of the eyes were not directed to the same point, and that it would be as well to tell him before they were finally marked in. They also thought that the left cheek was too big. I told them it was not yet finished and that in sculpture one had to be extremely chary with the chisel. He said in support of his criticism that he had done a portrait of the King not long ago and had particularly studied the left side of the King's face as it was the one he had drawn; also, there was still something lacking about the mouth; he begged me to say that these were my opinions, not his. Then he returned to the group and we talked about various subjects. He told the Cavaliere that he thought he looked a little tired. He replied that he was always so at the end of the day, either from exhaustion of body or of spirit, which he used up as he worked; the thoughtful artist was never satisfied, for his work could never come up to the nobility of his idea; in the morning, when he sets to work, he was hopeful that he would be able to carry out what he had in his mind, but as evening approached, he saw that he had been deceived in his hopes, and this, together with the labors of the day, makes him exhausted.

[194] Michel Colbert de Saint-Pouange (d. 1676), Almoner of the King and Bishop of Mâcon (1666).

Nanteuil replied that there were two things that should satisfy a man in his work, one was the nobility of his idea, the other his knowledge of the faults that he perceived in the works of his colleagues, which might seem to raise him above them; if the one thing did not bring him satisfaction, the other should. The Cavaliere answered that, on the contrary, one often saw in the achievements of others, at least of those whom one respects, much that was mortifying. The talk continued, and was only interrupted by M. de Saint-Pouange taking leave of the Cavaliere. I forgot to mention that Nanteuil showed the Cavaliere a pastel sketch he had made of one of these counsellors, which he admired very much. When they had left, the Cavaliere said that he was going to write letters for Rome and would not go out; with regard to the temporary allowances for the Italians, he would act on the assumption that the cost of living in Paris was double what it was in Rome, reckoning for lodging, food, and wood, on account of the cold which made all the difference; he could judge from what he had had to spend for himself and his own people since he had arrived, for on coats alone, he had had to pay bills amounting to six hundred crowns; together they were leaving their country and their employment and, he added, Pietro Sassi's wife was a further expense. Then he spoke to me about M. Mattia, who did not wish to remain in France. I told him the reasons that he had urged to me, that he did not wish to let him go alone, and felt he could not allow him to undertake so long a journey without him; further he wanted to have his wife with him, and as she was young, he wished to bring her himself; he wanted to put his affairs in order in Rome and anyway he had nothing to do here at present.[195] The Cavaliere said that his wife had a brother who could accompany her, and as for himself he had his own people and M. Mancini as well, who had taken great care of him on the way here and would do the same on the return journey; he was greatly indebted to him and had spoken many times in his favor to M. Colbert, although he could not see that this had so far produced any effect. I said it would work out in the end. I quoted the case of my brother, who had been at last persuaded to leave his retirement. I added that he must not try to assess the future from what had been done in the past. He retorted that in France things were undertaken with great enthusiasm and as quickly abandoned. I said that it might have been true in former times, but it was not so now. He cited their disposition to make war; I replied that would not prevent the building of the Louvre; even when the war was at its height, M. de

[195] Cf. Chantelou's conversation with De' Rossi, above, 17 Sept.

Noyers had continued with the work; in case of war M. Colbert had said that instead of a million, only two hundred thousand crowns would be spent annually. He said he was astonished at the number of things that were afoot at the same time; instead, it would be better if the building of the Louvre were the only or principal matter under consideration. I said that M. Colbert was beset by people of whom he would get rid little by little; he had good sense, and he thought of the glory that this undertaking would bring him; for a man who had not studied these things he had a very fair understanding; that kind of knowledge did not come by the light of nature, but from drawing, and looking at beautiful things, and talking to men who were distinguished in the arts; it was moreover essential to have a natural inclination. Then he left me, saying he was going to write letters.

26 SEPTEMBER

When I went to the Cavaliere's he asked me if it would be possible to obtain the plan of Saint-Denis, which M. Colbert had shown him when he took him there. I went to the minister's, and on learning that he was not there, I immediately wrote a note to M. Perrault, who came at once bringing the plan, which was given to the Cavaliere. He gave me the verses that the abbé de Bourzeïs[196] had written, as a reply to those that the abbé Buti wrote on the subject of the base for the King's bust.

Risposta del Cavaliere Bernino

Mai mi sovvenne quel pensier profondo
Per far di Ré si grande appoggio degno;
Van' sarebbe il pensier; che di sostegno
No è mestier a chi sostiene il mondo.[197]

The Cavaliere Bernini's reply

This profound thought has not helped me to make a base
worthy of so great a King; indeed it is useless, for there is
no need of a support for him who holds up the world.

I showed the *Venus* torso to Perrault and told him that it was an antique Greek work, and one of the most beautiful of its kind in the opinion of those best qualified to judge. I also asked him whether it

[196] That is, Amable de Bourzeïs.
[197] Domenico Bernini (pp. 136–37), probably led astray by their being written in his father's name, attributes these verses (with a slight variation in the last line) to the Cavaliere himself. The abbé Buti's quatrain is above, 19 Sept.

had been considered worthwhile to recast the other things that I had brought from Rome. He said that so far no one had thought of it.

Then we went to look at the vault which had been begun in the courtyard at the back. The Italian masons declared that they would need more mill stone. M. Perrault said that he would order some more, but that a sufficient stretch of vaulting had already been put up. They replied that they wished to do the next piece differently— they would wet neither the stone nor the mortar as they had done in the other—and then it would be possible to judge which was the better.

On our way back I pointed out to M. Perrault the back of the gallery of the palais Mazarin, where a roof had been built as straight as the wall, and I asked him if he did not think it was ridiculous, with which he agreed.[198]

When I returned, I found young Blondeau[199] in the apartment. He told me that the abbé Buti had promised to present him to the Cavaliere. I volunteered to act for the abbé and in fact introduced him. He showed some of his drawings to the Cavaliere who told him he was just at the right age to go to Rome, that to wait until he was any older was to waste time. He said young men should not be more than nineteen, and before that it must be ascertained whether they had a talent for the arts. In this way the King's scheme would succeed, and they would reap the hoped-for advantages.[200] He added that he would be very pleased to see those whom it was planned to send and would give his opinion of them. I said I would mention the matter.

Then we went upstairs for dinner, and while we waited he told me that the bust was nearly finished, and when the King had been twice more he would have nothing further to do; all that remained was for it to be polished, which he would have done; for the next ten or twelve days he would do some drawing and turn his attention to matters concerning the Academy; he would also rough-out a piece of the rocklike base of the Louvre. I begged him that on the next holiday he would be kind enough to go with me to Saint-Cloud. He said he would, holiday or not. When the question first arose he had said that something really beautiful might be achieved, but that was before he had seen the cascade that was there already; his idea had been to make a natural waterfall;[201] since then he had thought about it and had come to the conclusion that it would not meet with approval, for Monsieur

[198] The exact meaning of this passage is not clear. It is therefore translated literally.

[199] As emerges below, 20 Oct., the son of an artist working in England.

[200] See the letter to Poussin written by Colbert, but never sent, in Perrault, *Mémoires*, pp. 54–57.

[201] See above, 26 July.

had already gone to the expense of making an artificial one. I replied that it was a good thing that we here in France should be shown how these things were done and he agreed to do it to please me. He added that the duchesse d'Orléans had never been to see the bust. I replied that she had wished to come and had sent word to the Duke the last time he was here, but the King had been on the point of going, and so she had put off her visit until another time. He said perhaps she was offended that he had not praised her beauty when he was at Versailles and had spoken only of the Queen, but that I could say to her that no other beauty in the whole of France pleased him as much as hers, no other was so lively and so animated; some might need praise to tell their beauty, but she did not; he preferred her looks to the Queen's or any of the rest, for in her face alone there is a vivacity, a freshness, and a delicacy that are not to be found in that of the Queen or any of the other ladies. At table he gave me the toast of Signora Caterina (his wife), which he had never done until he was sure of the state of her health. He said he had not dared to, for fear that she would not be in a state to receive his good wishes. When we got up from table, I found the bishop of Lodève,[202] M. de Maisons, and another bishop who had come to see the portrait. M. Perrault's clerk had brought a plan on canvas showing the whole of the abbey of Saint-Denis. Mme. de Chantelou came with M. and Mme. de Boutigny,[203] my brother, and M. Mouton. Mme. de Chantelou spoke to the Cavaliere about the portrait. He paid her many compliments.

Later M. de Saint-Laurent came with the abbé Bossuet[204] and the Dean of Saint-Thomas,[205] followed by M. de Scudéry and his wife[206] and Mlle. de Canisy.[207] I had the drawings for the Louvre shown to M. de Saint-Laurent and his companions. The duchesse de Nemours[208]

[202] Roger de Harlay de Césy, Bishop of Lodève from 1658 to 1669.

[203] Possibly Roland Le Vayer de Boutigny (d. 1685), who was a jurisconsult, a maître des requêtes, and Intendant of Soissons.

[204] Jacques-Bénigne Bossuet (1627–1704), the orator, theologian, and philosopher, who became Bishop of Condom (1669) and then of Meaux (1681), Preceptor of the Dauphin (1670), and a conseiller d'état (1697). A popular preacher from 1659 to 1669, he later gave a series of famous funeral orations that established him as the greatest ecclesiastical orator of his time.

[205] According to Lalanne, the Dean of Saint-Thomas-du-Louvre at this time was one Delamet.

[206] Georges de Scudéry (1601–67), poet, dramatist, member of the French Academy (1650), and brother of the more famous novelist, Madeleine de Scudéry, was married to Marie-Madeleine Du Montcel de Martinvast (ca. 1627–1711).

[207] Possibly the daughter of René de Carbonnel (1588–1655), marquis de Canisy (1619), Lieutenant of the King in Normandy and Governor of Avranches, but probably of his son, Hervé de Carbonnel (d. 1693), who inherited his father's offices.

[208] Marie d'Orléans de Longueville (1625–1707), daughter of Henri II d'Orléans, duc

arrived, accompanied by M. Corneille.[209] She stayed an hour, going
back and forth between the portrait and the *Christ Child*; from time
to time she watched Marot drawing. The abbé Buti introduced
M. Corneille to the Cavaliere as the Hero of Poetry. The Cavaliere said
to him that a man of his stature must often find it difficult to satisfy
his own standards, to which he agreed. When Mme. de Nemours
praised the portrait, the Cavaliere repeated to her what he had said to
the Queen, that she had the image of the King imprinted on her heart,
and therefore all that she saw bore the likeness of His Majesty.[210] She
added that he had brought out well his sense of majesty, which was
such that one hardly dared to look at him. Once, when she was forced
to speak to him about something, she could not look at his face. I
said that in this portrait, majesty was softened by a benign sweetness,
with which she agreed. The abbé d'Espeisses[211] and the abbé de
Fortia[212] also arrived. I told the abbé Buti what Nanteuil had said
about the pupils of the eyes. He looked at them and said he was right.
He also told me that he had broken the ice and had informed the
Cavaliere what we had noticed about the nose, whereupon the Ca-
valiere had replied that he saw it that way. He added that people
thought the forehead went back too far and was hollowed out too
much above the eyes. I answered that this gave it grandeur, and that
all the most beautiful heads of antiquity were given this form. Actually
the King's forehead was shaped like that, but even if it were not, the
Cavaliere would have been forced to make it so, provided it did not
lessen the likeness; the secret of good portraits was to augment what
was beautiful, to impart a sense of grandeur, to diminish what was
ugly and petty, or suppress it altogether if that were possible without
seeming to flatter. The Dean of Saint-Germain l'Auxerrois[213] also
came. He is interested in medals and told us that he thought the bust
had a look of Alexander about it, particularly as it was turned to one
side like the medals of Alexander. While on this subject, he said that
a great quantity of medals had been found in the inventory of the

de Longueville, and Louise de Bourbon, who in 1657 married Henri de Savoie (1625–
59), duc de Nemours.

[209] Pierre Corneille (1606–84), the poet and famous dramatist of the French classical
theatre, whose popularity was about to be eclipsed by the success of Racine.

[210] Above, 19 Sept.

[211] Louis de Faye d'Espeisses, or Espais, Canon of Paris, abbot of Saint-Pierre in
Vienne, prior and sieur de Gournay.

[212] François Fortia (1631–75), abbé de Montboucher.

[213] Pierre Séguin, Dean of Saint-Germain-l'Auxerrois, called the *dictateur des anti-
quaires*, who possessed a splendid collection of medals, books, maps, and manuscripts,
and every Wednesday held an Académie de Medaillistes.

Public Prosecutor;[214] they had come from the collection of one Ferrier, a lieutenant in the Artillery, brother of the dead man's wife, who had inherited them from their father, Ferrier, the famous minister of Montpellier.[215] M. Colbert had asked him to look at the medals with a view to buying them for the King. The heirs had wished to make a present of them, but M. Colbert had insisted that they should be bought according to the probate valuation, just as if the purchaser were an ordinary citizen.

I forgot to mention that in the morning the abbé de Grave[216] came to call on me to ask if the Cavaliere would be so kind as to give his opinion on a present of coral work that he had to make to the King. He had given it to M. Fouquet and it had been returned to him by M. Colbert. I asked to see it and he brought in a large shell in which were the sea-gods, made from coral, but without skill or taste. They were like little dwarfs. I told the abbé that the artist had worked with exceptional care and diligence on this extraordinary subject. I described it to the Cavaliere and gave my opinion that the figures were like marionettes and that it was unworthy to be given to the King. The Cavaliere looked at it for some time without saying anything. He seemed, I thought, to be wondering what he could say without giving praise where none was due. MM. Paolo and Mattia were laughing behind their hands. At last the Cavaliere said that the figures were badly mounted, they could not be seen in that great shell, that his advice was to take out each piece and put it in a separate little box filled with cotton wool, where it would look much more valuable; he could have some little wax models made to show how they looked all together, but their effect was spoilt as they were now. This abbé repeated that it was a Greek work, but the Cavaliere contradicted him, declaring that it had never been in Greece, nor was it made by a Greek. He praised the ingenuity of making it in coral and said no more.

In the evening, on our way to the Feuillants, I told the Cavaliere that Mme. de Nemours was the daughter of a princess of the blood.[217] He said she seemed to have intelligence, but with it a restless disposition. Melancholy brought with it the quality of firmness. He asked whether he had not already repeated to me a little parable about the use of the seal, which was a favorite of Father Oliva's; it was no good,

[214] That is, Tardieu, the Public Prosecutor, who along with his wife had been murdered (above, 24 Aug.).

[215] Jérémie Ferrier (ca. 1560–1626), the Protestant minister of Montpellier, who converted to Catholicism and became a Counsellor of State.

[216] Pierre de Grave, son of Timothée de Grave.

[217] She was the daughter of Henri II d'Orléans(1595–1663), duc de Longueville, and his first wife, Louise de Bourbon-Soissons (d. 1637).

he used to say, just to place sealing wax on the paper and the seal on top of it; one had to press hard, it was that which stamped out the impression and gave it character. So in everything, there must be real effort, and only firmness and constancy could bring success.

When we came out of the Feuillants we went for a drive along the river. I forgot to note that before we left he had asked me to write a note to the commandeur de Souvré, to tell him that he had made a plan for the Temple, which he gave to me. He added that he had no doubt he would show it to the architects here, who were sure to find something to criticize in it; it would have been very worthwhile erecting it on the plot belonging to M. de Lionne. I agreed with him and said that a sheet of paper could be very valuable; this particular one could have saved the regret of having wasted 300,000 or 400,000 livres.[218]

27 SEPTEMBER

When I went to see the Cavaliere, they told me that he had ordered them to admit no one. I found him working on the hair of M. Paolo's *Christ Child*. He said he was giving it one or two loving touches out of his devotion to the Queen. As it was the day for our meeting, we waited for M. Colbert until half past eleven. Then the Cavaliere sent a message to his house, to find out if he was there, and, learning that he was at the Louvre, we went to dinner. He was very happy because he had heard in letters from Rome that his wife was better, and that a head abcess from which she had been suffering had discharged through the ear.

Immediately after dinner the pictures that Prince Pamphili was to present to the King were brought in. The Cavaliere said that he had advised him to send only the Titian[219] and not the six or seven others that he had wished to send with it. This led to a discussion on the question of the great number of drawings and paintings that are attributed to Raphael and that cannot in fact be from his hand as he died young and was occupied for a large part of his time in the execution of big public works in the Vatican and

After dinner he went on working at the *Christ*, and meanwhile two cases were brought in which contained the Prince's pictures. The abbé asked me to show them to the Cavaliere when they were unpacked, and then to have them locked up by the keeper of the wardrobe

[218] For Chantelou's and Bernini's criticism of Le Vau's hôtel de Lionne, see above, 17 and 20 Aug.
[219] The *Madonna and Child with Sts. Stephen, Jerome, and Maurice* (Paris, Louvre) of about 1520. See Wethey, cat. no. 72.

at the palais Mazarin. When the first case was undone we saw that the water had got in and the pictures were all wet and covered in mold; the *Gypsy telling a young man's fortune*[220] by Michelangelo da Caravaggio, half-length, a Benedetti,[221] a half-length by Guercino,[222] a picture by Albani,[223] and the one by Titian, which is a *Virgin with the Infant Christ and saints*, half-length. They were all so spoiled that one could hardly make out anything. In another case there were two large landscapes with hunting scenes by Annibale Carracci[224] and a *St. Francis* by Guido.[225] None of these had suffered from the damp. The Nuncio arrived while they were being unpacked and the abbé Buti with him. The Cavaliere looked at the pictures and found that their very bad state was due to the joins in the cases not having been filled with pitch, which would have prevented the water from entering. Then the Nuncio took the Cavaliere to Cardinal Antonio's, where we learned that His Eminence was leaving for Italy on the 30th. We returned. The Cavaliere told me that he would have to go back to Saint-Denis, but first he wanted to study the plan that had been given him. When I got home to my apartment I heard that the King of Spain was dead.[226]

28 SEPTEMBER

✿ When I went to the Cavaliere's, he drew me aside and told me that he had made a memorandum concerning the allowances to be made

[220] The *Fortune-Teller*, today in the Louvre. See M. Cinotti and G. A. Dell'Acqua, *Michelangelo Merisi detto il Caravaggio*, Bergamo, 1983, cat. no. 42.

[221] Probably, as Lalanne suggested, a painting by Giovanni Benedetto Castiglione (1616–70), although it should be noted that the Neapolitan painter, Domenico de Benedettis (d. 1678), and a Benedetto Benedetti, a member of the Accademia di San Luca in Rome, were also active at this time.

[222] Following Villot, L. Hautecoeur (*Musée national du Louvre, catalogue des peintures exposées dans les galeries, II, école italienne et école espagnole*, Paris, 1926, no. 1148) suggested that this painting might be the Louvre *Self-Portrait*, even though he notes it does not appear in Bailly's inventory of the royal collection (1709–10); more recently Jean-Pierre Cuzin (*La diseuse de bonne aventure de Caravage*, exh. cat., Paris, Louvre, 1972, p. 97, n. 1), who also identifies the other paintings in Pamphili's gift, has suggested it may rather be the *Circe* in the Louvre.

[223] Catherine Puglisi, who generously shared her knowledge of Albani, thinks that this is probably the *Diana and Actaeon* today in Rennes, as does Cuzin (ibid.). Below, 4 Oct., Bernini sees another version of the picture that had belonged to Mazarin and is now in the Louvre.

[224] The *Landscape with a Hunting Scene* and the *Landscape with a Fishing Scene*, both in the Louvre. See Posner, cat. nos. 43–44.

[225] Evidently the poorly preserved painting in storage in the Louvre, which was formerly in the collection of Louis XIV. See Garboli and Baccheschi, cat. no. 111b.

[226] Philip IV (1605–65), king of Spain from 1621, was the brother of the Queen Mother, Anne of Austria, and the father of the Queen, Marie-Thérèse. He had died on 14 Sept.

to Pietro Sassi, etc., and to ———;[227] he had suggested amounts that would have been suitable had it been I who had sent for them from Rome; they were in fact sent for by the King of France, which was quite another thing, but he would not touch on this point;[228] to Pietro Sassi and his wife he suggested 300 livres a month, and to each of the others 200 livres. They were all people who had left their businesses and their homes, and he told me in confidence that the Pope had shown his displeasure that he, the architect of St. Peter's, should take away men who were working there. I said I would go and find M. Perrault or M. Du Metz, and I spoke to M. Du Metz about it, and he said he would report the matter to M. Colbert. I then went back to tell the Cavaliere about it. He said that he had been working at the Saint-Denis plan. He asked me if I had seen the church of S. Maria della Vittoria in Rome, where he had designed the tomb of Cardinal Cornaro.[229] I said I had not. He added that his idea was to put the tombs of the Bourbons exactly facing the altar of St. Louis, which is the chief one in the church. Here they would be visible during all ceremonies and services held in the church; this seemed more appropriate than to make something separate like the Valois chapel, which cannot be seen from the other part of the church; by using somewhat extraordinary means he was able to fit into his design twenty to twenty-five kings, putting five or six in the same alcove as suppliants, in different attitudes, leaning against a kind of balustrade in their historical order. On the balustrade there would be a covering with cushions and underneath would be the tomb; as a further embellishment there would be mosaics behind the figures, and the tombs and ornamentation would be of black marble and gold leaf; in order

[227] Bernini had been asked to recommend allowances for the Italians on 25 Sept. (above).

[228] Although the idea may have been losing ground in the 17th century, by and large the Aristotelian virtue of magnificence was still considered a necessary attribute of the great prince. Thus Queen Christina, when she learned that Bernini's estate was worth 400,000 scudi at his death, is said to have remarked, "Had he served me and left so little, I should be ashamed" (Dom. Bernini, p. 176, and Baldinucci, *Vita*, p. 71). The appeal to the King's magnificence was therefore the great weapon wielded by Bernini in furthering his own grand conception of the Louvre (above, 4 June), and it explains why the Italian workmen should be paid more if they came to work for the King (cf. Mancini, I, pp. 139–40). Similarly, when it is later rumored that Bernini has scorned his own reward, the angry reaction of the French arises from this apparent denial of the King's virtue.

[229] In the Cornaro chapel (Wittkower, *Bernini*, cat. no. 48), Bernini had placed carved group portraits of Cornaro family members in shallow niches on the side walls flanking the altar. The niches have illusionistic backgrounds and the figures overlook the chapel from behind the cushioned and draped balustrades of apparently real balconies. For the Cornaro chapel, see now Lavin, *Bernini and the Unity of the Visual Arts*, pp. 77–165, 196–210.

to make the plan of the church more symmetrical, another chapel might be erected on the opposite side to balance the Valois chapel.[230] This idea had occurred to him after he had been to Saint-Denis, but he had perfected it that night; he said his habit was, when he had something to design, to think about it during the evening, and then in the morning before he got up, the thing was fixed, as it were, in his imagination. I said that therein lay what was divine in the creation of works of art, for it seemed to flow purely from the spirit; it was easy afterwards to give a form to the idea according to the rules of art. This reminded him of the design for the house at the Temple, and he said it was a happy thought to have realized that the beauty of the avenue might be turned to advantage in the design; when he was there he had thought it would be necessary, whatever was done, to lose that effect in giving the house the convenience of a porch where one could get in or out of one's coach under cover, as would have been possible, really, at M. de Lionne's; in Rome, a lawyer would not live in a house which did not have this amenity. He recalled what I had said the day before yesterday, that a piece of paper can be a priceless marvel, an idea he had greatly fancied. He added that a king of France before beginning the building of the Louvre, ought to have sent to the antipodes if there were men in that hemisphere abler than in this, even if it cost him 600,000 crowns; this man would be worth many millions which, were they misspent, would bring dishonor instead of adding glory to the King's reputation; advice was infinitely valuable and anyone or anything that could be helpful was precious.

The arrival of the Nuncio interrupted this conversation. He told us that according to the will of the King of Spain, the Queen of Spain was established as Regent, with six ministers—the Cardinal Aragon, Piñeranda, Castrillo, and three others; no mention had been made of Don Juan, and Medina de las Torres had been discarded.

Before dinner M. Rose,[231] one of the King's private secretaries, came in with his son.[232] He admired the likeness of the bust, saying that no one else had succeeded in giving to the King such qualities of nobility and grandeur. The Cavaliere replied that the first time he saw the King he had noticed that none of the portraits bore him a real

[230] This scaling down of his plans, although by no means now modest, reflects Colbert's opposition to the size, location, and expense of Bernini's first proposals. Cf. above, 15 and 20 Sept.

[231] Toussaint Rose (1615–1701), secretary to Cardinal de Retz, to Cardinal Mazarin, and to the King (1657), a member of the French Academy (1675), and président de la chambre des comptes (1684).

[232] Possibly Louis Rose (d. 1688), called M. de Coye, conseiller au Parlement de Metz.

resemblance, and his son had been of the same opinion. He added that many people had remarked in the bust a likeness to the beautiful heads of Alexander. M. Rose replied that Alexander was not so majestic. However that may be, I said, sculptors had attributed this quality to him, and as one can see in an ancient head of Alexander wounded, which was supported, so they say, by the figure that is now known in Rome as the *Pasquino*, it was also in the medals that exist of Alexander. The Cavaliere said that the words of the Cardinal Legate were true, one would recognize the King among a hundred noblemen without ever having seen him, for his bearing and his face were so filled with majesty and assurance. He added that was not the only thing; "but the *mind*,"[233] to use the exact word, corresponded admirably with this nobility of bearing, for nothing came from it that was not worthy of remark and as much to the point as possible. M. Rose agreed and told us that the very same day that Cardinal Mazarin died the King, who had withdrawn to his room, ordered him, after the rest had departed, to bring pen and ink. He then drew from his pocket a piece of paper on which he had put down the last words of advice that the Cardinal had given him concerning the three classes in the kingdom. The King asked him to set them out properly and he wrote a half-sheet of paper, which the King then requested him to read. When he had heard what he had written, he said, "You must expand it more, put in this and this." He did as he was asked and wrote a whole page and read that to His Majesty, who again criticized it, saying, "That is still too simple; you must make it more elevated in style." He was astonished by this incident, which seemed incomprehensible, as up to that day, the King had never taken part in any business of state. The Cavaliere said that it was the work of those two angels who according to the theologians were the guides of kings, or perhaps "that the King's mind is cast in sound metal";[234] he had mentioned this idea to Father Oliva, preacher to the Pope, who had made a note of it and said it was a beautiful metaphor and he would use it one day. He explained that in poor metal there was a great deal of iron so that it will not take gold, it seems actually to have an aversion to it and rejects it, whereas metal that had been freed from all traces of iron and was mixed with excellent English tin was extremely easy to gild. As soon as the gilt was applied, it seemed to drink it up and suck it in, so that it looked like solid gold; so it was with the spirit of the King, which received the impression of anything of really

[233] The phrase is in Italian in the text.
[234] This metaphor, which is in Italian in the manuscript and which Bernini had used earlier (above, 30 July), is explained below.

excellent quality with a remarkable facility; he had been astonished, at the time when he had first presented his design for the Louvre, to see how the King had appreciated its merits at once; for a knowledge of those sciences was acquired only after long study, which of course the King had never undertaken, or by being accustomed to things of beauty around one, as in Rome, where there were not only the remains of classical buildings, but also many wonderful modern works; this experience the King had not had either; on the contrary, he was surrounded by petty and fiddling designs, so that his sureness of taste was astonishing, if not miraculous.

He then went on to explain something about the habit of seeing and described how the eyes grew accustomed to extravagant forms. The first time he saw a Frenchman wearing the long collar that covered the shoulders and stretched down to the belt he happened to be in the neighborhood of a barber's shop, and he thought for a moment that he had walked off with the barber's towel round his neck after being shaved, but looking more closely he saw that it was a collar. Two or three months later he did not notice it any more, having seen so many similar collars, just as now he was used to the low hats that were in fashion in place of the high pointed ones of yesterday.[235]

Going back for a moment to the subject of the King's conversation, how it never failed to be to the point, M. Rose said he had heard Cardinal Mazarin say when speaking of him, the Cavaliere, that he never said anything that was not apposite; this testimonial should give him great satisfaction because it came from the lips of a great man and compared him favorably with a great prince. He replied he would not be so vain as to accept such a compliment. I forgot to note that he had said to M. Rose that no man who really excelled in his profession, whether as minister, secretary, or artisan, was ever boastful of himself, or could be, because he realized more clearly than others where he himself fails.[236]

At that moment Mlle. de Guise[237] came in, accompanied by the young duc de Guise.[238] The Cavaliere studied his face well and praised its features, which greatly pleased his aunt. He told her how in painting the material helps the artist, but that it hindered him in sculpture. Later the Nuncio and Cardinal Antonio Barberini came, and they stayed so long that the Cavaliere had not time to go out.

[235] Cf. Bernini's comments on the high roofs of the Tuileries, above, 7 June.

[236] Cf. Bernini's conversation with Nanteuil, above, 25 Sept.

[237] Marie de Lorraine (1615–88), called Mlle. de Guise. After the death in infancy of her great-nephew, François-Joseph de Lorraine (1670–75), seventh and last duc de Guise, she became duchesse de Guise et de Joyeuse.

[238] The nephew of Mlle. de Guise, Louis-Joseph de Lorraine, (1650–71), sixth duc de Guise.

29 SEPTEMBER

🐚 The Cavaliere sent his footman to ask me to order the royal coach so that we could drive to Saint-Denis. Before leaving we called on M. Colbert to enquire whether he had any special comments to make before we set off. He said he had not. He told the minister that he had worked at a design for the Bourbon tombs and had found one that seemed to him so suitable that if he had been building the church especially for that purpose, he would have employed it. M. Colbert expressed his delight and told the Cavaliere that the King wished to come to see him some time in the day. The Cavaliere assured him that he would be back from Saint-Denis in plenty of time, as he did not intend to be away more than two or three hours, but M. Colbert told him that there was no need for him to hurry as the King could deal with other business today and come tomorrow. The Cavaliere said he would rough-out some of the rocky foundation for the Louvre, which would serve as a model. M. Colbert asked him to be so good as to look at the memorandum he had sent him on the plans for the royal kitchens and butteries, the council rooms, and those required by the other royal officials. He said he would come to settle all these matters with him in a couple of days. As we were going, he happened to see a life-size portrait of the King on horseback,[239] and remarked that it was very good,[240] to which M. Colbert retorted that it was by Le Brun. Then we got into the coach, accompanied by Signor Mattia. Meanwhile M. Perrault had arrived to discuss the specifications, which he had in his hand.

When we reached Saint-Denis he asked M. Mattia to measure one of the transepts[241] of the church. He then went up the steps to the altar of St. Louis, entered one of the little chapels that surround it, and measured the width of the window aperture, and then went into the Valois chapel.[242] He remarked that the tombs are badly placed there and seem to be separate from the church, and he was surprised that the door was always shut. The monk who was acting as guide asked me to tell him that the chapel was not enclosed, so that if the door were not kept shut, it would be possible to rob the church that way. He studied the structure and also glanced at the effigies lying in the middle of the large chapel, and then looked much more closely

[239] Perhaps related to the drawing by Le Brun of the King on horseback. See *Charles Le Brun*, cat. no. 103.

[240] The phrase is in Italian in the manuscript.

[241] Chantelou uses the word *ailes*, which in the context of the Sorbonne (p. 275) seems to refer to the transept and in another reference to Saint-Denis (p. 202), to the small passages (or wings) that were to link the Bourbon chapel to the apse of the church. Here, however, transept seems the most likely sense.

[242] The chapel was at the east end of the south aisle.

at the fully robed recumbent effigies that lie in one of the small chapels. He admired the quality of the marble from which they are carved, saying they were the most beautiful thing in Saint-Denis; they represent Henry II and Catherine de Médicis.[243] He hardly glanced at the four bronze figures in the big chapel.[244]

We came out and drove home in the coach. The first thing he did was to order a fire to be lit in his son's room, where there are a number of pictures by different masters. I glanced at a *Herodias* by Romanelli and said in Italian, "This is negligible."[245] He said nothing for a little while, then remarked, "There are few things, no matter where one goes, that can rival the works of M. Poussin. I see more in a single figure, taken from one of your pictures, than in whole rooms of others; his mind is profound and he possesses an infinite fertility, a sense of design and of color. For a while he imitated the style of Titian very well indeed, and later that of Raphael." I replied that he had chiefly studied the antique. "Yes," he agreed, "no one has profited more from antiquity than he, nor better copied the antique style in dress. I put his pictures on a par with the very best anywhere." I told him that I had suggested to M. Colbert only lately that it would be a good idea to have tapestries woven portraying the seven or eight pictures of the *History of Moses*, which are all in France, but that unfortunately he prefers the works of M. Le Brun. I had even indicated to him some of the compositions of which the series of tapestries would be composed.[246] He agreed that it would have been a beautiful work.

As we rose to go to dinner, he happened to see a Bassano and remarked that he could not understand why so much fuss was made about the kind of pastoral picture like the one there, which might pass as far as color was concerned, but Bassano had never known how to portray dress properly, nor to convey a true air of nobility, and this defect became all the more apparent when he attempted some historical subject on account of his neglect of *costume*. I told him that both Titian and Veronese had given little attention to *costume*. He added that it was true "of all the Lombards."

[243] These figures of the King and Queen in their coronation robes were carved by Germain Pilon in 1583. The Cavaliere had already admired the one of the King on his first visit to Saint-Denis (above, 15 Sept.), and it is interesting for the history of taste that he prefers them to Pilon's earlier *gisants* of the King and Queen nude, at which he merely glances.

[244] These must be the statues of the Virtues by Germain Pilon that stand at the corners of the tomb of Henry II and Catherine de Médicis.

[245] This picture by Romanelli has not been traced.

[246] Chantelou and Colbert had discussed the series in the carriage that was taking them and the Cavaliere to Saint-Denis (above, 15 Sept.).

I afterwards discussed with him the pictures that Prince Pamphili had sent to the King. I said that they were all mediocre, the one by Albani being among his least successful pictures; the landscapes by Carracci are remarkable only for the freedom with which they are painted; they lack nobility; the *Gypsy* by Caravaggio is a poor work, lacking originality or spirit. He agreed with me entirely, saying that the best of them was the *St. Francis*, by Guido. I replied that figures were his strong point; he painted them divinely and gave to them more nobility than any painter before him.

Afterwards, the comte de Tessé[247] came to see the bust. The Cavaliere received him with some ceremony, as I had told him that he was one of the leading members of the nobility in our province.[248] Later Mme. de Fontenay-Hotman[249] came, accompanied by the marquis de Valavoire[250] and a M. Colbert,[251] who is an uncle of the minister. When he heard who they were, he welcomed them most cordially. Then we left and went to the church of Saint-Michel,[252] whose feast day it was. Later we took the abbé Buti home, and returned to the hôtel Mazarin. I forgot to say that when M. Colbert saw the bust, he remarked that he seemed to see the King as he was when he had come to the Parlement several years ago and was wearing riding boots. He had looked just like that.[253]

30 SEPTEMBER

🕱 When I went to the Cavaliere's he showed me a drawing of St. Jerome,[254] which, he said, was the fruit of yesterday evening's work.

[247] René II de Froulay, comte de Tessé, Lieutenant-General of the Armies and father of the Marshal, René III de Froulay (1651–1725).

[248] That is, of the old province of Maine, which corresponded roughly to the present departments of Sarthe (Haut Maine) and Mayenne (Bas Maine).

[249] Marguerite Colbert (1619–1704), married for the third time to Vincent Hotman de Fontenay (d. 1683), maître des requêtes (1656) and Intendant of Finances (1666), who acted as Intendant of Paris from 1675 to 1679.

[250] François-Auguste Valavoire, marquis de Vaulx (1652).

[251] Since none of Colbert's paternal uncles was alive in 1665, perhaps Nicolas Colbert de Turgy (ca. 1613–88), maître en la chambre des comptes and conseiller d'état, a cousin of the minister's father, who was the last surviving member of that generation and actually the uncle of Marguerite Colbert, whom he accompanies here.

[252] A chapel in the courtyard of the palais on the Ile de la Cité.

[253] In 1655, two years after the end of the Fronde, when the Parlement refused to register certain royal edicts, Louis XIV, who was only seventeen, appeared in the assembly chamber in hunting dress and holding a riding crop and ordered the Parlement to register them instantly. They obeyed and this incident was remembered as one of the first signs of the King's determination to impose his will and to crush all opposition.

[254] This drawing of a penitent St. Jerome (fig. 20), which Bernini later presents to Colbert (below, 4 Oct.), is now in the Louvre. A second, closely related version of the same subject came from Ariccia to the Vatican library with the Chigi volumes. See Brauer and Wittkower, p. 153.

To a connoisseur like me, he said, he could show his work without explanations. I thought it most beautiful, and the light and shade very effective with reflections in the right places, and above all, the most expressive feeling. He told me that each year in Rome he made three drawings, one for the Pope, one for the Queen of Sweden, and one for Cardinal Chigi, and presented them on the same day.

M. Renard came to see the bust, and the Cavaliere gave him a most cordial welcome. M. Renard begged him to send someone from time to time to fetch fruit and vegetables from his garden; he said that, if he wished to bring his wife to France, he would like to offer him the loan of his house and the reversion of his house and garden. The Cavaliere thanked him most heartily for his thoughtfulness and great kindness.

The Cavaliere continued to work on his design for the Bourbon tombs, using the plan itself which had been brought him. Although M. Colbert had said that the King would come, by two o'clock the guards had not arrived. At last the maréchal de Gramont came and with him the comte de Gramont and the comte de Chapelles.[255] He studied the bust for a little while and then went out with the comte de Chapelles and strolled up and down the gallery. The comte de Gramont stayed with the abbé Buti and me, remarking that he thought, from the way he was behaving, that the Cavaliere was in a very poor temper today and had a very odd manner. I replied that I had noticed nothing that could give rise to such an idea, but when I mentioned it later to the abbé Buti, he said the Cavaliere had not been very cordial to the Marshal, who, a little while later, came in again. Speaking to me and the abbé, he said that he was convinced that the portrait would not be popular; further, the Cavaliere praised nothing and that others returned the compliment. I replied he gave praise where it was deserved, and was silent about the rest. He had admired the Luxembourg and Vincennes.[256] "I should think so," he replied, "where could he see more beautiful rooms than those at Vincennes?" I added that he had also admired Versailles.[257] "That he need not have done," he said. "It is not good enough, considering what has been spent on it." I said his praise had not been without reserve; he had thought the rooms elegant, the gardens well laid out and suitably embellished; beauty, he said, comes from good proportion, and it possessed that quality; the interior was much decorated and the sit-

[255] Possibly Nicolas de Rosmadec, son of François de Rosmadec, comte des Chapelles, who, as second to the comte de Bouteville, was also executed for duelling in 1627.
[256] Above, 11 June and 16 Aug.
[257] Above, 13 Sept.

uation good. The Marshal disagreed. I said that the Cavaliere always preferred a high situation. I told him that the Cavaliere had seen Maisons and had admired it extremely.[258]

The King then entered, and as the Cavaliere had gone to meet him without my noticing, I went in search of him, but His Majesty stopped me, saying "He is there, but he cannot come in because of the crowd." In fact he came in at that moment. There were a great many people; the comte d'Armagnac, the duc de Gesvres, the duc de Noailles, the duc de Saint-Aignan, M. de Bellefonds, the marquis de Villequier,[259] M. de Nogent, the marquis de Lavardin,[260] and many others. The King was astonished to find such a change in the portrait and the draperies almost finished. He pointed this out to the maréchal de Gramont, who, perceiving that the King was pleased, began to praise it to the skies in every detail. Then the King got into his usual position and the Cavaliere began work on the left side of the nose, taking away a little in order to remove the appearance of slight crookedness; then he scooped out the nostrils with a trepan and worked at the eyes and the mouth. He changed the position of the pupils so that the eyes looked in the same direction.[261] I forgot to note that the King thought the collar very beautiful. I told him that the Cavaliere had not followed the design of the one left with him, but had invented a lovely sequence of flowers and foliage from his imagination. His Majesty asked me if it would remain as it now was. I told him that it would and that neither that part nor the face would be polished. The abbé Buti talked for a long time with the maréchal de Gramont, who praised the device for the two Hercules on the gates of the Louvre, *Vetita Monstris*.[262] It would be impossible, he said, to find anything more suitable; he also admired the one for the medal for the foundations, *Aucto regno regiam auxit*.[263] Both of these had been invented by the abbé Buti. The King walked around from time to time to see how the work was getting on and then resumed his position. Once,

[258] Bernini's visit to Maisons, which had taken so much trouble to arrange (above, 15, 22, and 24 Aug.), is not described by Chantelou.

[259] Louis-Marie-Victor d'Aumont (1632–1704), marquis de Villequier, who succeeded his father (1669) as duc d'Aumont, gouverneur de Boulogne et du Boulonnais, and capitaine des gardes du corps. In 1701 he became a member of the Royal Academy of Inscriptions.

[260] Henri-Charles de Beaumanoir (1644–1701), marquis de Lavardin, colonel des régiments de Navarre et Royal-Marine, Lieutenant-General of Brittany (1670), and Ambassador Extraordinary to Rome (1687).

[261] Cf. Nanteuil's criticism of the way the eyes were marked, above, 25 Sept.

[262] That is, "Barred to monsters," an allusion to Hercules' overcoming of evil in the guise of such prodigies of nature.

[263] "Having enlarged the realm, he enlarged the seat of royalty."

when the King went to look at the *Christ Child*, the Cavaliere asked me to show him the model he had made for the rocky base of the Louvre. The King liked it very much and also admired the drawing of *St. Jerome* which the Cavaliere had done the night before. When His Majesty returned to his place he asked me if Giulio was busy with something connected with the bust, and I told him that he was doing the greater part of the draperies.[264] The abbé Buti added that he had done a head of St. John in his spare time and in the evenings. His Majesty asked to see it and said he thought it very beautiful; had he really done it? I assured him that he had. When the King was on the point of going, he told the Cavaliere that he would return the next day, the Friday, and the Saturday following. He told the maréchal de Gramont that the Cavaliere had asked him for twenty sittings and that this was the tenth, but the work was so advanced that there would be no need for so many. Thereupon the Cavaliere begged His Majesty to come in future only when he took the liberty of sending for him, and that he would need but one more sitting; he was going to lay the bust down during the next few days so that the pedestal could be attached. The King replied that in that case he would come only on the Saturday or the following Monday. Then the King left.

A little while later M. Phélypeaux de La Vrillière arrived, accompanied by MM. Oursel[265] and Petit.[266] They looked at the bust and at the drawings for the Louvre, which Signor Mattia was showing to two fathers of the Theatine Order. He came and asked me who Petit was, saying that his questions were out of place and that he found fault with everything. I told him that he was a mathematician to whom it was not necessary to pay any attention. I went over to him and advised him as tactfully as possible to be a little more restrained in his criticism. Whereupon he took me up and told me that only in matters of faith was absolute submission required, in every other sphere one could exercise one's liberty of opinion; and he had been using the ruler and compasses for forty years. I said that of course I knew that he was an extremely clever man, but that truly great men

[264] According to Domenico Bernini (pp. 135–36), Giulio had roughed-out the second of the two blocks begun by Bernini and then, when this block was not needed, gave the Cavaliere "continual assistance" in finishing the portrait.

[265] M. Oursel, or Hoursel, was First Secretary to Louis Phélypeaux de La Vrillière, Secretary of State. In 1670, along with one Vinot (Jean Vivot?, d. ca. 1673), he sold to the King a group of paintings and statues, including works by Guido Reni and Valentin, as well as the *Portrait of Alof de Vignacourt* (Paris, Louvre) with its problematic attribution to Caravaggio. See Bonnaffé, p. 240.

[266] Pierre Petit (1594 or 1598 to 1677), a mathematician and physician, who was intendant général des fortifications de France.

were most sparing in declaring their opinion and never dogmatized as he was doing; their knowledge made them realize how much there was of which they were ignorant; then I left him. He came up to me several times again, but I met all his remarks with silence.

Meanwhile the Nuncio had arrived, bringing with him a letter from Cardinal Pallavicini. He said he had two items of news for the Cavaliere: first, his wife was planning to make an excursion to Frascati; secondly, the Pope was in excellent health, had visited two or three churches, and had even heard a sermon at ———.

❧ *October* ❧

❧ M. Rosteau asked me to take M. Villedo[1] to see the bust, which I
did. The Cavaliere had it placed on a piece of wood, which had been
made especially for that purpose. At the same time the marquis de
Louvois[2] arrived with someone else, and looked at the bust and the
other things and then went into the gallery and the apartments of the
hôtel Mazarin. As we were looking at the sculpture and the pictures,
M. de Louvois said he really preferred tapestry. He had a *Head*, which
was supposed to be an Aesculapius, he would like to find out whether
it was of any value, so that he might give it to the King if it was
worthwhile. I said I would come to see it. I talked to him about the
pictures that Prince Pamphili had sent. He had looked at those that
had not been spoilt during the journey, particularly the *St. Francis* by
Guido Reni. He asked me how much I thought it was worth. I said
at least 500 crowns. He replied rather sharply, "I would not give ten
pistoles."[3] He did not wish to see the others. After dinner the Cavaliere
worked at several details on the face and polished certain parts of it,
such as a bit of the forehead, and the nose and the chin.

In the evening M. de Saint-Laurent came with Furetière[4] and a
canon of Rheims,[5] an extremely intelligent man, who had a short time

[1] That is, Michel Villedo, the master mason and contractor.
[2] François-Michel Le Tellier (1639–91), marquis de Louvois, who succeeded his father
as secrétaire d'état de la guerre, then became chancelier des ordres du roi in 1671,
ministre d'état in 1673, and Colbert's successor as Superintendent of the King's Works
in 1683.
[3] 500 crowns or écus equalled 1,500 livres, 10 pistoles only 100 livres.
[4] The abbé Antoine Furetière (1619–88), author of the *Roman bourgeois* and lexicog-
rapher, who was admitted to the French Academy in 1662 and excluded 23 years later
for attempting to publish his own dictionary. Successfully suppressed by the Academy
during his lifetime, his dictionary was published in Holland two years after his death.
[5] François de Maucroix (1619–1708), a Canon of Rheims, writer, and friend of the
fabulist, La Fontaine. In 1661, he had been sent by Fouquet to Rome, where he met
Nicolas Poussin.

ago come from Rome, where he had been very friendly with M. Poussin. I forgot to note that between three and four, when the King left the house of the commandeur de Souvré where he had dined, his bodyguard, believing that he would come to the Cavaliere's, took possession of the doors, but His Majesty passed by and went to the Petit-Bourbon.

When I left the Cavaliere's I went to the commandeur's, for I knew that he had called on me, and left him the plan for the building at the Temple. After dinner one of those attendant on the Queen Mother came to see the bust and told us that she was fairly well, though that morning she had remarked that others decayed only when they were below ground, but she could see decay working in her even before she was buried.

2 OCTOBER

🦋 In the morning I went to the commandeur's, and explained to him the Cavaliere's design. I saw that he was astounded by the grandeur of the scheme on account of what it would cost. I tried to encourage him, saying that he must leave in the Temple something that would be a glorious testimony to his name, or nothing at all, for he was well enough housed to have no need to build anything there if it were not to commemorate his name. He replied that whatever he built could not help being more beautiful than what was there at present. I answered that that was not enough: it was up to one to undertake an ambitious design, even if it were never finished. He asked me to thank the Cavaliere and said he would come to see my pictures.

Then I went to the Cavaliere's, where I first looked at a drawing on the table of the *Virgin with St. Joseph holding the Infant Christ in his arms.*[6] I thought the inspiration beautiful and very well carried out. The Cavaliere came up and asked me my opinion of it. I told him that he would have a big account to settle with God if with his remarkable gift of producing such a flow of wonderful things, he did not continue to apply himself with the greatest consistency. I pointed out wherein I thought its excellence lay. He replied modestly that it was rather that everything that he did seemed beautiful to me, but he had, it was true, attempted to give it a certain grandeur of tone. I said it was filled with grandeur, love, reverence, and grace; that the awe

[6] Neither the drawing itself nor the composition as described here is now known, but some related variants have been preserved: an unusual drawing on a wall of the Chigi Palace at Ariccia representing *St. Joseph holding the Christ Child* (Brauer and Wittkower, pl. 115) and two drawings of the Holy Family (Brauer and Wittkower, pl. 178a, and Harris, *Selected Drawings*, no. 85).

St. Joseph feels is apparent even in his fingers, and there never had been a nobler and sweeter Child. When I looked at the bust, I saw that he had turned it a different way from what it had been, and that he was polishing parts of the face with pumice stone and linen. He told me that marble needed to be worked with great patience. I answered that once the general idea had been given form, it was the details that gave to a work the mark of excellence. He agreed with me and said that if the structure were not satisfactory no amount of detail could put it right. I added that in every work perfection consisted in the sum of many little things, which in themselves seemed of no account. Finishing off with skill was very important; Raphael had finished his pictures with an attention to detail that was extraordinary; whereas painters like Tintoretto and Paolo Veronese and some other moderns had abandoned themselves to a free and furious style of painting; however, there were certain things that might be neglected and were tolerated under the name of *trascuraggini*.[7] Then M. Du Metz came to deliver a letter, which Heron had brought from the abbé Elpidio.[8] I showed him the *Venus* torso, and told him that it was one of the most beautiful relics of antiquity. The Cavaliere, hearing its beauty under discussion, came up and said, "Anyone with a tendency to be puffed up should look at that torso to cure himself of vanity. All of us must be filled with humility in front of it; even Michelangelo could not approach its perfection." I said that he lacked talent where the female form was concerned. He added, "Also in making his works fleshlike."[9] I told M. Du Metz that I would give this torso to the Academy, together with several heads in my collection, which I was having cast. He said he was greatly obliged to me.

When M. Du Metz had gone, we sat down to dinner. During dessert M. de Bellinzani sent word to the Cavaliere to ask him if he would allow some ladies to see the bust. He asked MM. Paolo and Mattia to go for him.

As we rose from table, we were all talking of some purchases that he would have to make, and he told me the saying "chi sprezza vuol' comprar."[10] I said I had heard Cardinal Bichi[11] repeat it. He then

[7] That is, "the intentionally neglected or slighted" as an attribute of style. Cf. the related *trascurato*, defined by Quatremere de Quincy as an attribute of those works "in which a certain negligence appears that is sometimes, as in a sketch or bozzetto, intentional and sometimes derives from ignorance or deception."

[8] That is, Elpidio Benedetti, Colbert's agent in Rome.

[9] The same criticism of Michelangelo above, 25 June.

[10] That is, "Who decries, wishes to buy."

[11] Alessandro Bichi (1596–1657), who was Papal Nuncio in Paris from 1630 to 1634 and negotiated the end of the War of Castro for Mazarin. He was created cardinal by Urban VIII in 1633.

told me that he had made use of it once in a comedy in which he had introduced a painter with a very pretty daughter. One day, when Raguet, the painter's serving man was to look after the house, the painter forbade him to let in any of the young sparks who came not to buy the pictures but to flirt with his daughter. When some young men did arrive and praise the pictures that he had shown for sale, he refused to let them in despite their entreaties. They complained to the painter, saying that they were gentlemen and they should not have been accorded such rough treatment. The painter rebuked Raguet, who defended himself by saying that they began by praising the paintings so that he had assumed that they had come not to buy but to flirt with his daughter! He might not be very clever, but he had not forgotten the proverb *chi sprezza vuol' comprar*, which was very much to the point. This same Raguet told a young man who was making efforts to gain the girl's favor, that he did not know how to go about it, for he always told her stories of the past—"that with women there was no need to talk of the past or of the future, but only of the present."[12]

Father Mascaron[13] came to see the bust. Then Marot came and talked to me at length about Mansart, how much he wanted to have engravings made of his designs for the Louvre and the Val-de-Grâce; he had had two large plates made for them, but since then he had not mentioned the subject; he said Mansart had hoped to see my brother and me at Fresnes;[14] he had shown him his chapel there with such a wealth of explanation that he had been bored. He had spoken about the Cavaliere as a great man and an innovator, and ended by praising him as a sculptor. Marot begged me later that should the Cavaliere have need of an engraver, I would propose his name. I asked Signor Mattia if there was anything else to be drawn, but he told me there was not.

When the Cavaliere came down, he gave him the façade of the courtyard of the Louvre to copy; then he had the bust put on a stand and draped the shelf round it with a piece of velvet. Immediately afterwards the Nuncio, accompanied by the abbé Buti arrived and

[12] Raguet's conclusion is in Italian in the manuscript.

[13] Jules Mascaron (1634–1703), an Oratorian, who became Bishop of Tulle (1671) and then of Agen (1679). A celebrated preacher, he gave a sermon in the presence of Louis XIV that recalled the mission of the prophet Nathan, who came to reveal to David the punishment for his adultery.

[14] At Fresnes, near Meaux, Mansart had remodelled an earlier château for Henri de Guénégaud (1610–76), Secretary of State. This work, which included a well-known, though now destroyed, chapel that was said to show his unexecuted ideas for the Val-de-Grâce, was probably carried out between 1644 and 1650. Mansart, however, continued to work at Fresnes, evidently on the park. See Braham and Smith, pp. 64–67, 104.

saw it like this; he begged me and my brother to tell no one about it, so that the King should be more surprised when he saw it.

When the Nuncio left we went to the Feuillants. On the way, he told me that in three or four days he would have nothing further to do but take leave of His Majesty, and that he would be able to go in a week's time. I told him that I felt sad as the time of his departure drew near. He replied "I shall never forget your affection nor your understanding."[15] I begged him to remember that I had asked him to go back to Saint-Cloud.

3 OCTOBER

When I arrived at the Cavaliere's, he asked me to be sure that no one who came to see the bust should be allowed to enter, because he was going to put it on its pedestal, and to do this he would have to turn it over on its side. He then tried it on the pedestal and adjusted it, then took it off in order to seal it up with mortar and a piece of iron that runs right through it. Then he put it on a high wooden stool, on which it will remain until the base that the Cavaliere has designed is finished. When this was done, the Cavaliere went to dine. Upstairs, he found Gamart who was going to look at the Prince Pamphili's pictures. During dinner, Signor Giovanni Maria[16] said he knew that Gamart had very good pictures and that the Cavaliere ought to see them. I interrupted him, saying there were many collections in Paris where there were more noteworthy things; at M. de La Vrillière's for instance, who lived quite near, there were some much more beautiful pictures; those who looked for a name and not at the thing itself would be quite satisfied with M. Gamart's collection, but in my opinion names were nothing. He replied that he painted himself and had therefore some knowledge of how to make a selection.[17] The Cavaliere replied that of the two hundred painters who worked in Rome there were not three or four whom he would entrust with the choice of a picture; if he were advising a son who was a painter to study beautiful things, he would send him to none other than M. de Chantelou.

At two o'clock the gilder brought the frame for the *Christ Child*.[18]

[15] Bernini's reply is in Italian in the manuscript.

[16] According to Lalanne, one of the servants Bernini had brought with him.

[17] Cf. the description of Gamart in the *Banquet des Curieux*, where he appears among the Poussinistes as Pantolme: "He is a draftsman without knowing how to draw, a painter without knowing how to paint, and one who seeks to reason on these delicate matters with no more illumination than the dim light that leads astray all those who, through misfortune, have chosen him for their guide" (Bonnaffé, p. 121). Bernini visits Gamart's collection below, 12 Oct.

[18] This frame, which had become separated from the sculpture, has recently been identified by Marc Worsdale in *Revue de l'Art*, LXI, 1983, pp. 61–72.

The gilding was very well done. It was placed in the frame and put on its base of black marble.

In the evening the Nuncio came with the abbé Buti, but apart from them no one who came to see the bust was allowed in. When they left, the Cavaliere went to the Feuillants and on his way back, to the Irish Franciscans, where I left him.

I forgot to note that he asked Marot for his ink in order to finish a *Virgin*[19] he had started, and to shade the drawing of the court façade of the Louvre that Marot had drawn in outline.[20]

4 OCTOBER

✿ In the morning I went to the Cavaliere's, where I found that M. Colbert had already arrived and had sat down to discuss the building. There were only the Cavaliere, Signor Mattia, and M. Madiot. They were considering the foundations and the difficulty of getting the last part of them exactly vertical on account of the stays that were necessary to support the earth; these not only made it impossible to arrange the foundation stones, but also prevented large ones from being used. M. Colbert, being convinced that using large stones for the foundations outweighed the advantage of excavating the earth vertically, said that if the Cavaliere nevertheless preferred that method, a means must be found of surmounting the difficulty; M. Perrault said there was another obstacle, which was that the plan required digging to a depth of 25 feet which is ——— feet below solid earth: but Mattia declared that he only required the foundation to be the same as that of the riverside pavilion, or one foot deeper, which is not much, particularly as the foundation will only be a little over three feet lower than the ground level of the bottom of the moat. M. Colbert said it seemed very little, and he thought they should stick to that and carry out the plan. My brother came in while they were deciding and sat down. M. Colbert asked the time and on learning it was ten o'clock he asked for someone to tell the footman to fetch his coach. Meanwhile they studied the rooms on the plan intended for the pictures and statues belonging to the King, and the Cavaliere said they ought to find a dozen statues as beautiful as the *Diana*; he would bear it in mind when he returned to Rome. I said that when I was there the *Meleager* was for sale. He said he would remember that; there would have to be several rooms for pictures; a choice of a dozen, all first-rate, should be hung together, with no mediocrities among them. Then I had the

[19] Neither the drawing nor the composition is now known.
[20] Cf. above, 10 July, for the care Bernini exercised in washing his architectural drawings.

plaster cast of the *Venus* brought in for M. Colbert to see. I told him that the marble original was extraordinary and was considered more beautiful than the *Medici Venus*. He smiled, believing this to be absurd. The Cavaliere agreed with me; he said the torso had been found in the Roman Baths at Pozzuoli and he knew it had been taken to France. I said that it was at Richelieu, and if the King were to ask for it, it would not be refused; if it were then restored by the Cavaliere, it would be an object of great beauty. He mentioned to me *The Slaves*,[21] which were there. I told him they were Michelangelo's best works, and I added that at Richelieu there were another two or three very beautiful statues, among them an *Augustus*.[22]

Then I gave M. Colbert a memorandum of the bas-reliefs that I had brought from Rome on my first visit, and the molds that I had had made the second time, which were still there. I told him I had never been paid back for this expenditure as the letter of credit sent me by M. de Noyers had been cancelled as soon as he retired from the court. He asked me where the casts had been put. I told him in Cardinal Mazarin's palace in Rome, which was formerly the Palazzo Bentivoglio.[23] Signor Mattia then showed him the layout of the ground floor of the Louvre, and the arrangement of the royal kitchens and butteries, the rooms assigned to the council and to other officials, according to his memorandum. Then he rose, and the Cavaliere showed him the bust, saying that he had no more than three hours' work to put in on it and begged him to remind the King that he had promised to come. He said that he would. I told him that the Cavaliere had also expressed a desire to see the crown jewels, so highly praised by the Legate.

When M. Colbert had gone, the Cavaliere showed me the drawing of the *Virgin* which he had finished. He said he was going to give it to me, at which I expressed my gratitude. I learnt that he had given the *St. Jerome*, which he had also completed during the preceding

[21] The *Dying and Rebellious Slaves*, now in the Louvre. Originally intended for the tomb of Julius II, they were given by Michelangelo to Roberto Strozzi, an exiled Florentine living in Lyons. After passing to Francis I and then the Montmorency, they were acquired by Richelieu to decorate his château in Poitou. See C. de Tolnay, *Michelangelo, IV: The Tomb of Julius II*, Princeton, 1954, pp. 97–102.

[22] Originally in the salon of the château de Richelieu, along with marbles of Tiberius, Livy, Germanicus, and Septimius Severus, the *Augustus* was bought by the Empress Josephine for Malmaison. Acquired by M. Durand from the sale of Malmaison, it passed into the collection of Pourtalès, and from there went to Berlin. See Bonnaffé, pp. 271, 273.

[23] The palace, which stands near the Quirinal, was begun in 1611 for Cardinal Scipione Borghese, who sold it in 1616. It passed through various hands including those of Cardinal Guido Bentivoglio and was bought by Mazarin in 1641. It is now the Palazzo Rospigliosi Pallavicini.

days, to M. Colbert before I came in. Then we talked about Saint-Cloud, and he said that as the day seemed fine, I should order the royal coach. While we were waiting for dinner, we went with the abbé Buti, who had arrived since M. Colbert's departure, to see Prince Pamphili's pictures. They had been repaired by Michelin.[24] We thought the Titian very much spoilt, in spite of what had been done. The Albani was a little better. The custodian showed us a similar picture by Albani,[25] in which, however, the figures were smaller; the latter, the Cavaliere said, was the original; he then showed us a *Virgin with the Sleeping Child* by Guido[26] with the Virgin, less than half-length, adoring the Child. The Cavaliere admired this picture and said that it had been painted for Urban VIII when he was still Nuncio in Bologna. We then saw the picture by Raphael,[27] given by the late marquis de Fontenay-Mareuil to Cardinal Mazarin, which is identical with the one belonging to Mme. Desouches,[28] except that in this picture the figure of St. John is not finished. The custodian asserted that the one in front of us was the original, whereupon the Cavaliere pointed to a hand, saying, "You can always tell from the painting of these parts whether a picture is original or not. This could never have been painted by Raphael; it must be Giulio Romano."[29] He thought the St. Elizabeth very beautiful, and pointing to the way she was clothed, said, "This is how Signor Poussin arranges his drapery." Later the custodian showed us the portrait of an old woman which, he said, was Michelangelo's mother, painted by Michelangelo himself. The Cavaliere assured him that this could not be so.

[24] Several painters of this name, all Protestants and probably all closely related, are known, at least two of whom were living when Bernini was in Paris: Jean Michelin (d. 1696), a member of the Royal Academy (1660) and another Jean (d. 1670), maître peintre à Paris. See *Les frères Le Nain*, exh. cat., Paris, Grand Palais, 1978, pp. 339–40.

[25] This version of the *Diana and Actaeon* is in the Louvre.

[26] Probably a composition of the type known from a painting in Agrigento. See Garboli and Baccheschi, no. 1.

[27] This painting representing the *Virgin and a standing Christ Child with Sts. John and Elizabeth* is now in the Roussel Collection, Nanterre. Félibien confirms Chantelou's report that the picture had been bought for Mazarin by the marquis de Fontenay-Mareuil. French ambassador to Rome in 1641, and that he did so on the advice of Cassiano dal Pozzo. Modern opinion agrees with Bernini that the painting is a workshop production. See Dussler, p. 50.

[28] A slightly earlier version of Mazarin's painting, called the *Small Holy Family*, today in the Louvre. It was acquired for the King's collection from the abbé Loménie de Brienne in 1666 and is also a workshop picture. See Dussler, pp. 49–50.

[29] Bernini's comment on attribution, like some others of the 17th century (cf., for example, Baldinucci, *Notizie*, VI, pp. 461–85), anticipates the positivist method of Giovanni Morelli (1816–91), which depends on the artist's unconscious repetition of specific and habitual formulas, usually for subordinate parts of the figure, such as ears or hands.

We then saw a picture by Andrea Mantegna of the *Dead Christ*,[30] foreshortened, with several other figures. He made no comment. In front of a *Birth of the Virgin* by Paolo Veronese, in which the painter has put a cat and hens in the foreground, he turned to me with a smile saying that this pleased him very much.[31]

After dinner we went to Saint-Cloud, where the Cavaliere made a drawing for a kind of natural cascade, which might be placed opposite the big single fountain in place of the present balustrade. He was a good hour making the drawing, which he then showed to me, and explained it, but he added, "I am quite sure that no one will like it. People here are not accustomed to see things as they are in nature, they prefer them trimmer and smaller, like nuns' embroidery." The abbé Buti asked if he had seen the cascade that was there.[32] He replied that he had and that it fitted the description he had just given. He commented that his design would only appeal to those who had a taste for great and beautiful creations. "I am positive they will consider the other more suitable than the one I have designed, but I have done it out of regard for you. If it were well carried out, I don't believe anyone would look at the other; anyway there could be two, in different styles, but it must be well done, and a model should be constructed beforehand."

Then we went to see the cascade. There were a great many people looking because it only plays on His Royal Highness's orders. M. Billon,[33] our guide, asked the Cavaliere to stand at the foot of the steps, but he wished to go down to the bottom. The water was turned on and it began little by little to spread out all round. The Cavaliere went lower down still, so that he could see the effect better. Having studied the space between the first basin, at the foot of the ramp, and the second, he told me he thought an oval piece of water between the two basins would enrich the effect of the cascade, and secondly, that the canal could be widened by another twenty feet; the rest of the space on either side should be in gentle slopes and covered with grass; the oval would need to be dug only to a depth of five *palmi*, that is

[30] Mantegna's famous picture of the dead Christ in radical foreshortening is in the Brera, Milan, but whether or not it is identical with the painting described here and in Félibien as being in Mazarin's collection cannot be determined with any certainty from the sources.

[31] Bernini's comment on this picture, which has not been traced, is in Italian in the manuscript.

[32] That is, the cascade designed by Le Pautre, which the Cavaliere had already criticized in more or less the same terms above, 2 Aug.

[33] The concierge, to whom, it was reported in 1678, "the direction of this beautiful house has been given" (Berger, p. 68, n. 16).

three feet and a few inches. The abbé Buti said it might be continued the whole length as far as the balustrade which runs along the road. When the waterfall had ceased playing we went up along the site. The Cavaliere stopped to look at the figures that decorate the waterfall, which are by a young man, a protégé of Cardinal Antonio Barberini. The abbé Buti said they were after the manner of Michelangelo. He replied that one could see by the muscles that it was in his style. The Cavaliere remarked to the guide, "It is beautiful, beautiful";[34] in Rome it would be considered beautiful, but here in France it is something marvelous. Then he turned to me and said, "You must tell Madame yourself about my ideas for her gardens." I said that I had not liked to visit Monsieur until he, the Cavaliere, had been back to Saint-Cloud and had done what he had just done.

On our way back he remarked that he would like to have the design painted so that it would show up better. The abbé Buti said that Le Bourson[35] would come and paint it in his rooms; he would let him know about it. I said the essential thing was to have an outline drawn. He agreed and said he would have it done. When we came back to the apartment, he went to the nearby church of the Irish Franciscans.

5 OCTOBER

When I went to the Cavaliere's, I learnt that he was working in his room at his self-portrait in red chalk from the mirror.[36] M. Colbert had asked him for it. When he had finished, his son showed it to me. I thought it in the grand manner and a very good resemblance. He also showed me a drawing of *Cain murdering Abel*,[37] which he had done the evening before. I reminded the Cavaliere that I had begged him to spare me a few hours, in which I could have a likeness made of him and that he had promised me one by himself. At first he pretended to have forgotten, but then it came back to him; when we rose from dinner, he requested me to ask M. Colbert whether the King was coming or not, because if he was not coming he would arrange to do something else. I went to M. Colbert's, who had just come from the Gobelins, where the King had also been. He told me the King would come as soon as he had dined, and in fact he arrived

[34] Bernini's judgment is in Italian in the manuscript.
[35] The landscape specialist, Francesco Maria Borzoni.
[36] The well-known self-portrait (fig. 1) at Windsor Castle (Brauer and Wittkower, pl. 108) is in black chalk and cannot therefore be identified with the one described here, although it must certainly date to about this time.
[37] A replica of this composition was published by Brauer and Wittkower, pl. 179a.

soon after. Directly he saw the bust on the stand, draped round with the velvet, he showed his delight. He studied it for some time and made them all do the same. The duc de Mercoeur,[38] who accompanied the King, admired it extremely, and everyone vied with each other in praising it. His Majesty then placed himself in the usual position and asked if work was being done on the pedestal. The Cavaliere replied that it was not being worked on yet, and leading the prince de Marsillac,[39] who stood near him, to a place where the King could turn his eyes on him, he took a piece of charcoal and marked the pupils on the bust. That done, he said to His Majesty that the work was finished and he wished that it had been more perfect; he had worked at it with so much love that it was the least bad portrait he had done;[40] one thing only he regretted, that he was obliged to leave; he would have been happy to spend the rest of his life in the King's service, not only because he was King of France and a great king, but because he had realized that His Majesty possessed a spirit even more exalted than his position; he could hardly speak and, unable to say more, he broke down and withdrew. The King behaved in the most kindly way in the world, and told the abbé Buti, who was near, to tell the Cavaliere that, if he had only understood his language, he would be able to communicate his feelings to him and say many things that should make him very happy and would reveal how warmly he returned the Cavaliere's affection.

Then His Majesty went to look at Signor Paolo's *Christ Child* and praised it highly, saying that one could imagine nothing more beautiful, although it was only the work of an eighteen-year-old boy. The Cavaliere came up and said that it was meant for the Queen, for it was most important that women in pregnancy should be surrounded by pleasant and noble objects; one of his children bore a close resemblance to a picture that hung in his wife's room during her pregnancy. The King agreed, saying that the Dauphin looked like the Child in a *Virgin* that hung in his wife's room at Fontainebleau.[41] The King came

[38] Louis de Vendôme (1612–69), duc de Mercoeur, Viceroy of Catalonia from 1649 to 1651. A few weeks later on 22 Oct. 1665, with the death of his father, César de Vendôme, he became duc de Vendôme and his wife, Laure-Victoire Mancini, niece of Mazarin, having died in 1657, he entered the church and was created cardinal in 1667.

[39] François VII de La Rochefoucauld (1634–1714), prince de Marsillac, then in 1680 duc de La Rochefoucauld in succession to his father, the author of the famous *Maximes*. He became Governor of Berry in 1671, Grandmaster of the Wardrobe in 1672, and Grandmaster of the Hunt in 1679.

[40] Bernini had coined this modesty formula for the *St. Teresa*. See Domenico Bernini, p. 83.

[41] This extension of the efficacy of art from behavior to biology had both biblical precedent (Gen. 30:37–39) and scientific acceptance, as may be seen from Mancini (I,

back to the bust once more and looked at it for a long while, then he took an affectionate leave of the Cavaliere and went out. I forgot to note that His Majesty had said that, while he was deciding where to put the two pieces, they should be placed in the Queen Mother's new apartments.

When the King had left, we went to the Louvre, where we met M. de Boisfranc. He had heard that the Cavaliere had been at Saint-Cloud, and he went to tell the duc d'Orléans, who was with the Queen Mother, that I was there. His Royal Highness made me accompany him to the baths and then asked me what the Cavaliere had said about his cascade; I told him. Then he asked me whether the Cavaliere had gone into the house, but I said that he had not had time. "Did he come from Versailles?" he asked. I replied that he had gone to Saint-Cloud solely for the purpose of making a design for the area round the big fountain. "What is it?" I told him that it was a more natural, rustic cascade—and I had undertaken to have his drawing painted so that it would be easier to understand the idea. I said if His Royal Highness would care to see the Cavaliere, he was in the anteroom, and I would have him summoned, but he went to find him himself. The Cavaliere said at once that he had not been able to restrain himself from going once more to Saint-Cloud, that if he stayed in Paris, it would be his favorite excursion if His Royal Highness allowed it. Repeating what I had told Monsieur, he gave him his opinion of the present cascade and explained that his design was for another one which would be equally beautiful, but in a quite different style. Then he described the canal that might be constructed between the two fountains, and how the two spouts could be arranged along the end circle to distinguish them from the others which are in a straight line. Monsieur, having thanked him, returned to the side of the Queen Mother, and I conducted the Cavaliere to the Queen's new apartments.[42]

p. 143), who was the physician of Urban VIII: "And such lascivious paintings are appropriate in such places as one entertains one's consort because such a sight increases excitement and helps make beautiful, healthy, and vigorous children, as Sanus seems to note and acknowledge in the book, *De Matrimonio*. And this results not because the imaginative faculty imprints the fetus, which is of matter alien to the father and mother, but because the one and the other parent by such a sight imprint in their seed, as the proper part, a constitution such as is imprinted by the view of that object and figure and because the seed itself has the faculty not only to determine temperament, but also to give form and similitude of figure, although in itself undifferentiated and to the senses, homogeneous. And therefore the sight of such figures and objects of good form and good temperament, represented by means of colors, is of great use at the time of these meetings."

[42] That is, in the Petite Galerie of the Louvre.

We came in to the place where the statues are, and as I stood before the *Diana*, I remarked that it might be by the same hand as the *Apollo Belvedere*. He repeated that he would try to find a dozen good busts for the King; such decoration should appeal to intelligent minds after so much filigree work! He thought the *Diana* should be seen from the front instead of in profile. Then we went into the apartments to try to find a place for the bust. He expressed a wish that shutters should be put on the windows so that the light should fall from above. Belleau said they had started to do it. We went into other rooms and he complained in each one of the same difficulty; the bust would not show to advantage if the light were straight on it, and in many of the rooms the light fell far too sharply on the wall against which he would have liked to place it. In the last room, which is designed for audiences, there is a dais and he got a young man to stand there to see the effect of the light and found it very crude. He said he hoped there would be a sort of curtain to keep out some of the hard light. At last he said they would try one or two places. Really the most imposing place for the bust was the room with the dais, and the *Christ Child* could be placed opposite; the big mirror, which stands there now, could remain between them. Belleau said that Duru, the Keeper of the Royal Furniture, would have to be informed if they needed a curtain, which I did by sending a note to M. Du Metz.

The Cavaliere described to us a bit from one of his comedies, where he stages an imaginary conflagration.[43] The abbé Buti said he had seen it and that he was among the first to run, and the Cavaliere related how, knowing that the fire would frighten people, he had warned Cardinal Barberini, telling him that he was not to be alarmed at anything that he might see, that everything was part of the spectacle; nevertheless, when he saw the thing, he was afraid. He had only told his brother, Signor Luigi, the secret; the scene took place when the people were coming back from a festivity and were telling each other about all they had seen; one of them, whose torch was hardly alight, knocked it from time to time against the back cloth to light it up better, and he had orders to carry on doing this, until someone from the audience called out that he might set the place on fire; this was the sign for the Cavaliere to light up, and the fire in a very short while covered the whole stage and even caught on to a big cloud that hung above it; naturally everyone believed the fire had happened by accident and thought only of getting out. Seeing this the Cavaliere came onto

[43] This sensational scene is also described by Baldinucci, *Vita*, p. 84, and Domenico Bernini, pp. 55–56.

the stage and asked the audience to stay and see the end of the comedy and not to take fright without cause, and he arranged for a peasant to appear at that moment, leading a donkey slowly across the stage, and this served to convince everyone that the conflagration had been intentional.

After dinner, I took the Cavaliere to see the gallery of antiquities, which M. Colbert had asked me to show him. He remarked that the marble with which the gallery was decorated should be polished, as it had lost its luster, and that it would be a good idea to decorate the ceiling with stucco enriched with gilt.

At dinner he told us about a picture supposed to be by Raphael, which had belonged to the Maronite Fathers in Rome;[44] they had been asked to part with it many times but they had always refused to deal, and in fact had kept the picture so well hidden that it could not even be seen. Cardinal ———, having got the general of the Order to come to terms, asked the Cavaliere to go and see it and give him his opinion before he offered a price for it. When he saw the picture about which they made such a mystery, and had studied it well, he realized that it was nothing but a poor copy. He therefore told the good Fathers that they had every reason to keep it hidden and advised them to go on doing so and show it as little as possible. Then he told the Cardinal the facts.[45] I told the Cavaliere that two or three years ago, I had heard someone tell the Queen Mother how the King of Spain had tried to get a picture by Raphael out of Sicily, but there had been so much public feeling against him that he had had to give it up. The abbé Buti said in the end he had the picture—by substituting a copy, which he had made especially, in the place of the original. The picture was *Christ bearing the Cross*.[46]

6 OCTOBER

🐝 I did not go to the Cavaliere's until after dinner. He was still resting. There were a great number of people looking at the bust, among them

[44] The Maronites, a Christian people whose original seat and major concentration is Lebanon, have been in formal communion with the Roman Church since 1182. In 1583 Gregory XIII founded a hospice for Maronite pilgrims to the tomb of the Apostles and in the following year transformed it into a Maronite college under the direction of the Jesuits. The college and its church of S. Giovanni della Ficoccia (later dei Maroniti) lay near the Trevi Fountain and gave its name to the present via and vicolo dei Maroniti. In the 19th century the college was first suppressed by the French, then refounded as a Polish seminary, whose oratory of S. Giovanni Canzio stands on the site of the earlier church.

[45] Cf. the similar story told above, 25 July.

[46] Probably the painting called *lo Spasimo* in the Prado, Madrid. See Dussler, p. 44.

Mme. Colbert.[47] I had given orders for the royal carriage to be brought round, as the Cavaliere had asked for it, but when he came down he remembered that Monsieur said that he might come, so he was unable to go out. As there were so many people in the room where the bust was, he had the model for the rustication for the base of the Louvre brought into another room nearby, where he worked on it. There was no one else there but me. He asked me how I liked this second model, in which he had introduced a break or crack into the stone. I told him I thought the effect was enriched. Then he told me he had begun a drawing, which he wanted me to see, and he asked me to send Signor Mattia for it. I perceived it was a drawing of *St. Mary of Egypt*,[48] whom he portrays carried away by emotion at the sight of a crucifix, which stands before her. . . . I said it was in the grand manner; the body was full of tenderness and even modesty, although the saint is covered only by her hair; there was great understanding in the arrangement of light and shade. I added with a smile that lovers should console themselves by contemplating this subject, for perhaps they had only to change the object of their love to become a great saint— a Mary Magdalen, a St. Paul, or a St. Augustine. Returning to the drawing, I remarked that the effects of light were strongly indicated, which Raphael had done very little. He replied that Raphael had worked with great skill but had not explored the nature of color like the Lombards. At the end of his life he had begun to paint in this manner—in the portrait of Leo X, for instance, where there are beautiful effects of light. He had really then begun to paint in the manner of Titian's portraits. I told him that the portrait of Leo X which is in Rome is supposed not to be the original, that there is another one in Florence and I repeated the account of it given by Giorgio Vasari.[49] He replied that the picture at the Farnese Palace was so beautiful that there could be no doubt it was the original. I went on to tell him what the same Giorgio Vasari wrote about a copy that Andrea del Sarto made of this portrait. He said that once when a pupil of his who drew very well had made a copy of a portrait by him that he had touched up, he himself was unable later to tell the original from the copy.

[47] Marie Charron de Ménars (1630–87), whom the minister had married in 1648.

[48] Brauer and Wittkower (p. 181c) published a copy after this composition, presumably like that made for the abbé Buti (below, 14 Oct.).

[49] In his life of Andrea del Sarto (Vasari-Milanesi, v, pp. 41–43), Vasari reports that Clement VII had ordered Raphael's portrait of Leo X and his nephews (Florence, Uffizi) be given as a present to Federico II, the Duke of Mantua, but that Ottaviano de' Medici had Andrea del Sarto secretly make a copy of the painting, down to its stains, which he substituted for the original. The version formerly in the Farnese Palace is now in the Museo di Capodimonte, Naples.

Someone interrupted our conversation to say that the Nuncio and the Venetian ambassador were there and he went to find them. The ambassador looked at the royal portrait and remarked to the Cavaliere that when one thought how quickly he had finished it and how easily he worked, one realized that by the age he had attained he must have done a tremendous number of works. He replied that if all his work were put together, the room in which they were could not hold it. He had done several portrait busts, among others one of an Englishman[50] who had seen the bust of the King of England,[51] which he had just finished at that time from the paintings by Van Dyck[52] which had been sent to him. He wanted one of himself so much that he would not leave him alone until he had agreed to do it and had promised him any sum provided that no one should hear about it. When it was finished the Englishman gave him ———— crowns.[53] He said he should really have been a painter rather than a sculptor, because he produced with a certain ease; in painting he could have carried things out quickly, which one could not do in sculpture because of the hardness of the material. Then he explained to the ambassador the difference between sculpture and painting—there is an account of a similar discourse in the beginning of these memoirs;[54] sculpture is a truth; a blind man could realize that, but painting is a lie and a false-hood; one is the work of the devil, the other of the Almighty, Who was Himself a sculptor, having made man from clay, not in a moment like a painter, but rather after the manner of sculptors.

[50] Thomas Baker (1606–58) of Whittingham Hall, Suffolk. The unusual circumstances surrounding the commission, described below and elsewhere, have made the bust (London, Victoria and Albert Museum) the subject of a good deal of controversy, for which, see Wittkower, *Bernini*, cat. no. 40, and now, the full reconsideration by R. W. Lightbrown, "Bernini's Busts of English Patrons," *Art the Ape of Nature*, Studies in Honor of H. W. Janson, New York, 1981, pp. 439–76).

[51] Now lost, this bust of Charles I was probably destroyed in a fire at Whitehall. See Wittkower, *Bernini*, cat. no. 39.

[52] The triple portrait at Windsor Castle.

[53] The sum was left blank in the manuscript, but we know that for his work on the bust of Charles I, Bernini received a diamond from the Queen of England valued at 4,000 scudi (Wittkower, *Bernini*, cat. no. 39). Baldinucci, in his biography, raised the value of the diamond to 6,000 scudi and then reports that Baker, in order to get the Cavaliere to do his portrait, matched the royal reward (Baldinucci, *Vita*, pp. 23–24).

[54] Above, 6 June. The following contrast of painting to sculpture as lie to truth arises because, as Bernini said, "sculpture shows that which is, painting that which is not, implying that sculpture rests on exact rules of dimension and must make large what is intended to appear large and form subjects according to just what they are, but that it is otherwise with painting, which knows how and is able to render far what is near, little what is large, and three-dimensional that which otherwise has no relief" (Dom. Bernini, p. 29). Like the conception of God as world architect, the idea of God as sculptor, who models man out of clay, is very old and widespread.

He said that at six years he had done a head in a bas-relief by his father, and at seven another, which Paul V could hardly believe was by him; to satisfy his own mind, he asked him if he would draw a head for him. When paper had been brought, he asked His Holiness boldly what head he should do, so that he should not think he was going to work from memory; then the Pope realized that it was indeed he who had done it and asked him to do St. Paul.[55] Then he told us about the Constantine that he had been commissioned to do for St. Peter's; the marble alone would cost 3,700 crowns, and it would only be in bas-relief.[56]

So many people came in during this conversation that the room was nearly full. When the Nuncio and the ambassador left we went to the Louvre. He asked me to see whether the King was in the council room, for if he was not in his apartment we might try to find a place there in which the bust would show to advantage. As the King was in the council chamber we went into the new apartments of the Queen Mother, where he intended to put the bust on the dais, and the *Christ Child* in the small room behind. Then we went to the Queen's apartments, and so returned, as M. Perrault had sent word that he would come to see him at five o'clock. As he had not come, the Cavaliere asked me to go to the Feuillants with him, and when we got back, M. Perrault had arrived. My brother was with us, as he had wished to be present. The Cavaliere opened the conversation by saying that he hoped the foundations would be ready by Saturday for the laying of the foundation stone. M. Perrault replied that the medals would not be ready by that day. The Cavaliere said they could be put under other stones, since he wished to leave by Tuesday as the weather was getting cold; as regards the foundation they should not have to excavate any lower than the foundations of the pavilion, "not more than that," he said, showing his spectacle case. M. Perrault replied that so far they had never had buildings subsiding in Paris. Then he brought forward a number of things on which he wanted enlightenment before the departure of the Cavaliere, all of which seemed trifling matters, such as the arrangement of quarters below, really the business of the maréchal des logis, as the Cavaliere said; it was quite enough if he made a plan for the *piano nobile*, as he had said in the beginning, when he and Signor Mattia were working on it, and he added to M. Perrault, "Every time there is a new pope all the apartments in the Vatican are

[55] The same story above, 5 Aug.

[56] For the statue of Constantine, see Wittkower, *Bernini*, cat. no. 73. Domenico Bernini (p. 107) emphasized the scale of the work by citing not the cost of the block, but its weight—thirty *carrettate*, or what Wittkower roughly translated as "cartloads."

rearranged, according to the wishes of the new papal officials who want everything changed to suit them." Then M. Perrault brought up the question of the arches in the façade towards the service court-yard, saying that there would be a difficulty in closing them. The Cavaliere took a pencil and showed him how it should be done. I repeated that these were all small difficulties about which there was no urgency; they could be settled in three or four years' time; anyway in the Queen Mother's new apartments there were similar arches for which shutters had been made. He replied that it had caused a lot of trouble. I repeated again that these were all little things that did not matter now, and that everything was clear on the plan. He then told me that he had a notebook with all the difficulties he wanted to bring forward. The Cavaliere had the plans brought in so that he could show him the problems. Whereupon he said there was one thing that required explaining; not only he himself but a hundred others wanted to know why that part of the new wing that runs along the riverside is shorter than the other, it being quite against the laws of symmetry, as each should be in relation to the cupola which is in the center of this façade.[57]

M. Perrault demonstrated what he meant, and from this and from the few words that he understood in spite of knowing little French, the Cavaliere realized he was talking about his work and suggesting there were faults in his design. He told two Italians, who were standing by, to leave the room. Then taking a pencil he said that if he had extended this pavilion to the line of the return of the main block of his façade, it would have been a great error of judgment; it was only necessary for this part of the pavilion to correspond with the other, although it was not so long. He would like M. Perrault to know that it was not for him to make difficulties; he was willing to listen to criticism in what concerned matters of convenience, but only someone cleverer than himself could be permitted to criticize the design; in this respect he was not fit to wipe his boots; anyway the matter did not arise as the designs had been passed by the King; he would complain to the King himself and was going now to M. Colbert to tell him how he had been insulted. M. Perrault, seeing what effect his words had had, was very much alarmed. He begged me to soothe the Ca-

[57] This passage is not altogether easy to interpret, but it appears that Perrault was criticizing the fact that as shown in the plan (fig. 8) and the elevation (fig. 11) the river façade was not symmetrical, having a much larger pavilion on the right than on the left. Perrault's reference to the dome in the middle of the front is puzzling because in the elevation as engraved this would have disappeared. This almost suggests that even at this late stage Bernini was considering incorporating at least the central pavilion of Le Vau's river front (fig. 16).

valiere and to say that he had not wished to be critical of his work, but had merely wanted to have something to reply to those who raised this particular objection. I told the Cavaliere this and added that if he carried things so far, he would ruin the career of a young man, and I was sure that he would not wish to be the cause of his downfall. His son and M. Mattia, who were there, tried to calm him down but without success. He went into the next room saying at one moment he was going to M. Colbert, at the next, he would go to the Nuncio, and meanwhile M. Perrault was beseeching me to tell him that he had not intended to offend him. "To a man like me," the Cavaliere was saying, "whom the Pope treats with attention and to whom he even defers, such usage is a gross insult, and I shall complain of it to the King. If it costs me my life, I intend to leave tomorrow, and I see no reason after the contempt that has been shown me, why I should not take a hammer to the bust. I shall go to see the Nuncio." He seemed to be really going off, and I begged M. Mattia to stop him. He replied it would be better to let him unburden his heart; in the end, this would help to soothe him, and I could rely on him to handle the matter. Signor Paolo was also trying to make excuses for M. Perrault, who had besought him to do so, repeating that what he had said was not intended to offend him. Finally instead of going out they took him upstairs, and my brother and I accompanied M. Perrault as far as M. Colbert's. He said he was going to tell him about the outburst. I told him to be very guarded; it would be as well to know first whether the whole business could be hushed up; it would be better if he mentioned it to no one, and my brother and I would also keep quiet about it, which he entreated us to do.[58]

7 OCTOBER

🐝 When I went to the Cavaliere's about nine o'clock, I met MM. Carcavi and Perrault coming out. The latter came up to me with smiles of relief on his face and told me that he had just seen the Cavaliere, to whom he had been able to explain that he had not meant to offend him; the Cavaliere had agreed it had all been a misunderstanding, that no more should be said about it, and he wished to forget it altogether. I told him I was delighted and went in. I found the Cavaliere with M. Mignard. We stayed for a while in the room where the bust was, and then all three of us passed into the antechamber. As no one mentioned the events of the night before, I said nothing either. We discussed the plans under consideration in relation to the

[58] Cf. the account of this incident in Perrault, *Mémoires*, pp. 73–74.

future of the arts in this country and the Cavaliere remarked that he did not think much would come of them. I repeated what I had said many times before, that the King had a steady disposition, there was something of melancholy in his temperament that made him keep to what he resolved; he would not change; on the contrary, he would become more and more attached to beautiful things, for the more one knew about them the more one grew to love them. "It is true," the Cavaliere said, "that besides the prestige that they give to a prince in the eyes of foreigners there is a great satisfaction to be derived from seeing around one beautiful pictures and statues and busts, which recall the look and deeds of great men and, as the object of one's thoughts, fill one with the desire to emulate their virtues."[59] Mignard said that the old Duke of Modena[60] possessed a wonderful collection, that he used to go and comb his hair in the room, and as a result of having pictures by Correggio and Raphael (he had two beauties by him and Titian), his taste was greatly improved; in fact, he had himself been a witness when a highly valued picture was brought to the Duke, and he had put a price on it without any assistance. Whereupon, the Cavaliere said, "M. de Chantelou has so much understanding that he calls my attention straightaway to the finer points, even to things that can only be intelligible to those with great knowledge and practical skill." Mignard replied that I had been to Rome and seen many beautiful things. "But," said the Cavaliere, "there are many who have been there and many who remain there who have not that understanding." Mignard added that I had had many beautiful pictures by Raphael copied and casts made from the antique. The Cavaliere said it was not enough, one must have a natural gift; the King could not have shown him more consideration, had he appointed a great nobleman as his companion; the choice had confirmed him in his high opinion of the King's judgment; he remembered seeing me in Rome; later he added that he hoped the King would come to possess a dozen first-class pictures and a dozen good statues; if His Majesty continued in his devotion to the arts for the next fifteen years, they would flourish in France as they did in Rome. Mignard said that there were innumerable fine works in France. I added that during the last twenty years

[59] That art not only delights but, through the power of vivid examples, instructs more effectively than philosophy was the chief defense of the humanist theory against those who, like Plato, would banish poetry and painting from the republic of responsible men. See Lee, pp. 32–34.

[60] Francesco I d'Este (1610–58), Duke of Modena, of whom Bernini had made a portrait bust (Wittkower, *Bernini*, cat. no. 54).

we had bought everything that was offered for sale in Rome and in England.[61]

M. Colbert came in during this conversation, and the Cavaliere and I followed him into the gallery. We continued our discussion about the desirability of the King's acquiring a number of fine statues. The Cavaliere repeated what he had said about the effect that this would have on foreigners and what I had said about the constancy of the King's temperament. M. Colbert said the King would quickly get rid of worthless trifles and keep only what was good. The Cavaliere declared he had never met such natural beauty of character. Even finer than one could have imagined, said M. Colbert, "so that he does the right thing without thinking about it, by natural instinct." Nothing pleased the King more than to do a favor, and no one could do it with a better grace than he, particularly to anyone who serves him loyally. One could tell from his face, without his knowing, when he saw the opportunity of performing a kindness; he had once taken the liberty of telling him so; at the same time he had such a rigid conception of justice that no pleading would make him swerve from it. He himself had seen an example of His Majesty's integrity a few days ago; he had wished to tell me about it so that I could pass it on to the Cavaliere. He said I must have heard of the case that the comtesse de Brégy[62] during the last few days had been bringing in the Parlement against her husband. I replied that I was always so busy with the Cavaliere that it had escaped me. He continued, "Although this lady had the sympathy and support of the most important figures at court, for she is very close to the Queen Mother, she nonetheless lost her case, and it is said that her husband will even have a share of the acquisitions she has made since she took personal possession of the property that is claimed, an action that had been taken by surprise and that was quite irregular. A day or two ago, I cannot remember on what occasion, I happened to be one of the company at the bedside of the Queen Mother," continued M. Colbert. "The duc and the duchesse d'Orléans and everyone of note were begging the King to use his authority in favor of Mme. de Brégy. His Majesty replied that he liked her but he would never use his power to commit an injustice;

[61] For Chantelou's copies after Raphael and the molds he had taken from Roman antiquities, see above, 25 July and 6 Sept.

[62] Charlotte de Saumaise de Chazans (1619–93), dame d'honneur of the Queen Mother, who held outspoken views about the deleterious effects on women of multiple pregnancies. In 1637, after having his daughter, she married Nicolas de Flecelles, or Flesselles (1615–89), comte de Brégy, who was first charged with diplomatic duties and then entered the military, becoming a Lieutenant-General in 1655. A court decision of 1651 had separated them in both body and goods.

he knew that when M. de Brégy married her she had nothing; that for her sake he had incurred the anger of his father, who had disinherited him; as his love for her had brought him to this condition and, further, as she had amassed a fortune while the marriage lasted, what justice would there be in preventing the decision that had been made from being carried out?"

To give another example of the King's sense of justice, he told us that when the council was considering the proceedings against the princesse de Monaco—although it was said she was in love with the King and that he was very fond of her too—when His Majesty realized that he could not avoid condemning her without injustice, he was the first to pass judgment against her, leaving the seven or eight people who were there staring at each other in amazement. This did not prevent the King from remaining with her for two or three hours afterwards as if nothing had happened. It was evidence of the farsightedness and resolution of the King, he said, that when he made plans that might not come to fruition for thirty or forty years, he still worked at them every day, just as he would at something that might mature tomorrow. I asked whether he meant the improvement of forest-lands, but he said that he was speaking of the reform of the system of justice. M. Colbert was standing in front of M. Paolo's *Christ Child*, and he remarked more than once that M. Paolo must become a Frenchman.

Then he came up to the table and said that he wanted to talk to the Cavaliere about the plan of the apartments on the ground floor, about which he had sent him a memorandum. He also spoke to him about the exit from Paris by way of the Tuileries; he sent for the plan from M. Le Nôtre, and also for a map of the environs to see the roads that were to lead from Paris to Saint-Germain. He began to talk about these projects and the stone bridges that would have to be built at Saint-Germain, but the Cavaliere remarked that the design for the Louvre was such a great undertaking that nothing further should be contemplated at present. I replied that this road[63] and the radiating roads which were planned at the exit of the Tuileries were only a matter of planting. If the saplings were put in in good time, they would grow night and day without further attention. M. Colbert added that the trees in the warrens at Saint-Germain had been planted with this in view.

Speaking of the cost, the abbé Buti, who had arrived, suggested there were so many military appointments that when a place fell vacant

[63] The text should read *route* instead of *voute*.

it might be sold and that money used for the Louvre. "Heaven fore-fend," exclaimed M. Colbert. "We are trying to destroy this venality." He asked us what we thought were the budgets for war, for justice, and for finance. I said, more than there was coin in the kingdom. He replied that he had himself worked them out and it came to more than 450 million livres.

Then we turned to the question of the apartments of the King and Queen, which it was agreed must be on the south side and must consist of two sets of rooms, one for their private use, the other for holding audiences. The abbé Buti pointed on the plan to those on the side of the service court. "But those face west," said M. Colbert, and laughed at him. Then he suggested making them in Dubreuil's gal-lery,[64] but there was no passage through. M. Colbert said he was waiting for the opinion of the Cavaliere, who said nothing beyond that he would think about it. Then we discussed the Tuileries bridge.[65] He said it would have been a good thing to put a square in the center, and he made a sketch on a piece of paper. M. Colbert pointed out that the river was already too narrow at that point, as it was only 324 feet across, instead of the six hundred at the Pont-Neuf. He suggested a means of managing the flow of water, with very pointed, projecting piers. Then we discussed the large theatre hall[66] and noted all its faults. The Cavaliere pointed out that the real and the counterfeit do not go together, that it was two or three times as long as it should be and half as wide, and he showed us what he meant; there should be no raised seats because the people in them could see the apparatus, which is a great mistake; the ceiling should slope down from the stage so as to give good acoustics; a sea on this stage would look no more than a fountain; no one could see or hear; and a lot of other faults. Then we talked about fountains and how they could be used to make Paris more beautiful and more agreeable. M. Colbert said that he hoped one day to have possession of all the water from the fountains at Saint-Cloud, for His Royal Highness would tire of so small a house, that he would also have those of Vaugirard, and Issy, and other places near Paris.[67] He would like to discuss this with the Cavaliere who replied that he could fix whatever time he liked. Then M. Colbert left.

[64] That is, the Petite Galerie of the Louvre, where Le Brun's Galerie d'Apollon replaced the paintings of Toussaint Dubreuil (d. 1602), which had been destroyed in the fire of 1661.

[65] The Pont-Rouge, the wooden bridge that was the predecessor of the stone-built Pont-Royal (begun 1685). See Hautecoeur, II, p. 621.

[66] The Salle des Machines, which Bernini had already criticized (above, 26 July).

[67] For Colbert's attempts to increase the water supply of Paris, see Hautecoeur, II, pp. 433–36. Vaugirard and Issy, whose waters Colbert coveted, were two small villages to the southwest of Paris.

I have forgotten to note that the Cavaliere on several occasions had spoken very highly of M. Mattia; of the five or six architects whom he had trained, he was easily the best; he had persuaded him to leave his work in Rome and make a home in France with his wife; a better man could not be found for carrying out the designs for the Louvre as they have been proposed. He said he had gone hunting with M. Paolo that morning; he had sent him off in spite of his protestations and taken his drawings away from him. When M. Colbert left it was already half past twelve and they had not returned. We went to dine and when we rose from table, they came in.

The Cavaliere went to rest and they set about telling the abbé Buti of the Perrault affair;[68] when they had finished, I said the matter was settled; Perrault had told me himself, when I met him as I was coming out of the palais Mazarin and he was going to M. Colbert's. Mattia said that the evening before, the Cavaliere had gone up to his apartment, as I had seen. He had sat down at the table without saying a word, then he had sent them away and read some passages from devotional books as he usually does in the evenings, prayed for a while, and never mentioned what had passed.

I left the sportsmen and went downstairs, where I found Pietro, Mattia's servant, who confirmed that the affair was settled; M. Perrault had come that morning at five o'clock and got him out of bed; he had brought someone with him, who had conveyed his apologies to the Cavaliere, who had then summoned him to his room and told him that he would think no more about it, that he [Perrault] should not talk about it and he would never do so in return. I told Pietro that I was extremely relieved: what a change from the evening before! and how true it is that night helps to solve all troubles! He told me that during the evening the Cavaliere had been to see the Nuncio, which made me think that it had occurred to them that it was just as well not to push the matter when he was on the point of leaving in case it made a bad impression; besides, the Cavaliere, being a truly religious man, had laid his resentment at the foot of the Cross.

After dinner there were always a great number of people to see the bust. The Cavaliere and I went to the Louvre; he went into the bedroom and the private study of the King. He wanted to go into the salon but Rossignol, the room-attendant who has the key, could not be found. Then we went downstairs to the Queen Mother's new apartments to see whether the bust could be placed below the canopy at the side of the audience-chamber, and the *Christ Child* on the other side, or in the room at the back. The Cavaliere said he would try the

[68] Of the day before.

place where it would look best. From there we went to the theatre, as M. Colbert had asked me to show it to him, and thence to see M. Le Nôtre. He looked at his pictures, and praised the Poussins much more than the Domenichinos.[69] Afterwards we went to the Tuileries, and then back to the hôtel Mazarin and from there to the Feuillants. When I left him he asked me to come in the morning so that we could work at the arrangement of the offices, and the apartments for the officials.

8 OCTOBER

� At the request of the Cavaliere, I worked at the arrangement of the apartments on the ground floor of the main façade. I also made a memorandum with letters corresponding to those on the plan, showing the room for the King's council, the apartments of the Provosts of the Grand Marshal, the maréchal des logis, the captain of the Louvre, the guard, the pensioners and the janitors.

While I was working at this, the Cavaliere asked me to look at an idea that he had had for a playhouse, which he thought could be part of the amphitheatre planned to face the carousel. He had found a means of giving the theatre a width sufficient for really vast spectacles, such as sea scenes or open country, and had planned to arrange it so that there would be room for the court, for the necessary properties, and for the actors and the public, also for a bridge leading from it to the Long Gallery. I thought the idea very good, bearing in mind what he had told M. Colbert about this sort of thing. Immediately afterwards, the minister appeared himself and took the Cavaliere to the Louvre with him. I could not go with them as I had not yet got a suit of mourning for the death of the King of Spain. I learnt on his return, that in the coach he had shown him his new idea for the theatre hall, and he had liked it very much. They had been together to the apartments of the Queen Mother to see where the bust would look best. Then the Cavaliere returned to his own rooms, where he talked for some time with Vigarani.[70] The abbé Buti asked me what he had

[69] For Le Nôtre's collection, which included the *Adam and Eve* by Domenichino now in Grenoble (Spear, cat. no. 86) and Poussin's *Finding of Moses, St. John Baptizing the People*, and *Christ and the Woman taken in Adultery* (Blunt, *Poussin Cat.*, nos. 12, 69, and 76), see Bonnaffé, pp. 179–80, and J. Guiffrey, "Testament et inventaire après décès de André Le Nostre," *BSHAF*, 1911, pp. 217ff.

[70] Probably the conversation described by Vigarani in a letter to Modena of 9 Oct. 1665: "He himself has told me of the proposal to build a new theatre on another site that he has made to his Majesty and to M. Colbert—not so much because in ours he has found some faults caused by the site, as because made in accordance with his design it will be more convenient and perfect, since it will be made with every freedom of invention and not constrained by the confines of two walls bound to the symmetry of an old building like ours" (Rouchès, no. 228; Fraschetti, p. 347, n. 1).

done yesterday in the theatre. I told him he had just looked in and had then gone for a walk in the gardens of the Tuileries. He went on to say that Vigarani had no knowledge whatsoever of perspective or drawing. I told him that in my opinion such halls should be hollow and oval in the inside, with no projections or concavities, the walls being absolutely unbroken and simple, so that the sound can spread out evenly in circles without hindrance, such as one sees when one throws a stone or some other solid body into the water. This was known to the ancients, and their theatres were always built on those principles, as Vitruvius points out.[71] He replied that Vigarani's father knew something about stage machinery, but that most of those in this theatre were made by a young man employed by them who was much cleverer than they were; it was he who had made the most ingenious machines.

The Cavaliere joined us as we conversed and we walked along together discussing these matters. The abbé Buti repeated that Vigarani was very unintelligent and had spoilt this playhouse with balconies, cornices, and columns; he had said so again and again, and all the father and son would answer was that all he was concerned about was that his verses were heard;[72] the Cardinal, had he lived, would have engaged a German painter living in Rome, known as Tedesco,[73] who knew a great deal about such decorations. The Cavaliere replied that he was a very good draftsman; for theatre and plays a man should have plenty of inspiration and fertility of ideas; then, with the help of someone who could develop his ideas, and another perhaps who understood stage properties, astonishing things could be created. The abbé Buti asserted that what was needed was a man like the Cavaliere. I agreed and said that, if large sums were to be spent, it was good to have someone who understood how to use money and how to create novelties and spectacles. Then we broke up and went in to dine.

When we sat down, he said he did not know how he could eat

[71] *De architectura*, V, III, 6–7.

[72] The abbé Buti, it will be recalled, wrote the libretto for the *Ercole Amante* with music by Francesco Cavalli and Jean-Baptiste Lully, which inaugurated the Salle des Machines in 1662. In a letter of 16 Oct. 1665, attributing these personal attacks on his father's work to Bernini, Carlo Vigarani describes Buti as "our perpetual persecutor" (Fraschetti, p. 266, n. 1).

[73] Johann Paul Schor (1615–74), called Giovanni Paolo Tedesco, who did designs for a wide variety of decorative applications—architectural ornaments, carnival cars, festive decorations, vases, candelabra, etc.—as well as paintings, both figural and ornamental. In Rome by 1640, he became a member of the Accademia di San Luca in 1654. He had worked with Bernini on the fireworks display of 1662 at Trinità dei Monti celebrating the birth of the Dauphin; and for the *Cathedra Petri* he provided the design for the floral ornaments beneath the seat of the throne (1665) and painted the Dove of the Holy Spirit in the glory (1666).

anything, being filled by the delight he felt at having been addressed
as *illustrissime* by M. Colbert. After dinner he had a fire lit, and we
sat round it talking of the same subject; then he went to rest. When
he came down, we walked to and fro in the room for a little while,
and I brought up again the need we had of him in France to carry out
the grand schemes of the King; what had been done so far did not
express his magnificence at all; in fact, it might even be said that it
had been better left undone. He agreed, "True it is that buildings are
the mirror of princes."[74] It was better to do nothing than something
that lacked grandeur. He mentioned Tedesco again, saying it would
be a good thing if he were to settle in France. I asked him to rec-

[74] This statement, which is quoted in Italian in the manuscript, perfectly expresses
Bernini's attitude towards the design of the Louvre, and if it is a typically Baroque
sentiment, it nevertheless has its roots in the 15th century. From the Neoplatonic notion
that matter is informed by spirit and the soul is mirrored in the body, Marsilio Ficino
had already drawn the corollary that the same relationship obtains between an artist
and his work: "In paintings and buildings the wisdom and skill of the artist shines
forth. Moreover, we can see in them the attitude and the image, as it were, of his mind;
for in these works the mind expresses and reflects itself not otherwise than a mirror
reflects the face of a man who looks into it" (trans. E. H. Gombrich, "Botticelli's
Mythologies," *JWCI*, VIII, 1945, p. 59). Then under the impact of the Aristotelian
concept of magnificence and the pervasive acceptance of a formal decorum that defined
the fitting and proper, the notion was extended to a patron and his building projects
(A. D. Fraser Jenkins, "Cosimo de' Medici's Patronage of Architecture and the Theory
of Magnificence," *JWCI*, XXX, 1970, pp. 162–70). The Grand Duke Cosimo, Vasari
wrote, "displays a most happy genius and the greatest judgment in the government of
his people; he spares neither expense nor anything else, in order that all the fortifications
and buildings, public and private, correspond to the grandeur of his spirit (*animo*) and
are not less beautiful than useful" (Vasari-Milanesi, IV, pp. 451–52). Thus great archi-
tecture became the measure of a great prince, as Colbert, writing to dissuade Louis
XIV from his predilection for Versailles, argued: "Your Majesty knows that outside
brilliant feats of war nothing marks so well the grandeur and spirit (*esprit*) of princes
than buildings; and all of posterity measures them by the standard of the superb houses
that they have erected during their lives" (Clément, p. 269). Such ideas, although
undoubtedly welcome to architects, were nevertheless readily manipulated and could
easily lead to pompous ostentation; for magnificent architecture not only perpetuated
virtue, it also bestowed it: "because building is one of the things in which princes and
great lords are largely accustomed to distinguish themselves and to derive glory and
applause . . . one cannot err in making the building majestic and magnificent, since for
many reasons it will yield no small praise of Your Most Illustrious Lordship such as
for having adorned the city with it and for having made most resplendent your most
excellent house" (O. Pollak, "Brief eines anonymen Florentiner an den Fürsten Bar-
berini, betreffend den Bau des Palazzo Barberini," *Jahrbuch der königlich preuszischen
Kunstsammlungen*, XXXIV, 1913, Beiheft, pp. 65–66). Moreover, as an accepted material
reflection of intangible qualities, architecture could be used for purely political ends, as
Colbert suggested to Bernini in a memorandum on his first plan for the Louvre: "It is
necessary to observe well that in disagreeable times, which always occur during mi-
norities, not only must the kings be secure in their palace, but even the quality of their
palace must serve to hold the people in the obedience they owe them . . . and that the
whole structure instill respect in the spirit of the people and leave some stamp of their
power" (Depping, p. 246).

ommend him to M. Colbert who would be sure to act on his advice. He said he did not wish to do harm to anyone. I replied that on the contrary, we should be greatly obliged to him. He said this artist was a man of a different calibre from Le Brun for designing silverwork, and in many other things as well. I answered that it would help rather than injure the latter because he would be able to devote so much more of his time to painting, which brought him greater fame. Then we talked of his departure. I asked him again to consider coming back. Surely there was glory and advantage in working for a great prince, who was devoted to the arts. He said he thought his taste was as yet undeveloped. "He must see some really great work of architecture, which so far he has not done. He has seen some sculpture and he knows more about that than about architecture." I had to confess that was true but I said I thought it a marvel that the princes, who had been brought up by the Queen Mother, had any appreciation of beauty and grandeur in art, for without prejudice to her many virtues and good qualities, it must be admitted she had the taste of the Spaniards in the arts, liking only what was highly finished and what they call *lindo*.[75] Anything there was of importance in France we owed to Catherine and Marie de Médicis, both from Florence, where there were many buildings of considerable beauty which inspired grander ideas. Then we walked through the rooms and galleries of the palais Mazarin. He saw the Titian sent by Prince Pamphili and found its condition very bad in spite of the efforts to restore it. He asked for a bit of charcoal and marked with an asterisk the works, busts, and statues that he thought were good. There were very few. In a small room we saw the portraits of the duc and duchesse de Mazarin[76] by Mignard. He remarked how much more beautiful she was than the Princess Colonna,[77] whose haggard face bore an air of coquetry.

Then we went to the Louvre. I mentioned something that I thought could be done with advantage to myself. He said he had already done it. I added that it was in the interest of both of us, and he agreed. As we got out of the coach we met M. de Lionne, who greeted the Cavaliere with the greatest courtesy. He said he would come to say goodbye and to thank him. When the Cavaliere got to the Queen's apartments, he looked again at all the possible places for

[75] That is, "pretty."

[76] Armand-Charles de La Porte, duc de La Meilleraye et de Mazarin, and his wife Hortense Mancini.

[77] Marie Mancini (1639–1715), sister of Hortense and niece of Cardinal Mazarin, married in 1662 to Prince Lorenzo Onofrio Colonna (1636–89), High Constable of Naples, Grandee of Spain (1659), and Viceroy of Aragon and then Naples.

the bust. Just as he had done at the palais Mazarin, he marked with an asterisk the statues and busts that he considered outstanding, among them the *Diana* (which he liked best), the two *Dancing Fauns*, an *Amazon*, the *Bacchus*, and a few busts.

I forgot to mention that on our way to the Louvre we met the duc d'Orléans who told me that he was coming to see the Cavaliere. I said we were coming back, which we did in order to receive him. He examined the bust very carefully and expressed his admiration for it and for M. Paolo's work. The Cavaliere told him the gist of what he had asked me to say to the duchesse d'Orléans.[78] His Royal Highness said she would come the next day; she had asked to see the design for the waterfall. The Cavaliere said he was having it colored, so that it would be easier to understand his ideas. Monsieur thanked him and then left.

Then the Cavaliere went to look at the foundations, where M. Mattia was working. The Cavaliere went right down into them and was able to see that they had dug down twenty-five feet, so low, in fact, that water came if one poked the ground with a stick. I went down with him and we looked at the three courses that are underneath the rustication. The Cavaliere said he wanted them covered with the earth from the moat so as to give the building greater solidity. He asked where the lime had been prepared. Mazières said it would be ready for Saturday morning so that the foundation stone might be laid on Monday afternoon after dinner, if the Cavaliere wished. He said that the largest rough stones should be put in the first course. We noticed that the earth had been cut straight down, without shoring as he had ordered. We then went to the Oratoire, where the Cavaliere prayed before three different altars—the High Altar, the altar of the Virgin Mary, and the altar of the Infant Christ; then he returned home. I asked him what time he could give the duchesse d'Aiguillon,[79] who had asked when she could come to take him to the Sorbonne, to ask his advice about the tomb of Cardinal Richelieu.[80] He said it would have to be at ten the next morning because that afternoon he expected Madame. Thereupon I sent a note to Mme. d'Aiguillon.

M. Perrault came two or three times, once with Warin, who

[78] Above, 26 Sept.

[79] Marie-Madeleine de Vignerot Du Pont-de-Courlay (1604-75), dame de Combalet, then duchesse d'Aiguillon. She was the niece of Cardinal Richelieu, who had been protector of the famous college founded by Robert de Sorbon, Canon of Cambrai, in the mid-13th century.

[80] The tomb of the Cardinal, which went through various projects, including an earlier one by Bernini than that described here, was finally executed by François Girardon (1675–77).

brought his medal of the King, with the reverse showing the façade of the Louvre just sketched in. The Cavaliere pointed out that he had omitted a window on either side, having put one instead of two, and he had also put columns instead of pilasters. The abbé Buti pointed out that Warin had given the profile the likeness of the bust. I have also heard that he intends to make a bust in marble and has had a block transported for that purpose.[81] He assured us that now that his houses were requisitioned, he had nothing left, and would have to resort to the King's justice. Another time he had told me that M. Colbert had promised to keep an eye on his affairs and that he was only ambitious to enhance the King's reputation and his own. Marot, who was there, showed Signor Mattia two or three façades of the Louvre and told him that he had done as many as eighteen, which he had engraved in accordance with the heights and measurements of the Louvre.[82]

<h2 style="text-align:center">9 OCTOBER</h2>

� I found the Cavaliere working at a drawing of the *Deposition of Christ with the Magdalen*[83] and he asked me to tell him what I thought of it. I said that the body still bore the marks of the agony of the Passion, particularly in its extremities, also love and suffering. A little while later Mme. d'Aiguillon arrived with Mme. Du Vigean[84] and they looked at the royal bust for some time. The Cavaliere replied with much wit and gallantry to the praises of these two ladies. He

[81] Warin did indeed carve a bust of the King (below, 12 Oct.), which was finished a year later. Mattia de' Rossi, who had returned to Paris, wrote to the Cavaliere on 1 Oct. 1666: "I sent your lordship news that M. Warin, who made the medals, has made a portrait of the King in marble. After it was finished, the King and all the court went to see it, and everyone exclaimed, 'There now, that is good! there now, that is beautiful!' in such a way that, there being those there who were little friendly to your lordship, they meant it was more beautiful than yours. Curious, I went with a virtuoso, who is a friend of mine, to see this portrait. How it has been done, I describe to you here: first, it is humpbacked and looks toward the ground; it is dead; then it has one eyebrow protruding a good finger more than the other; its nose is bent contrary to the King's; one eye is a finger further from the nose than the other; and between the eyes there is room for two more" (Mirot, p. 268, n. 1). This bust by Warin was used in the decoration of the Escalier des Ambassadeurs, the great staircase at Versailles by Le Vau and Le Brun, but it was later replaced by Coysevox's bust of the King and is now at the foot of the Queen's staircase.

[82] Marot, who eventually did engravings of four of Bernini's designs for the façades of the Louvre, must be referring here to his engravings after the work of other artists, such as Le Vau.

[83] Cf. the two copies after a drawing by Bernini of this subject in Brauer and Wittkower, pl. 80.

[84] Anne de Neufbourg, wife of François Poussart, marquis de Fors and baron Du Vigean.

told them of the difficulties and apologized if it did not come up to their expectations or to his desire of what it should have been. While he was working at something, he said, he was often quite pleased with what he did, but as soon as it was finished he became disgusted with it. Mme. d'Aiguillon said that she was convinced that the bust surpassed anything done in modern or ancient times, although antiquity had reached such high standards of perfection. He replied that he would have done better if it had lain within his powers, but his work did not stand comparison with that of the ancients. They also admired the inspiration and the execution of Signor Paolo's work. We then went to the Sorbonne, discussing the Louvre on our way. I said, as a joke, that we would demolish nothing, but nevertheless change everything.[85] Mme. d'Aiguillon said that the Cavaliere must have been very handicapped by the necessity of fitting in with what was already there. He replied, "If you want to see what a man knows, put him in a difficult position."[86]

When we arrived he looked round and said the courtyard was fairly good. As we entered the church,[87] he remarked that it was one of the best he had seen in Paris. I said that I thought the roof rather low and he agreed. I added that the niches in the vault[88] were in the wrong places, and the figures of angels in them too small by half; if they had been larger they would have had to be on a curve, as the niches followed the line of the vault. He also pointed out that the corner pilasters were double, and they should be single and broken in the middle; there were only two chapels in the nave, which was unusual, there should be five, or anyway three.[89] He noticed that in the central space under the dome the doors leading to the chapels were not opposite each other, which was a bad fault.[90] We then held a long

[85] Chantelou's joke is an allusion to Bernini's plans for the Louvre, and a play on the epigram that the artist had invented to describe them (above, 2 Aug.).

[86] Bernini's reply is in Italian in the manuscript. Cf. Bernini's statement as recorded by his son that "the greatest merit in architecture consists in knowing how to make beautiful things from little and from what is bad and ill-adapted to the purpose, and to make them in such a way that what was a defect becomes so useful that had it not existed, it would be necessary to invent it" (Dom. Bernini, p. 32, and similarly in Baldinucci, *Vita*, pp. 80–81).

[87] Designed and built (from 1635) by Jacques Le Mercier for Cardinal Richelieu, along with a complete reconstruction of the entire college (begun 1626). For the Italianate style of the church, see Blunt, *Art and Architecture*, pp. 197–98.

[88] There are no niches in the vault of the church, and Chantelou is probably referring to the roundels in the cupola painted with angels by Philippe de Champaigne.

[89] Presumably Bernini meant three or five on each side of the nave.

[90] This comment is baffling. There are no doors in the crossing leading to chapels. If he means those leading from the transepts to the chapels, they appear both in Marot and in modern plans to be exactly opposite each other.

discussion on the right place for the monument to Cardinal Richelieu and the form it should take. The Cavaliere said he had made a sketch putting it beneath the cupola. Mme. d'Aiguillon said that His Eminence had always wished to be portrayed in the act of offering himself to God rather than in prayer, which is too commonplace. He wanted the monument to be where he lies at present. The Cavaliere said that if they wanted to do something really good, they must put the altar where it is in St. Peter's,[91] and the tomb of the Cardinal where the altar now is and so create something magnificent. She replied that when such a suggestion had been made, there had been an objection that it might happen in the course of time that someone would ask to be buried where the pall of the Cardinal now lies, and it would then be most difficult for the members of the Sorbonne to refuse although the whole church had been founded by His Eminence; further, it could be objected that the Holy Sacrament itself had been moved to make a place for the monument of the Cardinal. To the first objection he replied that it would be possible to leave the tomb of the Cardinal in the place where the body lies at present, so that no one else should occupy it, and to the second, that it would be even more awkward to make a large monument in the place in front of the altar, so that those who came to pray would see nothing but the back of the Cardinal; if, on the other hand, the monument were to be a small one, it would be unworthy of so great a man. She replied that, provided it was designed by the Cavaliere and carried out under his direction, it would certainly be impressive and noteworthy. He maintained that if there was not grandeur in the whole the details would be nothing, and he kept on returning to the fact that he considered it essential for the monument to be further back or in one of the transepts, and the altar under the cupola; if it were arranged the latter way, it would be possible to reconcile all the elements of the design, but it would be much better if the monument were at the end; anyway, if she hoped to have a monument that would meet with no criticism and would please everyone, she would be luckier than anyone had ever been before. But Mme. d'Aiguillon was not at all satisfied with the idea that the monument should be in one of the transepts; the Cardinal had himself chosen the place where he lies, and she asked the doctors who were with us to bear her out in this. It was not hard to see that she wanted to get something big for a small outlay, and the Cavaliere, realizing this, said that he had not come to argue but

91 That is, under the dome.

to give his opinion, and he had already said what he had to say and could add nothing.

The abbé Buti suggested that, if the altar were put beneath the dome and kept low, it would be possible to see the monument over it, and there was a design of the Cavaliere's in existence, done on an occasion when the needs had been similar, which he would send to Mme. d'Aiguillon. All the doctors agreed that such an arrangement would be very suitable, and they decided to see the drawing. When she had gone they asked the Cavaliere to look at their library, which is magnificent. Just then he heard it strike midday and remarked he would rather see the refectory. One of them explained that they were not permitted to ask guests to meals; when he understood this, he got in the carriage remarking, "This is a house to get out of,"[92] and we returned to the palais Mazarin for dinner.

After dinner, the Cavaliere had the fire lit, and he read over the report he had made for the Academy, then gave it to the abbé Buti to read and correct. Having warmed himself before retiring, he left us. At his request I ordered the royal coach for between three and four. The abbé Buti told me that the Cavaliere was going to look at Mignard's work on the cupola,[93] which was coming on very well, as he had profited by the Cavaliere's advice to enlarge the subject of the Trinity as the principal part of his design for the *Vision of Paradise*, which he was painting in the dome. In the first design he had put it in the distance where it could hardly be seen. The Cavaliere had suggested placing it on a cloud drifting down towards the principal figures, which he had done most successfully. I remarked to the abbé Buti that it was I more than anyone who had secured him this commission, for I had been summoned by the Queen Mother while they were deciding to whom to entrust the work, and I had said that, as it must be in fresco, there was no one who knew more about it than Mignard, and in any case Le Brun was ill.

During the Cavaliere's rest I went to pay several calls. When I returned he told me he expected the duchesse d'Orléans, but that if she did not come he would be waiting the whole afternoon. I went to see Her Royal Highness who, to tell the truth, was not thinking of visiting him. The duchesse d'Angoulême[94] was with her. When I

[92] Bernini's remark is in Italian in the manuscript.

[93] Of the Val-de-Grâce. Cf. above, 13 June, for Bernini's visit to the church, where Mignard was painting Anne of Austria amidst all the saints of Paradise offering the church to God.

[94] Françoise de Nargonne (1621–1713), second wife (1644) and now widow of Charles de Valois (1573–1650), natural son of Charles IX, King of France, and Marie Touchet, who had been created duc d'Angoulême in 1620 by Louis XIII.

told her that the Cavaliere was expecting her to come and see the bust she said she had nothing to do that afternoon and she would certainly come, and she would go and tell Monsieur, which she did. Monsieur asked me when he would be able to see the design for the cascade. I said it was being colored under the supervision of the Cavaliere, and I went ahead to warn him that it would be wanted. The maréchal de Gramont was there, praising the bust up to the skies, which led me to think that we were in favor at court. When the duchesse d'Orléans arrived in a chair, the Cavaliere went down to receive her, and she greeted him very cordially. When she came into the room, she and all the ladies with her expressed their great astonishment at the likeness of the bust, whichever way one looked at it. Her Royal Highness also admired Signor Paolo's work. The Cavaliere went out of his way to say the most flattering things to Madame, praising her beauty for the nobility and delicacy of the features and for the vivacity that illumines them. He told her that she had much to thank God for, since He had seen fit to endow her mind and person so richly. He repeated to her what he had said to the Queen,[95] that, thinking always of the King, she saw his likeness everywhere.

When Madame had gone, we went to the Val-de-Grâce. With us were the Cavaliere's son, the abbé Buti, M. Du Metz, and my brother. Once arrived we climbed on to the scaffolding to see the dome, where we found Mignard. The Cavaliere looked at it from every angle, saying he considered it extremely beautiful, and he added that a painter who had not done a cupola could hardly be called a painter in his opinion. This design was rich without being confused. We talked about the difficulty of carrying out these huge paintings; a brush a yard long was needed; one could not step back to see the effect, nor could one see near to what one was doing, as everything was on such a large scale. When the Cavaliere Lanfranco was touching up the cupola of S. Andrea della Valle,[96] he used long brushes tied on to a stick; they were so heavy that they had to be held by two men, whom he himself guided; "an awkward and difficult feat," he said. Michelangelo had got so used to working with his head and body thrown back during the lengthy period that he was doing the Pope's chapel, that when he was shown anything he had nearly to turn himself upside down to see properly what was before him.[97]

[95] Above, 19 Sept.

[96] Giovanni Lanfranco (1582–1647), painted the dome of S. Andrea della Valle in Rome between 1625 and 1627.

[97] Cf. the early sonnet written by Michelangelo that contains an ironical description of what painting the Sistine ceiling was doing to him (*Complete Poems and Selected Letters of Michelangelo*, trans. by C. Gilbert, New York, 1963, no. 5, pp. 5–6).

He asked Mignard how he liked the plaster. He replied he found it very agreeable to work with, and it suited him better mixed with river sand, as he made it, than with pozzolana: colors used on it retained more of their natural beauty and it was easier to see what one was doing than with the preparation they had in Rome. He mentioned that we had a color here instead of lake which is very good; Romanelli had taken forty or fifty pounds of it away with him. He told the Cavaliere that if it were not so late he would take him up on the roof, outside the dome, from where he would get the most beautiful view in the world and from where Paris looked better than from any other place in the city.

10 OCTOBER

On my way to the Cavaliere's I met Signor Paolo, who was going to M. Colbert's. On his return, he told us that M. Colbert was going to the Louvre. The Cavaliere had heard someone say that the prince de Condé was in Paris and he wanted to call at his apartments to see His Highness, but he was not in Paris, and the duc d'Enghien had just left for Chantilly to see his father. We went on to the Gobelins where the Cavaliere was received by M. Le Brun. He first studied a design for a tapestry of *Endymion in the arms of Sleep*, which he thought in excellent taste and praised highly. He was then shown two big pictures of *The Battle of the Granicus* and *The Triumph of Alexander*.[98] After some time M. Le Brun had the *Battle of the Granicus* taken into the courtyard, as he had done when the King visited the Gobelins. The Cavaliere looked at it again from every side and withdrew as far as possible so as to see it from a distance. Then he repeated many times "It is beautiful, beautiful."[99] A cloth had been placed above it as a kind of ceiling, to act as a focus, which the Cavaliere had removed, and he continued to gaze at it. He also saw the big picture by Paolo Veronese,[100] which was given to the King by the Venetians, and which used to belong to the monastery of the Servites in Venice. He looked at it again and again, and pointed out that the heads were exquisitely painted; they were portraits of contemporary senators and of the Doge himself. He praised the bold handling, but found several bits rather malformed, particularly the hands, which were badly drawn. He said

[98] Two of the four huge paintings by Le Brun illustrating the victories of Alexander the Great, with whom, as we have seen, the King was wont to be compared. The series is now in the Louvre. See the *Le Brun Cat.* nos. 29–32.

[99] Bernini's comment is in Italian in the manuscript.

[100] The *Christ in the House of Simon* (Versailles, Musée National), which had been painted for the refectory of a Servite house in Venice, probably before 1573. It was given to Louis XIV by the Venetian Republic in 1664. See Pignatti, cat. no. 176.

the Magdalen at the feet of our Lord was marvelously in relief, but very poorly drawn from the waist down; the nearer leg of the Christ was all wrong and His arm and right hand completely malformed. He admired more than anything else a figure sitting at the table near the figure of Christ, whose back only is visible. M. Le Brun pointed out to me that there are different viewpoints in the picture, that although the horizon is lower than the table, one can see the top of the table, that the lines of the architecture do not meet on this horizon, and that anyway Veronese was probably not responsible for this part. He recalled that when the King saw the picture, he had praised the figure of the Magdalen and had considered the right side of the picture much more beautiful than the other, which is in fact the case. We then looked at another picture by Veronese, *Perseus and Andromeda*, [101] that once belonged to M. Fouquet, which is well painted like most of the works of this artist, but he thought the figure of Perseus was peculiar and seemed all in a heap. I pointed out the left leg of the Andromeda, which was very badly drawn. The Cavaliere took Le Brun aside, and after giving him some advice said, "I have not hesitated to speak to you because it is easy to talk to someone who is so little short of perfection, while it is impossible to criticize someone who lacks almost everything; Annibale Carracci often used to say, 'Advice should be given to those who know, not to those who don't know.' "[102] He told us that one day quite a gifted sculptor had asked Michelangelo to come and see the figure that he had done, and as he did not consider the light good enough, he kept on opening one window and shutting another while the great man was looking at the work, and because of the sun could not obtain a light that he considered would be suitable; at last Michelangelo said, "There is no better light than the open square where the statue is to stand; it is there that we shall be able to see it and say how good it is."

[101] Now in Rennes, Musée des Beaux-Arts (Pignatti, cat. no. A262). Nicolas Fouquet (1615–80) had been Superintendent of Finances before Colbert succeeded in engineering his downfall. Three weeks after Fouquet brilliantly entertained the King and court at his new château of Vaux-le-Vicomte, he was arrested for embezzlement and all of his goods were confiscated. Appropriated by Colbert, the team of artists, architects, poets, and composers harnessed by Fouquet to create Vaux were later set to work on Versailles.

[102] Chantelou quotes Annibale in Italian. Cf. Bernini's explanation (above, 13 June) of why he had not criticized the Val-de-Grâce and his answer to a student who asked why he never reproved works of poor quality: "One ought not to reprove badly made works, because they reproach themselves, but rather the beautiful works in their blameworthy parts; because in reproving some part, one praises the whole, which is good, and rightfully so, because one seeks the perfect by reflecting on what is lacking. However, to give great praise to something, it is not enough that it should have few errors, but that it should have in itself much to praise" (Dom. Bernini, p. 31).

They showed the Cavaliere some drawings of the *Triumph of Alexander* done by a boy of eleven. He thought they were extremely good and was astonished that he was so advanced. He was even more delighted with original drawings by this lad and said that he must be given assistance and sent to Italy for nine or ten years. When the pupil, however, brought him some studies of the model he had done, he said, "It spoils youngsters to make them draw from nature so early, for they are not capable of distinguishing what is beautiful from what is ugly;[103] further, the models in this country are very poor. The King must send for some, and he should choose some from among the eastern slaves." He said the Greeks had the best-formed bodies and they could be bought.[104] Turning to me, he said he had forgotten to put that in his notes for the Academy, and it must be added.[105] He had brought Signor Paolo with him and sent him off to look at all the productions of the factory.

On our way back he remarked to me that a certain engraver who had been to see him when he first arrived had never called again. I remembered that his name was Mellan.[106] I said that he was not doing much at present; there were others better at his profession than he; I had never thought much of his work, for he was too preoccupied with a good line. He replied that he had seen some wonderful engraving by him, notably some of Signor Poussin's works, of which he mentioned one of *Eternal Wisdom*.[107] I told the Cavaliere that M. Poussin, like myself, considered his drawings poorly engraved, as he only tried to give a good line and never attempted to render light and shade nor the half-tones; this was all the easier as M. Poussin's works were extraordinarily finished, considering how shaky his hand was; M. Mellan only produced a sort of shell with no half-tones or shadows for fear of hiding the outline. The Cavaliere said that he

[103] Cf. above, 5 Sept.

[104] Slaves from the East—Tartars, Russians, Circassians, and others imported into Italy by Genoese and Venetian merchants—had been relatively common in the years following the Black Death of 1348, when they were used as domestic servants. Although the Ottoman advance of the mid-15th century had curtailed their supply, such slaves were still to be found in Italy, as Bernini's remark indicates.

[105] On 6 Sept. (above), Colbert had asked Bernini to put in writing his remarks to the Academy of the previous day.

[106] Claude Mellan (1598–1688), a draftsman and engraver, who had been to Rome and who had engraved after Bernini's designs a *David and the Lion* and a *Portrait of Urban VIII* for the 1631 edition of Urban's Latin poetry (*Bernini in Vaticano*, nos. 52–53). Bernini's original drawing for the *David and the Lion* is in Harris, *Selected Drawings*, no. 25.

[107] For this engraving by Mellan, which appeared as the title page of a bible printed at the Louvre in 1642, see G. Wildenstein, "Les graveurs de Poussin au XVIIᵉ siècle," *GdBA*, XLVI, 1955, no. 169.

thought it fine and well engraved. I said there were many in France who engraved better. I said I admired the engravings of Marcantonio,[108] who had copied painting with such skill; the paintings of Rubens were being well engraved at the moment. He asked me whether there was anyone competent at etching in this country. I said it was a form of engraving practiced only by the great masters who sometimes etched their own drawings. I knew Annibale Carracci had etched some of his works, among them the *Samaritan* and one or two of the *Virgin*. The Cavaliere said he doubted that.[109]

We found the abbé Buti there when we got back. He told the Cavaliere that he had done the honors while we were away and a great number of people had been to see the bust. We went into the gallery to see how Bourson was getting on with the design for the cascade at Saint-Cloud. The Cavaliere thought it would be very successful, but he would have to make a clay model on his return to Rome, which would then have to be copied in wood so that it could be sent back with Signor Mattia. I repeated that His Royal Highness had asked me about it yesterday, and I had said it was being done now. While talking with the abbé Buti about the big picture by Veronese, which we had just seen, he said to me, "It was due to me that the King got it because I sent word to His Majesty that the Duke of ——— had fixed the price at 10,000 crowns and that the Republic did not wish to part with it. I said to the King," he continued, " 'Sire, if Your Majesty will say one word to the ambassador now that the price is fixed, Your Majesty will get it.' " The King agreed, and he wrote to the Republic, who gave it to him. "I know of another beauty which His Majesty could buy for 10,000 crowns." I replied that was a big price; Veronese was a great painter but two or three of his works were enough. "Perhaps they are not to the taste of M. de Chantelou," he retorted, "but whose paintings are there to equal his?" I said many painters surpassed him, for instance, Raphael and Giulio Romano. "Would you not prefer," I asked him, "a picture by Annibale Carracci?" The Cavaliere, agreeing, said that had Annibale lived at the time of Raphael, his work might have been a source of jealousy to him, and even more to Veronese, Titian, and Correggio, although

[108] Marcantonio Raimondi (ca. 1480 – ca. 1534), an Italian artist and engraver, who had come under the influence of Dürer. He worked chiefly in Rome ca. 1510–27, and his engravings after Raphael, Giulio Romano, and others established engraving as a reproductive medium that was superseded only with the advent of photography.

[109] The Cavaliere's doubts are unfounded since Annibale did indeed do etchings. See now D. DeGrazia Bohlin, *Prints and Related Drawings by the Carracci Family: A Catalogue Raisonné*, Washington, D.C., 1979. The etching of *Christ and the Samaritan Woman* however is now generally given to Guido Reni.

they all had a marvelous sense of color. Michelangelo had been right when he said that God had not given them the art of drawing for then they would have been more than men.[110] The Cavaliere added that if one compared the pictures of all the masters with those of Raphael, there would be only one thing lacking in Raphael, while in the others, there would be many different faults. Raphael was exact in drawing, skilled in composition, in *costume*, in grace, in beautiful drapery, in grouping his figures in the proper position according to the laws of perspective, and he shared none of these gifts with others; what he lacked, however, was the lovely handling of the Lombards. They on the other hand were often out of proportion, without drawing, or knowledge of *costume*. Poussin, the greatest and most learned painter of all time, had first imitated Titian but finally took Raphael as his model, showing in this way that he considered him greater than all the rest. The abbé said he had seen his picture of *Germanicus*.[111] The Cavaliere replied that he must see those of M. de Chantelou; they are something quite different; there was a series of seven, the *Sacraments*, that he himself could look at for six months at a time without tiring of them. The abbé Buti asked how big they were. "Of his usual size; the figures two feet high. There is nothing more beautiful. He formed his mind on antiquity, and was a great genius as well. I have always admired him greatly, and have even made enemies on that account in Rome." Addressing the abbé, he again insisted he must see them, although there were things he had done since that were not so good: the *Woman taken in Adultery*[112] and the *Virgin going into Egypt*,[113] which I saw at the merchant's house, and turning to me, he added, "your *Woman of Samaria*.[114] None of these are so powerful; a man should know how to stop when he gets to a certain age."

I forgot to note that he told us that sometimes Veronese and Titian would take their brushes and paint whatever came into their heads, letting themselves be carried away by a kind of madness; and this accounts for the great difference there is between some of their paintings and others; those which had been thought out are often incomparably fine; others, in which there is nothing but the handling,

[110] Cf. above, 9 Aug., and below, 19 Oct.

[111] The *Death of Germanicus*, now in the Minneapolis Institute of Arts, had been painted for Cardinal Francesco Barberini and was at that time in the Palazzo Barberini, Rome. See Blunt, *Poussin Cat.*, no. 156.

[112] Owned by Le Nôtre and seen by Bernini (above, 7 Oct.).

[113] Cf. above, 10 Aug., where on seeing this painting at Cériser's Bernini first makes the following remark on Poussin's late style.

[114] A *Christ and the Woman of Samaria* (Blunt, *Poussin Cat.*, no. 73) painted for Mme. de Chantelou in 1662, the original of which is now lost.

are without drawing or reason;[115] the Queen of Sweden had nine or ten paintings by Veronese, some good, some bad, with only three or four really good ones.

After dinner while we were warming ourselves before the fire, the abbé Buti and the Cavaliere went back to the subject of Giovanni Paolo Tedesco; how he was just the man who could be most useful here as he had an inexhaustible fund of invention that he could apply to anything. "Do you want a coach?" he would say, and straightaway design one, "or a chair, or some silverwork?" and so on for everything, but the abbé Elpidio, in whose service he now was, and who himself took the credit for much that he did, would prevent his coming. I said one would have to deal openly. They replied that it was unlikely to succeed, that M. Colbert was prejudiced about it; as for Paolo Tedesco himself, he would not have to be approached more than once to get a favorable answer. Signora Olimpia[116] had an amusing story, which was à propos, about Borromini, the architect. He was rather an extravagant character, quite the opposite of Pope Innocent who was very matter of fact. She told Borromini that, if someone who had great influence with the Pope would talk to him incessantly about something, the drop of water would in the end wear away the porphyry, but she could only talk to him from time to time and so made little impression on him.

The Cavaliere pointed out an abuse that had crept into the design for the tapestry borders woven at the Gobelins, flowers and children being introduced in the same tints as appear in the main subject; this was a bad mistake as the border should be like a gold frame or simply a decoration of bronze-colored leaves. I told the Cavaliere that had always been my opinion, but Raphael had put figures into the borders in his series, the *Acts of the Apostles*. He replied that he had done it probably to please the public; in a similar series belonging to the Pope the borders were quite plain.[117] Then he talked about Paolo Tedesco and so returned to the subject of the cupola of the Val-de-Grâce. He said that in the composition of the big works it was necessary to think in masses—he said *delle macchie*[118]—it was best to draw the figures on

[115] Cf. above, 6 June, where Bernini describes his own creative frenzy when drawing on the wall of a gallery in his house at Rome and the need then for judgment.

[116] Olimpia Maidalchini-Pamphili (1594–1657), sister-in-law of Pope Innocent X (1644–55), upon whom she exercised a great deal of influence, though he sometimes resisted her most persistent requests.

[117] Cf. the similar conversation on the borders of tapestries above, 15 Sept.

[118] The Italian word *macchia*, meaning spot, blot, or stain, had entered the critical vocabulary of art "to express the quality of some drawings, and sometimes of paintings, made with extraordinary facility and with such accord and freshness and in such a way,

a piece of paper and then cut them out and place the different masses to make a loose composition for the whole, and to create a fine contrast of masses, then to fill in the empty spaces with carefully drawn figures, going into great detail. It was the only way to obtain something grand and well organized; with any other method the details, which are the least significant part, are bound to predominate. Then he left us to go and rest. When he came down, he expressed his astonishment at having had no news of ————. I said he had gone into the courtyard and from there had returned home. I asked him if he wanted me to go and find him. He said no, that he would not refer to it again, that he had sent his son, that he had gone himself, that he would do no more.

Then several people came to see the bust, among them the bishops of Soissons,[119] of Autun,[120] and of Dax,[121] and the Cavaliere talked to them for a while. Dom Côme[122] came with Le Nôtre, and they exchanged compliments. The Cavaliere returned again to the subject of his departure. He said he did not understand at all what they were doing about his affairs; he had come at the expense of the King, and he was now ready to go back at his own; he was on tenterhooks about missing the valuable time before winter set in. I said it was because M. Colbert had so much to do. When the abbé Buti came back we

with little color or pencil, that it almost seems that they are not by the hand of the artist, but have appeared of themselves on the sheet or canvas, and they say: this is a beautiful *macchia*" (Baldinucci, *Vocabolario*, s.v. *macchia*). It therefore shared certain connotations of facility and simplification or roughness of form with what Bernini called *trascuraggini* (above, 2 Oct.); but it was also related to the idea of spontaneous or unmeditated invention. In this latter sense it recalls Leonardo's well-known recommendation that the artist exercise his imagination by finding forms and compositions in the chance stains (*macchie*) on a wall. Cf., too, the description of Piero di Cosimo in Vasari-Milanesi, IV, p. 134. This element of fantasy and invention was noticed as well by Baldinucci, who says, "this term is also used among painters for representations made without the object in front of them, who say to portray *alla macchia* or this representation is made *alla macchia*" (*Vocabolario*, s.v. *macchia* and *ritrarre alla macchia*). Bernini's usage relates to this sense of the word and his method for composing aims at the integration characteristic of the *macchia* that might be described with the Wölfflinian term *painterly*, as in Malvasia's description of Guercino's early paintings in which "he took the light from high enough to obtain the effect of a 'gran macchia,' which he knew how to accord with tenderness, and his works appeared painted in chiaroscuro rather than not" (Malvasia, II, p. 280).

[119] Charles III Bourlon (d. 1685), Bishop of Soissons from 1656.

[120] Lalanne pointed out that this must be an error on the part of either Chantelou or his copyist, since there was no Bishop of Autun between the death of Louis II Doni d'Attichy in 1664 and the elevation of Gabriel de Roquette (1623–1707) in 1666.

[121] Guillaume V Le Roux (1621–93), Bishop of Dax (1658–65) and then of Périgueux (1666–93).

[122] Côme Roger (d. 1710), General of the Feuillants, and from 1672 until his death Bishop of Lombez.

took him home and then went on to the church of the Barefooted Carmelites. The abbé remarked to me as we entered, that Vigarani knew nothing and thought only of enriching himself. Signor Mattia, who was with us, made me a sign to say no more.

I I OCTOBER

On arriving at the Cavaliere's, I saw in the anteroom the drawing that Le Brun had made for the painting in the salon at Vaux;[123] he had sent it for the Cavaliere to see, and when he returned from Mass, he looked at it very carefully and then said, "It is beautiful, rich without being confused."[124] It is in the shape of an oval, but he thought that it would have been better if the palace of the sun, which is part of the subject of the design, had been oval or round like the sun; it would have suited the place for which it is intended. The subject is the *Four Seasons* and the *Four Elements*. As it is for a cupola it presents great difficulties; the parts must be strictly subordinate to the whole, everything must converge on one point, and everything appear foreshortened, as it is seen from below. I said that Raphael had always avoided that kind of picture. The Cavaliere had the drawing turned round so that he could see every view of it, and then said that M. Colbert must have it executed somewhere, as it would be a great pity not to.

While we stood there an engraver called Château[125] showed him the copy that a girl had made in miniature of a *Virgin* by Le Brun. He thought it quite good. He told us what Urban VIII had said about girls who painted; that it was very rare for them to do any good, as from the moment they began they got so much praise, that they early on had far too high an opinion of themselves. Anyway they could never draw as well as men, as it was against propriety for them to draw from the nude; the best advice one could give them was to choose only the best examples to copy. The engraver then showed him some of his own studies from the model, done in pen and ink. The first he said was good; in the second he pointed out that there was a thigh that was far too big, and in the third he found the legs were too short. He said that for the most part nature was not beautiful; he had sent to Civitavecchia and the March of Ancona for Levantines to act as models and had found them very satisfactory. There was one piece of general advice he would give to those who drew from life,

[123] For this design by Le Brun, see R. Berger, "Le Brun and the Louvre Colonnade," *AB*, LII, 1970, pp. 394-96.

[124] Bernini's comment is in Italian in the manuscript.

[125] Guillaume Château (1635–83), an engraver and member of the Academy of Painting and Sculpture (1663), who did engravings after Annibale Carracci and Poussin.

and that was to make a point of studying the model well, to make the legs long rather than short, for that beautifies, whereas shortening them makes the figure ugly and heavy. A man's shoulders should be broad, which is more frequent in nature, rather than narrow, and the head small rather than large; on the other hand, a woman's shoulders should be narrower than one usually sees them, for God gave man broad, strong shoulders to work with and woman broad hips to enable her to bear children. The feet should be small, rather than big, which is always the way in good models and in classical figures.[126] He repeated that the King must have models brought from Greece, and that he would put it in his notes for the Academy; further, the principal artists of the Academy must give lectures for the students, making them suitable for the different classes, of which there should be three. Referring to the figures that he had just seen, he said that in his studies he had discovered one very important thing about the posing of figures, that was the distribution of their weight as one observed it in nature; it is very rare for a man, unless he is very old, to rest his weight on both legs, and therefore it must be well noted that the weight of the body falls on one leg, that the shoulder on that side should be lower than the other, and that, if one arm is raised, it should be on the opposite side to the leg that bears the weight of the body; otherwise the figure will lack gracefulness and seem forced; one always finds this feature in ancient figures.[127]

M. Du Metz, who was there, said he would remember these excellent observations. I said such good advice would be most helpful

[126] Such rules of thumb, based on observation and example, decorum and taste, were a convenient and flexible counterpart to the mathematical definition of proportions frequently urged on artists. Consequently they enjoyed wide currency during the 16th and 17th centuries, when artistic interest shifted from the object to how it was perceived. In his commentary on Vitruvius, for example, Daniele Barbaro wrote: "The ancients made bodies large, heads somewhat small, and achieved slenderness by lengthening the thigh . . . similarly, within the proper limits, the ancients loved length and slimness in certain parts because it seemed to them to give an I know not what greater access of grace to the works."

[127] Bernini's observations are scarcely original. Alberti (*De pictura*, pp. 83f.) had already commented on the ponderation of the figure, and in the 16th century these reciprocal adjustments were frequently identified with grace of movement. Thus Baldinucci (*Vocabolario*, s.v. *Grazia di movenza*) adduced the following rules to achieve such grace: "if the right leg advances, the right arm goes back; if the arm along with the shoulder falls, the side along with the leg rises; if one arm is raised over the head, the corresponding leg stretches; the head always turns toward that arm which comes forward. One never makes the figure fall or rise all on one side; instead the members should always contrast with one another; and similar admonitions well known to those who are masters of art and who also know when to observe them and when not." For *contrapposto* as a theoretical concept, see D. Summers, "Contrapposto: Style and Meaning in Renaissance Art," *AB*, LIX, 1977, pp. 336–61.

to those following the profession of art, for it might take years off their time of study which, anyway, might not bear fruit; there were very few artists who were not chary of giving away their own secrets; the rules of art were well taught, but rarely or never those which the artist had worked out for himself; we should be very grateful to the Cavaliere for speaking so openly. The Cavaliere replied that we owed our gifts to God, and to teach others was to render them again; there were three things of importance: to see, to listen to great men, and to work.[128]

The young Blondeau showed him his studies from the nude, which he thought were quite good for a young man. "But," he said to him, "you must go to Rome; this is the right age, not too young, but less than twenty." He told us that he had been advised by Annibale Carracci when he was a youngster, to copy Michelangelo's *Last Judgment* for at least two years to learn the sequence of the muscles. Later, when he was drawing from life at the Academy, Cigoli[129] watching him remarked, "You are a rogue, you don't draw what you see; this comes from Michelangelo," which was due to his studies.[130]

So the time passed while we waited for M. Colbert, who did not come but sent word that he could not, as the King was on the point of leaving for Versailles. I then suggested that we should go and see M. de La Vrillière's house, which we did. The brothers Anguier accompanied us, and also my brother. The Cavaliere liked the house and the garden; he looked at the bronze statues and said they were badly modelled and badly cast. We went into the lower gallery, where there are copies from the Farnese gallery.[131] He looked at them very carefully for a considerable time, remarking, "It's a marvel. I have

[128] One may judge the change in attitude toward art that had taken place within the Renaissance tradition by comparing Bernini's maxim with that of Alberti, "Arts are learned first by study of method, then mastered by practice" (*De statua*, p. 128), or Leonardo, "First study the theory, then follow the practice to which the theory gives birth" (*Quellenschriften für Kunstgeschichte*, ed. Ludwig, XVIII, no. 54).

[129] Chantelou wrote *Scivoli* for which the most probable emendation is *Cigoli*, that is to say, Lodovico Cardi da Cigoli (1559–1613), who was in Rome at least by 1604 and spent most of his remaining years there.

[130] Quoted in Italian in the manuscript. Cf. the comment by Dom. Bernini (p. 14), who says that in his youthful exercises, his father studied the paintings in the Vatican, including Michelangelo's *Last Judgment*, not in order to acquire the art of coloring or those things appertaining to the painter, but for the design and expression of their figures, which he extracted from their compositions like the marrow from a bone, drawing the design of every part and of every part numerous copies. And Baldinucci (*Vita*, p. 9) says that in his drawings at that time, "He tried with all his power to arrive at an exact likeness and quickly gained such fame that men spoke of him in the Roman academies as an incredible marvel."

[131] That is, from the Farnese gallery painted by Annibale Carracci.

seen the originals hundreds of times, and yet I derive great pleasure from looking at these; it is the effect of excellence." Then we went to the upper gallery, and to the room next to it where there are a great number of pictures by different masters. Of the big works he thought a *Last Supper* by Tintoretto was a great picture; of the smaller ones he said the Albani was from a good period. He liked a *St. Francis* by Carracci, a portrait by Dosso, and a *Nativity* by Poussin;[132] looking at the works by Bassano, he remarked that there were none by Jacopo.[133]

On entering the gallery,[134] the first picture he saw was a Guercino,[135] on which he made no comment. Then he saw the Poussin[136] in which the figures are life-size, the subject being the master who wanted to hand over to the enemy his young pupils, the sons of Romans, who were beating him.[137] He said, "This is beautiful and painted in the manner of Raphael."[138] He saw the others by Pietro da Cortona and praised the Virgin in the sky in the latest one.[139] Of the *Rape of Helen* by Guido Reni,[140] he said that truly no one could endow a figure with more grace than he, nor give a face a more divine expression, and he drew our attention to the women in Helen's train; but he pointed out to me that the pose of the soldier in front of Paris was bad, and the feet too far apart. "One must be patient," he added. On our way back, he looked at the busts and thought that of *Agrippina* extremely beautiful, also the one of *Brutus*, and several others. He said

[132] None of the paintings mentioned here have been traced, but from what Bernini says below about the *Nativity* by Poussin, it must have been a late work in the manner of the Munich composition (Blunt, *Poussin Cat.*, no. 41) rather than that in the National Gallery, London (ibid., no. 40).

[133] That is to say, the most talented and best known of the family.

[134] The decoration of this gallery with heroic subjects painted by artists working in Italy seems to have been part of the original plan for the house (begun 1636), since La Vrillière commissioned paintings from Guercino and Poussin as early as 1635 and 1637. See Braham and Smith, pp. 212–13; G. Briganti, *Pietro da Cortona o della pittura barocca*, Florence, 1962, pp. 230–33; and the review of Briganti by W. Vitzthum in *BM*, CV, 1963, p. 216.

[135] Guercino was represented in the gallery by three paintings: a *Cato*, a *Battle between the Sabines and the Romans* (Paris, Louvre), and a *Coriolanus* (formerly in Caen, but now destroyed).

[136] *Camillus and the Schoolmaster of Falerii*, now in the Louvre. See Blunt, *Poussin Cat.*, no. 142.

[137] Chantelou has got the story wrong. The schoolmaster was a Faeliscian (i.e., an inhabitant of Falerii) and his pupils were the sons of noble Faeliscians, whom he offered to hand over to Camillus, the Roman general who was besieging Falerii.

[138] Bernini's comment is in Italian in the manuscript.

[139] Pietro da Cortona contributed three of the paintings commissioned by La Vrillière for his gallery: the *Romulus and Remus* in the Louvre, the *Caesar and Cleopatra* at Lyons, and the *Augustus and the Sibyl* at Nancy, the Virgin of which Bernini praises here.

[140] The *Abduction of Helen* now in the Louvre. See Gnudi and Cavalli, cat. no. 71.

the one next to the *Agrippina* was in bad company. Seeing the picture by Poussin again, he said he was a truly great man to be able to transform his style from that of the *Nativity*, which is in the Lombard style of coloring, to this, in the manner of Raphael. On leaving he said he felt he had been in some palace in Rome; it was the first he had seen here where there was no gilt. The children of M. de La Vrillière were there, and they accompanied him to the gate.

When we got back to the hôtel Mazarin, Signor Paolo and M. Coiffier called to take him to see some pictures by Poussin in a house opposite.[141] He looked at the *Adoration of the three Kings*[142] (the one that belonged to M. Charmois)[143] and *Moses trampling on the Crown of Pharaoh.*[144] Of the latter he said it was in his best manner. This house belongs to M. Cotteblanche, and Le Brun, who was there, said he had seen this picture painted twenty years ago. Coming back to the other, the Cavaliere said he was astonished that Poussin, who knew so much about *costume*, had given the kings the appearance and manners of ordinary people like the apostles; one king looked like St. Joseph, and if there had not been a Moor there he would not have taken it for an *Adoration*. I said that many people thought that they were only wise men and great astrologers. Le Brun said M. Poussin had wanted to represent them as he had heard they were and according to his own opinion on the subject. The Cavaliere replied that one must follow the Scriptures, which said they were kings. Le Brun argued that it said *magi*. The Cavaliere said no more, and went to dinner.

Afterwards we went to see Jabach's drawings. M. Coiffier had taken Signor Paolo to dine there and MM. Le Brun, Mignard, Gamart, Roland, Cotteblanche, and others were present. We saw a great number of drawings by all the masters. The Cavaliere said there were few drawings of which one could be surer than Annibale Carracci's, for his work was less finished than that of others and therefore more difficult to copy. A great number he pronounced to be copies. There were several extraordinarily beautiful ones by Raphael, among them

[141] As appears immediately below, to the hôtel of the financier, Cotteblanche, in rue Neuve-Saint-Augustin.

[142] Probably the *Adoration of the Magi* today in the Gemäldegalerie, Dresden, which is signed and dated, 1633. See Blunt, *Poussin Cat.*, no. 44.

[143] Martin de Charmois, or Charmoys (1605–61), sieur de Lanzé and secretary to maréchal de Schomberg, who with Le Brun, Stella, and the other founding members secured the establishment of the Royal Academy of Painting and Sculpture (1648), of which he became the first director.

[144] The picture (Blunt, *Poussin Cat.*, no. 16) that Chantelou wanted to include in the series of tapestries after Poussin's paintings of Old Testament subjects (above, 16 Sept.).

one for the *Attila*.[145] Jabach said that he paid 1,000 livres for them to the late M. de Fresne.[146] He also saw Poussin's drawing of *Armida carrying off Rinaldo*, of which the picture is in France,[147] and a great many by Giulio Romano, Titian, Paolo Veronese, and other masters. Suddenly he got up saying his eyes were tired from looking at so many beautiful things. On our way back we went to the house of M. Joly who teaches acrobatics. Count Strozzi, Signora Anna, and the abbé Bentivoglio were there. M. Joly and his pupils did several turns on the wooden horse, and then we returned to the hôtel Mazarin.

12 OCTOBER

🐝 I found the Cavaliere making a drawing for the pedestal to the bust, which he has designed in the form of a globe. It is placed as if on a sort of platform. He asked me to find out from Warin whether the medal to be placed under the foundation stone was nearly ready. Signor Mattia and I went to call on him and he told us that it would not be finished before Thursday. He showed us two inscriptions,[148] one in Latin and the other in French, which were to be placed with the medal under the stone. They were on sheets of bronze and ran as follows:

<div align="center">

Louis XIIII
King of France and Navarre,
Having conquered his enemies and given peace to Europe,
Eased the burdens of his people.

</div>

Resolved to finish the royal building of the Louvre, begun by Francis I and continued by his descendants, he had the work carried on for a time according to the same plan, but from his greatness of spirit and his courage there was born a new and more magnificent design, in which what was there already would be no more than a small part, and he laid in this place the foundations of this superb edifice.

[145] That is, for Raphael's *Attila Repulsed by Leo I*, in the Stanza d'Eliodoro of the Vatican Palace.

[146] Presumably Raphael Trichet Du Fresne (1611–61), who collected books and works of art for Gaston d'Orléans and later for Christina of Sweden, whom he served both before and after her abdication. A large part of his personal collection was acquired by Queen Christina before his death, and his library was purchased by Colbert for the King's collection from his widow. See Bonnaffé, pp. 311–12.

[147] The painting, executed for Jacques Stella ca. 1637, is now in East Berlin (Gemäldegalerie, Staatliche Museen). See Blunt, *Poussin Cat.*, no. 204, where the known drawings for the painting are also cited.

[148] The first inscription is in French in the manuscript and is followed by the one in Latin, which differs slightly.

The year of grace MDCLXV
the . . . day of the month of October.
Mre. Jean-Baptiste Colbert, Minister of State, and the King's
Treasurer being then Superintendent of Buildings.

Ludovicus XIV, Francorum et Navar. Rex
christianissimus.
Florente aetate, consummata virtute
Devictis hostibus, sociis defensis, finibus productis
Pace sanctita, asserta Religione, navigatione instaurata,
Regias Aedes
Superiorum Principum aevo inchoatas,
Et ab ipso juxta prioris exemplaris formam magna ex
parte constructas,
Tandem pro majori tum sua tum imperii dignitate
Longe ampliores atque editiores excitari jussit,
Earumque fundamenta posuit.
Anno R.S.M. DCLXV . . . octobris.
Operi promovendo solerter ac sedulo invigilante
Jo. Bap. Colbert, Reg. Aedif. Praefecto.

Signor Mattia looked at the bust that Warin had begun of the
King, and at some of his other works, which he liked very much. I
also showed him the Poussins at Stella's house.[149] Then I went to the
Queen Mother's apartments to arrange where the bust was to be put.
A big cupboard had to be moved. I then went on to the foundations,
and saw that they were getting ready to lay the first course of stones,
leaving a gap for the King to place the stone with the inscriptions and
the medal underneath. This block is to be of marble, since according
to Signor Mattia this is the practice in Rome. Mazières, the contractor,
said he was eager to take advantage of the good weather we were
having, for if he waited the water might rise, and he suggested that
the stone might be laid in the third course in the middle of the wall.
I said that I would have to ask M. Colbert's opinion. I went to see
him about it and he gave his approval.

I returned to the Cavaliere's to tell him and found him still draw-
ing. I told him everything I had done and he thanked me. He sent

[149] For the paintings owned by the Stella, a family of artists and collectors with
quarters in the Louvre, see Bonnaffé, pp. 297–99 and the inventory of 1693 made by
Claudine Bouzonnet Stella (1636–97), the last surviving member, in Jean-Jacques Guif-
frey, *Archives de l'art français*, 1877. Thanks to the efforts of Jacques Stella (1596–1657),
a founding member of the Royal Academy and a personal friend of the artist, the
collection contained a large number of Poussins.

Giulio for his portfolio and took from it a drawing of *Cain slaying Abel*,[150] which he asked me to keep as a token of affection. I thanked him and said I would never forget these tokens of his regard for me.

Later we went to the Louvre and down to the foundations. He did not like the way the stones were laid, saying they were too near to each other. He said there should be a space of seven or eight inches in between for the mortar, saying to the Italian workmen, "You must build like Christians."[151] He wanted them to use the biggest stones they could find on the site. He told the contractor that when he found something to criticize in our ways here, he should tell him and he would listen carefully to his reasons; the mortar should be made in the Italian way, at least for the first courses, and mixed with the sand on the spot, as it was quite good enough without getting the river sand. When we got home we found Signor Tonti,[152] who was waiting to ask the Cavaliere to come and see M. Gamart's pictures after dinner. The abbé Buti also tried to persuade him, saying that it would be a bad time to transport the bust to the Louvre as after the King's dinner there would be so many people about.

After dinner we talked about Cardinal Mazarin's avarice. The abbé Buti told us that one day the cardinal had attacked him violently because the bill for the royal ballet amounted to 20,000 crowns, and he had wanted them to spend only 20,000 livres; that Gaboury,[153] who was there, told him as he left that one ought not to be surprised at the Cardinal's attitude, for he had made a contract to be responsible for the day-to-day expenditure of the royal household and he thought anyone who increased the outgoings was stealing from him.

The Cavaliere told us an anecdote about a man who had stolen from everyone, whom the priests would not absolve unless he made restitution. He complained of this to a friend, who said that these monks were so very scrupulous and he knew of a doctor [of theology] who would give him absolution without so much fuss. This priest heard his confession and then asked him if his servants did not steal from him. He replied that they did and that he could do nothing to stop it. "All right," said the confessor, "let the one sin cancel the

[150] Presumably the drawing shown to Chantelou above, 5 Oct.

[151] That is to say, on a firm foundation (Luke 6:48–49). He is quoted in Italian in the manuscript.

[152] Lorenzo Tonti (d. 1695), a Neapolitan banker, who had come to France in 1650. He was the eponymous inventor of the tontine, a financial arrangement whereby the advantages (originally a life annuity) shared by the participants pass on the death of any one to the remaining members.

[153] Evidently Jacques de Gabouri, or Gaboury, who had been portemanteau to Anne of Austria and in 1665 was intendant et contrôleur de l'argenterie et des menus.

other," and he gave him absolution. The abbé described to us a picture by a Spanish artist, in which the king is saying, "I steal from my subjects"; a minister of state says, "I steal from the king"; a tailor says, "I steal from the minister"; a soldier says, "I steal from them all"; the confessor says, "I absolve all four of them"; and the devil says, "I carry off all five of them."

At two o'clock we went to Gamart's, where we found Mignard. The Cavaliere looked at the pictures. He studied a *Head of the young St. John* by Annibale Carracci[154] and remarked that he often found himself thinking that if Annibale had been a contemporary of Raphael's, "he would have given him cause for worry."[155] Seeing a *Magdalen*[156] by Paolo Veronese he said that there was not a single picture by this artist that did not have some fault in drawing, and he pointed out a hand that was deformed. There was a *Man eating Peas*,[157] which we all praised, and which he liked too. He liked the *St. Sebastian* by Guido[158] but criticized it because the Sebastian did not look like a saint. The *Birth of Bacchus* by Giulio Romano[159] he hardly bothered to look at.

From there, we went to the duc de Richelieu's[160] but we did not find him at home. Thence to the hôtel de Guise.[161] Mlle. de Guise asked him to look at the site, so we walked round outside, and he said it would be a good thing if a plan were drawn of it. I forgot to note that the abbé Buti told me that he had been astonished to see Mignard and Le Brun together at Jabach's. He had asked Mignard how it had happened, and the latter had replied that Jabach had begged him to come; it must have been M. Du Metz who had asked Jabach

[154] This painting cannot now be identified.

[155] The phrase is in Italian in the manuscript.

[156] According to Ridolfi, a *Conversion of the Magdalen* by Veronese, which had been bought by M. du Houssay, the French ambassador to Venice, was in Paris by 1648. This picture has been identified as one of two known paintings, the first in the National Gallery, Ottawa (Pignatti, cat. no. 207), the second in the Prado, Madrid (ibid., cat. no. 269).

[157] This painting cannot now be identified.

[158] Perhaps the *St. Sebastian* (Garboli and Baccheschi, cat. no. 63a) now in the Louvre, which had belonged to Mazarin and was purchased by the King in 1670 from Oursel and Vinot (?Vivot).

[159] Only a *modello* for a painting of this subject by Giulio Romano is now known. See F. Hartt, *Giulio Romano*, New Haven, 1958, I, pp. 213–14.

[160] Jean-Armand de Vignerot Du Plessis (1629–1715), duc de Fronsac et de Richelieu, grandnephew and heir of Cardinal Richelieu, lived in the place Royale (now place des Vosges) in a hôtel left to him by his great-uncle. Bernini succeeds in seeing his collection (below, 13 Oct.).

[161] The ducs de Guise lived in the old hôtel de Clisson (Archives Nationales) in the rue du Chaume, which had been bought by the Cardinal de Lorraine.

to do this; they had exchanged politenesses and had drunk each other's health. [162]

On our way to the hôtel de Guise the abbé told us that the Cardinal[163] had promised the duc de Guise[164] to help him become king of Naples, and he was to have made over his wealth to his brother,[165] who was to marry one of his nieces; when the Frondeurs made him marry Mlle. d'Alais,[166] he abandoned the cause of M. de Guise, Changing the subject, he said that Giovanni Paolo Tedesco was a man who could be very useful in France, but it would be difficult to persuade him to come. I showed him the inscription to be placed under the foundation stone. He said that some reference should have been made to the Cavaliere, it was customary everywhere to do so. I said he should mention it; he said he would not do so because an Italian was involved. I told him that it was not usual here; that Le Vau's name was not put on any of the medals that had been put in the foundations. He added that he had always wondered whether the plans would be carried out and he was still doubtful; it was the King who wanted it, but there had been a debate whether to carry it out or not and M. Colbert had been against it, although some of the council had been of a contrary opinion and the King had wanted it to be done, and he was anxious about the way things would turn out. I replied that all would be well, the King loved to do something spectacular, and M. Colbert's honor was involved. He said that if he was no longer there things might not go so well, but they must remember that there were projects for an equestrian statue,[167] for the big statues of Hercules and so many other things that the commission we should give him would be spectacular and worthy of his productions. I asked him if

[162] The rivalry between Le Brun and Mignard was well known at the time (see above, 13 June, n. 99).

[163] That is, Mazarin.

[164] Henri II de Lorraine (1614–64), fifth duc de Guise, who became Archbishop of Rheims at age fifteen, but abandoned (1641) his ecclesiastical career when both his father and older brother died. The story of his expedition to Naples (1647–48), which was in revolt against Spain, is told in his *Mémoires* (published posthumously in 1668). Taken prisoner and interned in Spain, he was released only in 1652 through the intervention of the prince de Condé, whom however he quickly abandoned in favor of Mazarin. Then in 1654, he again made a vain attempt to become King of Naples.

[165] Louis de Lorraine (1622–54), duc de Joyeuse, Grand Chamberlain and Colonel-General of the Light Horse.

[166] Françoise-Marie de Valois-Angoulême (1630–96), daughter and heiress of Louis-Emmanuel de Valois (1596–1663), comte d'Alais, then duc d'Angoulême (1650), and his second wife, Marie-Henriette de La Guiche (1600–82).

[167] The decision to have Bernini carve an equestrian statue of Louis XIV, carried out only after long delays (Wittkower, *Bernini*, cat. no. 74), was evidently taken by this date. The idea goes back to one of the artist's projects for the amphitheatre between the Louvre and the Tuileries (above, 13 Aug.) and the wish to have him do a full-length portrait of the King (above, 22 June).

he knew who had thought of inviting the Cavaliere. He said that Cardinal Antonio had first brought it up, and then M. de Bellefonds. I said I had heard that the Cavaliere had stipulated the sum he expected in payment before he left. He assured me this was not so; that he had been given 3,000 pistoles without his asking for anything. He added that the Pope was now furious that he had come to France. "But," I said, "he ordered him to come." "That's quite true," he answered, "and if he repented of his sins as he had repented of that, he would prove a great saint. He cried about it like a child." "A great weakness," I said. "One could hardly have a greater," he added. "If one is annoyed with the Pope about anything, it is impossible to get him to move with threats, better to dangle a couple of cherries before him, as with children." When all's said and done, it was the King who made the Cavaliere come; he said so when he saw his first design for the façade of the Louvre, and he was sure that he had done the right thing.

From the hôtel de Guise the Cavaliere went to the Louvre, where he saw the first course of stones being laid. He thought that they were not close enough together for the *langues* to be put between them. We then went to the Oratoire, and so home.

13 OCTOBER

🐦 The Cavaliere had the bust taken to the Louvre, and immediately afterward we also went over. The Queen Mother, who was not well enough to get up, wanted the bust to be brought into her room for her to see before it was placed in her new apartment, but the doors were too small. The Cavaliere, therefore, had it put in the antechamber of the room where the King holds audiences in this new suite. As it faces east, he thought the light was rather hard and wondered whether to put it in the little closet behind, and he would have done so but for the fact that they had already gone to get the *Christ Child*, the work of Signor Paolo. In the meantime the sun had moved a little and the light had softened, so that he was better pleased with the place he had chosen, considering that would have more dignity and would allow people to see it at a greater distance. The *Christ Child* was put opposite, between two cabinets, where it looked very well. Mme. de Beauvais[168] came to see the work. The Cavaliere paid her many compliments, saying the Cardinal Legate had talked to him about her and

[168] Catherine-Henriette Bellier (d. 1690), wife from 1634 of Pierre de Beauvais (1620 – ca. 1674), lieutenant général de la prévôté de l'hôtel (1630) and conseiller d'état (1643). At the time of her marriage femme de chambre to the Queen, Anne of Austria, she later succeeded her mother as première femme de chambre and was said to have been given the task of introducing the young King to sexual experience.

her house[169] and had told him that she was an extremely clever woman. Then MM. Tubeuf, de Maisons, and d'Argouges,[170] and other officials of the Queen Mother's Household came in, and later Mme. de Flex,[171] the duchesse de Noailles,[172] and everyone belonging to the Household. From there the Cavaliere went on to the foundations of the Louvre, which he looked at very carefully, and also the way the stones were laid; his son and Signor Mattia were there. We then went to Mellan's house to see his pictures. He showed us among others a *Magdalen*[173] by Titian smaller than life-size, and a *St. John in the Wilderness*;[174] there are other versions, but bigger, of both these pictures in France. He also showed us some prints engraved after his own drawings. The Cavaliere then returned to dinner. While we were waiting we talked about painting. I told him there were ten or a dozen good collections in Paris; during the last fifteen or twenty years no expense had been spared to obtain works in Rome, Venice, and other parts of Italy; as much as 400 giulios[175] had been paid for a Poussin; although they had been sold at that price, he had of course never touched the money. He said that Guido had complained to him about the same thing, for his pictures were being sold at enormous prices without his deriving any profit from the sales,[176] and this had made him determined to

[169] Mme. de Beauvais was the proprietor of two hôtels, both equally admired in the 17th century (Bonnaffé, p. 16). The best known is the surviving house built for her by Antoine Le Pautre in rue Saint-Antoine (now 68 rue François-Miron), for which, see Berger, pp. 37–46. Less well known, because destroyed shortly after 1763, is the second hôtel de Beauvais (rue de Grenelle), begun in 1661 as a remodelling of two adjacent houses (Berger, pp. 90–91) and evidently finished by 1663 when the King, the Queen Mother, and Monsieur visited it (Bonnaffé, p. 16).

[170] François d'Argouges de Tillevot (1622–95), conseiller au grand conseil (1645), intendant de la maison et finances of the Queen Mother, Anne of Austria, maître des requêtes (1655), premier président du Parlement de Bretagne (1661), and conseiller d'état et du conseil royal des finances (1685).

[171] Marie-Claire de Bauffremont (1618–80), marquise de Senecey, première dame d'honneur of the Queen Mother, and widow since 1646 of Jean-Baptiste-Gaston de Foix, comte de Fleix.

[172] Louise Boyer (1631–97), daughter of a secretary to the King, who had married (1646) Anne, duc de Noailles, and was from 1657 to 1665, dame d'atours to the Queen Mother.

[173] For the originals and copies of Titian's popular *Magdalens*, see Wethey, cat. nos. 120–29.

[174] For Titian's *St. John in the Wilderness*, see Wethey, cat. nos. 109–10.

[175] Lalanne noted that the giulio, or jules, was valued at about 11 sous, which would yield in this case only about 220 livres and is therefore likely to be an error on the part of the copyist. Cf. above, 1 Oct., where Chantelou says that the *St. Francis* by Guido Reni given to the King by Prince Pamphili is worth at least 500 écus or 1,500 livres. Some forty years later, Claudine Bouzonnet Stella estimated the value of the Poussins in her possession at up to 15,000 livres.

[176] Cf. Malvasia's comments on the same subject in *The Life of Guido Reni* (trans. by C. and R. Enggass, University Park and London, 1980, pp. 71–72). The same situation, of course, still exists today and is still keenly resented by artists.

charge fifty crowns for a head, a hundred for a half-length and two hundred for a full-length.[177] After dinner he wanted to visit the duc de Richelieu and go to the Celestines.[178] M. de Richelieu was not at home, but he looked at all the pictures in his collection.[179] He pointed out that a picture of the *Plague*,[180] which was hung very high, should be lowered, so that it could be better seen. He studied all the others and particularly one of Titian's;[181] the sky, he said, had changed and blackened, so that it came forward instead of receding. He very much admired two landscapes by Annibale Carracci, in one of which there is a *St. John in the Wilderness*,[182] a *St. Sebastian*,[183] and a *St. Jerome*,[184] paintings by Poussin,[185] and a big landscape of his. When he came to the end, he said, "This is just how a collection should be, with nothing in it but the best." In another room he saw a picture by Poussin, of the *Virgin appearing to St. James* in which the figures are more than life-size; he thought it wonderful and painted with great force.

Then we went on to the Celestines, where he was shown the

[177] Pricing paintings by the number and completeness of their figures was not uncommon in the 17th century (Mahon, *Studies*, pp. 53–54) and Malvasia once again says that Guido Reni, addicted to gambling in his later years, turned out hastily painted heads at 50 scudi apiece in order to pay off his debts.

[178] The Celestines were a religious order who assumed this name after their founder, Pietro Angeleri da Morrone, was elevated to the papal throne as Celestine V (1294). They were introduced into France by Philippe Le Bel in 1300 and established at Paris in 1318. Secularized in the late 18th century, their houses were suppressed, and their monastery in Paris passed to the Cordeliers before being diverted to other uses in 1785.

[179] Bernini saw the Duke's first collection of pictures, which according to an old but probably unreliable tradition he lost to Louis XIV in a tennis match, but which in any case was bought by the King for 50,000 livres later in 1665. See C. Ferraton, "La Collection du Duc de Richelieu au Musée du Louvre," *GdBA*, XXXV, 1949, pp. 437–48.

[180] Poussin's *Plague of Ashdod*, today in the Louvre. See Blunt, *Poussin Cat.*, no. 32.

[181] Evidently the *Virgin and Child with St. Catherine and a rabbit* (Wethey, cat. no. 60), which was sold to the King and is now in the Louvre.

[182] The *Landscape with St. John* by Annibale is in Grenoble; its pendant, a *Landscape with a Concert on the Water* is in the Louvre, but is attributed by Posner (cat. no. 163) to Domenichino and by Spear, p. 317, to G. B. Viola.

[183] This picture, formerly attributed to Annibale, was sent to the Musée des Beaux-Arts at Quimper in 1897. It is rejected by Posner, cat. no. 203 [R].

[184] This *St. Jerome* is included in a document published by Bonnaffé (p. 274), in which, along with the two landscapes and the *St. Sebastian*, it is also attributed to Annibale. However, it does not appear in the 1665 receipt for the paintings sold by Richelieu to the King, nor in the 1683 inventory of the King's collection made by Le Brun, and it is now not traceable.

[185] Other than the *Plague of Ashdod* (above), the paintings by Poussin that went to Louis XIV in 1665 and are now in the Louvre were *The Four Seasons* (Blunt, *Poussin Cat.*, nos. 3–6); *Eliezer and Rebecca* (ibid., no. 8); *The Finding of Moses* (ibid., no. 13); *Christ healing the Blind Man* (ibid., no. 74); *The Ecstasy of St. Paul* (ibid., no. 89); *The Virgin Appearing to St. James* (ibid., no. 102), which is mentioned below; *The Andrians* (ibid., no. 139); a *Landscape with Diogenes* (ibid., no. 150), which is evidently the big landscape mentioned here; and *The Saving of the Infant Pyrrhus* (ibid., no. 178).

tomb of the duc de Longueville.[186] He remarked to the elder Anguier, who was there, "You did well here."[187] He said the idea was good, and he asked me if he had thought of it himself. I told him that he had. He said nothing about the *Three Graces* by Pilon,[188] but he thought the tomb of Admiral Chabot[189] was by a good sculptor. I forgot to note that when we got up from dinner, the abbé Buti came in with a long list of pictures, which I recognized as those belonging to M. Gamart. He told him that Tonti wanted him to write underneath that he liked them, with which he complied; he also asked the Cavaliere to say that a certain portrait was of Annibale Carracci, although on a former occasion, he had said it was not of that great man. From the Celestines we went to the Arsenal, to see the foundries. He made very exact enquiries about the composition of the clay that they used for the ovens. He was told they made the ovens with house tiles, and the clay was brought from Corbeil, but the foundryman, who was a Lorrainer, said that he mixed several different clays so that it should not melt. He asked how much tin they put in the alloy. He said, "It depends on the metal, in one kind more, in another less." He told the man that when he cast the big statues for the throne of St. Peter, he had two ovens to cast one figure.

From the Arsenal we came back on foot, walking along the port Saint-Paul to the Grève, and we looked at the view of the head of the island.[190] We then got back into the carriage and drove to the Louvre to see the foundations on which Signor Mattia was working, then back to the palais Mazarin, after which I returned home. I met M. Perrault, who asked me what had been happening. I told him that the Cavaliere had been twice to the Louvre. He enquired whether he was satisfied with the mortar. I said he was, that as they built they were soaking the wall according to Italian methods, and they had already finished one course and begun the second. Then he asked me whether I knew anything about the ceremony of laying the foundation

[186] Executed by François Anguier, referred to below as the "elder Anguier," and now in the Louvre.

[187] Bernini's comment is in Italian in the manuscript.

[188] The figures of the three Graces by Germain Pilon from the monument for the heart of Henry II are now in the Louvre. See Blunt, *Art and Architecture*, pp. 146–47.

[189] The tomb of Philippe de Chabot (d. 1543), called the admiral de Brion, today in the Louvre, is attributed to Pierre Bontemps.

[190] The port Saint-Paul lay between the Celestines and the place de Grève, now the place de l'Hôtel-de-Ville. Bernini and Chantelou would have walked past both the Ile Notre-Dame (now the Ile Saint-Louis) and the Ile du Palais (Ile de la Cité), but Chantelou is probably referring to the former, at the head of which, facing east up the river, two great private houses had recently been built by Louis Le Vau, the hôtel Lambert and the hôtel de Bretonvilliers.

stone. I said that in Rome the stone itself was always of marble. "Was the church not represented?" I said I thought not. He requested me to make sure.

14 OCTOBER

🐝 Bourdon came to see me. I took him to the Cavaliere's, and we went on together to the Louvre, where he had gone to design a pedestal for Signor Paolo's *Christ Child*. M. Du Metz arrived, bringing with him a covering in cloth of gold for the table on which the bust of the King stands. Later we went to see the King's medals. The Cavaliere remarked to the abbé Bruneau, who is in charge of them, that there were three things to look for in medals—their history, what they are made of (metal or precious stone), and the skill of the maker; he himself was only interested in the workmanship. Among others he was shown two of agate, one large and one small, both of which he thought were extremely beautiful, and also some in bronze. He said he had noticed one thing, that the best were in lower relief than the others. Some of the bronze ones were of great beauty, but he could not see the Greek examples as the case was warped and could not be got open. He admired one of *Antinous*, which, he pointed out, was in very low relief, and that the profile was that of the figure by Phidias on Montecavallo.[191] Then we looked at the shells, which he thought were very pretty. He showed us how spiral staircases, or "snail stairs"[192] as they are called in Italy, and twisted columns were based on some of the shells that he showed us. He said he marvelled at the infinite variety of nature, who expresses herself in these trifles, with as much power as in her larger creations. Earlier he had seen an engraved shield, which he picked up and found very heavy. He told us he had been shown one in Rome, four or five feet long and big enough to cover the whole body, which weighed only two pounds and was bulletproof, although it was only made of three fish skins. He added that no one knew how they were joined together.

I forgot to note that on leaving the Queen's apartments he showed M. Du Metz that he had marked the statues and busts that he considered the best—the *Diana*, the *Fauns*, the *Amazon* and the *Poppaea*, but, he said, the lower part of that figure was not by the same hand

[191] The Quirinal Hill in Rome was popularly called Montecavallo from the presence there of two colossal statues of the Dioscuri, Castor and Pollux, reining their horses. Roman copies of Greek works of the 5th–4th centuries B.C., the statues come from the Baths of Constantine and their bases are inscribed with the names of Phidias and Praxiteles, to whom therefore they were attributed.

[192] *Lumaque* in the manuscript, from the Italian *lumache*.

as the upper part; however, there were other examples where the great masters neglected to finish certain parts, leaving them to less well-known artists.

We returned to the palais Mazarin, where we found the abbé Buti, who took away with him two copies, one of *St. Mary of Egypt*, and the other of the *Dead Christ*, both of which Signor Paolo had made for him.

After dinner, M. Colbert came. He took the Cavaliere through the rooms to show him the tapestries and then to the Louvre to see the foundations. M. Perrault had that morning brought along the two bronze plaques, which were to be attached to the foundation stone with the medal. The marble was being prepared, and we discussed what was done in Rome on these occasions. The Cavaliere said the stone was always blessed before being laid in place; it had been so at St. Peter's, and everywhere else where he had done anything; when he was responsible for the building of an arsenal at Civitavecchia,[193] there had been a salute of guns as well as the benediction. M. Perrault said there would be fanfares of trumpets and drums, and a salute could be given by the regiment of guards. The Cavaliere suggested that a canopy would add more dignity to the occasion, as the King was to be there. M. Colbert saw that they had got to the second course, and then Mazières told him that the Cavaliere now wanted a recession two feet across; if that were done the weight would fall on the gaps between the large roughstones that had been used for the outer wall. They explained this to the Cavaliere, who agreed that the recession should not be so wide, no more than a foot and a half. Next, we went to the room where the bust stands. He looked at the pictures by Paolo Veronese,[194] which hang at the entrance to this room. Of the *Susannah* he said that anyone who pricked her arm would draw blood, and he found the head of one of the Elders remarkable, but it was no good looking for either good drawing or proper perspective in Veronese; in the *Susannah* and in the *Rebecca* it is all wrong; the vanishing point was low and yet the feet and the vases were drawn as if it were high. The abbé de Montaigu, MM. d'Albon and Benserade were there. M. d'Albon said that his friends would have liked the bust to have been without a collar. I asked him just how they would have liked it. He said, "An open neck, like the heroes of antiquity." I replied that

[193] For Bernini's arsenal at Civitavecchia, built for Alexander VII, see *Bernini in Vaticano*, pp. 207–27, with further bibliography.

[194] Veronese's *Susanna and the Elders* (Pignatti, cat. no. A242) is now in the Louvre, the *Rebecca at the Well* (Pignatti, cat. no. A379) at Versailles. They were acquired for the King's collection from Jabach in 1662.

Frenchmen should not copy the Romans and the Greeks; it was right that the King should appear in the fashion of his time; that it would be of interest to future historians; and he agreed with me. Then we looked at the *Christ Child* for a long time and afterwards accompanied M. Colbert to his coach. I forgot to say that on our way, the abbé Buti and I discussed the young Blondeau's going to Rome. When M. Colbert had got into his coach, the Cavaliere got into the King's, and we went to Benoît's to see the wax portraits, which he liked very much. He saw that of the duchesse de Mazarin and Mme. de Lionne's and various others. He enquired how it was done. Benoît told us that he did some of the ladies' with the eyes open, others with the eyes closed; the mixture was composed of powdered marble, ground up eggshell, and plaster; the right proportions were most important; the eyes should be as lifelike as possible, and great care taken to keep them in good repair. The Cavaliere remarked that these portraits were intended to give pleasure in the family circle. Then we went to van Obstal's[195] where we saw some bas-reliefs of his, downstairs. He studied them and said they were in the grand manner.

Upstairs he was shown many sketches for friezes, which displayed great imagination; he saw models in ivory of women and children, which he said were very beautiful; he had not known there was anyone in Paris who could do work like that. He also admired some highly finished works in marble. When he had seen innumerable things, the abbé Buti told him that this very gifted artist had nothing to do because of intrigues at court; he did not get on with Le Brun, who therefore prevented any work coming his way; in order to make fun of him it had been suggested a little while ago that his pilasters in the Long Gallery should be scrapped. The Cavaliere replied that that sort of thing made him very unhappy. The abbé Buti added that he should speak to M. Colbert about him, but the Cavaliere said it would be useless, as he was ruled entirely by Le Brun; that van Obstal would be most helpful in the designing of the models for the large silver basins and vases that they made at the Gobelins. He repeated that it displeased him to see him neglected and a way must be found of bringing him into favor. We went on from there to visit "le petit" François de Tours,[196] who was delighted to welcome the Cavaliere.

[195] Gerhard van Obstal, or Opstal (ca. 1597–1668), a Fleming by birth, who became a student of Jacques Sarrazin and a foundation member of the Academy of Painting and Sculpture (1648).

[196] Simon François of Tours (1606–71), a member of the Academy of Painting and Sculpture (1663), who had gone to Italy in 1624 with the French ambassador, Philippe de Béthune, and remained there until 1638.

He told him that he was one of his pupils, that he had drawn at his school for a long time and had often been chided for the noise he made. He showed him a *Virgin*, a *Crucifix*, and *Ecce Homo* and a little portrait of a *Child carrying a Cross* that he had done from life. Next we went to Mme. de Beauvais,[197] who took enormous pleasure in showing her house to the Cavaliere. We entered through a spacious apartment, of which the Cavaliere found the proportions excellent. He praised the mistress of the house for her artistic qualities and her understanding, which had enabled her to create such a well planned and convenient house. From the main apartment we went into the gallery, at the end of which there is the chapel, then into the garden and into the long avenue. She had refused 100,000 livres for this site, she said. Then we passed into the other wing of the house. Everything was wonderfully neat and clean. The Cavaliere said he had no idea that there existed a house in Paris where the rooms were so well proportioned and so comfortable. Mme. de Beauvais begged him to tell the King. He said that the King ought to come there sometimes, for there were not more beautiful apartments in the Louvre. She told us that the house cost her 30,000 crowns; she had been tied down by what was already there, otherwise she could have built something even more beautiful; her family would have been furious if she had pulled everything down. When we left, we went to pick up the abbé Buti, who told the Cavaliere that, if he wanted to make a really gracious gesture, he should go and do some work at the Academy; he suggested the next day. He said he would, but he preferred no one to know about it. Finally, I took him back to the palais Mazarin. I forgot to say that, while the Cavaliere was having his midday rest, a young Provençal sculptor brought a bas-relief that he had done and also a number of copies of well-known medals and ancient bas-reliefs, which were all extremely good. He said they belonged to a collector in Aix who wanted to sell them. He possessed a great number, and they were all exceptionally beautiful; I advised him to take them to M. Du Metz.

15 OCTOBER

When I went to the Cavaliere's, I found M. Colbert working with him. Signor Mattia was also there, looking over the work that had

[197] It is uncertain whether Bernini visited the hôtel built by Le Pautre or Mme. de Beauvais's second hôtel (cf. above, 13 Oct., n. 169). The reference to the gardens and the fact that Mme. de Beauvais says she had not been able to pull everything down—only the mediaeval foundations were preserved and used by Le Pautre (Berger, p. 38)—suggests that the Cavaliere visited the second hôtel de Beauvais. On the other hand, the sequence of grand-cabinet, gallery, and chapel described by Chantelou is a striking feature of Le Pautre's plan.

been done in accordance with M. Colbert's memorandum. A place had been reserved on the other side, near the kitchen courtyard for the butteries and kitchens serving the two Queens and the Dauphin, and the council chamber and apartments for the other officials were to be in the wing facing Saint-Germain. M. Colbert said anything would be better than having the kitchens right in front of the council chamber and the rooms of the high officials, and the arrangement must be changed. We discussed the water pipes and the reservoirs, the privies, which must be carefully placed to prevent infection, and the place to store the water for putting out fires. Various proposals were made for this, and for the privies which, said the Cavaliere, would be best placed at the top of the larger and smaller staircases, since the smell from them would rise and would inconvenience no one. He said that if fire broke out in the lower part of the building, the secret of extinguishing it was to stop up all the vents so as to stifle it, while if it was on the higher floors it was best to allow it air; it would be a good thing to put four water containers under the first flight of the big stairs, which could be drawn on with pumps. M. Colbert made many objections to the idea of cisterns in the little courts; he said he did not wish to be responsible for creating under-ground places where powder could be put[198] or where people of evil intent could hide themselves. The Cavaliere said the cisterns would not be dangerous as they were under the courtyards, not under the building, and the water would prevent people from concealing themselves.

While we were talking, the abbé Buti came in and sat down and, like me, helped to explain to the Cavaliere what M. Colbert was saying. He began by pointing out that the King's apartment should be bigger, as it was too small, and the Queen's also. The Cavaliere said he would consider how to enlarge them; we went on to discuss the position of the ballroom and banqueting hall, which M. Colbert criticized for being too far away where the Cavaliere had put them. The Cavaliere insisted that they were very well where they were, but said he would see what he could do. There was a long discussion about the chapel, to see how it could be made big enough to serve the court as a parish church where episcopal and parochial functions could be performed, as had originally been done at the Sainte-Chapelle which had been the chapel of the royal palace, but the kings had decided to leave the palace and had handed it over for the use of the law courts, in order not to be too much in the center of the town; there were disadvantages in having two chapels, and there would be

[198] Colbert is thinking of the English Gunpowder Plot of 1605.

a further disadvantage if the King had to go down [to the Sainte-Chapelle] or if the rabble was admitted to the King's private chapel; we argued about all these things until two o'clock, then M. Colbert left, saying that in the time that remained to the Cavaliere they must try to find a way out of all these difficulties. When he had gone we had dinner. When we rose from table I was alone with the Cavaliere who told me that he would wait until Sunday evening, but if permission were not then given him he would go off without, at his own expense; he was old and did not wish to travel in winter, and anyway he was doing nothing at present. I assured him that he would be sent off at an early date, that M. Colbert had begged me to ask him to see the large stables, and to say where they and the smaller ones could be placed. The Cavaliere said that the small stables were very well where they were except that there is nowhere to put the officials and the pages. I suggested that apartments might be put in the gallery, were it not that the chimneys would interfere. But the Cavaliere said chimneys were quite successful built into the walls if they were made round—it did not make the walls weaker and they could be cleaned quite easily.

After dinner he arranged the cloth underneath the bust, and then we went to see the big stable and the riding school. He told me that in Italy they had different levels in the schools to train the horses to go up and down. We went to the foundations where we saw the conduit pipes made by Le Vau to carry water into the Louvre, which he said he could make use of in spite of what had been said this morning; he pointed out that they were underground, and he would continue them below the façade where the door was to be. Then he went to the Oratoire and thence home.

16 OCTOBER

❧ As I was unwell, my brother and my nephew Fréart went to keep the Cavaliere company. They told me that they found him working at the arrangement of the ballroom and banqueting hall to get them as M. Colbert had suggested on the previous day. Mme. d'Aiguillon had come about the Sorbonne. After dinner he went to the Academy, where he drew, then to the foundations, and then to see me. He showed me the study he had made of a figure posed like a slave;[199] it

[199] Lalanne identified this Academy with a drawing now in the Louvre, an attribution accepted by Brauer and Wittkower (p. 152 n. 5), who however had only seen it in a photograph, and questioned by A. Sutherland Harris, "New Drawings by Bernini for 'St. Longinus' and Other Contemporary Works," *Master Drawings*, VI, 1968, p. 386, n. 2.

is very beautiful and in what is called the grand manner. He told me jokingly he had come to see me so that I would not forget him in my will. The abbé Buti was with him. He then talked about his departure and said he could not understand how they could put it off without even explaining why. The abbé Buti said M. Du Metz had asked him how many people were with him, doubtless to arrange for the coach, and he had told him the Cavaliere and six others.

17 OCTOBER

� I found the Cavaliere drawing the Virgin adoring a draped Christ Child carried by two angels.[200] M. Du Metz came in, and told him that the laying of the foundation stone would take place at midday. The duc de Créqui also came in and talked to the Cavaliere for a little while. In the meantime I sent for the royal coach. Mignard sent a Paolo Veronese that belongs to him for the Cavaliere to see. It is a *Moses in the Bulrushes.*[201] M. de Créqui asked me what it was worth. I said at least five hundred crowns. "I would pay just a hundred and fifty," he replied. I forgot to say that I took the drawing for the cascade at Saint-Cloud to His Royal Highness. The Cavaliere had had it painted by Bourson. The moment he saw it he said, "Where am I to put that?" I told him, "Where the large fountain now stands." "And what about my fountain?" asked Monsieur. I replied it would be retained and that in order to make it easier to carry out the design, the Cavaliere had promised to make a clay model of the cascade when he got back to Rome, which would then be copied in wood so that it could be transported here. His Royal Highness then spoke about the design for the Louvre; the idea of reducing the size of the courtyard and taking away all the ornament displeased him very much; it looked as if they wanted everything to be very plain. I replied that what was going to be done would have the decoration that suited it. The maréchal Du Plessis said that in Italy they had good reason to hide the roofs because they had no slate and they were ugly; here, on the other hand, they possessed a beauty of their own. I did not argue the question and went over to the Cavaliere, who was with M. de Créqui, and we both got into his carriage, the abbé Buti accompanying us; as the royal carriage drew up at the same time, Signor Paolo and Signor Mattia came on in it.

We went down to the foundations and there discussed the procedure usual on these occasions, and someone said that at the Val-

[200] This drawing is now lost.
[201] Today in the Musée des Beaux-Arts, Dijon. See Pignatti, cat. no. A63.

de-Grâce, Mansart gave the trowel to the Queen. M. Du Plessis-Guénégaud[202] said he thought it was for the Superintendent of Buildings to hand the medal and the trowel to the King. The abbé Buti begged me to find out more, but no one else said anything. A little later M. Colbert arrived and asked the abbé Buti to tell the Cavaliere that he need only say what he wanted about the honor to be shown him on this occasion. At the same moment the King sent to ask if all was ready and was told that it was. Warin was there, holding his medal. He had that morning shown it to the Cavaliere, who had told him it was in too high relief. He had replied that was how M. Colbert liked it, but was delighted to hear the Cavaliere say that it should be in lower relief as that was his own opinion. He also had the two copper plates, on which were written the inscriptions. They were placed side by side in a square piece of marble, and in between them was the medal, which is valued at five hundred crowns. There was also a silver trowel, the royal coat-of-arms, a hammer and two pairs of pincers. M. Colbert held on to a six-foot rule for some time, but then handed it to M. Perrault and did not ask for it back. The King greeted the Cavaliere and looked at the instruments for the ceremony. M. Colbert showed His Majesty the medal. He looked at it and passed it round to several other people and then put it back in its place. The Cavaliere then handed the King the trowel with mortar on it taken from a big silver bowl. The King took it and put the mortar in the setting made in the piece of marble. The maréchal de Gramont then arrived, and the medal had to be taken out again to show him, and for this a pair of compasses was necessary so that it could be levered out with the point. The maréchal looked at both sides, and then the King put it back and laid a large stone on top of the marble, on which the Cavaliere put several trowelfuls of mortar. Villedot handed the King a hammer, with which he made several strokes, and the stone was then adjusted over the marble block with the pincers. The ceremony being over, the King took his departure. The Cavaliere and Signor Mattia, who had stood near him all the time, went to the carriage with the abbé Buti. Meanwhile trouble arose over the tools. Pietro, who is a servant of Signor Mattia, was holding the trowel and was struggling to get the hammer from Villedot. Bergeron wanted to get the trowel from him, but was prevented by the Cavaliere's

[202] Henri Du Plessis-Guénéguad (1609–76), seigneur Du Plessis et de Fresnes, marquis de Plancy, and comte de Montbrison. He succeeded his father as trésorier de l'épargne in 1638, then became secrétaire d'état (1643) and garde des sceaux (1656). Imprisoned for a time in 1664, in 1669 he was disgraced and succeeded as Secretary of State by Colbert.

footman. Then a lot of men acting on behalf of the contractors arrived; I told them that M. Colbert would decide everything, and that meantime they should leave the things with the Cavaliere's servants, but they refused to do this. Then I asked them to leave them with me, and I would look after them until M. Colbert should have made a decision. So I put them in the Cavaliere's coach. This argument was followed by others, for the King had distributed a hundred pistoles in pieces of thirty, fifteen, and five sous, which he threw into the foundations, and there ensued a furious scramble among workmen, navvies, and even soldiers to get this money.

After dinner the Cavaliere was busy shading his drawing of the *Virgin* and towards the evening we called on M. de Ménars, who was not at home. I then took the Cavaliere to Bourdon's house. I forgot to mention that while the Cavaliere was working, he told me he was thinking of how when he took leave of the King he would best be able to thank him for arranging for me to be his companion during his stay; he intended to tell him with what care and thought I had helped him and what a profound understanding I had of the arts. I said it was more than enough for me to have had the pleasure of being with him, and it was a wonderful experience to have been with such a rare and illustrious man who for so long had been at the top of his profession. He said he did not deserve such praise. I told him that if he were to speak well of me, it would lend authority to the good opinion that I would express of his work, for in France there were so many who knew nothing about art that if every effort were not made to enhance the position of the few who did, their words would carry no weight at all. I told him what M. Du Plessis had said that morning.

When we left Bourdon's, I took the Cavaliere back and then went to M. Colbert's to tell him what had happened that morning. He said that if it was the Cavaliere he could have the tools and everything else, but as for this Pietro and another whose name he did not even know he did not consider that they had the semblance of a right to them; that really the contractors had the right to them, but, he repeated, if the Cavaliere wanted them he should have them. I said I would tell him. He said he would see him and, as we were leaving, added that he feared that once the Cavaliere had left, things would not go so well. After I got home, Mazières came, who asserted that the trowel and the other instruments had been made at their expense and belonged to them; that M. Messier,[203] who had been a contractor

[203] Nicolas Messier, the mason and contractor, who had also worked under Mansart at the hôtel Tubeuf.

for the Val-de-Grâce, had had the trowel that he, Mazières, had bought from his estate. If the Cavaliere wanted it, he was master of course; but he must leave them the hammer and the one pair of pincers; Pietro had been heard to say "These French c———s."[204] I told him that I had been there the whole time and had heard nothing of the sort, and he should not believe that kind of thing.

18 OCTOBER

❦ M. Colbert sent word to my brother to go to the Cavaliere's. I went myself. I told the Cavaliere what M. Colbert had said about the instruments, and he said he did not want them. M. Colbert then arrived. We sat down and the plan of the Louvre was laid on the table with M. Colbert's notes, and he began by saying that if the construction were to be sound, the foundations should all be on the same level. The Cavaliere answered that although that was a good idea, it was not absolutely necessary, the Louvre being so built that the different parts of the foundations did not meet anywhere, being separated by Le Vau's work. The plan was verified, and several faults were corrected. These had crept in because M. Perrault, in summarizing the general specifications drawn up by Signor Mattia, had not understood various things. The Cavaliere showed M. Colbert what he had thought should be done to improve the accommodation for the King and the Queen, and how he had found all the arrangements that would be required; they would have to knock down a big partition wall and build it a little further along. M. Colbert frowned at this and said in an aside that it would cause too much disorder. The Cavaliere heard this and said that there was no other means of giving more space to the apartment, which had been considered too small and which had to be in that position in order to face south as was required. Then we came to the chapel, which the Cavaliere had put in the place of the ballroom and the banqueting hall.[205] From these two rooms he had made a large, low chapel about a hundred feet long;[206] at one end, he had designed a gallery for the King on the same level as his suite and opposite, at the other end, above, a musicians' gallery. He pointed out that this should be opposite and not too near if the music was to sound well, particularly as the King's choir was composed of strong voices and had besides, organs, violas, violins, bass cornets, and other

[204] The phrase is in Italian in the manuscript.

[205] This probably means in the block on the central axis of the extension that Bernini proposed to the west of the Square Court.

[206] In Lalanne's text this sentence has no main verb; *en faisant* should probably read *il faisait*.

instruments. M. Colbert thought it much too far off; the King liked
to see his musicians, and they liked to be near so as to be seen, and
further, they got careless if they were so far away. Besides, in all old
churches, the choir was in the middle of the building so that it could
be heard everywhere; it was always in the part of the church near the
pulpit;[207] and he expatiated at length on this. The Cavaliere replied
by saying that he had placed it there to make the acoustics as good as
possible; it had another advantage: it did not encourage worshippers
to turn their heads to the choir rather than to the altar; but one could
instead of this gallery at the end put two, one on each side of the
chapel; it might be an advantage to have two porches, so that in wet
weather there would be somewhere for people to clean their shoes
and shake off the rain before entering the chapel, and these galleries
would be over the porches. Apart from these problems M. Colbert
also brought up another serious one which was, to get to this chapel
one would have to cross a large room that, he said, the King wished
to keep for his own use, himself having the only key. Moreover, on
the other side one would have to go through several large rooms and
some smaller ones, which meant giving them up and never putting
any furniture in them because of the need to leave a passageway. The
Cavaliere replied that the people of lower rank would be downstairs,
while the nobles would go with the King, as was the custom.
M. Colbert answered that there were many different ranks and classes;
he agreed that the lesser officials would be down below, but there
were a great number of people of rank who would be very annoyed
to be anywhere else than near the King himself; that was how French-
men liked it to be, and in fact was usual; among other things, the
ladies, who are never present at the royal Mass, like to be near the
King as he passes, so that in fact it meant losing the use of four or
five rooms in that part of the Louvre, in order to make a passage to
the chapel. The Cavaliere said there was a staircase on the floor below
that could be used for reaching the gallery; further, a corridor could
be built on the outside so that only one of the rooms would be needed,
and the symmetry would not be broken as it would be obvious that
it had been constructed solely for this purpose; there was one like it
in the Vatican. M. Colbert declared it would be most unsatisfactory,
and they must find some other way. My brother was listening, as he
had arrived shortly before they had begun their conversation. The
abbé Buti also came in. M. Colbert made him sit down and told him
all the problems. He said with a smile that he would be willing to get

[207] In the text *l'aigle* should read *l'angle*.

mixed up in it if he could find some solution, but M. Colbert asked him in a friendly manner to be content to serve as interpreter without trying his hand at architecture, and they once more set about the matter. The abbé Buti suggested that apartments could be made in one of the little courtyards, and so free all the rooms; the Cavaliere answered shortly, "No, in this way we should lose the light."[208]

M. Colbert rallied him, saying, "I told you, my dear abbé, that you should not play the architect." It was obvious to me that all these obstacles annoyed the Cavaliere extremely. He said it was not possible both to do things and not to do them; it was a great deal to have designed the large staircases in such a way that they did not break into the royal apartments on the main floor of the Louvre at any point in its whole course; to this end he had placed them in the four corners of the courtyard; but this project, which was to make a chapel as large as a church, which was for the King's private use but must also serve the public, which further must be reached without using any available space, was clearly impossible; he did not know how to do it; he had done it as best he could; it would have been very well where he had first placed it; then he had tried to change it to please them and could do no more; he was thinking only of leaving now and had asked permission to go; the Pope had granted him leave of absence only until the end of August. M. Colbert replied that he only wanted to get as much enlightenment as he could on these problems; if he would continue to study these and other matters set forth in his notes on Monday and Tuesday, he would arrange for him to leave on Wednesday. He said he had done what he could; he had not forgotten that one should never say, "It can't be done," but what was asked of him was to put a quart in a pint pot. M. Colbert answered that he was free to build a church quite separate from the main block and make it as magnificent as he liked; provided he found a means of connecting it with the Louvre proper and allowed the King a suitably wide passageway, he would greatly prefer it to having his own rooms used. He told Signor Mattia afterwards that the Cavaliere must try to work out the arrangement of the offices and rooms for the officials of the court according to the notes he had made. He replied that he and I would do it. Then M. Colbert took his leave and I went to hear Mass at his house, as it was one o'clock. As we were going up the stairs, he remarked to me, "The Cavaliere is angry." I told him, "Someone with a volatile nature such as his, who thinks quickly and is prompt to find expedients, is likely to be disheartened sooner than another if

[208] Bernini's comment is in Italian in the manuscript.

these do not meet with approval." I was at the Mass held by his chaplain. I forgot to note that M. Colbert's children were at the door of the chapel and, as soon as they saw him, came up to embrace him. When we left the chapel he took his daughter's hand and insisted on my going on in front of him. I bowed to him and returned to dine at home.

After dinner Mme. de Chantelou and I took the abbé de La Chambre[209] to the Cavaliere's to be received by him before travelling to Rome in his company. As soon as we were alone together, he shut all the doors and told me in a rage that he now wished to leave, that they were making fun of him, that M. Colbert treated him like a small boy; he took up whole meetings with long and useless discussions on privies and water pipes; he wished to show off his knowledge and he understood nothing at all; he was a real c——; he would go without telling anyone; he had noticed in the last few days that he wanted to force him to make a *faux pas*;[210] they had egged him on but reason had restrained him. I conveyed to him as gently as I could that it would be grossly impolite to do as he threatened to do, and as M. Colbert asked him to stay only two days longer, he must wait; the King had treated him so well that if only for that reason he should do nothing that could displease him; it would cause a sensation; I advised him that as M. Colbert had suggested building a church separate from the Louvre that could be reached by a kind of bridge, he should work at it and make a plan; afterwards he could say that he had done it to comply with his wishes, and then tell him it spoilt the symmetry and say whatever was in his mind. He said he would not bother about that, he would do nothing more and wanted to leave tomorrow. I tried to soothe him, but he said he needed nothing; he was a great deal better off than those who sought to slight him. I reminded him of the welcome the King had always given him, how as late as yesterday the King had been more gracious and smiling to him than to anyone else; if he went off after that without seeing His Majesty, he could imagine how it would be interpreted. He replied that it was more than thirteen days since he had had anything to do,

[209] Pierre Cureau de La Chambre (1641–93), curé de Saint-Barthélemy in Paris, Almoner of the King, and a member of the French Academy (1670). After Bernini's death, he published a *Eulogy* of the artist in the *Journal des Savants* (24 Feb. 1681), which then appeared separately but preceded by a *Préface pour servir à l'histoire de la vie et des ouvrages du Cavalier Bernin* (1685). For his relations with Bernini, see J. Vanuxem, "Quelques témoignages français sur le Bernin et son art au XVII*e* siècle en France—l'abbé de La Chambre," *Baroque (Actes des journées internationales d'étude du Baroque, Montauban, 1963)*, II, 1965, pp. 159–64.

[210] The phrase is in Italian in the manuscript.

that the Pope's permission lasted only until the end of August and if he stayed longer His Holiness might be displeased; they had done nothing for him; the Pope could easily ruin him; many of the problems that were now being discussed could well be brought up again in two or three years; even if he left, that did not mean that he could not leave a statement to be given to the King explaining why he had gone; he realized that the King had more need of M. Colbert than of himself; he wanted to avoid a dispute, for the weakest always lost, and he did not want to get involved in these intrigues. I repeated that he must believe me, that nothing that was done in anger was likely to be successful. Signor Mattia came in at that moment and asked me to help him find places for the butteries and kitchens of the King and the two Queens, so that I left the Cavaliere who, from what I later saw on the table, had got the overall plan and had made a sketch for a church.[211] It looked as if it was going to be such a one as M. Colbert had suggested, of an order quite different from the Louvre and perhaps more beautiful and more ornate than the King's palace, so that it could be said that the King had wished to build God a more magnificent house than the one for himself; it would be so planned that the King could go straight from the first floor of the Louvre to a big gallery in the church.

When Signor Mattia and I had finished our work, the Cavaliere came in, and we once more went over the same ground; he began by saying again that it was obvious to him that they wished to force him to make a *faux pas*.[212] I told him I did not believe it, but that in any case he must be extremely careful to say nothing that could be so interpreted, that it would be a poor way of repaying the kindness and consideration that the King had always shown him. I repeated to him that I, who knew the King well, had been astonished at the extraordinary graciousness with which he had been received, and he should take advantage of the high opinion the King had of him. He replied that he was honored by the esteem in which the King held him, and he did not complain about His Majesty, but of the way in which he was treated by M. Colbert; he had no need of France; they had declared that they desired him to stay in France; but this behavior made it apparent that they did not want him, and he did not want to stay; he had a higher opinion of himself than of those who treated him so badly, and he was not impressed by the cross of their Order; M. Colbert, it was quite obvious, understood nothing of these mat-

[211] Bernini's chapel design is described below, 19 Oct.
[212] The phrase is again in Italian in the manuscript.

ters, and it was that which particularly sickened him and determined him to leave. He asked me afterward who was the abbé who wanted to go to Italy, and then we talked of other matters: how much it cost to keep a coach in Paris; how one obtained an audience with the King if one needed to speak to him. I told him one could speak to His Majesty when he went to Mass; there was too much of a crowd at the morning levée. He asked if there was no Master of the Bedchamber, and I informed him that the first gentlemen-in-waiting performed this function, but ministers and the secretaries of state arranged the audiences. I was still waiting for my coach; he had told me that he did not want to go out. When I saw that it was not coming, I went outside, saying I was going to send my footman with a message, and I then went away. I forgot to say that a gentleman called on behalf of the prince de Condé and the president[213] to thank him for having been to see the tomb of the late prince de Condé at the Jesuit church and to ask him if there was anything that should be altered. He said he did not remember what it was like, and he would go back if he had time.

19 OCTOBER

When I got to the Cavaliere's he drew me to the window and said to me, "There is one thing I want to know, and I ask you to tell me on the honor of a gentleman." I promised. Then he said, "Yesterday, when you left here, did you not go to M. Colbert's about the conversation we had together?" I was astonished and told him he must have a poor opinion of me; I perceived he did not know my character at all, that when anyone told me something in confidence I was not in the habit of betraying it. When he saw that I was angry he said he was sorry; I must not take what he said in that way; he had not doubted that I had been there as a friend. I told him that I did not like any action of mine to give rise to such thoughts and I would sooner go all the way to Rome than to enter M. Colbert's house two doors away from him. He then told me that while he was talking to me the evening before, he had been eager for me to leave as he wanted to get on with the work that I had suggested. He was so overexcited that he had not slept a wink, but he had hit upon a design for a chapel with which

[213] Jean Perrault (1603–81), baron d'Angerville, conseiller du roi, and président en la chambre des comptes, who paid for the tomb erected to Henri II de Bourbon (1588–1646), prince de Condé, designed by Jacques Sarrazin, which is discussed here and which is now at Chantilly in a much altered form. As far as can be ascertained, none of the suggestions put forward below were followed up. For an account of the tomb, see M. Digard, *Jacques Sarrazin*, Paris, 1934, p. 82.

he was extremely pleased; as for the other matter, shortly after I had left, M. Du Metz had come to say that if he wished to leave on Tuesday he would arrange it, and then he had thought that I must have said something about his impatience to be gone; nothing more.

A little while later, the abbé Buti arrived and then we sat down with M. Colbert. The Cavaliere began by declaring that what M. Colbert had said to him had so aroused his imagination that he had found a way of placing the chapel as he had suggested;[214] it would be a big chapel and would hold as many people as the Pantheon, its form would be elegant, being a perfect oval; then, with a laugh, he turned to the abbé Buti, and said, "I am wrong. It was the abbé who made the design and sent it to me early this morning to show to Your Excellency." The abbé replied, turning to M. Colbert, "Quite true. I worked at it all night; here is the result of yesterday's poetic thought, 'after the smoke comes the flame which delights the eyes.' "[215] The Cavaliere continued, and showed us how the King had only to walk straight from his apartment to reach the chapel; on special occasions, such as *Corpus Christi*, the procession could go round the loggias of the Louvre and then enter the chapel; there was a wide and comfortable staircase leading downstairs, a gallery for the use of the King on ordinary occasions, one for the choir, and next to it a place for the sacristy. M. Colbert thought it a pity that the sacristy, being attached to the main body of the chapel, should interrupt the order decorating the exterior. We discussed this for some time and also how to make it accord with the symmetry of the general design in view of the gallery that was to be built on the side facing Saint-Honoré. The Cavaliere agreed with this criticism of M. Colbert and said that it could be altered; further, he intended that the materials as well as the design for the chapel should be as magnificent as possible; the big columns which were to support the pediment must be of that lovely white and red French marble that he had seen in many places, and the capitals, of Carrara marble; these could be carved on the spot as there were craftsmen working there now who were very good, and this would save half the expense; the other columns that form the gallery should be of bronze with gilt capitals. He said he had thought so much about it and turned it over so much in his mind ("but, I am wrong, it was the abbé Buti") that he had found a means of creating a sym-metrical design facing Saint-Honoré, which there otherwise would not have been, and he showed how this symmetrical design had given

[214] Cf. fig. 14.
[215] The abbé's proverbial expression is in Italian in the text.

him part of the space necessary for a large chapel; at this I repeated what I had heard the Cavaliere say about something else, "If you want to see what a great man can do, put him in a difficult position."[216] M. Colbert made it clear that these alterations suited him very well.

Then the Cavaliere showed us how he could enlarge the King's apartment, and how he would be able both to make a design for the façade along the waterfront and include a magnificent state room, which would be at right angles to the passage that leads to the burnt-out gallery and would have windows on both the east and the south.[217] M. Colbert also suggested enlarging the King's *garde-robe* and making two rooms of it, but it was pointed out to him that the one would have no light. I said that nonetheless the one could be lit through the other and would be useful for the room attendants and for the overflow from the King's bedchamber. The abbé Buti suggested that a beautiful apartment could be built for the King in the destroyed gallery, and that one day it would be done. M. Colbert answered that the King would never have apartments outside the courtyard proper of the Louvre, and added that he was satisfied; he told the Cavaliere to decide whether he would go the next day or Wednesday. He replied that being idle exhausted him a great deal more than being busy, and he feared the onset of bad weather on account of his age and would therefore be very glad to leave. He talked about van Obstal, the sculptor, saying he was very skillful and would have been capable of working on the column based on Trajan's. I told them how much I admired Trajan's Column and how I had had casts made which I brought to France; this column had been studied by Raphael and Giulio Romano and all the great masters. He said he had suggested to the Pope having it moved to the square where the Column of Marcus Aurelius stands and putting two large fountains there which could have been used to flood the square in summer; it would have been the most magnificent thing in Rome; he would have been responsible for transporting it without damage.[218] M. Colbert asked of which order it was. I told him, the Tuscan order. "And the height?" About a hundred feet, but the reliefs are so designed that those at the top looked the same size as those below them; the figures were reduced in size and made to be seen through the same angle of vision so that they appeared to be all of the same height, although they were not.[219]

[216] As above, 9 Oct., Chantelou quotes Bernini in Italian.

[217] This passage is not easily understood, and it is unclear from Chantelou's text exactly what Bernini meant.

[218] Bernini had already described this project above, 25 June.

[219] Chantelou, as Perrault (*Mémoires*, pp. 78–79) pointed out, is wrong. His error

The Cavaliere said it was a source of inspiration for all the great artists, and from it they drew the power and grandeur of their designs. He repeated what Michelangelo had said when he saw the *Danaë* of Titian, which he painted in Rome during the pontificate of Paul III; if they, meaning the Venetians, had known how to draw, no one would look at the works of the Roman painters,[220] but it was only in Rome that one found a Trajan's Column. We returned to the subject of van Obstal, and the Cavaliere said he had seen five things by him and that he could be very useful. M. Colbert said he ought to have been given some designs to do. I added that he had a fertile mind. He retorted that in that case he did not know what he could have been thinking of in the several things that he had seen of his. The Cavaliere repeated that what he himself had seen had been good; of course, they were small things; he could not say how he would do with anything bigger.[221]

Going back to the subject of Trajan's Column, the Cavaliere told us that he thought it must have been left standing by the barbarians because of the difficulty of knocking it down—it was this that had preserved it; they had ruined everything they could reach, as they had done to some parts of the pedestal, such as the eagles that were at each corner and other ornaments. The rest was too high for them to reach; they would have had to construct scaffolding to get at it. He went on to talk about the frontispiece of Nero[222] and how its ruin had been completed during the present century; there were pieces of stone in that building measuring thirty feet or more each way; what was even more astounding was that we have no idea how they could have been lifted into place. I said that the enormous number of slaves they

arises as a deduction from Euclidian optics, according to which equal visual angles subtend equal lengths. A simple diagram reveals that a man standing on the ground would see the upper registers of the column through a smaller angle than the lower ones, if they were all the same height. Thus, in order to make the registers appear equal, as they do, he concludes that it would be necessary to equalize the visual angles by proportionately increasing the height of the upper registers. Chantelou's authority was undoubtedly his brother's *La perspective d'Euclide* (Le Mans, 1663, pp. 13–14); but the principle was already stated and recommended by Dürer and was then repeated many times thereafter.

[220] Cf. above, 9 Aug.

[221] Whether as a result of Bernini's and Chantelou's advocacy or not, in 1666 Obstal was paid for work at Versailles, Fontainebleau, and Vincennes. See Guiffrey, *Comptes*, cols. 134, 142, 146.

[222] The popular misnomer for the Roman ruins in the Colonna gardens on the Quirinal Hill, which are now associated with the Temple of Serapis, but were formerly believed to be from the Golden House of Nero (cf. P. M. Felini, *Trattato nuovo delle cose maravigliose dell'alma Città di Roma*, Rome, 1610, pp. 351–53). They were originally part of a structure of colossal proportions; a fragment of its Corinthian cornice was said—at 27 tons—to be the largest block of marble in Rome.

had at their disposal enabled them to do what to us seem extraordinary things. I mentioned as an example the Pont du Gard;[223] some of its arches were made up of only three stones, the keystone and those resting on the imposts. M. Colbert said that if peace lasted twelve years or so, he hoped that we would be able to create wonders such as these. Then he rose and said he would go to the Louvre to ascertain when the Cavaliere should take his leave of the King; he should wait, as he would come back for him. And in fact an hour later, he returned and took him to the King through the study. Paolo, Mattia, Giulio, the abbé Buti, and I were also present. We found the King in the state bedroom standing with his back to the window with the duc de Saint-Aignan. M. Colbert presented the Cavaliere to the King; he came forward, paid his compliments, and then made a deep bow. The King leant over to answer him while he was still bowing and spoke to him apparently most graciously, showing every sign of regard for him. As he withdrew, he noticed his son and the others and came forward again to present them and they all bowed. The King said to Signor Mattia that he must return very soon. The Cavaliere then addressed His Majesty, saying that he was only going to fetch his wife and would be back at the beginning of February, and when all his suite had taken leave of the King, he added that he had to thank him once more for having arranged for me to be his companion here; he had been astonished at my knowledge of the arts which he professed. The King replied it was for that very reason he had chosen me. Then M. Colbert made the Cavaliere withdraw with him to the King's study and went to see himself whether the Queen was in a state to receive him. He was in there for a little while and then he asked the Cavaliere to enter. He went through the audience chamber to the small bed-chamber, where he took leave of the Queen, who was still in her dressing gown. She received him with great kindness and affection. The duchesse de Montausier and the maréchale de La Mothe-Houdacourt[224] paid him many compliments and said it would have been marvelous if he could also have made busts of the Queen and the Dauphin. He told them that his son's work was something that the Queen could often contemplate, for it presented a devout thought to her mind, and a picture of a pretty child to her imagination. Mme. de Montausier asked me to convey to the Cavaliere her regret that

[223] Presumably the first-century Roman aqueduct near Nîmes, known as the Pont-du-Gard.

[224] Louise de Prie (1624–1709), wife of Philippe de La Mothe-Houdancourt (1605–57), Marshal of France (1642). She was governess of the children of Louis XIV in 1664 and later of the children of the Dauphin and of the duc de Bourgogne.

she had been unable to render him any service, and so did Mme. de La Mothe. When that was done, M. Colbert asked him to wait as he was going to be shown the crown jewels. "Indeed," said the Cavaliere, "the Legate told me not to leave without asking to see them." Shortly afterward an attendant brought in a cloth in which were wrapped a belt and a sword, both studded all over with diamonds of great value, which M. Colbert showed us. Then the casket containing the crown jewels was brought in with the keys, which the comtesse de Béthune[225] handed to M. Colbert. He opened the casket and took one piece after another out of its case, and arranged them all on a table, particularly those worn by the Queen, among which there are an infinite number of necklaces, clusters of diamonds, brooches, earrings, hairpins and watches, some with rubies, some with emeralds, hyacinthines, opals, and some with a number of different colored gems in one setting; these all spread out on the table made the richest and most agreeable impression imaginable. He set apart several necklaces and other ornaments in emerald, which the Queen brought with her from Spain when she came to France. There were so many necklaces, bracelets, and earrings of every shape and size, without counting the strings of pearls, that the eyes grew tired. The sight of the emeralds prompted the Cavaliere to remark that he was not surprised that the Queen had brought just these gems with her, for, he said, "the Spaniards are now *al verde* (down to the green)."[226] The abbé Buti said that God could not give all that to one poor human being. The Cavaliere added, "Given this lot one could go in for stone throwing."[227] Then M. Colbert opened a long box that contained the largest pieces, among which, he said, were fourteen given by Cardinal Mazarin. We were shown the *Mirror of Portugal* and the big *Sanci*, the two most famous stones in Europe.[228] The *Sanci* is pear-shaped and is supported only

[225] Anne-Marie de Beauvillier de Saint-Aignan (1610–88), dame de chambre of the Queen, married in 1629 to Hippolyte, comte de Béthune, and his widow since 24 Sept. 1665.

[226] The phrase is based on the proverbial expression *essere al verde* evidently derived from the fact that the bottoms of candles were formerly green and meaning "to be at the end of one's resources." A surprisingly insensitive witticism in the presence of Louis's Spanish queen—though it may have been *sotto voce* and not intended for her ears, since no one attempts to cover it up; it probably refers to the recent death of Philip IV (above, 27 Sept.) and the fact that the heir to the Spanish crown was a minor, always a serious problem in those times.

[227] Bernini's comment is in Italian in the manuscript.

[228] Like other famous gems, these two stones have a complicated and colorful history, parts of which M. Pierre Verlet has kindly elucidated. The *Sanci*, or *Sancy*, a 54-carat Indian diamond takes its name from Nicolas de Harlay de Sancy (1546–1629), its first recorded owner, although how he came to acquire it is still obscure. It next appears in the possession of the English crown, and along with the *Miroir de Portugal*, a 21-carat

by a gold thread that goes round its length. When we had finished,
M. Colbert himself put everything back in its case, and the cases in
the casket, which was handed back to Mme. de Béthune. Then we
went down to see the Queen Mother. The Cavaliere paid her his
compliments. Among other things, he told her he had seen the cupola
of the Val-de-Grâce, which was very successful, and he hoped, as the
Lord never did things by halves, that having allowed her to recover
from her dire illness he would grant her sufficient health to enjoy this
beautiful building. The Queen replied and, thinking that he did not
understand, called me to act as interpreter. She said she was extremely
pleased that he liked the Val-de-Grâce and heard his good augury with
much joy. He added that France should be grateful to her for the
children she had borne; the King had so remarkable a mind that he,
the Cavaliere, had never heard him say anything on the subject of the
arts that he professed that was not admirably sound; and he could
only be guided by an excellent natural sense; he had gained some idea
of what he must be like in the affairs of state, which is the profession
of kings. The Queen agreed with him.

I told the duc d'Orléans, who was there, that the Cavaliere was
now ready to receive his commands and those of Madame. He had
already seen him when he entered and had thanked him for the drawing
that he had made. His Royal Highness said he could take leave of him
and Madame there, which he did. Meanwhile the Queen had ordered
her jewels to be shown. She told him they were not so fine as the
crown jewels, nor were there so many, but there were some beautiful
things. Mme. de Navailles[229] brought in the casket, and we went over
to the window. Meanwhile the King had entered and himself helped
to set them out. The Cavaliere looked at them and admired them,
and then said that he derived a completely pure pleasure from seeing
these and the crown jewels, which one could say were masterpieces
of nature, for he did not want to possess any of them, but this was
not the case with Greek statues, for there one's pleasure was mixed
with a regret at finding one's own productions so far below the stand-

diamond, seems to have been sent abroad with Henriette-Marie de France, consort of
Charles I, in order to raise money for the beleaguered royalist cause. Both stones were
subsequently acquired by Mazarin, who bequeathed them and many others to Louis
XIV. They remained in the royal collection until the Revolution, when on 17 Sept.
1792 they were stolen from the *garde meuble*, where the crown jewels were kept. Al-
though other of the stolen gems were recovered, the *Sancy* and the *Miroir de Portugal*
disappeared, the latter possibly surfacing in a sale of 1887, the former evidently passing
through the hands of Prince Demidoff of Russia before being bought by Lord Astor
in 1906.

[229] Suzanne de Baudéan (1609–84), wife of Philippe II de Montault (1619–84), ma-
réchal-duc de Navailles.

ard attained by these great masters in his own art. This thought delighted the King, who brought it to the attention of those around him. His Majesty then withdrew to the Queen's bathchamber. The Cavaliere accompanied M. Colbert to his coach, and then he and I got into the royal coach and drove to the palais Mazarin. There we found the Treasurer of the Royal Buildings, M. Du Metz, and M. Perrault. They handed to him two royal warrants, one for himself for two thousand crowns as pension, the other for Signor Paolo for 400 crowns, also as pension.[230] To Signor Mattia they gave a written undertaking that the King would pay him 4,000 crowns a year as long as he was in charge of the execution of the Cavaliere's designs for the Louvre. There were also arranged on the table a number of purses, the King giving to the Cavaliere 3,000 pistoles, 2,000 crowns to his son, 2,000 crowns to Mattia, 400 crowns to Signor Giulio, 800 livres to Cosimo, attendant to the Cavaliere, 300 crowns to Pietro, who is in Signor Mattia's service and translated the specifications, and 500 livres each to the Cavaliere's and Paolo's footmen.[231] They gave receipts, then the treasurer offered to count the money, which the Cavaliere refused to have done. He invited M. Du Metz to dinner and M. Perrault returned with the treasurer. After dinner the Nuncio arrived and remained for some time in private with the Cavaliere. Then we went to the Jesuit church in the rue Saint-Antoine,[232] where we met a man who had come on behalf of the président Perrault. While the Cavaliere was in prayer, four or five priests assembled. They explained to him how they wanted to decorate the altar by the tomb of the late prince de Condé; instead of the picture that now hangs there, they would like to put a piece of black marble with a bronze crucifix and a figure of St. Francis Xavier in front of it, marble columns on either side with bronze capitals. Because bronze darkens unless it is gilded he advised them to gild anything that they had made in bronze, in order to make the effect richer. He also advised them to enrich the frieze, which is so barren of ornament as to belie its name,[233] by introducing the instruments of the Passion. They asked him if he

[230] Mirot (p. 259, n. 2) noted that the brevets given to Bernini and his son are in the Bibliothèque Nationale, ms. ital. 2083, pp. 347 and 349.

[231] These gifts, widely reported, are documented in Guiffrey, *Comptes*, col. 105, where however the Cavaliere is listed as receiving 33,000 livres. The discrepancy arises because instead of the 3,000 pistoles (equal to 30,000 livres) reported by Chantelou, Bernini actually received 3,000 louis d'or in three sacks (Perrault, *Mémoires*, p. 80), which were equal to 11,000 écus or 33,000 livres (as Lalanne noted was reported by the *Gazette de France* of 24 Oct.).

[232] That is, to the church of Saint-Louis.

[233] In Italian, *frisare* means "to decorate."

thought it would be proper to put confessionals at either side of the altar. He said it would be all right if they put them in the corners, provided they were not as big as those opposite. The Fathers told him that everyone complained that their altar was placed too low. He looked at it for some time and commented that the altar where Holy Communion was held was not itself too low; but the design was bad, which made it seem low, but nothing could be done about it now. I said I had told them twenty years ago that they were ruining their church by filling it with poor work, but at that time there was a Father Derand,[234] a certain Father Pierre,[235] and a Fleming, whom they looked on as oracles in architecture, who had ruined this lovely building. They replied that the number of people without taste was so much greater than those with it, and they were forced to please the majority who liked things decorated in this way. They added that, when Cardinal Richelieu entered the church for the first time, he admired it very much. I replied that he was a very great statesman, but that he understood little about architecture; one must listen to those who did understand it; they could see how the church of the Novitiate, of which M. de Noyers was in charge, assisted by my brothers and myself, had the approval of all, while their church was admired by no one. They agreed. The Cavaliere said he would complain to Father Oliva, their general, that he had received visits from everybody in France excepting members of his Order. I told them that the Cavaliere had made it his first duty to see each of their establishments as soon as he could after he arrived. He finished by asking them to say an *Ave Maria* for him as a body, which they promised to do. Father Annat,[236] who arrived just as we were going, also promised.

When we left the Jesuits, the Cavaliere went to see the Venetian ambassador. He welcomed him most cordially, saying repeatedly, "My dear Cavaliere, my good Cavaliere."[237] Having remained half an hour with him in conversation, he accompanied him right down the stairs in spite of his rank, although the Cavaliere tried to stop him; he said the Republic would forgive him as he was doing it because

[234] The Jesuit architect, François Derand (d. 1642 or 1644), who replaced Etienne Martellange, designer of the Novitiate church of the Jesuits, as architect of Saint-Louis in 1629. For the conflict between Martellange and Derand, an echo of which is heard here, see P. Moisy, "Martellange, Derand et le conflit du baroque," *Bulletin Monumental*, CX, 1952, pp. 237ff.

[235] Pierre Goict (1598–1653), also a member of the Society of Jesus, who assisted Derand in the cupola and façade of the church. In 1652 he was called to Rome, where he died.

[236] François Annat (1590–1670), the Jesuit confessor of Louis XIV (1654) and opponent of Jansenism, to whom Pascal addressed the 17th and 18th of the *Lettres Provinciales*.

[237] Chantelou quotes Bernini in Italian in the manuscript.

he was his friend. Then we went on to M. de Lionne's, where we only found Mme. de Lionne. She asked him for a little advice about the vestibule, where she had had two of the doors blocked up. He told her that some ornamentation could be introduced as she wished. When he took leave of her, she embraced him on both cheeks in the French manner. Then I took him back home.

<center>20 OCTOBER</center>

When I went to the Cavaliere's, I found he had gone to M. Colbert's. I followed; he was saying goodbye to him. M. Colbert told him he would always remember the benefit he derived from his discussions with him, which would be a very great help to him in carrying out the task imposed on him by the King of supervising the royal buildings. The Cavaliere replied that, on the contrary, M. Colbert had given him ideas that he would not otherwise have thought of. M. Colbert told Signor Mattia that he must return soon, and then they parted. As he was leaving M. Colbert asked me if he was not going back to his apartment. I said I thought he was, and soon after we had got back to the palais Mazarin, M. Colbert arrived. They exchanged compliments, and then, most likely because the Cavaliere could think of nothing else to say, he told him that he was never tired of making it known how much he had appreciated my excellent judgment in everything connected with the art that he practiced. In the beginning he had been astonished at the way, when he produced two or three alternative sketches, I infallibly chose the best from among them. "Indeed, M. de Chantelou is a man of quick perception.[238] Whenever he has told me that I was going to see something beautiful, I have found he was right, and he always points out to me the good and the bad in works of art; no doubt his travels in Italy have been of great help to him, but he must also have an inborn understanding of the arts. No doubt there were others in Paris with as good taste, but he had not met them." M. Colbert said I had a great reputation in Paris as knowing about this kind of thing. I was rather embarrassed meanwhile; also, besides this conversation, I heard later from my wife, who had been told by Signor Paolo that before I had arrived to fetch the Cavaliere, he had told M. Colbert that if there was anything they did not understand in the plans, they were to consult me, as I understood them as well as he did. Then they spoke about Signor Mattia's return, and M. Colbert said two or three times they would have to make a Frenchman of Signor Paolo; turning to the Cavaliere, he said,

[238] The Cavaliere's judgment is in Italian in the manuscript.

"It is to be hoped, that you, Monsieur, will have sufficient interest in your work in the Louvre to come and see it in a few years' time." He replied that his interest in the Louvre was greater than in anything else he had done; it was usual for him to be interested in his work at the beginning, but once finished, his feeling for it evaporated, for he realized then that it was far from the perfection he had envisaged. I said that when the workman was content with his work, it was usually a sign of his lack of judgment; besides, this was the natural order of things: animals only care for their young until they no longer have need of them, that is when they are fully grown. The Cavaliere told us that as soon as he got back to Rome, he would begin to think about his design for the Cathedra Petri; in fact, he would have it in mind every minute of his journey, just as on his way from Rome to Paris he had never stopped thinking about the Louvre, for that was the way he was made. Then M. Colbert took leave of the Cavaliere and drove away. When he had gone, we walked up and down the room for a little while, and he said to me that there were two qualities in M. de Chantelou that made him greatly admire him; one was his prudence, which made him remain silent about matters that should be kept secret; I had been to him, so to speak, father, brother, and friend, for it had been I who had always helped him to regain his self-control when he lost his temper; such was his character that he could not always control it; he realized that I was wiser than he; he was extremely grateful for the frank way I had treated him, and he would never forget it; the other thing was that he had found that I had more taste and under-standing for the arts than anyone else he had known and more knowl-edge than he would have believed possible. At that moment Mme. de Chantelou arrived and with her, my brother and my nephew. She begged him to accept a basket of dried sweetmeats and patties, and she also gave to Signor Paolo and Signor Mattia a hair purse each. "I'm the gourmand; I only get good things," the Cavaliere said with a smile, and straightaway began to eat the sweets. Then he went to his bedside and brought back a drawing of the *Virgin*, which he gave her. She thanked him and after more conversation said goodbye to him. He paid her high compliments and said many pretty things, and then she left us. He talked for a while with the abbé Buti, while I spoke to M. Du Metz about young Blondeau and told him that it would be a real kindness to help him. He said there was still hope, but that M. Colbert had remarked, after he had seen the list of those to be sent to Rome, that it might so turn out that after costing the King large sums of money, he would go to England. I said there was

BERNINI'S VISIT TO FRANCE

little fear of that, for his father[239] was doing so badly there, he would be the opposite of attracted to it. He assured me he would do what he could; he had written against his name, "Recommended by the Cavaliere Bernini"; the King was sending only eight boys, four painters and four sculptors. The sons of Vouet, Sarrazin, and other members of the Academy were among them, and Blondeau was not a member. I told him that, on the contrary, the Cavaliere had himself found his name there.

The gentleman-in-waiting to Prince Pamphili,[240] who was due to leave, was there, but he had not yet received his dispatches, so that he could not go with the Cavaliere as he wished. Mignard came to say goodbye, and the Cavaliere told him how he had spoken most highly of his work to the Queen Mother. We discussed frescoes, and Mignard said one must use different methods for summer and winter; by now he was so experienced that he never had to retouch anything and his work could be washed down as many times as desired; he thought it had helped him to work in tempera when he was young. The Cavaliere declared that experience was extremely necessary; when Guido Reni had been summoned to Rome to do a fresco in St. John Lateran or S. Maria Maggiore,[241] finding he had nothing to do, he had a piece of masonry covered with plaster and painted on it a sleeping child just for practice; this piece was painted with so much sincerity that Cardinal Barberini kept it, although it was spoilt in one or two places where the plaster had not had time to dry. Annibale Carracci often said that anyone who could not do a fresco was not a painter.

While we were at dinner, the brothers de La Chambre[242] called. The Nuncio also sent a footman, who was instructed to inform him half an hour before the Cavaliere's departure. Then two six-horse coaches drove up for the Cavaliere and his suite and baggage, which were to take him as far as Lyons where he would find chair and litters

[239] Pierre Blondeau, a medalist, said to have been a student of Nicolas Briot. He had first gone to England in 1649, where he remained for seven years before returning to Paris. Then in 1662 he again went to England. Although Blondeau became head of the Mint in the Tower of London and a naturalized citizen, things do not seem to have gone well for him, as Chantelou remarks, and in 1664 he left for Poland, where he died.

[240] Evidently Francesco Mantovani, who left Paris on 24 Oct. See Fraschetti, p. 355, n. 1.

[241] After his return to Rome in 1605, Reni executed a fresco of St. Philip Neri in the Baptistry of St. John Lateran and two over the tomb of Clement VIII in the Cappella Paolina of S. Maria Maggiore.

[242] The abbé Pierre Cureau de La Chambre, who was to travel with Bernini to Rome, and his older brother, François Cureau de La Chambre (d. 1680), First Physician to the Queen.

for himself and other conveyances for his family. Mancini, a courier, was to accompany him to Lyons, and Signor Beaupin[243] as far as Rome, with the butler and the cook and others who had been responsible for his catering since he had been in France. A little while after he had finished dinner, the Nuncio arrived and made the Cavaliere, the abbé Buti, the abbé de La Chambre, and me get into his coach, and we went ahead as far as Villejuif. On our way we discussed among other things Cardinal Richelieu and Cardinal Mazarin. The Nuncio was for the latter, the abbé said they were to each other as the day to the night; Cardinal Mazarin was a prodigy of fortune, but he could not be compared with Cardinal Richelieu, whose qualities far excelled his; it had been his lot to find a Spanish queen on the throne who was distrusted by the French, two children just out of the cradle, the duc d'Orléans,[244] who had no other wish than to amuse himself, and the Prince de Condé[245] in a mood to cause trouble with everyone, but Cardinal Richelieu established himself in power and kept himself there in defiance of the whole of France. The Nuncio continued to maintain that Cardinal Mazarin must have possessed great qualities to rise from nothing to so high a place in the state; at the very beginning of his career he became important both to the Spaniards and to the French, and they turned only to him instead of to Panciroli,[246] who was the Nuncio and the man to whom they should have come. The abbé Buti asked if it was not he who had said[247] that Panciroli was "an ugly face" and good-for-nothing, and whether that had not been his fate.

The Cavaliere remarked that Cardinal Pallavicini had said he had two great contemporaries, Cardinal Mazarin and another to whom he was reluctant to give a name. The Nuncio said he suspected it was the Cavaliere himself. He denied it rather weakly. Then we went on to discuss the design for the Louvre. I said that three or four Italians had sent designs, among them the Cavaliere Rainaldi, but to my mind none of them had been successful.[248] The Nuncio asked me why. I

[243] That is, Jacques Esbaupin (see Guiffrey, *Comptes*, col. 149).

[244] That is, Gaston, duc d'Orléans (1608–60), brother of Louis XIII.

[245] That is, Henri II de Bourbon (1588–1646), prince de Condé and father of the Grand Condé.

[246] Giovanni Giacomo Panciroli (d. 1651) became Nuncio to Madrid in 1642. He was created cardinal by Urban VIII in 1643 and later served Innocent X as Secretary of State.

[247] The text should read *dit* instead of *fait*.

[248] For the Italian designs for the Louvre described below, see Mirot, pp. 170–76; K. Noehles, "Die Louvre-Projekte von Pietro da Cortona und Carlo Rainaldi," *Zeitschrift für Kunstgeschichte*, XXIV, 1961, pp. 40ff.; and P. Portoghesi, "Gli architetti italiani per il Louvre," *Quaderni dell'Istituto di storia dell'architettura*, nos. 31–48, 1961, pp. 243–68.

replied that Rainaldi's design was hardly correct in regard to the orders
of architecture, and there was no part that was not deformed and
disfigured by some form or cartouche or other poor sort of orna-
mentation, such as broken pediments, or else pediments stuck one
inside another over the windows of the first and second floors, with
a continuous confusion of projecting cornices and, finally, three
crowning structures that form the top and the roof to the façade, the
biggest of which would be more than 300 feet round. Candiani's design
was equally extravagant, as he wanted the roof of the dome which
he puts in the middle of the façade to be in the form of a royal globe,
held up by two figures resembling a couple of Hercules, each eighty
feet high; Pietro da Cortona's was more like a temple than a palace
and had no regard to what was already in existence in the Louvre.
The Cavaliere said that what was distressing about the designs of
Pietro da Cortona, otherwise a very able man, was that when he
estimated that the cost of something was likely to be about 500 or
600 crowns, it more often ran to two or three thousand; this happened
to Cardinal Barberini with the altar to S. Martina and the church of
the same saint;[249] instead of 50,000 crowns, it would take two or three
millions to complete.

We discussed Borromini, a man of extravagant ideas, whose ar-
chitectural designs ran counter to anything imaginable; a painter or
sculptor took the human body as his standard of proportion; Bor-
romini must take a chimaera for his.[250] I said I had heard that when
he was asked to do a design for the Louvre, he had demanded payment
before he began.[251] The Cavaliere intervened saying it was unfair to
spread this story around, but he knew that all that he had asked was
that the King should write to him. He added that the abbé Elpidio
had wanted to show him the design done by the King's architect, a
man much in favor with M. Colbert, but that he had refused, as it
was a habit of his never to look at the designs of others for anything
for which he had been asked to do a design himself. I said that Signor
Elpidio had brought Le Vau's plan to Rome so that it could be ex-
amined and criticized by able artists. Thereupon the abbé Buti said it

[249] SS. Luca e Martina, the church of the Academy of St. Luke in Rome. In 1634
Pietro da Cortona, who wished to be buried there, had undertaken to reconstruct its
crypt at his own expense and on his own designs. When work began, however, the
body of S. Martina was discovered, and in January of 1635, Cardinal Francesco Barberini
ordered the entire church rebuilt according to Cortona's design.

[250] This often quoted remark illustrates quite well the distance that separated Bernini
and Borromini in their attitude towards architectural design.

[251] There is no evidence to support the statement that Borromini made this request,
which is entirely out of character, and indeed Bernini immediately denies it.

was a question of 4,000 pistoles if he had got it accepted, and that the abbé Elpidio had wanted to show them to him just to swindle his approval out of him; he had done perfectly right to refuse to see it. The Nuncio asked if he had not met this architect.[252] The Cavaliere replied that he had not, that there had been a misunderstanding, for they had been staying at the same inn, and Mancini had told him there would be time for him to rest as Le Vau had not yet dined, but, although he got up as he thought in plenty of time to see him, Le Vau had already left;[253] he had regretted what must have seemed like rudeness[254] on his part.

The Cavaliere talked about the Louvre; he said he feared that it might not please at the beginning; those who did not understand the plan could not appreciate the building until it was finished. I said perhaps in the future we should always build in that manner; it might not be better, but it would be the fashion.

When we got to Villejuif, we had to wait at least an hour for Signor Paolo and the rest of his suite. They finally arrived, and the Cavaliere, turning to my brother who had come with us, told him that he was an old debauchee, and begged him to say an *Ave Maria* for him. Then he got into his coach and had the abbé de La Chambre placed next to him. When I embraced him I saw that his eyes were wet, and I was very much touched, and so left him. The Nuncio got back into his coach, and I into mine.

21 OCTOBER

🕮 I sent back to M. Du Metz the armor belonging to the King designed by Giulio Romano, which had been taken from the armory, for the use of the Cavaliere.

22 OCTOBER

🕮 At the King's supper, at which I was present, the maréchal de Gramont said mockingly that the Cavaliere had made some big presents; he had given thirty sous to an old servant, and when she chucked it away, he had picked it up again; he had taken the money that the King had given to his employees; he himself was a man who could not tolerate the presumptuous and would not flatter their work. The comte de Gramont aided and abetted him. Before the King took his

[252] That is, Louis Le Vau.

[253] This story hardly explains why Bernini had not met Le Vau who, as far as we know, had been in Paris during the Cavaliere's visit.

[254] The phrase is once again in Italian in the manuscript.

place at table the comte de Sault[255] said that the Cavaliere had not been satisfied with the presents he had received. I told him that he was overcome with the favors showered upon him and by the high esteem in which he knew he was held by the King.

When I gave the Cavaliere's messages to M. Colbert, he remarked to me that he had not appeared to be very grateful. I answered that he had seemed very deeply touched by the King's favor and the good opinion he seemed to have of him; moreover, there was no record of anyone else having been received with so much honor, and that went for Signor Mattia, too, and all his people. M. Colbert said he would speak to the King about the things that concerned me.

The same day,[256] at the King's levee, various people said to me that the Cavaliere had not been contented when he left. The duc d'Orléans whispered it to me at his breakfast. Although I tried to undeceive His Royal Highness, he repeated twice, "The King believes it to be so." I went downstairs and had confirmation from M. d'Albon, who said that the abbé de Montaigu had been there when the matter had been raised in the King's presence. He and the abbé de Montaigu advised me to write to the Cavaliere, telling him to send word to M. de Lionne to undeceive the King. I did this, having first been to M. Colbert to ask him if he thought it would be a good thing.

24 OCTOBER

🐾 Saturday. Monsieur said the same thing to me again at his breakfast. I pointed out to him what a wrong was done the Cavaliere to spread these rumors, and he replied that the King had it from a source that he considered reliable.

26 OCTOBER

🐾 Monday. I was quite near the King at supper, and he asked me if it were true that the Cavaliere had given 30 sous to the serving woman in the palais Mazarin. I replied that I had heard nothing about it. But the King continued in a low voice, "Is it true that he left so dissatisfied?" I replied that I had seen him depart full of gratitude for the favors shown him by the King, delighted by the high opinion that he believed His Majesty had of him and the honor that had been done him. When I had heard these rumors about him I thought it my duty

[255] François-Emmanuel de Bonne de Créqui (1645–81), comte de Sault, then in 1677, duc de Lesdiguières.

[256] Actually, according to Chantelou's letter below, 26 Oct., not the same day, but the day after, 23 Oct.

to write and inform him and this I had not failed to do. His Majesty asked, "You have written to him?" "Yes, Sir," I answered.

Following are the letters that I wrote to the Cavaliere and his replies.[257]

> *Sir,*
>
> *You, who have lived in the foremost court of Europe, where self-interest, jealousy, and envy reign as in other places, will not be surprised with what I am going to tell you.*
>
> *Yesterday, I learnt from many sides that the rumor had gone round that you had left here dissatisfied. I replied to those who spoke to me with the only answer possible. At the King's supper, at which I was present, there were several discussions, more or less on those lines. Today at the King's levee various people spoke to me again about it, and at the levee of the duc d'Orléans, he himself whispered to me that you had departed feeling dissatisfied with the presents you had received. I replied to His Royal Highness that these rumors did you a grave injustice, that when you left you were quite overcome with the marks of affection and esteem showered on you by His Majesty and by the favors shown to you and yours. He answered that the King believed you were not contented. I replied it was the usual way with the wits at court, who carried out the useful service of turning everything to poison.*
>
> *The comte d'Albon, gentleman-in-waiting to the duchesse d'Orléans, and the abbé de Montaigu confirmed this state of affairs to me, as they were present when it had been spoken of in front of*

[257] Although Chantelou uses the plural "replies" and the manuscript contains five letters written by Bernini at this point, only the first, written from Lyons on 30 Oct., responds to the charges being made in Paris. The others were written at later dates and on different subjects. For this reason these four letters have been removed to Appendix C where they will not interrupt the chronological continuity of the narrative. This appendix also contains three further letters from Bernini to Chantelou that appear at the end of the manuscript. That Bernini did, however, write more than once protesting his satisfaction and gratitude as Chantelou urged is confirmed, as Gould (p. 113) points out, by an undated excerpt to the artist's "correspondent in Paris" printed by Dom. Bernini (p. 145): "With regard then to what Your Lordship writes about the prattle stirred up against me in Paris, I almost glory in it rather than grieve over it, for not having been able to reproach my deeds, those who bear me ill will endeavor to discredit me on the very feeble grounds of words. Whence I do not know who are the more simple-minded, those who invent it or those who believe it, because the grandeur of the gifts with which I have been honored by the King is well known, and I can say that after six months in France my labors have received greater remuneration than after six years in Rome. But to be worthily distinguished by royal gifts the myrrh of malevolent deception is also required—the gold of riches and the incense of honors having already been received in abundance. Time will reveal the truth, as it has to my benefit also on other occasions, etc.".

the King. As everyone knows about it, I thought it my duty to write to you, and I advise you, Sir, to write to M. de Lionne or to M. Colbert, asking them to assure the King of the falseness of these reports and to reiterate your gratitude for his generosity and esteem. Forgive my liberty, which is caused only by my eagerness to be of service to you; for the rest I wish you again a good journey, and I remain, etc.[258]

27th October 1665

Sir,

In my letter which went by the last post, I told you of the rumor that was going round that you had left feeling dissatisfied, that the duc d'Orléans had mentioned it, and that the King was convinced of it. On the following day His Royal Highness repeated it to me. I insisted that it could not be so, but he said that the King had it from a source that could not be doubted.

Yesterday evening the King asked me in a whispered aside whether it was true. I assured him that it was not, that on the contrary, I had seen you depart very satisfied with the honor done you, the high esteem in which you were held by His Majesty, and the favors you had received from him. I told him I had informed you of these rumors, so that, Sir, you must write as I asked you, so that the King may be undeceived; you owe it to the King, for the esteem and affection he has for you. I am glad you are having this beautiful weather, and remain, etc.

Most Illustrious Lord and My Dear Patron Most Worthy of Regard,

Today, the 30th of October, we have arrived in Lyons, all in good health by the grace of God and by those graces that are given to me by the great king of France.

I have always recognized in you a great prudence, accompanied by a true bond of friendship, and this is fully confirmed for me by your affectionate letter, to which I reply: if Holy God will give me life, I shall show to His Majesty and to all the world, not with words, but with results, how much I have been grateful to and

[258] Chantelou's first letter, undated in the manuscript was written on 23 Oct.

inspired with love for so grand a king. And so, enough. I salute Your Lordship, Madam, your wife, and my dear gambler.[259]

<div style="text-align:right">

Lyons, 30 Oct. 1665
Of Your Most Illustrious Lordship, your servant,
Gio. Lorenzo Bernini

</div>

[259] Chantelou's brother, Roland. Cf. below, Appendix C, the first letter.

❦ *November* ❦

❦ When I talked to M. Colbert about the rumors and how he could see they were false from the letter he had written me from Lyons, he replied that the Cavaliere had told the Nuncio, and that the abbé Buti had not denied it.

❦ Meeting the abbé Buti in the Louvre chapel, I said to him with a smile that he was missing when we had need of him to help counteract the rumors spread that the Cavaliere had left dissatisfied. While he was in the country I had to deal with everyone who made these suggestions. The King and Monsieur had spoken to me about it. I had tried to undeceive them as best I could. He told me it all came from a formal speech that the Cavaliere made to M. Colbert the day he was leaving; people were not used to his way of talking; in fact he had told M. Colbert that no one but the Pope and the King could have made him leave his home; he would not have left it for 50,000 crowns to oblige anyone else; in this conversation he had not mentioned the King's generosity, but had spoken only of the honor and the affection shown him, for which he would be eternally grateful; from this M. Colbert had inferred that he was not satisfied; besides, as a proof of the falseness of these rumors, it was only necessary to see the letter written by a painter of Lyons called ———— which showed that the Cavaliere had left feeling quite content. I said that he had written to me from Lyons; also an architect called La Monie who is in the service of the Duke of Savoy and who had seen him at Chambéry described to me how he had gone off, covered with honor and delighted with the favors he had received from the King.[1] The abbé said

[1] This letter, which appears later in the manuscript, is in Lalanne.

that these letters must be made public; he added that the Cavaliere could be difficult at times, and that it was hard on these occasions to coax him round. I asked him if he had really said to him that he was dissatisfied; he said no; "or to the Nuncio?" He said no. "Whence comes this rumor then?" He replied that it was started by the wrong interpretation put on his speech to M. Colbert. I told him I had not been present and could not therefore say anything about it; I had arrived just as he was taking his leave of the minister. The abbé Buti told me that M. Colbert's assistant,[2] whose loyalties were elsewhere, had enlarged upon the rumors; they were letting the Italians who remained here die of hunger by failing to give them means of subsistence, so that they would get sick of it and go; the Cavaliere had, while in Lyons, praised the sculptors and van Obstal, but had said that the architects knew nothing. On the 15th June 1668 I gave to M. Colbert a sealed letter which contained the following:

> *The fact that my brother and I have been under an obligation to you, has encouraged us to take the liberty of saying that in our opinion, there is nothing that would bring you greater glory, than to carry out the designs of the Cavaliere Bernini for the Louvre. We have not mentioned it before, Sir, believing that plans for the war, more than any other factor, had forced you to abandon the project. It should not be possible to believe that M. Le Brun who has complained of the little respect accorded him by the Cavaliere, when he went to visit him with members of the Academy, could have inspired this change of policy after the building had been begun, for fear of losing his position as minister in charge of buildings, which he holds under your orders; nor that M. Perrault could be implicated because of the quarrel he had with the Cavaliere; were this so, it would mean that a large and important undertaking was being held up for very small interests indeed.*

I saw M. Colbert on 23rd June, and asked him if he had read my note, and begged him to believe that I had only taken the liberty of telling him what I thought from my eagerness to increase his reputation. He answered that he had seen it, but the Cavaliere's design, although grand and magnificent, was so badly conceived, insofar as it concerned the comfort of the King and the convenience of his rooms in the Louvre, that although it would require an expenditure of ten millions, it would leave his apartment in the Louvre as cramped as it would be without all that expense; it was so unsuitable that before

[2] That is, Charles Perrault.

giving his consent, he would have required ten written orders from the King; the Cavaliere would listen to no criticism on this subject; I answered that he had wanted to make a royal suite in the corner of the Louvre nearest to the Pont-Neuf. He replied that it was ridiculous to want to make apartments for the persons of their Majesties in a part of the palace where it would be necessary to have sentries posted to prevent coaches from driving near the Louvre in the mornings; he had tried to make him understand that the apartments of the King and Queen could be in no other place than where they now were, but he had refused to realize it and had continued to be guided only by his imagination; no one would deny that his design was magnificent and beautiful to look at, but it would spoil the Louvre and cost ten millions and leave the King's apartments much as they were before; he had attempted to create great rooms and halls for everyone but had done nothing for the King; I ought not to think that he had allowed himself to be persuaded by other people; he had in fact heard of the quarrel between M. Perrault and the Cavaliere and had been most surprised by it, as M. Perrault was under his orders; the Cavaliere was a most gifted man but he had too much confidence in his own opinion and would not listen to those of others; he had made the Louvre too high and would do nothing about making it lower while he was in France; however, in a drawing that he had sent from Rome, he had corrected it and brought the height down by ——— feet. I said I feared that, if the Louvre was completed according to the old plan, the ornamentation would appear too small; I and my brother had always thought the original intention was to make the Louvre only a quarter of its actual size. He said he thought so, too. He asked me what I meant by ornamentation. I said the orders; in the original design, they looked right from the distance from which they would be seen, but from further away they seemed to be out of proportion; another point, the courtyard being so wide, arcades would be necessary as protection against sun and rain. He told me there would be arcades, and to house the King properly he was going to build out towards the river; he had been connected with buildings for so long that he was a good enough judge himself of what was needed; he was very happy to have had the opportunity of telling me that he had not been influenced by others. I repeated that only eagerness for his great reputation had impelled me to take the liberty of writing to him; I had not seen what had been done, so I could not discuss it; and bowing to him I retired.

❧ *Postscript* ❧

❧ Chantelou's diary of Bernini's visit ends on 20 October, the day of his departure, though he added a few notes on later events connected with the Cavaliere and copies of two letters that he wrote to him; but the story does not end here.

By the time Bernini left Paris it was obvious that his plans for the Louvre were not going to be carried out and that the ceremonial laying of the foundation stone had been a bluff designed to send him away happy, outwardly at least. Correspondence between Paris and Rome about the plans continued in a desultory way and models were prepared by Mattia de' Rossi based on Bernini's drawings, but the pace got slower and slower and by 1667 it was clear that nothing was going to be built. Colbert put off conveying this decision to Bernini so long that when he wrote, he was able to say that the war which had broken out with Holland made such an undertaking impossible for the moment, though in fact the decision to abandon the Cavaliere's projects had been taken before hostilities broke out. In the same year the King ordered Colbert to set up a commission of three artists; Louis Le Vau, Charles Le Brun, and Claude Perrault—all enemies of Bernini—to design the east front of the palace, the Colonnade, as we see it today. Meanwhile Bernini was at work on a heroic equestrian statue of the King. Judging by the pace at which this advanced he was not interested in it; indeed, it was only a variant of the *Constantine* that he was making for the landing joining the vestibule of St. Peter's to the Scala Regia, and the execution of it was left almost entirely to members of the studio. The statue was ultimately sent to France in 1685—by which time both Bernini and Colbert were dead—and was shown to the King who took a dislike to it and eventually had it taken to a remote part of the gardens of Versailles. Three years later the sculptor, François Girardon, was paid for altering the head of the statue, transforming it into a representation of the ancient hero Mettius Curtius jumping into the abyss to save the city of Rome. It still stands at the end of the Pièce d'Eau des Suisses farthest from the palace, visited by no one.

On leaving Paris Bernini had been given a handsome present of money and the promise of a good pension, but this was not paid after 1674. In 1680, the year of Bernini's death, Colbert was still urging the director of the newly founded French Academy in Rome to persuade Bernini to visit the Academy; but he rarely came.

Thus ended in sadness and frustration one of the grandest projects of the whole Baroque period.

✿ *The Louvre* ✿

✿ Since the problems that faced Bernini in making his designs for the Louvre were largely conditioned by the previous history of the building it may be useful to give a short summary of the palace over previous centuries.

In the Middle Ages the kings of France resided when they were in Paris—which was relatively seldom—in the old palais on the Ile-de-la-Cité (now the palais de Justice), in the palais des Tournelles near the east boundary of the city, or in the hôtel Saint-Pol in the shadow of the Bastille. Thé Louvre was a fortified outpost, outside the city walls to the west. It was originally built by Philip Augustus (1180–1223) and enlarged by Louis IX (1226–70) but it was Charles V (1364–80) who formed it into something more habitable and extended the walls of Paris to enclose it. It was not, however, until 1527 that Francis I announced that he intended to make the Louvre his principal residence. He immediately set about pulling down the keep of the mediaeval fortress in the southwest quarter of what is now the Square Court, but it was only in 1546, a year before his death, that he began to demolish the west wing of the château and to replace it with a wing designed by Pierre Lescot in the new "Italian" style. This block remains today as the southern half of the wing that closes the Square Court on the west. As originally planned there would have been three other wings of the same size, enclosing a court one quarter the size of the present Cour Carrée. When in the reign of Francis I's successor, Henry II, it was decided to double the size of the wings enclosing the court, the original elevation was followed, with the result that, as Bernini observed, the orders are too small for the scale of the wings as built. In the later 16th century the west half of the south wing was built, the Pavillon du Roi was added at the southwest corner of the court, and the Petite Galerie, now the Galerie d'Apollon, was added, running north and south towards the river and linked to the Pavillon du Roi by a narrow passage. (This gallery was destroyed by fire in 1661 and was being restored when Bernini was in Paris.) In 1563 Catherine de Médicis, widow of Henry II, decided to build a palace just outside the walls of Paris in a property called the Tuileries, which belonged to the crown. This remained unfinished because the Queen abandoned it in favor of the hôtel de Soissons within the city, but Henry IV decided to link what had been constructed of the Tuileries to the Louvre by means of the Long Gallery running along the

river. Thus the Tuileries became part of the Louvre complex and had to be taken into account in all future plans. It engendered great complications because its axis was not exactly aligned with that of the Louvre.

Under Louis XIII work on the Square Court continued. The Pavillon de l'Horloge designed by Lemercier was built as the central feature of the west wing which was continued to the north to balance Lescot's original block. During the early years of Louis XIV the south wing was extended to the east and the western half of the north wing was also built. In 1654 Lemercier died and was succeeded as first architect to the King by Louis Le Vau.

The events leading up to Bernini's commission to complete the Louvre have been recounted in the Introduction and need only be summarized here. In 1661 Louis XIV appointed Jean-Baptiste Colbert as his first minister. For the first few years of his administration little was done at the Louvre but in 1664 he was appointed surintendant des bâtiments and immediately began to make plans for the completion of the palace, which meant primarily the construction of the east wing of the Square Court, which would form the principal approach to the palace from the city.

Colbert, who for unknown reasons had a strong prejudice against Le Vau, first applied to François Mansart, who produced a series of brilliantly original designs, but lost the job because he refused to tie himself down to carrying out exactly any one of his plans. Colbert then submitted Le Vau's designs for comments and criticism to various French architects who, naturally, produced designs of their own. Still dissatisfied, he decided to send the designs to Rome for the opinion of the greatest architects active there. In due course the Italians were asked to produce designs of their own. Four of them did so: Carlo Rainaldi, Pietro da Cortona, an otherwise unknown architect named Candiani, and Bernini. We need not be concerned here with the intrigues which went on, but it soon became clear that Bernini was going to get the job.

His first design, which is known from drawings of the plan (fig. 5) and eastern elevation (fig. 6), was a bold Baroque conception based on strongly contrasting convex and concave curves. On its arrival in Paris it was examined by the King and by Colbert, who sent Bernini a series of criticisms, not on the style or invention of the proposed building, but on its convenience. Bernini was outraged but prepared a second design, known only from an elevation drawing (fig. 7), so that we cannot tell how he incorporated Colbert's criticisms into the plan. This second project provoked further comments from Colbert,

but it is not known whether they reached Bernini before he left Rome or, if they did, how he received them.

On arrival in Paris Bernini produced a third plan, which is recorded in a few studio drawings and more completely in the engravings by Jean Marot (figs. 8–12). It is entirely different from the first two designs and consists of a massive block without curves, with four fronts articulated by a giant Corinthian order. Along the inner sides of the Square Court were to be two superimposed open loggias leading to large square staircases in the corners, an arrangement which would have completely concealed all the work of Lescot and his successors. To the east and west of the Square Court were to be added symmetrical sections, each consisting of a vestibule and two small courts leading to two blocks that would have contained suites of state rooms and would have formed the most important façades, one facing east over Saint-Germain-l'Auxerrois (the main approach), the other over the confused area between the Louvre and the Tuileries (fig. 10), which would eventually be cleared to form a giant courtyard.

This was the project that was the basis of all the discussion that took place while Bernini was in Paris. Many of the features over which disagreements arose can be seen in these designs, but some of those mentioned in the *Journal* are not recorded. For instance it is not clear where Bernini originally intended to put the chapel; and the plans do not include either the square that he planned between the east front of the Louvre and the church of Saint-Germain-l'Auxerrois or the "amphitheatre" designed to be somewhere between the Louvre and the Tuileries. Further they do not help to elucidate certain difficult passages in the text, such as the alterations being made to the elevation of the west front (p. 46) or the project for making an extra State Room near the Petite Galerie (p. 315).

ILLUSTRATIONS

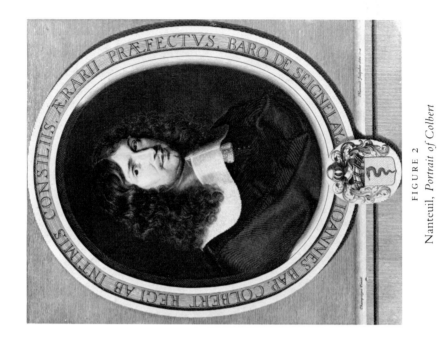

FIGURE 2
Nanteuil, *Portrait of Colbert*

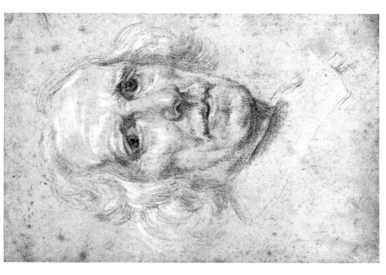

FIGURE 1
Bernini, *Self Portrait*

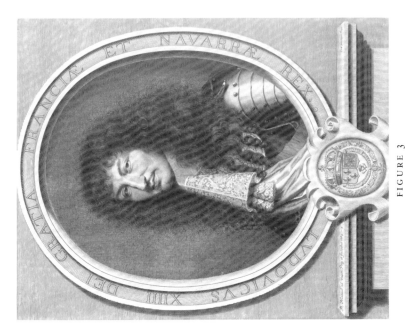

FIGURE 4
Bernini, *Bust of Louis XIV*

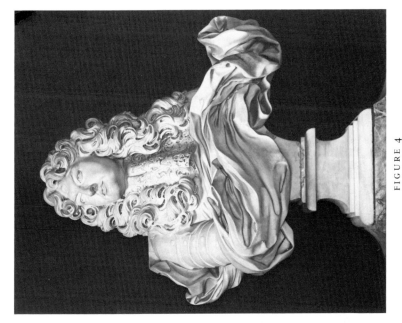

FIGURE 3
Nanteuil, *Portrait of Louis XIV*

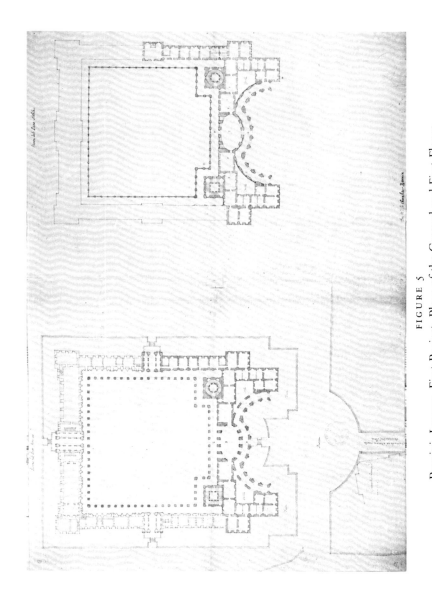

FIGURE 5

Bernini, Louvre, First Project, Plans of the Ground and First Floors

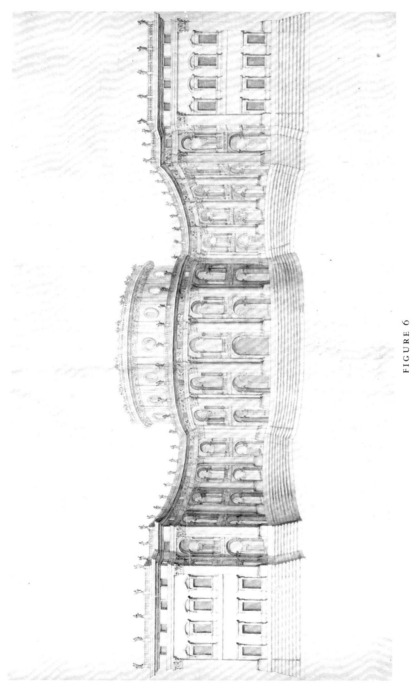

FIGURE 6

Bernini, Louvre, First Project, Design for the East Façade

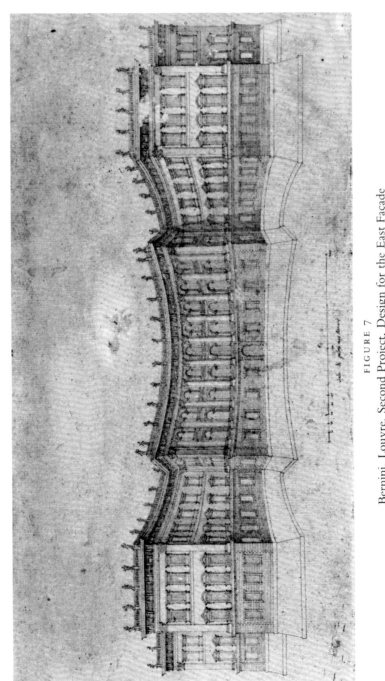

FIGURE 7

Bernini, Louvre, Second Project, Design for the East Façade

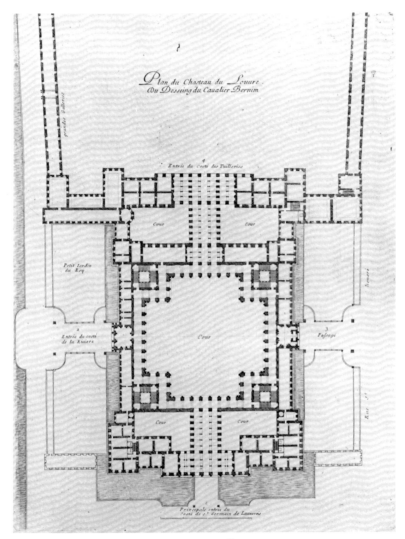

FIGURE 8

Bernini, Louvre, Third Project, Plan of the Ground Floor

Principale Entrée du Chasteau du Louvre du costé de S.t Germain, du desseing du Cavalier Bernin

FIGURE 9

Bernini, Louvre, Third Project, Design for the East Façade

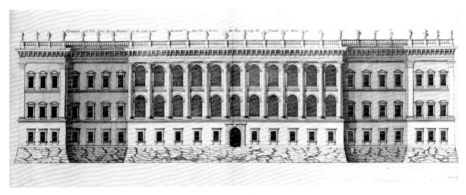

FIGURE 10

Bernini, Louvre, Third Project, Design for the West Façade

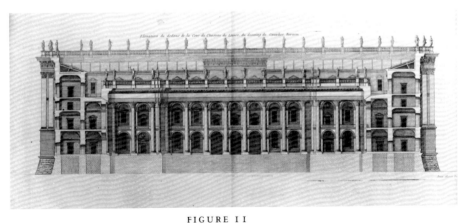

FIGURE 11

Bernini, Louvre, Third Project, Design for the Courtyard Façade

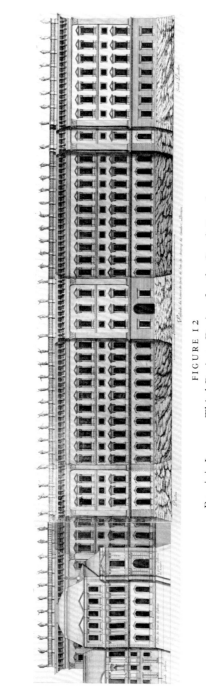

FIGURE 12

Bernini, Louvre, Third Project, Design for the South Façade

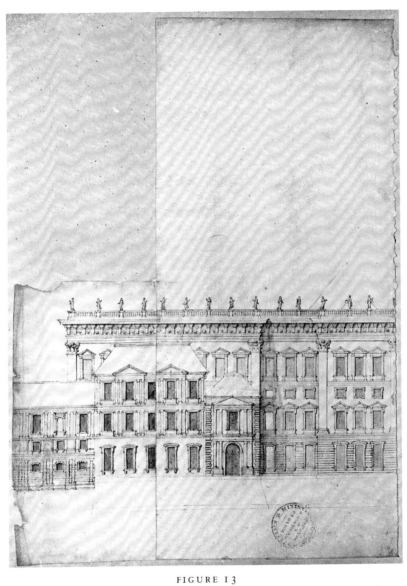

FIGURE 13

Bernini, Louvre, Third Project, Design for the Junction of the South
Façade with the Existing Building

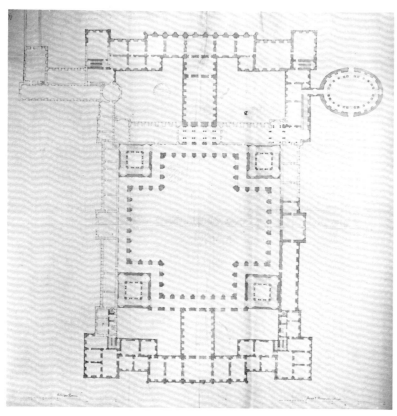

FIGURE 14
Bernini, Louvre, Fourth Project, Plan of the First Floor

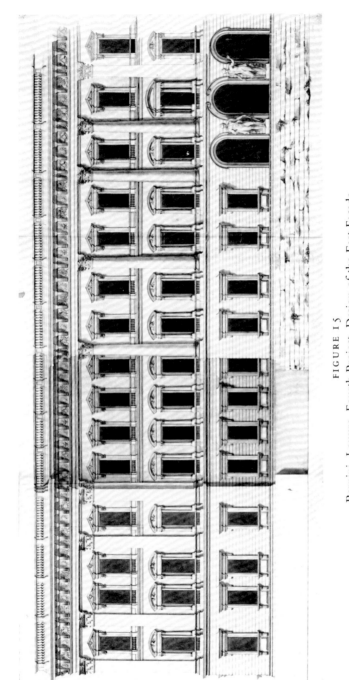

FIGURE 15

Bernini, Louvre, Fourth Project, Design of the East Façade

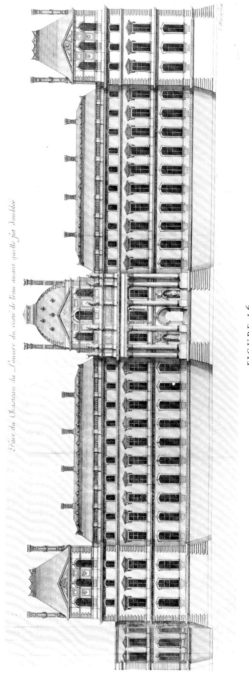

Face du Chasteau du Louvre du costé de l'eau auant qu'elle fut doublée

FIGURE 16

Le Vau, Louvre, South Façade

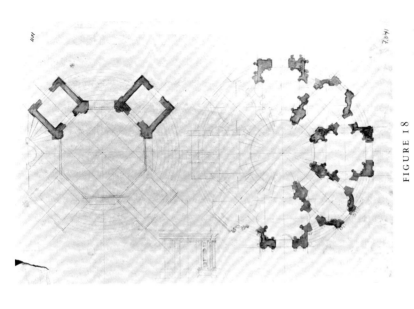

FIGURE 18

Bernini, Two Projects for the Bourbon Chapel
at Saint-Denis

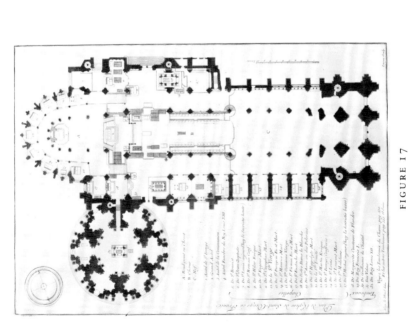

FIGURE 17

Plan of the Abbey Church of Saint-Denis

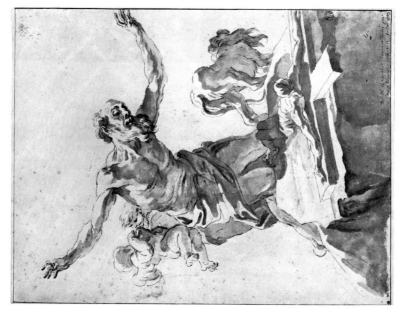

FIGURE 20

Bernini, *The Penitent St. Jerome*

FIGURE 19

Paolo Bernini, *The Christ Child Playing with a Nail for the Cross*

🌿 *A Note on Bernini and the Theatre* 🌿

🌿 Like other artists of his time, Bernini was often called upon to provide designs for the many festive and theatrical events that gave form, color, and texture to the religious and political life of Rome. This ephemeral art ranged from architectural decorations of wood, canvas, and plaster through processional floats and displays of fireworks to actual stage sets. Unlike most artists, however, Bernini cultivated the theatre as a vital and autonomous expression of his personality (cf. Chantelou's comment, 6 June), producing from the early 1630s a series of comedies that he wrote, designed, directed, acted, and according to one report (John Evelyn), for which he even composed music. Because they were both modest and personal—he produced them himself, eventually in his own "theatre," prided himself on their costing no more than a few pennies, used his studio hands as actors, and accepted only space to perform and protection from influential patrons—his comedies have left few traces beyond a certain notoriety. Consequently, they remain something of a mystery, although many individual details are known.

According to Domenico (p. 54), Bernini's son, what was beautiful and marvelous in the comedies consisted primarily "in satirical and witty sallies and in the invention of stage effects." Bernini himself describes some of his most famous stage illusions (26 July, 5 Oct.), and many sources confirm his audacious and pungent wit. Of the two, it was the latter that most amazed his contemporaries: "Everyone is astonished at how freely he speaks, and it seems strange that he dares offend so many people in public" (letter of 1633, in Fraschetti, p. 261, n. 1). At the same time this made his comedies truly funny: "Monday the Cavaliere produced a comedy that he had composed in which there are things to make anyone who has experience of the Court die with laughter, because everyone, high or low, prelate or cavaliere, especially if he is Roman, has his part" (Fulvio Testi, letter of 1633, in the S. S. Ludovisi ed. of Baldinucci's life of Bernini, Milan, 1949, pp. 262–63). The fact that Bernini directed his biting gibes and pointed barbs "against many of this Court and against the corrupt customs of our century" led those of his audience who were so inclined to compare his comedies to the *commedia all'antica* (Fraschetti, p. 261, n. 3; Dom. Bernini, p. 54). More immediate sources were the modern Italian comedy and the *commedia dell'arte*, from which Bernini drew his stock of characters speaking in dialect—Dottore Graziano, Zanni, Coviello,

etc.—a lively air of improvisation, and a certain crudity or licentious-
ness that was apt to offend the fastidious.

This vulgar buffoonery was disingenuously concealed in ambi-
guity and double-entendre: "The comedy of the Cavaliere Bernini has
been recited twice in the palace of Donna Olimpia. If the equivocations
of which it is full are carefully examined, the liberties it takes are
scandalous, so that Cardinal Caraffa and other scrupulous persons who
attended were greatly indignant. But if the equivocations are consid-
ered in relation to the actual subject matter, it is both merry and
decent" (Francesco Mantovani, letter of 1646, in Fraschetti, p. 268,
n. 1). Similarly, those whom he held up to ridicule were never named,
but more or less transparently masked by symbol or parody. In one
play, an ox brought on stage and cudgeled was recognized with laugh-
ter as a Borgia, whose family coat-of-arms contained a bull (Fraschetti,
p. 261, n. 1); in another, "Dr. Graziano was played by the Cavaliere
himself and many in the audience saw in this character the Marchese
Mario Frangipani and the Office of Counsellor that he holds with His
Holiness. Coviello was the brother of Bernini, who played a bigot
and pietist, so that everyone identified him with Cardinal Francesco"
(Francesco Mantovani, letter of 1646, in Fraschetti, p. 268, n. 1).

Just what form the comedies took, however, is not clear. The
satire of contemporary figures suggests something analogous to a
modern review, but the probably unfinished text for a comedy dis-
covered and published by Cesare D'Onofrio (*Fontana di Trevi*) is con-
ventionally, if loosely, plotted, with all the parts written out. In at
least one instance there was even a moral to the story: "the entire
subject of the comedy was limited to showing how much false good-
ness in this world jeopardizes the next, and with what severity this
deception is finally punished by God" (Massimiliano Montecucoli,
letter of 1638, in Fraschetti, pp. 264–65). These indications, coupled
with the fact that his parodies were developed by characters involved
in the plot, suggest that his plays took the form of a normal comedy
in which major and minor incidents lead to a denouement.

The role of scenography in Bernini's productions is also not en-
tirely clear. Although widely known for his astonishing stage effects,
in the most famous of these—the Inundation of the Tiber and the Fire
(described above, 5 Oct.)—it was evidently not the technical content
that was so original, but the illusion they created that art and life had
unexpectedly collided. As Irving Lavin (review of D'Onofrio, *Fontana
di Trevi* in *AB*, XLVI, 1964, pp. 568–72) has shown, this sudden "thrust
to heart and mind" depended less on stage engineering than on the
artist's subtle psychological calculation, or to quote Bernini's char-

acter, Dottore Graziano, as he does, "Ingenuity—design—is the magic art by means of which one so deceives the eye as to create amazement" (D'Onofrio, *Fontana di Trevi*, p. 74).

In Bernini's theatre what was real and what was feigned were constantly undergoing kaleidoscopic inversions: conventional *commedia dell'arte* masks were parodies of real people, stage effects threatened to involve the audience, and a continuous parade of real carriages, horses, asses, and people were part of the set, a practice that Passeri found "completely against the rules, which permit no one on the stage who is not involved in the plot" (Passeri-Hess, p. 389). But stage machinery as such contributed little to this effect. In at least some of his productions, there were few scenes. The *Two Theatres* had only two, at the beginning and at the end; and for the comedy with the Inundation of the Tiber, there were three—beginning, middle, and end—along with a collapsing house (descriptions in Fraschetti, pp. 262–65). Changes of scene that took place in sight of the audience, for which the elaborate machinery was designed, were also probably used sparingly. In the *Two Theatres* the scene was changed behind the curtain, which then fell to reveal the new set. In an actual transformation scene, such as the Fire (and possibly the Inundation of the Tiber) Bernini employed the traditional expedient of distracting the audience's attention from what was happening on stage, but the distraction he created was at once so thoroughly unexpected and so apparently accidental and uncontrolled that the change itself passed unnoticed and the new scene was greeted with relief. In no instance would complex machinery have been required. Thus it was that Bernini could put on productions that cost little, yet nevertheless succeeded "in making appear true what was in substance false" (Dom. Bernini, p. 57).

🐦 *Seven Letters from Bernini to Chantelou* 🐦

My Most Illustrious Lord and Patron Most Worthy of Regard,

My dear friend, how much I cherish you, for in you I have known a man of great prudence, as well as a true and royal bond of friendship rarely found among men. I arrived in Rome in the best of health, as did all the others, Signor Mattia excepted, who at first was not able to regulate his bowels. The trip seemed to me brief, though in truth it is very long. I think this happened because I was so well satisfied and so well contented in mind and spirit by the special favors and grand gifts I received from His Majesty that nothing could upset me. All of the princes whom I have seen on the way and in Rome have exhausted me with their requests to see the drawings for the Louvre, and all of them recognized there the great soul and mind of the King; and I myself have confessed that without his wisdom and sublime thoughts I should not have been able to do what I did. And if it pleases God that this building be begun, I do not know that I shall be able to keep myself from seeing it, because it is so much to my taste and so fixed in my mind that I almost always think of it and even draw various parts of it.

I beg you to salute in my name Madam, your wife, and tell her that I found the abbé de La Chambre a most agreeable young man (although a little too respectful). I salute too that sorry figure of a gambler, your brother. Advise me if he has received my letter from Lyons. You, my dear friend, I salute more in my heart than in my words, and I beg you to remember me in your prayers and to continue to write me.

I have found that M. Poussin is dead.

Rome, the 8th of December 1665.

Most Illustrious Lord and Patron Most Worthy of Regard,

This week I have had letters from no one in Paris, so that in truth I can say that already everyone has forgotten me, as well they may. But I have no right to forget so quickly the good company and counsel that I know Your Lordship has given me. Now in Rome, as so often on the way, I cannot resist showing the drawings for the Louvre; and all who see them know that the wisdom and high thoughts of His Majesty enabled me to do that which alone I should never have known

how to do. My Lord, you will never be able to imagine how much I have been inspired with love for the King and for this building of the Louvre. I constantly think of it and make some design for its perfection. I indulge myself because it is something entirely fit to my taste. Many princes would like to have a bronze cast of the portrait of His Majesty, and it is so impressed on my mind that I think I can reproduce it without seeing it. I hope within a month to finish the work on the Cathedra and intend immediately to begin the statues of Hercules for His Majesty. I salute Your Lordship with all my heart, Madam, and your brother.

<div style="text-align:right">

Rome, 14 December 1665.
Your Devoted and Obedient Servant,
Gio. Lorenzo Bernini

</div>

My Most Singular Lord,

I have received by the last regular courier two of your letters that had been written well before they were posted. They are completely filled with affection and love, and every day I know better your true friendship and your prudence, to which I cannot reciprocate with anything other than a sincere and deep affection. I, by the grace of God, have finished the work on the Cathedra and have immediately set to work on the designs for the building of the Louvre. Signor Mattia, after having had fever for a month, with the aid of God is now healthy again and wants to depart in a few days. But because he is so recently recovered and the weather is very severe, no one agrees with him, for it seems to everyone that he is putting his health in manifest jeopardy. I equivocate, because on one hand, I prize his health, but on the other, I would dearly like to see this building progress quickly, since I hope I shall be able to see it, as well as to enjoy some day your good conversation. My wife salutes Your Lordship, and Paolo, as do we all, most cordially bends his knee.

<div style="text-align:center">

Rome, the 30th of January, 1666, etc.

</div>

My Most Illustrious Lord,

Signor Mattia will present this note to Your Lordship and recall to you the memory I hold of your rare virtues and firm bond of friendship and that I am entirely at your service. Signor Mattia is there willingly to serve His Majesty, but also because he knows how much I prize this work of the Louvre and can offer me no greater mark of

gratitude. I, on the other hand, cordially loving him for his virtues and excellent qualities, recommend him to Your Lordship, declaring that all you will do to favor him shall be to me as if it were done for Paolo, my son. I beg you to salute your wife and brother, and to you, I bend my knee with all my heart.

Rome, 2 March 1666.

I took great pleasure in receiving your letter, remembering always, as I do, your good company, the favors you have shown me, the good example you have set me, and the patience with which you bore the infinite number of my failings while I was in Paris. Signor Colbert has sent the orders for the payment of my pensions directly to my house, and I ought to go directly to Paris to thank him. I beg you please to thank him in my name and to say that seeing me and Paolo in Paris depends on the construction of the Louvre. To be able to see the model is my great passion, although I see it with the mind's eye and it seems to me to be the least bad thing I have ever done. And in as much as I am approved by your judgment, I believe it all the more, knowing what good taste you possess in these matters. I beg you to salute your consort in my name, telling her that it is not true that distance heals great wounds, for even though I am far away, my affection for her is greater than ever. I salute, too, your excellent brother, and to you I bend my knee, most humbly and with all my heart. Your name is often mentioned to the Cardinal legate, who truly wishes you well. Farewell, my dear friend.

Rome, the 30th of January, 1667.

It is two weeks since I have had a letter from Signor Mattia; I fear for his health.

Today, the 18th of July, Signor Mattia, together with his lady wife, has arrived in Rome in the most excellent health. He has brought me a letter from Madam, which reveals that the affection we share has not yet ceased. I am quite blazing with choler over M. l'abbé and how he behaves. He clearly lets me know that I have not been able to serve him in anything. Patience! Also, an agreeable gentleman arrived here in Rome during the past days, whom your letter introduced as a relative, but because he understands no Italian, we saw little enough of one another. I, meanwhile, keep always an eternal memory of the favors that I have always received from you, to whom,

along with Madam and your most excellent brother, I most humbly bend my knee.

Rome, the 18th of July, 1667.

My Most Illustrious Lord,

Your letter arrived while you were in my thoughts. Concerning the young painters, I reply that I am doing—and neither for charity nor for the obligation that I profess to their masters—more than I need have. I have great reason to rejoice in the death of your brother because he was a good man and as such through the infinite goodness of God must be in Paradise.

The house that you have had built, the place you have given to the bust of the King, and the acquisitions you have made of further paintings must all be worth seeing, since your lively intelligence and good taste could not produce other than beautiful things, and I see and enjoy them with my mind's eye.

My Lord, the recollection of you and your company ever more obliges my affection and I keep you fixed in my memory. I believe that to see one another again in this world is to be desired, but not hoped for; let us therefore seek to see one another in heaven, trusting thus in the infinite goodness of God.

The statue of the King on horseback has been finished for a while now . . . but after they see it, they will find it of small value; but because the other gentlemen are prudent, discreet, and full of courtesy, they will pardon me.

I beg you to salute affectionately Madam Chantelou and say to her that I would be contented if she should give to me one tenth of that heartfelt affection which I bear for my Lord Chantelou.

Rome, the 18th of December 1678.
Gio. Lorenzo Bernini

❧ Bibliography and Abbreviations ❧

AB	*Art Bulletin*
BM	*Burlington Magazine*
BSHAF	*Bulletin de la société de l'histoire de l'art français*
GdBA	*Gazette des Beaux-Arts*
JWCI	*Journal of the Warburg and Courtauld Institutes*

Ackerman, J. *The Architecture of Michelangelo*. London, 1964.

Alberti, L. B. *On Painting and On Sculpture*. The Latin texts of *Depictura* and *De statua*, ed. with trans. by C. Grayson. London, 1972. 1972.

Baglione, G. *Le vite de' pittori, scultori et architetti*. . . . Rome, 1642.

Baldinucci, F. *Notizie dei professori del disegno da Cimabue in qua*, ed. P. Barocchi. Florence, 1975.

————. *Vita del Cavaliere Gio. Lorenzo Bernino: scultore, architetto, e pittore*. Rome, 1682. Cited here in the English trans. by C. Enggass, University Park, Pa., 1966.

————. *Vocabolario toscano dell'arte del disegno*. Florence, 1681.

Bauer, G. C. *Bernini in Perspective*. Englewood Cliffs, N.J., 1976.

Bellori, G. P. *Le vite de' pittori, scultori et architetti moderni* . . ., ed. E. Borea. Turin, 1976.

Berger, R. W. *Antoine Le Pautre. A French Architect of the Era of Louis XIV*. New York, 1969.

Bernini, D. *Vita del Cavaliere Gio. Lorenzo Bernino*. Rome, 1713.

Bernini in Vaticano. Exh. Cat. Braccio di Carlo Magno, Vatican City, 1981.

Blunt, A. *Art and Architecture in France 1500 to 1700*. Harmondsworth, Middlesex, 1973.

————. *Nicolas Poussin*. New York, 1967.

————. *The Paintings of Nicolas Poussin. A Critical Catalogue*. London, 1966.

Bonnaffé, E. *Dictionnaire des amateurs français au XVIIᵉ siècle*. Paris, 1884.

Braham, A., and P. Smith. *François Mansart*. London 1973.

Brauer, H., and R. Wittkower. *Die Zeichnungen des Gianlorenzo Bernini*. Berlin, 1931.

Brice, G. *Description nouvelle de* . . . *la ville de Paris*. Paris, 1684. Ed. cited here, Paris, 1706.

Charles Le Brun 1619-90, peintre et dessinateur. Exh. Cat. Château de Versailles, 1963.

Clément, P. *Lettres, instructions et mémoires de Colbert*. Paris, 1861–82, vol. v.

Depping, G. B. *Correspondance administrative sous le règne de Louis XIV*. Paris, 1850–55, vol. iv.

Dolce, L. *Dialogo della pittura*. In M. W. Roskill, *Dolce's "Aretino" and Venetian Art Theory of the Cinquecento*. New York, 1968.

D'Onofrio, C. *Gian Lorenzo Bernini, Fontana di Trevi: Commedia inedita*. Rome, 1963.

————. *Roma vista da Roma*. Rome, 1967.

Drawings by Gianlorenzo Bernini. Exh. Cat. Princeton, The Art Museum, Princeton University, 1981.

Dussler, L. *Raphael*. London and New York, 1971.

Fraschetti, S. *Il Bernini*. Milan, 1900.

Garboli, C. and E. Baccheschi. *L'opera completa di Guido Reni*. Milan, 1971.

Gnudi, C., and G. C. Cavalli. *Guido Reni*. Florence, 1955.

Gould, C. *Bernini in France*. Princeton, 1982.

Guiffrey, J. *Inventaire général du mobilier de la couronne sous Louis XIV (1663–1715)*. Paris, 1885–86.

————. *Les comptes des bâtiments du roi sous le règne de Louis XIV*. Paris, 1881–1901, vol. i.

Harris, A. S. *Selected Drawings of Gian Lorenzo Bernini*. New York, 1977.

Hautecoeur, L. *Histoire de l'architecture classique en France*. Paris, 1943–48, vols. i–ii.

Jal, A. *Dictionnaire critique de biographie et d'histoire*. Paris, 1867.

Jouin, H. A. *Charles Le Brun et les arts sous Louis XIV*. Paris, 1889.

Krautheimer, R. and R. B. S. Jones. "The Diary of Alexander VII: Notes on Art, Artists, and Buildings." *Römisches Jahrbuch für Kunstgeschichte*, 15, 1975, pp. 199–225.

Laurain-Portemer, M. "Mazarin et le Bernin: à propos du 'Temps qui découvre la Vérité.' " *GdBA*, lxxiv, 1969, pp. 185–200.

Lavin, I. *Bernini and the Unity of the Visual Arts*. New York and London, 1980.

Lee, R. *Ut pictura poesis: The Humanistic Theory of Painting*. New York, 1967.

Lomazzo, G. P. *Trattato dell'arte della pittura, scoltura et architettura*. Milan, 1584. Ed. cited here, Rome, 1844.

Mahon, D. *Studies in Seicento Art and Theory*. London, 1947.

Malvasia, C. C. *Felsina pittrice, Vite de' pittori bolognesi*, ed. G. Zanotti. Bologna, 1841.

Mancini, G. *Considerazioni sulla pittura*, ed. A. Marucchi and L. Salerno. Rome, 1956–57.

Mirot, L. "Le Bernin en France." *Mémoires de la société de l'histoire de Paris et de l'Ile-de-France*, XXXI, 1904, pp. 161–288.

Passeri, G. *Vite de' pittori, scultori ed architetti . . .*, ed. J. Hess. Leipzig and Vienna, 1934.

Pastor, L. von. *The History of the Popes*. London, 1891–1953.

Perrault, Ch. *Mémoires de ma vie*, ed. P. Bonnefon. Paris, 1909.

Pevsner, N. *Academies of Art Past and Present*. Cambridge, 1940.

Pignatti, T. *Veronese*. Venice, 1976.

Posner, D. *Annibale Carracci. A Study in the Reform of Italian Painting around 1590*. New York and London, 1971.

Poussin, N. *Correspondance de Nicolas Poussin*, ed. C. Jouanny. Paris, 1911.

Rouchès, G. *Inventaire des lettres et papiers manuscrits de Gaspare, Carlo et Lodovico Vigarani . . . 1634–1684*. Paris, 1913.

Schiavo, A. "Il viaggio del Bernini in Francia nei documenti dell' Archivio Segreto Vaticano." *Bollettino del centro di studi per la storia dell'architettura*, X, 1956, pp. 23–80.

Serlio, S. *Tutte l'opere d'architettura et prospetiva*. Venice, 1619.

Tessin, N. "Osservationi dal discorso der Sig:or Cav:ro Bernini." In B. K. Kommer, *Nicodemus Tessin der Jüngere und das Stockholmer Schloss*. Heidelberg, 1974, pp. 158–61.

Thuillier, J. "Académie et classicisme en France: Les débuts de l'Académie Royale de Peinture et Sculpture (1648–1663)." In *Il mito del classicismo nel Seicento*. Florence, 1964, pp. 183–84.

Vasari, G. *Le vite de' più eccellenti pittori, scultori ed architettori*, ed. G. Milanesi. Florence, 1878–81.

Wethey, H. E. *The Paintings of Titian, I: The Religious Paintings*. London, 1969.

Wittkower, R. *Gian Lorenzo Bernini. The Sculptor of the Roman Baroque*. London, 1966.

———. *Bernini's Bust of Louis XIV*. London, 1951.

🦢 *Index* 🦢

Index

LIBRARY OF CONGRESS
CATALOGING IN PUBLICATION DATA

Chantelou, Paul Fréart de, 1609–1694.
Diary of the cavaliere Bernini's visit to France.

Translation of: Journal du voyage en France
du cavalier Bernin.
Bibliography: p. Includes index.

1. Bernini, Gian Lorenzo, 1598–1680—Journeys—France.
2. France—Description and travel. I. Blunt, Anthony,
1907–1983. II. Bauer, George C. III. Title.

N6923.B5C513 1985 709'.2'4 85–42680
ISBN 0–691–04028–1 (alk. paper)